BODYBUILDING

BODYBUILDING

REFORMING MASCULINITIES IN BRITISH ART 1750–1810

PUBLISHED FOR THE PAUL MELLON CENTRE FOR STUDIES IN BRITISH ART BY

YALE UNIVERSITY PRESS NEW HAVEN AND LONDON

Designed by Paul Sloman

Printed in China

Library of Congress Cataloging-in-Publication Data

Myrone, Martin.
 Bodybuilding : reforming masculinities in British art 1750-1810 / Martin Myrone.
 P. CM.
 Includes bibliographical references and index.
 ISBN 0-300-11005-7 (CL : ALK. PAPER)
 1. Masculinity in art. 2. Heroes in art. 3. Art, British–18th century.
 4. Art and society–Great Britain–History–18th century. I. Title.
 N8222.M38M97 2005
 704.9'423'094109033--DC22
 2005012041

CONTENTS

Acknowledgements VI

INTRODUCTION Masculinity as Cultural Work in Eighteenth-Century Britain I

PART ONE 'Our Arts May Hope for New Advances':
 The State of the Arts 1755–65 15

1 Reforming the Hero: London in the Early 1760s 23
2 Gavin Hamilton and Rome in the 1760s 47
3 James Barry in France and Italy 75

PART TWO 'Over-stocked with Artists of all Sorts':
 The State of the Arts 1765–75 95

4 General Wolfe among the Macaronis 105
5 Outlaw Masculinity: John Hamilton Mortimer in the 1770s 121
6 Alexander Runciman in Rome and Edinburgh 145
7 Henry Fuseli and Thomas Banks in Rome 163

PART THREE 'A Weak Disjointed Age':
 The State of the Arts 1775–85 191

8 The American War and the Heroic Image 201
9 Gothic Romance and Quixotic Heroism: Fuseli in the 1780s 227
10 The Male Nude at the Royal Academy 253
11 'Three Young Sculptors' of the 1790s 275

 'I Never Presum'd to Class the Painters':
 The State of the Arts 1785–1800 295

CONCLUSION Genius, Madness and the Fate of Heroic Art:
 Blake and Fuseli in the Nineteenth Century 305

 Notes 315
 Selected Bibliography 370
 Photograph Credits 374
 Index 375

ACKNOWLEDGEMENTS

This book has been in development for a decade, in the contexts of formal study and professional life as a curator, and has been shaped in decisive ways by both. The germ of the book and the approaches represented here were planted while an undergraduate student at University College, London, where the teaching of David Bindman on Fuseli, Blake and eighteenth-century British art, and the questioning approach to art history which prevailed there have had a lasting influence. At the Courtauld Institute, where I studied subsequently, I was first taught by David Solkin and Katie Scott, both of whom represent the standard of scholarly integrity and professional dedication. David, with Tamar Garb, supervised my Ph.D. thesis, patiently seeing the text develop through a succession of treatments. The present volume derives from, expands upon and revises very considerably, the resulting study: 'Body-building: British Historical Artists in London and Rome and the Remaking of the Heroic Ideal 1760–1800' (Ph.D., Courtauld Institute of Art, 1998). David Solkin's research and publications are among the most searching and influential in the whole field of British art history, and I have been truly fortunate to have had his advice, his guidance, and his support, as a student and latterly. Alex Potts and William Vaughan were the examiners of the thesis; their encouragement and insightful comment were crucial to the further development of the study.

I was fortunate at the end of my postgraduate studies to be able to take a post in the project team of the nascent British Galleries at the Victoria and Albert Museum, among inspirational colleagues, including Leela Meinertas and Christopher Wilk, who affirmed the possibility for a real, critical engagement with visual culture in the context of a museum. Also at the Museum at this point was Malcolm Baker, whose studies in the history of sculpture and in the realm of historiography and methodology have informed the thinking behind this book in important ways. I subsequently joined the exhibitions and display team at Tate Britain, where the Director, Stephen Deuchar, has been unremitting in his support of innovative research and new curatorial approaches. His very great efforts have established Tate Britain as a vital centre for the research and interpretation of British art. The stimulating setting of Tate Britain has encouraged and informed this study; I have been privileged to work alongside some of the most creative people working in the fields of historic, modern and contemporary British art and art publishing, and to experience at first hand the real and pressing questions of identity and cultural value at stake in the practice of art history. Additionally, Tate Britain was kind enough to grant me a period of leave with the financial support of the Paul Mellon Centre for Studies in British Art in the winter of 2001–2, allowing me to develop several new aspects of the present study and to work on a draft of the final text.

There are many further individuals I would like to thank. John Sunderland kindly shared his knowledge of John Hamilton Mortimer, and gave me access to his collection of photographic records relating to the artist. Ted Gott checked the files of the National Gallery of Victoria regarding their Gainsborough portrait of an *Officer of the Fourth Regiment of Foot* and made several useful suggestions. Phil Hudson, Nick Harling, and Peter and Sheila Harling generously shared their knowledge of Thomas Procter with me. John Barrell's incisive response to a paper I presented at the University of York in 2000 helped steer my work in a whole new direction; his scholarship has been a guiding influence on the present work. Michael Rosenthal, with whom I co-curated the Thomas Gainsborough exhibition (Tate Britain, 2002–3), has offered many

fruitful thoughts and encouragement. Anne Puetz, Sarah Monks and Lucy Peltz have sustained and shaped this project in many ways: I have been lucky to enjoy their friendship and conversation, as well as the fruits of their exemplary research in eighteenth century British art. Victoria Worsley knows better than anyone the sometimes taxing history of this text; her personal support was a vital ingredient in the genesis of the book. The present study has benefited from suggestions, advice and assistance from many more people, including: Susan Bennett, John Bonehill, Carol Brown, Luisa Calè, Ulf Cederlof, Matthew Craske, Fintan Cullen, Duncan Forbes, Christopher Frayling, the late Richard Godfrey, Jackie Hunt, Valerie Hunter, Karen Junod, Alex Kidson, Corinne Miller, Nathalie Padilla, Tamzin Phoenix, Marcia Pointon, Kate Retford, Nick Savage, Tessa Sidey, MaryAnne Stevens, Marjorie Trusted, Helen Valentine, Laura Valentine, Phillip Ward-Jackson and Helen Watson. My warmest thanks, and growing debt, are due to Felicity Kerr, for reasons which have already multiplied, and will, I know, proliferate.

I would also like to thank all those private individuals and the institutions who have supplied the illustrations used in this volume and granted permission for publication. I would particularly like to thank the staff of the photographic libraries at the Courtauld Institute including Barbara Thompson, Jane Cunningham, Matthew Percival, Geoffrey Fisher, and at the Paul Mellon Centre for Studies in British Art, where Mary Smith has been particularly helpful. I would also like to thank in particular the Witt Library, the Conway Library, the Photographic Survey at the Courtauld Institute and the Paul Mellon Centre for Studies in British Art for kindly supplying many of the photographs. Colleagues at the Department of Prints and Drawings at the British Museum have been unstinting in their assistance. I would like to thank Antony Griffiths and Sheila O'Connell in particular for their help and for granting permission to reproduce so many works from the collection.

At Yale University Press, Gillian Malpass offered patient support for this book project, while Paul Sloman succeeded Sarah Faulks as the appointed editor, overseeing the production of the finished volume. The material support of the Paul Mellon Centre for Studies in British art has been essential to the realisation of this project. Mark Hallett and an anonymous reader read the whole manuscript, at perhaps its most cumbersome: their support, and their perceptive comments, are warmly appreciated.

Some of the material on Fuseli appearing here in chapters 7, 9 and 10 appeared in a different form in my book Henry Fuseli (Tate Publishing, London, 2001). The discussion of Fuseli and of exhibition culture in part three develops ideas presented by me in 'The Spectacle of the Sublime: The Transformation of Ideal Art at Somerset House' in David Solkin ed., *A Rage for Exhibitions: The Royal Academy at Somerset House, 1780–1836*, (Yale University Press, New Haven and London, 2001). The discussion of Thomas Robinson and the Grand Tour in the 1760s in chapter two is expanded in 'Taste, Travel and the Reform of Culture in the 1760s', in *Drawing from the Past: William Weddell and the Transformation of Newby Hall* (Leeds Museums and Galleries, City Art Gallery, 2004).

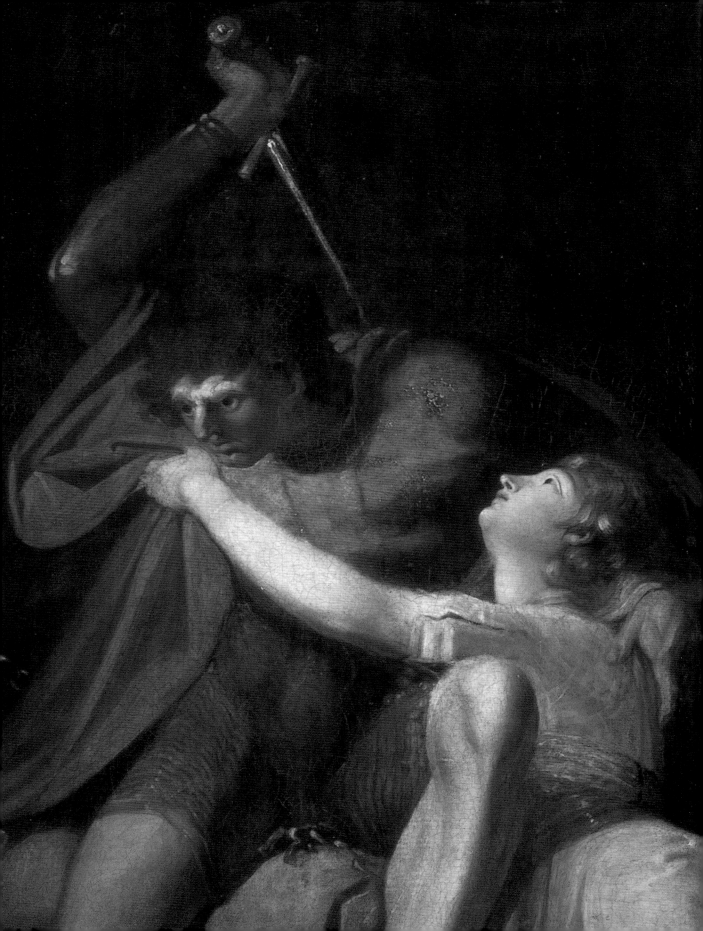

INTRODUCTION

MASCULINITY AS CULTURAL WORK
IN EIGHTEENTH-CENTURY BRITAIN

AUTHOR: *Pray, what are the ingredient qualities of which a hero is compounded? what idea have you formed of such a personage? tell me, I beseech you, what is a hero, my good friend?*

FRIEND: *Pshaw! – what a question – every fool knows that. – A hero is – as though one should say – a man of high atchievement [sic] – who performs famous exploits – who does things that are heroical – and in all his actions and demeanour, is a hero indeed – why do you laugh – I will give you the instances approved throughout the world; recorded and duly celebrated by poets, painters, sculptors, statuaries and historians. – There was the Assyrian Ninus, the Sesostris of Egypt, the Cyrus of Persia, the Alexander of Greece, the Caesar of Rome, and, partly in our own days, there was the Conde of France, the Charles of Sweden, and Persia's Kouli Kan. – What the plague does the fellow laugh at?*[1]

The question asked by Henry Brooke's 'Author' in this excerpt of dialogue from his novel *The Fool of Quality* (1765–70) was posed repeatedly throughout the eighteenth century, and never more than in the decades after 1760, when Britain underwent some of its most traumatic transformations and the newly forged empire became both a source of unexampled power and an acute liability. The issues this enquiry raised about masculine authority, exemplarity and virtue were deeply felt by individuals seeking to insert themselves into the emerging social order – a social order now recognized as distinctly, representatively modern – and were publicly addressed in novels and histories, political debate, essays, poems, and – the primary focus of this book – paintings and sculptures. From the 1760s, the definition of cultural forms that could represent exemplars of heroic virtue effectively for a contemporary Britain became an urgent project, subscribed to by social groups who had previously either neglected such concerns entirely, adopted them only superficially, or affiliated themselves with alternative models of virtue that did not require elevated cultural expression. Painters and sculptors were encouraged to believe that, by creating heroic images like those of the acknowledged masters of art from antiquity and sixteenth-century Italy, they could reap material rewards and contribute to a flourishing national

(Facing page) Henry Fuseli, *Perceval Delivers Belisane from the Enchantment of Urma*, detail of fig. 137.

culture. They could become, like Phidias or Michelangelo, heroic in their own person – giants in their fields, acclaimed in the present day, commemorated in future eras.

But it is the 'friend's' answer, or rather that broken statement that fails to establish an effective response and disintegrates into tautology, that reveals more of the truth of the situation. Even as the question 'what is a hero?' became insistent, searching for an answer was not only difficult but might also itself inspire scepticism or ridicule. Brooke's 'friend' recommends a succession of conquerors and warriors, from Ninus, the warlike founder of the ancient Assyrian Empire, to 'Kouli Kan' (Nadir Shah), the ruler of Persia who had successfully invaded India at the end of the 1730s. His 'author' goes on to propose, instead, that the most admirable heroes of history were to be found among lawmakers, pacifists and humanitarians, and that the greatest hero of modern times was Don Quixote.

The protagonist of Miguel de Cervantes's much-read novel, first published in 1605–15, had been inspired by 'romantic stories' to become a knight errant, 'at a time when the regulation of society had rendered the profession unnecessary, and indeed illegal'.[2] For commentators of the eighteenth century, Quixote's self-destructive madness revealed the anachronism of the martial values promoted in chivalric romance, the absurdity of acting like an epic hero in an age of commerce, enlightenment and social refinements. For all the noble qualities ascribed to him by some, Cervantes's hero was in this context inescapably a comical character, a fool whether self-deluding or simply deluded. Brooke's 'author' proclaimed him an exemplary hero only ironically, because the character's foolishness prevented him bringing about the 'desolation and calamity' that inevitably ensued from successful conquest and adventure.[3]

Brooke's dialogue refers, in a most casual fashion, to one of the fundamental challenges for the discursive formation of the eighteenth-century state and society and the effective management of gendered subjectivities in that era. As elaborated most influentially by the historian J. G. A. Pocock, the Hanoverian state inherited from sixteenth-century Italy a rationale for its social inequalities and economic inequities that was based on a decisively gendered notion of citizenship. This 'classical' or 'civic humanist' discourse of virtue described, by referring to ancient exemplars, 'an armed citizenry, which involved the individual in both political and military action through the exercise of his immediate personal qualities, often known as his virtue'.[4] Later seventeenth-century revisions brought this account of the ideal state closer to the manifest realities of the post-Stuart polity, with its powerful landed class and its delicate balance between a compromised monarchy and a limited parliamentary body, by claiming that property, rather than bearing arms, could qualify a man as a citizen with a right to wield political power. Still, financial and political change threatened to revolutionize relations between virtue and commerce, the state and the subject, rendering even this revised version of civic humanism anachronistic. As the national interest became increasingly defined in terms of commercial and imperial enterprise, the historical dimension of the classical account of virtue was brought forcibly into play, rendering vulnerable the ideally self-possessed masculinity it fostered. To take up Pocock's account:

It was the modern economy which had made militias obsolete and professional armies possible and therefore necessary, and this was perceived, in Britain and Europe from about the year 1700, as a momentous historical change, among the greatest ever recorded, occurring in contemporary experience. The profound change which had occurred in ancient history, when the legions became the armies of the emperors, had now to be understood in the light of the change in the modern world, signalling Enlightenment to some, corruption to others, and the interplay between the two to philosophical analysts. Without this debate we cannot hope to understand the historiography of the eighteenth century, or the historical world in which it was situated.[5]

The military, administrative and fiscal revolutions of the late seventeenth century had removed the individual from direct participation in the state and had placed him instead in relationship with a service economy based on exchanges that could be perpetually deferred:

> Virtue was no longer direct and personal, valorous and honourable, except in those special-ized cases where the individual found himself involved in the exercise of arms at a higher than mercenary level: it had become indirect and prudential, exercised in the conduct of a system of delegated, monetarized, specialized and in the formal sense alienated relations between personalities never displayed in their wholeness. Liberty was the exemption from this display, the freedom to be many things at different times. The defence of this freedom, or its extension in the wars of commerce, was delegated to low-paid and low-skilled operatives, the military proletarians of the post-classical and post-feudal world.[6]

For the advocates of this new civil society, commerce, translated into the cultural and social realm as 'manners' and 'refinement', offered the foundation for novel forms of personal virtue, not predicated on land ownership and the disinterest this was meant to cultivate. For its critics, the advance of civil society compromised virtue, undermining gender distinction and forcing the concession of political power and social authority to groups whose values were thought to be inimical to the progress of humanity.[7]

The following chapters are concerned with exploring the ways the decisive disjunction between historicized paradigms of heroic masculinity and the experience of masculinity as a way of being in the world was manifested at this time in the field of high art, where questions of gendered exemplarity were addressed in a supremely reflexive manner. Transformations in the cultural representation and enactment of masculinity in the late eighteenth century indicate a transition into modernity, with its more highly devolved forms of identity formation; a shift into new modes of social existence. This book starts from the assumption that the role of art in this shift needs to be understood in several dimensions within the wider field of social power as it changed over time. The concern is not only with the way in which images give gender roles fig-urative form, embodying or producing paradigms, but also with the shifting status of the genres that make those representations possible and the varying fortunes of the producers of such images.

Bodybuilding seeks to apprehend the constitution of a new order of gendered social reality manifested in complexly related ways in the widest economic and social transformations, in changes within the world of art (with its mutating forms of professional consecration), in the formal and thematic content of works and in the social and professional activity of the artists individually.[8] It argues that the constitution of this new social reality, legislating for and making possible capitalist hegemony, was not inevitable or predictable, even if in the event its opponents were readily crushed or marginalized. Instead, it aims to draw attention to the fundamentally illusory character of gender difference as a structuring feature of capitalist society – a means of managing the individuals who inhabit that society as economic units and subjects. It is the impos-sibility or inherently contradictory character of the heroic bodies envisioned in the art of the painters and sculptors considered here, and the complexities around identity and professional advancement in the careers of the makers of such images, that make visible the fault lines within this ascendant capitalist modernity.

In a more casual way, it can be said that this was a moment in which men recognized the absurdity and irrelevance of masculine archetypes drawn deep from history, the brute heroes and supermen of ancient myth, but stopped caring. This, in eighteenth-century terms, is the hedonistic acceptance of Quixotism as the essential precondition for the figuration of heroic masculinity in a commercial society. This was, to quote a commentary on the contemporary

action hero that is equally pertinent here, 'a realm of extravagant courage and literal violence where modern scepticism of the hero could be magically suspended'.[9]

As a theoretical genre, the 'Grand Manner' had a special role to play not despite but because of its relative autonomy, its pronounced distance from those forms of image-making ostensibly concerned with the direct representation of social types, namely portraiture and genre painting. By the 'Grand Manner' (the 'Grand Style' or the 'Ideal') was meant the most elevated form of narrative art created in imitation of the (largely lost) models of the ancient world. As proposed by the art academies and theorists of Europe since the sixteenth century and codified as a genre by the artists and writers associated with the Académie Royale of France in the later seventeenth century, the Grand Manner was the embodiment of masculine virtue in its various aspects as a memorial to role models drawn from history and literature, a narrative prompt to heroic action, and an exemplification of the principles of manly understanding and skill. It was because of its stringent generic conventions that the Grand Manner could be married to the idealized discourse of civic virtue and heroic exemplarity taken by Britain's social elite in the process of their political self-definition.

John Barrell has provided the most sophisticated and persuasive account of this process with his *Political Theory of Painting from Reynolds to Hazlitt* (1986).[10] He details a civic humanist discourse of art, promoting in principle the ideals of a Grand Manner dedicated to exemplifying masculine virtue and stated most influentially in the writings of Anthony Ashley Cooper, third earl of Shaftesbury (1671–1713). In a most literal way, Shaftesbury suggested that to qualify as heroic, the work of art had not only to draw on distinguished literary and historical themes, but also to be large and to be physically situated in the context of the aristocratic or princely household, where it would serve to instruct the future leaders of the state.

It should be noted, aside from the very particular arguments wrought by Barrell about a civic humanist discourse of art, that the absolute, paradigmatic status of the classical past as a source of exemplars was a commonplace, given definitive form with Sir William Temple's commentary on the 'ancients' in his essay 'Of Heroic Virtue' (1690).[11] To define more closely the formal and thematic qualities of the ideal work of art and to tie such exemplary subject matter more securely to the promotion of virtue, commentators on the civic humanist version of the Grand Manner further borrowed their terms from writing on elevated literature. Barrell discusses epic and heroic exemplarity in relation to John Dennis's 'On the Moral and Conclusion of an Epick Poem' (1721):

> The rules for the painting of history were closely modelled on the rules for the writing of epic . . . and those writers on painting who adhered to a civic humanist theory of painting in its 'traditional' form would certainly have been willing to define the function of heroic painting in the terms in which John Dennis, transposing Le Bossu's theory of epic into the language of civic humanism, had defined the function of epic . . . For Dennis, this function was 'to encourage publick Virtue and Publick Spirit'; to this end the hero of epic was to be a man of public virtue; and because the dignity of the epic did not allow it to be concerned with anything but the public character of its hero, the epic poet should not suggest that this character was either compromised by the private vices he might happen to indulge, or further dignified by the private virtues he exhibited.[12]

Thus the political language of virtue was coordinated with an extant scale of value in art. Of singular importance here was the standard set by Leon Battista Alberti (1404–72) in the sixteenth century, wherein elevated narrative as expressed through the visible motions of the human form (*istoria*) provided the measure by which all works of figurative visual art could be judged. The Albertian notion of *istoria* had provided the cornerstone of Continental academic theory

as it was codified in the seventeenth century – theory that not only established a scale of aesthetic value by which individual works of art might be assessed but also underpinned the institutional organization of the arts, determining a hierarchy within the profession. So, André Félibien, secretary of the French Académie asserted that: 'It is certain that in Proportion as one employs himself in the most difficult and noble Parts, he excels those which are low and common, and aggrandises himself by a more noble study. Thus he who paints fine landskips, is above him who paints Fruits, Flowers, or Shells: He who paints after Life is more to be regarded when he who only represents still Life.' By this logic, the artist in pursuit of the greatest acclaim must 'paint History and Fable; he must represent great Actions like an Historian, or agreeable ones as the Poets. And soaring yet higher, he must by allegorical Compositions, know how to hide under the Vail of Fable the Virtues of great Men, and the most sublime Mysteries.'[13]

This insistent, dehistoricizing attention to general principles, ideals and abstractions was meant to find perfect expression in relation to the human body and

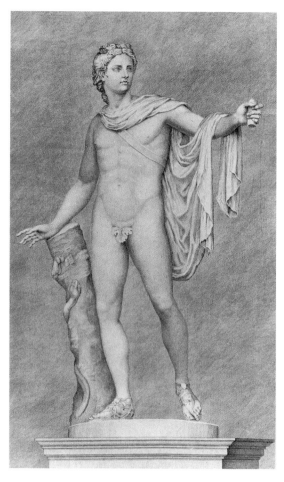

1 The *Apollo Belvedere*, engraving by Louis-Philippe Boitard from Joseph Spence, *Polymetis*, London, 1747.

the male body supremely, represented in canonical form by the ancient sculptures of the graceful and effortlessly heroic *Apollo Belvedere* (Museo Pio Clementino, Vatican City) (FIG. 1) or the more brute *Farnese Hercules* (Museo Nazionale, Naples), the figures that marked the poles of legitimate masculinity. In this way the representation of the male nude was the exemplum of artistic practice, supplying in its God-given perfection (its 'symmetry') the organizational principles for the image as a whole.

A series of illustrative passages from Charles Dufresnoy's *De Arte Graphica* (1668), a standard handbook of Grand Manner principles translated by John Dryden (1631–1700) and reissued several times throughout the eighteenth century, is worth giving in full, as they illuminate the elision of the representational body and the work of representation:

Let the Muscles be well inserted and bound together according to the knowledge of them that is given us by Anatomy. Let them be design'd after the manner of the *Graecians*: and let them appear but little, according to what we see in the Ancient figures. In fine, let there be a perfect Relation betwixt the parts as a whole, that they may be entirely of a piece . . .

Let the principal figure of the Subject appear in the middle of the Piece under the strongest Light, that it may have somewhat to make it more remarkable than the rest, and that the Figures which accompany it, may not steal it from our Sight.

Let the Members be combin'd in the same manner as the Figures are, that is to say, coupled and knit together. And let the Grouppes be separated by a void space, to avoid a confus'd heap . . . Many dispers'd Objects breed confusion, and take away from the Picture that grave Majesty, that soft silence and repose, which give beauty to the Piece, and satisfaction to the sight. But if you are constrained by the subject, to admit of many Figures, you must then conceive the whole together, and the effect of the work at one view; and not every thing separately and in particular.

The extremities of the Joints must be seldom hidden; and the extremities or end of the Feet never . . .

Remember to avoid objects which are full of hollows, broken in pieces, little, and which are separated, or in parcels: shun also those things which are barbarous, shocking to the Eye and party-colour'd, and all which is of an equal force of light and shadow: as also all things which are obscene, impudent, filthy, unseemly, cruel, fantastical, poor and wretched; those things which are sharp and rough to the feeling: In short, all things which corrupt their natural forms, by a confusion of their parts which are intangled in each other: *For the Eyes have a horrour for those things which the Hands will not condescend to touch.*[14]

The same principles of unity, continuity and homogeneity were extended still further into the institutionalized structuring of the artistic field. It was through emulation, the desire of professional artists to imitate their artistic forefathers and compete with contemporaries, that the traditions of the Grand Manner deriving from antiquity were perpetuated and advanced and the exemplars of virtue maintained in an unbroken continuity. By definition, this desire to excel was a male enterprise, based on an ability to achieve a level of mental abstraction and technical breadth that was, reputedly, unavailable to women. If directed by an institutional system for the arts, emulation ensured the preservation of the official hierarchy of aesthetic value and served to maintain a patrilineal continuity in the artistic professions.[15]

But in the eighteenth century the absolute homology between the ideal work of art and the idealized political state envisaged by Shaftesbury and his ilk – a homology defined by academic art theory but hinging more completely on the production of heroic exemplars – was assailed on several fronts. The nature of and interplay between public 'virtue' and private 'vices' were thoroughly interrogated and overhauled – a phenomenon with cultural dimensions that have been explored fully by Barrell, David Solkin and others.[16] It was patently obvious to anyone who cared to look that the dominant culture that emerged in earlier eighteenth-century Britain did not encourage the production of heroic art. The political settlement of 1688, the financial transformations of the 1690s and the ascendance of a social middle rank established a fundamentally compromised polity that did not require heroic representation and in which heroic masculinity might in fact garner oppositional political associations. Writing of literature, Steven Zwicker has proposed that the revolution of 1688 could not legitimately be represented as actively heroic, and in the subsequent 'age of military, commercial, and colonial triumph', which 'steadily resisted epic construction', the genre of the heroic 'took shelter in translation, nostalgia and parody'.[17]

With its embracing of financial revolution and commercial enterprise, the emerging 'civil society' could not sustain the impossible standards of heroic masculinity set up by Dennis and, with its internalization of moral standards under the aegis of 'taste' and 'politeness', it had little need of rigid principles to enforce behavioural and representational norms.[18] While the Continental tradition of writing on epic exemplified by René le Bossu (1631–80) provided the key terms for Dennis's statements on the genre, the English writer's definition of the hero was a departure. Le Bossu had claimed to follow Aristotle in warning against a too-perfect character in the central male protagonist of the epic. As translated by Alexander Pope (1688–1744), the Frenchman had said that such a figure, combining 'the Valour of *Achilles*, the Piety of *Aeneas*,

and the Prudence of *Ulysses*', would be a '*Chimera*', a monstrous impossibility that could only repel.[19] John Dryden had even opened up the possibility that the epic hero might be positively imperfect:

> If the Hero's chief quality be vicious, as for Example, the Choler and obstinate desire of Vengeance in *Achilles*, yet the Moral is Instructive: And besides, we are inform'd in the very proposition of the *Iliads*, that this anger was pernicious: That it brought a thousand ills on the *Grecian* Camp. The Courage of *Achilles* is propos'd to imitation, not his Pride and Disobedience to his General, nor his brutal Cruelty to his dead Enemy, nor the selling his Body to his Father. We abhor these Actions while we read them, and what we abhor we never imitate: The Poet only shews them like Rocks or Quick-Sands, to be shun'd.
>
> By this Example the Criticks have concluded that it is not necessary the Manners of the Heroe should be virtuous. They are Poetically good if they are of a Piece. Though where a Character of perfect Virtue is set before us, 'tis more lovely: for there the whole Heroe is to be imitated.[20]

In such arguments, poetic perfection and moral perfection were not to be so completely identified as they were in the Shaftesburian account of art, particularly by Dennis, who wished to align his reform of poetry with a project of coercive social change. Two models of epic exemplarity were thus concurrent, to be often confounded and confused: one where the hero's virtues impress virtue on the spectator or reader by a process of identification; the other where the formal characteristics of epic inspire (potentially incidentally) virtue by the subjective impact of their heroic proportions, theme and manner.[21]

The boundaries of what constituted the epic were thus more mutable and porous, and the relationship with neighbouring genres of tragedy and more elevated kinds of historical writing more intrinsically insecure, than the severer kinds of civic humanist account allowed. The creation in the earlier eighteenth century of a literary culture of politeness within which the emerging values of an urban middle rank of society could be expressed and legitimated incorporated within it novel schema for the evaluation of high art that departed from the models inherited from Continental art academies and rehabilitated by the Shaftesburian writers.[22] Joseph Addison's essays on the 'Pleasures of the Imagination' in the *Spectator* (1712) and Mark Akenside's poem of the same name (1744) put an emphasis on perceived reality that potentially disrupted the traditional notion of abstracted idealism, thus identifying the price that had to be paid in establishing a visual culture whose didactic dimension was appropriate to polite society. Even if art had to deal with moral and philosophical abstractions if it was to instruct, these, as explored by Richard Steele (1672–1729) in his important essay on Raphael in issue 226 of the *Spectator*, had to be derived from lived experience if they were to contribute usefully to the viewer's moral and aesthetic education:

> Who is the better Man for beholding the most beautiful *Venus*, the best wrought *Bacchanal*, the Images of sleeping *Cupids*, languishing Nymphs, or any of the Representations of Gods, Goddesses, Demy-gods, Satyrs, *Polyphemes*, Sphinxes or Fauns? But if the Virtues and Vices which are sometimes pretended to be represented under such Draughts, were given us by the Painter in such Characters of real Life, and the Persons of Men and Women whose Actions have rendered them laudable or infamous; we should not see a good History-Piece without receiving an instructive Lecture.[23]

It was, instead, in the psychologically persuasive scenes of human interaction represented in Raphael's cartoons for tapestries in the Sistine Chapel of 1515–16, brought to England by Charles I when he was prince of Wales and on display at Hampton Court since 1699, that the

great model of art was to be discovered, according to Steele (FIG. 2). In this, his essay can be connected with attacks on mythological art as expressive of courtly corruption that had appeared with Shaftesbury and were, within a few years, to feature influentially in the writings of the Abbé Dubos in France. More specifically, as Ronald Paulson has proposed, Steele can be seen as rather ingeniously laying claim to a Protestant tradition of pictorial narrative purportedly to be derived from Raphael.[24]

What this line of argument gives licence to – although only incidentally – is a more emphatically modernist aesthetic in which the models of antique art and the norms of academic art practice might be abandoned (or at least modulated) in favour of the 'Characters of real Life'. Under these conditions, narrative paintings of everyday activities and types might take up a more elevated place within the hierarchy of the genres, and might even take precedence over the ideal subjects stipulated by academic theory. So, according to William Hogarth (1697–1764), in his treatise *The Analysis of Beauty* (1753), the highest aesthetic pleasure was to be derived from the representation of normal life, as famously expressed in his advocating a preference for the flesh of 'living women' over the chilly idealism of the 'Grecian Venus' (a recommendation that further aligns correct aesthetic judgement with normative sexual appetites).[25]

This revision of the aesthetic frameworks for the reception of high art was part of the larger effort to formulate models of gendered identity appropriate to post-courtly culture. How little significance was attached in this culture to the conventionally hieratic model of masculinity is demonstrated by the limited discussion of the heroic in discourse specifically on the visual arts during the earlier eighteenth century. The representation of vice and virtue by which art fulfilled its instructive purpose was not pivoted on the presentation of an exceptional male figure, as was the case in the rationales for literary epic. Steele, together with his co-authors on the *Tatler* and the *Spectator*, was at the forefront of the effort to generate models of masculinity more appropriate to the modern world. Here, the power of exemplarity was extended to a wider social franchise, and the pursuit of the kinds of heroism defined by epic theory was classified as inappropriate in relation to the realities of modern existence. It is Steele, again, who points the way, in a slightly later essay from the *Spectator*:

> It bears some Spice of romantick Madness for a Man to imagine that he must grow ambitious, or seek Adventures, to be able to do great Actions. It is in every Man's Power in the World who is above meer Poverty, not only to do things worthy but heroick ... Men of publick Spirit differ rather in their Circumstances than their Virtue; and the Man who does all he can in a low Station, is more a Heroe that he who omits any worthy Action he is able to accomplish in a great one.[26]

This relativist, sociable notion of the heroic was pursued through the earlier eighteenth century, elaborated into sociological theory by the economist and philosopher Adam Smith (1723–90), and given wide expression in the language of sentiment, until Samuel Johnson (1709–84) could imagine a quite forthrightly democratic definition of the forms of heroism appropriate to representation in his well-known essay on biography from the *Rambler* in 1750.[27] The sympathetic model of heroic representation proffered by such writers did not demand of its subjects the exceptional character and endeavours of the epic hero. On the contrary, as Oliver Goldsmith (1728–74) noted in *The Citizen of the World* (1760), such exceptional acts might be inimical to modern society: 'The boast of heroism in this enlightened age is very justly regarded as a qualification of a very subordinate rank, and mankind now begin [sic] to look with becoming horror on these foes to man.'[28] Thus scepticism about epic heroic values is rendered here as an outright condemnation of the heroic per se (in a gesture intimately linked to the ongoing critique of commercial–imperialist expansion).

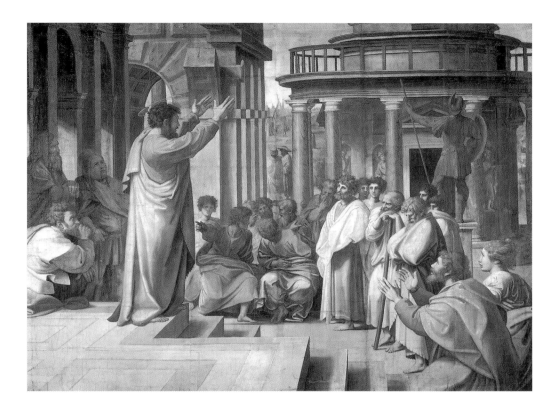

2 Raphael,
St Paul at Athens,
*c.*1515–16.
Gouache on paper,
343 × 442 CM.
Victoria and Albert
Museum, London.

Such arguments not only persisted, but also developed and strengthened in new ways through the last third of the eighteenth century, consolidating in part into the enormously popular cult of sensibility.[29] The vital currency of such alternatives makes it all the more remarkable that the kinds of heroic masculinity considered here – so often outlandish, superheroic or brutalized – appeared at all. In seeking a way toward a historical explanation, this book takes a point of departure in the years around 1760 when the definition of epic was overhauled, the nature of heroic exemplarity interrogated, and the intrinsic possibility that virtue, heroism and artistic value did not coincide became the source of growing anxiety. The trigger for these initiatives was the Seven Years' War (1756–63), which historians have come to understand had a pivotal role in Britain's history, whether viewed from economic, political or cultural perspectives.[30] The war years raised issues regarding national identity, masculine virtue and the purpose of culture that were not resolved by the ultimate military victory of 1763. The newly expanded empire brought with it massive problems of practical administration and political authority, a national debt of almost unimaginable proportions, and major questions about the nature of Britain's sovereignty over subjects that ranged over the full spectrum of culture, faith and ethnicity. The intensive cultural work witnessed by the war era sharpened the struggle over the cultural authority of civil society, in which the consensus reached around the figuring of modernistic and nationally specific masculinities in the 1740s and 1750s was exposed and ultimately destroyed. In particular, the versions of moderated masculinity so widely promoted as a foundation of civil society fell into disrepute in some quarters.

During the early, doom-laden period of the war cultural debate focused on the corrupting and feminizing effects on the nation of commercial wealth amassed over the previous decades, resuscitating the terms of the old luxury debate, which held as axiomatic the negative consequences

of such materialism. According to John Brown (1715–66) in his best-selling *Estimate of the Manners and Principles of the Times* (1757–58), the nation's present decline was directly a result of the faulty character of modern British manhood.[31] Brown claimed that the norms of social behaviour, aesthetic judgement and gender had been disrupted under the legitimating banner of polite refinement, which had been introduced into Britain by the great enemy France. So 'The sexes now have little other apparent distinction, beyond that of person and Dress: Their peculiar and characteristic Manners are confounded and lost: The one Sex having advanced into Boldness, as the other have sunk into Effeminacy.'[32] The epitome of this disrupted state was the effete Frenchified fop who indulged in chinoiserie and decorative fripperies at the expense of true art and classical learning. The 'vain, luxurious and selfish EFFEMINACY' that consequently prevailed in British culture brought the 'Debility' of the body politic. This must lead, inevitably, to the 'Destruction' of the state.[33]

There was nothing very new in the basic terms of this argument. Brown could here take advantage of an existing tradition of criticism against modern taste that took as its central figure the sexually deviant man. Bonnell Thornton (1725–68) recapitulated the established tropes of the genre in an essay published in the *Connoisseur* in 1755. Thornton's essay described a variety of effeminate types, dwelling on a description of the morning toilet of such men and detailing a 'neat little chamber, hung around with India paper, and adorned with several images of pagods and bramins, and vessels of Chelsea China'.[34] Kept away from the discipline of classical learning in the public schools, effeminate men were instead absorbed by the domestic comforts of modern consumer society: 'While other lads are flogged into the five declensions, and at length lashed through a whole school, these pretty masters are kept at home to improve in whip-syllabubs, pastry, and face-painting. In consequence of which, when other young fellows begin to appear like men, these dainty creatures come into the world with all the accomplishments of a lady's woman.' As part of the bluffly patriotic Westminster literary bohemia of the 1750s that did so much to shape cultural discourse at mid-century, Thornton was concerned to establish his allegiance to what he considered to be forms of normative masculinity to be instilled into the modern youth.

Since Addison and Steele's *Tatler* (1709–10), polite essay journals had been structured by such a project of gently persuasive, internalized reform, given voice by the figure of the detached, urbane male delineating manners and mores for polite society.[35] Yet what had been the subject of comic writing in polite literature as recently as 1755 became, with the advent of war, a matter of much greater import. What was at stake now was the fate of the nation, and what was needed was what Brown called a 'coercive Power' that would force change.[36] The influence of 'Taste' alone might not now be enough to regulate and manage manners, and taste itself had to be 'controuled and regulated'.[37] Only a return to the stringent values of heroic masculinity, as defined within Country Whig and Tory political discourse, would save Britain from imminent disaster, it was claimed. The revival (referred to by Brown and others as a 'reformation') could be effected by the appearance of a severely masculine 'Patriot', who would lead the nation by example, by the raising of a militia, forcing a large portion of the nation's men to assume actively heroic roles, and by the influence of chastened and chastising forms of cultural consumption. Here was a crisis that was at once heavily, even extravagantly gendered and yet productive of a crucial instability in the ways gender values were related to subjectivity and to social utility.

As much as the reformist arguments of Brown and others can be interpreted as drawing from a tradition of Country Whig and Tory politics, the discourse of reformation tends to a novel excessiveness in its rhetorical operations, articulating and giving value to a sense of its own impracticability. It is, indeed, the rhetorical nature of reformist cultural discourse from this moment that is its distinguishing characteristic, compounding questions of masculine identity,

cultural practice, political values and the national interest in a way that did not offer immediate, pragmatic solutions.

As Peter de Bolla and others have argued, these characteristics are to be discovered in a great variety of texts created during the era of the Seven Years' War, quite aside from the direct political intervention represented by Brown's *Estimate*.[38] Within this short span of years a series of publications was issued that proved decisive in reformulating the discursive frameworks for the production, appreciation and understanding of the Grand Manner. Edmund Burke's *Philosophical Enquiry into the Origin of Our Ideas of the Sublime and Beautiful* (1757, with a revised edition in 1759), Edward Young's *Conjectures on Original Composition* (1759) and Richard Hurd's *Letters on Chivalry and Romance* (1762) can be considered in this light, along with James Macpherson's 'Ossian' publications (1760–63) and works on English literature by Thomas Percy (1729–1811), Thomas Warton (1722–90) and Joseph Warton (1722–1800). All are complex texts, with proposals in diverse fields of intellectual inquiry that originate in a range of social and political circumstances and are orientated to differing audiences. Around one point, though, there is a degree of coherence: all share a concern to explore or address discursive territories beyond the pale – original genius beyond rules, experiences beyond description, taste without order and heroes greater than any ever imagined – giving representation to a queasy marriage between classical virtue and modernity, martial heroism and refinement, which both brought ancient exemplars into play with renewed vigour and undermined their value.[39]

The most powerfully persuasive device for incorporating a rhetoric of excess into the discourse of aesthetic judgement was the concept of the Sublime, mobilized in a decisive fashion in Edmund Burke's *Philosophical Enquiry*.[40] As in Brown's *Estimate*, the idea of reform lies at the heart of Burke's *Enquiry*. His is an aesthetic of crisis that posits an enemy to masculine virtue as invidious and dangerous as – and perhaps to be identified with – the characteristically corrupt products of the modern consumer economy. This enemy is termed by him the Beautiful. The absolute ease that comes with the encounter with the Beautiful – the ease that is immediately visually present in the smooth contours of the objects and scenes to be classed under that heading and that is subjectively felt in the body of the viewer – presents no danger, difficulty or intellectual challenge and so allows for the triumph of a feminized and feminizing luxuriousness.

When Burke states that 'beauty acts by relaxing the solids of the whole system' he is referring not only to immediate physiological effects, but also to the universe of ethical and political and sexual structures ordered by the purportedly 'natural' facts of the body. As the organs of taste are just like other organs, and indeed include biological organs ('though what they are, and where they are, may be somewhat hard to settle'), they can be exercised. The experience of the Sublime, the antithesis of the Beautiful, provides such exercise, comparable to 'an exertion of the contracting power of the muscles'.[41] The eye, before a great and Sublime scene, is tested; the body, shocked by novelty or terror, hardens; the mind expands. In sum, the self, identified with the body both metaphorically and by some uncertain, never-identified physical intersection, becomes greater (perhaps phallic) through the experience.[42] Yet, importantly, the absolute opposition of the Beautiful and the Sublime was maintained only anxiously, for the Sublime may overpower and weaken the subject, and the powers of the Beautiful are tremendous, the purportedly absolute distinctions between these categories being in practice fuzzy and fudged.[43]

Burke's text presents the recipe for a kind of aesthetic body-building that would prepare the individual self for the political and moral challenges of the late 1750s and – as the continued circulation of Burke's ideas would testify – in the decades beyond. It is the Sublime that gives licence to the cultural representation of the most brutal and primal forms of heroism, regardless of scepticism about the social utility of such models of masculinity and an acute con-

sciousness of their historical estrangement. The interest of this Sublime revision of heroic masculinity is in its very vulnerability, incoherence and irresolution.

The present study takes as axiomatic what Dror Wahrman has called the 'gender panic' that shaped the representation and experience of sexual identity on the eve of modernity. From around 1760, and certainly after 1780, the playful inversion or subversion of gender roles that had seemingly been an entirely legitimate aspect of cultural representation in earlier decades became very swiftly outlawed. Where female heroism, cross-dressing and gender play had previously been received with 'tolerance or begrudging acceptance' they were now stigmatized and 'the relative elasticity of former perceptions of gender became socially unacceptable and culturally intelligible'.[44] The conventional poles of legitimate masculinity – defined by grace and ease at the one end, effort and brutishness at the other, by Apollo and Hercules, Virgil and Homer, or Raphael and Michelangelo – were tested out and interrogated, abandoned or lampooned, the very possibility of their polarity undermined, effaced or exaggerated to the point of absurdity. An alternative, excessive model, found in art history in the figures of Salvator Rosa and Pietro Testa and in literature in the revised vision of Homer and the primitive world, came powerfully into play to help define an awkward, confrontational model of antisocial masculinity at this time.

Without matching Wahrman's chronology or arguments precisely, the following chapters demonstrate that in the visual arts an emphatic, hyperbolic gender identity is produced in these years that is entirely, and knowingly, unsustainable. Heroic bodies are defined that could only be masculine but that are simultaneously (to borrow a phrase from a writer on contemporary screen culture) 'impossible bodies'.[45]

This book describes the struggle of a selected sample of men who, by seeking to found their careers on the representation of such impossible bodies, sought to position themselves in a meaningful and productive relationship with a social order that at once demanded their existence and treated them with, at best, caution and often open hostility. As cultural analysts repeatedly construed during this period, the institutions of high culture elevated hopes and raised expectations that could never be fulfilled. From John Gwynn (1713–86) and William Chambers (1723–96) in the 1760s and 1770s to Henry Fuseli (1741–1825) and William Blake (1757–1827) at the beginning of the new century, a succession of well-placed commentators identified cultural institutions that misdiagnosed the problems of the cultural economy and that, in attempting to apply their ill-conceived solutions, only made things worse. Each despaired of the internecine conflicts within the artistic community, lamented the dispositions of the patron class and the public, and feared for the effects of consecutive domestic and imperial upheavals.

These were not abstract questions but were experienced personally. Taken as a class, the more dedicated acolytes of high art in this period incorporate a disproportionate number of self-destructive misanthropes, eccentrics and social renegades from the 'fringes' of the Anglo-British state, centred on London and on the linguistic and social regimes emanating from or legitimated within the metropolis. They occupied awkward positions in the cultural realm further aggravated by tensions within still-forming hegemonic national identifications, positions that were not yet wholly rationalized as that of the 'bohemian', which later came to define the contradictory but complicit function of the artist in the bourgeois social universe.[46] While the personal isolation of many of these figures could be seen as a sign of artistic authenticity by way of temporally displaced biography and anecdote (the production of which accelerated massively at this juncture), the symbolic and material structures necessary to capitalize on (as in create capital out of) such positions were as yet undeveloped.

This book charts the achievements and travails of three generations of artists – what statisticians would term 'cohorts' – men who shared enough of a historical and social experience to

be productively considered together. The first cohort, born in the 1720s and represented most prominently here in the figures of Gavin Hamilton (1723–98), Joseph Wilton (1722–1803), Joshua Reynolds (1723–92) and the architect William Chambers, were by 1760 established with greater or lesser success in their careers. During the 1760s, as senior figures in the art world, they were to re-establish themselves as leading lights in the reformation of culture. Hamilton, as the pre-eminent history painter at work in Rome, dedicated to giving renewed pictorial expression to the most elevated traditions of classical heroism, provided a model for younger artists. Wilton, Reynolds and Chambers took forward the institutionalization of artistic reform in London, culminating in 1768 in the foundation of the Royal Academy with Reynolds as president. The second generation, including Benjamin West (1738–1820), Nathaniel Dance (1735–1811), James Barry (1741–1806), Alexander Runciman (1736–85), John Hamilton Mortimer (1740–79), Henry Fuseli and Thomas Banks (1735–1805), were born in and around 1740. These figures sit at the heart of this book. Their activities in London, Rome and elsewhere in the late 1760s and 1770s transformed the Grand Manner as a vehicle of heroic exemplarity, and their behaviour radicalized the image of the artist. Their careers bridged (with greater or lesser success) the more informal artistic contexts of mid-century and the formalized and idealistic environment fostered by the academy. The third group of artists – Thomas Procter (1753–94), John Deare (1759–98), John Flaxman (1755–1826) and William Blake were born in the 1750s and so were of an age to define themselves more completely through – or against – the Royal Academy. As they reached their maturity in the early 1780s, the pursuit of heroic art became ever more perilous. In their diverse fortunes the fate of heroic art towards the end of the eighteenth century is recorded.

The text follows a variety of courses over the cultural landscape of late eighteenth-century Britain, but always with attention to the interrelationship between shifting ideals of artistic expertise and cultural value, competing claims to social authority between different political factions, class interests and national affiliations and the changing conditions of imperial and commercial enterprise. Part one describes the inaugurating years of cultural reformation, exploring how the Seven Years' War set a new course for cultural enterprise in Britain and reformulated the values associated with the Grand Manner. By considering efforts towards the creation of heroic imagery at Westminster Abbey and Vauxhall Gardens and under the sponsorship of the Society for the Encouragement of Arts, Manufactures and Commerce, chapter 1 highlights the complexities involved in formulating an image of the hero even during the height of patriotic enthusiasm and political consensus. chapter 2 turns to the British artistic community in Rome, describing new levels of symbolic and material investment in the ideals of the Grand Manner by aristocratic Grand Tourists. Gavin Hamilton's series of canvases depicting scenes from Homer's *Iliad* is the first focus here. While he was enormously successful as an artist and formed a model for a younger generation, before the 1760s were over the Grand Manner he purveyed was overhauled and the genteel model of artistic behaviour he represented was challenged. chapter 3 introduces the Irish painter James Barry, who pursued a self-consciously more rigorous form of classicism, exploiting the reputed enthusiasm that existed in Britain for the Grand Manner while attempting to challenge the dominance of the Anglo-British social establishment.

Part two focuses on the 1770s as a period of vital activity in the Grand Manner and amplified debate about modern masculinity and the question of heroic exemplarity. By turning to Benjamin West's *Death of Wolfe* and the contemporary phenomenon of the 'Macaroni', chapter 4 shows the dramatization and polarization of masculine identities in the years immediately after the foundation of the academy, and thus the insufficiencies of its attempt to shore up the heroic ideal in institutional form. chapters 5, 6 and 7 explore the radical reworking of the relationship between art, virtue and heroic masculinity in the work of John Hamilton Mortimer, Alexander

Runciman, Henry Fuseli and Thomas Banks. For each of these artists, the refined classicism pursued by Nathaniel Dance and West proved insufficient as a vehicle for artistic ambition. Following in the footsteps of Barry, they offered a much more confrontational reworking of the image of the hero, staking their claim to artistic authority on a degree of isolation from established taste and academic ideals. Their images exposed the radical dissociation of artistic value and socialized virtue in the most explicit way, exploiting to dramatic effect the loophole within epic theory that allowed aesthetic and moral quality to be independent of one another. By locating their works in the different cultural economies of England, Scotland and Italy within the same time-frame and with reference to a shared repertoire of themes and pictorial effects, it is possible to reveal the highly local nature of shifting ideals of heroic art and the heroic artist.

Part three reviews the period from American War of Independence (1775–83) through to the French Revolution (1789–93) and French Wars (1793–1815). Taking a tour of London in 1784, chapter 8 details the extent to which modern Britain, in military defeat, financial depression and political strife, could accommodate only thoroughly volatile formations of heroic exemplarity. By this point, the pursuit of more stringent ideals of masculine heroism appeared to many to be a necessarily Quixotic affair, potentially exhibiting madness, sickness or criminality rather than real nobility. This is the theme of chapter 9, explored with reference to the work of Henry Fuseli. His stridently imaginative art served a variety of agendas, conforming in some respects to the ideals of the Grand Manner while also addressing the tastes of a market place defined by a hunger for cheap sensation and a disregard for the moral dimensions of heroic exemplarity. In these respects, Fuseli's art was able to represent the interests of social groups who stood to some degree aside from the metropolitan social establishment. chapter 10 considers the works of art submitted to the Royal Academy by Fuseli, Thomas Banks and John Francis Rigaud (1742–1810) on their election to its membership. These show that within the academy itself, the exemplum of academic idealism, the male nude, was transformed into the over-inflated symbol of lost dreams and hopeless aspirations, or the surrogate for masculinist assertions that could not be brought into fully socialized and materially functional effect. chapter 11 traces the careers of three younger artists, the sculptors Thomas Procter, John Deare and John Flaxman. Weaned on the heroic idealism of the academy, their different fates illuminate the realities of pursuing the Grand Manner at the end of the eighteenth century. A final 'Retrospect' casts a wider view over the field of artistic production in the 1790s and the dynamic roles of commercial enterprise, cultural conservatism and nationalist ideologies in reshaping the terms on which the 'public' role of art and of the exemplary hero could be understood.

The conclusion looks briefly at William Blake and at the reputation of Henry Fuseli at the beginning of the nineteenth century. With a consensual view of the national culture being staked on the compromising of artistic idealism and the growing dominance of varieties of middle-class gender conformity that were not predicated on reference to classical exemplars, their pursuit of dramatic, heroic idealism was damned and abandoned materially. In place of a socially engaged form of narrative art, which would have required more concerted symbolic and material support from the dominant classes, a step was taken towards allowing bourgeois complacency to shape the cultural field and the forms of masculinity that it helped sustain. An alibi was formulated for the lack of practical and temporal investment in an area of culture from which the dominant class could nevertheless derive, via more tortuous, devolved and elusive routes than direct patronage or ownership, substantial cultural capital and therefore social distinction. The heroic conceptions of the artist and the artistic conception of the heroic were cast as equally, hopelessly romantic.

PART ONE

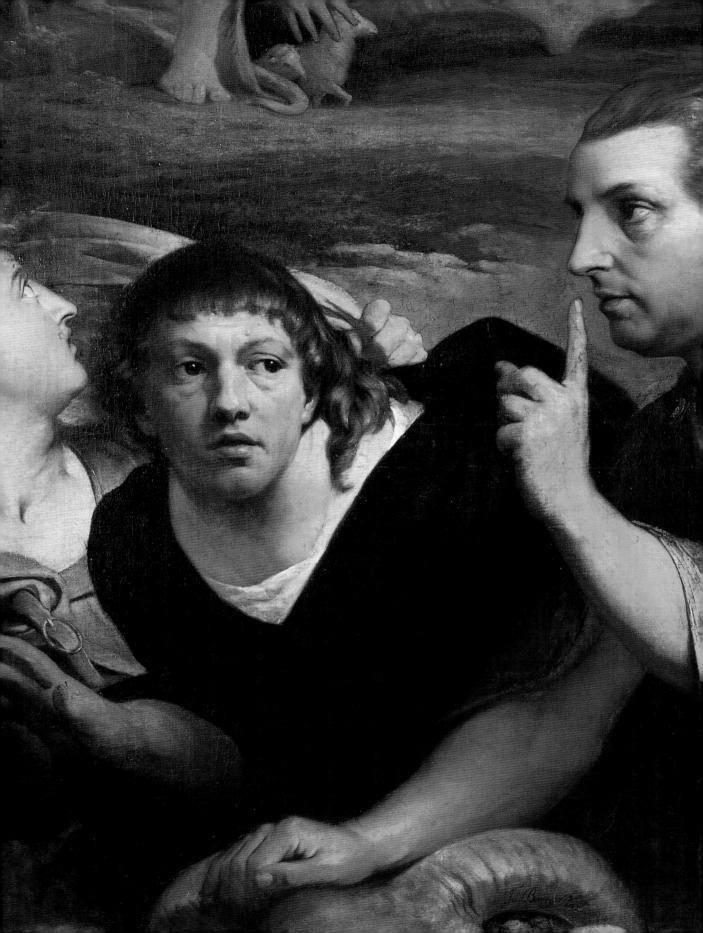

'OUR ARTS MAY HOPE FOR NEW ADVANCES'

THE STATE OF THE ARTS 1755–1765

With his *The Present State of the Arts in England*, published in French and then in English in 1755, the Swiss miniature painter André Rouquet (1701–58) offered an overview of contemporary art and design that, even in its brevity, was quite the fullest to date and almost without precedent.[1] While his 'Preliminary Discourse' established that the British as a people, being naturally inclined to 'judgement' rather than 'imagination', were more occupied with commerce and science than the polite arts, Rouquet was at pains to point out that these were, nonetheless, pursued with more vigour than anyone had previously been willing to acknowledge. Drawing on observations made during three decades in London, the author's overall impression was of a metropolitan culture that, if imperfect in any one area, demonstrated considerable vitality and variety in its totality. After thirty-one separately headed chapters dedicated to different branches of art, performance and the crafts, ranging across painting, sculpture, architecture, music, rhetoric, the work of goldsmiths and designers, surgeons and apothecaries, Rouquet still closed his text by claiming that: 'There are a great many others, with which this catalogue might have been augmented.'[2]

Yet Rouquet chose to commit his first commentary to an area of artistic activity that appeared the most impoverished and unsuccessful. Under the heading 'Of History Painting', he wrote:

> History Painters have so seldom an opportunity for displaying their abilities in England, that it is surprising there are any at all who apply themselves to this branch: whoever happens to fall into this business, very rarely meets with a rival. Those who are acquainted with the force of emulation, will therefore readily conclude that it is impossible there should be such able history painters in that country, as might be, if they had more emulation. Mr Hayman, who professes this branch, is master of every qualification that can form a great painter.
>
> In England, religion does not avail itself of the assistance of painting to inspire devotion; their churches at the most are adorned with an altar-piece, which no-body takes notice of; their apartments have no other ornaments than that of portraits or prints; and the cabinets of the virtuosi contain nothing but foreign pictures, which are generally more considerable for their number than their excellence.[3]

(Facing page) James Barry, *Self-portrait with Edmund Burke in the Characters of Ulysses and a Companion fleeing from the Cave of Polyphemus*, detail of fig. 48.

The 'Mr Hayman' mentioned in this context was the English painter of portraits and literary scenes, Francis Hayman (1708–76). Having supervised the decoration of the supper boxes at Vauxhall Gardens with theatrical and rustic subjects in the early 1740s and contributed to decoration of the charitable Foundling Hospital, Hayman was established as a senior figure within the London art scene.[4] Even so, Rouquet could only say that Hayman 'professes this branch' and was competent to do so. With the market dominated by 'insolent brokers' who damned modern art as worthless, he noted instead that even those living painters who were so qualified were employed only 'with the greatest repugnance, and when it cannot be avoided'.

The basic observation about the paucity of high art in Britain was not new. For a succession of writers throughout the eighteenth century, including, notably, the Abbé Dubos, Baron de Montesquieu (1689–1755) and Johann Joachim Winckelmann (1717–68) the combination of Protestant Reformation, commercial enterprise and a climate that quite literally dampened any inclination to indulge in visual pleasures had served to stymie any national engagement with the arts. Writers in English had, too, been forced to acknowledge that, even while portrait painting thrived, there were simply no or at best few history painters. In one of the first English-language expositions of academic art theory, *Painting Illustrated in Three Diallogues* (1685), William Aglionby (*c.*1640–*c.*1719) lamented the demise of the Stuart courts that had once sustained high culture and stated that 'we never had, as yet, any of Note, that was an *English Man*, that pretended to *History-Painting*'.[5] Writing early in the eighteenth century, Anthony Ashley Cooper, third earl of Shaftesbury, similarly had to acknowledge that 'we have as yet nothing of our own native growth of this kind worthy of being mentioned'.[6] Half a century later, in outlining an economic explanation for this situation in his 'Apology for Painters' (a manuscript prepared around 1760–61), William Hogarth calculated that Britain could not support 'More than three History painters'.[7]

Yet, it would be a mistake to read Rouquet as the latest contribution to a simply pessimistic tradition. Shaftesbury, whose stringent proscriptions haunted writers on art throughout the eighteenth century, proclaimed that the lack of a native tradition of visual art in Britain was not wholly to be regretted, since the country's collective energy had instead been committed to the establishment of a form of government that could ensure liberty.[8] That there were arts in Britain at all, and that the 'national taste' was still developing, was presented as proof of how far superior the nation must be to its Continental neighbour and almost perpetual enemy in war, France. For writers exploring patriotic themes, such comparisons were fruitful. From the perspective of polite, urban Whiggery, Joseph Addison (1672–1719) had proclaimed in his 'A Letter from Italy' (1704) that modern Britain's supremacy within the world was founded upon its political temperance and on an accompanying rejection of the imperialist splendour that characterized the despotic courts of Europe:

> Others with towering piles may please the sight,
> And in their proud aspiring domes delight;
> A nicer touch to the stretcht canvas give,
> Or teach their animated rocks to live:
> 'Tis *Britain*'s care to watch o'er *Europe*'s fate,
> And hold in balance each contending state,
> To threaten bold presumptuous kings with war,
> And answer her afflicted neighbours' pray'r.[9]

In poetry, the immediate examples of the absolutist-Catholic states of Europe and the historical precedent of ancient Rome combined to provide dire warnings about the potential consequences of the cultivation of high culture. So even with James Thomson (1700–48), often taken as the

strident prophet of cultural nationalism, there is hesitancy in recommending the pursuit of high art at all. In his 'Liberty' (1736), Thomson has the Goddess of Liberty ask in the closing arguments of the poem:

> SHALL BRITONS, by their own JOINT WISDOM rul'd
> Beneath one ROYAL HEAD, whose vital Power
> Connects, enlivens, and exerts the WHOLE;
> In FINER ARTS, and PUBLIC WORKS, shall *They*
> To *Gallia* yield?[10]

The answer Thomson provides was, in a sense, 'yes', for France had produced great literature and criticism (with Nicolas Boileau, Pierre Corneille, Jean Racine) and painting and sculpture (with Nicolas Poussin and François Girardon), so *'The Encouragement of These'* in Britain was necessarily *'urged from the Example of* France, *'tho' under a Despotic Government'*.[11] The promise was, though, that the British political system would make possible even greater and more morally legitimate achievements:

> THESE laurels, LOUIS, by the Droppings rais'd
> Of thy Profusion, it's Dishonour shade,
> And green, thro' future Times, shall bind thy Brow;
> While the vain Honours of perfidious War
> Wither abhorr'd, or in Oblivion lost.
> With what prevailing Vigour had they shot,
> And stole a deeper Root, by the full Tide
> Of War-sunk Millions fed? Superiour still,
> How had they branch'd luxuriant to the Skies
> In BRITAIN planted, by the potent Juice
> Of *Freedom* swelled? Forc'd is the Bloom of ARTS,
> A false uncertain Spring, when *Bounty* gives,
> Weak without ME, a transitory Gleam.[12]

Across the political spectrum, this contrast between the show and artifice of Continental culture and the organicism and liberty of Britain was replayed continually throughout the eighteenth century, through to and beyond the Seven Years' War, and was, eventually, consolidated into a powerfully resilient new formation in response to the French Revolution.

In Rouquet's account, this opposition was not only a matter of poetic speculation; it had also been manifested in the recent politics of the London art world. Having established the paucity of high art in Britain, Rouquet turned to the question of practical artistic education. It is in discussing the drawing school at St Martin's Lane, the closest approximation of a Continental art academy in England, that the love of liberty that characterizes the nation is seen most directly to undermine the pursuit of high art on the European model:

> The English artists have established a public drawing school in London, where they have supported for some time, with great order, and even with success to their pupils, a model of each sex, by the annual and voluntary subscription of those who come there to learn. This institution is admirably adapted to the genius of the English; each man pays alike; each is his own master; there is no dependence; even the youngest pupils with reluctance pay a regard to the lessons of the masters of the art, who assist there continually with an amazing assiduity.
>
> Some of those who contribute to the support of this school with a view of rendering the arts more respectable, and at the same time of establishing a public free school, entered into

a scheme of incorporating themselves into an academy. They imagined that as soon as they had chosen the professors, and the other officers, and established a great many laws, for which the English are famous, they had erected an academy. And what was very droll, lest they should give offence to any of the business, by excluding them from a nomination to the professorship, they named almost as many professors as there were artists. But they forgot to observe that this sort of establishment can never subsist without some subordination, either voluntary or forced; and that every true born Englishman is a sworn enemy to all such subordination, except he finds it strongly his interest. Be that as it may, the project of an academy did not take place, either because it was ill planned, or because its inutility must have naturally produced its ruin.[13]

The dynamic of cultural progress embraced by the term 'emulation' required subordination to other artists on the part of the student, and of both student and master to an institutionalized male hierarchy within which each man would know his proper place. The 'true born Englishman' spontaneously rejected such 'subordination', so there could be no emulation, and no history painting produced. Only, Rouquet argued, where the indulgence of the private interests fostered by the commerce polity was married to appropriate forms of cultural organization could British artists achieve anything. Thus, he notes that the Foundling Hospital was raised rather by an aggregate of charitably minded private persons than by the state, and its painted decorations by Hogarth and Hayman and others volunteered in the same spirit, while tomb sculpture was in a healthier state than painting because of its role in commemorating private individuals.

As Rouquet acknowledges, efforts were being made to ensure that the kind of 'subordination' he associated with the hierarchy of the genres and art institutions would be brought to modern Britain. Since the late 1730s there had been occasional agitation towards the establishment of a continental-style academy in London, and by the 1740s the school at St Martin's Lane was being run on a more formal basis, with hopes for royal sanction and support focusing on Frederick, prince of Wales (1707–51).[14] For the leading spokesperson of this faction, the architect John Gwynn, this meant accepting the French model of a hierarchical and state-run royal academy (although funded by 'private and voluntary Subscription' as an interim measure until the taste of king and parliament was reformed).[15] Frederick's unexpected death in 1751 offered a profound disappointment, but even this could not quell the ambitions of the artists involved.

What Rouquet referred to was a concerted effort by a group of artists associated with St Martin's Lane to establish a formal art school in 1753. This, again, faltered, and it was only in 1755 that a further effort was made to institute an academy, which brought the offer of support from the elite gentleman's club, the Society of Dilettanti. The desire on the part of the members of the Dilettanti to maintain administrative control of the proposed academy meant that negotiations collapsed. But the momentum behind a more rigid systematization of metropolitan artistic practice continued to build. The group of artists involved in the 1755 scheme, notably Gwynn, Hayman and Joshua Reynolds, subsequently took an active role in promoting the institutionalization of art. As members of the newly formed Society of Artists they organized the first temporary group exhibition of contemporary art in 1760 in the display rooms of the patriotic Society for the Encouragement of Arts, Manufactures and Commerce in the Strand. This was immediately followed by the splitting of the Society of Artists into two groups in 1761. One of these established a paying annual exhibition in Spring Gardens and subsequently secured a royal charter in 1765, becoming the Incorporated Society of Artists. This was taken as a sign that the hoped-for royal patronage promised by the accession to the throne in 1760 of Prince Frederick's son as George III (1738–1820) might in fact emerge.

Within only a few years, members of Incorporated Society seceded again to establish the Royal Academy of Arts in 1768, with Reynolds as its first president. Intersecting with these develop-

ments within London's art community in the same period, the Duke of Richmond opened his galleries of casts after antique sculpture to young art students and, as will be discussed more fully in chapter 1 below, a system of art competitions (including prestigious prizes for historical art) was set up by the Society for the Encouragement of Arts.

Consequently, during the 1760s a market place for ambitious modern art based around the annual exhibitions emerged, its affairs conducted with an unprecedented degree of publicity and commercial aggression. Nor was this activity entirely limited to London. In Dublin over the same period the drawing school run by the Dublin Society since 1747 became more closely controlled by the state, receiving in return greater funding from government, while the artists of that city formed an exhibiting society that first displayed its works in 1765. In Edinburgh, a society for encouraging arts, sciences, manufactures and agriculture had been set up in 1754–55 by the philosophical debating group, the Select Society, and a formal academy was established in 1760 by the Board of Trustees for Fisheries, Manufactures and Improvements in Scotland. The Trustees' Academy, as it was known, was set up primarily to teach applied design, but its first master, William Delacour (d.1767), was a decorative painter who also provided teaching in figure drawing. In Glasgow, the publisher Robert Foulis (1707–76) had set up an academy in 1753 that was closely modelled on Continental models, providing a salary for its students and making them copy the antique, draw from the life and study classical texts. While the scheme was faltering even by 1759 and eventually collapsed completely, the academy managed to send out a number of students to further their studies in Italy and organized, in 1761, the first formal exhibition of art in Scotland, showing original paintings and copies after the old masters at the university to mark the coronation of George III the previous year.[16] In an international context, and perhaps most significantly of all, Grand Tourists in Rome offered major commissions for heroic art to British artists at work in the city. Following the lead of the most successful of these, Gavin Hamilton, a succession of painters and sculptors arrived in Italy during the 1760s fully anticipating that they would be able to establish themselves as artists working in a rigorously heroic mode.

The resurgent nationalism and aesthetic discourse of the period of the Seven Years War generated an unprecedented demand for images of the hero and, at least initially, it seemed that the material foundations necessary for the creation of such imagery might be established. In particular, the succession of George III to the throne promised a new era of cultural patronage, in fulfilment of the promise of his short-lived father. In an address made by the Society of Artists to the new king in January 1761, the sense of expectation was made explicit, along with the recognition that the arts needed to be brought in line with some kind of reforming enterprise:

> It is our Happiness to live in an Age, when our Arts may hope for new Advances towards Perfection, assisted by the Favour of a British King, of a Monarch no less judicious to distinguish, than powerful to reward: who knows the Usefulness and Value of that Skill, which delights the Eye with Beauty, but not corrupts the Manners by unlawful Passions, and which has been hitherto learned in Foreign Countries, for Want of sufficient Encouragement in our own.

> The present Felicity of your Majesty, who rules over a People, blessed at the same Time with the Triumphs of Conquest, and the Plenty of Peace, leaves us nothing to desire but its long Continuance. May You live many Years to Reform our Manners, and regulate our Taste; to make the Arts of Elegance subservient to Virtue and Religion; to bestow Happiness upon us, and teach us to enjoy it.[17]

The point made here is not that the arts should be fostered simply to demonstrate royal munificence and courtly grandeur. Rather, a specifically British art might be raised by George III that

responded to and represented the reformist agenda and, in this, a kind of 'national' interest. It might, in fact, be argued that high art was a necessary weapon against the effects of luxury that had possessed and corrupted the arts in Europe. As Henry Home, Lord Kames, put it in the Royal 'Dedication' of his popular *Elements of Criticism* (1762):

> To promote the fine arts in Britain, has become of greater importance than is generally imagined. A flourishing commerce begets opulence; and opulence, inflaming our appetite for pleasure, is commonly vented on luxury and on every sensual gratification: Selfishness rears its head; becomes fashionable; and, infecting all ranks, extinguishes the *amor patriae*, and every spark of public spirit. To prevent or retard such fatal corruption, the genius of an Alfred cannot devise any means more efficacious, than the venting opulence upon the fine arts: riches so employ'd, instead of encouraging vice, will excite both public and private virtue. Of this happy effect, ancient Greece furnishes one shining instance; and why should we despair of another in Britain?[18]

Thus a variety of opinion cohered around the notion that the high arts as traditionally pursued in Continental academies could and should now be planted and fostered in modern Britain, whether as an expression of national wealth or as a disciplinary instrument. Whichever the intention, Rouquet's claims that history painting did not and, indeed, could not exist in modern Britain were invalidated; both the practical models and the institutional frameworks necessary for 'emulation' had appeared. In the metropolis at least, historical painting and elevated sculpture found a place in the public eye as it had never done before, along with economic and institutional support that, if still insufficient, was quite new. The arrival of impressive commissioned works from Italy for display in London further stoked the fires of ambition.

These developments may bear description with reference to the internal dynamic of the art community, with a small band of wholly self-interested artists aligned with an increasingly autocratic aristocracy and their elitist taste, in consequence demolishing the more democratic cultural achievements of Hogarth at mid-century.[19] But what was at stake was not only the competing claims to cultural leadership on the part of different sectors of London's art community, but also the course of heroic art. As the following three chapters will demonstrate, the years of the Seven Years' War saw questions of heroic masculinity and the memorialization of the imperial enterprise assume a new importance. The reformation of art so that it could become the effective vehicle of these endeavours became an urgent project subscribed to by a variety of social groups whose interests and dispositions did not necessarily otherwise coincide. But even before the decade was over, there were signs that the management of these issues was beyond the powers of any of these groups and that heroic art was going to assume new and more socially antagonistic roles.

I

REFORMING THE HERO

LONDON IN THE EARLY 1760S

Writing to *the Royal Magazine* early in 1761, a correspondent from Hampstead identified as 'H. C.' lamented how 'little care [is] taken in this opulent nation to transmit with honour to posterity the names of those who have spent their lives in the service of the country, and humbled Britannia's hereditary foe'.[1] The recent death of the naval commander Admiral Boscawen (albeit from fever during a period of leave on his estate in England rather than in battle) had prompted this writer to consider how well the nation's heroes had been memorialized in modern times. The only public monument he could call to mind was Sir Robert Taylor's elaborate sculpture of Captain James Cornewall (1698–1744), erected with funds voted by parliament in 1747 and unveiled in a prominent position in the south nave of Westminster Abbey in 1755.[2] By contrast, the correspondent claimed, the Dutch had long been assiduous in raising memorials to their heroes. Citing Rombout Verhulst's 1681 monument to Admiral de Ruyter in the Nieuwe Kerk in Amsterdam as exemplary in this respect, the correspondent laid out the functions of monumental art. After an account of de Ruyter's life and death and a detailed description of Verhulst's sculpture, he wrote: 'to perpetuate the memory of his eminent services, the States erected the superb monument above described; at once to shew their gratitude to the hero, and inspire the breast of others with the same ardour, as, by performing actions equally glorious, they should be sure of obtaining the same rewards.'

The point about the superiority of Dutch memorial art had been made before by Joseph Addison in the *Spectator* in 1711, writing in critical response to Grinling Gibbons' recently completed monument to Sir Clowdisley (or Cloudisley) Shovell (1650–1707) in Westminster Abbey.[3] Strictly speaking, this was been the first truly public monument of the eighteenth century, being paid for by the treasury rather than funded from private sources.[4] Yet it was from the outset reviled and was long held to reveal most fully the failure of British monumental art to create an appropriate image of the nation's heroes: André Rouquet in his *Present State of the Arts in England* of 1755 had forgotten it altogether.[5] Furthermore, state sponsorship for this sculpture had been raised only under duress from Queen Anne (1655–1714), and the inscription ensures that the monument appears to be the result of her direct patronage. Its origins were clearly forgotten by the time that 'H. C.' came to write, as, in time, the public character of Cornewall's monument was simply overlooked.[6] So in his call for a public monumental art to rival that of the Dutch, perhaps gaining an extra edge from current efforts to bring the Dutch Republic into alliance with Britain against the French and thus, hopefully, repeat the Anglo-Dutch victories of the 1740s, 'H. C.' could confidently claim that such an art simply did not exist.

Rouquet's commentary in his chapter entitled 'Of Sculpture' notes that it is in funerary monuments that the national lack of interest in the arts finds an exception: as a 'funeral talent' directed towards the private interests and selfish passions that were understood as holding English culture in its sway, tomb sculpture was encouraged.[7] Given this English interest in such monuments, the comments of 'H. C.' might seem surprising. Since the installation of the monument to the poet Alexander Pope in 1724, Westminster Abbey had emerged as a major site of national commemoration, a sequence of ambitious and often elaborate sculptural monuments being erected to the memory of prominent cultural and political figures. With these, the Abbey became one of the major sites for the production of a public of cultural consumers in eighteenth-century Britain (FIG. 3).[8] But as a consequence of responding to the emerging values of this public, the more rarefied virtues that were meant to be embodied in memorials did not always find easy physical expression here. In fact, even the most elaborate monuments can be seen to represent a degree of scepticism about the heroic, as David Bindman has argued in relation to the prominent military monuments created by Louis François Roubiliac (1702–62) in the 1740s and 1750s.[9] Westminster Abbey was the place where the incongruities of social deterritorialization became most highly visible and where the simple accumulation of monuments over time meant that heroic virtues were not necessarily privileged spatially.

It was at this time that Oliver Goldsmith's fictional 'Citizen of the World', Lien Chi Altangi, visited Westminster Abbey in search of the memorials of 'characters of the most distinguished merit' who would provide 'the finest lessons of morality, and be a strong incentive to true ambition'. What he found to his alarm was quite different – monuments to money, not to merit, where the finest and most prominent were those erected to men who had both vanity and wealth.[10] Where 'H. C.' coincides with these observations is in a shared sense of disappointment that this space for national memorials was occupied by monuments raised by, and even to, a society defined by commerce instead of public virtues and heroic representations. What 'H. C.' was calling for was the creation of a public art under the supervision of the state and thus an affirmation that the public sphere, being constituted in a rather haphazard way through the social rituals of metropolitan life and unregulated cultural activity, could be brought under the management of the state.

As 'H. C.' must have known, by the time his letter was published plans were well underway for what would be remembered as the first truly national monument to a national hero. This was the sculptural memorial to General James Wolfe (1727–59) in Westminster Abbey, proposed by the prime minister, William Pitt (1708–78), and voted unanimously by parliament only days after the general's body had reached England in November 1759.[11] His death on the battlefield below Quebec in Canada in September 1759 had signalled a remarkable turning in Britain's fortunes. It marked a victory that, combined with naval success in the Mediterranean, seemed finally to turn around the shameful sequence of defeats at the beginning of the Seven Years' War. Wolfe, the hero of Quebec, became also the hero of the war as a whole and was the subject of an immediate and seemingly spontaneous outpouring of emotion across the English-speaking world. Yet, if the response to Wolfe's death marked the high point of the popular nationalism that would fuel and rationalize Britain's renewed imperial and mercantile efforts, resolving those impulses into visual form – into the image of a hero – while maintaining the interest of the improvised publics of the eighteenth century proved a more severe challenge than might have been expected.

Pitt's proposal for a monument was acutely political, as Joan Coutu has described.[12] He used the hero's martyrdom as a means of giving emotive justification for his ministry's controversial desire to conquer Canada. While Britain's maritime interests had in the previous decades formed a focus for patriotic feeling, the settlement and expansion of land-based empire had not previ-

ously had the same wide appeal, being widely thought of as endangering by overextension those
mercantile interests that had emerged as a focal point of demotic political activity.[13] Pitt managed
the situation to ensure that the monument also served to confirm the allegiance of government
with monarchy – an allegiance that was much in question.[14] Wolfe's public persona helped con-
siderably. Having risen through the ranks of the army because of his talent rather than through
preferment, Wolfe was a demotic figure, in conformity with the mythology of Dutch memorial
art that both Addison and 'H. C.' had held up as exemplary, and in line with contemporary
doubts about heroic exemplarity expressed by Samuel Johnson and Goldsmith.[15]

The Public Advertiser of 13 November 1759 immediately established a reforming agenda for
the monument. It proposed that the designer of a memorial needed to be chosen on those com-
petitive principles that had underpinned the 'encouragement' of arts by the premium schemes
that had appeared in Dublin and London, and that its form needed to be innovative:

> As a Monument to the brave and great General Wolfe is intended to be erected at the public
> Expence; it may not be improper to observe, that as such Things have been conducted, hereto-
> fore, Favour and Interest have sometimes given the Job into such Hands, that the Structure
> has neither done Honour to the Subject, nor given Credit to the Employed or the Employer;
> it were to be hoped therefore that, in the present Instance, no regard should be paid to Inter-
> est or Recommendation; but the Preference given only to Merit. As we have many Artists of
> Eminence at this Time in the Kingdom, each might be allowed to present his Design, and the
> Author of the best to be employed, provided he had shewn by former Works, that he was
> able to execute, as well as invent; on this Foundation, we might expect to see, instead of that
> Load of Lumber, and those stolen Fragments from the Ruins, now so common, something
> original and new. A single Thought of this kind would be worth all the confused Clutter of
> modern Medleys: and might (if any Thing can) be worthy of the subject.[16]

These comments draw on a decade of social criticism, summed up in the very title of an essay
published in the *Connoisseur* in 1755: 'Of the present Taste in Monuments – Flattery of *Epi-*

3 Thomas Bowles,
*The Inside of
Westminster Abbey*,
first published 1753.
Hand-coloured
engraving, 28 × 43
cm. Guildhall
Library, Corporation
of London.

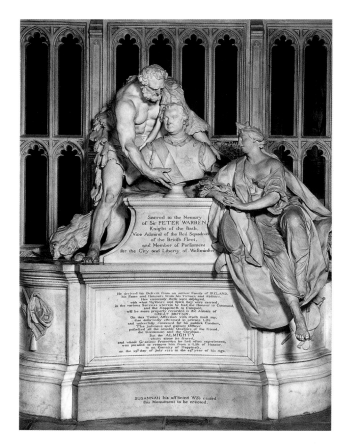

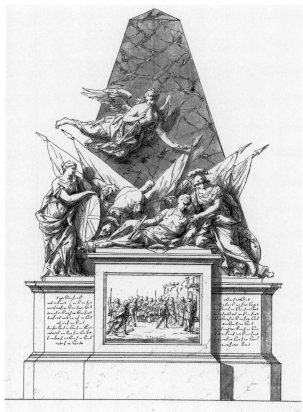

4 (top left)
Louis François
Roubiliac,
monument to Sir
Peter Warren,
erected 1757.
Westminster Abbey,
London.

5 (top right)
Michael Rysbrack,
design proposal for
a monument to
General Wolfe,
1760. Pen and ink
and watercolour on
paper, 33.5 × 24.2
cm. Victoria and
Albert Museum,
London.

taphs – Heathen Gods improper Decorations for *Christian Monuments*'.[17] Such a critique by the youthful Charles Churchill (1731–64) had been directed specifically at the monuments in Westminster Abbey:

> In fam'd cathedral, who'd expect
> Pallas, a heathen goddess,
> To lift her shield, come to protect
> Lord Stanhope! – this most odd is!
>
> Or to see Hercules, a son
> Of Jupiter (as fabled)
> Hov'ring like an old nurse, o'er an Admiral's bust,
> As if his pupil, or by him enabled.[18]

A bullish member of the metropolitan cultural circles populated by the authors of *the Connoisseur* and by William Hogarth, Churchill objected to the pagan imagery in use here and perhaps to the foreign origin of their executants. The monuments that Churchill cites are two of the most prominent in the abbey, Michael Rysbrack's monument to James, first earl Stanhope (1733), which was partnered with the same sculptor's *Sir Isaac Newton* on either side of the entrance to the choir, and Roubiliac's monument to Sir Peter Warren (1757), the first memorial to a naval commander to go into the north transept (FIG. 4). Whether the classical elements in either would qualify them for consideration as among the 'stolen Fragments from the Ruins' condemned by the writer in the *Public Advertiser* is moot: the point stands that this writer was able to claim on the back of a decade of such criticism that some new departure was required

in memorial art. However, other than being 'original and new', the journalist offers no advice or direction as to what this different approach might be.

The exact course of the commission remains obscure. It appears that a competition was held for the design, with a number of elements being specified: a figure of Victory, Wolfe being shown at the moment of death, a mourning Britannia. These were reviewed by the lord chamberlain, who by the summer of 1760 had selected a design by the English sculptor Joseph Wilton, probably produced with input from the architect William Chambers.[19] The son of a successful manufacturer of papier mâché ornaments, Wilton had enjoyed a long and privileged artistic education, spending time in the studios of the eminent sculptors Laurent Delvaux in the Netherlands and J. B. Pigalle in Paris, where he had also attended the Académie Royale. A long period in Italy followed, during which a lifelong alliance to Chambers, Robert Adam (1728–92) and the Italian draughtsman G. B. Cipriani (1727–85) was forged. After returning to England in 1755, Wilton had established himself in a central role in the metropolis's cultural life, becoming director, with Cipriani, of the Duke of Richmond's sculpture gallery.

The choice of Wilton as sculptor may well have been motivated by a desire to use a native English artist (as was the case in the previous decade with the sculptural commissions for Mansion House and the Cornewall monument), and thus a first step towards fulfilling the demands of patriotic reform. Also important – perhaps decisively so – was Wilton's association with George III: he had been appointed carver of state coaches in 1760, and was to become statuary to his majesty the following year.[20]

Without more information on Wilton's original design, it is necessary to reserve a fuller discussion of the reception and significance of the monument itself until the final sculpture is considered (see chapter 4). The protracted period before the installation of the work at the beginning

6 (top left) Attributed to Agostino Carlini, design proposal for a monument to General Wolfe, 1760. Pen and ink on paper, 33.2 × 54 cm. Sir John Soane's House and Museum, London.

7 (top right) Joseph Wilton, monument to Admiral Holmes, erected 1764. Westminster Abbey, London.

of the 1770s makes quite possible dramatic revisions to the original scheme.[21] The earliest account of the form of Wilton's design comes from the spring of 1765, when the French visitor Pierre-Jean Grosley (1718–85) recorded his visit to the sculptor:

> I saw a complete model of it, in the sculptor's work-shop, such as it is to be executed in marble. A grenadier is represented supporting him [Wolfe] on an antique couch, and at the same time shewing him at a distance, Victory, which flies towards him, with a crown and laurel: opposite to this figure, a group of military men and Canadians express, by a variety of attitudes, the most profound sorrow: the drooping hero has, a carpet under his feet, a great pair of colours, thrown there at random, part of which falls upon the monument: upon these colours are represented three flower-des-luces, in the strongest embroidery.[22]

Even from this brief textual evocation, it seems probable that Wilton's design represented something of a departure from the 'stolen Fragments' that the *Public Advertiser* and Churchill had bemoaned. Wilton's design of 1765, and presumably that of 1760, showed Wolfe as a living figure in a pictorial scene that even incorporated the depiction of a living audience as well as the figure of Victory. Whereas the surviving designs made by Roubiliac, Michael Rysbrack (1694–1770) and Agostino Carlini (1718–90) for the Wolfe monument showed the dying Wolfe accompanied exclusively by allegorical figures, the inference of Grosley's commentary is that Wilton's design presented a narrative involving figures in modern dress, instantly identifiable as a 'grenadier', 'military men' and 'Canadians' (FIGS 5 AND 6).[23]

Although classical parallels were drawn repeatedly in contemporary literary responses (particularly a poetic comparison with Epaminondas, the Theban general who had died at the moment of victory), casting around the contemporary response to Wolfe more widely reveals that there were doubts about the validity of such iconography in the context of modern Britain. These went beyond the condemnation of bad taste and paganism that appeared in the commentaries of patriotic essayists and satirists during the 1750s. An 'Epigraph' for Wolfe published early in November 1760 brought out this theme:

> In future Times his Deeds shall seem
> Like antient Heroes Acts, a well told Dream
> To fright the Foe, of Britain. – But this Age
> For Fable and for Fiction much to[o] sage,
> Mov'd by Qubec, which now they call their own,
> Admit the Fact, and rear this Votive Stone,
> Not to Wolfe's Glory, but that we may claim
> Our envied share in his immortal Fame.[24]

The rejection of 'Fable and Fiction' recalls Steele's comments about allegory and, in turn, Hogarth's proclamation of a modernistic naturalism as the foundation of contemporary cultural form. 'More generally, such arguments elevate the idea of a distinct modesty of visual form as being better suited to modern Britain than full-blown classicism.' Doubts about the contemporary validity of allegory appeared as a criticism of Carlini's proposed design. When this was exhibited in 1760, it was damned for being 'too allegorical, which was unnecessary in a hero who has done so much himself', suggesting that allegory was only a compensation for a lack of true heroism, further noting that 'any allegory . . . is a perfect riddle to all but the learned'.[25] While classical iconography was criticized for its illegibility for a modern audience, Horace Walpole (1717–97) suggested (in response to Pitt's speech proposing the monument) that Britain's modern achievements in war and commerce exceeded those of the ancients to the degree that classical imagery could only 'flatten the pathetic of the story', the emotive effect of con-

temporary fact superseding the potency of historical reference.[26]

It can be suggested that, in rejecting the classical allegory adopted by his contemporaries, Wilton was looking to create something 'new and original', seeking in pictorial narrative a means of addressing the contemporary public in sympathetic terms that had greater currency than the harsher ideals of exemplarity. If so, it was an incomplete effort, and the extended period before the final sculpture was unveiled and its rather muted reception even then may point to the shortcomings of this attempt to combine 'Fable and Fiction' with a more pictorial sculptural manner. In the meantime, Wilton's monument to Admiral Holmes, unveiled in Westminster Abbey in 1764, displayed an equivocal combination of a pictorial naturalism indebted to the grand-style portraiture of Joshua Reynolds in the previous decade, and an architectonic for-

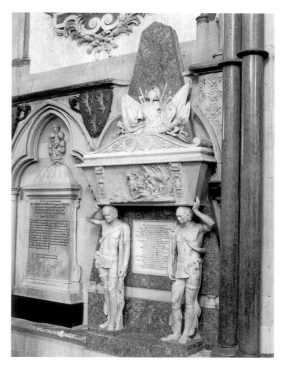

8 Monument to Colonel Roger Townshend, designed by Robert Adam, erected 1762. Westminster Abbey, London.

malism drawn from monumental tradition. The result, as a later commentator recalled, was 'a clumsy fiction' that won admirers only because of its fine craftsmanship (FIG. 7).[27] Consequently, Wilton seems to have acquired a reputation as a sculptor of delicacy rather than the heroic. As a commentator in 1772 put it: 'He has in very few, if any, attempted the fierce stile of manly or painful expression. That his genius is more turned to the beautiful than the sublime, will appear very evidently from contemplating his principal works.'[28]

More immediately, there was a sign in Westminster Abbey that the visual language of classicism could successfully be married to a sympathetic framework of response, if only on a more

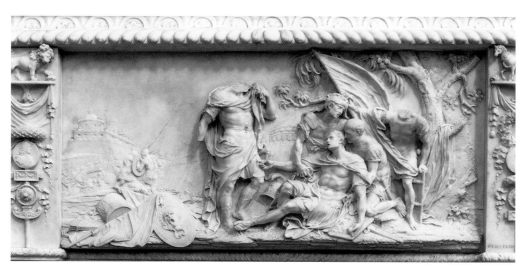

9 Detail of the relief on the monument to Colonel Roger Townshend, executed by Luc-François Breton, 1760–1762. Westminster Abbey, London.

modest scale. This was the case with a less publicly contentious monument: that raised at the expense of Lady Townshend to her son, Colonel Roger Townshend, who had died in the assault on the French Fort Carillon at Ticonderoga in Canada in July 1759 (FIGS 8 AND 9).[29] Like Wolfe's death, Townshend's fatal end at the point of victory helped mark the turning point in the war in the eyes of contemporaries. Such was the parallel, indeed, that Robert Adam, who had been a competitor for the Wolfe monument, was able to redeploy essentially the same design. Adam may even have been working on both designs hand in hand, for in February 1760 the fine and burial fees for Townshend's monument were paid to the abbey, suggesting that the patron was in anticipation that the monument would shortly be erected.[30] The French artist Luc-François Breton (1731–1800) was still at work on a relief for the Wolfe monument in Rome in the summer of 1760, apparently under Adam's orders, even though Wilton had been chosen for the commission sometime previously, but was eventually set correctly to work on the Townshend memorial, with the installation taking place in November 1762.[31]

In its form, it marks a significant move away from the elaborate constructions Roubiliac produced in the previous decade, and equally from the simple tablets of an earlier age that surrounded it. Evoking the classical models being given such wide currency by Giovanni Battista Piranesi's etched designs, the monument as a whole serves as a support for a narrative relief inserted into the face of a sarcophagus, which is raised by two generalized American Indians and topped by trophies. Perhaps tellingly, this format is essentially that used by Adam and his brothers contemporaneously in the domestic sphere, and the design as a whole bears a resemblance to the architects' novel classical fireplace for Hatchlands, the house in Surrey of Admiral Boscawen, from 1760.[32] This may be a monument to a martial hero, but it would not be entirely out of place were it in the interior of a country house rather than Westminster Abbey.

If in its form the monument can be distinguished from its neighbours, its position in the abbey secured Townshend within a network of emulative allusions. It is placed to the right of the monument to Sir Palmes Fairborne, who had died in Tangiers in 1680 and whose death in this colonial context is commemorated in full-blooded and vengeful verse by John Dryden. To the left of the Fairborne monument was originally a tablet commemorating Major Richard Creed, who had been shot and killed at Blenheim in 1704. The Creed monument inscription makes explicit reference to the nearby inscription mentioning the Earl of Sandwich on the monument to Sir Charles Harbord and Clement Cottrell in the next bay:

> To his Memory his Sorrowful Mother, Here
> Erects this Monument: placing it near another
> Which Her Son (when living) us'd to look upon with pleasure,
> For the worthy mention it makes of that
> Great man Edward Earl of Sandwich,
> To whom he had the Honour to be Related:
> And whose Heroic Virtues
> He was Ambitious
> To Imitate

Thus was made manifest a martial ideal of heroic virtue exposed by cultural commemoration and preserved by emulation. It is, though, the theme of maternal mourning and the consolation of national achievement that is most pronounced in the inscription on the Townshend monument, grafting the personal and the patriotic together:

> This Monument was erected
> By a disconsolate Parent,

The Lady Viscountess TOWNSHEND
To the memory of her Fifth Son
The Hon^ble *Lieu^t Colonel* ROGER TOWNSHEND
Who was killed by a Cannon Ball
On the 25th of July 1759, in the 28th Year of his Life
As he was reconnoitering ye French Lines at Ticonderago
In North America
From the Parent, the Brother, and the Friend
His social and amiable Manners,
His enterprising Bravery,
And the Integrity of his Heart,
May claim the Tribute of Affliction
Yet Stranger! Weep not;
For tho' premature His Death,
His Life was glorious:
Enrolling Him with the Name
Of Those Immortal Statesmen and Commanders
Whose Wisdom and Intrepidity
In the course of this comprehensive and Successful War
Have extended the Commerce
Enlarged the Dominion,
And upheld the Majesty of the King
Beyond the Idea of any former Age

The spectator, reflecting first on the personal loss of Lady Townshend and then on the wider fate of the nation, is situated at a crucial juncture between the private and the public and is invited to bridge these realms by regulating their spontaneous emotional response to the memorial. The injunction, 'Stranger! Weep not' marks the point at which the spectator shifts from being a private person sympathizing with a mother to a citizen of more stoical qualities. The 'Stranger' is a citizen in a specifically modern sense because he (or she) can respond emotionally to the tragic fate of this man and can contemplate his glory, finding consolation in the fate of the British Empire. By the standards of civil society, neither the absolutely emotional nor the severely philosophical would be sufficient; it is the combination of, or movement between, them that constitutes the citizen.

This combination of sentiments finds its analogue in the form of the monument. The relief may show figures in classical costume in an architectural setting meant to conjure ancient precedent, but it presents a scene of narrative that asks the viewer to read a temporal series of events and a set of emotional relations between figures. Remarkably, a privately expressed response to the sculpture that suggests as much survives. An unidentified Irish clergyman visited London in 1772, and at the end of his account of the abbey's monuments gave notice of this work:

I had almost forgot to mention one of the most Neat, Elegant, & finished pieces in the whole Abbey, wch is Col. Townsends Brother to our Ld. Lieutent which in the last war was killed in the Taking of Ticanderogo wch appears at a Distance at the Left Angle of the Tablet from whence the Col's Corps being brought on a Bier & Coverd with a warlike Mantle is Plac'd Bleeding & Dying at the Feet of a Fond Mother who in the Character of Niobe seems converted into stone like the whole Group of her surviving sons standing in the most sorrowful Attitudes at the Feet of their Slain Brother.[33]

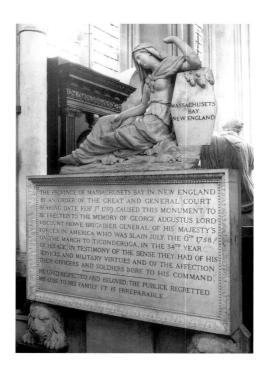

This clergyman's sentimental description of the scene as a domestic tragedy means that he interprets the rather generic fortification given in the relief as a precise topographical description, classical soldiers as modern, and even imposes a sex change on one of the mourning soldiers, imagining that the 'Fond Mother' of the inscription has materialized within the relief. Distinctions between the classical and the contemporary, the heroic and the sentimental, are dissolved in this account to wholly emotional (not to say deluded) effect.

In this the Townshend monument could be distinguished even from the closely contemporary and thematically linked monument to Viscount Howe, also in Westminster Abbey, commissioned in 1759 and executed to designs by James Stuart (1713–88) by Peter Scheemakers (1691–1781; FIG. 10). George Augustus, Viscount Howe (1724–58), general of the British forces, had died in an earlier, unsuccessful assault on the fort at Ticonderoga and consequently, when Townshend died, the two events were likened; 'The army compared this melancholy event with the death of Lord Howe; they remembered how much these young soldiers resembled each other, both in their virtues, and in the circumstances of their fate: both dear to the troops, and having both lost their lives on an expedition against this place.'[34] The Howe monument was unveiled in 1762, and in 1763 'A. B.', reporting his annual walk around the abbey in the *London Magazine*, connected it with the memorial to Townshend:

> The neatness and elegance of that which celebrates the memory of the late colonel Roger Townshend pleased me much, and in reading the inscription (which I am apt to think was dictated by the right hon. Lady who placed there that last tribute of love to her deceased son) I know not whether I was more affected by the sentiments of maternal tenderness it conveyed, or by the patriotic warmth I felt from the just compliment paid to my country on the successes of the late war. In the monument of the late lord Howe, I admire most the generosity and gratitude of the province of Massachusets Bay.[35]

Sponsored, as 'A. B.' notes, by the court of the province of Massachusetts, Scheemakers' sculpture comprises a mourning female figure, identifiable as Britannia or Virtue, seated on a simple sarcophagus form. This carries no pictorial elements but a prominent inscription, in stark contrast to the narrative relief that activated such an emotional response in the Irish clergyman. 'H. C.' might have imagined that the elaborate, architecturally greedy, sculptural form of the de Ruyter monument could provide a model for contemporary examples, but such accounts suggest that the affective pictorial narrative, personal sentiments and domestic scale of the Townshend memorial served contemporary observers much better.

Westminster Abbey provided a socialized space in which the threads of emulation were delicately woven in a largely improvised fashion, given the ever more crowded conditions of the interior. The eventual erection of Wilton's monument to Wolfe planted an image of the hero

into a radically transformed situation, and the next war was to see the Townshend monument dramatically recontextualized by a new neighbour. But, at the beginning of the 1760s, a far more deliberate and complete pictorial scheme was forged in a quite different kind of public space: Francis Hayman's four canvases relating to the Seven Years' War, commissioned by Jonathan Tyers for the Rotunda at Vauxhall Gardens and installed between 1761 and 1764.[36]

As David Solkin and others have argued, Vauxhall was a key site for the definition of the social practices and cultural representations of the emerging public sphere, and through these war paintings was further established as the most visible site for the consolidation of a broad range of mercantile-imperial interests. [37] Of the four enormous canvases created by Hayman for Vauxhall (each measuring 4 x 5 metres) two were allegorical: *The Triumph of Britannia* (FIG. 11), known from an engraving, showing portrait roundels representing Britain's victorious naval leaders being carried by nereids accompanying Neptune and Britannia in a seaborne chariot; and *Britannia Distributing Laurels to Victorious Generals*, whose title alone makes up somewhat for the total absence of any visual record, although a contemporary literary account notes that the generals were in classical costume. The other two were narrative pictures representing contemporary events in modern costume: *The Humanity of General Amherst* (FIG. 12) and *Lord Clive Receiving the Homage of the Nabob* (National Portrait Gallery, London), both known from small preparatory paintings.

Hayman's pictures can be seen as a response to a more general trend towards sentimentality as the foundation of a publicly relevant art language, and an accompanying unease with or compromise of classical models. In offering scenes of charity and mercy, they are in conformity with sentimental revisions of the hero; in presenting portraits they offer points of identification for the viewer, a way of projecting himself (and perhaps herself) into the picture frame and the nationalistic narrative it contains. Simultaneously, they are works of emphatic Grand Manner ambition. The *General Amherst*, in particular, is immodest in its pictorial debt, evoking the example of Charles Le Brun's *Alexander before the Tent of Darius* (1660; Musée national du Château), a work known in Britain through a reproductive engraving and the translation of André Félibien's essay on the picture, detailing its exemplary pictorial and narrative qualities (FIG. 13).[38] The pictures may have depended to an extent upon the visitor's spontaneous recognition of the artist's model in Le Brun if the works were to be appreciated as 'high art', but rested more simply on their scale and their narrative clarity if they were to be interpreted as contributions to an iconography of modern British patriotism. Hayman's Vauxhall pictures can thus be situated in relation both to a modern ideal of a humane and sentimental manhood, alternative to the aggressive masculinity imagined to be characteristic of the imperialist adventurer celebrated in epic, and the patriotic celebration of the extension of empire. At the same time, they can be read both as exercises in Grand Manner narrative in the European tradition and modern-dress genre works or large-scale group portraits.

They also conform to a quite specifically post-Pittite view of the war. The conquest of Montreal in September 1760 marked the conclusion of the war of aggressive conquest. Subsequently, and with the support of George III, there was greater pressure to attain a favourable peace. Many observers in the period after 1760, when Hayman's scheme was conceived and installed, feared that the newly militarized citizenship would not be content with peace. After Pitt's removal from government in 1761, calculated to clear the way for an early peace settlement, the inflammatory reformist strategies that had earlier fuelled the war effort appeared to be a liability. In 1762–63 concerns escalated into an extended public debate, pitching those who argued that a continuation of war served to expand Britain's commercial interests (predominantly from the City), against those who argued that the conflict was now only draining

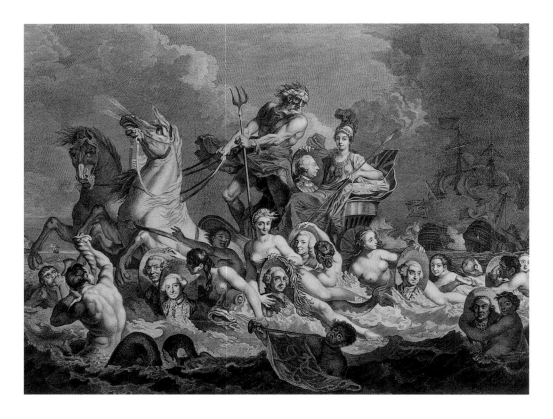

BODYBUILDING

11 Simon Francis Ravenet after Francis Hayman, *The Triumph of Britannia*, published by John Boydell, 1 January 1765. Engraving, 38 × 51.8 cm. Yale Center for British Art, Paul Mellon Collection.

resources (the prime minister, John Stuart, third earl of Bute and the court). As one commentator feared 'By a thirst of military glory . . . we seem to have entirely forgot that moderation and equity which always gave this nation the greatest weight in Europe.'[39]

Hayman's Vauxhall decorations were one of the major pictorial achievements of the 1760s and treaded a delicate path between modernity and tradition, high culture and public taste, negotiable because a local tradition of art theory had rendered generic distinctions fragile, lending portraiture heroic status and permitting heroic art a portrait-like dimension. But it did not signal the simple triumph of modern-dress history painting or a wholehearted commitment to contemporary versions of masculine heroism. The limits of cultural patriotism and the extent to which an appeal of sentiment might be permitted to revise the conventions of heroic art were highlighted in the confused circumstances surrounding George Romney's depiction of the death of General Wolfe, submitted in 1763 into the annual competition for history painting run by London's Society for the Encouragement of Arts, Manufactures and Commerce.[40]

The society, more conveniently known as the Society of Arts, was founded in 1754 with the purpose of promoting a wide range of cultural, technical and mercantile activities, primarily through the annual distribution of premiums according to set classes of competition.[41] Like its precursor in England, the Antigallican Society, its aim was to stimulate British trade and industry and so curb the need for foreign imports.[42] And, arguably, like the immediate and privately acknowledged model for the society's scheme, that run by the Dublin Society, it was intended to bolster the social authority of the gentry and business class, albeit without the sectarian urgency of the Irish group.[43] For a relatively brief period, the promotion of the fine arts was accommodated to this larger project and the society ran a series of competitions for artists. From

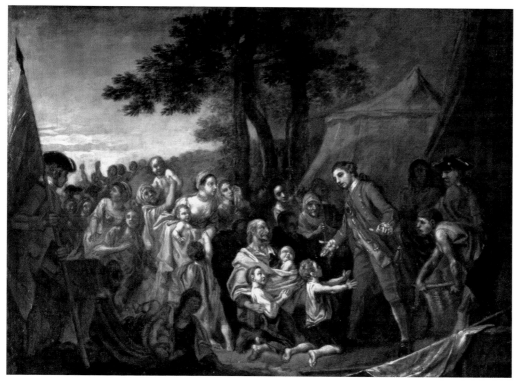

12 Francis
Hayman, painted
study for *The
Humanity of
General Amherst*,
1760–61. Oil on
canvas, 70.8 × 91.4
cm. The
Beaverbrook
Foundation, the
Beaverbrook Art
Gallery, Fredericton,
New Brunswick.

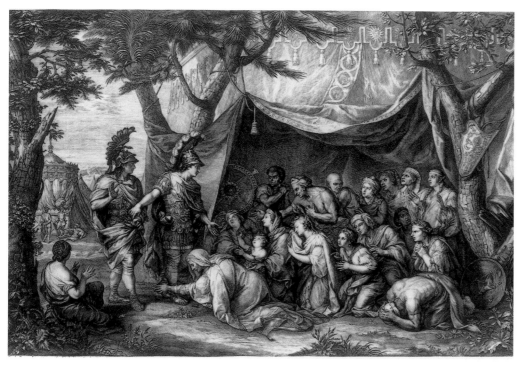

13 Simon Gribelin
after Charles Le
Brun, *Alexander
Before the Tent of
Darius*, published by
Simon Gribelin,
1693. Engraving,
28.4 × 36.4 cm. The
British Museum,
London.

1759, awards were given for drawn studies and models done after the life in the St Martin's Lane Academy or at the Duke of Richmond's gallery of casts, and from 1760 to around 1770, larger prizes still were bestowed for works that fell into the category of the Grand Manner, including bas-reliefs and drawings.[44] The major prize of up to one hundred guineas was offered from 1760 for large-scale history paintings, including at least three life-size figures and treating a theme from national history.[45]

The picture that George Romney (1734–1802) submitted to the society's history painting competition in 1763 does not survive but descriptions, fragments of what appears to be a study for the painting, and two small studies in one of the artist's sketchbooks indicate that it was a modern-dress treatment of the subject (FIG. 14). But if, in the context of the leisure park of Vauxhall, the deployment of modern dress in contemporary subjects appears to have been unproblematic, at the Society of Arts Romney's picture proved controversial. The painter was initially offered a second prize, but this was withdrawn and eventually a compensation prize of twenty-five guineas was granted to the painter. Although accounts vary, and there may certainly have been professional rivalry and preferment involved, the question of pictorial propriety is generally agreed to have been at issue. In one of the earliest retrospective accounts of these events, Richard Cumberland (1732–1811) claimed in 1803, that 'the judges, who had decreed the second prize to the painter of *The Death of Wolfe*, found their adjudication in danger of being reversed by the objections which were started by the friends of the rival candidate, not to the merit of the picture, but to the propriety of its being considered as an historical composition, when, in fact, no historian had then recorded the event on which it was founded.'[46]

This raises a fundamental question about the representational mode most appropriate to modern heroism. Taken as a form of epic, history painting would have to follow the rule in literary works that dictated that the subject had to be drawn from a historically distant era, even as this was openly debated. In 1762, Lord Kames asserted that the qualities of epic subsisted in style rather than substance: 'As to the general taste, there is little reason to doubt, that a work where heroic actions are related in an elevated style, will, without further requisite, be deemed an epic poem.' However, even here distinctions between epic and the relatively inferior form of tragedy were reasserted in considering the choice of subjects:

> The subject chosen [for elevated representation] must be distant in time, or at least in place; for the familiarity of persons and events nearly connected with us, ought by all means to be avoided. Familiarity ought more especially to be avoided in an epic poem, the peculiar character of which is dignity and elevation: modern manners make but a poor figure in such a poem.*
>
> After Voltaire, no writer, it is probable, will think of erecting an epic poem upon a recent event in the history of his own country. But an event of this kind is perhaps not altogether unqualified for tragedy: it was admitted in Greece; and Shakespear has employ'd it successfully in several of his pieces. One advantage it possesses above fiction, that of more engaging our belief, which tends above any other particular to raise our sympathy. The scene of comedy is generally laid at home: familiarity is no objection; and we are peculiarly sensible of the ridicule of our own manners.
>
> * I would not from this observation be thought to undervalue modern manners. The roughness, plainness, and impetuosity of ancient manners, may show better in an epic poem, without being better fitted for society. But without regard to this circumstance, it is the familiarity of modern manners that unqualifies them for a lofty subject. The dignity of our present manners, will be better understood in future ages, when they have become ancient.[47]

14 Attributed to George Romney, unfinished fragment of *The Death of Wolfe*, c.1762–3. Oil on canvas, 35.5 × 45 cm. Abbot Hall Art Gallery, Kendal, Cumbria.

Kames argues that a modern subject would be simply too familiar and lack the gravitas required for epic representation and that, correspondingly, epic manners must be estranged from social reality. Modern manners were, though, wholly appropriate for the somewhat less elevated tragic mode, where the imperfections of the main protagonist were dramatically vital and the emotional proximity of the subject all-important, although this would bring the subject closer the realm of comedy. The generic mode most appropriate for an elevating commemoration of the modern hero precluded those qualities for creating high art; the hero, the figure meant to be at the centre of elevated art, instead undermined its elevation. Considered as the analogue of epic, the prohibitions against the representation of contemporary life in history painting were strong enough for the society, or at least a vocal majority within it, to recoil at this point from the idea that a modern British heroic art could draw its subjects from modern Britain itself. Even if the stories around Romney's *Wolfe* are dismissed as wholly apocryphal (which seems unlikely), there is no evidence of any other painter submitting such a modern subject to the competitions over these years, despite the model of Hayman at Vauxhall and Edward Penny's modern-life subjects

at the exhibitions. The conventions of genre remained compelling, at least in the context of a formal competition.

It may not be irrelevant that the society's premiums for historical painting and sculpture had not originated in a simple way from within the artistic community.[48] Although professional artists were active in the society, including prominent figures such as Reynolds, Allan Ramsay (1713–84), and Sir Henry Cheere (1703–81), they formed a small constituency within the membership. Though artists were brought into the Committee of Polite Arts to oversee the distribution of prizes and acted as judges for the premiums, they had no special control over the competitions. The dominant force in the society was, rather, the urban middle rank – professionals, men of letters and businessmen and some forward-thinking aristocrats, brought together by a common patriotic concern with the economic and cultural well-being of the nation and a degree of distance from the court.

Why should these men have become concerned in 1759 with the promotion of high art? Hogarth, at least, was sceptical that the society was anything more than a place for 'people of leisure tired with public amusements' to talk fine talk while the 'artificers of all professions' who were invited in found it hard to have their voices heard.[49] The prime mover behind the foundation of the society, William Shipley (1715–1803), was a drawing master, and his students benefited from the competitions to an extent that the cynic might find suspicious. But accepting that, the point of greater importance is that drawing, properly regulated, was understood from the perspective of the polite, urban culture shared by the membership of the Society of Arts as essential to what are now called the 'industrial arts' and therefore to the commercial prosperity that secured and advanced civil society.[50] The distinction between 'correct' taste and 'fancy', which had long been a preoccupation of polite literature, was in the 1750s extended into a rationale for cultural rejuvenation by a diverse range of commentators. The moment at which the society turned from the encouragement of practical skills that could be transferred from the drawing school directly into the manufacturing industries to the promotion of forms of high art whose social influence was considerably more vague can be quite specifically pinned down to the years 1757–59 and the influence of arguments for cultural reformation that emerged at this time. While these were persuasive enough for a moment to draw in a relatively wide political spectrum – and the society's support ranged from severe Country Whigs such as Thomas Hollis through to conservatives and Tories – arguments for the revival of culture could not necessarily be resolved into an iconographic programme.

The fullest statement made at the time about the premium for history painting offers little in the way of enlightenment on that front, though it is telling in other ways: Samuel Johnson in the *Idler* in 1759. For Johnson, who was intimately involved with the formulation of the history-painting prize, the Society of Arts' premiums rather arbitrarily made possible Grand Manner art in a nation not otherwise inclined to encourage it:

> That the painters find no encouragement among the English for any other works than portraits, has been imputed to national selfishness. 'Tis vain, says the satirist, to set before any Englishman the scenes of landscape, or the heroes of his history; nature and antiquity are nothing in his eye; he has no value but for himself, nor desires any copy but of his own form.
>
> Whoever is delighted with his own picture must derive his pleasure from the pleasure of another. Every man is always present to himself, and has, therefore, little need of his own resemblance; nor can he desire it, but for the sake of those whom he loves, and by whom he hopes to be remembered. This use of the art is a natural and reasonable consequence of affection, and though, like other human actions, it is often complicated with pride, yet even such

pride is more laudable, than that by which palaces are covered with pictures, that, however, excellent, neither imply the owner's virtue nor excite it.

Genius is chiefly exerted in historical pictures, and the art of the painter of portraits is often lost in the obscurity of his subject. But it is in painting as in life; what is greatest is not always best. I should grieve to see Reynolds transfer to heroes and to goddesses, to empty splendour and to airy fiction, that art which is now employed in diffusing friendship, in reviving tenderness, in quickening the affections of the absent, and continuing the presence of the dead.

Yet in a nation great and opulent there is room, and ought to be patronage, for an art like that of painting through all its diversities; and it is to be wished, that the reward now offered for an historical picture, may excite an honest emulation, and give beginning to an English school.[51]

Thus Johnson tries, but only by following the path of least resistance, to rationalize the encouragement of history painting from within the inherited arguments of polite culture. Arguments about national selfishness can be traced back through the eighteenth century, from the Abbé Dubos through to André Rouquet, and were being restated contemporaneously by Hogarth in his 'Apology for Painters'. Positing sociability as the mechanism by which such self-interest is converted into a virtue was the defining gesture of bourgeois versions of civic discourse. But Johnson was not able to modulate the argument further to accommodate the promotion of traditional history painting as part of that socializing process: portrait painting fulfiled that role quite sufficiently. So he is left in the position of stating that art should reflect the wealth and prosperity of Britain, but only incidentally – that as the nation could afford history painting, it should afford history painting. He does not ascribe any particular social or economic functions to art and suggests that, once initiated, the English school of painting would take on a life of its own.

From this it can be concluded that the discourse of middle-class civic virtue did not contain the terms by which the specific qualities of an autocratic version of high art could be analysed in economic or social terms. It made available a place for history painting only by means of proposing a sympathetic (rather than an emulative) relationship between the viewer and the painted subject, a relationship that was much more readily addressed by portraiture. Without a clearly articulated agenda guiding the choice of subject matter for the major premium competitions, did the stipulation that history painters take their subjects from the national past represent only a pragmatic gesture towards compromise and consensus?

This could hardly have been the case. Without a central literary academy to authorize an official version of history, the history of Britain had been, in the words of J. G. A. Pocock, 'one shaped by the productive activity of a London press industry never lastingly subjected to censorship and existing in the interplay between court, city and country'.[52] As such, national history was fraught by political factionalism, and the first full-scale written history of Britain in a self-consciously elevated mode appeared only a few years before the paintings produced for the Society of Arts. In writing his *History of England* (1754–62), David Hume faced a series of challenges – the weakness of a native historical tradition, factionalism, market pressures, and affective models of literary value that militated against the Grand Manner – that were parallel to the challenges faced by painters competing for the society's premiums at the beginning of the 1760s. Hume's triumph was founded on his ability to conform to the formal demands of classical history writing while incorporating a level of emotional engagement that he expected would draw a vital female readership, resulting in a history that assumed a prestigious form and style and had the commercial viability of popular literature.[53]

If pictorial representations of national history were to achieve success, it might be expected that they would have to pull off much the same trick, and this, it might be inferred from the controversy around Romney's submission, could not be achieved through subjects taken from the recent past. By 1763, when Romney submitted his modern-life picture, factionalism had risen again, and Hume was shrinking from the idea of carrying his *History of England* into the present age. The national histories that did emerge after this date were deliberately political in character – a development marked by the publication in that year of the first volume of Catherine Macaulay's stridently radical *History of England*.[54]

The Society of Arts' rejection of Romney's picture could, then, have been motivated by a desire to withdraw from the factional politics associated with modern history, and, more than that, the need to generate cultural capital by affiliating itself with the entrenched values represented by the conventions of Grand Manner painting, equated with literary epic. Modern-life history painting might serve well at Vauxhall, which was, for all its patriotic subtexts, a leisure space that did not raise prohibitively high cultural expectations. Romney turned to the most patriotic subject that could be imagined at this point, an understandable decision given the patriotic agenda of the society. But he had miscalculated the degree to which the members of the society would risk the association with cultural tradition forged by their premiums. Without a forcefully articulated intellectual programme that could rationalize such iconographic innovation and with its highly visible status as the most energetic patron of contemporary British art, the society fell back on the most conventional stipulations it could find to draw the parameters of its artistic programme. The history paintings that they supported needed to be unequivocally 'epic', if only to preserve a genre whose social utility was far from clear.

These complexities were, nonetheless, negotiated with considerable aplomb by other artists. The first premium winner in the category of national history painting in 1760 had been a work by Robert Edge Pine (1730–88), the *Surrender of Calais to Edward III*, now known only through an engraving published by the artist and later reissued by the commercial print publisher John Boydell (1719–1804; FIG. 15).[55] This was a highly proficient exercise in history painting on traditional Continental models. As a commentator noted at the time: 'Some think that the general idea of this picture was taken from that celebrated one of the tent of Darius, by Le Brun.'[56] In this strategy Pine is comparable to Hayman, certainly, but in treating a subject from older history in this way he is also comparable to Hume who, seeking to write a national history that would grant him lasting fame, knew that he would have to work in the prestigious idiom of the classical tradition.[57]

Like Le Brun's *Alexander before the Tent of Darius*, Pine's picture concerns the actions of a national leader (Edward III) towards his defeated enemy (representatives of the besieged city of Calais). Pine has similarly organized his composition around a central event to ensure a dramatic focus on the gesture of the most significant actor, in this case the raised hand of Edward III. In narrative terms, the king's is a decisive gesture, giving physical (and thus visually legible) expression to his decision to spare or execute his prisoners; formally, the hand occupies the apex of a triangle encompassing the king, the burghers and the kneeling figure of the queen. But in a radical departure from the model of Le Brun, Pine's picture implies a critique of the king and his authority. The king is characterized as a tyrannical, almost bestial figure, with deeply set eyes. The curious, Hogarthian narrative detail of a dog sniffing his ermine-trimmed cloak must serve to suggest his repulsive personal nature. The queen is evidently pregnant and is depicted on her knees pleading desperately, perhaps pushing at the bounds of acceptable taste. Subsequently, Dorment de Belloy's play *The Siege of Calais* (1765) made a point of excising her from the narrative, since she was not 'to the taste of these times'.[58] Effectively, Pine perverts the meaning of Le Brun's design. In Pine's composition, it is Edward, occupying the post of Le Brun's

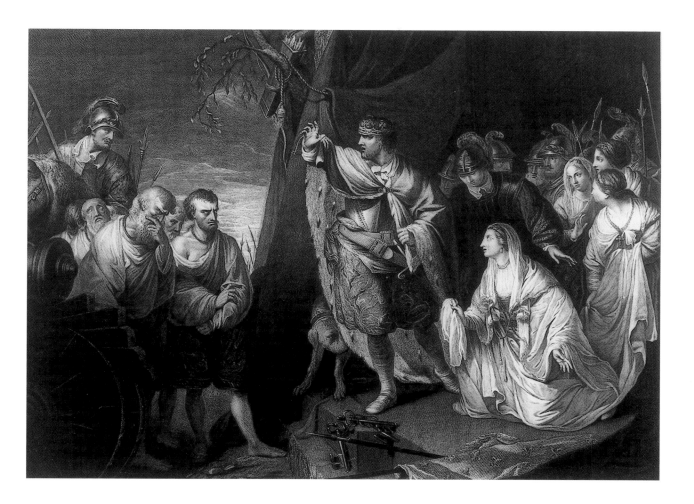

Alexander, who appears corrupted when judged by the standards of custom or nature. Pine undermines the role of the very king who was held up as an exemplar by those Tory support-ers of Frederick at mid-century who had now transferred their hopes onto George III.[59]

During the 1760s, the medieval past was politically charged as the purported locus of perti-nent lessons about the limits of royal power. On the one hand, there was the revived Whig inter-est in the medieval foundations of the state and the historical arguments for personal liberty. On the other, there were Tory and courtly appeals to an ancient imperial heritage that took as its founding figure Edward III. Pine, in the first year of George III's reign, explodes a corner-stone of royalist ideology: that conquest and civilization go hand in hand. As the text appended to the print explains, Edward was intent upon a cruel punishment for his prisoners, which even the entreaties of the prince of Wales could not prevent. Only when the queen intervened were the prisoners spared. It is her presence that bridles the king's brutal passions; she represents the feminine qualities that refine and regulate the otherwise base actions of men. Hence, in addi-tion to being a direct political critique of authoritarian monarchy, the image functions also to question the validity of martial masculine authority and represents virtue (or at least the effec-tive enforcement of virtue) as the province of women. Pine's picture is a public statement val-orizing 'private' virtues, borrowing the feminized notions of virtue current in theories of civil society.

15 Francis Aliamet after Robert Edge Pine, *The Surrender of Calais to Edward III*, published 1762, republished 1771. Engraving. The British Museum, London.

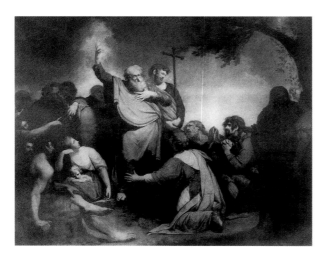

16 John Hamilton Mortimer, *St Paul Preaching to the Ancient Druids in Britain*, exhibited 1764. Oil on canvas, 350 × 366 cm. Wycombe District Council, displayed in the Guildhall, High Wycombe.

As John Sunderland has demonstrated, a succession of early premium paintings fit this model of anti-monarchical political criticism.[60] Pictures like Andrea Casali's *The Assassination of Edward Martyr* (second premium, 1760; Burton Constable, East Yorkshire) and Pine's *King Canute Rebuking his Courtiers for Flattery* (premium winner in 1763; lost) are certainly legible as attacks on the institution of monarchy, but they could also be viewed as more gentle advice about the proper management of power – the message that prevailed among radicals until the more strident criticism of the crown later in the decade emanating from John Wilkes and his supporters. The most sustained critique of Pine's *Surrender of Calais* published at the time is remarkably even-handed, neither indicting Edward III nor belittling the citizens of Calais. The review in the *Imperial Magazine* (1760) states that the subject was well-chosen 'whether you consider the example of a king whose resentment flows not from his own private wrongs but for the mischiefs done his subjects by these people; or that of the citizens of Calais, who, out of a generous love for their country, offer themselves willing victims to the resentment of a monarch who had so much reason to punish them; or lastly, the humanity and Philanthropy of the queen, and of other attendants, and for which this nation has been always illustrious.'[61]

The political significance of these subjects remains a little indefinite. The more important point is that these works, epic in their proportions, insisting on their significance, had, once they had served their part in demonstrating the society's 'encouragement', nowhere to go but back to the artist's studio.[62] Hayman's Vauxhall paintings were destined for a specially crafted physical and social context in which their meanings could be manipulated. His pictures illuminate and support each other; there is an overall message to be communicated by the passage between genres and the shifts between private sympathies and public sentiments, and the audience's membership could be anticipated. Westminster Abbey provided a rich – possibly over-rich – historical context for any monument erected there. The premium pictures were, in contrast, what has been called in another context 'truant works', potentially never settling anywhere.[63]

The political complexities around the national past and the limitations of the society's 'encouragement' of heroic art were revealed most fully with *St Paul Preaching to the Ancient Druids in Britain* by John Hamilton Mortimer, which won the first premium in 1764 (FIG. 16).[64] A pupil of Pine, Mortimer was well placed to get the attention of the society. Even so, this painting represents the most full-blooded adoption by an artist working in England of the heroic mode seen to date. The subject concerns the legendary visit to England by Paul the Apostle, and his conversion, by the power of his rhetoric alone, of the pagan Druids to Christianity. While treated sceptically by most historians (Hume did not even deign to mention the story in the relevant volume of *History of England* published in 1762), the legend of Paul's conversion of the Druids proved resilient, offering an origin for the Anglican Church among the apostles that was both flattering to the modern Church authorities and politically amenable.

Like Pine in 1760, Mortimer has not shied from claiming elevated pictorial precedents. The subject alone prompts a comparison with Raphael's quintessential depiction of St Paul among

the cartoons for the Sistine Chapel tap-
estries (controversially removed from
public view in 1763; FIG. 2). The
picture is more clearly derived in stylis-
tic terms from Bolognese precedent,
and the figure of Paul from the model
of James Thornhill's design of *St Paul
Preaching at Athens* for the cupola at St
Paul's Cathedral (FIG. 17). If Raphael
and the Bolognese, and Thornhill in his
way, each stood for a reformist ten-
dency within the visual arts, the idea of
reform was a theme of the painting
itself. Paul was taken as the epitome of
the Sublime rhetorician: Raphael's
design had been adapted as the illustra-
tion to William Smith's translation of
Longinus, and Thornhill's version of
the subject was engraved as the fron-
tispiece of a 1767 book on rhetoric.
Like his master, Pine, Mortimer had
radical Whig sympathies, and the
choice of subject may have a political
aspect. As noted in the Introduction,
Raphael's cartoons had ingeniously
been reclaimed as standing at the head
of a native Protestant pictorial tradi-

17 James
Thornhill, *St Paul
Preaching at Athens*,
c.1720. Oil on
canvas, 76.2 × 50.8
cm. The Dean and
Chapter of St Paul's
Cathedral, London.

tion. The subject of the conversion of the Druids establishes an ancient, native origin for the
Anglican Church over and above the authority of any particular secular regime or monarch and
contrary to any adherence to the Church of Rome.

Regardless of any sectarian reading that may be extracted from the painting, the point should
be that, as far as the Committee of Polite Arts was concerned, Mortimer had succeeded in trans-
lating that theme into a visual form stressing heroic physicality and artistry that conformed to
their reformist and patriotic demands. Yet, while it conformed successfully to the expectation
that history painting could be Sublime and purposeful, Mortimer's painting failed to find a buyer
and no reproductive print was issued. Reportedly, years later Mortimer was found playing tennis
against the canvas as it lent neglected against the wall of his studio; the painter 'said he did not
value the picture particularly'.[65] Quite possibly apocryphal, the story nonetheless provides an
eloquent illustration of the displacement of heroic art from the physical and social contexts that
could lend it meaning. While it could hardly be thought that such a fate was intended by the
members of the Society of Arts for any of the paintings made at their prompting, nor did they
supply any assurances for the future of such productions once they had been assessed and exhib-
ited.

Mortimer's cause was taken up in a revealing way in 1767 by the Welsh clergyman Evan
Lloyd (1734–76). Officially the vicar of an isolated parish, Lloyd in fact lived in London and
was active as a satirical poet. A friend of David Garrick and Charles Churchill, Lloyd was aligned
with the oppositional metropolitan bohemia that was to coalesce around John Wilkes (1727–97,
whom Lloyd was to meet and ally himself to while they were both in prison in 1768). His *Con-

versation (1767) provided an extended critique of modern urban life. He maligns Grand Tourists – 'travell'd Fops, who, from a three years' roam, / Bring nothing but the *Grin of Monkies* home' – people of fashion, mainstream politics, the merchant class and, in its totality, a socially promiscuous urban scene exemplified in the contents of newspapers where 'Things of no Kin are jumbled in a Breath, / A *Kitt'ning* coupled with a *Monarch's Death*'. The final passages of the poem turn to questions of taste. Taking a cue from the essayists of the 1750s, Lloyd laments the shabby taste of the connoisseurs, who bandy around the names of Palladio and Inigo Jones in architecture at the expense of native talent and true taste:

> Shew him a *Picture*, and you will be sure
> To hear of *Raphael*, *Rubens*, CLEAR-OBSCURE;
> *Titian's* soft Tints, and *Guido's* graceful Lines,
> He traces in the *Daub* of common Signs,
> Whilst to the Master-Strokes of *Genius* blind,
> Faults with the PAUL of *Mortimer* he'll find;
> Where, while to *Druids* Gospel-Truths he'd teach,
> You *see* him *live*, and almost *hear* him *preach*. –
> He cannot give to *Nature's* Self her Due,
> He's so sophisticated by *Virtù*.
> Shew him some *living Beauty*, whose Excess
> Of Charms might tempt a Seraph to transgress,
> Where it were *downright rudeness* to be chaste,
> And blushing Modesty mere want of Taste,
> The *Virtuoso*, full of Critic Doubt,
> His Compass draws to find her Beauty out,
> Gravely applies it to the Lady's *Toes*,
> Then cries, "She wants the MEDICAEAN *Nose*."
> 'Tis Poison to mine Ear – such vile Pretence
> To *Taste refin'd*, without *plain Common Sense*.[66]

Mortimer's *St Paul* is placed by Lloyd within the old argument about the impoverished taste of the connoisseurs and the corrupting influence of cosmopolitanism, taken here to extend into a lack of (hetero)sexual interest, recalling Hogarth's comments on the 'Grecian Venus'. The man of 'Common Sense' would, he suggests, appreciate Mortimer and the lesson represented by his *St Paul*, and for the same reasons like women: both aesthetic sense and sexual desire are spontaneous, unaffected, plain and direct. In Lloyd's account Mortimer's *St Paul* represents an icon of truthfulness, plainness and sexual normativeness within a sphere of cultural and social activity characterized by effeminacy, foreignness, disorder and affectation. The characteristics projected around Mortimer's art operated as signs of an authentic and politically oppositional masculine creativity for the literary nexus that actively contested aristocratic authority in cultural matters and was to become more vocal at the end of the 1760s with regard to politics.[67]

By the time of Lloyd's *Conversation*, the Society of Arts had become noticeably hesitant in its encouragement of the visual arts. An argument between the Society of Artists and the Society of Arts in 1761 over the introduction of entrance fees to the exhibition hosted by the latter group revealed a conflict of interest between artists and what could be described as a patron class (even if their patronage was mediated by an institution) over their relationship with the public. Then the forthright cultural criticism that had a decade before been subsumed under the banner of 'antigallicanism' and could incorporate aristocrat, business class and metropolitan

bohemia, was turned in the wake of the Stamp Act crisis of 1765 into a tool of socially divisive political critique allied to rising Wilkesite agitation. The authority of the society as an institution useful to professional fine artists came increasingly into question from the mid-1760s. The Committee of Polite Arts was sullied by accusations of nepotism and corruption, while the emergence of more authoritative artists' groups, first the Incorporated Society of Artists and then the Royal Academy, meant that by the beginning of the next decade artists had abandoned the society almost entirely. The Society of Arts' premium for history painting was suspended between 1765 and 1768, when it was run in a rather diminished form for a few years more.[68]

Perhaps this deterioration was inevitable: 'encouragement' was, after all, one of the linguistic 'intangibles' that infested the discourse of genteel patronage; it could, but did not have to, describe a direct financial relationship.[69] Rather, 'encouragement' meant different things to those different people who had subscribed to it. As John Gwynn complained in 1766, while the society encouraged the creation of historical artists, it had not encouraged a comprehensive system of patronage for them:

It has been said that the society in the Strand, have made some feeble efforts towards the encouragement of the arts, and as some may possibly think this expression was meant as a reflection upon that society, it becomes necessary to explain its meaning. That the society meant to encourage the polite arts, cannot admit of a doubt, but that the method they took to bring about so noble and desirable an event was ill judged and badly conducted, will not perhaps be so candidly admitted. The great force of complaint among the artists of this kingdom has ever been the want of encouragement, not a deficiency of numbers. There have always been ingenious men, but there has not always been employments for them suitable to their genius and abilities. The great error of the society therefore was this, they set out as if there really had been no artists at all existing in England, they (if the expression may be allowed) beat the drum for recruits and immediately raised an army of raw unexperienced soldiers, who like those raised from the serpents teeth sown by Cadmus, were to cut one another to pieces, and if any survived, the plunder of the war (which was the premiums) being adjusted, they were of course to be disbanded and left to shift for themselves. The society instead of giving pecuniary awards for the study of historical painting, should have bestowed honorary ones, and endeavoured by some method to have promoted the sale of productions of the present professors, who by being thus encouraged would not have failed of bringing up a sufficient number of pupils to succeed them, of whose abilities they would undoubtedly have been the best judges.

What must have been the consequence if historical painting, (the promoting of which seems to have been the chief aim of the society) had been closely pursued by these young artists? What churches, what publick buildings, what stair-cases, are now painted, by which they might have procured employment? Pictures are banished from the former, and the two latter are filled with stucco or covered with paper. It may be urged, that to pursue the study of historical composition is to become a master in every other branch of painting, as that alone comprehends all the rest. But why should we multiply artists? If there was not encouragement for a few before, will the study alone of historical composition prove the means of providing for ten times the number? By the method the society took for the encouragement of the polite arts, it will appear that by the confluence of those who might be seduced, by the expectation of pecuniary awards from the society, the polite arts instead of being benefited would be only rendered subservient to the mechanical as those who could not possibly subsist by the one fly for relief to the other. In fact the society in respect to its present plan, so far

as it regards the polite arts, may be very justly compared to a green house, in which every plant thrives and flourishes, but upon being transplanted into the open air becomes instantly chilled, and is destroyed by the severity of the climate.[70]

Thus Gwynn presents the Society of Arts as a kind of 'hothouse' artificially raising the hopes and expectations of a generation of artists. He then provides an account of the model example of France under Louis XIV, where artists served within government. Gwynn had been a leading force in the faction that disputed the democratic character of St Martin's Lane and had staked their hopes on Frederick as a potential 'patriot king'. He is here providing a correspondingly Tory – or at least court-centred – version of cultural history, where the courts of Charles I and even of Charles II provide high points in the progress of the arts, while the business and trades-men classes are venal and mercenary and can do nothing to elevate culture, and the mass who visit exhibitions are only ignorant. Gwynn envisions a hopelessly idealistic future reformation of English culture that could be secured only by a union of learning and taste in the education of the social elite, with future royal princes taking the lead by going to university.

The Society of Arts had sought an alternative to the prospect of a centralist, monarchical culture like this, and sought the means by which an urban middle rank, comprising gentlemen, professionals and artists, could join together to promote the arts. Matching this ambition to the generic hierarchy established by elevated art theory proved difficult in practice. Alternative histories could be imagined where the society staked its claim to represent a national culture on the kind of modern-life history painting presented by Hayman at Vauxhall, abandoned an attachment to the genres altogether, or sponsored students and set up an academy. Instead, its 'encouragement' served best as an alibi for the limited direct and practical support offered to the arts by the middle rank, illuminating thereby the profound disjuncture between the kinds of masculine artistic performance invested with the highest cultural authority and the practical means of support that could underwrite such performances. That, perhaps, was the enduring legacy of the patriotic cultural efforts that accompanied the Seven Years War.

2

GAVIN HAMILTON

AND ROME IN THE 1760S

The attempts to create heroic images in the contexts of Westminster Abbey, Vauxhall Gardens and for the Society of Arts in London in the 1760s exposed the ambivalent status of the Grand Manner. The interplay of classicism and modernity, refinement and martial action, the domestic and the public in physical and social contexts that were themselves in the process of change made the image of the hero necessarily unsteady. But at the same moment, a Scottish painter based in Rome was embarking on a series of canvases that appeared to offer a simpler image of Sublime and primal heroism based on classical models: Gavin Hamilton (1723–98), who began work on six paintings representing subjects from Homer's *Iliad* at the end of the 1750s. To judge from the surviving works, each would have been around 3 metres high and 4 metres wide. With one or other design constantly on view in Hamilton's studio in Rome, three of them exhibited in London and five of the six canvases reproduced in print and widely distributed, the *Iliad* series was the most visible attempt by a British artist to establish himself as a painter of heroic subjects.

Even so, when the series is examined in detail in the context of the Grand Tour layers of complexity and paradox are revealed that further expose the fault lines within epic heroism and demonstrate how those fractures were exploited, explored and given meaning. Hamilton's *Iliad* can be considered not only as proceeding from the radically reformed ideas of the Sublime and the primitive that propelled contemporary appreciation of Homer, but also as occupying the same discursive space, which had been opened up around 1760, where alienation and the absurd could take on fresh social and cultural value. Furthermore, the exceptional nature of Hamilton's particular achievements should be emphasized, however, as well as the importance of his material and social inheritance in underwriting the risk-taking involved; in the latter part of this chapter, Benjamin West and Nathaniel Dance provide examples of painters who, though they enjoyed certain personal privileges, moved their art in more compromised or at least moderated directions.

Hamilton's work as a painter, antiquarian and art dealer has long been acknowledged as having an important place in the transformation of the Roman art world of the late eighteenth century.[1] He can be located more precisely as part of the generation of artists born in the 1710s and 1720s whose passage into professional life coincided with the cultural patriotism and early moves towards 'encouragement' of the 1750s. The years immediately after the Treaty of Aix-la-Chapelle (1748) witnessed the first great influx of such artists into Italy, including Joshua Reynolds, Richard Wilson (1713?–82), Joseph Wilton, William Chambers and Robert Adam.

Along with, importantly, the well-established Italian painter Pompeo Batoni (1708–87), and his younger German rival Anton Raffael Mengs (1728–79), these men were able to enjoy the first flourishing of patronage extended by British and Irish Grand Tourists.[2] Although in the midst of war, in 1758, it was reported from Rome that 'there are but few English People of fortune; and little or no encouragement of Painting; which is owing to the War with France', the years around 1760 saw a sudden and remarkable series of initiatives.[3] Far from representing a simple expansion of the traditions of Grand Tour cultural patronage, the circumstances that made possible the creation of Hamilton's monumental series of canvases testify to a thorough reform of elite taste.

The tradition of sending aristocratic young men in their late teens or early twenties on an extended Grand Tour of Europe lasting months or even years had developed in the later seventeenth century, but took on a heightened significance under the Hanoverian regime.[4] With Paris and Italy as the prime destinations, sometimes supplemented with travel in the Low Countries, Switzerland and, more rarely, Germany and Austria, the young gentleman would go abroad in order to experience Continental society and scenery, to look, converse, learn – and spend money. A disproportionate significance was attached to the financially prohibitive Italian leg of the tour. It was here, and especially in Rome, that the British or Irish gentleman would encounter the material fragments of the classical heritage to which he was supposedly heir, where he could discover the rapture of identification with his noble predecessors.

Occurring generally after formal education had ended and before marriage and a settled country life, in exposing the young gentleman equally to the splendours of the ancient world and decayed Catholic modernity, the Grand Tour to Italy was intended as a moment of transformation or rite of passage, when the boy became a man. It needs to be considered as among the institutions for the social reproduction of the governing elite, related to study at Eton or Westminster or one of the other major public schools, because it so often succeeded such study and because it resembled and amplified the form of personal development imposed by those institutions.[5] The emphasis in each case was on physical hardiness and emotional independence – qualities not wholly amenable to the values of enlightenment, politeness and refinement upheld by civil society, as the historian Edward Gibbon (1734–94) parenthetically acknowledged: 'According to the law of custom, and perhaps of reason, foreign travel compleats the education of an English gentleman.'[6]

As a means of habituating the gentleman to a set of dispositions that qualified him for political and cultural leadership, the Grand Tour was fraught with problems. There were a number of widely acknowledged challenges: women, wine and the ruffians who populated tourist pathways were the most immediate and obvious, but the tempting splendours of the Roman Church, the aching melancholy that must accompany reflection on the historical passing of the grandeur of Rome, and the seductions of fine art (a 'feminine' predilection if not properly measured and guided by reason) were all less tangible dangers nevertheless widely considered as real. As a component in the genteel polishing of the gentleman, the Grand Tour had always been prey to criticisms applied more generally to the social activities of the upper class, being seen to create effeminacy and dissolute behaviour, with cosmopolitan elegance degenerating into outright Frenchified foppery. The traditions of criticism against the corrupting mores of cosmopolitanism had established a protest culture the tone of which sharpened in the 1750s, even before the Seven Years' War brought such worries to a head.[7] What was then at stake in the discourse around the Grand Tour were competing claims for social authority, each based on alternative models of social identity.

The new terms of Grand Tour identity politics were distilled into a dialogue between 'Shaftesbury' and 'Locke' imagined by Richard Hurd (1720–1808) in his *Dialogues on the Uses of*

18 Nathaniel Dance, *James Grant, John Mytton, Thomas Robinson and Thomas Wynn*, c.1760. Oil on canvas, 98.1 × 123.9 cm. Yale Center for British Art, Paul Mellon Collection.

Foreign Travel (1764). 'Shaftesbury' proposes that the man who does not travel might even be considered as a sort of savage, while the 'young gentleman, who has been trained abroad; who has been accustomed to the sight and conversation of men; who has learnt his exercises, has some use of the languages, and has read his Horace or Homer', was socially adept and useful to society. This line of argument gives Hurd's 'Locke' the chance to complain that this cosmopolitan ideal is in danger of leading to the vices of courtliness and superficial, effeminate overgentrification. Instead, 'Locke' proposes:

> What a reasonable man wants to know, is, The proper method of building up *men*: whereas your Lordship seems sollicitous for little more than tricking out a set of fine *Gentlemen*. It seemed, indeed, as if your Lordship had calculated your defence of travelling for a knot of Virtuosi, or a still more fashionable circle (where, doubtless, it would pass as with much ease and without contradiction); and had, some how, forgotten that your hearers are all plain men.[8]

Hurd's 'Locke' sets a socially exclusive and gendered version of gentility against a relatively inclusive notion of manhood in a statement that emerges from the dramatic testing of models of masculinity over the previous years of war. The author succeeds in opening up a potential fault line within elite ideals of masculinity, between gentility as a socially desirable quality and an appropriate and necessary assistance to the political management of the modern British state, and gentility as a corrupting influence that undid manhood. For the Grand Tour to remain in service as a tool for the reproduction of socially exclusive forms of masculinity, it needed to be reformed to acknowledge the limits and dangers of such over-gentrification.

A series of letters from the Yorkshire gentleman and dedicated Grand Tourist Thomas Robinson (1738–86) gives a most explicitly gendered commentary on the visual arts as an index of these competing social values and is worth considering at some length. Robinson was of that generation of elite visitors to Italy who arrived in the early 1760s and was closely connected with a circle of culturally enthusiastic young art patrons, including Sir James Grant of Grant (1738–1811). This circle had featured together in a group portrait commissioned from Nathaniel Dance by Robinson, which registers both the social and cultural dimensions of the Grand Tour, presenting the travellers as intimate companions habituated to the classical remains that surround them, easy in their postures, in their relations, in their sense of belonging in this historically ennobled context (FIG. 18).[9] Managed by the conventions of the conversation piece, it is enough for the painting to make this assertion on its own terms; in his letters, Robinson gave voice to the comparative character of such claims. In Turin in the early stages of his tour, Robinson had written to his brother complaining about the effete gentlemen of the Continent:

> I am sure to meet several very pretty young Counts and Marquis, with bags & swords, but I always think when I see them how easily you would lick them, & that tho' they should draw their swords, that a knock on the mark would lay these tough Fellows flat. Any but you would think that tough meant hardy & stout, but tell them to look tough out in the Westminster Dictionary, & they will find the meaning of it to be Proud, self-sufficient & conceited of themselves.[10]

Both former Westminster pupils, the Robinsons can share a joke that pitches their prowess with their fists against the fashionable affectation of swords on the part of their Continental counterparts. Written in 1759, at the turning point of the war against those Continental peers and in the city that was the conventional gateway into Italy for the Grand Tourist, the letter gives personal representation to that national effort and predicates that act of representation on a cryptic, socially exclusive deployment of language. This may be a private joke made in a personal letter, but it registers also a sense of what was at stake in defining the gentleman and defining the English at this point.

The potential for such oppositions to become translated into cultural terms even at this informal level is revealed in an important letter written by Robinson later in his tour, when he had been in Rome for some months and had taken the opportunity to view the work of the two pre-eminent modern artists in the city, Batoni and Mengs. According to Robinson, in their respective portraits of the pope, 'Battoni made one take notice of how well the Gold lace was finished, how transparent the Linnen was, & complained of the Difficultly & patience in getting thro' so elaborate a performance', while Mengs 'dwelt on the effect of his whole picture, on the Composition of it, it's Force, & it's Dignity'. Comparing the Homeric history paintings the two had produced, Robinson noted 'Menx has drawn Hector Andromache & Astyamax within the walls of Troy, while Battoni's is il Signor Ettore, la Signora Andromache, & il fancinello Astanax, on the Theatre in the Haymarket.'[11] Both of these pictures have been lost, and the Batoni alone has a visual record attached to it in the form of a preparatory design (FIG. 19), but a surviving painting of *Augustus and Cleopatra* by Mengs of this date, commissioned by Henry Hoare for Stourhead, is mentioned by Robinson in the same letter as exhibiting 'good Drawing, expression, force without blackness & clearness without faintness' (FIG. 20).[12] Robinson's comments resonate with that stress on the general and the abstract characteristic of reform discourse, qualities gendered masculine in opposition to the feminized sphere of luxury consumption and entertainment, with its dissembling concern with surface and refinement. His argument echoes, more particularly, a point made only months earlier in one of Reynolds' contributions to the *Idler*:

I have only to add a word of advice to the painters, that however excellent they may be in painting naturally, they would not flatter themselves very much upon it; and to the connoisseurs, that when they see a cat or a fiddle painted so finely, that, as the phrase is, 'It looks as if you could take it up,' they would not for that reason immediately compare the painter to Raffaelle and Michael Angelo.[13]

The same themes of taste, judgement and patriotic sense are repeated in the letters written when Robinson went back to the Continent in 1763, this time to stay in Paris. Here his bluff Englishness was contrasted to the despicable 'frivoleté' of the French, a characteristic that may be forgiven only as relieving the gloomier aspect of 'good English Common Sense'. And this sense of national pride was extended, tellingly, to contemporary taste, with Robinson's ambivalent view of the 'Gout Grec' that then raged in Paris. Of the French, Robinson wrote that, while 'their Taste is very much improved & in all Matters of Ornament they now almost entirely adopt the Antique', this rage for classicism was to be viewed sceptically, as 'Their Notions of Erudition on that head seem to be confined to calling everything a la Grecque'.[14] So, even if fashionable Paris led the way in the revival of classical forms and motifs in the arts, the French remained essentially frivolous and superficial compared to Britons. In this, Robinson manifests the complex attitude towards France that prevailed in British culture. As a French satirist of the time had an English Grand Tourist say: 'We love France, and we hate the French.'[15] But it also, more specifically, chimes with the views of leading French artistic reformers and *philosophes*, for whom the 'Gout Grec', while preferable to the florid decorations of previous years, still needed to be disciplined and invigorated.[16]

Robinson's letters demonstrate how the critical years around the Seven Years' War inaugurated a search for authentic and purified masculine authority that, by being articulated around and in the judgment of taste, could find an index in cultural form. These years witnessed an immense flood of new tourists going to Europe, with the old values of the upper class both affirmed and disturbed by the revised patterns of cultural distinction manifested by Robinson

19 Pompeo Batoni, *Hector's Farewell to Andromache*, c.1758–60. Black chalk heightened with white chalk on paper, 24.8 × 38 cm. Musée des Beaux-arts, Besançon.

and, more materially, by the first distinct stirrings of the ascendant middle-class tourism that would undermine the conventions of the Grand Tour.[17] The acts of patronage and the performances of judgement assumed within the British Grand Tour class around 1760 marked their participation in the (even martial) ethos of artistic reform, the initiative for which had otherwise been seized by the metropolitan gentry and mercantile class. In his personal reflections on this period, Gibbon (an associate and contemporary of Robinson) gave expression to a need for self-possession that was, arguably, shared by this generation of Grand Tourists: 'in the militia I was armed with power; in my travels, I was exempt from controul: and as I approached, as I gradually passed my thirtieth year, I began to feel the desire of being master in my own house.'[18]

For artists, this reforming spirit among elite travellers combined with developments at home to raise the promise of new opportunities. So, the Irish painter Matthew William Peters (1741–1814) could, writing from Rome in 1762, dismiss the old climactic explanation for the progress of the arts and affirm instead the possibility that, properly patronized, British artists could rise to equal the national achievement in commerce and war:

> The former Italian sense of greatness is diminished into the pusillanimous operations of an eunuch, or the capers of a rope-dancer. The merit of the painter has fallen with the decay of the respect and love which is due to the arts, and seems to have finished its career in this country. The spirit of them is now rising in England; so I hope, ere long, to see the genius of Britain uniting the pencil with the sword, while Liberty conducts both in triumph to the temple of Fame.[19]

Yet, while the collective enthusiasm of the social elite in Italy certainly did stimulate a period of unprecedented activity in the field of heroic art, this was neither sustained in economic reality nor definitely sustainable with regards to the social currency of the ideals of masculinity it promulgated. The naturalism and technical skill that had been central to the Hogarthian conception of the artist, and the associated gendered values of temperance and modernity, might now be neglected. Instead, with the proper support, the artist might pursue a kind of idealism that was meant to bring him into the lineage of the Grand Manner and the elevated and self-possessed masculine values associated with that heritage. But this turn towards the heroic ideal opened up the possibility of a more radically unstable and inhospitable version of masculinity. It was precisely this that became apparent in the work of Hamilton and his circle.

Quite exceptionally for a professional artist, Hamilton – properly Gavin Inglis Hamilton – was himself a member of the landed class who populated the Grand Tour. He was the second son of Alexander Hamilton, laird of Inverdovat, Fifeshire, who had inherited Murdieston House, Lanarkshire, from his great uncle Alexander Inglis. Together with his older brother, Alexander Inglis, and younger sibling, James Inglis, Gavin was admitted to Glasgow College (later University) in 1738, where he was to remain as a student for four years.

If a university education was a crucial marker of elite social status and provided the means for the lesser sons of the British gentry class to enter a professional life that would sustain them in the (potentially prolonged) period before inheriting, Glasgow's university provided a unique context. In contrast to the exclusive and fundamentally conservative universities at Oxford and Cambridge, and those at Edinburgh and Aberdeen, which were closely tied to the Scottish gentry and governing class, Glasgow drew nearly as many students from the industrial and commercial sector as from the landed elite. Hamilton's education may have affirmed his gentry-class status but it did so by bringing him into immediate contact with commercial society (and it should be noted in this context that his sister was to marry a Glasgow merchant). Alexander Carlyle, who attended the college from 1743 to 1744, recalled snootily of the students: 'There were only a few Families of antient Citizens, who pretended to be Gentlemen – and a Few others who were Recent Settlers there who had obtain'd Wealth or Consideration in Trade. The Rest

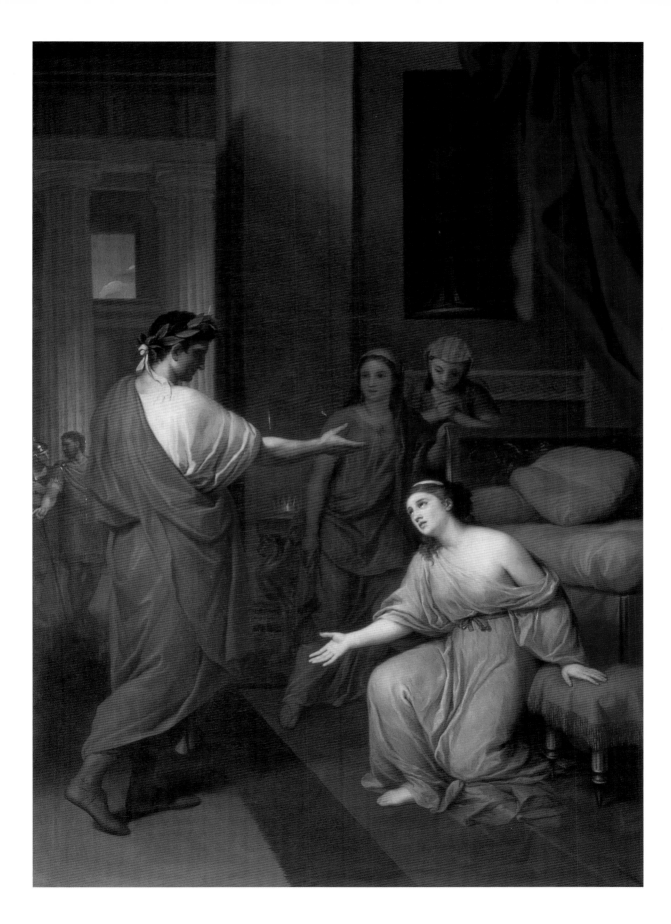

were Shopkeepers or Mechanics, or Successful Pedlars . . . Few of them could be call'd Learned Merchants.'[20]

Hamilton's educational and social formation was, then, that of a member of the lesser Scots gentry necessarily affiliated through personal connection and education to the merchant class. The union of England and Scotland in 1707 and dissolution of the Scottish Parliament meant that the upper echelons of Scottish society were simply unable to exercise much direct political influence in Scotland itself. The wealthiest transferred their interests (and usually their persons) to London and became incorporated into a distinctly Anglo-British elite.[21] It was the lesser gentry who were left behind and who, in collusion with the professional classes, forged Scotland's distinctive civil society.

What Hamilton did during the mid-1740s, the years of the Jacobite rebellion, is not known, but at the end of the 1740s he had moved to Italy and trained for a period under Agostino Masucci (1692–1768), a pupil of Carlo Maratta and, as the last of the 'Marattechi', the belated purveyor of the Italian grand tradition.[22] If this was an unconventional career choice for a gentleman, it was not entirely without precedent in Scotland: William Aikman (1682–1731) had been of gentle birth, and several members of Clerk family of Penicuik studied painting in Rome, with one, Alexander (fl. 1729–37) trying to establish himself professionally. But Hamilton was part of that generation of artists who, in travelling in unprecedented numbers to the Continent in the wake of the imperial and domestic conflicts of the 1740s, hoped to capitalize on what promised to be an era of peace and plenty. Presumably in anticipation of the imminent revival of the arts promised within the circle of Frederick, prince of Wales, Hamilton had travelled to London by 1751, where he attempted to establish himself as a portrait painter. He was not, though, successful. A friend reported in that year that he 'has a great many Enemies here' who issued rumours that 'he cannot finish a picture', going on to draw a telling portrait of the artist:

> As to his appearance in the World and in Conversation it is extremely genteel, everybody that knows him, must allow him to be a Lad of great honour and in all his appearances much like a Gentleman. I must own he very often requires a Spur to industry, it often happens that he is not in the humour of painting and loves to indulge himself in thinking of fine pictures, and fine Compositions, but this sort of indulging is very natural to a Man who has been so long in Italy, and will wear off by degrees in England.[23]

By his mid-twenties, Hamilton was a curious mixture of impecuniousness, professional laxity and artistic aspiration that could hardly have been unique, even if the marrying of these to a relatively elevated social status was.

Hamilton's dreams of 'fine Compositions' did eventually find fuller expression in 1755, when he was temporarily back in Scotland, perhaps in connection to his sister's marriage to the Glasgow merchant John Bogle that summer. While involved, apparently in a consultative role, in the decorations of the Great Saloon of Yester House for the Marquess of Tweeddale, which was being designed by William and Robert Adam, Hamilton seized the opportunity to present himself as a painter of historical works. In the course of a letter dealing with the progress of the interior, Hamilton suggested that he could supply a work in keeping with the 'grand Italian taste' of the setting. Specifying the location of Tweeddale's old masters, he added:

> I have taken the liberty to introduce a history picture in the other side representing some great & heroick subject so as to fix the attention of the spectator & employ his mind after his eye is satisfied with the proportion of the room & propriety of its ornaments, I am entirely of the Italian way of thinking viz: that there can be no true magnificence without the assistance of either painting or sculpture, & I will venture to say that if this room is finished in the manner that I propose it will be the finest room at least in Scotland, & few equall to it in England. [24]

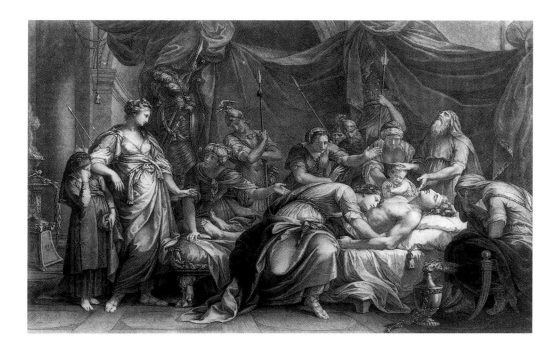

The bait of a 'great & heroick subject' did not prove to be appealing to Tweeddale, and in July 1756 Hamilton announced that he was departing for Italy, as 'it is what I am obliged to doe in consequence of my being a historical painter'.[25]

Though it seems that the use of the present tense to describe himself as a history painter at that time could hardly be backed up materially, the artist's expectations were swiftly fulfilled. Hamilton secured commissions for mythological paintings – broadly similar in style to Mengs' in their dependence on the model of Guido Reni (1575–1642) – and portraits. The latter included *Wood and Dawkins Discovering Palmyra* (National Gallery of Scotland), a work that cast an antiquarian field trip into heroic form, in effect an elaboration into large-scale narrative of the classicizing portraiture that Reynolds had created earlier in the decade.[26]

Whether by virtue of his family money or by way of these commissions, Hamilton was rapidly installed in a comfortable life in Rome. In 1757 he was resident in a country villa outside the city, reported to be 'A most delightfull Spot Situated on the antient Janiculum'.[27] The following year saw the initiation of the cycle of six paintings from the *Iliad*. The first, *Andromache Bewailing the Death of Hector*, was commissioned in Rome in 1758 by Charles Compton, Seventh Earl of Northampton (1737–63), as the pendant to the Homeric painting by Batoni so belittled by Thomas Robinson (FIG. 21). Further commissions followed swiftly: Sir James Grant of Grant ordered *Achilles Lamenting the Death of Patroclus* in 1760, Lord Tavistock (1739–67) *Achilles Vents his Rage on Hector* in 1762, and Lord Palmerston (1739–1802) *The Anger of Achilles for the Loss of Briseis* in 1765 (a subject previously painted by the artist for the Duke of Bridgewater). The sequence of six canvases was brought to completion with *Priam Pleading with Achilles for the Body of Hector*, ordered by the Irish gentleman Luke Gardiner (1745–98) in 1771, and *Hector's Farewell to Andromache* for the duke of Hamilton, underway by 1775.

That the *Iliad* was selected by Hamilton as the vehicle for his reforming artistic effort should not be surprising in some ways. Classical literature had a vitally important place in the formation of the Anglo-British elite's self-image, at a personal and at a collective level. If the patriot

21 Domenico Cunego after Gavin Hamilton, *Andromache Bewailing the Death of Hector*, published by Gavin Hamilton, 1764. Engraving, 45.4 × 63.2 cm. The British Museum, London.

poets had imagined in a relatively generalized way that the Hanoverian governing class were heirs to ancient values, as beneficiaries of an ongoing westward drift of power that meant that the *pax britannica* was an historical inevitability, classical learning played a material role in creating and maintaining their hierarchical position. Classical education at public school, succeeded by some years at Oxford or at Cambridge, was a cornerstone of the reproduction of social and political capital in the Hanoverian state. Homer, the fountainhead of all epic and the author of the paradigmatic heroic narrative, occupied a special place in this scheme. In his classical compendium *Polymetis* (1747), Joseph Spence (1699–1768) referred to the manner in which public schoolboys were forced 'to repeat whole books of Homer and Virgil, by rote'.[28] The antiquarian William Cole (1714–82) later cited Spence and termed this practice 'the Eton method of teaching boys', while the 'Westminster Method' seems customary as a term for the didactic kind of classical learning, forced on students at the expense of the vernacular.[29]

Of the six patrons of Hamilton's scenes from the *Iliad*, three had been schooled at Westminster and two at Eton; the earliest education of the sixth, Palmerston, is not recorded, but he had been to Cambridge, like three others. Compton had been to Oxford and the duke of Hamilton had not been to university at all. Robinson's friend, William Weddell (1736–92), who purchased two classical subject paintings from the painter at this time, and John Fitzpatrick, earl of Upper Ossory (1745–1818), who commissioned an *Agrippina Weeping*, were both educated at Cambridge. Hamilton's patrons were thus drawn exclusively from a highly Anglicized educational elite, tightly unified in their cultural, educational and social capital as well as by their experience of the Grand Tour in the late 1750s and 1760s, the only major exception being the wealthy merchant John Boyd.[30] Rather than being simply typical Grand Tourists, the great majority were highly educated and tended towards relative maturity, being in their twenties when they went on the Tour, presumably reflecting the general obstacle to travel presented by the recent war (with several of the party serving in the military over those years). For these men, the Grand Tour was not an alternative to an academic education or a kind of finishing school where a final social polish could be acquired, but a crucial cultural experience undertaken when they had already made some headway in the adult world.[31] Hamilton's vision of Homeric heroism might be taken as conforming closely to the self-image of these men, steeped in classical values and believing themselves natural heirs to an esteemed cultural heritage.

The significance of Hamilton's painterly articulations of these values is lost if this elite self-image is accepted at face value. The 'Westminster' method was a means of inculcating reactionary political and sexual values in the future state nobility, but it did so by exposing the inherent contradictions of elite masculinity. What this might mean in personal terms was apparent in the mock-heroic but remarkably impassioned poetic account of public school traumas published anonymously by Thomas Maurice (1754–1824) in 1775. *The Schoolboy* details the horrors of boarding school that he had experienced a decade before and tellingly relates the physical culture of public-school education to the primitive (pre-gunpowder, pre-steel) societies that formed a central object of their curricula:

> Thus under the tyrant Power I groan, oppress'd
> With worse than Slav'ry; yet my freeborn Soul
> Her native Warmth forgets not, nor will brook
> Menace, or Taunt from proud insulting Peer:
> But summons to the Field the doughty Foe
> In single Combat, midst th'impartial Throng,
> There to decide our Fate; oft too enflam'd
> With mutual Rage, two rival Armies meet

> Of youthful Warriors; kindling at the Sight,
> My Soul is filled with vast heroic Thoughts,
> Trusting, in martial Glory, to surpass
> Roman or Grecian Chief; instant, with Shouts
> The mingling Squadrons join the horrid Fray;
> No Need of Cannon, or the murd'rous Steel,
> Wide-wasting; Nature, Rage our Arms supplies.
> Fragments of Rocks are hurl'd, and Showers of Stones
> Obscure the Day; nor less the brawny Arm,
> Or knotted Club avail; high in the midst
> Are seen the mighty Chiefs, thro' Hosts of Foes
> Mowing their Way; and now, with tenfold Rage,
> The Combat burns, full many a sanguine Stream
> Distains the Field, and many a Veteran brave
> Lies prostate; loud triumphant Shouts ascend
> By Turns from either Host; each claims the Palm
> Of glorious Conquest; nor till Night's dun Shades
> Involve the Sky, the doubtful Conflict ends.[32]

A poet and scholar, Maurice had attended a series of boarding schools as a boy and was presently a student at Oxford. That his natural father had died in 1763 and that his stepfather was an Irish and Methodist are facts that conspire to provide a potent psychological context for the confessional tone of this piece. Whatever the personal motivations, Maurice highlights the central problem of the eighteenth century: the incompatibility of modern refinement and heroic virtue. He articulates a resolution in the form of a fantasy of heroic physical fulfilment in which the subject is positioned as awed spectator.

The vicarious potential of the Homeric hero was taken still further by William Cowper (1731–1800) in a poem of 1784, 'Tirocinium'. Cowper, a Westminster boy of the same generation as Hamilton's patrons and, in later life, an important translator of Homer and admirer of Hamilton's depictions of the *Iliad*, had been a weakly child who had been bullied and intimidated by his fellow scholars in the 1740s. In 'Tirocinium' he breathlessly characterizes such physically superior youths:

> The stout tall Captain, whose superior size
> The minor heroes view with envious eyes,
> Becomes their pattern, upon whom they fix
> Their whole attention, and ape all his tricks.
> His pride, that scorns t'obey or to submit,
> With them is courage, his effront'ry wit.
> His wild excursions, window-breaking feats,
> Robb'ry of gardens, quarrels in the streets,
> His hair-breadth 'scapes, and all his daring schemes,
> Transport them, and are made their fav'rite themes.[33]

Cowper is writing here from the perspective of an adult whose sense of alienation led to bouts of suicidal depression, but his articulation of a desiring gaze directed at the hero cannot be entirely cast aside in considering the imaging of such figures if the nuances and instabilities of Hamilton's work are to be appreciated. Public-school education provided a resource for the imagining of self in a heroic role. If the physique and inclination were there, this was effected

22 Pompeo
Batoni, *Charles
Compton, Seventh
Earl of
Northampton*,
1758. Oil on
canvas, 237.6 ×
149.3 cm. The
Fitzwilliam
Museum,
Cambridge.

through the sort of personal, hand-to-hand combat that the *Iliad* celebrated and that was so absent in modern warfare. For the weaker boys like Cowper, it occurred by way of an eroticized gaze that consumes such heroic peers and enjoys vicariously their conquests. Not incidentally, these two modes correspond to the shifting subject positions dramatized by the discourse of the Sublime.

Taking as their theme schoolboy fantasy, Maurice and Cowper are able to indulge fully the heroic physicality that was central to the classical ideal. In adult literature, the epic status of the *Iliad* may never have been in question, but the social utility of its heroic values was quite another issue. The critical tendency as the century progressed was to emphasize the alien properties of Homer's world, the moral distance that separated the modern reader from his savage heroes, even as the supreme poetic qualities of the ancient epic were reappraised.[34] Homer was cast, in the terms that became current in the 1750s, as the greatest 'original genius', a sublime, primal and authentic poetic voice whose powers exceeded the polished, refined productions of later ages. Such claims coexisted with the historicization of the epic (most notably in Thomas Blackwell's work). What this meant was that the inhabitants of a modern world of refinement and politeness were put in the position of taking as the epitome of poetic excellence an epic extolling the values of a – from their perspective reprehensibly – savage society. As Duane Coltharp has concluded: 'Criticism of the *Iliad* contains at its core the contradiction of epic heroism itself: the contradiction between self-assertion and civic virtue.'[35]

If the Grand Tour was the site in which elite forms of masculinity were made and unmade in dramatic ways, if Homeric heroism was the basis of powerful forms of self-identification and complex homosocial desires, and if the period after 1760 witnessed the expansion of a sense of cultural entitlement in ways that exposed and dramatized the contradictions of heroic masculinity, it should be evident how Hamilton's *Iliad* series must be of special interest. The following survey of Hamilton's production of the first pictures in the cycle focuses on the ways in which that transformation contributed to a remodelling of, and revealed tensions within, the classical masculine ideal. The disorderly nature of Hamilton's *Iliad* as a practical project reveals the extended negotiation (symbolic and material) requisite for the production of a body of heroic images at this juncture, even in the most privileged circumstances.

The slippages between desire and identification, the exclusive and the demotic, the heroic and the enervated, were apparent in the first picture of the *Iliad* series, *Andromache Bewailing the Death of Hector*, commissioned by Charles Compton in 1758. Compton was a young landed gentleman recently out of formal education at Eton, enthusiastic to define himself as an energetic young man familiar with the grand traditions of classical culture.[36] As was becoming conventional, he was painted by Batoni in one of the artist's most flamboyant portraits, his sitter proud in ermine and silk, a man of culture, learning and ostentatious good taste (FIG. 22). His commissions for Homeric paintings from Batoni and Hamilton advertised his commitment to contemporary art, although, as Robinson's comments might suggest, extending patronage to the polished Italian could be viewed as suspect from the more self-consciously 'reformed'.

Hamilton, though, wears his reforming tendencies on his sleeve. The painting explicitly references the work of Nicolas Poussin (particularly his *Death of Germanicus*; FIG. 23) and, in turn, the antique (FIG. 24), in the shallow pictorial space, dramatic and simplified postures and the device of the curtain hanging as a screen behind the main protagonists, as much as Francis Hayman and Robert Edge Pine Pine were to announce their debt to Charles Le Brun. To judge from the painted sketch for the work, the Scottish painter did not employ the same range of bright local colours as the French painter, but a more muted palette of browns and dull reds, silvery whites and greens (FIG. 25).The inclusion of prominent 'archaeological' details such as the vase in the foreground and the idealized, archaizing features of the leading figures served to

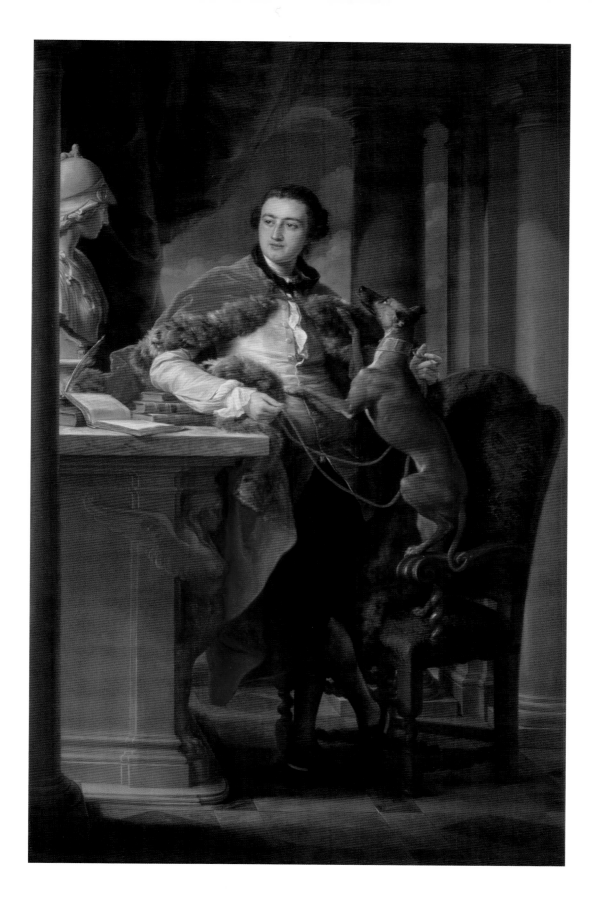

23 Nicolas Poussin, *Death of Germanicus*, 1627. Oil on canvas, 148 × 198 cm. Minneapolis Institute of Arts, MN, USA.

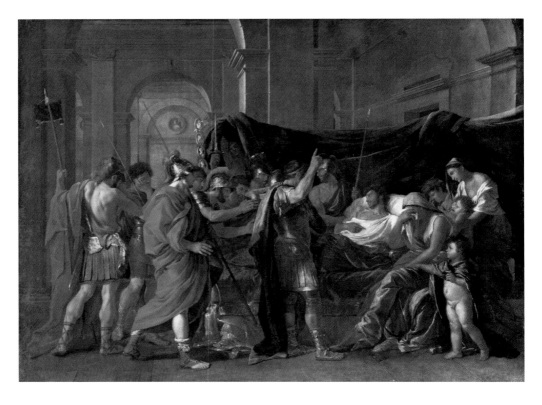

24 (facing page, top) Pietro Santi Bartoli, engraving of an ancient triclinium, plate from Giovan Pietro Bellori, *Admiranda romanarum antiquatatum ac veteris sculpturæ vestiga*, Rome, 1693.

25 (facing page, bottom) Gavin Hamilton, painted study for *Andromache Bewailing the Death of Hector*, c.1759. Oil on canvas, 64.2 × 98.5 cm. National Galleries of Scotland, Edinburgh.

give the work an emphatically classical character, in contradistinction to Batoni's effort. The body of Hector, in particular, is exemplary of idealized classical masculinity, physically pristine and free from any outward signs of emotional trauma.

The *Andromache Bewailing* can be read as an attempt to produce an image of an ancient, heroic world that claims authenticity based on evocative decorative details and its stark formality – and no less an authority than Winckelmann himself claimed that Hamilton had succeeded in comparison with the Italian painter.[37] As the property of Compton, the painting would serve to fabricate an identification between the English nobleman and Homer's martial world of well-muscled heroes, albeit, given the historicizing effect of the archaeological details, a nostalgic one. In its denial of the visual pleasures offered by rich colouristic display or evocative spatial effects, and in its provision of recondite antiquarian references, Hamilton offered Compton an image to 'employ his mind after his eye is satisfied'. In effect, the rigid power structure of Homeric society was restated for the modern gentleman in the only register in which it could now feasibly exist: the aesthetic.

Yet, it is not certain that the image was ever construed in that fashion. The painting was in London by the spring of 1762, when it was exhibited with the Society of Artists.[38] At that time, Compton was again in Italy on an official appointment, where he remained until his youthful death in Lyons the following year. The painting passed to a female relative and was sold in 1773 and has since disappeared.[39] Though in the text of the exhibition catalogue it featured as one entry among a mass of portraits and works in the minor genres, its extraordinary visual impact can only be imagined. One commentator, writing in the *St James's Chronicle* of 22–25 May, remarked that it was 'a very large Picture, that takes up almost a whole side of the Room'. Although the picture was dislodged from the regulating framework of the aristocratic house-

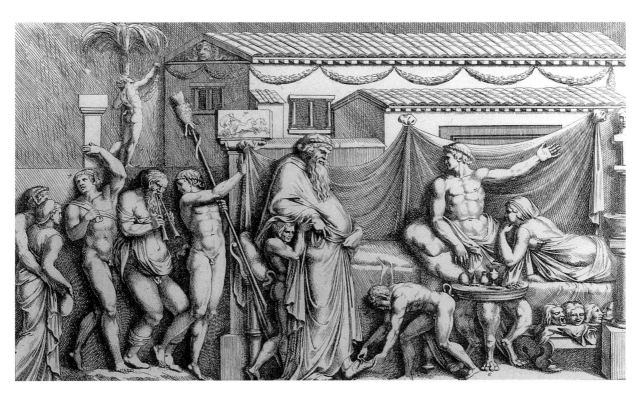

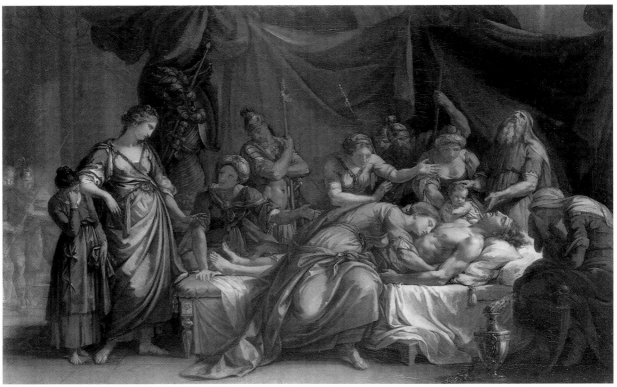

hold, its new audience may have been better equipped to deal with its domineering presence. Just as the exhibition was opening, Daniel Webb's *Inquiry into the Beauties of Painting*, which was highly derivative of the writings of Mengs and Winckelmann, was being advertised in the *London Evening-Post* of 22–24 April as: 'Very proper to be read by those who go to see the Exhibitions of the British Artists'.

Hamilton's painting, like Webb's book, was an intervention in a shifting economy of social distinction that now encompassed an audience defined less in terms of their social status than in their capacity to participate in the metropolitan cultural market (whether by buying the book or buying entrance to the art show). Moreover, Hamilton's painting arguably bore the imprint of the revised social concerns current among the metropolitan audience for culture. The image presents the male body as an object of sympathetic responses and clearly fits the model of civil society: a suffering body is presented to the gazes of both a representational audience and the actual viewers, fabricating a sense of a sentimental community of feeling.[40] It could be argued that this myth of community has been bought at the expense of a determined heroic and masculine presence within the representation. Hector is literally a deathly pictorial presence, an inert core to the drama. In the terms available to a British audience in the early 1760s, Hamilton's image makes a theme of the retirement from social accountability characteristic of the culture of sentiment. In the grey, marble-like body of Hector was to be found a consummation of the Winckelmannian ideal of eroticized masculinity and the deathly embodiment of a sentimental retreat from public responsibility or heroic self-assertion.

This basic formula was repeated in the second work for the *Iliad* series, *Achilles Lamenting the Death of Patroclus*, commissioned by Sir James Grant of Grant in 1760, and completed in 1763 (FIG. 26). The existence of a pair of what appear to be finished presentation drawings reproducing this picture with the *Andromache Bewailing the Death of Hector* (Yale Center for British Art) suggest that these two works may have been considered as a pair, at least retrospectively. In correspondence with his customer, Hamilton proposed the image as the focus of a primarily emotional response:

> I hope that by this time my picture of Achilles bewailing the death of Patroclus is arrived safe, as a painter I am anxious to know the opinion of the world, as a person honoured with your friendship, I am still more desirous to know your own sentiments of a performance where the generous passions of benevolence & compassion have so great a share. when I painted Patroclus I thought as much of pleasing you as greaving Achilles, that compassion gives an inward satisfaction you can better feel than I describe, if you are touched with this sentiment on looking at the picture the painter has succeeded & I am happy.[41]

This is a wholly affective model of pictorial representation, in which the issues of exemplarity and the idea of the work of art as a prompt to virtuous action are dissolved rhetorically into a scene of emotionalism beyond reason and language, where the patron may 'better feel' than the artist 'describe'. Thus is introduced into a correspondence between the painter and his high-born patron about a picture of a scene drawn from the canonically heroic ancient text a passage operating on those emotive terms of sentimental responsiveness characteristically associated with feminized modes of reading. As David Hume found, working contemporaneously on his *History of Endland* (1754–62), the Grand Manner could, perhaps should, be married to a sentimental framework to give it currency.

The painting did not reach London until 1765, when it was exhibited at the Society of Artists. Hamilton had to go to considerable efforts to persuade Grant that the picture should be displayed at all. Recruiting the Earl of Findlater and Alexander Cozens to his cause, Hamilton had

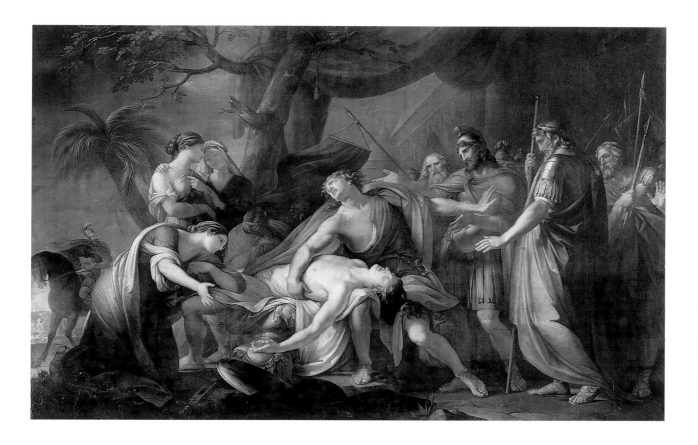

to fend off Sir James' initial expectation that it be set into the panelling of his house in Scotland, and it was instead put into a temporary frame so it could be exhibited.[42] Cozens in London pleaded with Grant that, as Hamilton's previous exhibit had been maligned for its poor colouring, the painter needed the opportunity to let 'the people of England see, that Mr Hamilton can colour as well as design, and thereby procure the proper reward for so much merit, in the approbation of the Public'.[43] Grant may have had good reason to be concerned: sending off his later *Lucretia* for exhibition in London, Hamilton had specified to his brother James that it should be shown in the Spring Gardens exhibition only, 'as Mr Grant's Picture suffered so much in the carelessness of repacking'.[44] But, beyond the physical dangers of the extra handling entailed in the exhibition of pictures, there was the perhaps still more serious matter of the exposure of this item of personal property to an unregulated critical view as a form of 'furniture' (that is, framed and mobile rather than set into an architectural interior). Hamilton may have written of the painting to his patron in terms that could establish the image as the object of sentimental values, but that patron resisted a move that would make the image physically available to the relatively socially indiscriminate, urban spectatorship for which such values had been forged.

During the exhibition, the *Achilles Lamenting* received mixed reviews. The *Gazetteer* of 21 May 1765 wrote:

> Achilles undoubtedly should be the principal figure; if he is well represented, the painter will secure his piece from contempt. The agony of Achilles grief is, I believe, well enough conceived in the posture it has been thrown into: but take the whole painting together, it is cer-

26 Gavin Hamilton, *Achilles Lamenting the Death of Patroclus*, exhibited 1765. Oil on canvas, 227.3 × 391.2 cm. National Galleries of Scotland, Edinburgh.

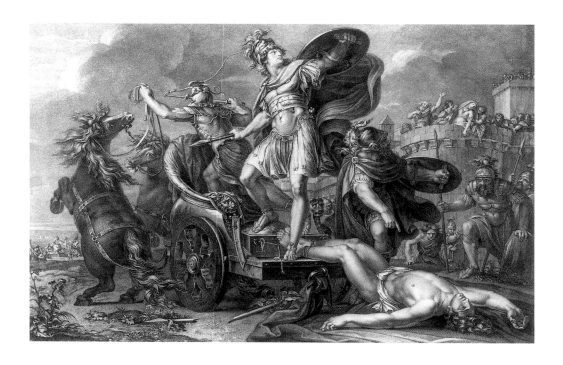

27 Domenico Cunego after Gavin Hamilton, *Achilles Vents his Rage on Hector*, published by Gavin Hamilton, 1766. Engraving, 45.5 × 62.6 cm. The British Museum, London.

tainly not a capital performance. The figures are too many for the piece, and too much crowded.

The basic rules of the Grand Manner are in place: the placing of the protagonist in the most prominent position in the picture; the need for expression of emotion; and the orderly disposition of the whole and limitation on the number of actors. The *St James's Chronicle* of 7–9 May 1765 took the opportunity of Hamilton's picture to make a general point about the need for Grand Manner art, deploying the conventional opposition between the universal and the individual: 'Great Encouragement should be given to those Painters, who cultivate the nobler Provinces of the Art, and endeavour to touch the Passions by historical or poetical pieces, rather than to sacrifice to the vanity of mankind by Portrait-Painting.'

Via the exhibition, Hamilton's picture provided an opportunity for a non-aristocratic audience to participate in and revise (if only pedantically) an elite vision of the ideal. Its display granted licence to the expression of an idealist rhetoric that nonetheless, by virtue of the notion of 'encouragement', brought the Grand Manner into relation with the national interest. While evidently conceived as a celebration of the specifically and even exclusively masculine world of ancient Greece, in the exhibition the painting was instead exposed to unregulated criticism on the part of journalists working to quite different and more clearly populist agendas.[45]

In taking on the subjects of *Achilles Lamenting* and *Andromache Bewailing* as the first public works of the series, regardless of the narrative sequence of the *Iliad* itself, Hamilton was responding to the emotional criteria current in polite discourse. In 1762, he received a further commission, from Francis Russell, Lord Tavistock, for a painting of *Achilles Vents his Rage on Hector* on a matching scale. This represents a departure from the formula (fig. 27). The first two commissions had hardly gone smoothly, with the premature death of one patron and the reluctance of the other to have his painting displayed in London as the painter wished. The circumstances of this third work demonstrate the perilous nature of Hamilton's project at both material and symbolic levels.

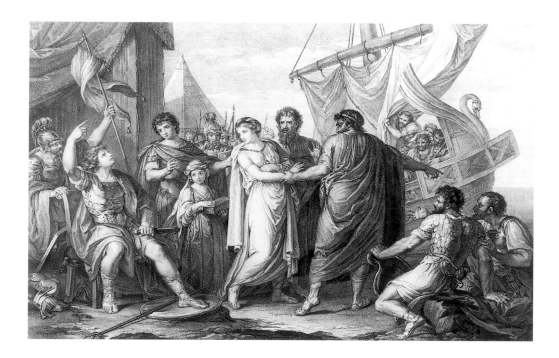

The scene where Achilles drags the body of Hector around the walls of Troy, publicly insult-ing his corpse despite the Trojan's heroic and virtuous actions, was taken as the most complete demonstration of the brutality and cruelty of the Greek.[46] What this developed into was a pro-found doubt that heroism itself was properly represented by Homer's text, which takes the Greeks as its heroes: 'barbarity, ignorance, lust, and cruelty were still in fashion: and we may justly say, that heroism was never worse known than in those ages which were called heroic'.[47]

It was with this skewed emotional perspective in mind that a visitor to Hamilton's studio early in 1763, by which time either the full-scale canvas or more probably a study was begun, noted that 'the horror of the Subject bids fair to be well hid' and hoped 'the distress of Andro-mache, to become the Stricking & affecting parts'.[48] The response of Andromache and her com-panions is, though, only a tiny, insignificant detail of the finished composition. While the body of Hector in *Achilles Vents his Rage* conforms to the ideal in its physical features and evokes a type of fallen warrior found in classical reliefs, it is presented within the image as the object of horror rather than sympathy.[49] At the narrative heart of the image, this body is not simply an ennobled object that in turn ennobles its spectators and forms them into a community: it is a source of alarm and distress and forces its spectators to turn away. Though it could be argued that the *Achilles Vents his Rage* is, indeed, a sentimental subject, in representing the reprehen-sibility of an absence of sympathy, this reading only proves that any sentimental message was, at best, oblique and more probably wholly muddled.

Alternatively, the image functions as a sensational visualization of masculine brutality as a Sublime spectacle. The posture of the hero recalls, indeed, the most literally gigantic heroic figures surviving from antiquity: the *Dioscuri* of Monte Cavallo on the Quirinal in Rome. Yet the image brings into question martial virtue: Achilles' violence is driven by vengeful feelings that disrupt a community and horrify even the barbaric-looking soldier approaching from the right. While *Achilles Vents his Rage* represents the most uncompromising example of martial masculinity to appear in the *Iliad* cycle, it represents also the displacement of such an unequiv-

28 Domenico Cunego after Gavin Hamilton, *The Anger of Achilles at the Loss of Briseis*, published by Gavin Hamilton, 1769. Engraving, 45.3 × 62 cm. The British Museum, London.

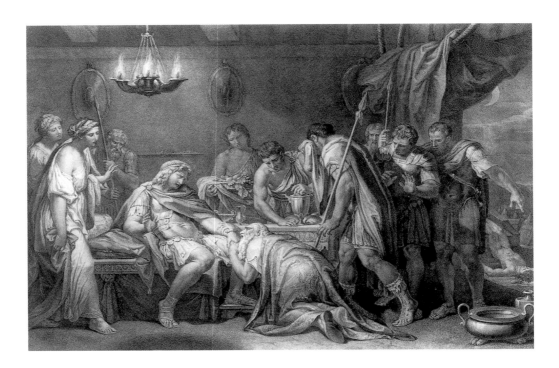

29 Domenico
Cunego after Gavin
Hamilton, *Priam
Pleading with
Achilles for the
Body of Hector*,
published by Gavin
Hamilton, 1775.
Engraving, 44.3 ×
63.5 cm. The British
Museum, London.

ocally masculine figure from contemporary social discourse (a displacement that could only be
recuperated in aesthetic terms as an instance of the Sublime). In the event, Hamilton's canvas
was rejected in a literal sense. When Tavistock died in a riding accident in 1767, his mother
refused the painting, reportedly because she found the subject so distressing, and its subsequent
history remains unclear.[50]

Hamilton's *Iliad* series represents an attempt to negotiate the necessarily diverse audiences
required for the support of the history painter. Each image had to function variously as a show-
piece in the artist's Rome studio, as a finished work of art in a public exhibition and in an aris-
tocratic household, and as a reproducible commodity for more general consumption. They were
imagined as a series to be seen together: Hamilton had been commissioned to paint the subject
of the *Anger of Achilles* for the Duke of Bridgewater in 1758, but he noted when writing to
Lord Palmerston in 1765 that it was 'of a size & proportion that woud [sic] not accompany
the rest of my set (FIG. 28).[51] Yet the only place that they could, in actuality, be brought together
was in the medium of print. In the same letter to Palmerston, Hamilton indicated that he had
already planned the whole six plates for the Iliad series, though only three of the canvases had
been commissioned.[52]

Such a project reveals Hamilton as a canny commercial operator. He was acutely aware of
the importance of print publication and recognized the commercial possibilities of a public more
extensive and socially diverse than had ever existed for original, painted heroic imagery. Though
advertised together and widely distributed, the prints were priced individually for the London
market and there is evidence that they were circulated in that form.[53] Necessarily reduced in
value as units and subjected to the wilful caprice of individual owners, Hamilton's heroic cycle
could (perhaps literally) be cut up, reorganized or thrown away (FIG. 29).[54]

In their format and thematic unity, Hamilton's *Iliad* paintings were conceived as a coherent
cycle. But, ultimately, these pictures represent a faltering and incomplete endeavour, even as repro-
duced in print. They were divided among their various patrons and perhaps neglected by them,

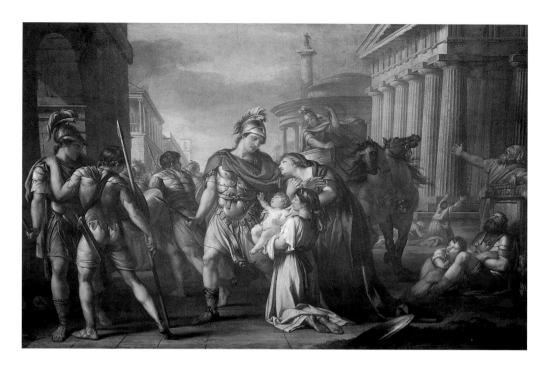

the prints were dispersed and disconnected from each other, and the series was never actually completed, for the final painting, *Hector's farewell to Andromache*, was not engraved (FIG. 30).

Hamilton's success as a painter of history based in Rome depended upon his ability to contrive the public display of his works, to socialize effectively with the elite classes and, perhaps most of all, to operate as an art dealer of some celebrity. Although the painter shared a degree of equity with his patrons, his particular social trajectory meant that this was not, perhaps, a matter of complete identification. Rather, Hamilton's correspondence with these patrons articulates a shifting set of identities, as equal, associate, servant and employee. With a few exceptions, Hamilton's discussion of his practice as a painter of the heroic occupied a marginal place in this correspondence, even sometimes appearing as a postscript after other matters. The artist's success rested on his alignment of his economic self-advancement with the cultural advancement of his patron – an alignment made possible through the currency of a discourse of aesthetic reform. Hamilton's patron, Henry Temple, Lord Palmerston, demonstrated his mastery of the historicizing rhetoric characteristic of that discourse in a letter of June 1764:

> I believe that in the real Comforts and Conveniences of life we surpass the Ancients and we have many admirable Inventions of which they were totally ignorant. but certainly in the Arts which they practised and in all the magnificence of Luxury, we

30 Gavin Hamilton, *Hector's Farewell to Andromache*, 1775. Oil on canvas, 315 × 395.6 cm. University of Glasgow, Glasgow.

31 David Allan, *Hector's Farewell to Andromache*, 1773. Oil on canvas, 73.7 × 99.1 cm. Accademia Nazionale di S. Luca, Rome.

have nothing to do but wonder and submit. the greatest Painters that have been since the Revival of the Arts have formed themselves by studying the ancient Artists and have borrow'd from them the happiest Ideas of simplicity Elegance and Beauty.[55]

Thus is summarized the predominant art-historical narrative of the period: that art had declined in modern times and that only with a return to the stylistic and thematic traits of the antique might it be revived. Hamilton himself would, it was later reported, provide a historical narrative of the seventeenth-century decline of art and the lost splendours of the antique that fits this model quite precisely.[56] This is proof of the way the pan-European reform project of mid-century opened up a discursive space shared by artists and patrons, but this did not necessarily bring into being the mechanisms for the realization of works of art fully in tune with and expressive of that project. The discourse of cultural reformation incorporated a compulsion to high art production, but did not establish a compelling agenda for the content of high art.

Nevertheless, through the display of individual works in Rome and London and particularly in the Iliad cycle of paintings as they were reconstructed in the medium of print, Hamilton rapidly established his identity as the leading British historical painter. He provided a model for other Britons who settled in Italy and established dual careers as businessmen – archaeologists and historical artists. More pertinently, Hamilton's work defined a repertoire of formal and thematic models that was quite closely followed by a number of the most successful historical painters of the 1760s. Homeric subject pictures became a prominent feature of the London art exhibitions of the later 1760s and 1770s. Among those who undertook such themes were members of Hamilton's immediate circle in Rome. William Cochrane (1738–85) was sent out by the publisher Robert Foulis to study under Hamilton, expressly to become 'a history painter of a rank to do honour to his benefactors and his country', but came to little, being mainly occupied as a copyist.[57] Another product of the Continental-style academic training sponsored by the Foulis Academy, David Allan (1744–96), created a succession of severe classical subjects under Hamilton's instruction, winning, exceptionally, the *Concorso* of the Accademia di San Luca in Rome in 1773 with his *Hector's Farewell to Andromache*, a painting that wears its pictorial debts on its sleeve (FIG. 31).[58] His self-portrait of 1770 exemplifies the artistic self-image to be associated with such accomplishments: Allan is here, notwithstanding the presence of a porte crayon and a thick portfolio of drawings, quite the Grand Tourist (FIG. 32).

While the academic school run by Foulis in Glasgow provided Hamilton with a number of students, the most immediately successful of his associates during the earlier 1760s was English: Nathaniel Dance. The son of the successful and well-connected City of London architect George Dance as well as being a pupil of Francis Hayman, Dance was well positioned to be the recipient of a patrilineal cultural inheritance.[59] With a grammar-school education and considerable financial backing from his father, his advantages over the more strictly schooled Scottish contemporaries who took Hamilton as a master were substantial and, at least initially, Dance's period on the Continent arguably resembled a Grand Tour as much as a professional studentship.[60] Although he moved to Rome as early as 1754, only in 1759 did he start to produce ambitious history paintings, after being advised by Gavin Hamilton to enter a picture into the Society of Arts' competition for historical painting.[61]

The sketch that records the resulting work, *The Death of Virginia*, reveals the robust physical types and prosaic draughtsmanship typical of Hayman, translated into the idiom of contemporary Anglo-Roman painting (it should be noted that the subject was treated at this time by Mengs) (FIG. 33).[62] The image's dramatic content, prominent historical details and architectonic structuring make obvious allusions to Poussin and Raphael, as well as more immediately to Hamilton. Furthermore, the figure of Virginia is clearly intended to evoke a specific antique

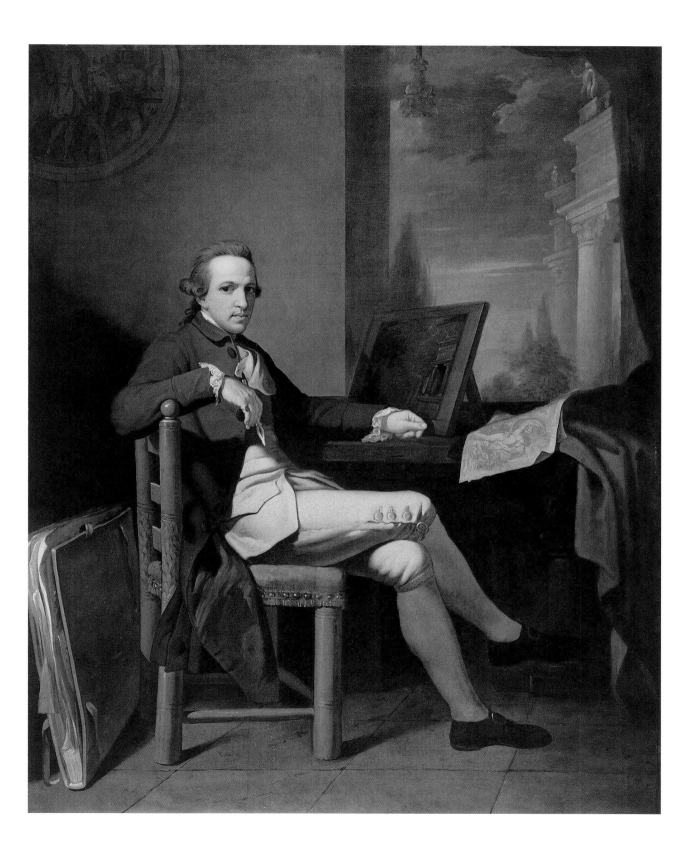

33 Nathaniel Dance, *The Death of Virginia*, drawing in a letter dated 28 July 1759. Sir John Soane's House and Museum, London.

model: the dead female figure in the famous *Paetus and Arria* group (museo Nazionale Romano, Rome). But more particularly like Hamilton, Dance was here intent on bringing these cultural references to bear on a theme that tapped into contemporary concerns about citizenship, virtue and sentiment, even if the choice of an ancient Roman subject and the fact that it was painted outside Britain precluded the picture's submission into the Society of Arts' competition. Virginius' murder of his own daughter, Virginia, to prevent her becoming enslaved to Appius Claudius represents in itself an exemplary act of manly self-sacrifice in opposition to tyrannical power and, in terms of historical narrative, the prompt to a political revolution 'whereby the citizens of Rome recovered their Liberty'.[63] The subject matter presents the stern, even savage virtues of the ancient world, in defiance of the sentimental ideals of civil society, which sought to strengthen, as its foundation, affective relations between men and women, husbands and wives, fathers and daughters.

In the event, *The Death of Virginia* was the only exercise in this line of exemplary history painting that Dance undertook. He was commissioned in 1760 to create three ambitious mythological compositions: *Nisus and Euryalus* for James Grant (lost), *Aeneas and Venus* for Sir Henry Mainwaring (1726–97; sold Christies, London, 23 May 1994) and The *Meeting of Dido and Aeneas* for George, Lord Grey (1737–1819; FIG. 34). These are accomplished exercises in classical history painting of the type exemplified by Mengs and Hamilton, but their narrative content is focused on the theme of love rather than heroic virtue. Unlike the brute Achilles, Virgil's hero could be recommended for his genteel accomplishments, sheer physical beauty and his dutiful patriotism, which fitted with a moderate image of masculinity in civil society, as David Hume had stated:

It is certain, that the ideas of manners are so much changed since the age of Homer, that though the Iliad was always among the ancients conceived to be a panegyric on the Greeks, yet the reader is now almost always on the side of the Trojans, and is much more interested for the humane and soft manners of Priam, Hector, Andromache, Sarpedon, *Æ*neas, Glaucus, nay, even of Paris and Helen, than for the severe and cruel bravery of Achilles, Agamemnon, and the other Grecian heroes.[64]

34 Nathaniel Dance, *The Meeting of Dido and Aeneas*, exhibited 1766. Oil on canvas, 122 × 171.8 cm. Tate, London.

Where Achilles represented a brute and unpredictable masculinity, Aeneas represented polish, steady accomplishment and reliability. The same could apply to the authors: comparing Virgil with Homer, Richard Steele had claimed that 'He every where charms and pleases us by the force of his own Genius; but seldom elevates and transports us.'[65] Dance matches such an interpretation with his painting. Though compositionally center stage, Dance's Aeneas has a passive role to play in the meeting with Dido: he is objectified by her desiring gaze, 'complaisant, peacock-proud and more than a little goofy' as a modern commentator has put it.[66] The very technique of the picture, its high finish and limited tonal range, signalled the kind of easy beauty associated with the Latin poet. In this context, it is worth noting an exactly contemporaneous reference to the closely comparable works of Benjamin West as 'Virgilian'.[67]

Notably, Dance marked his return to England with the public presentation of a full-scale copy after Pietro da Cortona's *Ananias Restoring the Sight of St Paul* to the Church of All Hallows, London Wall, in the City of London (where it remains), built by his brother George (FIG. 35).[68] While copying old masters was quite a conventional part of artistic training, the presentation of the picture suggests that it was more than a student exercise. Instead, it was a statement of artistic allegiance, in this case to the most technically refined and pictorially elaborate sort of

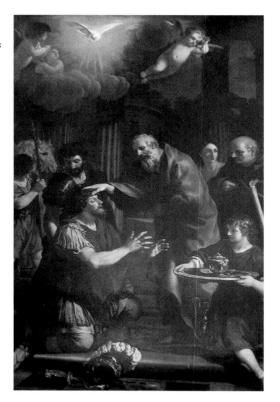

35 Nathaniel Dance after Pietro da Cortona, *Ananias Restoring the Sight of St Paul*, c.1766–67. Oil on canvas, approx. 280 × 205 cm. All Hallow's Church, London Wall.

seventeenth-century Roman classicism. Contrasted with the fire of Michelangelo or the correctness of Raphael, Cortona was conventionally characterized as an artist and person of undemanding elegance and perhaps facile technical assurance. To quote Roger de Piles (1635–1709), 'His genius was fruitful, his thoughts full of flowers and graces, and his execution easy', and accordingly, 'his temper was mild, his conversation agreeable, and his manners sincere.'[69] Dance's comparably tempered and decorous classicism provided a reassuring image of virtue shorn of the rough edges that came with a fully historicized Homer and stripped of the libertarian political associations evoked by Robert Edge Pine and John Hamilton Mortimer (see Chapter 1).

While this affiliation to Virgilian refinement won Dance some early successes, there were dangers associated with this strategy. De Piles had noted of Cortona that, since his was a 'general grace that pleased everybody', it was bought at the expense of expression, an opinion that remained current.[70] More immediately, during his Grand Tour, Thomas Robinson – who had featured with Grant in a group portrait by Dance – gave a highly articulate account of his reservations regarding the refined style of Pietro da Cortona and Carlo Maratta:

> These Painters absurdly fired of the noble simplicity of Raphael & ye Roman School, & perhaps unequal to the task of copying a grand & beautiful Nature, ran into a contrary extreme, & by an affected Contour & excess of Gracefulness made incorrectness less perceivable, & consequently the art in their hands became more Easy. This Saving of Trouble & Reflexion was to agreable to idle & uningenious Painters not to be adopted by them, & whatever good Pieces may have come out of their hands, I am almost bold enough to affirm that they have spoilt more painters than almost any thing can reform.[71]

Although Dance evidently set out to emulate Hamilton, his early career trajectory indicates that the attempt to reconcile the elitist classicism of contemporary Roman art with themes of broadly political relevance, thus generating representational masculinities appropriate to modern Britain, might viably be abandoned with the support of a close network of aristocratic patrons. The vigour, rigour and, in Robinson's terms, 'Trouble' of the reformed style of complex narrative imagery represented in the work of Hamilton and Dance at the beginning of the 1760s gave way in the latter's case to a more decorative manner and then to an abandonment of history painting altogether.

This pictorial and personal amollishment is especially evident in the case of the American painter, Benjamin West, who was in Rome in the early 1760s.[72] Born in the small Quaker community of Springfield outside Philadelphia, West had, with minimal training, spent several years

as a portrait painter in America before travelling to Italy in 1760 on a boat loaded with sugar, having been sent to Europe by the Philadelphian businessman and civic leader William Allen (1704–80). While West got an essential opportunity to study and make professional contacts, Allen expected receive from the young painter copies of the old masters and the cultural credit these would accrue to him in the context of a colonial society where the signifiers of European cultural tradition assumed amplified value.

When Allen stumped up a further £150 for the artist in 1762, he told his bankers in Europe: 'We have such an extraordinary Account

36 Benjamin West, *Venus and Cupid*, exhibited 1765. Oil on canvas, oval, 95 × 82 cm. The Parthenon, Nashville, Tennessee.

of Mr West's Genius in the painting way, that we venture to afford him these Supplies, and for his Incouragement to take it out in Copies.'[73] Thus the vague language of 'encouragement' allowed for the existence of a relationship that could be described as a straightforward business affair, with the artist's works being purchased in a cash exchange, but equally cast in the language of civic responsibility. West was both a young professional advancing his skills and his career and a representative of the cultural interests of that party of Philadelphians who were seeking actively to secure their social and economic status in colonial society, their loyalty to the crown and their links with European culture. He was clearly highly conscious of the value attached to his copies in colonial society: he requested of Allen that the first batch of paintings he sent over not be copied by any local artist, so that they would remain unique and their rarity value and aura be maintained. That West's professional advancement could, as a by-product, augment the cultural aspirations of his colonial patrons was a situation that could not be long maintained once the economic obligations owed by the painter were weakened.

West moved to England in 1763, ostensibly only for a brief period before returning with his new-found skills to America. In the event, he quickly established himself as the most materially successful and well-patronized history painter of the age. As William Allen wrote back to America while visiting England at that time:

He is really a wonder of a man and has so far outstripped all the painters of his time as to get into high esteem at once, whereas the famous Reynolds was five years at work before he got into Vogue, as has been the case with all the others who generally drudged a longer time before they had any thing of a name: If he keeps his health he will make money very fast, he is not like to return among us.[74]

Later in life, West wrote an autobiography where he cast himself at this time as a swingeing artistic reformer making an appearance in the midst of luxury and corruption.[75] More realistically, West's success was founded on a combination of personal preferment and a singular facility in presenting his works as, effectively, ersatz old masters. Having painted a series of direct copies for his American sponsors, West presented a succession of erotic mythologies to his prospective British customers at the London exhibitions of the mid-1760s, evoking the models of Correggio and Titian, Guido Reni and Domenichino and Mengs – the artists he had copied in Italy.[76] West's success in those years would seem to have depended to a degree upon the erasure of his authorial presence, allowing his works to appear as relatively unmediated transcriptions of esteemed pictorial precedents, in combination with light, romantic subject matter, which made no great claims towards narrative exemplarity. Claimed as his first commission after arriving in England, his *Venus and Cupid* can be taken as representing the consummate example of this approach, created, so the artist said 'while his mind was full of Correggio' (FIG. 36).[77]

West himself readily theorized the cautious, synthetic approach in a letter to a slightly younger compatriot, John Singleton Copley (1738–1815), who, like he, was intent on becoming a great painter by travelling from his colonial home to Italy.[78] As his advice to Copley makes clear, the purpose of artists' travel was the opportunity it afforded for the absorption of different pictorial manners. West specified the range of works his younger colleague would have to see in order to gather together their excellence: the ancients offer 'various characters of nature' and the 'soundest principles', Raphael ideal composition, Correggio 'the management of clear obscure', and so on. Copley is directed to attend to each of them promiscuously, 'as every perfection of the art of painting is to be found in one or other of their works'.[79] While this advice falls in line with the eclectic principles promulgated within the academies, its particular inflections might be explained by reference to recent discourse on polite education. The West–Copley exchange reproduces in modulated form long-standing arguments for the value of foreign travel in the education of the elite male. Copley's 'too liney' images that assault the viewer's eyes can be related homologically to the awkward social manner of the untravelled gentleman as it was imagined in Grand Tour literature. The 'polish' invoked in polite literature is figured in the West–Copley exchange as the literal and tactile property of a painted surface; Copley's newly 'gracefull' brush would smooth over and sweep away the awkward traces of provincialism.[80]

West's comments exemplify a temperate model of artistic expertise based on direct imitation of old masters, which had as its practical concomitant the social graces that granted the painter ingratiation with the network of dealers and patrons who fuelled the Roman cultural economy. West's immediate and considerable success by these means cannot be denied. But it could be questioned. In 1764 a satirical poet was suggesting that the sort of carefully acquired technical polish advertised by West and by Dance was as suspect as the social polish of the Grand Tourist:

> Go abroad – take your palette and pencils to Rome,
> And when you return from your tour
> If a few foreign graces and airs you assume
> You will charm a complete connoisseur[81]

The examples of West and Dance at least gave the appearance that it was possible to forge an independent career as a history painter by affecting 'graces and airs'. The case of Hamilton had seemed more uncompromising but was all the more exceptional and was dependent on the very particular position of that artist. At the end of the 1760s, however, one artist set out to pursue heroic art without cultivating the social and business networks that sustained Hamilton and Dance or affecting the self-effacing artistic polish advocated by West: James Barry.

3

JAMES BARRY

IN FRANCE AND ITALY

The new ideas of original genius and the Sublime, optimism about Britain's imperial fate and the flourishing of the Grand Tour had combined in the 1760s to make it appear that Grand Manner art, even of the most severe and challenging kind, might find favour in modern times. But the brief rush of optimism at the beginning of the decade was fugitive. In the event, the uncompromising vision of the ancient world represented by Gavin Hamilton's *Achilles Vents his Rage* or Nathaniel Dance's *Death of Virginia* proved unpalatable to those members of the social elite who had the resources to support such physically ambitious and time-consuming productions. The evidence was that aristocratic patrons were more willing to support a kind of refined classicism that was patently cosmopolitan and ambitious but that did not obviously proceed from the most pressing social and aesthetic demands of the early 1760s. This is reflected in the turn taken by Dance after that initial Roman subject to classical love themes and the dedication to such subjects manifested by Benjamin West in the middle part of the decade.

Even accepting the more ready appeal of paintings in this mode, the creation of original subject paintings remained an unusual occupation. The commissions received by Dance were exceptional and were doubtless facilitated by the easy social relations he enjoyed with the patron class, while West was effectively bankrolled through his Italian years by his American supporters. The vast majority of British painters in Rome were, rather, preoccupied with work of a more prosaic character, predominantly copies after established masterworks. For sculptors in particular, the booming market in restored, faked and copied antiquities supplied much sustenance. Surveying the British artistic community in the city in 1766, the surgeon and travel writer Samuel Sharp (*c*.1700–1781) surmised:

It is with pleasure that I can tell you that the *English* students here, both in painting and in sculpture, have great merit, and are a set of sober modest men, who, by their decorum, and friendly manner of living amongst one another, do credit to their profession. It is a pity they should leave this city and their studies; for, as certainly as they arrive at *London*, they will quit their works of genius, and be totally absorbed in portrait-painting, the stumbling-block on which all the *English* painters fall. It is very possible, however, that they will, most of them, remain some years longer here, as it is of late become a fashion amongst our Nobility, to bespeak copies of statues and pictures from their countrymen, and they find employment to subsist comfortably, by this new-invented species of encouragement, which, with a little share of enthusiasm, the common lot of painters, who have any taste or feeling, will be a sufficient allurement to keep them in a place where they have continually before their eyes such excellent gratifications. They do, as I am told, earn one hundred pounds a year, each of them,

by their labour, which they esteem equal to three hundred pounds a year in London; not that living is three times as cheap here, but because the plan of living is humble and sober at *Rome*, whereas in *London*, it is dissipation and extravagance.[1]

Before the end of the decade it was becoming apparent that this model of artistic expertise, in which an emulative identification with past masters was established through direct imitation undertaken in a 'humble and sober' spirit, was felt to be insufficient. Indeed, at the end of the 1760s, one British artist in particular set out to produce ideal art of a more assertive character, and without cultivating the social and business networks that sustained Hamilton and Dance or affecting the self-effacing artistic polish of West or even becoming one of those 'sober modest men' observed by Sharp.

Unlike Hamilton or Dance, the Irish-born James Barry (1741–1806) did not have a prolonged and formal artistic training, nor did he have an assured social status and, perhaps most importantly, his Catholicism made him socially vulnerable in ways they or the American West (so often imagined to be a Quaker) did not have to experience.[2] According to his first biographer, Edward Fryer, Barry's mother's family 'possessed considerable landed property in the county of Cork, of which they had been dispossessed by the revolution of king William', and, while his father was said to be connected to the Barry family, 'which has been honoured with the earldom of Barrymore', he worked first as a builder and then as a coastal trader travelling between England and Ireland.[3] Although the Penal Laws did not provide direct inhibitions to Catholic trade, and Cork was a predominantly Catholic district where these laws were applied in a relatively relaxed way compared to Dublin, social stigma and customary legal prejudice pushed many Catholic traders into a feigned conformity with the established Church, and this seems likely to have been the case with the elder Barry.[4] Fryer, who commits the first few pages of his life of Barry to this issue, noted that in his youth he 'could not avoid mixing at times in the company of priests resident in Cork', but while this has led to rumours that Barry intended entering the Catholic priesthood, Fryer's investigations revealed that 'no authority appears for the assertion':

> To the religion then of his choice he was tolerably steady through life; perhaps a little enthusiastic for it in youth, as he was certainly rather too bigoted to it in the decline of life. There was a short interval however when, according to a declaration he once made, he had been a little wavering in his belief of revealed religion: it was the unfortunate fashion of the day, and was picked up during his residence on the Continent; but a short conversation with Mr Edmund Burke put an end to this levity.[5]

The Edmund Burke mentioned in this context is, of course, the Irish statesman and philosophical writer (1729–97). Burke was introduced to the young Barry in Dublin late in 1763 by the Cork-born medical doctor Joseph Fenn Sleigh (1733–1770). While in the city, the painter may have studied briefly at the drawing schools run by the Dublin Society. If this had long been an organization closely aligned with the Anglo-Irish Protestant establishment, Barry had become involved with the society precisely as state involvement was being stepped up and as the schools were being more tightly regulated – a situation that was shortly to bring the gentleman members of the society into conflict with the professional artists, who grouped themselves as a Society of Artists.[6] Barry benefited from the association, though, winning a premium with a painting of *The Baptism of the King of Cashel by St Patrick*. As an image of Irish history representing the moment Christianity was accepted by the ancient Irish, it is a work that both conforms to sectarian demands for a nationalistic imagery that would suit the Protestant establishment and, in Luke Gibbons' argument, introduces, by choosing the moment St Patrick's crosier accidentally pierces the king's foot, an evocation of the stigmata with unmistakably Catholic connotations.[7]

Barry did not linger in Dublin. Edmund Burke, with his brother Richard and cousin William, swiftly sent him to London and then supported him through several years of independent study in Paris and Rome. This sustained support from the Burkes was exceptional in any context and it was particularly charged in relation to the sectarian politics of Ireland. The extended correspondence between Barry and Edmund Burke from the late 1760s testifies to a closely cultivated and intimate relationship. There was, perhaps, an unusual degree of personal sympathy between these men. Burke was the son of a zealous Catholic mother from the decayed old gentry and a Protestant father whose religious conformity was probably feigned to accord with the penal laws. He may have been born in Cork and his family certainly originated there, and in these respects shared fundamental social character (if not rank) with Barry.[8]

Against the background of heightened sectarian violence in these years, which saw the Burkes subjected to vicious rumours and the establishment of the resilient image of Edmund as a 'Jesuit', the Irish politician cultivated one other particularly telling epistolary relationship: with the Irish parliamentarian Charles O'Hara (1715–76).[9] It may be speculated that the relationship with the younger Barry formed a kind of complement to the relationship with O'Hara. On the one hand, there was an older man who had disavowed his Catholic origins and who, as Burke intimated in their correspondence, had effectively sold out to the Anglo-Irish establishment. On the other, there was the younger, openly Catholic painter. Did Barry, who professed Catholicism 'even to a degree which many of his protestant friends justly thought bigoted', represent the vicarious fulfilment of an identity that was necessarily coded, disguised and suppressed in Burke himself?[10] O'Hara and Barry would thus represent the poles of shameful conformity and dangerous rebellion that provided key coordinates for Burke's thought, not least with his aesthetic proposals around the Beautiful and the Sublime.[11]

Certainly, Burke's support of Barry was of rare kind in being a form of extended patronage. The only closely comparable known example is that extended by the Philadelphian mercantile elite to West. Could it be said that this cultural investment in Barry on the part of a 'colonial' group offered a comparable sort of surrogate entry into established culture? If so, it would be an entrance of a particularly intrusive kind. For Barry himself, in Fintan Cullen's account, education as an artist formed a synecdoche of Ireland's repositioning within the British Empire – an attempt actively to force an Anglocentric cultural establishment to accept the legitimacy of a distinct Irish and Catholic component.[12]

Barry was in England with Richard Burke by 1764, where he was found work as a draughtsman under the architect James Stuart, an associate of Sleigh and the Burke family. This introduction to London's artistic community was a circumstance that Fryer noted astutely 'does not always fall to the lot of young artists on their arrival in the British capital'.[13] Barry himself was aware of the advantage, not only in being thus given privileged access to the cultural networks of the metropolis but also in his exposure to the most current artistic productions. Stuart had starting publishing the *Antiquities of Athens* in 1762, a pioneering work of antiquarian illustration that Barry described as 'distinguished by that unaffected air of the antients, which alone constitutes true taste, and is joined to such a certainty of outline and mythology, as is rarely found any where else'.[14] In London Barry was also able to see Hamilton's *Achilles Lamenting the Death of Patroclus*, which he claimed to admire particularly.[15] He had, then, experienced a crash course in reformed classicism by the time he set out to Europe.

Barry's stay in Paris from December 1765 to September 1766 – an unusually long period for artists travelling to Italy – propitiously coincided with a distinct sharpening and radicalization of the reformist cultural discourse that had been an important critical current in France since mid-century. The Salon of 1765, which had closed only weeks before Barry's arrival in the French capital, had included three classical subjects commissioned by the Marquis de Marigny,

Directeur-Général des Bâtiments, for the royal chateau at Choisy, marking the state's renewed efforts to establish itself as the sponsor of a reformed history painting. But the resulting attempts to address the vulnerable post-war polity through scenes of benevolent acts by exemplary ancient rulers, painted by Carle van Loo, Noël Hallé (FIG. 37) and Joseph-Marie Vien, were disastrous. Intended to contribute to the renovation of taste by the example of their elevated subject matter, they were rejected not only by that key proponent of such reform, Denis Diderot (1713–84), but even by the state-approved art critic Mathon de la Cour.[16] Dismissed for their prettiness and triviality and as a botched attempt to temper classical virtues in order to make them more palatable in the modern era, the Choisy canvases represented to contemporary commentators a corrupt visual tradition that undermined the pictorial values of 'le grand gout', in fact only fortifying the call for a harsher, more disciplined contemporary art. Barry was obviously aware of these discussions and his views on French art are completely in conformity with the reformist discourse given voice by Diderot:

> All the merit of the modern French, and I think a great deal more, may be found in a single performance of Le Moine's, whose effect is pleasing, his attitudes variegated into what may be called a pretty manner: his forms are agreeable, though I should say *form*, for he has one agreeable head for his men, one for his women; it is enough for the sake of variety, if a beard and a few furrows now and then are introduced, if the cheeks swell out and fall in, though the monotony is as visible, as it is in a puppet show, where the same voice is traceable in all the personages from Scaramouch up to king Solomon. We are not to look for dignity, character, or indeed any of the leading parts of the art in him; but then without meanness or deformity, he possesses an agreeable assemblage of all the lesser ones in a superior degree. This man, with a little of the outré of Boucher, one of the professors of the academy, is the model and the standard. There are, however, here a few who by no means come under what I have said, as Restout, a nephew of Jouvenet, who is, I take it, the only follower of the old French school, and Greuse, who is in the Flemish manner. Vernet may also be excepted, and I believe one more, but I do not know enough of them yet, to say they are distinguished for any great perfections.[17]

François Lemoyne (1670–1737) stood, as the master of François Boucher and Charles-Joseph Natoire, at the head of modern French decorative and mythological art – a school that had accumulated extensive criticism regarding its purported decadence and effeminacy and that, by the passage of French drawing masters and painters, had spread across Europe (FIG. 39). Barry would have been conscious of the modern French style from his time in Dublin, where an Irish pupil of Boucher's, Robert West, had dominated the art teaching at the Dublin Society's school. One of West's pupils, Jacob Ennis, had succeeded him as master of the Figure School around the time Barry was there. The French academic manner of drawing with red chalks was stringently pursued at the society's schools, to the exclusion of painting. As the Irish clergyman Thomas Campbell (1733–95), complaining about the shortcomings of the Dublin Society in this respect in 1767, put it: 'The Academy has produced many excellent in chalks, and more than this it could not do, for more that it did not teach.'[18] John Williams, in his generally abusive account of art in Ireland (1796), complained of West that 'He principally excelled in his drawings of the human figure in chalk and crayons, but could never embody a subject.'[19]

For Barry in Paris, only the example of Jean Restout (1692–1768), offered, as a solitary adherent of 'the old French school', any model of history painting to be followed. Otherwise, it was those heroes of reformed art (also singled out by Diderot in 1765), the genre painter Jean-Baptiste Greuze (1725–1805) and the landscape painter Claude-Joseph Vernet (1714–89), who might be admired, although they offered nothing in the way of being an immediate model to

the history painter.[20] Only they marked 'character', while the modern French painters made their women and their men look the same. The debates and pictures Barry was exposed to in Paris accentuated a resistance on his part to the moves to establish an academy in London and aggravated attacks he had made on the perceived superficiality and 'glitter' favoured in England and in Dublin. While it was the reformist cultural discourse current in London and Paris that provided the language and set the limits of his statements, when Barry moved on to Italy in the autumn of 1766 circumstances were to change in ways that turned established artistic critique into self-destructive paranoia and the languages of cultural criticism that were in the process of being socialized in England and France into signs of a pathology.

Travelling via Parma, Bologna and Florence, Barry arrived in Rome at the end of October 1766, where he immediately issued correspondence full of the conventional expressions of enthusiasm that accompanied first encounters with the city's antiquities and architectural heritage. But here, rather suddenly, the reformist discourses of antique idealism became a resource for the articulation of what would become a violently antisocial position. Perhaps within only weeks of arriving in Rome, Barry was describing his argument with a leading art agent, probably the Scottish Jacobite James Byres (1734–1817), 'who from the nature of his business and situation is courted exceedingly, by such artists as desire to make either money or friends here'. Byres had been talking up the work of Anton Raffael Mengs and particularly his copies after Raphael com-

37 Noël Hallé, *The Justice of Trajan*, dated and exhibited 1765. Oil on canvas, 269 × 230 cm. Musée des Beaux-Arts, Marseilles, France.

missioned by the Duke of Northumberland for his London house, according to Barry at the expense of British artists:

> I had no sooner attempted to excuse our people at home from the aspersions thrown upon them, and from the prepossessions which our travellers here were likely to get against them, but I was immediately pointed out as a person who, not coinciding with the designs of the dealers, might be dangerous in the company of English cavaliers, where it was necessary every now and then to run out into the praises of an indifferent antique head, with a modern body and legs cobbled to it, or of an old picture which they christen in the name of this or that master, and which has no other merit, but that, as nothing is visible, so nothing can be objected to. It requires no proof that there are great numbers of ancient statues and bas relieves here, little worthy of notice, for any skill in the workmanship, and are only preserved but for some costume, which they may serve to represent, or some opinion of the ancients, which they may elucidate; and this may be when they are entire, or in great part so. But there are legs, and thighs, and feet, and heads, brought out of old houses, and gardens, and other places, most of which have laid unheeded ever since the fifteenth century, when they were thrown away as soon as they were found, as wanting everything that could entitle them to any place in a repository. As the English have much money to lay out on Vertù, and have, perhaps, a greater passion for the ancients than they have, generally speaking, judgement to distinguish among them; those in whose hands they fall here, and to whom their commissions are sent, take care to provide heads with bodies and legs, and vice versa. Fragments of all the gods are jumbled together, legs and heads of the fairies and the graces, till, as when the gods p—d into the cow's-hide, a monster is produced neither human or brutal. There are instances of some good things being sent over, but the multitude of bad ones make us the amazement and ridicule of French, Germans, and all other indifferent people. It is a pity to see our gentlemen, who come out of England with the best intentions, and with a national spirit, so duped, and made even instruments of dissension betwixt the artists.[21]

What starts out as a state-of-the-art account of the kind Barry had previously given his Irish supporters while in Paris becomes swiftly a highly personal and linguistically violent attack on the Roman cultural economy, taking as its central figure a vividly grotesque vision of the representational body.

Barry was not isolated in this general concern about the impact of dubious dealers' practices. In an essay published in 1764, Giovanni Battista Piranesi (1720–78) had similarly lambasted the conjoining of antique fragments that results in 'A ridiculous statue, a monster which will repulse you', and the Italian antiquarian Giovanni Battista Casanova (1730–95) complained in 1770 of the physical division of antique reliefs so that they could be sold to collectors as several separate pieces.[22] If the 'jumble' of parts undeserving of preservation and inappropriately joined under the direction of commercially motivated dealers was monstrous in character and effect, this was not merely an offence to taste or scholarship. Through these procedures the representational body failed to be organized into a signifying totality by a sole author; it assumed, through merely manual and thoughtless operations, a false sense of wholeness while retaining the multiple, perhaps contradictory signification of its individual parts and diffuse origins. It was fully a grotesque body 'in the act of becoming': polysemous, communal and disorganized, it was transgressive because it refuted the aesthetic and historical classification of the individual fragments of the past, because it controverted authorial integrity, and because it denied the individual completeness of any given representational body in favour of an arbitrary construction.[23]

More dangerously still for Barry, the resulting fraudulent products were hungrily bought up by Grand Tourists, so that the only source of income for modern artists was this deceitful trade. The misapplication of British patrons' funds had been a pronounced concern of native artists since the 1730s; for Barry, ambitious but lacking the social and economic resources that might assure him a place in Anglo-Roman society, it was a concern especially deeply felt that fuelled a self-destructive paranoia:

> I am almost afraid even to send what I have wrote, as I always dread the resentment of base spirited people, incapable, I know, of an open generous revenge. There are two sorts of people they are desirous of gaining over, – such, who are likely to be known or recommended to the gentlemen, who come hither, and others, whose understanding and conversation may be use-fully employed to their purposes, and from the compliments paid me in the beginning, it should appear they judged me in some measure proper for them; a very little time shewed the contrary, and on speaking civilly of the works of Reynolds, Barrett, Hamilton, who is here, Nevi, and others, it was whispered that I spoke too much for a young man, and they resolved from that time, that for the future, I should have but few opportunities of speaking in the company of Cavaliers, to whom it was necessary to convey opinions of another nature. As we know each other, we are very quiet, and as sociable as I can, when we meet together some nights, is the course I think you would advise me to take for the time I stay here. You will, I believe, think it prudent to keep this letter to yourself, as, if it should take wind, these people would be soon advised of, and God knows where it might end.[24]

Barry even articulated this threat to his professional ambitions as, in a different version of this letter, a threat to his life.[25]

Yet if the painter reflected on his own professional anxieties in his perception of the disorganization of the classical body, he also saw in that body a means of salvation. In recognizing a compulsion to buy up versions of the antique (Sharp's 'new-invented species of encouragement'), the artist perhaps imagined he saw an opportunity for the modern artist. In the 'Observations on Different Works of Art in France and Italy' compiled during his travels, Barry provided a sceptical account of this history of art, proposing that the renaissance of antique ideals in Raphael and Michelangelo hadn't reached its full potential when it was cut short by the Protestant Reformation:

> The English then, notwithstanding the noise and impertinence of system-mongers, seem to me to have taken up the arts at a most happy period. The scholars of their own country and of all Europe, have, by their successive labours, so cleared the way, and brought into light ancient learning, that every thing now lies open to them, which is an advantage their prede-cessors, the French and Italian artists, enjoyed but partially, and in a very faint degree, and if we are but wise enough to make choice of true men, able to turn to account the advantage we possess, I have great hopes that posterity will see the people, rejected by the builders, become at last the head of the corner.[26]

Barry's revision of the history of art to establish the potential for cultural reform in modern England had a radical potential: in claiming a Catholic foundation for the great cultural achievements of the Renaissance and associating cultural decline with Protestant Reformation so emphatically, he was ultimately to imply that the present-day reformation of art would necessarily be led by Catholic artists.[27] In a revealing letter, written early in 1767 (while Dance's copy of Pietro da Cortona's *Ananias Restoring the Sight of St Paul* must have been being installed in London; FIG. 35), he told the Burkes:

38 (top left)
Attributed to
Nathaniel Dance,
satirical portrait of
James Barry.
Graphite on paper,
26 × 19.4 cm. The
British Museum,
London.

39 (top right)
Louis Charles
Chêteau after
François Lemoyne,
Adam and Eve,
engraved plate from
*Collection de Cent-
Vingt Estampes,
Gravées d'apres les
Tableaux & Dessins
qui composient le
Cabinet de M.
Poullain*, Paris, 1781.

40 (facing page)
James Barry, *The
Temptation of Adam*,
1767–70, exhibited
1771. Oil on canvas,
233 × 183. National
Gallery of Ireland,
Dublin.

People now, to be painters, copy and imitate every thing, Barocci, Murillo, Bernini, Carlo Maratti, Cortona, Mengs, and others of less note; in whom art is little more than a painted and varnished shadow, the substance being quite lost by the multiplicity of mediums and reflections through which it has passed from one imitator to another. They go on, as I said, still grafting upon this perishing stock, that is of the species of a mule, which was never intended to succeed beyond the first transfusion; whilst invention and genius, which strengthens and comes to maturity only by the labouring and perpetual exercise of it, is lying either an uncultivated waste, or else choked up by what they transplant from this noxious soil. This is clearly the ignis fatuus, which has so long misled the artists, and that to which is principally owing the long decay of art; as certainly even less labour, more properly directed, would be attended with more success.[28]

Thus is mounted a comprehensive attack on both the high illusionism of seventeenth-century Roman art and what might be termed the 'Virgilian' mode of history painting practised by Mengs, West and Dance, with its emphasis on technical polish, synthesis and slick exactness.[29] The immediate stimulus may have been the social isolation Barry was experiencing, having dared, heretically, to question the value of Mengs' copies of Raphael, but the discursive resources were available to rearticulate this socially specific event in culturally meaningful terms, and found a maxim of practice.

Mobilizing the discourse on originality that had emerged from the crisis of the late 1750s and that had been inculcated into more forward-thinking Grand Tourists such as Thomas Robinson, Barry condemns the imitator as stagnant and unproductive and so a liability to the artistic economy. Where such rhetoric had served Hamilton in locating his own creative labours within a narrative of cultural renewal resonant among the Grand Tour elite whose attentions he cultivated, Barry proceeded to act upon the proposals it contained in an unprecedented fashion. Unlike his forerunners, he did not nurture relations with art dealers and antiquarians,

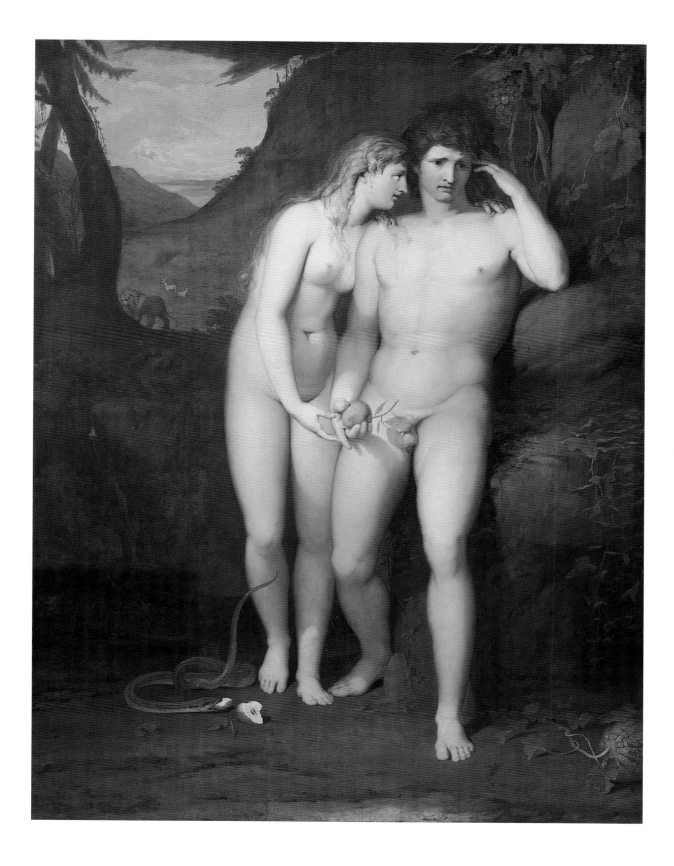

nor did he undertake to paint portraits of Grand Tourists. If the Irish, Catholic and ill-educated Barry could hardly have integrated with Grand Tourists as readily as Hamilton or Dance, in his correspondence of the time he actually flaunted his social alienation as a sign of his distance from what he presented as degenerate visual traditions. In a telling caricature of Barry in Rome that has been attributed to Dance, the artist is depicted as a squat, burly figure disclaiming against a bagged and sword-wearing gentleman – presumably one of Robinson's 'pretty young Counts and Marquis' (FIG. 38).[30]

Burke's reply to Barry's letter complaining of the 'traffic of antiquity' recommended that the artist be more worldly: 'fraud will intermeddle in every transaction in life, where we cannot oppose ourselves to it with effect, it is by no means our duty or our interest to make ourselves uneasy, or multiply enemies on account of it.'[31] In the same item of correspondence, Burke enquired how his painting of 'Adam and Eve' was progressing. This was the main occupation of the artist from 1767 to 1770, and was exhibited at the Royal Academy in 1771 to coincide with his return to England, representing to the London art public the consummation of the artist's formerly more private and decidedly unworldly pursuit of the Grand Manner (FIG. 40).[32] The composition features two large-scale nudes, one of each sex – the basic units of the Grand Manner presented boldly, exactly differentiated. Adam is an erect and muscular figure; Eve is smaller, more slender, and the curve of her right arm leads the eye across her genitals to the apple and Adam's penis, making obvious and emphatically visual reference to her role as the sexual corrupter of man. Both figures are conceived in explicitly classicizing terms, with the near-abstract conception of their forms and sharply defined contours giving the impression of an antique sculptural group.[33] The sculptural integrity of these figures is underscored by their sharp outlines and broad forms, set against a strongly contrasted background so that they are presented through their silhouettes.

The difference from Lemoyne's treatment of the subject is emphatic. The French painter's image had featured two figures whose poses interacted with the greatest complexity, the rhythmic opening and closing of spaces between them bringing Adam's foot and hand into contact with Eve's body and drawing his glance over her breasts to her face, conveying a sense of formal intricacy and erotic charge.[34] And where Lemoyne had created a subtle spatial play between the figures and the detailed foliage of their setting, Adam resting back and Eve's body tilting and swaying to rhyme with the abundant form of the apple tree, Barry presents his landscape as a relatively flat and uninteresting backdrop. His tonal modelling is restricted to broad volumes, disavowing any attempt to convey the idiosyncrasies of living bodies – renouncing in a painterly register the fleshly pleasures that are at stake in the narrative.

In these qualities, the painting can be read as a direct response to Johann Joachim Winckelmann's call for a return to antique values and his valorization of 'contour' as the pre-eminent form of visual communication. With an introduction to Count Alessandro Albani, Winckelmann's employer, Barry must have known of his ideas and may even have had direct contact with him. As conceived by Winckelmann, 'contour' ensured precisely the corporeal and aesthetic unification that Barry saw destroyed in the commercial manipulation of actual antiquities: 'Contour unites and circumscribes every part of the most perfect Nature, and the ideal beauties in the figures of the Greeks; or rather, contains them both.'[35]

The use of pure outline was well established as a graphic technique appropriate to the antiquarian depiction of classical remains; its association with discipline, control and reason made it appropriate as a vehicle for pure and 'neutral' (and hence 'masculine') representations.[36] The philosophical and critical writers of the 1760s, most eminently Winckelmann and Francois Hemsterhuis (1721–90), were much more emphatic. Their reformist rhetoric was aligned to a val-

orization of primitive artistic expression as most pure and most free of the corrupting influences of modern life. As noted above, Barry was acutely aware of the corrupting influences of modern commerce upon the prime emblem of masculine integrity: antique sculpture. The pictorial evidence and Ozias Humphry's description of Barry's drawing technique from the early 1770s suggest a sense of an effort towards a reformed graphic style: 'After having made a rude imperfect sketch of the idea to get an outline from it correct, or nearly so with a lead or crayon, and then to fix it with a pen and ink. He recommended to avoid a multiplicity of lines, but to get everything as correctly as possible with one.'[37] The contrast here with the subtle tonal and textural effects associated with the French (and Irish) red-chalk manner is plain.

Although the emergence of a 'linear style' was a general phenomenon in European art in the 1760s and 1770s, for someone who felt socially isolated and aggrieved, it must have been politically charged and thoroughly gendered. As he was preparing to transport the *Temptation of Adam* to London, Barry wrote to Burke:

> My enemies, you see, so contrived it as to make my profession of no profit to me in Rome, for which I will certainly strike a balance with them, if they ever suffer me to get to England. It has been a real grief to me that I could not contribute hitherto to lighten the expenses your good nature and generosity led you into for me. I have nothing to say in my own behalf but that I shall carry myself so, both as a man and an artist, as never to bring a blush on your face on my account.

> The object of my studies is rather contracting itself every day, and concentrating upon a few principal things, compositions of one, or a few figures, three or four at most, turning upon some particular of beauty, distress, or some other simple obvious thing, like what is to be seen in the antique groups, or like what is told of the Greek painters, which exactly corresponds with what we find in the statues that remain of them.[38]

Barry's account of contracting and concentrating his attention suggests the mental and physical tightening and toughening that had been central to the Burkean Sublime, with its 'contracting power of the muscles' (see above, p. 11). The formal resolution of the painted image – and the exact gender distinctions it could make apparent – offered for Barry a means of compensation for the injuries experienced in social life, a route to phallic plenitude that gained value set against the indiscriminate, hybrid productions that reigned over the cultural economy.

The positioning of the image as the site for the symbolic enactment of the artist's own troubles was given further expression in the second original painting Barry executed while in Italy, *Philoctetes on the Island of Lemnos* (FIG. 42). This was completed while the artist was in Bologna and was intended for presentation to the Accademia Clementina at Bologna on the artist's election into its membership. Like *The Temptation of Adam*, it is an exercise in the 'contracted' style, deploying in this case a single large-scale male nude as the vehicle of Barry's artistic ambitions. By Barry's own account, this was intended as an explicit re-creation of the antique: 'as to the point of time, &c. in the story, I followed closely the Greek epigram upon Parrhasius' picture of the same subject, and I found the Philoctetes of Sophocles, an useful comment upon it.'[39] In this instance Barry's effort is channelled into an institutional context of especial significance: it marks the insertion of the artist into a distinguished artistic heritage. The finished painting owes almost everything to the *Hercules on the Pyre* by the Bolognese artist Guido Reni, which Barry could have known from the original (then in the royal collection in Paris) or the engraving (FIG. 41). With Annibale Carracci (1560–1609), who founded the academy at Bologna, Reni was esteemed as an artist who had rescued art from its decline in the later six-

41 (top)
Gilles Rousselet after
Guido Reni,
*Hercules on the
Pyre*, c.1669.
Engraving, 43.3 ×
29.9 cm. Witt Print
Collection,
Courtauld Institute
of Art, London.

teenth century by drawing together all the characteristics of ideal art – characteristics increasingly diffused through artistic specialization.[40] By emulating Reni so closely, Barry cast himself in the role of an artistic reformer (as John Hamilton Mortimer had done with his distinctly Bolognese *St Paul Preaching to the Ancient Druids in Britain*).[41]

As with the *Temptation of Adam*, his reformist intent was expressed through a forcibly classical corporeal aesthetic. Similarly, the figure is given a decidedly sculptural presence, with a perfunctory landscape setting, broadly conceived forms and sharply defined contours. Notably, Reni was especially admired as a painter by academic critics for the clarity and unity of his forms. Barry made great efforts to draw attention to Philoctetes' foot: where Reni had the extended leg of his suffering hero supported on the pyre, Barry depicts his figure's leg suspended in mid-air – a feature he might have derived from Pietro Testa's etchings of *The Dead Christ* (FIG. 43) and *The Prophecy of Basildes* (both c.1650–55). On the preparatory sketch, where this resemblance is at its strongest, Barry noted that 'There will appear more Agony & ye disordered leg will be more distinctly mark'd by having it stretched out in air without any support from ye rock he sits on' (FIG. 44). By turning to Testa as a model (as Alexander Runciman and Henry Fuseli were to do around this date), Barry was claiming allegiance to a severe kind of reforming classicism, which retained expressive and imaginative properties even as it adhered to the 'Greek' ideal.[42]

42 (facing page)
James Barry,
*Philoctetes on the
Island of Lemnos*,
presented to the
Accademia
Clementina,
Bologna, in 1770.
Oil on canvas, 228 ×
157.5 cm.
Pinacoteca
Nazionale, Bologna.

With its emphasis on physical degradation and open suffering, it is hard to argue that this work operates in the heroic mode in a simple way, whether viewed from the perspective of civil discourse or exemplarity. Philoctetes' wound was not received in any kind of noble combat, nor

Inscribed below the image: *Pietro Testa Inu* · *E. Io CeseTestafec.* · *Gio Iacomo de Rossi formis Rome allaPace*

43 Giovanni Cesare Testa after Pietro Testa, *The Dead Christ*, *c.*1650–55. Etching, 19.1 × 25.1 cm. The British Museum, London.

were his sufferings the prompt to heroic action: his fate was simply tragic. However, in his commentary on Sophocles' play, Pierre Brumoy (1688–1742) had noted that 'The subject . . . is an important affair of state'. While the recovery of Hercules' bow and arrow from Philoctetes was essential to the success in war of the Greeks, making Philoctetes 'another offended Achilles', the important feature was the essential passivity of the hero and, as Brumoy notes, his sufferings were wholly repulsive to modern taste. Thus Philoctetes ultimately fails to conform to conventional notions of exemplary heroic masculinity as defined in civic discourse and epic theory.[43] In 'On the moral and Conclusion of an Epick Poem' (1721), the critic and playwright John Dennis had proclaimed that it is simply impossible to have a suffering hero: if the hero suffers in stoical silence, the reader will not be able to sympathize, while if the hero exhibits passions these would be 'incompatible with that Admiration, which ought to be mov'd thro the Poem, but which will sink its Spirit and debase its Majesty'.[44]

Barry's picture embodies a scene of tragic suffering, its theme suggesting that its hero was utterly isolated from society and its broader social significance far from obvious. It thus contests the emerging sociological valuations of visual art that were appearing from Scotland. Indeed, referring specifically to the subject of Philoctetes, Adam Smith (1723–90) had argued that the acute pain in the hero's foot was incapable of generating a communal sense of sympathy. By graphically describing the horrific aspects of the hero's tortures, Sophocles could only repulse his audience; such scenes of suffering gained meaning solely in the context of a narrative.[45] In his 'Lectures on Rhetoric' Smith had expanded on this with explicit reference to the art of painting:

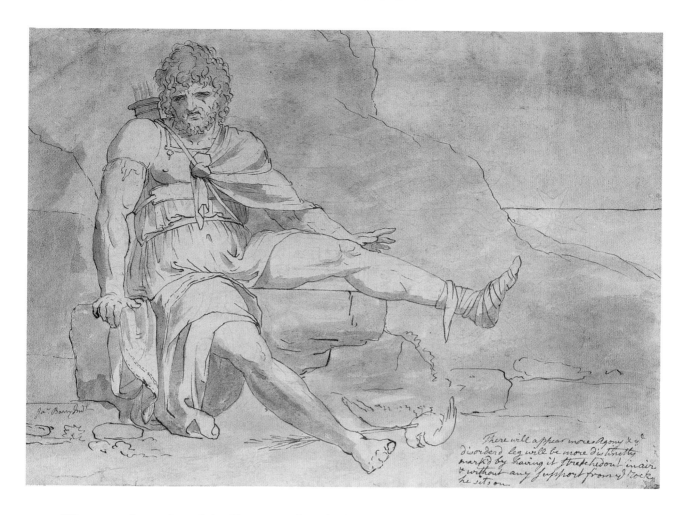

There will appear more Agony & *c*
disorderd leg will be more distinctly
mark'd by having it stretched out in air
& without any support from *ye* rock
he sits on.

When one takes a view of the Chartoons of Raphael, it is not Paul Preaching at Athens or Elias Struck with Blindness that first attract our attention but Peter receiving the Keys, Peter feed my Sheep. This piece represents a state of mind in all the figures not much different from that we are in. Poussin used to say that the tranquil pieces were what he liked best. Whereas the emotions in the others are so violent that it takes a considerable time before we can work ourselves up so far as to enter into the Spirit of the pieces.[46]

44 James Barry, drawn study for *Philoctetes on the Island of Lemnos*, 1770. Pen and brown ink and grey wash on paper, 21 × 28.7 cm. Tate, London.

Equally as pertinently, given Barry's pictorial source, Samuel Johnson had dismissed the death of Hercules as an appropriate subject for the history painter in an *Idler* essay of 1759, since the poetic narrative that made the death of Hercules a noble subject 'cannot be united in a single moment': an image of Hercules on the pyre would be incomplete as a heroic representation.[47] And in Henry Home, Lord Kames' *Elements of Criticism* (1762) appears the instruction that, while pain can be a most appropriate subject for visual art, given its limitation to emotions that are expressed physically, still 'our passions, those especially of the sympathetic kind, require a succession of impressions'.[48] Narrative provided a way to police the meanings of the image; specifically, the suffering male figure who was potentially emasculated could be rehabilitated – the potential gender transgression of the narrative moment of masochism thus being recuperated within a narrative of masculine affirmation.[49] But here, Philoctetes' sufferings are not represented as a spur either to noble political action or even to the Sublime and brutal heroism found in the *Iliad*.

To an extent, Barry might be said to have been operating within the framework of a Winckelmannian ideal. In his commentaries on the *Laocoön* (Vatican Museum, Rome), during which

he cited Sophocles' play *Philoctetes* as a further example, the German argued that the ancients gave the most complete expression to heroic sentiments in representing superhuman nobility in the face of extraordinary pain.[50] With the *Philoctetes*, Barry sought to display this ideal in a most complete fashion. He played out the part of a classical painter to the extreme of reinventing an absent masterpiece of ancient art: as well as being recorded as the subject of a painting by Parrhasius, a 'Philoctetes' was included in Philostratus the Younger's imaginary gallery of ideal paintings, and Barry may have been indebted to that author for the detail of the altar of Chryse on which his hero is seated.[51] Without the ancient painting, Barry's sources were sculptural: Philoctetes' torso is patently evocative of the *Belvedere Torso*, while the conception of the figure as a whole suggests the *Laocoön*. But if the painting is read in terms of Winckelmann's aesthetic proposals (and such sculptural references in combination with the insistent linearity of the figure suggest it should be), it might then be removed from the dynamics of emulation that underpinned narrative, heroic art and be subjected instead to the play of desire and objectification, the 'intermingling of erotic pleasure and traumatic self-annihilation' that Alex Potts has so persuasively identified.[52] What may be left is an image that, instead of being heroic and exemplary in moral terms, is in the fullest sense of the term sensational, and in this ultimately confounds the distinction between the masculine Sublime and feminine Beautiful upheld by Burke.

Alternatively, it could be argued that, in removing the heroic male body from those narrative contexts and isolating it as the expression of more completely fulfilled artistic desires, Barry was playing more to Burke's notions of the Sublime, which offered an additional (perhaps decisive) rationale for the production of such a wholly tragic, even nihilistic subject. It was in viewing such scenes of horror that an aesthetic confirmation and extension of masculine subjectivity could be fabricated, regardless of issues of civic virtue or sentimental sociability or even physical beauty. The sheer scale of the figure, emphasized by the relatively low viewing point and his compression within the canvas, together with the 'privations' expressed in the picture's theme, was aimed at producing distinctively Sublime effects. Notably, when he reworked the design for a specifically British audience by publishing a reproductive print first issued in 1777, Barry emphasized its Sublime qualities by introducing a storm-wrecked tree, a lightening bolt and even showing the hero's hair and beard distressed by a high wind, all visual props to the appreciation of sublimity (FIG. 45). In thematic terms, Philoctetes' social isolation and physical self-absorption typify the de-socializing tendencies of discourse on the Sublime; in a pictorial sense, Barry's painting presents itself as a Sublime object that could confer a sense of identity through a form of subjective reception inimical to any practical idea of the citizen. Thus, Barry was supplied with a sanction for the production of an art that disregarded the social questions present in much of the narrative imagery of the previous decade, a spur to the exploration of pictorial effects, and a means of reforming the Grand Manner in order to demonstrate his capacities as an artist in the academic tradition.

Whether Barry was pursuing a Greek idealism that could be opened up to erotic play or a Burkean Sublime that denied such play, he did so without securing a market for his works: he advised the Burkes to give the *Temptation of Adam* away after it was exhibited, and the *Philoctetes* was created as a presentation piece. Without commissions, Barry conceived of his vocational choices in terms of a form of masochism, a willed self-destructiveness that was the necessary consequence of his adherence to the ideal. This becomes apparent in considering the role played by the English Catholic history painter and draughtsman Giles Hussey (1710–1788) in Barry's self-conception around this time.[53] Hussey had worked in Italy in the 1730s and, though his drawings were known and respected, had slipped into obscurity since. As early as 1761 Hussey was being proclaimed a martyr to art, a consequence of 'the little Encouragement given here in History Painting'.[54] The collection of Hussey's drawings kept by the Catholic lawyer

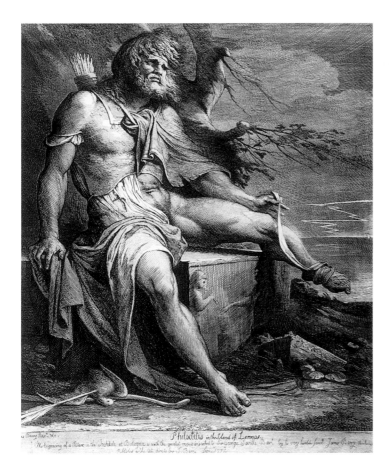

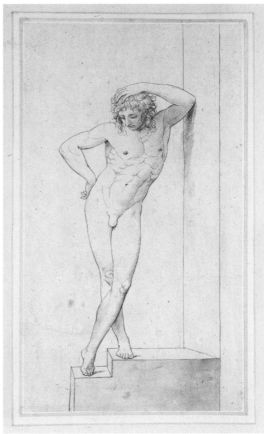

and amateur Matthew Duane (1707–1785) was available to artists, many of his drawings were in circulation later in the century, and in Bologna Barry had access to a collection of drawings kept, apparently with some care, by the Academia (FIG. 46).[55]

Barry openly stated that his relationship with Hussey (who he did not appear to know personally) was emulative, writing at a later date: 'With fervour I went abroad, eager to retrace all Hussey's steps, through the Greeks, through Raphael, through dissected nature.'[56] The English artist's work provided Barry with a model and a point of departure, helping to define the almost physical fortitude required by the heroic artist in his conception: 'I would to God that Hussey, (in whose steps I have long been treading) had been provided with a little of my stiff-neckedness, and he would not have, foolishly, and in a pet, thrown up his abilities and his art.'[57] Through his identification with Hussey, Barry recast the heroic pursuit of heroic art as inevitably a tragedy, but a tragedy in which it was possible to recover, despite the debased nature of contemporary artistic practice, some more secure sense of masculinity. Barry dramatized himself as occupying a moment of professional masochism in which his artistic authenticity might be tested and proven, both against the slavish imitators of decadent masters and the inferior Hussey who lacked his (perhaps phallic) 'stiff-neckedness'. Barry's display of wounded vulnerability, manifest in his correspondence and figured in his *Philoctetes*, may be interpreted as representing a strategy for a reformed masculinity that accrued value according to the degree of its social exclusion.?

45 (left)
James Barry, *Philoctetes*, published September 1777. Etching and aquatint on paper, 45.4 × 37.1 cm. The British Museum, London.

46 (right)
Giles Hussey, study of a nude figure. Pencil, pen, ink and watercolour on paper, 24.4 × 13.3 cm. Tate, London.

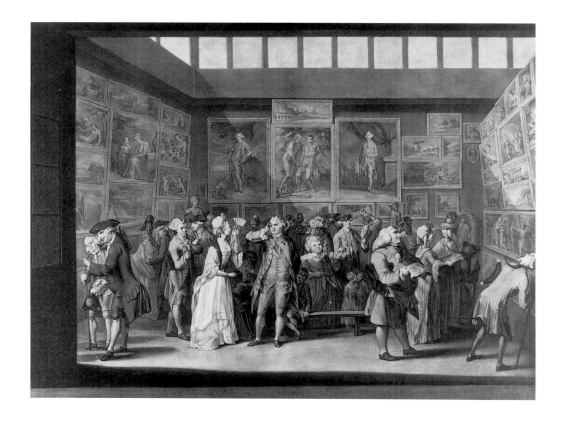

47 (top)
Richard Earlom
after Charles
Brandoin, *The
Exhibition of the
Royal Academy of
Painting in the Year
1771*, published
1772. Mezzotint,
47.2 × 56.6 cm. The
British Museum,
London.

48 (facing page)
James Barry, *Self-
portrait with
Edmund Burke in
the Characters of
Ulysses and a
Companion fleeing
from the Cave of
Polyphemus*,
exhibited 1776. Oil
on canvas, 127 ×
100.8 cm. Crawford
Art Gallery, Cork.

In symbolic terms, this strategy achieved considerable success. Barry had already won the approval and support of two of the most influential men in English culture: Joshua Reynolds and Burke. On returning to London it ensured his rapid election into the Royal Academy in 1772, where he later became the professor of painting. And it secured a generally favourable reception among London's art critics, albeit one sometimes marred by racist jibes: it is his painting of Adam and Eve that occupies pride of place in the earliest representation of the academy exhibition (FIG. 47). But it still did not win him patronage of the kind that could support him professionally on a long-term basis and the 1770s saw a series of rebuttals and disappointments that embittered and politicized the artist, opening up a public rift with Reynolds as early as 1773.[58] Then, in 1774–75, Barry and Edmund Burke argued bitterly and the two became estranged.

This affair must form the background for the fancy-dress double portrait of Barry and Burke exhibited by the artist at the academy in 1776 (FIG. 48). Depicting the painter as the panicked and cowering companion to Burke in the character of Ulysses leading the surviving members of his crew of adventurers in escape from the cave of the Cyclops Polyphemus, the allegory appears both deliberate and opaque. As F. P. Lock has pointed out, Burke may be the hero of the piece and has been interpreted as 'a good shepherd leading his flock from danger', but Ulysses was responsible for getting his crew trapped in the cave in the first place and they suffered horror and death at the hands of the monster. Even on their escape, Ulysses taunted the monster and further inflamed him in pursuit of personal glory rather than in the service of his men. Should the monster then be taken as an emblem of England's establishment? Burke had led Barry into danger by financing his entry into English culture and had roused the ire of the carnivorous

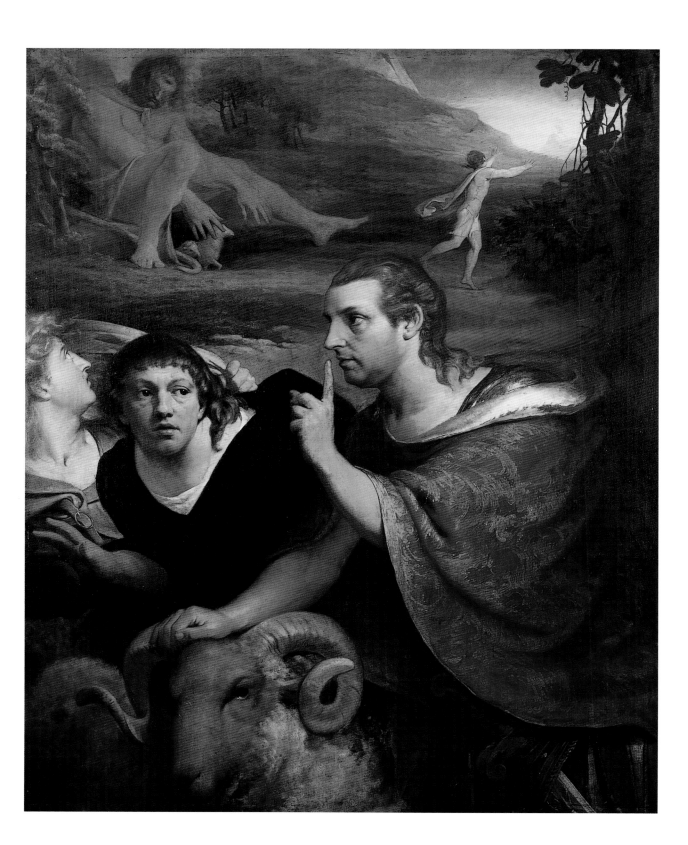

Anglo-British state. He is visibly better equipped to deal with the situation compared to the artist. It is Barry, without the arms and armour or the physical poise of Burke–Ulysses, who seems to suffer most, sweating and crouching as his patron stands erect and authoritative. How many eighteenth-century portraits are there that show the effects of fear in their subjects? Indeed, how many subject paintings are there that go so far as to show the visible effects of perspiration, whatever the exertions of their protagonists?[59] It is Barry, the ill-educated, openly Catholic builder's son from Cork who had most to risk in the confrontation with the establishment.[60]

The painting remains ambiguous as a commentary on the artist's situation by the mid-1770s, but no new supporter stepped forward to take Burke's place as Barry's sponsor. If the revised rules of art (those coordinated around the values associated with the Sublime, original genius and a severe idea of the 'classical') were recognized by artists and critics, the class who could best proffer material support remained reluctant to invest in it materially. The point to draw from this assertion is not that Barry was an outsider who forced himself upon a society that wanted simply to repel him. It is rather that what this metropolitan society found repellent about Barry was also what gave his work currency. His election to the Royal Academy and his recognition among critics meant the symbolic incorporation into established culture of those forms of formal and behavioural extremism that stood for a kind of artistic authenticity necessarily exterior to that establishment and thus readily to be identified as deriving from his actual social estrangement. The extent to which Barry delivered on his cultural capital would have been compromised if material support had been forthcoming: the form of cultural capital associated with heroic art seems predicated on the diminishment of material or economic capital. The mutually exclusive relationship between heroic art and socially utile models of masculinity was taking shape in a decisive way.

PART TWO

'OVER-STOCKED WITH ARTISTS OF ALL SORTS'

THE STATE OF THE ARTS 1765–1775

Within a decade of André Rouquet's *Present State of the Arts in England* (1755), the opportunities for the creation of heroic art had been transformed beyond recognition. British artists in London and Rome had produced a rich variety of heroic images, attuned more or less successfully to the shifting demands of patrons and an emerging appetite public for culture. Variously sublime and sentimental, savage and humane, tragic or triumphalist, the heroes that had appeared at Westminster Abbey, Vauxhall Gardens and at the exhibitions could, for all their complexities and for all the compromises involved, be taken as evidence of a surge of enthusiasm for the Grand Manner. Yet the artistic activities of these years must still be characterized as decentralized and the achievements of individual artists were dependent upon largely improvised combinations of institutional promotion, commercial print publication, private sales and more sustained personal support. While the imagery of the period presented several alternative forms of masculine power and virtue, there was no single patron or institution able effectively to regulate artistic activity and authorize a given version of the Grand Manner.

At the end of the 1760s this situation appeared to change with the direct intervention of George III. His accession to the throne in 1760 had been welcomed by those artists who had previously staked their interests on the person of Frederick, prince of Wales, and who had spent the decade since his death engaged in destructive infighting. John Surart, Third Earl of Bute had, as prime minister in 1762–63, distributed pensions and sponsorship to a number of writers, but painters and sculptors did not yet benefit extensively.[1] When it did appear, the king's support of the modern British Grand Manner was initially limited to a handful of high-profile purchases of paintings by artists with an established public profile.

The first substantial such acquisition was Nathaniel Dance's *Timon of Athens*, exhibited with the Society of Artists in 1767 (FIG. 49). Taking its source from Shakespeare, Dance's image treats a 'domestick tragedy' which 'therefore strongly fastens on the attention of the reader'[2]. It is broadly in the polished, classical visual idiom of Anton Raffael Mengs and Gavin Hamilton, but with the higher finish associated particularly with Pompeo Batoni, and thus represents an effort towards the kind of compromised, affective history painting of which Francis Hayman's Vauxhall decorations were an important precedent. Timon stood as the archetypal misanthropist, who turned his back on the privileges and bounty of life in Athens and became consumed with bitter hatred for the world. Dance depicts the scene in which Timon, in self-imposed

49 Nathaniel Dance, *Timon of Athens*, exhibited 1767. Oil on canvas, 122.2 × 137.5 cm. The Royal Collection © Her Majesty Queen Elizabeth II.

exile following his threatened bankruptcy and being spurned ungraciously by the friends who had previously enjoyed his generosity, gives full rein to his loathing for society. Digging in the woods for a root to eat, he ironically finds only gold. When he is approached by Alcibiades, also in exile, and his mistresses, Timon ends up hurling the gold at them, which is greedily accepted in place of his advice. Exemplary in its noble treatment of the human form and crisply delineated – 'The figures faultless, not one atom wrong' as a rhyming review put it – the picture may not offer narrative content to match.[3] While Timon is a noble social outcast, he is also a tragic misanthrope rather than an inspiring role model, too bitterly twisted and too emotional to fit either the classical conception of the self-sacrificing hero or the more moderate versions of masculinity that prevailed in polite culture.[4] Such was the ferocity of his words that eighteenth-century versions of the play, including that put on by Dance's brother James Love in 1767, toned down Shakespeare's language as unfit for modern ears.[5]

A second major royal purchase of a history painting came in 1768, and this time marked what was to be a sustained patronage of an individual historical painter. George III's commission from Benjamin West that year tackled the theme of heroic virtue in an emphatic way, and by the painter's own account represented a retort to the contemporary decline of art:

By war, and the instability in the minds of those who directed the pencil caused influence that proud patronage to decline till both patronage and painting became degraded by lavishing attention on Legantary Fables . . . the more discerning part of mankind became disgusted with its productions and frivolity. To that degraded state was painting reduced. Mr West finding that painting was degraded in Italy and France . . . stimulated him with the laudable desire and emmulation to cultivate its higher excellencies for honourable purposesses and he painted

under those impression his pictures of Agrapina, Regulus, Hanibal – Wolfe, and Penn . . . pictures exhibiting famanine conjugal affections to departed Greatness, patronism for love of country, Heroism, and a rectitude of justice.[6]

50 Benjamin West, *The Departure of Regulus from Rome*, exhibited 1769. Oil on canvas, 229.9 × 304.8 cm. The Royal Collection © Her Majesty Queen Elizabeth II.

The 'Agrapina' mentioned here was his Poussinesque *Agrippina Landing at Brundisium with the Ashes of Germanicus* (Yale University Art Gallery, New Haven), commissioned in 1767 by Robert Hay Drummond (1711–1776), archbishop of York, and shown with the Society of Artists in 1768 and again later that year in the special exhibition organized by the society for the visit of the king of Denmark.[7] The next painting mentioned was the first documented commission from the king: the large-scale and uncompromising image of heroic masculine self-sacrifice, *The Departure of Regulus from Rome*, exhibited in the first Royal Academy show in the spring of 1769 (FIG. 50).[8] The hero of the piece, Marcus Atilius Regulus, was a former Roman consul captured by the Carthaginian enemy. He had been set free and sent to the capital in order to negotiate an exchange of prisoners. Instead he argued against compromise and is shown by West leaving Rome to deliver that message to the enemy at Carthage – an act that he knows will lead to his death. Thus the picture presents the most severe version of masculine exemplarity – a harsh, self-sacrificing hero whose noble sufferings would inspire his people. There were reports at the time that West sold his *Regulus* to the king for the massive sum of a thousand guineas, and he was rumoured to be in line for a knighthood.[9]

Given the conviction, expressed through the notions of 'encouragement' and 'emulation', that a British school would proceed naturally from such acts of patronage, George III's support of Dance and West established the monarchy at the centre of the effort to create modern historical art. Commenting on the *Regulus*, the *Public Advertiser* of 27 May 1769 could announce

'Portrait painting has had its day . . . the superiority of History painting, over works of every kind, is now universally acknowledged.' If this had any truth, it was mainly with regard to West alone, for the *Regulus* marked what was an effective monopoly over the king's patronage of historical painting, which would last more than three decades.

In the winter of 1768–69 George III's support for art in general – not history painting per se – was expressed by the foundation of the Royal Academy of Arts in London.[10] The foundation of the academy effectively forged a deal between a self-elected elite from within London's artistic community and the monarch. On the one hand, the desire for social distinction expressed by the group within the Society of Artists who implemented the new academy was answered; on the other, the king's cultural leadership was clearly and publicly marked. The interests of each could be absorbed within the discourse of national progress that had taken shape a decade before, in the midst of the optimism that had first accompanied George's accession to the throne. Thus Sir Joshua Reynolds proclaimed in his first official lecture (that is, the first of his presidential *Discourses*) that 'the present age may vie in Arts with that of LEO the Tenth; and that *the dignity of the dying Art* . . . may be revived under the Reign of GEORGE THE THIRD.[11] The economic aspects of such old arguments for national greatness were brought out in the poetical 'Triumph of the Arts', written by the Revd. Thomas Francklin (1721–1784) in January 1769:

> Here's a health to the Great who are *Patrons of Arts*
> Who for good British hands have true British hearts
> *Abroad* who disdain for their pleasures to roam
> But encourage true merit & genius at *home*.[12]

Behind Francklin's lines lies a simple argument that had been articulated frequently since the crisis of the Seven Years' War: if Britain were to compete with its European adversaries, it must find the means of both expanding and rationalizing its domestic production. It was this argument that had informed the Society of Arts' activities, which were aimed at the replacement of foreign imports with goods produced on native soil. The cultural rhetoric that claimed that Britain was taking the place of Greece or Renaissance Italy was simultaneously claiming that British consumers would no longer need to spend money abroad.[13]

George III's cultural activities during 1768 and 1769 were a means of signalling not only his authority over the nation's artistic life by implementing an art institution on the Continental, centralist model, but also, more obliquely, a contribution to the national economy. A context for this effort is, of course, the mounting criticism of the monarchy that accompanied unrest in the American colonies and political discord at home.[14] The legitimacy of the king's rights over his subjects, indeed, the very feasibility of a centralized British empire on the scale then current, was the subject of dramatic political debate and, by 1768, popular unrest. The academy provided a means by which George III could reassert his supremacy in a cultural register, laying claim to the economic arguments of the patriot opposition associated with popular antigallicanism. At least for those closely associated with the academy, the result would be a new dawn for British culture. Reporting on the state of the arts, West could claim: 'In reguard to the arts hear in England this seem's to be the Augustan Age. Tho this is a Nation so long faimed, for her greatness yet the arts have never apeared hears till the Reighn of *George Third* which is owing to his Tast and Munifisiance and under his Patronage London bids faire to vie with *Rome* and *Paris*.'[15]

In the present context, it is important to note that these claims to cultural authority were not visibly staked on the effective figuration of masculine heroism or exemplarity. It might be expected that the new president of a formal art academy based on the Continental model would

set out the generic principles of the Grand Manner, but Reynolds avoided this task. Firstly, there was the simple problem of definition: 'The Moderns are not less convinced than the Ancients of this superior power existing neither in the art; nor less sensible of its effects. Every language has adopted terms expressive of this excellence. The *gusto grande* of the Italians, the *beau ideal* of the French, and the *grand style*, *genius*, and *taste* among the English, are but different appellations of the same thing.' And yet 'It is not easy to define in what this great style consists; nor to describe, by words, the proper means of acquiring it, if the mind of the student should be at all capable of such an acquisition.'[16] Instead, Reynolds' academic lectures, the *Discourses on Art*, delivered annually from 1769 and then biennially from 1772, were taken up with articulating a gendered rhetoric of authenticity. According to the president, instead of 'presuming on his own sense' the young artist should submit himself to a gruelling education in the rules of art, to searching self-criticism and to the absolute authority of artistic heritage and empirically observed nature.[17] He should follow the established masters not just in general principles of design and effect but down to the stages involved in making a work of art:

> When they ['the most eminent Painters'] conceived a subject, they first made a variety of sketches; then a finished drawing of the whole; after that a more correct drawing of every separate part, – heads, feet, and pieces of drapery; they then painted the picture, and after all re-touched it from the life. The pictures, thus wrought with such pains, now appear like the effect of an enchantment, and as if some mighty Genius had struck them off at a blow.[18]

The student who deviates from this slow, arduous route to excellence, neglects nature and seeks short cuts to the 'dazzling excellencies' of virtuoso technique, and 'has been debauched and deceived by this fallacious mastery' will run counter to nature.[19] Reynolds states that the neglect of 'scrupulous exactness' is 'one of the reasons why Students so often disappoint expectation, and, being more than boys at sixteen, become less than men at thirty'.[20] Such a depraved youth is, despite his material successes, vulnerable: he is 'a juggler, who lives in perpetual fear lest his trick should be discovered'.[21]

This rhetoric of authenticity enjoyed a complex relationship – certainly not one of simple dependence – with the hierarchy of the genres, which in the Continental model provided the foundation upon which any claims to artistic authority were to be based. The highest genres were accepted as the ultimate object of the artist, but what the president recommended was that the qualities association with the Grand Manner be transferred into other modes, and even that the practical pursuit of the Grand Manner as generically defined might be misplaced. All these points emerged in 1770 from the final important passages of the 'Third Discourse', in which Reynolds conceded on behalf of the modern artist that 'if from particular inclination, or from the taste of the time and place he lives in, or from necessity, or from failure in the highest attempts, he is obliged to descend lower, he will bring into the lower sphere of art a grandeur of composition and character, that will raise and ennoble his works far above their natural rank.'[22] Thus is described an idea of the Grand Manner that consists in obeying certain formal rules, almost regardless of the subject at hand. In this context, the educational role of the academy lay not in encouraging one genre or another (as the Society of Arts had sought to do) but in instilling into its students certain values that could be carried into a market place that demanded a variety of different productions aside from the Grand Manner.

But, in very real and immediate terms the academy militated against workshop practices and against the economic self-realization of the artists who submitted to its forms of professional consecration. Aside from the Rome prize, which benefited a handful of scholars with three years of funded study in Italy, students at the academy were not provided with any form of direct

funding nor even pecuniary prizes; the annual and biennial competitions were for gold and silver medals rather than the cash premiums that had been on offer at the Society of Arts. More importantly, they were not given the opportunity to develop the full range of practical skills that would serve them in professional practice: they were rewarded not for producing large or finished works, but for sketches or models; painting was not taught formally within the walls of the academy until the nineteenth century; and ornament design was excluded from the curriculum. There were also no facilities for students of sculpture to work with stone or marble.

As early as 1770, a generally sympathetic commentator was suggesting that there needed to be a collection of old masters available so that students could learn the techniques of colour by practical example.[23] The anonymous author of *Letters Concerning the Present State of England* (1772) gave an extended critique of the academy's failures with regard to its sculpture students, calling for the creation of a whole separate institution dedicated to the medium. The author noted that as a 'block of marble is a considerable expence', this 'precludes much useful exercise', while painters could try 'many experiments on colours at a trifling cost'. Yet such 'exercise' was essential to the sculptor, 'for as to working in plaister, by way of studying it [sculpture], it will never make an artist, for want of exercising the chissel'.[24] In other contexts, these restrictions and stipulations could have taken on a different significance. But they proved decisive when applied to a generation of artists who were promised the establishment of a new national school of history painting and ideal sculpture and who enjoyed unprecedented possibilities for artistic publicity through the annual exhibitions and the print market.

In the event, the confidence in the future of historical art that accompanied the foundation of the academy was remarkably short-lived. For all the subtleties of Reynolds' arguments, the success or failure of the academy was still generally measured by the state of the Grand Manner. The institution's close connections with George III, its exclusive membership and high-minded exhibition policy divided the artistic community, and in the heightened political circumstances of the later 1760s and early 1770s invited the wrath of anti-monarchical critics, most prominently 'Fresnoy' writing in the Wilkesite *Middlesex Journal*.[25] In its edition of 9–12 May 1772 that paper directed its anger at the academy's failure to promote the Grand Manner. The academy, it claimed, had not encouraged historical painting as the Society of Arts had done (Robert Edge Pine's *Surrender of Calais to Edward III* was cited as an example of that body's efficacy), the reason being that 'a generous and discerning public is a much better patron than the King and all his courtiers'. A critique of the cultural economy was thereby married to an attack on the constitutional framework that economy inhabited: the lamenting of Britain's artistic poverty was brought into the service of a politicized opposing of the 'public' to the monarchy.

While such criticisms registered the wide political unease of the moment, some disquiet regarding the particular issue of the academy's patent failure to encourage historical art emerged from the very heart of the institution. This was focused on the attempts at establishing a formal public role for the academy, not just as an exhibiting society or as a school but in connection with some permanent public space. The first space considered was St Paul's Cathedral. Since James Thornhill's limited programme of decoration in the early eighteenth century there had been no efforts to embellish the church with art. As the French traveller Pierre-Jean Grosley observed, echoing Rouquet's statement quoted at the beginning of chapter 1, British historical art could not hope to develop without emulative competition between artists, and 'The nakedness of St Paul's church offers a noble field for the competition.'[26] During 1772 and 1773 the academy led an initiative to have modern paintings installed in the form of large-scale altarpieces by six of the academicians. As Sir Joshua Reynolds explained at the time in writing to Thomas Robinson, now Lord Grantham, this was expressly to be as an incentive to potential patrons: 'We

think this will be a means of introducing a general fashion for Churches to have Altar Pieces, and that St Pauls will lead a general fashion in Pictures, as St Jamess does for dress, It will certainly be in vain to make Historical Painters if there is no means found out for employing them.'[27]

If Reynolds is obliged to borrow the language of the fashionable market place to explain the intended effect of the project, the seriousness with which such a project was anticipated as a means of blocking the encroachment of that market place on artistic production should not be doubted. The scheme met with objections from the bishop of London and never came to fruition, striking what appeared to be a 'mortal blow' to the still nascent school of historical art.[28] The academy's treasurer, Sir William Chambers, writing to Grantham after this disappointment, in April 1774, reported on a very successful exhibition but expressed concern about the new generation of artists, for 'at present they have little or no encouragement, we are over-stocked with Artists of all Sorts, and it will soon be as necessary to have an Hospital for the Support of decayed Vertuosi as it was a few years ago to establish an Academy to raise them'.[29] Chambers here admits that the academy is guilty of precisely the charge that John Gwynn had levelled at the Society of Arts: that it existed to create artists rather than create work for artists and in this endangered the cultural economy as a whole.

Shortly after Chambers wrote these comments, worse still came, for 1774 witnessed the collapse of a second effort to create an exemplary set of historical pictures by leading academicians, destined for the Great Room of the new home of the Society of Arts, in the Adam brothers' Adelphi complex on the north bank of the Thames.[30] If the academy was founded on the idea that it could foster British historical art by providing models for emulation and offering theoretical encouragement to young artists, within only five years the two best opportunities to realize model schemes had gone astray.

These same years saw the open questioning of the idea of emulation itself. From the middle of the 1760s, art journalism had given voice to the apprehension that repeated use of the same subjects by modern artists threatened the vitality and validity of the Grand Manner. As early as 1764 a London commentator noted that Hamilton had 'exhausted' all the subjects in Homer.[31] After 1770, such observations become frequent. A newspaper critic in 1772 claimed: 'Most subjects in history, whether ancient or modern, sacred or profane, have been so hackneyed by painters, that he who hits upon a new topic, or one that has been but little touched, merits great praise.'[32] Matters came to a head during the exhibition season of 1773, when pictures of Agrippina were shown by West at the Royal Academy and James Nevay (c. 1730–after 1811) at the Society of Artists. Both painters were subjected to explicit criticism regarding their choice of subject and many of the newspapers took the opportunity to make more general comments about the state of the arts in Britain. The most elaborate of these reports expressed concern about the apparent stagnation of the British artistic imagination:

Considering the infinite number of subjects, fit for history paintings, that are to be found in ancient and modern, real and fabulous, sacred and profane history, it is surely somewhat surprising that our Artists should not be at more pains to aim at originality, by pitching upon untouched incidents, and not indolently content themselves with giving us representations of scenes that have been represented a hundred times before. An Artist's taste and judgement are no less visible in the choice of his subject, than in the manner in which he executes his design.[33]

Having noted that Nevay's subject had already been treated by Hamilton and others, this critic granted the artist some praise only because 'he has contrived to give his piece the air of novelty by introducing into it persons, and placing them in attitudes, that are not to be seen in the works

of his predecessors'.[34] On occasion, such criticisms took the form of attacks aimed directly at the visual manner of the leading classical history painters. West in particular was censured for his close imitation of Poussin, leading to a 'sameness of Manner and Colouring'.[35]

The palpable shortcomings of the academy, the absence of programmatic statements about or practical support for the genre of the Grand Manner, and intensifying criticism about the unhealthy monotony of contemporary art were contributing factors in the dramatic reformation of the image of the hero in the coming decade. In the 1770s the potential for the more interrogative creative liberty promoted in the 1750s and 1760s by patriots and reformers came to the fore, as politics itself became more sharply polarized and as unease about the fate of modern masculinity erupted into yet more raucous (and sometimes literally physical) conflicts. It was in this context that a sequence of younger artists came forward, artists whose highly mannered styles and exploration of extreme and esoteric themes exploded any hope that public virtue and artistic ambition could be reconciled in a consensual imagery of the hero.

4

GENERAL WOLFE

AMONGST THE MACARONIS

A decade after the close of the Seven Years War, in which General James Wolfe had lost his life, and thirteen years since the design of a national monument to his memory had been agreed, London's public finally had a chance to see the most ambitious and prominent sculpture commemorating a national hero ever conceived in Britain. Work on the installation of Joseph Wilton's Wolfe monument in Westminster Abbey was finally underway by May 1771. Even then it was still another year and a half before the monument was fully on view, and it was not formally unveiled until towards the end of 1773 (FIG. 51).[1] This delay remains unexplained. That Wilton inherited substantially from his father in 1768 and had largely withdrawn from professional practice could not have helped the project. Given the politically specific nature of the original proposal for the monument, administrative wrangling among succeeding governments might have already delayed matters.[2]

Whatever the cause of the hold-up, Wolfe's image was unveiled in a radically transformed political and social setting. William Pitt the Elder (1708–78), the hero of 1757–59, had become marginalized in terms of real power but inflated as a symbol of a political opposition concerned with a general appeal to 'virtue' and hostility to 'luxury' and 'corruption'. Bringing to fruition a monument intended as a celebration of this former first minister as much as Wolfe himself could hardly have been a top priority for either the government headed by John Stuart, third earl of Bute, from 1762 to 1763 or the Rockingham Whigs that followed. Factionalism, quietened through the earlier 1760s, had renewed with vigour and venom, and political radicals offered open challenges to the authority of king and court. The empire raised by the sacrifices of so many thousands, Wolfe included, was looked upon now as at best a burden, at worst a liability and an embarrassment. And organizing and expressing these conflicts, there was a prominent genre of social criticism that dramatized the fate of modern masculinity in the most extreme and specific terms, throwing into doubt the viability of historical and literary exemplars. If giving wide social currency to an elevated image of the masculine hero was a challenge in 1760, by now it was looking impossible.

As executed, the monument comprises Wolfe being supported by a grenadier as he leans back on a sofa shrouded by voluminous drapery (FIG. 52). The inscription highlights his personal attributes and the tragedy of his death in battle but makes nothing of the imperial or conquesting character of his leadership, in contradistinction to the Townshend monument which, so much more intimate in its form and motivations, proposed empire as the ultimate consolation:

TO THE MEMORY OF
JAMES WOLFE
MAJOR-GNERAL AND COMMANDER IN CHIEF
OF THE BRITISH LAND FORCES
ON THE EXPEDITION AGAINST QUEBEC
WHO AFTER SURMOUNTING BY ABILITY AND VALOUR
ALL OBSTACLES OF ART AND NATURE
WAS SLAIN
IN THE MOMENT OF VICTORY
ON THE XIII OF SEPTEMBER MDCLIX
THE KING
AND THE PARLIAMENT OF GREAT BRITAIN
DEDICATE THIS MONUMENT.

The figure of Wolfe is naked, his waist shrouded by drapery, and his uniform discarded to the left. Drapery falls over the front edge of the sarcophagus that supports him. To the rear, in low relief, a Highland soldier leans against his pike; a grenadier is shown directing the expiring Wolfe's gaze towards the emblematic figure of winged Victory. The whole is organized within an attenuated triangular backdrop, represented in the form of a tent that is shown in its termination to be intruding between the branches of a tree. This scene, suggestive of a field hospital, is positioned on a large sarcophagus that carries the inscription and is in turn supported by two lions on the 'actual' plinth, which bears a bronze relief of the marine siege of Quebec. The audience of soldiers and 'Canadians' proposed in Wilton's design of 1765 has been abandoned in the final design, or rather the presence of an affective specatatorship has been reduced to two figures, one the grenadier, the other, simply spectating, the highlander.

This last character is a significant presence. Given that Wolfe had served at Culloden, the stories that circulated in the wake of his death about the fierce loyalty of the Highland soldiers at Quebec were pointed, serving to illustrate the incorporation of these former enemies of England into the Anglo-British state. The Seventy-eighth (Highland) Regiment of Foot, or Fraser's Highlanders, which was the only Highland regiment to serve at Quebec, had existed as an independent Highland company raised in the Jacobite cause in the rebellion of 1745. The regiment had been decimated at Culloden. The presence of this Highland soldier in Wilton's design represented the incorporation into the imperial project of a rehabilitated Celtic fringe that had formerly been considered criminal (the regiment raised in 1745 was referred to by one Lowland writer as *banditti*).[3] By the time the monument was erected, however, there was a certain irony in the presence of this figure. The early 1770s saw a rising concern about the emigration of Highlanders to America, effectively depopulating and deskilling Scotland and helping to dissolve the unity of the Anglo-British state.[4]

When the monument was finally unveiled, the public appears to have been largely unmoved. There was no great fanfare, and although the initial reports of the erection of the monument prompted an outburst of new poetic tributes to Wolfe, the recorded responses of early visitors to Westminster Abbey indicate little enthusiasm for the work.[5] The London surgeon David Samwell (1751–98) was one more enthusiastic spectator:

I have lately seen the Monument of General Wolfe, which I think for the Design & Execution superior to all in the Abbey, a naked whole length Figure of the Hero, in a recumbent Posture, supported by a Soldier, looks earnestly at Victory, who descends from the Clouds with the Laurel Wreath in her Hand, to crown him in the Arms of death. The Attitude of

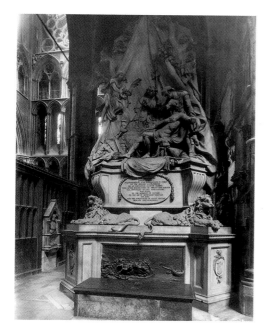 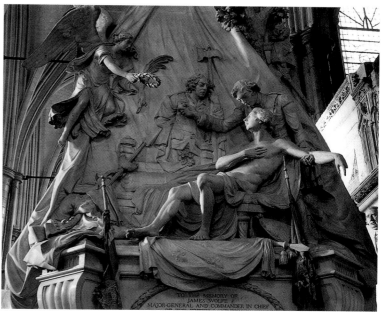

Wolfe is extreamly fine & noble, it partakes so much of the Theatrical as to give it all the wild Grace & Expression of that, without exceeding Nature.[6]

Having previously made favourable comment on David Garrick's performance as Richard III, Samwell was aware of current theatrical practice. That there was a degree of sympathy between theatre and the visual arts in the matter of dramatic expression was a commonplace of criticism; that the visual arts should be measured by expressive efficacy is a register of the degree to which the hero was to be judged emotionally rather than according to his virtue and exemplarity. But there were limits to this, as well. Garrick himself was conscious of the challenges represented by staging modern subject matter. He observed in October 1772, apparently in response to the suggestion at the time of the unveiling of Wilton's monument that the subject would be proper to represent on stage: 'Many thanks to You for yr kind, & very sensible *hint* – I should certainly make use of it, were we allow'd to treat a Subject so recent as the Death of Wolf. The tragedy of Charles the first was stop'd at Lincolns Inn-fields, because the Catastrophe was too modern; the Same way of reasoning holds Stronger wth regard to the death of Wolf.'[7]

Wilton's representation of his hero as nude was almost without precedent in sculpture and, as Horst Janson has noted, was complex, invoking equally classical ideals and the examples of Christian saints, and functioning diegetically.[8] The fine balancing act that Wilton strikes, evoking esteemed exemplars and making provision for a prosaic narrative explanation in his hero's seeking medical attention (thus the abandoned uniform and the tent backdrop) would, arguably, not bear frequent repetition. It might, in fact, be seen to represent equivocation and hint at the anxieties around the propriety of modern subjects in heroic representation, as may have surfaced at the Society of Arts in the 1760s. But in the spring of 1771, as Wilton's monument was being erected, Wolfe's death was brought back into the public spotlight with a painting that would appear to supersede these debates and make a decisive commitment to contemporaneity, to the extent of overshadowing the sculptural memorial almost entirely. This was, of course,

51 (left)
Joseph Wilton, monument to General Wolfe, erected 1773. Westminster Abbey, London.

52 (right)
Detail of the monument to General Wolfe.

Benjamin West's painting of the *Death of General Wolfe*, included in the Royal Academy exhibition of that year (FIG. 53).

Where Wilton's monument deploys a compromised classicism that accommodates a degree of portrait likeness and narrative interest in line with recent developments in public art, West's painting is a full-blooded exercise in modern-dress history painting that takes its cue from the works of Francis Hayman from the previous decade. If in 1759–60 there were a few dissident voices who claimed that classical imagery might not be precisely appropriate for modern times, by now the very issue of exemplars was at stake. A sentimental novelist in 1769 could write:

> The virtues of kings, the crimes of tyrants, the rapid conquests of heroes, their dazzling achievements, are all so general, so supernatural, so foreign to our being, that far from approaching such objects, we rather depart from them as far as we are able; or if we go in quest of them, it is only to behold them in a miraculous light. They seem new beings to us, Collossus's raised on the tops of mountains: they strike the eyes, and feed our stupid curiosity; but we are far from drawing a parallel between them and us, who look upon ourselves as pigmies compared to them, and as a race of men of a different nature. Thus we never enter into that spirit of combination, which supposes a resemblance betwixt their actions and ours, and equalling us with them, makes us of consequence only look upon them as models for us.[9]

And in 1771 an essayist in the *London Magazine* proposed that classical models should be discarded altogether in the modern age:

> The exploits of Plutrach's heroes, though interesting, are too distant in time and place to be brought home and applied to our present business and pursuits without an effort of the imagination and a facility at comparison, of which few but those, who have by study and practice acquired the habit of reading, are capable; but the application of domestic and living examples of virtue and vice is an operation within the reach of the most vulgar and untutored mind.[10]

This latter writer is being ironic, as this passage comes from an essay introducing a series of articles dealing with the gossip and scandal of figures from contemporary high life. As such, it speaks of the dangers that accompanied the displacement of a classical language of high art in favour of an explicitly modern one (however desirable this may be): the hero could be trivialized and the hierarchy of values that could endow any given hero or action with significance might be dissolved.

West, at the beginning of the 1770s, explored the possibility of some kind of compromise. Taking up David Solkin's important discussion of the painting, West can be seen to pursue a consumer-orientated adaptation of the conventions of epic art, assembling a composition that simultaneously advertises its references to high-art tradition and incorporates contemporary detail and a sympathetic model addressed to the socially heterogeneous spectatorship that attended the Royal Academy.[11] His *Death of General Wolfe* proposes that the hero could suffer and thus be the object of sympathetic responses yet also be an appropriate subject for a painting in the heroic mode, and that the modern costumes that helped guarantee the spontaneity and immediacy of the sympathetic response could with decorum be represented in a composition that was explicitly based on elevated precedents.

The generic instability of this approach was important. Both the suffering evident in the features of Wolfe and his fellow soldiers, and the 'familiarity' that came with modern dress and that facilitated sympathetic responses, might be appropriate to the 'tragic' mode rather than the 'epic'. In a report contemporary to the exhibition, George III was said to have complained that 'there was too much dejection, not only in the dying hero's face, but in the faces of the sur-

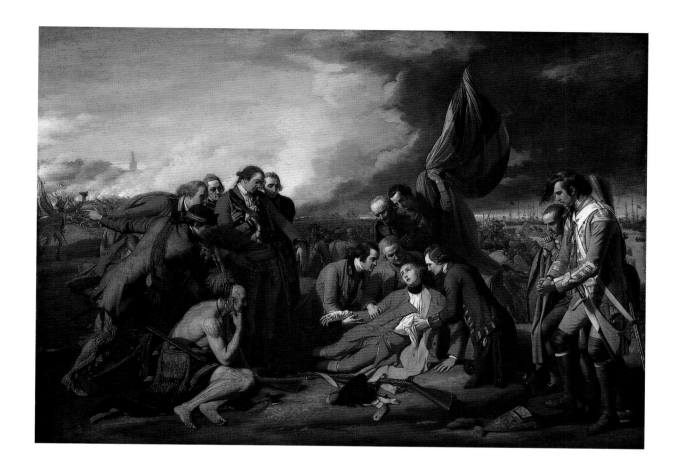

rounding officers, who, he said, as Englishmen should forget all traces of private misfortunes when they had so grandly conquered for their country'.[12] Perhaps because of such ambivalence, granting a degree of currency to both tragic and epic interpretations of the scene, West's Wolfe enjoyed an extended life, appearing in a number of versions, engraved and published with enormous success in 1776.

The basic formula of the 1771 picture was repeated in the coming decades to represent tragic deaths in India and Ireland, at sea or, with John Singleton Copley's *Death of Major Peirson* on the island of Jersey (FIG. 54).[13] For perhaps half a century, if a painter was to commemorate the death of a hero in battle, it was to West that he was obliged to turn as a source and point of reference. In effect, West's *Death of General Wolfe* now served painters of modern history as Charles Le Brun's *Alexander before the Tent of Darius* had served Robert Edge Pine and Francis Hayman: as a formal model whose evocation provided a stamp of authority and a guarantee of legibility.

Yet, for all its resilience as a formal and narrative model, West's *Death of General Wolfe* represents a finely calculated effort to represent the conquest of Quebec as a specifically British and imperial – and not just English – victory, and visibly so, in a way that can be tied to its particular historical moment. West went to particular efforts to make visible the ethnic range of the British military project in the make-up of the extended audience for his hero's death.[14] It is worth detailing what is known of these figures, bearing in mind the complex racial and cultural mix of the British Empire forged through the wars of the previous decades.[15]

53 Benjamin West, *The Death of General Wolfe*, dated 1770, exhibited 1771. Oil on canvas, 153.7 × 213.2 cm. National Gallery of Canada, Ottawa. Transfer from the Canadian War Memorials, 1921, gift of the Second Duke of Westminster, Eaton Hall, cheshire, 1918.

Perhaps most importantly, in the group to the left there is, in the foreground, a kneeling American Indian. Native troops had controversially been used in the war against the French, although not in the campaign to take Quebec. For the Revd Bromley, West's stringently conservative friend and supporter, writing in 1793, the American Indian was blankly inexpressive and contemplative, establishing the racial exclusiveness of the community of sentiment imagined by West.[16] Yet visually the figure occupies the subordinate position conventional for mourning figures in funerary monuments and found in a number of pictures by West himself (for instance, in the female figure with a child to the bottom right of *The Departure of Regulus from Rome*). What seems important is the inclusion of this figure at all, perhaps following Wilton's mid-1760s design of the Wolfe monument where 'Canadians' were incorporated in the crowd of mourners alongside soldiers, and in sharp contrast to Louis François Roubiliac's conception of the monument from the competition of 1760, which featured an American Indian being trampled underfoot by the British lion. If accepted as an emblem of America, it represents an America that is moved by noble sentiments and poignant sympathies to submit willingly to British authority.

Next in West's picture is a figure in the distinctive green costume of Robert Rogers' unit of rangers, combining European and native American Indian elements. His powder horn is inscribed '*Sr Wm Johnson* MOHAWK RIVER', a reference to the superintendent of Indian affairs, Sir William Johnson (1715–74). Johnson had left Ireland as a young man to manage property in the Mohawk Valley that his uncle, Admiral Sir Peter Warren, had obtained by marriage. Having established good relations with the Iriquois and Mohawks, Johnson played a key role in enlisting American Indian support for the British cause. The status of this inscription is, though, unclear, as Johnson was not at Quebec nor was he a ranger. Since 1764, when he was granted a tract of land for his services in the war, he had installed himself in what was in effect a feudal castle (albeit made of wood and on a moderate scale), where he held court over a community of unexampled ethnic and social diversity.[17]

Behind this figure is a soldier in Highland costume, who has been identified as Simon Fraser, twelfth Lord Lovat, and colonel in Fraser's Highlanders. Standing with his arm in a sling is the figure of Brigadier-General Robert Monckton, Wolfe's second in command, supported from behind by Captain Hugh Debbieg of the Royal Engineers. Immediately around the supine figure of Wolfe are the army surgeon John Adair, pressing a dressing to the general's chest, and Captain Hervey Smyth, holding his arm. Wolfe's head is supported by Isaac Barré, who had in fact been shot in the face at an earlier stage in the day's conflict. Barré was born in Dublin to French Huguenot parents and, while under Wolfe's command, he had risen to considerable military office, raising suspicions of preferment. Behind Barré, holding the flag, may be Lieutenant Henry Browne of the regiment Wolfe led at Quebec, the Louisburg Grenadiers. Next to him is Colonel George Williamson, artillery commander, and to the far right two grenadiers.

The company is thus partly made up of portraits, identified in a key to the famously successful 1776 engraving of this painting, and in the other part made up of 'types', adding up to a relatively comprehensive vision of the ethnic scope of the British Empire in North America, crowded below the flag of the Union and united by sentiment. In fact, when set against the previous versions of the subject by George Romney and by Edward Penny (1714–19) (private collection), the picture begins to take on an almost emblematic quality as a vision of British imperial assimilation, extending even across the boundaries of race, or at least taming the savage by its powers of sentiment. It is closer in spirit to George Cocking's robustly patriotic *Conquest of Canada* (1766), which featured a dramatis personae consisting of 'Three *English* Generals' – Wolfe, 'Leonatus' and 'Britannicus' – together with two '*Caledonian* Chiefs' and 'Three Officers, in the Troops of *Great Britain*', named Octherlony, Macdonald and Peyton. The play sees

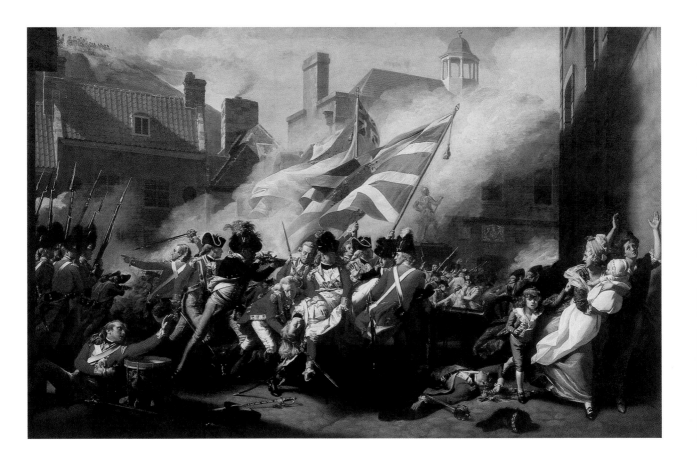

a repeated stress on the composite Britishness of Wolfe's army, as when the general contrasts his men with the French enemy:

> WOLFE: I cannot boast twelve thousand Regulars,
> With many savage scalping Bands; my Troops
> Will scarcely to eight Thousand rise; but these
> Are gallant Fellows; and I have seen them
> Try'd: They're *Britain's* Troops; and from *Old England*,
> *Caledonia* and *Hibernia* drawn.
>
> BRITANNICUS: They're the Descendants of those very Men,
> Who fought at *Cressy*, *Poictiers*, *Blenheim*!

54 John Singleton Copley, *The Death of Major Peirson*, *c.*1782–84, exhibited 1784. Oil on canvas, 246.4 × 365.8 cm. Tate, London.

The central portion of the play is occupied by a scene that features an Irishman (Peyton) and a Scotsman (Octherlony) who, though both wounded, insist on remaining behind in a desperate last stand against an overwhelming onslaught of 'savages', taking time to swear affective allegiance to one another before salvation comes in the form of Macdonald and his Highland troops. Transparent as it is, this allegory of union enjoyed a certain degree of success, in America more than Britain.[18]

The appearance of West's icon of assimilationist Britishness and martial virtue becomes particularly pointed in relation to current debates about the fate of Britain's empire and its men,

particularly its soldiers. These were the years of what Edmund Burke termed the 'great crisis'.[19] The early 1770s saw the flowering of a new kind of gendered anxiety about commerce and luxury, and this proved to be a highly adaptable form of social criticism.[20] A correspondent to the *Oxford Magazine* in 1772 wrote:

> The effeminacy of our manners, so often complained of by our moralists of late years, seems now to have risen to the utmost height of extravagance. The state of corruption and degeneracy, which Dr Brown, in his Estimate of the Manners of the Time, foresaw was to happen, has actually arrived. The liberal and manly genius, which distinguished our ancestors, appears entirely to have fled from this country.[21]

Accounting for 'Modern Manners', an essayist of 1773 lamented that: 'The constitution of this country, from the effeminacy of our manners, and from the luxury of our entertainments, seems not to rest on a permanent foundation. True nobility *now* consists in splendid titles, gay equipage, and princely palaces.' Now a rampant 'middle class . . . seek to acquire respect and esteem from the vulgar' through ostentatious consumerism manifest in 'childish baubles'.[22] This phenomenon was certainly 'of a very late date . . . Our fathers were simple in their manners, and in our own memories we find an amazing alteration'; it may even have been just a few years old, another commentator noting that only five years previously tea, coffee and chocolate were luxuries available to only the very wealthiest, but they are now consumed by everyone: 'We send to the East and West Indies to furnish our poor with their breakfasts.'[23] In a telling comparison, modern Britain was considered to be subject to the same dangers that had destroyed the status and reputation of Spain in the seventeenth century: 'The amazing quantity of wealth of late years brought into this kingdom will do us as little service as it did the Spaniards from the conquests of Mexico and Peru . . . our accessions in the Eastern world may prove as dangerous to us.'[24]

The movement of the luxury debate beyond classical attacks on luxury to become a usefully nuanced tool of social criticism was most apparent in the emergence of the 'Macaroni'. This designated a type of affected and ultra-fashionable young metropolitan man who emerged as the subject of satirical comment from the middle of the 1760s and who, in the years 1770–73, formed the focus for intensive satirical activity in magazines and newspapers, the London stage and caricatures (FIGS 55 AND 56).[25] An essay from the fashionable *Town and Country Magazine* in 1772 brings together all the major themes and motifs associated with this social type:

> The Italians are extremely fond of a dish they call Macaroni, composed of a kind of paste; and as they consider this as the *fummum bonum* of all good eating, so they figuratively call every thing they think elegant and uncommon *Macaroni*. Our young travellers, who very generally catch the follies of the country they visit, judged that the title of Macaroni was very applicable to a clever fellow; and accordingly, to distinguish themselves as such, they instituted a club under this denomination the members of which were supposed to be the standards of *taste* in polite learning, the fine arts, and the genteel sciences; and fashion, amongst the other constituent parts of taste, became an object of their attention. But they soon proved, they had very little claim to any distinction, except in their external appearance; in their dress, indeed, they were high-finished *Petits-Maitres*; in every thing else they were *Coxcombs*. The infection of St James's was soon caught in the city, and we now have Macaronies of every denomination, from the colonel of the Train'd Bands down to the errand-boy. They indeed make a most ridiculous figure, with hats of an inch in the brim, that do not cover, but lie upon the head, with about two pounds of ficticious hair, formed into what is called a club, hanging down their shoulders as white as a baker's sack: the end of the skirt of their coat

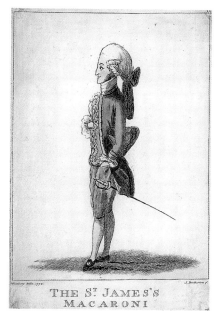

THE ST. JAMES'S
MACARONI

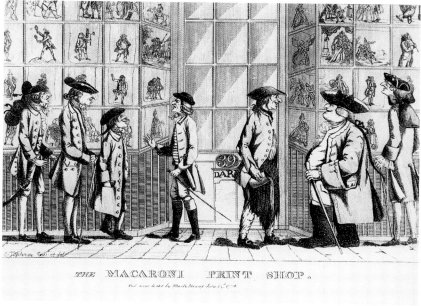

THE MACARONI PRINT SHOP.

reaches the first button of their breeches, which are either brown striped, or white, as wide as a Dutchman's; their coat-sleeves are so tight, they can with much difficulty get their arms through their cuffs, which are about an inch deep; and their shirt-sleeve, without plaits, is pulled over a bit of Trolly lace. Their legs are at times covered with all the colours of the rainbow; even flesh-coloured and green silk stockings are not excluded. Their shoes are scarce slippers, and their buckles are within an inch of the toe. Such a figure, essenced and perfumed, with a bunch of lace sticking out under *its* chin, puzzles the common passenger to determine the thing's sex; and many a time an honest labouring porter has said, *by your leave, madam*, without intending to give offence [. . .]

Whither are the manly vigour and athletic appearance of our forefathers flown? Can these be their legitimate heirs? Surely no; a race of effeminate, self-admiring, emaciated fribbles can never have been descended in a direct line from the heroes of Poictiers and Agincourt.

In this free country every one has a right to make himself as ridiculous as he pleases, either in politics or dress; but when a writer tilts against common sense in the papers, or a Macaroni renders his sex dubious by the extravagance of his appearance, the shafts of sarcasm cannot too forcibly be pointed at them.[26]

There were several dimensions of anxiety arising around the London Macaroni – historical, class-based and sexual. The etymology might draw attention to the compounded and confused character of such figures – being part male, part female or incomplete.[27] While the Macaronis' effeminacy and extravagant fashionable display linked then to the fops of earlier ages, they seemed to offer quite new dangers and represented an unknown level of sexual confusion. Commentators distinguished the Macaroni from earlier social male fashions: 'It is the reverse of the *Mohocks* of the last age, and the *Bucks* and *Blonds* of this. *They* were rough and terrible. *It* is delicate and contemptible.'[28] The diachronic aspect of the Macaroni was distilled into a comparison between two soldiers' bodies in a caricature of 1773, *The Military Contrast* (FIG. 57).

55 (left)
James Bretherton after William Henry Bunbury, *The St James's Macaroni*, published by James Bretherton, 1772. Hand-coloured engraving, 26.4 × 17cm. Guildhall Library, Corporation of London.

56 (right)
Matthew Darly after Edward Topham, *The Macaroni Print Shop*, published by Matthew Darly, 11 July 1772. Etching, 16.8 × 23.6cm. The British Museum, London.

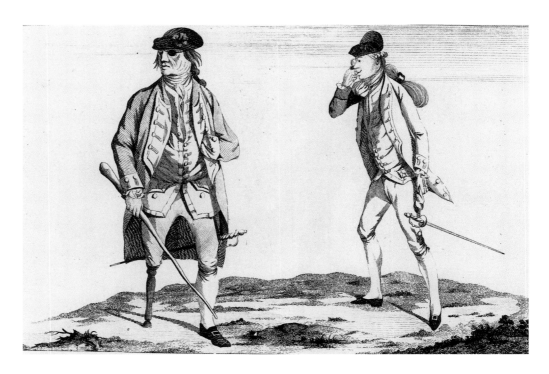

57 Matthew Darly, *The Military Contrast*, published by Matthew Darly, 1 May 1773. Etching, 17.3 × 34.6 cm. The British Museum, London.

The modern Macaroni soldier has the typical club of false hair and exaggerated costume, overwhelming his slight physique; the burly invalided veteran represents the military efforts of the recent past, his costume and age suggesting that he has fought in the domestic and international wars of the 1740s and 1750s.

The perceived decay of British manhood was not, it seemed, just an effect of the debilitating luxuries brought home by imperial conquest and commerce. The very success of empire had created problems. A relatively sustained period of peace since the end of the Seven Years' War in 1763 had seen elevated levels of criminality, understood to have arisen as lazy but hardened soldiers were left unemployed to roam the country as thieves and desperadoes. For Henry Home, Lord Kames, in 1774, the contrast between the years of Wolfe's death and triumph and the years of West's depiction of that scene marked out historical poles: 'In the years 1759 and 1760, when we were at war with France, there were but twenty-nine criminals condemned at the Old Bailey. In the years 1770 and 1771, when we were at peace with all the world, the criminals condemned there amounted to one hundred and fifty-one.'[29] Between these dates the imperial project seemed, to the widest range of observers, to have become derailed.

In 1770 Britain found itself on the brink of another international conflict, with Spain, over the Falkland Islands. Although the discovery of the islands was claimed by the British at the end of the seventeenth century, a French settlement was established in 1764 and a British settlement in 1765. When the French sold their settlement to Spain, the new owners took this to mean that they had rights over the islands as a whole. The threatened war with Spain over its proposed occupation of this distant territory prompted a flurry of pamphleteering, with progovernment writers insisting on a pacifist view that damned imperial conquest (and pointed to the example of the Spanish conquistadors), while the opposition took the opportunity to damn the apparent cowardice and unpatriotic outlook of the ministry. In one of his most vivid considerations of the nature of heroism, Samuel Johnson, writing on the ministry's behalf, contrasted the realities of modern warfare with the fantasies favoured by tradition:

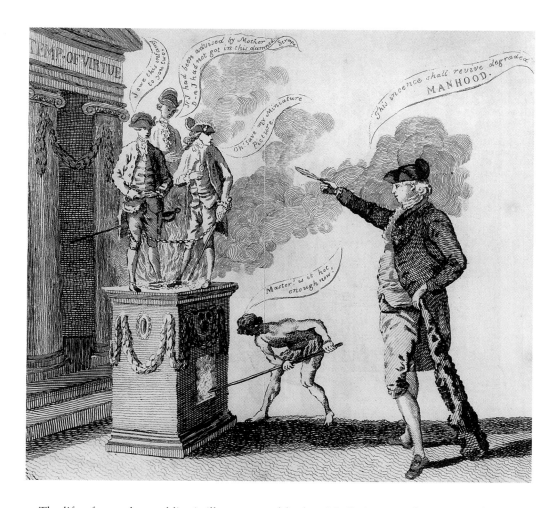

58 'The Maccaroni Sacrifice', engraved plate from Henry Bate, *The Vauxhall Affray*, London, 1773.

The life of a modern soldier is ill represented by heroick fiction. War has means of destruction more formidable than the cannon and the sword. Of the thousands and ten thousands that perished in our late contests with France and Spain, a very small part ever felt the stroke of an enemy; the rest languished in tents and ships, amidst damps and putrefaction; pale, torpid, spiritless and helpless; gasping and groaning, unpitied among men made obdurate by long continuance of hopeless misery; and were at last whelmed in pits, or heaved into the ocean, without notice and without remembrance. By incommodious encampments and unwholesome stations, where courage is useless, and enterprise impracticable, fleets are silently dispeopled, and armies sluggishly melted away.[30]

This is an image far distant from either the sentimentalized sufferings of classical heroes made visible with the premium competitions of the Society of Arts, or, alternatively, that unrestricted heroic physicality associated with Homer or, latterly, James Macpherson's Ossian.

Where military action did take place, it seemed similarly to throw the legitimacy of the imperial project into doubt. The 'St George's Field Massacre' protesting John Wilkes' imprisonment in London in May 1768 had sharpened concerns about the abuse of the justice system and reawakened old fears about the use of the standing army as a tool of state power. When news of the 'Boston Massacre' reached London in April 1770, it confirmed opposition fears about

59 (facing page)
Thomas
Gainsborough,
*Reverend Henry
Bate*, exhibited
1780. Oil on canvas,
223.5 × 149.9 cm.
Lord Burton; on
loan to the Tate,
London.

the lethal potential of military interventions in the civilian sphere, and London supporters of the American cause circulated inflammatory accounts of the brutality of British soldiers.[31] The criminal prosecution of the British soldiers held responsible for the deaths in Boston dragged on through 1771, so that just as West's picture was on display in London, the 'Poets Corner' of *The Massachusetts Spy* of 16 May and 23 May 1771 was asking 'Who spilt our blood like glorious sons of war?' and answering that it was British '*Soldiers* did spill our blood, like sons of war!'

The interweaving of gendered anxiety, imperial issues and luxury had its apogee in the 'Vauxhall Affray' of 1773. The course of events that made up the affray was documented in competing accounts, and it is now impossible to ascertain the accuracy of any of these or even the reality of the events they describe. What matters more is that these accounts represented a conflict that set hegemonic and dissident masculinities in direct confrontation, referring to a set of identifiable historical individuals. Essentially Henry Bate (1745–1824) was, it was reported, in the company of his sister-in law, the actress Elizabeth White, known as 'Mrs Hartley', at Vauxhall Gardens on the evening of 23 July 1773, with a Mr Colman (presumably the theatrical producer George Colman) and perhaps a Mr Tatham (more speculatively to be identified as Edward Tatham). He got into an argument with a group of young men of fashion, including, according to various accounts, some combination of Thomas Lyttelton, George Robert Fitzgerald, a Captain Crofts of Burgoyne's Light Dragoons and an O'Bourne or O'Byrne. Bate, taking offence at the way these men were looking at Mrs Hartley, argued with Captain Crofts. A verbal duel ensued, insults were exchanged, apologies demanded. The groups then broke up, with the promise of a meeting the next day to settle the matter. The next day the parties met, as agreed, at the Turk's Head tavern in the Strand, and while Bate, accompanied by a Mr Dawes, and Crofts, accompanied by Lyttelton, were on the point of agreeing an amicable conclusion to the affair, they were interrupted by O'Byrne and Fitzgerald, who insisted that a duel be proposed, demanding that Bate fight a 'Captain Miles'. Reportedly, the fight took place and even though 'Captain Miles' was in fact Lyttelton's prize-fighting footman, Bate triumphed.

Bate's account of these events is presented in a compilation of newspaper reports in the volume *The Vauxhall Affray*, accompanied by a caricature of Bate as an upright masculine hero and his opponents as effete fribbles (FIG. 58). What offended him was that the men leered at Mrs Hartley 'with that kind of *petit maitre* audacity, which no language, but the modern French, can possibly decribe!', while Fitzgerald was described as 'a little effeminate being . . . dressed *a la Maracroni*'.[32] The most recent accounts of the Vauxhall Affray (or should that be *Vauxhall Affray*?) have explored the gendered and political values at stake here, with the affray dramatizing the conflict between normative and stigmatized male sexualities in a space that was exemplary of the unregulated social interactions made possible by urban expansion and consumerism.[33] But the Vauxhall Affray was also a more specific social and national conflict, bringing dominant and marginalized British and colonial identities into contest.

Bate was the son of a Church of England rector, who had spent some time at Oxford and perhaps the army. By 1773 the younger Bate had developed his literary aspirations with his editorship of the *Morning Post*, a leading daily in the pay of the ministry. Subsequently active as an art critic (giving sustained support to Thomas Gainsborough) and the founder of the *Morning Herald*, he tried to develop as a dramatist, though, as a biographer of 1782 put it, he remained 'more celebrated for conducting a ministerial News-paper than for his dramatic writings, and still more for his duels than either' (FIG. 59).[34] Mrs Hartley was born in Somerset, and was celebrated for her auburn-haired beauty. She had debuted on the London stage in 1771 and in late 1772 had taken the title role in a production of Nicholas Rowe's *Jane Shore* at Covent Garden, and was to be painted in the guise of this tragic heroine of English nationalism by Joshua Reynolds in 1773.[35] The producer of that play, George Colman, was an English essayist, play-

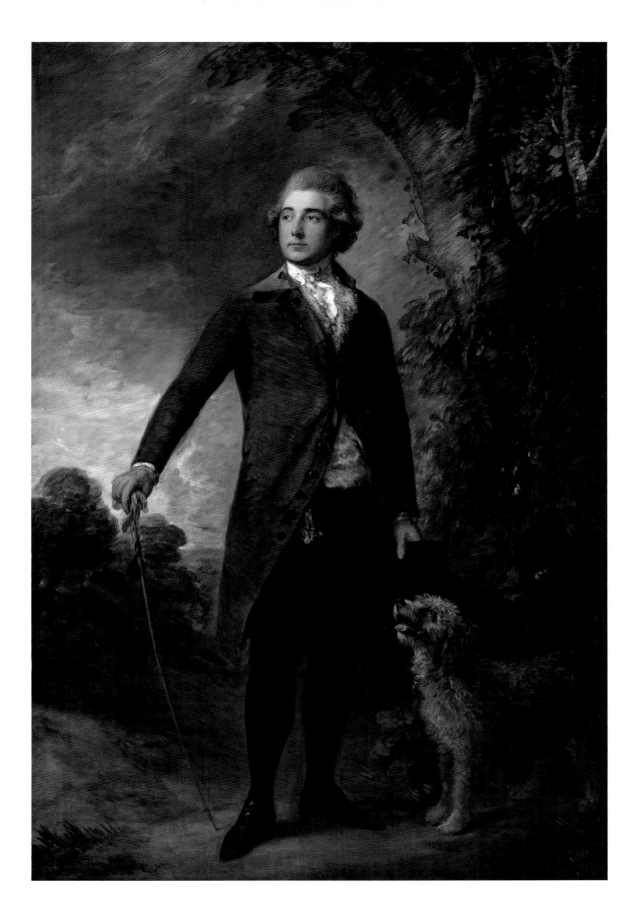

wright and theatrical producer, at the heart of London's stridently patriotic English cultural community, focused on the 'Sublime Society of Beefsteaks'. The casual racism of this group found vivid expression in Colman's literary output, from the virulent anti-Semitism of one of his essay contributions to the *Connoisseur* (1754) to the caricatured Irishman in the *Oxonian in Town* (1767).[36] The 'Dawes' mentioned in the *Vauxhall Affray* was described as a law student, so is perhaps Manasseh Dawes, later a barrister at Inner Temple.[37] The Yorkshire-born Edward Tatham, who may also have been of the company, had recently graduated from Oxford, where he was later rector of Lincoln College.

By contrast, Thomas Lyttelton was the only son of Lord Lyttelton (whom he was to succeed in August 1773) and had dabbled in politics, but was described by Horace Walpole as 'uncommonly odious and profligate, and his life a grievous course of mortification to his father'.[38] He was further, perhaps, tainted by his association with colonial wealth, marrying, in 1772, the widow of a former governor of Calcutta. William Crofts was a cornet in the Sixteenth (Burgoyne's) Light Dragoons.[39] The rest of Bate's opponents are identifiably Irish in origin or affiliation. Fitzgerald was born into the Anglo-Irish gentry.[40] Although sent to Eton for his schooling, he had fallen into loose company in Paris and Dublin and had already sustained serious injuries in reckless duels. The 'O'Bourne' was identified elsewhere as Matthias O'Byrne, a Catholic Irishman who had been sent by his family to Germany to acquire the education that his religion debarred him at home.[41] While he was abroad, the family had fallen on hard times, and he remained on the continent, joining, like many other Irishmen who sought an army career, the German army (which allowed Catholics to hold the commissions they were banned from in the British forces).[42] The pseudonymous 'Captain Miles' who stood in for Captain Crofts was, with his very name, to be identified as a 'Milesian' (a descendant of the legendary Spanish king Milesius who was meant to have conquered Ireland in ancient times, founding the Irish as a people).[43]

Irish stereotypes were particularly in evidence when it came to the minor players in the affray. A correspondent to the *Morning Post* who described himself as 'A Milesian' claimed that a gang consisting of '*Paddy Murphy, Teddy Bughlin,* and *Murd. O'Shochlin*' had been raised to mug Bate in the street.[44] Elsewhere Bate's opponents were referred to as a 'savage', 'an *Irish renegado*' and 'the *Shilelah* alliance', while Fitzgerald in his deceitfulness and cowardice was said to prove himself 'a native of Hibernia!' According to 'A Brother Briton' in the *Morning Post*, the 'Macaronies' had hired a Nugent, 'an Irishman now in prison over the water', to attack Bate.[45] An apparent exception was 'Mr Storer', one of Fitzgerald's '*worthy armed* friends', but he was nonetheless characterized as a marginal, colonial figure, 'a certain lank, lean, loose, *self-created* figure . . . who was transplanted some years since from the West Indies to an apprenticeship at *Bristol*, from whence he removed himself to a merchant's counting-house in this city, with a view to become a *vendor of rum and sugar*.'[46]

Thus contemporary accounts play up this confrontation between Irish and English, between established Church and the sexual, religious and political forms of dissidence compounded in the figures of Lyttelton, O'Byrne, Fitzgerald and their cohorts. The triumphalist final lines of the poetic 'Macaroniad' from the *Whitehall Evening Post* cast Bate as a Christian hero wielding his club (referred to by another writer as his '*English Oak*') in defence of the Anglican Church:

> As *Sampson* seiz'd the prison-gate,
> In spite and rancour, Parson Bate
> So seiz'd the doughty culprits round,
> And sprawling laid them on the ground:
> The paltry, petty heroes lay,
> With eyes, like puppies, seal'd from day;

> Here courage left them in the lurch,
> And huzzas echo'd for the Church.[47]

Bate's scene of conflict between the upstanding and the outrageous can be recast as a face-off between a member of the entrenched Anglo-Saxon elite who claimed to stand for normative masculinity and 'colonial' figures whose masculinities were stigmatized as deviant or dangerous. The sexuality of the Irish in London formed a particular preoccupation of eighteenth-century satire and the stage. In the most immediate and graphic way, the intrusion of the colonized 'other' into metropolitan life was demonstrated by the purported sexual audacity and pugnacious character of so many Irish adventurers, in the social realm as well as in the world of literature and the stage.[48] Hence the issue is not sexual orientation so much as visibility and visuality; the dissident Macaronis of the *Vauxhall Affray* are a problem because they defy classification according to the disciplining norms of Anglo-Britishness and yet insist on being seen and on looking. In this they give representation to those imperial subjects who dared to walk the streets of London, who dared to enter Vauxhall Gardens on equal terms to an Anglican parson, who dared to look at an Englishwoman, to dress fashionably and to claim any sense of self-esteem.

The appeal of West's *Death of General Wolfe* in this context should be richly evident. Here was a great Briton who had died valorously establishing an empire, in a role of personal leadership that exposed him to immediate danger from the enemy, who was a hero even to imperial subjects (the Highlander, the ranger, the American Indian), who combined valour and personal grace, and who had risen to high status by his virtuous action alone. While the constituent peoples of the empire were getting into ugly scuffles in the metropolis, in West's paintings they stood shoulder to shoulder, moved by the fate of a common hero.

Still, by incorporating the refined qualities of a genteel masculinity that would make Wolfe available as the object of sympathy, the image needed some degree of policing. Writing to the fashionable *Town and Country Magazine*, a correspondent identifying himself as Amico recorded how, moved by the 'melancholy satisfaction' of seeing West's picture at the Academy, he fell into conversation with a gentleman who claimed to know the hero personally, who told him the following anecdote:

> General Wolfe, it seems, had very fine hair. Observing one day several young officers more attentive to the out-sides of their heads than he imagined they ought to be, in the *field*, and wishing to give the strongest discouragement to their *effeminate manoeuvres*, took a pair of scissors out of his pocket, and cut off those locks which had been frequently admired by both sexes. When he had performed his *manly* operation, he gave his scissors to the young gentleman who seemed to have the greatest affection for his hair. 'I dare say, Sir, you will be polite enough to follow *my* example.' He did so, and his *well curled* companions immediately *cropped* themselves.[49]

Short hair was a conventional signifier of Roman stoic virtue, while the Macaronis' long hair was one of their most obvious traits. The story thus reaffirms classical gender values against the luxuries and excesses characteristic of modernized manhood.[50] In reducing the exemplary nature of Wolfe's virtue to a question of hairdressing, the anecdote carries the domestication of the hero to an absurd degree. Yet it was a particularly pointed issue at this time. West's Wolfe entered the scene at precisely the point that the issues of heroism and masculine exemplarity, and the intersection of these with empire and the institutions of soldiering, were evident on the popular critical agenda as never before, over matters of hair and dress more than anything else.

More seriously, West's image of Wolfe was given a defensive narrative context by its owners. The exhibited original was purchased from West by Richard, Lord Grosvenor (1731–1802). He

went on to commission a series of historical canvases from West to accompany the *Wolfe*: *The Battle of the Boyne* (Duke of Westminster), possibly commissioned as early as 1771 and completed by 1778; *The Battle of La Hogue* (National Gallery of Art, Washington), begun 1775 and completed by 1780; and *Oliver Cromwell Dissolving the Long Parliament* (Manchester Art Museum, New Jersey) and *General Monk Receiving Charles II on the Beach at Dover* (Milwaukee Art Centre), both finished by 1782.[51] A copy of the *Wolfe* commissioned by George III was joined by commissioned works showing *The Death of Chevalier Bayard* (1772, Royal Collection) and *The Death of Epaminondas* (1773, Royal Collection).[52] In each case, West's painting of the modern hero was put into historical context. In the case of Grosvenor, the context was Protestant national history, in which Wolfe appears as the latest martyr and Canada the latest Protestant colony, following on from Ireland. In the Royal Collection, it was put in relation to models of self-sacrificing heroes from ancient history and from the medieval past.

What each of these contexts register is the desire to manage the meanings of the death of Wolfe and a retreat from the more radical potential that this modernization of the hero might have in extending the cultural franchise and remodelling the physical and behavioural ideals of British men. Grosvenor and the king each wanted to have their cake, and eat it: Wolfe was at once a specifically modern kind of hero, visibly of the present age and representing manners and morals belonging only to the present time that did not need the prop of historical reference. But he was also situated by these patrons in relation to historical and moral exemplars and thus related into a supposedly universal set of political and gender values. West's *Wolfe* proposed that civilization and empire could still travel hand in hand and that exemplary heroes could be made meaningful for the modern public. Incorporated into historical, narrative contexts in the setting of the elite household, this icon of modernized masculinity could further render its symbolic capital in a more exclusive setting.

West's *Death of Wolfe* may, in its initial, exhibited context, represent precisely that invitation to 'celebrate the death of heroism itself' and heroism's replacement with specifically bourgeois 'ideals of a sympathetic humanity' so incisively described by David Solkin.[53] But the story of the hero in British art was far from over. As the next chapters will explore, such attempts at the management of the image of the hero were to prove ever more difficult. As the British Empire was jeopardized and as the politics of artistic production became aggravated, the tensions between gentility and manliness, exemplarity and historicism, were played out as never before. The compromises represented by West's *Death of General Wolfe* not only could, but it seemed in some quarters also had to, be rejected if heroic art was to survive as a means of asserting artistic authority in an era of effeminate public taste and state impotence. And neither the king nor his academy were able fully to control these developments.

5

OUTLAW MASCULINITY

JOHN HAMILTON MORTIMER IN THE 1770S

One year after the display of the West's *Death of General Wolfe* at the Royal Academy in 1771, and as anxieties about the course of modern manhood reached new heights with the Macaroni phenomenon, visitors to the exhibition of the Society of Artists were offered a quite radically different image of the soldier: John Hamilton Mortimer's *Belisarius* (FIG. 60). This was catalogued at first as simply 'a large historical picture' and then with the subject stated and a reference to the French author Jean-François Marmontel (1723–99). The painting offers an image of an elderly but rugged hero in a composition very obviously indebted to Bolognese art and resonant, in the choice of subject alone, of Salvator Rosa's well-known and widely admired depiction of the same theme (FIG. 61; Raynham Hall, Norfolk). Belisarius was 'a celebrated general, who, in the degenerate age of Justinian, emperor of Constantinople, renewed all the glorious victories, battles, and triumphs which had rendered the first Romans so distinguished in the time of their republic. He died after a life of military glory, and cruel experience of royal ingratitude, AD 555.'[1] His historically documented mistreatment by the emperor was amplified by apocryphal accounts of his blindness and his being forced to beg for charity.

As a symbol of the regrettable consequence of state corruption, Belisarius could hardly be beaten, and this potential was distilled by Marmontel in his short novel *Belisarius* (1767), which enjoyed enormous vogue in Europe and in the English-speaking world. An English translation published in London in 1767 went through three editions in that year alone, with republications in 1768 and 1773, while a rival translation was published in London in 1768 and further editions were issued in Edinburgh, Dublin and Philadelphia. In 1770, the Amsterdam literary correspondent for the *Gentleman's Magazine* could note wryly that:

> Three editions of M. Marmontel's Belisarius have been published here at almost the same time. This admirable work, one of the best that has appeared this century, is so well known, that the mention of it is sufficient. The Author has here displayed all the charms of his genius, and all the generosity of his mind. To complete his glory, nothing was wanting but persecutions; and persecutions he has had.[2]

The 'persecutions' in question came from the French state. Marmontel's advocacy of religious tolerance had provoked censure from the Sorbonne, followed by a paper war involving Voltaire. In the English context, Marmontel's *Belisarius* provided a catalyst for a political opposition that

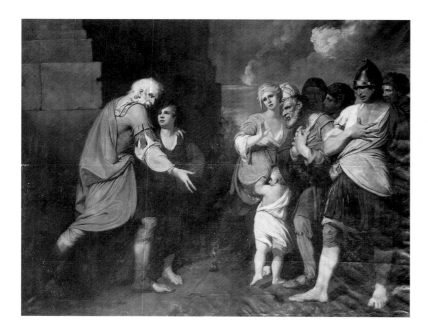

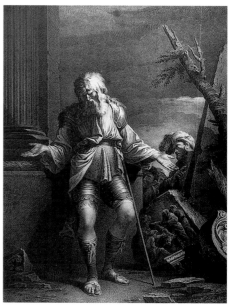

60 (left)
John Hamilton
Mortimer,
Belisarius,
exhibited 1772. Oil
on canvas, 229.2 ×
289.5 cm. Private
collection.

61 (right)
Robert Strange
after Salvator Rosa,
Belisarius, undated.
Engraving, 50.5 ×
35 cm. Witt Print
Collection,
Courtauld Institute
of Art, London

had already landed on the ancient general as a means of representing their discontents. The Roman had featured in Edward Thompson's *The Soldier* (1764), a poetic attack on the current administration, voiced by a hard-done-by old British veteran:

> But here, ye Gods! I ask to stand alone,
> And if I cannot starve without one groan,
> Retain my honour 'midst such pressing woes,
> My courage quit me 'mongst my Country's foes,
> Yes – let me starve amongst those *friends* I've fed,
> Or, like a Belisarius, beg my bread.[3]

In the heightened political circumstances of the years after the Stamp Act crisis of 1765, politics appeared to enter a phase of cynicism and self-interest. Even the return to the fray of the 'patriot minister', William Pitt, could not turn around the tide of criticism, and in the event only aggravated the situation. Now pursuing policies that lost him the support even of his old stalwarts in the City, his ministry seemed to perpetuate rather than reform the creeping corruption of national life. As one commentator put it in that year: 'There is no partie, everything is blended together, no connections, for they tye and untye every day as convenience and advantage offer. Honor and faith and friendship may be scratched out of the Dictionary, for they are all words without meanings.'[4]

In this context, Marmontel's novel took on the character of social criticism, no less than John Brown's *Estimate* of a decade earlier, as the translator of the 1767 edition stated explicitly:

> The reader is desired not to consider this little volume as a mere romance, or a modern novel. The vehicle of fiction, is, indeed, made use of, but it is in fact *an estimate of the manners and principles of the times*. It is more than that: we have here a review of an interesting period of history, in which the causes that precipitated the downfall of a great empire are unfolded in a masterly manner, and with such a spirit of political reflection, that I will venture to say

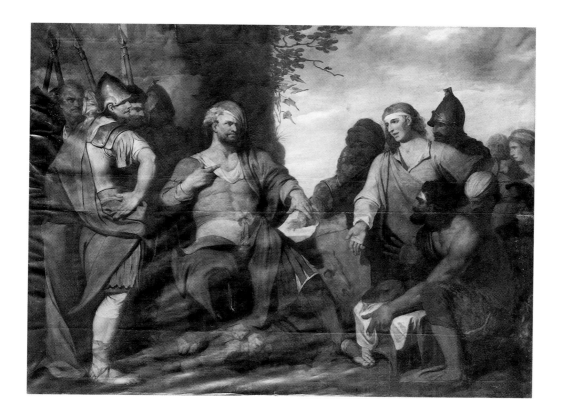

... that the gentlemen, who take upon them the care of the nation in our daily papers, may for a while lay down their pens. Faction is here detected, and the governors and governed may find in this piece very seasonable admonitions. It is a work for kings, for ministers, and for the people in general.[5]

Thus Mortimer's *Belisarius* might serve as a successor to his *St Paul Preaching to the Ancient Druids in Britain*, in deploying a reformist visual language to represent a subject that had oppositional political resonance. The presentation of classical virtue and heroic discontent had only a few years earlier, with Nathaniel Dance's *Timon of Athens* and Benjamin West's *Departure of Regulus from Rome*, been readily accommodated to the project of royal reassertion. Mortimer's picture provides a more strident and divisive vision of masculinity predicated on a figure less readily accommodated to the sort of generalized and consensual notions of virtue that had currency in polite society.

Mortimer's *Belisarius* was destined to become part of a scheme of decoration for the first-floor saloon of Radburne (or Radbourne) Hall in Derbyshire, the house of Edward Sacheverell Pole (1718–80).[6] The Poles were a long-established Derbyshire family, who had dominated the life of the tiny community of Radbourne since medieval times. Pole's father had been an army man, and after being educated at Repton, Harrow and Cambridge, Edward Sacheverell Pole joined the army himself, serving in the Twenty-third Foot (the Royal Welsh Fusiliers) in the 1740s. He became a lieutenant colonel in the regiment in 1756 and was wounded severely at Minden in north-western Germany in August 1759, one of the most vast and bloody battles of the Seven Years' War. He inherited Radburne in 1765 from his uncle, German Pole, certainly a

62 John Hamilton Mortimer, *Caius Marius on the Ruins of Carthage*, exhibited 1774. Oil on canvas, 225 × 294 cm. Private collection.

Tory and perhaps a Jacobite who was said to have played host to Charles Stuart during the Jacobite rising of 1745.[7] The painting was to form part of a scheme comprising a further narrative painting by Mortimer of another embittered hero and soldier, *Caius Marius* (FIG. 62), portraits of Edward Sacheverell Pole in armour and of his wife and young son in classicizing costume painted by Joseph Wright of Derby (1734–97) and a set of overdoors (four by Wright, one by Mortimer).[8]

Mortimer's two large paintings for the scheme were closely linked thematically. Like Belisarius, Caius Marius was a disgruntled and neglected veteran. When Mortimer's picture was exhibited with the Society of Artists in 1774, the catalogue entry was accompanied by a quotation from Thomas Otway's play *The History and Fall of Caius Marius*. First produced on the London stage in the 1679–80 season, the play was frequently performed during the next four decades, effectively displacing from the London stage its source, Shakespeare's *Romeo and Juliet*. It had not, though, been performed since 1720, the Shakespearean original having come back into favour. The text had been out of print as a separate publication since 1735 but was included in various editions of Otway's collected *Works*, the most recent dating from 1768. The play deals with the consequences of civil conflict in republican Rome, with the plebeian Caius Marius leading one group, the patrician Metellus the other. Mortimer refers to the scene where Marius in exile rejects the request for his return, damning the issuer of this order, Sextilius ('My menial Servant once, and wip'd these Shoes'):

> Go to *Sextilius*, tell him thou hast seen
> Poor *Caius Marius* banished from his Country,
> Sitting in Sorrow on the naked Earth,
> Amidst an ample Fortune once his own,
> Where now he cannot claim a Turf to sleep on.[9]

The scene exemplifies the mixture of rugged republican pride and queasy self-pity that permits Otway's character to embody effectively the unstable politics of its author and the tangled factionalism of the era. Otway (1652–85) was a disgruntled former soldier and the play can be orientated with Tory loyalism in its critique of political ambition run mad in the absence of royalty, or interpreted as a more generally applicable cautionary tale about the relationship between the family and the state. Otway had been part of the force sent briefly by Charles II to Flanders in 1677 as part of the threatened English effort to take direct action against what was perceived as French expansionism. As France remained neutral, with a diplomatic settlement between Charles II and Louis XIV (the former effectively selling out the Netherlands), the expeditionary force became redundant. Otway's play was written on his return to England with the other English troops in 1679, and his epilogue offers a plea that chimes with the theme of *Belisarius*: 'This Play came forth, in Hopes his Friends would come / To help a poor disbanded Soldier home.'

The subject of Caius Marius had been recently recommended by Robert Baker in his review of the 1771 Royal Academy exhibition. Baker, who made a point of highlighting his own humble origins and isolation from the art establishment, was primarily a writer on language and in this capacity a pioneer of standard English and a decided snob who announced his faith in the legitimacy of the king and aristocracy as keepers of a representative national culture. His forays into art criticism continued in this reforming and aspirational spirit. In his review of the 1771 exhibition, he follows a descent from what he takes to be the exemplary paintings of West through Joshua Reynolds' poorer efforts and Thomas Gainsborough's portraiture to settle on Angelica Kauffman's *Edgar and Elfrida* (FIG. 63; original at Saltram House, Devon) and *Ermina Finding Tancred* (lost):

I don't greatly admire this lady's choice of subjects. Points of history that are little known (as are those of the English history before the conquest) and events related in romances (which we always look upon as fiction, how well soever they are represented) seldom interest the spectator much.

I have often wondered that the following circumstance in the Roman history, a very grave and awful one, should not have been treated in painting (for I dont remember to have seen it) and particularly that it seems to have escaped Poussin, to whose character of genius it seems to be perfectly suited.

Caius Marius, after having been long at the head of the Roman common-wealth, and been six times consul, was forced to flee before the more fortunate Sylla. Having escaped many and most imminent dangers, he landed in Africa, on the very spot where lately had stood the city of Carthage, the rival of Rome. But he had scarcely set foot on shore, when an officer arrived from Sextilius the pretor, commanding his immediate departure: for that otherwise the decree of the senate must be put in execution, and he be declared an enemy of the Romans. Hereat he was for some time dumb with grief and amazement: looking sternly on the mes-senger, who required his answer. At length, with a deep sigh, *go tell the pretor*, said he, *that thou hast seen the exiled Marius sitting on the ruins of Carthage*: by this expressive image placing, says Plutarch, in a strong light the fortune of that celebrated city, and his own, as terrible examples of the instability of human affairs.[10]

The Swiss painter Angelica Kauffman (1741–1807) was particularly associated with a kind of refined, even androgynous image of the body, sentimental and polished and suited to, not to say expressive of, ideals of polite refinement.[11] In its scale and the heroic proportions of its figures

63 William Wynn Ryland with William Sharp after Angelica Kauffman, *The Interview between Edgar and Elfrida after her Marriage with Ethelwold*, published by Mary Ryland, 1 February 1786. Stipple engraving, 49 × 62.2 cm. The British Museum, London.

– particularly the Herculean torso of Caius Marius himself, which contrasts so starkly with the slim figures characteristic of Kauffman's work – as well as its weighty theme, Mortimer's picture can be taken as a very deliberate attempt at pictorial reform, the terms of which appear still to have been shared even with a snooty monarchist like Baker.

The grizzled veterans represented in Mortimer's two large pictures may well have had a quite particular significance for their patron, but quite what his grievance was is obscure, unless the old stories about the Pole family's Jacobite sympathies are to be trusted. But if the scheme reflected some unique requirement of the aged veteran Pole, it also fitted in with the oppositional critique of contemporary masculinity that had wider currency. Cuthbert Shaw's poem *Corruption* (1768) provides some key interpretative coordinates. Railing against the 'Corruption raging like a dire disease' through Britain, Shaw evokes the character of a veteran of the battle of Minden (where Pole had in reality been injured) who under the present administration suffers every kind of personal woe:

> The sun-burnt vet'ran from ill fated wars
> Victorious comes – with poverty and fears.
> Flies to his long forsaken home, to find
> The dear, dear pledges he had left behind:
> But ah! his wife, all grace, and beauty fled,
> Scarce owns the once-lov'd partner of her bed,
> Th' affrighted children stare, and shift their ground,
> Nor read their sire through many a glorious wound:
> The big tear starting, as he tries to tell
> How his lov'd friends, and fellow-soldiers fell;
> On Minden's plains, how smoke obscur'd the day,
> How heaps on heaps, in slaughter'd thousands lay.[12]

The veteran recounts the horrors of the battlefield, but:

> Condemn'd like Oglethorpe, to prove forlorn,
> Each toil repaid with indigence and scorn!
> Now left with years and injuries t'engage,
> The Belisarius of a thankless age![13]

The 'Oglethorpe' referred to was the soldier and philanthropist James Edward Oglethorpe (1696–1785) who in 1740–42 had raised his own army to defend Georgia for the British against Spain, but who was never recompensed for his endeavours. Pursuing a controversial political career in England, he suffered a final electoral defeat in 1768 and disappeared from public life. Living in London, Oglethorpe became the living model of the disgruntled patriot and Tory malcontent, damning modern luxury and corruption and reluctantly finding consolation in a cultured retirement funded by his wife.[14]

Ignored by the state, the only relief Shaw's hero can find is similarly in the private comforts of the family home:

> Thus the brave chief – his wife with tear-swoln eyes
> Hangs on his hand, and answers with her sighs;
> The children, list'ning to the mournful tale,
> Till Nature's feeling o'er their fears prevail,
> Wishful draw near, and bolder by degrees,
> Twine round his neck, and gambol on his knees.[15]

The Radburne scheme might be interpreted in such terms: in Wright's portraits, Edward Sacheverell is the rugged veteran (FIG. 64) and Mrs Pole the exemplary wife and mother (FIG. 65). The overdoors bear interpretation as exemplifying the simple but transient pleasures of family life, and Mortimer's history paintings the ingratitude of ignorant state powers towards the noble veteran.[16]

The Radburne pictures were almost unique in being large-scale paintings on heroic themes destined for the contemplation of a man of genteel status. Fashionable taste in interior design leant towards the decorative classicism of Robert Adam and William Chambers, where finely detailed decorative borders and small, regular compartments precluded large-scale figurative elements. As a commentator noted in the *Moring Chronicle* of 8 May 1773, 'The rooms in this country are seldom built lofty enough to admit the large whole lengths.' By contrast, the design of the saloon at Radburne Hall preserved two large panelled spaces for classical subject paintings, and incorporated these with full-size portraits and overdoors in a coherent iconographic scheme. They represent one of the very few times that the Grand Manner coincided with the interests of people able to afford and willing to make the necessary financial and temporal investment to realize this kind of scheme.

Having experienced long years of neglect after his triumph with *St Paul Preaching to the Ancient Druids in Britain*, Mortimer was not, after the works for Radburne Hall, to be employed again in this line. He was to be plagued by financial problems, aggravated, it seems, by a dissolute lifestyle (at least up until his marriage in 1775). With his exact contemporary, James Barry, Mortimer suffered those personal distresses that were a consequence of pursuing the Grand

64 (left)
Joseph Wright of Derby, portrait of Colonel Edward Sacheverell Pole, dated 1772. Oil on canvas, 91.4 × 76.2 cm. Private collection.

65 (right)
Joseph Wright of Derby, portrait of Elizabeth Sacheverell Pole and her son, Sacheverell, dated 1771. Oil on canvas, 233 × 173.3 cm. Private collection.

66 John Hamilton
Mortimer,
caricature group,
c.1765–70. Oil on
canvas, 83.9 ×
106.7 cm. Yale
Center for British
Art, Paul Mellon
Collection.

Manner without adequate financial backing. Still, he was never as spectacularly confrontational as the Irish painter. The sustained support of Dr Benjamin Bates (1736–1828) from the mid-1770s secured him some moderate patronage from the Buckinghamshire gentry, primarily for portraits, and the artist sustained long-term and professionally beneficent social affiliations.[17] Mortimer took a leading role in the Society of Artists and was a boon companion and erstwhile artistic collaborator of Wright of Derby, Thomas Jones (1742–1803) and a host of others. Mortimer figured himself as a diminutive observer on the left of a crowded caricature group, probably representing the Howdalian Society, a London drinking club for writers and artists and actors that met at the Feather's Tavern (FIG. 66).[18] It is hard to imagine Barry doing the same.

Yet more than any other artist, Mortimer was to make the theme of social isolation a central preoccupation of his art. *Belisarius* and *Caius Marius* each represent a hero cast out of society as the subject for monumental art. Mortimer was to continue this theme in separate drawings related to these paintings, and in further designs of the biblical outcast Nebuchadnezzar (exhibited 1772; Fitzwilliam Museum, Cambridge). Don Quixote (lost; engraved by Robert Blyth 1784), and two portraits of artists from history, the academic painter and art writer Gerard de Lairesse (c.1778; private collection) in his blind old age among ruins, and Salvator Rosa wearing armour and seated, isolated, in a rocky landscape (FIG. 67).[19] This last is most revealing of all, as Mortimer was identified in his own lifetime – indeed, even in the exhibition pamphlet *A Candid Review* (1772), which he contributed to personally – as the 'English Salvator', and that

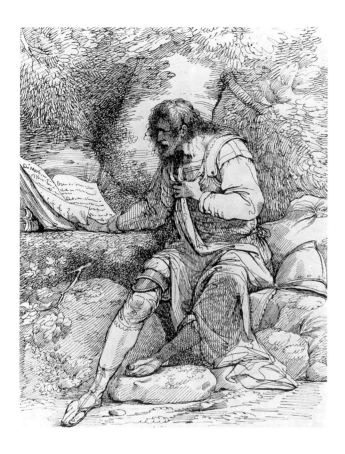

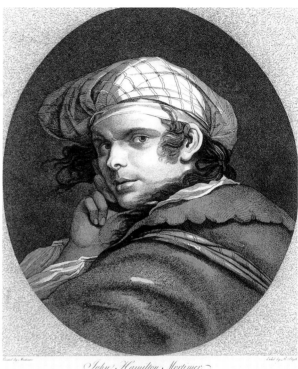

John Hamilton Mortimer,
Historical Painter.

From an original Picture painted by Himself in the possession of Richard Strahld Esq: to whom this plate,
is humbly inscribed by His much obliged and most obedient Servant Robert Blyth.

artist, according to legend, had lived as a bandit in the wilderness. Mortimer's self-portrait pro-pounds such identification, showing him with wind-blown hair escaping from under an exotic-looking turban, gazing outwards with a passionate glare (FIG. 68). The original painting prompted Allan Cunningham (1784–1842) to write that Mortimer 'was fond of the wild, the savage, and the wonderful; and it was his pleasure in the fine picture before us to imagine himself a chief of banditti'.[20]

This identification stems from Mortimer's numerous compositions of vaguely historic-looking criminals, conspirators and irregular soldiers at rest, play, preparing for and engaged in combat. Designated as *banditti*, they were based in part on Rosa's celebrated *Figurine* – a series of etch-ings of soldiers and genre figures, published from 1656 and republished and copied throughout the eighteenth century (FIGS 69 AND 70). About thirty drawings described as including 'pirates' 'soldiers' or *banditti* were exhibited by Mortimer from after 1772, with a number of such sub-jects issued as prints in his lifetime and some twenty more by his widow in the decade after his death, suggesting that there was a meaningful market for such designs.[21] For critics and com-mentators, these designs captured the essence of Mortimer's artistry. They represent a complex departure from the conventions of narrative art and an exploration of the thrills to be derived from the imagining of masculinities beyond the norms of society – a striking alternative to the refined masculine hero being presented contemporaneously by West in his *Wolfe*, and a chas-tening counter-image to the degenerate masculinities thought to prevail in social life. Where

67 (left)
John Hamilton
Mortimer, *Salvator*
Rosa, dated 1776.
Pen and ink on
paper, 28 × 21 cm.
Location unknown;
formerly in the
collection of Sir
John and Lady
Witt.

68 (right)
John Hamilton
Mortimer, self-
portrait. Etching,
36.3 × 29.7 cm.
Published 19
September 1782 by
Robert Blyth.

Belisarius and *Caius Marius* represented alienated masculine figures anchored in specific literary and historical references, the *banditti* are outsiders in the very fullest sense, estranged from society according to the internal narrative of these designs, estranged as figures from literary tradition, geography and history. Such figures exhibit the specifically pictorial version of the 'outlaw masculinity', which, as Michael Mangan has explored with reference to the eighteenth-century stage, offers 'a kind of masculine energy which undermines the social consensus that was being created in the bourgeois public sphere, and which teases out the developing double standard in Hanoverian ideology, and particularly in Hanoverian gender construction'.[22]

Salvator's *Figurine* series was very well known and much admired in eighteenth-century Britain and was central to Rosa's reputation as an artist whose imagination was libertarian and unique.[23] The prevalent idea among historians and critics was that Rosa implemented a distinct brand of pictorialization that broke with the shackles of emulation and imitation. So Matthew Pilkington in his *Dictionary of Painters* (1770) summarized: 'The style in which he painted, was formed by his own elevated genius, nor was he indebted to any preceding artist, for any of his ideas, or for any traces of the manner which he always followed.'[24] This view was elaborated by Reynolds, for whom Rosa's works were paradigmatic of that individuated manner that fell short of the Great Style but had powerful emotional and aesthetic effects: 'though void of all grace, elegance, and simplicity, though it has nothing of that sort of elevation and dignity which belongs to the grand style, yet, has that sort of dignity that belongs to savage and uncultivated nature'.[25] Thus this deviation from the norm, or excess of the normative, was given a particular function. It was a risk-taking strategy that could now be described as the Sublime, which might, as with Reynolds, support a tempered idea of the Grand Manner as much as it might also undermine and exceed it. With the revaluation of artistic expertise and the gnawing doubts about the validity of a more moderated classical style that were current in press accounts of contemporary art, the potential for such a form of deviant grandeur to gain new significance is clear.

While the pictorial sources of the *banditti* are easily enough revealed, pinning down the broader associations of such figures is more difficult. The etymology of *banditti* remains uncertain. Rosa himself did not use it and in truth not many of his paintings, and only a portion of the *Figurine* even, represent the soldier types associated with the term. It presumably derives from the Italian *bandito* (outlaw) and came into English usage in the late sixteenth century, often linked with the similarly Italianate *renegadoe*, which was more specifically used in connection with Europeans who were taken prisoner by Muslims and converted to their faith and culture. While the term was used in a variety of contemporary contexts in the eighteenth century, it was associated above all with the criminals of Italy. Sicily was most famously a complete bandit culture, a perverse mirror image of civil society. In the early 1770s several published reports described how Sicily was in a state of utter corruption, where the 'police' employed as soldiers and guards were violent thugs: 'Justice of every Kind is relaxed, the most horrid Crimes are perpetrated with Impunity; the very Government seems to authorise them, while it keeps a Banditti in Pay, who are to Day employed to protect the Traveller, whom to Morrow perhaps they may strip and murther.'[26] A widely circulated account of 1773 claimed that Sicily was ruled over by a 'police' made up of 'the most daring, and most hardened villains, perhaps, that are to be met with upon earth, who, in any other country, would have been broken upon the wheel, or hung in chains; but are here publicly protected, and universally feared and respected.'[27] Yet they were seen to retain heroic qualities:

> In some circumstances these banditti are the most respectable people on the island; and have by much the highest, and most romantic notions of what they call their point of honour. That,

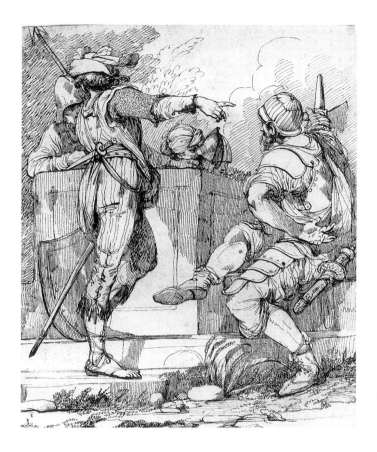

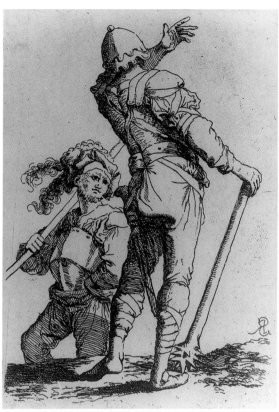

however criminal they may be with regard to society in general; yet, with respect to one another, and to every person to whom they have once possessed it, they have ever maintained the most unbroken fidelity . . . their barbarous ferocity, and the horrid mixture of stubborn vice and virtue (if I may call it by that name) that seems to direct their actions.

Obviously, the real experience of criminals who might be designated as *banditti*, whether in Italy or nearer to home, was hardly to be enjoyed on any level. With the introduction of a certain distance (the characteristic perspective of the Sublime), the more ambivalent status of such romantic criminals became apparent.

If the idea of the *banditti* can be located geographically, the characterization of such figures by Mortimer, following Rosa, resists such localization in time or place. The costumes of Rosa's and Mortimer's figures combine and juxtapose elements of classical armour, Renaissance parade equipment and invented elements.[28] As much as these figures may be Italian they might also be Arabian, and as much Asian as European. Such eastern elements as turbans and vaguely oriental-looking arms and armour suggestively extend the associations of Mortimer's *banditti* beyond Italy to the established genre of the 'Oriental Tale', with its narratives of adventure in Arabian and Far Eastern contexts.[29] The 'Orient' thus conceived provided the most immediate and convenient analogy for representing the excesses of modern metropolitan life, whether negatively, as in social criticism and visual satire, or in the naïve enthusiasm of Tobias Smollett's character Lydia Melford, whose first encounter with London in his novel *Humphrey Clinker* (1771)

69 (left)
John Hamilton
Mortimer, *A
Captain of Banditti
Sending out a
Party*, c.1775–78.
Pen and ink on
paper, 28.8 × 21.3
cm. The British
Museum, London.

70 (right)
Salvator Rosa, plate
from the *Figurine*,
c.1656. Etching
with drypoint, 14 ×
9.3 cm. The British
Museum, London.

prompts her to reflect that the city represents 'all that you read of wealth and grandeur, in the Arabian Night's Entertainment, and the Persian Tales'.[30] The east of the oriental tale was a territory of unbridled imagination, excess, a guilty pleasure for polite readers whose tempers and tastes were meant to be more regulated.

There was a further, martial dimension of the oriental tale that is relevant here. The interpenetration of western and Islamic cultures in the Middle Ages and Renaissance was an acknowledged phenomenon, elaborated into a literary theory by William Warburton (1698–1779), who claimed crucial eastern influences, via the Spanish romances, on early European literature.[31] Much debated and ultimately dismissed, such arguments ensured that Muslim heroes found their place within the search that was so prevalent in the 1760s and 1770s for novel and authentic heroic forms outside degenerated modernist literatures. This was made explicit in the poetic 'The Moor's Equipment' translated and prepared for publication as part of Thomas Percy's proposed *Ancient Songs Chiefly on Moorish Subjects* in 1775 (FIG. 71):

> Saddle me my dappled Courser,
> Saddle him I won in fight.
> Bring to me my Moorish target;
> Bring to me my hauberk bright.
>
> Tipt with steel of highest temper
> Give to me my trusty spear:
> Give to me my cask of iron,
> Deadly dints on it appear.
>
> With it bring my purple turban
> Richly deck'd with feathers gay;
> Proudly nods the chequer'd plumage,
> White and yellow, green and gray.[32]

With its fetishistic investment in the equipage of the Moorish corsair, the poem chimes with Mortimer's graphic preoccupations. There is in Mortimer's drawings a recurring theme of arming and armouring, with men setting out or coming back from conflict, horses loaded, treasures spilled and appetites indulged (FIG. 72). His drawings express an insistent, defining interest in communicating the character of the many and assorted elements of equipage: his characteristically complex and varied drawing style conveys in dots and dashes and looping contours the details of stitching, the joining and overlapping of plates of armour, the conjunction of metal and leather and silk or fur with flesh and human hair.

The use of such materials was a conventional test of graphic virtuosity, in printmaking especially. Notably, Mortimer took his notational systems at least in part from the model of engraving, where a combination of laboriousness and ingenuity was required to convey texture and even colour through monochrome marks alone. But this obsession assumes an added significance in the context of Mortimer's historically and geographically truant criminal figures. The *banditti* are shown as if they had gathered their arms and armour from wildly different, apparently random sources – places they had been and fought in person. They do not represent those deferred forms of heroism favoured by the modern state, where the bourgeoisie and gentry at home could profit from conflicts fought by their social inferiors on the other side of the world. The *banditti* forge no empires that must inevitably fall but live within the remains of some older, greater culture in roaming, loosely organized tribal groups or gangs. Among them, capital is always embodied: it is gold, fur, jewels, female flesh, and so always tangible and never trans-

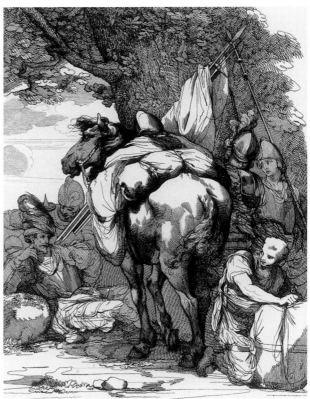

formed into the symbolic or virtual. Mortimer's *banditti* offer a highly conventionalized exploration of a pre-capitalist economy, where the accumulation of capital takes place without the hoarding and without the endlessly deferred debts of the paper economy that underpinned civil society.

It might also be noted that, for all the variety of arms exhibited in Mortimer's designs, no cannon or gun is ever present. Wherever the *banditti* might be located historically, they are determinedly in a pre-gunpowder era. Within accounts of civil history, the introduction of gunpowder into European conflict had marked the beginning of a debilitating modernity, with honourable forms of hand-to-hand combat displaced by deferred and impersonal modes of mortality: 'Before fire-arms were known, people gloried in address and bodily strength, and commonly fought hand to hand. But violent exercises becoming less and less necessary, went insensibly out of fashion.'[33] More immediately, it was in the 1770s that guns superseded swords as the duelling weapon of choice, ensuring (given the notorious inaccuracy of pistols used at range and at speed) that the exchange of blows took on a largely symbolic role. In a very real and immediate sense, modern politeness inhibited masculine physical expression (and, in this case, harm).[34]

Considered negatively, the improvisational method represented by and in the figures of the *banditti* was simply scavenging, as Henry Fuseli suggested when he later criticized Rosa's *Figurine*: 'Though so much extolled and so ambitiously imitated, his *banditti* are a medley made up of starveling models, shreds and bits of armour from his lumber-room, brushed into notice

71 (left) Engraved frontispiece to Thomas Percy, *Ancient Songs Chiefly on Moorish Subjects*, printed but not published 1775.

72 (right) Robert Blyth after John Hamilton Mortimer, *Packhorse with Soldiers*, published by Robert Blyth, 26 April 1783. Etching, 32 × 21.2 cm. The British Museum, London.

by a daring pencil.'[35] The costuming of the figures thus provides an analogue to the tawdry but risk-taking improvisations of the artist. But in the context of the 1770s, Mortimer's rehabilitation of such improvised signs of martial masculinity served as an effective form of counter-image to the uniformed modern soldier whose virtues and character were so much in question. Old anxieties about a standing army being antithetical to English liberties found a new form of expression in criticisms of modern military uniforms as the focus of emasculating, narcissistic desires.[36] The anxiety was that the uniform itself, as a conventional emblem of a martial identity, might become fetishized at the expense of the masculinity of the wearer, who was subject to feminine self-absorption. This was given expression in graphic satire with the appearance of martial variations on the Macaroni theme, such as Matthew Darly's *The Martial Macaroni* (FIG. 73) and the print of *The Military Contrast* (FIG. 57). Whatever might be said about Mortimer's *banditti*, it is hard to imagine that personal hygiene was much of a priority among them, in contrast to the well-groomed military Macaronis (a more serious point than it sounds, as will be discussed later).

The point here is that such heroism as was celebrated in primitivist fantasy was, if detected in the social realm or assumed as a model for social behaviour, generally castigated. An essayist in the 1750s commented that 'nothing can be more absurd than their [most of mankind's] different apprehensions of the Hero and the Thief . . . both sought a private gratification at the expence of others.'[37] In the following decade the writer Henry Brooke was to conclude that heroes were responsible 'for mischief merely, for spreading desolation and calamity among men . . . this wise world has bred up its heroic reprobates, by ascribing honour and acclamation to deeds that called loudly for infamy and the gibbet'.[38] At mid-century this impeachment of the heroic had been tied quite exactly to the patriot critique of imperialism, given classic expression by Thomas Gordon (1691?–1750) in his essay on heroes in the textbook of opposition, *Cato's Letters*:

> Mischief is inseparable from the profession of a present hero, whose business and ambition is to multiply conquests, and consequently miseries, upon those whom he conquers. What a wild and inhuman spirit! to plague the world, in order to make a figure in it; to commit great villanies, for a good name; to destroy the peace and prosperity of mankind, to gain their esteem! For none gain by such accomplishments of theirs, but their soldiers, whose lives too they throw away as wantonly as these take away the lives of others . . . Such is the difference between the old original heroes and these their apes, who by fraud, violence, perjury, and restless cruelty, make war upon their subjects and neighbours; and, by sacrificing the virtuous and the brave, or, by making them their instruments to sacrifice others, and by distressing, exhausting, plundering, and chaining, all, push human misery as far as it can go.[39]

As discussed, the critique of civil society was being renewed and revised from the late 1750s and incorporated within a project of cultural reform that had currency with a wider political spectrum than previously. But it was in the early 1770s that the fears surrounding the conquering hero were aired most fully, in the wake of a series of reported events that seemed to imperil the imperial project and indict the martial values that underpinned it.[40] When British soldiers did take up arms during these years, it seemed always to be in morally suspect circumstances. As noted in the context of West's *Death of General Wolfe*, British imperial policy was brought seriously into question by the brutal oppression of rioters in London in 1768. The 'Boston Massacre' of 1770 displayed 'a degree of cruelty unknown to British troops, at least since the house of Hanover has directed their operation'.[41] These conspired to bring British imperial military action into disrepute and government itself seemed to its critics to be criminal; in 1770 Mor-

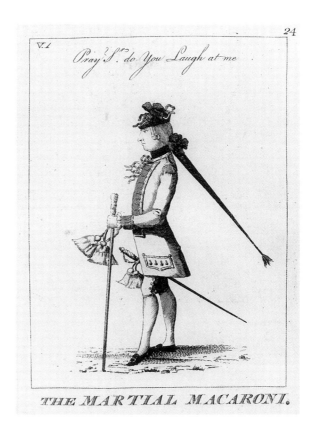

Pray'S.ᵣ do You Laugh at me

THE MARTIAL MACARONI.

timer's friend, Evan Lloyd, wrote of the 'state-Banditti' who made up the government.[42]

Imperialist modernity was meant to see 'barbarity and cruelty give place to magnanimity; and soldiers converted from brutes into heroes'.[43] The present age threatened to overturn or pervert this progress. The deployment of British forces in the Caribbean island of St Vincent against the Caribs in 1772–73 prompted the accusation that 'This is the British Government reviving the Spanish cruelties at the conquest of Mexico.'[44] Simultaneously with developments in the Caribbean – which culminated not in British military triumph but a treaty to pacify the intransigent Carib resistance – there was escalating unease about reports of corruption and exploitation within the East India Company, coming to a head in 1773. As Horace Walpole summarized at the beginning of 1773: 'there is an eastern empire to be settled, governed, or held *in cammandem* [ruled by terror]; and there is a little war and not a little tyranny at St Vincent's.'[45] When British soldiers attacked a printing house in Williamsburg, Virginia, in October 1775, the way was prepared for their condemnation as 'downright pirates and banditti'.[46]

Mortimer's *banditti* play across the boundary between heroism and criminality, offering up what were necessarily guilty pleasures arising from the sight of uninhibited brutality and rapine. His anti-heroes could gain currency in the context of a wider indictment of contemporary masculinity that destabilized the architecture of exemplarity. As such, they might appear to be simply antithetical to the effete and ineffectual Macaroni. But the Macaroni and the *banditti* were, in the structure and nature of the gendered identity imagined through them, closer than might be expected. They shared the same sense of being self-created, desocialized men, antagonistic to

73 *The Martial Macaroni*, published by Matthew Darly, 6 November 1771, from 24 *Caricatures by Several Ladies Gentlemen Artists & c.*, London, 1771. Etching, 15.9 × 10.6 cm. The British Museum, London.

the dominant norms of civil society. Both effectively resisted the mechanisms of inheritance and capitalist accumulation that ensured the reproduction of social hierarchy. Both insisted on making visible the artifice of social and gendered identity, and both visibly resisted the moderation of polite society and the insistence that capital be made virtual or disguised by tasteful investment.

Aside from the literary and visual caricatures of the early 1770s, it would appear that the gang culture of London's metropolis configured fashionable masculinities that could be as aggressively heterosexual and outlaw in character as those projected onto the *banditti*.[47] In a letter of 1772, Elizabeth Carter (1717–1806) observed of the Macaronis she had seen in London:

> Surely this species of animal is not an English character. Such a composition of monkey and demon, as at one half of the day appears to be studying all the tricks of the most trifling and contemptible foppery, and in the other is raving and blaspheming at a gaming-table, must be an aggregate of all the follies and the crimes that a worthless head and a profligate heart can collect from all parts of the globe.[48]

In his *Memoirs*, William Hickey (1749–1827), then a rather dissolute young law student in London, wrote of a gang that met at Lovejoy's in Covent Garden in the early 1770s:

> In the winter of 1771, a set of wild young men made their appearance, who from the profligency of their manners and their outrageous conduct in the theatres, taverns and coffee houses in the vicinity of Covent Garden, created general indignation and alarm, actually driving away many sedate persons from their customary amusement in an evening. They were distinguished under the title of 'Mohawks', and as such severely attacked by the public newspapers, which, instead of checking, seemed to stimulate their excesses. They consisted of only four in number, their Chief, Rhoan Hamilton (afterwards known as an Irish Rebel by the name of Hamilton Rhoan, having taken what had been his Christian for a surname). This gentleman, when he first came forward in the character of Mohawk, was in the prime of life, a remarkably fine figure upwards of six feet high, and perfectly well made. He, being a man of fortune, was the principal hero. The second in command was Mr Hayter, whose father was an opulent merchant and Bank Director; the third, a Mr Osborne, a young American who had come to England to study law; and the last, Mr Frederick, a handsome lad without a guinea, said to be a son, or grandson, of the much talked of and unfortunate Theodore, King of Corsica. He had dubbed himself with the convenient travelling title of 'Captain'; but no one knew from what corps he derived that rank.
>
> This Quartette were in a constant state of inebriety, daily committing the most wanton outrages upon unoffending individuals who unfortunately fell in their way.[49]

Eventually, Hickey reports, early in 1774, the Mohawks were brought up before the justice in Bow Street: 'Hamilton' went to Paris, Hayter was sent off to Holland by his father; Osborne went back to America; and Frederick joined the army and was killed at the battle of Germantown in October 1777.[50] The Hamilton in question was Archibald Hamilton Rowan (1751–1834), the son and heir of Gawin Hamilton of Killyleagh, a well-connected Ulster landlord. The younger Hamilton had been born in London and educated at Westminster and Cambridge, where he gained a reputation for rough sports and high living.[51] The Frederick is recorded as the son of the supposed king of Corsica, a notorious conman who had made a mark on London society in the previous decades. The American Osborne and the English Hayter have

proved impossible to identify. They were further associated with the Irishmen who figured in Henry Bate's *Vauxhall Affray* (see Chapter 4): it was Rowan's account of the affair that put his friend Matthias O'Byrne among the proceedings.

What makes the Mohawk gang particularly interesting is their active claim to a confrontational group identity by a resourceful deployment of the tropes of primitivism, a kind of role-playing enactment of the outlaw masculinity represented in Mortimer's drawings. Including an Irishman, an American and a claimed Corsican – the oppression of Corsica by the French being the great cause of the moment among British libertarians and dissenting radicals – the Mohawks can be said to represent the margins of empire and suppressed libertine traditions irrupting into fashionable London society. Their claim to savage identities confronted the proclaimed moderation of metropolitan politeness. If the Macaroni can be said to represent that fault line within temperate masculinity that allowed refinement to become effeminacy, Mortimer's *banditti* and the Mohawks explore a corresponding fissure between heroic virtue and criminality.[52]

Mortimer's *banditti* contradict the reasoned masculinities of polite culture and the squalid brutalities associated with the professional army while sharing in the unstable play of masculine identities emerging in relation to empire and represented in London's fashionable high life. Where the disenfranchised Irish of the metropolis laid claim to savage Mohawk identities (as the rebelling Americans did to such effect), Mortimer laid claim to the bandit identity of Rosa as a symbol of a savage imagination that could not be controlled. What legislated for this move was the Sublime, which provided a structure of cultural distinction detached from the regulating mechanisms of exemplarity, effectively splitting open the contradictions of epic tradition. The possibility of projecting a Sublime aesthetic onto the amoral hero was explored in particular depth by James Beattie (1735–1803), first in 'An Essay on Poetry and Music as they Affect the Mind', published in 1776, and then in 'Illustrations on Sublimity', published in his popular *Dissertations, Moral and Critical* (1783). In the section of the 'Essay' addressing the idea that 'Poetry Exhibits a System of Nature Somewhat Different from the Reality of Things', Beattie recommends ancient heroes as the proper subject for painters and poets, even though their manners may be reprehensible:

> To conceive the idea of a good man, and to invent and support a great poetical character, are two very different things, however they may seem to have been confounded by some late critics . . . characters of perfect virtue are not the most proper for poetry . . . Virtue, like truth, is uniform and unchangeable. We may anticipate the part a good man will act in any given circumstances; and therefore the events that depend on such a man must be less surprising than those that proceed from passion; the vicissitudes whereof it is frequently impossible to foresee. From the violent temper of Achilles, in the Iliad, spring many incidents; which could not have taken place, if he had been calm and prudent like Ulysses, or pious and patriotic like Aeneas.[53]

The internal, formal logic of the work of art provides a rationale for the dissociation of aesthetic and moral 'goodness', ultimately acknowledging market principles as paramount: 'the end of Poetry is to please, and therefore that the most perfect poetry must be the most pleasing'.[54] Elaborating his proposals regarding the hero in his later essay on the Sublime, Beattie reinforced the distinction between artistic effect and moral worth:

> When great qualities prevail in any person, they form what is called a sublime character. Every good man is a personage of this order: but a character may be sublime, which is not com-

74 John Hamilton
Mortimer, *The
Progress of Virtue*,
exhibited 1775.
Tate, London.

(top left)
*The Hero Decides
to seek his Fortune.*
Oil on canvas, 76.5
× 62.2 cm.

(top right)
*The Hero's Father
Blesses his
Departure.* Oil on
canvas, 76.2 × 63.5
cm.

(bottom left)
*The Hero Rescues
the Prisoners.* Oil
on canvas, 76.2 ×
63.5.

(bottom right)
*The Hero's Father
Blesses his
Marriage.* Oil on
canvas, 75.2 × 62.9
cm.

pletely good, nay, which is upon the whole very bad. For the test of sublimity is not moral approbation, but that pleasurable astonishment wherewith certain things strike the beholder . . . be not surprised, that we sometimes admire what we cannot approve. These two emotions may, and frequently do, coincide . . . but they do not necessarily coincide: for goodness calls forth the one, and greatness the other.[55]

There is a particular moment in the text when Beattie goes further in counting the heroic male body in itself as among those objects whose qualities demonstrate the principles of the Sublime by their intrinsic nature. In making an argument against 'too minute description' that chimes closely with Reynolds' discussion of the 'general', he presents as a demonstration the spontaneous response to the sight of a hero:

Were a hero to appear in arms before us, we should not think of looking at his teeth, or observing whether his beard were close shaved, or his nails nicely cut; at first, it is likely, that we should take notice of little besides his general appearance, and more striking features; or, if those other small matters were to engage our attention, might it not justly be said, that we had no true sense of the dignity of the person, nor any curiosity to know those particulars concerning him, which alone were worthy to be known?[56]

Beattie here suggests that the essential physical qualities of the hero in themselves provide a guarantee of the Sublime. To attend to those niceties of personal hygiene recommended by polite culture was to fail to grasp the heroic in its fullness. Rather than the Sublime providing a means of assessing the male body, it is the male body, when that body belongs to a hero, which provides the means of testing the Sublime. In conclusion, Beattie draws back from the logical implications of his own argument – perhaps extending to festisthistic homoerotic desires – claiming that the Sublime 'may, by preserving us from vice, which is the vilest of all things, and by recommending virtue for its intrinsick dignity, be useful in promoting our moral improvement'. But the viability of the amoral hero, or even the vicious anti-hero, has already been established.[57]

Mortimer's *banditti* occupy precisely the blind spot, exposed by Beattie, where aesthetics and morality may or may not meet. His figures offer no exemplars of moral action but they may not need to if represented as appropriately heroic-looking. They may not, indeed, even require a narrative support: their physique could be a sufficient guarantee of their value. It is interesting that, in contemporary criticism, Mortimer was subject to complaints that his works in this mode lacked narrative clarity. A reviewer of the six drawings exhibited as scenes from a 'soldier's life' in 1773 noted that 'Though the *design* of these drawings possesses a considerable share of merit, the *story* is rather indifferently conceived, and in many places much confused.'[58] Considering Mortimer's various exhibits at the Spring Gardens exhibition of 1771, Robert Baker mused that the painter 'seems to paint with freedom; and most of his figures, considered singly, are well done. But I can't admire either his compositions, or his choice of subjects . . . I can't help thinking, that this painter would shine more, if he made it his business to paint whole-length portraits.'[59]

Even when anchored in a more explicitly narrative structure, in the *Progress of Vice*, Mortimer does not provide an elaborate narrative. The four canvases in this series, shown at the Society of Artists in 1774 (dispersed; two in private hands), attempted to place his *banditti* figures in a clear narrative context, much along the lines of William Hogarth's 'Progresses'.[60] Yet there was not the dense, multi-layering of meaning and symbolism found in the older artist. For *The London Chronicle* of 17–19 May 1774 this served to distinguish these works as 'historical', in contrast to 'humorous and satirical pieces, such as Mr Hogarth's' where 'a variety of those little domestic images gives the whole a greater degree of force and a stronger appear-

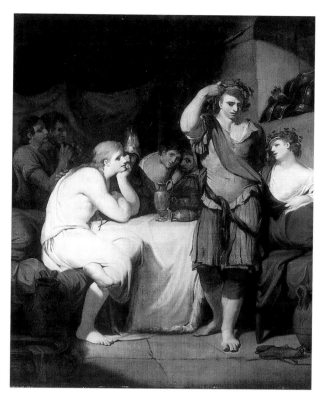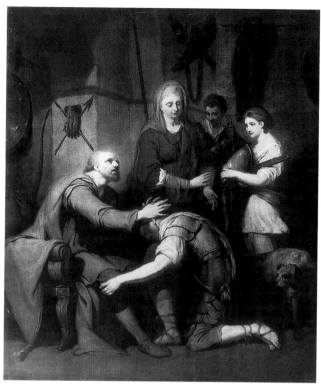
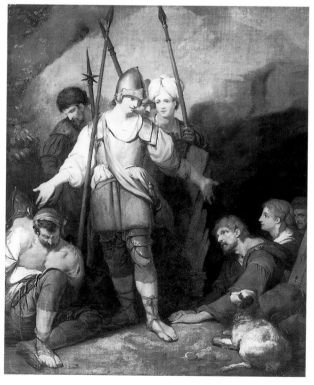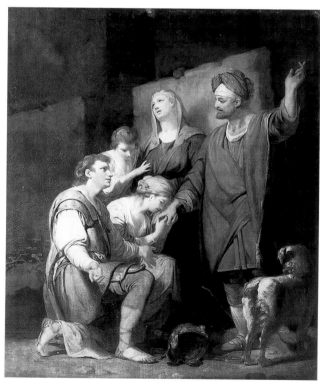

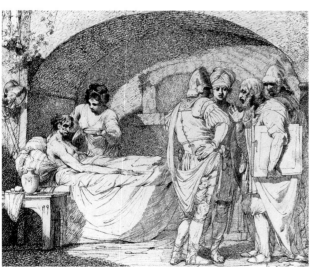

ance of reality'. The dynamic played out in this commentary is that of a Reynoldsian, generalizing and unifying aesthetic, aligned to the Grand Manner, opposing Hogarthian particularities and variety. But the same generalizing aesthetic embodied in the *Progress of Vice* could, when underpinning an imaginary subject, simply be confusing. The *Progress of Virtue* series exhibited the following year (FIG. 74 A–D) received the complaint: 'the several steps in the *Progress of Virtue* are not clearly marked. There is an obscurity in the expression of the idea, which the truth of mechanical expression cannot atone for.'[61]

With the posthumous publication of prints after Mortimer's drawings, there was something of a concerted effort to impose narrative sense on his designs. This is most in evidence with the set of four scenes presented as depicting the *Life and Death of a Soldier* when they were reproduced by Robert Blyth in 1781 (FIG. 75 A–D).[62] Although printed, by Blyth, in a uniform format with identical letterpress, indicating what is ostensibly the clear narrative progress of the soldier from courtship through family life to sickness and death, the drawings may not originally have formed a sequence. The evidence is that only two of them were originally exhibited together by Mortimer. Moreover, it is impossible to follow a single narrative through the four images; who the central protagonist is, is quite simply not clear. Instead, the figures seem to swap roles over the four scenes.[63] Is the figure on the left of the first composition the 'Soldier' of the title? If so, he is presumably courting the standing woman while a fair-haired woman and child watch. In the second scene, the child seems to form part of the soldier's family. He, meanwhile, is costumed completely differently. His female companion from this scene reappears as his nurse in the deathbed scene of the third composition. It is, though, the mother figure from the first two designs who appears as the mourner in the final, burial scene. Elements of costume or physique reappear across all four compositions but with little consistency. Indeed, the two other works shown in the same year as these, 1772, but not published as part of the group, connect equally as effectively – in which case the young woman cast as an attentive wife in the prints might also be read as a violated prisoner (FIG. 76).[64] Beattie was to suggest that morality is not important in the creation of a Sublime image of the hero: Mortimer's *banditti*, who are equally rapist and loving husband, had already demonstrated as much.

Such vagueness could find sanction within a Reynoldsian aesthetic of generalization – he had, after all, said that the pursuit of a Grand Manner was not only possible, but was to be highly considered, regardless of the genre in which an artist was working. Attempting 'a grandeur of composition and character' could, according to Reynolds, ennoble even a still-life painting, so that logically such formal aspirations could raise the themes of rapine and rape to the level of high art. To resist such claims required that the issue of content in the Grand Manner – that definition of 'history painting' by its source matter avoided by Reynolds – be revisited to exclude such morally ambiguous efforts:

Indeed it is Pity that this Artist has not many History Pieces this Year, and that he does not employ his Pencil to illustrate the History of his own Country, as he seems particularly calculated for that important Purpose. His Pictures of Banditti are strong Proofs that his Imagination is warm and pregnant with Ideas. If he has been able to make imaginary Scenes appear true and striking, and Banditti appear like Heroes, how much more interesting and sublime would the God-like Heroes of Antiquity, and even those of Great Britain, appear to a Lover of the Arts and of History?[65]

Mortimer's response, at the end of his life, was to undertake subjects precisely anchored in literature and in history, even as they share the aesthetic of his *banditti*. His painting of *The Battle of Agincourt* (private collection), and his life-size depiction of *St Artegal and the Iron*

75 John Hamilton Mortimer, *The Life and Death of a Soldier*, c.1772–75. The British Museum, London.

(top left) *Soldier's Courtship*. Pen and ink on paper, 36.9 × 41.6 cm.

(top right) *Soldier's Family*. Pen and ink on paper, 35.7 × 41.4 cm.

(bottom left) *Soldier's Death*. Pen and ink on paper, 36 × 41.6 cm.

(bottom right) *Soldier's Funeral*. Pen and ink on paper, 26 × 41.6 cm.

76 (top)
John Hamilton
Mortimer, *Banditti
Returning*, perhaps
exhibited 1772. Pen
and ink on paper,
35.2 × 41 cm. The
British Museum,
London.

77 (facing page)
John Hamilton
Mortimer, *Sir
Artegal the Knight
of Justice, with
Talus the Iron Man*,
exhibited 1778. Oil
on canvas, 236.2 ×
144.8 cm. Tate,
London.

Man from Edmund Spenser (FIG. 77) offer a vision of masculinity as rugged and uncompromising as that of his *banditti*. But this vision is more securely legible in relation to commonly understood sources (and in the latter case is rendered in the full-length portrait format recommended by Baker).[66] To interpret the *banditti* meant interpreting above all else an individual artistic imagination; to interpret these later images required, instead, knowledge of history books or of classic English literature. By the time of Mortimer's premature death in 1779 before, according to his friend Ignatius Sancho, 'he was cloyed or surfeited with dull sickly repetitions', he had effectively been brought into the fold of the cultural establishment.[67] At the end of 1778 he was elected an associate of the Royal Academy and, to flatter his new president, dedicated to him a set of fifteen etchings, including among them a version of his representations of Rosa.

The significance of Mortimer's *banditti* is not, or not only, in contributing a new range of subjects to the established repertoire of topics for British historical painting, though such themes were treated by Thomas Stothard (1755–1834) and Charles Reuben Ryley (c.1752–98) in the years immediately after his death. Nor is his importance to be exhausted by identifying the impact of his draughtsmanship, though his works set a standard of graphic work emulated by James Gillray (1757–1815) and Thomas Rowlandson (1756–1827) and later William Blake, for whom Mortimer represented one of the great lost heroes of the British Grand Manner, neglected by the cultural establishment. The greatest interest may be, instead, in his demonstrating how

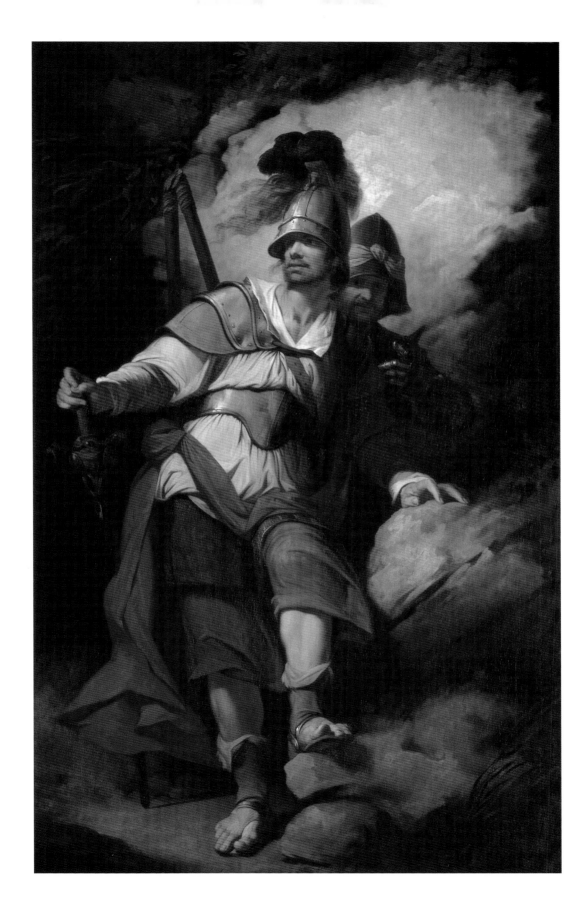

the aesthetic reforms of the 1760s made possible the creation of a form of heroic art that departed radically from conventional, moral narrative, and that could still be reconciled to market realities and even the Royal Academy. His thematic treatment of the outsider and his performance of such a role highlights the rhetorical nature of the artistic field at this time and the inevitably ambivalent status of the forms of heroic masculinity represented within it.

6

ALEXANDER RUNCIMAN

IN ROME AND EDINBURGH

The preceding consideration of James Barry and John Hamilton Mortimer, and of the Macaronis and the Mohawks should have made apparent the degree to which the radically alienated characterizations of heroic masculinity that emerged around 1770 were the product of national and class conflicts and the active contestation of Anglo-British cultural hegemony. The image of British union promulgated in Benjamin West's *Death of General Wolfe* can be appreciated in this context as a carefully contrived fantasy, created in the midst of heightened tensions around Britain's empire and the future of modern manhood. The painting has rightly been taken as an icon of a rapidly consolidating sense of nationalism, providing a vital point of identification among the polite classes of the constituent nations of the kingdom.[1] Yet it would be fraudulent to set these two visions of masculinity in simple opposition, with the conflicted, unpredictable forms of dissident masculinity explored by Mortimer and the genteel, sentimental hero of West's painting representing irreconcilable poles of masculine identity. Polite society and the extra-social models of heroic masculinity formulated with reference to the Sublime and associated ideas of the primitive and original genius enjoyed a more complex relationship and need always to be considered in a highly localized way.

The case of Alexander Runciman, a Scottish painter based primarily in Edinburgh, provides a dramatic illustration of this point.[2] Runciman's *Ossian's Hall*, created for Penicuik House near Edinburgh, represents the most comprehensive pictorial scheme of its age and the most extensive exploration of the revision of heroic ideals of the previous decade – a revision both joined to the consolidation of an Anglo-British polite society and antagonistic to that society.

Runciman's father, James, was by profession a 'wright' (joiner or carpenter) in Edinburgh, and thus a member of the elite within the building trades. James Runciman appears to have been employed on general maintenance on the estates of the powerful earl of Beadalbane and made forays into building work. As a practising wright, he was a member of the Incorporation of Mary's Chapel, the guild body in Edinburgh that had, since the beginning of the eighteenth century, included painters and decorators as well as the wrights and masons who had made up its original membership. Alexander Runciman's route into the art world was, unsurprisingly, by way of an apprenticeship to Robert Norie at the age of fourteen – a distinctly old-fashioned form of art training by mid-century, undertaken in a distinctly old-fashioned firm affiliated to Mary's Chapel.[3] Through his twenties, Runciman remained a part of Edinburgh's civic organization. He was admitted a 'burger' of Edinburgh in 1762 and by about 1765 he had specialized as a landscape painter in the decorative idiom, working under the aegis of the Norie firm. In 1767 he became a senior partner and then continued the business in partnership with Dugald McLaurie or McLauren.[4]

78 Alexander Runciman, *Thetis Dipping the Infant Achilles in the Styx*, c.1770. Pen and brown ink and red chalk on paper, 18.8 × 24.8 cm. The British Museum, London.

In 1767 Runciman and his precocious younger brother John (1744–68/9) were contracted by Sir James Clerk (1709–82), a client carried over from the Nories, to decorate the new house he was having built on the family estate at Penicuik, a few miles south of Edinburgh. The son of Sir John Clerk, Baronet and Baron of the Exchequer, businessman, landowner and one of the architects of the Act of Union, Clerk was heir to a rather recently made fortune (established by his grandfather through art dealing in the 1650s) and to a financial and political commitment to the imperial British state that took as its concomitant a cosmopolitan notion of gentlemanly virtu.[5] In investing in the Runciman brothers it appears Clerk was hoping for a fashionably classical scheme in the latest Continental taste, with small figurative or landscape scenes subservient to the overall ornamental effect. His employment of Runciman was really only a continuation of the family's former employment of the Nories, and McLaurie worked on the ornamental elements of the Penicuik decorations while his business partner was in Italy. Runciman himself appears to have initially been entirely in accord with this plan, and when he announced his departure to Italy and the business arrangements that would prevail in his absence in the press in 1767 he described himself as an 'Ornamental Painter'.[6] But in Italy, driven by the tragic and unexpected death of his brother in rather mysterious circumstances in Naples, Alexander announced to his patron his ambition of becoming instead a history painter.

Like his friend, Barry, Alexander's ambitions took form in a potentially self-destructive rift with the dominant cliques of Anglo-Roman dealers and agents. He was to intimate that his brother's death was related in some way to the villainy of a fellow artist, naming James Nevay. As early as August 1768, the Runcimans were having to beg for more money from Clerk, explaining through Clerk's friend, the solicitor Walter Ross (1738–89), that 'they could make a good shift by copying for English gentlemen &c but that branch is engrossed by one or two people who have created a prejudice against them upon account of their short stay at Rome,

79 (left)
Alexander Runciman, *Achilles Dragging the Body of Hector around the Tomb of Patroclus*, *c.*1770. From a bound album of drawings, collection of Viscount Runciman of Doxford.

80 (below)
Pietro Testa, *Achilles Dragging the Body of Hector Around the Walls of Troy*, *c.*1648–50. Etching with drypoint, first state, 26.5 × 41.5 cm. The British Museum, London.

81 Ossian's Hall, Penicuik House, Midlothian (destroyed by fire 1899). Photo in a private Scottish Collection.

which it seems is there considered a standard of merit'.[7] While Clerk in this instance granted a further sum of money to his protégés, the later news from Alexander that he was to embark on a career as a narrative history painter could hardly have been welcome. Sir James seems to have responded negatively to this decision but Runciman persisted nonetheless, taking up additional financial support from the Edinburgh banker Robert Alexander.[8]

Initially, Runciman's scheme for Clerk was to have been classical and would have overlapped thematically with Gavin Hamilton's advancing Homeric series.[9] The ceiling was to be filled with a scene of the council of the gods and the concave spaces around the room were to depict scenes from the life of Achilles, beginning with the birth of the hero and following his life story through to his death (FIGS 78 AND 79).[10] Surviving studies for the scheme indicate that the areas devoted to the *Iliad* would have been heavily indebted to the visual precedents of Hamilton, with a similar emphasis on visual and narrative grandeur and heroic physicality. But, even allowing for their sketchiness, they mark a departure. The sketches exhibit a range of graphic techniques, with the textural possibilities of pen, ink and chalk explored in their fullness, and areas of dotting, outline and wash frequently juxtaposed for expressive rather than descriptive effect. So

83 Photograph of painted coving in Ossian's Hall, Penicuik House, Midlothian, showing the subject of *Cormar Attacking the Spirit of the Waters*. Photo in a private Scottish Collection.

even where the basic physical types recall the canon of mid-century classical painting and in turn antique models, they are described through an almost brutal deployment of heavy hatching and cross-hatching, rather abrupt outline and broadly – one might say sloppily – applied areas of wash.

It may be allowed that Runciman was not a particularly gifted draughtsman in conventional terms: his line lacks exact descriptive grace, forms are often generalized, the particulars of anatomy disregarded. But even so, the mechanisms that made such graphic liberties possible and perhaps permissible should be considered. As with Mortimer contemporaneously, these designs advertise an awareness of the work of Salvator Rosa, with all that implies about original genius and 'savage and uncultivated nature', and perhaps more of an association still with Pietro Testa, whose series of designs presenting the life of Achilles provided specific compositional prompts for the Scottish artist (FIG. 80).[11] Testa, like Rosa, was generally judged to be admirable but to tend to contemptible excess, and was thus a risky model to follow. Although he was famed for his dedication to the antique and 'was a Man of a *quick Head*, a *ready Hand*, and a *lively Spirit*, in most of his *Performances*... yet for want of *Science*, and good *Rules* to cultivate and strengthen his *Genius*, all those hopeful *Qualities* soon ran to *Weeds*, and produced little else but *Monsters*, *Chimeras*, and such like wild and extravagant *Fancies*'.[12]

Apparently while still in Italy, Runciman changed his plans again: the painted scheme that was completed at Penicuik in the latter part of 1772 was based on the poems of the legendary Gaelic bard Ossian. This, together with four ceiling paintings of the story of St Margaret in an adjoining staircase, was destroyed in a fire at the end of the nineteenth century. However, the scheme is documented by a set of photographs, a late nineteenth-century watercolour and two written records – the first an account published at the beginning of 1773, the second a late nineteenth-century description – as well as a body of drawings and some related etchings created by the artist.[13]

The room decorated by Runciman was planned as a picture gallery, although it was used as a drawing room. It was therefore large, around 36 × 24 by feet, and heavily decorated (fig. 81).

82 Alexander Runciman, *Cormar Attacking the Spirit of the Waters*, *c*.1773. Etching, 7.5 × 12.8 cm. Private collection, London.

The ornamental elements of the decoration were completed by McLaurie while Runciman was in Rome, leaving Runciman to complete the centre of the ceiling and its surrounds and the coving. The central oval was painted with a scene of Ossian singing, with four river gods at the corners – the Tay, Spey, Tweed and Clyde. The curved surfaces between the walls and ceiling were painted with a succession of twelve separate scenes taken from the poems of Ossian (FIGS 82 AND 83).

Ossian was an entirely new subject for a painted scheme. The first Ossianic translations had been circulated in manuscript form in Edinburgh by the Highland schoolteacher and aspirant poet James Macpherson (1736–96) in 1759. These came to the attention of the Edinburgh dramatist John Home, and the first slim volume of Macpherson's translated verse, *Fragments of Ancient Poetry Colected in the Highlands of Scotland and Translated from the Gaelic and Erse Languages*, was published in 1760. A second volume of prose and poetry, *Fingal: An Ancient Epic in Six Books*, appeared at the end of 1761, and a third, *Temora: An Ancient Epic in Eight Books*, in 1763, with a collected *Works of Ossian* appearing in 1765, a significantly revised collection in 1773 and numerous re-editions thereafter.[14] Macpherson claimed that these publications were translations of the Gaelic poems of the third-century Scottish bard, Ossian, the son of Fingal, king of Morven, celebrating his battles and tribulations. Whether cynical fabrications (the view taken by sceptics, mainly English, at the time), authentic translations of genuine manuscripts (as most Scottish commentators believed), arrogant plagiarisms of Irish sources (as some Irish and English commentators thought) or sincere attempts to capture imaginatively a Gaelic cultural heritage on the brink of extinction (the view that has come to dominate modern accounts), they had enormous popularity both in the immediate Scottish and British contexts and internationally.

For enthusiasts, Ossian's primal vision of rugged heroism offered a clarion call to cultural reform. Macpherson's cause was taken up by a group of Edinburgh intellectuals associated with the Moderates (the liberal force within the established Church of Scotland), who sought to promote virtue within a nation they construed as corrupt and weak. Their first cause was a militia, which they believed would serve to defend the Union and instil masculine virtues into its members. This was blocked by London government (the memory of the Jacobite rebellions was still too strong). Deploying elements of Burkean aesthetics, they conjectured that the pure emotionalism of 'Sublime' poetry held the potential for emotional, moral and artistic cleansing and a sense of certainty in an era confused and polluted by luxury.

Macpherson's own rationalization of the poetics of Ossianic texts was elaborated by Hugh Blair in his 'Critical Dissertation on the Poems of Ossian' (1763).[15] Here, the admirably elevated formal qualities of Ossian's texts are posited as consequent upon a specific stage in the history of humankind.

> Those times which we call barbarous, are favourable to the poetical spirit. That state, in which human nature shoots wild and free, though unfit for other improvements, certainly encourages the high exertions of fancy and passion . . . As their feelings are strong, so their language, of itself, assumes a poetical turn. Prone to exaggerate, they describe everything in the strongest colours . . . In the progress of society, the genius and manners of men undergo a change more favourable to accuracy than to sprightliness and sublimity.[16]

Blair positions Ossian's style as the manifestation of the earliest stage of mankind's economic progress: the era of hunting, prior to the establishment of settled agriculture and the subsequent development of modern commerce. In line with the traditions of civic discourse, this pre-commercial society is untainted by the greed, luxury and effeminacy that accompanied commerce and imperialism.

But neither is the Ossianic age simply savage. English Whig discourse had operated around polarities of virtue and vice, modernity and antiquity, progressive thinkers suggesting that the savagery of ancient times had been superseded by the comforts of modernity. Ossian steers an alternative course, proposing that antiquity need not be simply savage or virtuous. Homer's world (obviously calling to mind Achilles' treatment of the dead Hector) is compared to Ossian's, where 'If an enemy fell in battle, his body was not insulted, nor dragged at the chariot wheels of the conqueror.'[17] While most recent commentators have agreed that the popular appeal of Ossian must rather demonstrate the success of this compromise, Dafydd Moore wonders whether the poems offer, in their lack of resolution and generic instability, testament to the incommensurability of poetic–moral authenticity and the comforts of modern-day culture: '*Ossian* reconditions violence and martial activity for an age of politeness but only at the cost of its effectiveness, relevance, and indeed the coherence of narrative itself.'[18] While the 'unity of the hero' in classical literary theory both reflected and guaranteed the unity of the whole, in Ossian the reverse is true. Ossianic heroes are precisely that '*Chimera*' imagined by René le Bossu, combining 'the Valour of *Achilles*, the Piety of *Aeneas*, and the Prudence of *Ulysses*'.[19] Thus the virtues associated with the citizen–warrior were rendered palatable in an era wary in the extreme of Scots militarism (to the extent that Scotland was excluded from the militia acts of the Seven Years War and the American Wars).[20]

So this account of cultural progress is not one in which the ancient world is simply lost; instead natural, spontaneous virtue is masked and ahistorical states of nature and art are opposed as the historical states of antiquity and modernity are. Ossian is effortlessly epic, spontaneously creating a work that accords to the conventions of the genre without knowing its rules; in fact, the rules and regularities of the modern epic might, in themselves, be deceitful. The absence of lucid narrative in fact provides a guarantee of moral authenticity and authority:

An epic poem is by its nature one of the most moral of all poetical compositions: But its moral tendency is by no means to be limited to some common-sense maxim, which may be gathered from the story. It arises from the admiration of heroic actions, which such a composition is peculiarly calculated to produce; from the virtuous emotions which the characters and incidents raise, whilst we read it; from the happy impression which all the parts separately, as well as the whole together, leave upon the mind.[21]

The faults of Ossian's text, when judged by academic rules, do not just permit but actually enable such a direct, artless form of appreciation and understanding:

All the circumstances, indeed, of Ossian's composition, are favourable to the Sublime, more perhaps than to any other species of beauty. Accuracy and correctness; artfully connected narration; exact method and proportion of parts, we may look for in polished times. The gay and the beautiful, will appear to more advantage in the midst of smiling scenery and pleasurable themes. But amidst the rude scenes of nature, amidst rocks and torrents and whirlwinds and battles, dwells the Sublime. It is the thunder and lightning of genius. It is the offspring of nature, not of art. It is negligent of all the lesser graces, and perfectly consistent with a certain noble disorder.[22]

If this evokes the established terms of cultural nationalism (with its rejection of academic rules associated with authoritarian government and promulgation of organic models of British cultural enterprise), it goes further in rejecting learnt responses to poetry altogether. Thus the 'noble disorder' of the Ossianic text and the society that produced it is not just a sign of an authentic poetic voice but in itself a guarantee of a kind of virtue that, in being instantaneous, spontaneous and 'natural', is superior to the learnt or cultivated virtues of more modern poetry.[23]

Heroic virtue was in this way made available not in a fully narrated form but in fragments, their partial quality ensuring authority. It was this fragmentary, anti-narrative tendency that was registered in telling terms in a letter of 1760 by Horace Walpole, who derided claims that the published Ossian represented fragments of 'an heroic poem; nothing to me can be more unlike – I should as soon take all the Epitaphs in Westminster Abbey, and say it was an epic poem on the history of England'.[24] Both Blair and Walpole produce, in their different ways – one sincerely, the other ironically – an image of Ossianic epic as a vehicle of exemplarity detached from any reliance on sustained narrative, finding in this an idea of heroic virtue whose effectiveness, or absurdity, is revealed, in its abruptness and disconnectedness. Ossianic poetry presents not only novel subject matter but also a new mode of reception for the epic.

As interpreted by Edinburgh's Anglicized literati, Macpherson's Ossian could readily be accommodated within an iconography of North Britishness. If there was a Highland patriotic dimension to Ossian, it was thoroughly brought under the wing of the Hanoverian state. As a member of the Scottish state nobility, Sir James Clerk had no need to play up the Jacobite aspect of Ossianic myth and legend. His father had been a Commissioner for the Union of the Crowns in 1706 and was later made one of the five Barons of the Scottish Court of the Exchequer. His extended didactic poem on 'The Country Seat', written around 1727, had tackled the question of an explicitly and empathetically British architectural style and imagery, and James Clerk's vision of Penicuik sat within the Burlingtonian ideals presented by his father. The mural scheme the elder Clerk had envisioned as appropriate for the grand country house (albeit, specifically, a royal palace) had been a national history beginning with prehistory and travelling through Caractacus and Boadicea, culminating with the Act of Union, illustrating the *fata Britannica*.[25]

Still, the initial reluctance of Clerk to permit Runciman to undertake narrative history painting at all and the absence of any confirmation that Clerk approved the Ossian scheme beforehand raises the possibility that the new painted scheme did not correspond exactly with the interests of the patron. On the contrary, the painter's social background and immediate affiliations suggest that Ossian's Hall stood as a point of resistance to Anglo-Britishness as much as compliance. Runciman was a founder member of Edinburgh's Cape Club in 1764, a mock-chivalric, pseudo-Masonic fraternity. Put on a more formal footing in 1768–69, the club's membership swelled to hundreds. The circumstances of its organization and its original range of interests coincided with the gentry-class Poker Club, founded in 1768. This latter was committed to raising a Scottish militia, to the degree that the name 'Militia Club' was first proposed but tellingly dropped as being too confrontational. The term 'Poker' had some pro-militia significance, though precisely what may remain contested, and this symbolism was incorporated into the Cape Club: a poker was used during initiation ceremonies, and one of its founders, James Aiken, went under the title 'Sir Poker'.

However, this should not be allowed to blur the real and urgent social distance between the Cape Club and contemporary middle-class societies like the Poker. The membership of the Cape included, besides Runciman, the bootmaker, prosthetics engineer and Masonic poet Gavin Wilson; the heraldic painter James Cummings; the comedian Thomas Lancashire; the accountant's clerk and collector of traditional songs David Herd; as well as William Brodie – like Runciman the son of an Edinburgh wright, but later famous for being condemned to death for his part in organizing a gang of housebreakers. A full list of the membership drawn up in around 1769 noted the professions of the Cape's 'knights' under a heading that directly mocked the solemnities of the Board of Trustees and the Select Society: 'A Complete List of his Majesty's Commissioners for Encouraging the Arts & Sciences of CFD.'[26] The list includes thirteen merchants, six wine merchants, eight 'writers' (clerks or solicitors), six painters, five 'Doctors in

Musick' and five 'Doctors in Physick', brewers, bakers, printers, a shipwright, a hosier, a druggist, a bookseller, and a miscellany of different kinds of craftsmen, including a joiner, a hatter, a cutler, a watchmaker and a barber. By contrast, the Poker Club counted as members historians and philosophers including Adam Fergusson, David Hume, John Home, William Robertson and Adam Smith, drawing heavily from the body of gentry and educated gentlemen who made up the Select Society and who, if they worked at all, served in the higher ranks of the law or at one of the universities. From its list of membership in 1768, consisting of a number comparable to the Cape by that point, there were twelve 'Drs', fifteen 'Esqs', four 'Cols', five 'Sirs' and assorted Lords, Barons and 'Hons', a handful of Advocates and a couple of 'Merchants'.[27]

In this respect Runciman's close relationship with a fellow knight of the Cape, the poet Robert Fergusson (1750–74), bears closer examination. A son of an Edinburgh clerk, Fergusson had won a bursary to St Andrew's, but had not graduated and eked out a living as a clerk in the Commissary Office, copying documents. But away from his desk job, Fergusson enjoyed a full social life as part of Edinburgh's cultural underworld, joining the Cape Club in October 1772 and publishing an innovative body of poetry in the tragically short period that followed before his mental decline and death, perhaps precipitated by alcoholism or syphilis or a combination of these, in 1774. In the pieces published in Edinburgh's *Weekly Magazine* in 1772–73, and especially in 'Auld Reikie, A Poem' (1773), Fergusson employed a pioneering poetic vernacular to articulate a vivid vision of Edinburgh.[28] His poetry expressed a commitment to Scotland's progress and modernization, but countered the proposed changes to the city that would divide the gentrified new town, built on the English model of the physical separation of the classes, and the socially heterogeneous old town, making brisk use of the language and themes of the street. Against the cosmopolitan polish and fashionable excesses of the Scots who had been to London and on the Grand Tour and become absorbed by luxury and immorality – the Maraconi, *petits maitres* or 'butterflies' repeatedly lampooned by Fergusson – the Cape Club members claimed to stand for a hard-drinking, demotic, chaotic, virile authenticity, their meetings offering a fraternal consolation for the hardships of modern life:

> But chief, O CAPE, we crave thy Aid,
> To get our Cares and Poortith laid:
> Sincerity, and Genius true,
> Of Knights have ever been the due:
> Mirth, Music, Porter deepest dy'd,
> Are never here to Worth deny'd;
> And Health, o' Happiness the queen,
> Blinks bonny, wi' her Smile serene.[29]

For the Cape Club in the early 1770s, asserting a moral, manly and virile (which is not to say necessarily heterosexual in the modern sense) and authentic Scots identity meant rejecting the English model of cultural progress as it was being interpreted by the Edinburgh social and civic elite.[30] The project of reform so enthusiastically subscribed to by Blair and latterly James Beattie was viewed by Fergusson, and, it might be assumed, Runciman, with scepticism. For the gentlemen of the Select Society the primitivist impulse was a matter of tweaking polite discourse, and any resistance it offered to the political settlement with England was entirely in the cultural register; for men like these, it could become a way of life, a complete anti-social stance.

Within the Cape Club, Runciman was identified as 'Sir Sawney Brimstone'. After a decade of savage anti-Scottish feeling, focused in song and print and caricature on the grotesque figure of 'Sawney', the stereotype Scot, the social environment of the Cape allowed for the reclama-

84 John
Runciman, portrait
of Alexander
Runciman,
*c.*1768–69. National
Galleries of
Scotland,
Edinburgh.

tion and inversion of English stereotypes.[31] By his assumed name, Runciman contested Anglo-British norms of polite society. Fergusson was characterized by a contemporary as the carelessly dressed outsider:

> Tho' Tom is young – yes, almost beardless –
> Surrounded by the gay and fair,
> Of dress he's slovenly regardless,
> Wears dirty shirts, nor combs his hair.
>
> Of boon companions and acquaintance,
> Tom's taste's not high, nor over nice;
> Headstrong, he seldom feels repentance,
> Nor mends upon a friend's advice.[32]

Runciman was similarly to be depicted by John Brown, in a drawing dated to the year of the painter's death but representing him as a youth, as a haggard, intensely staring figure (Scottish National Portrait Gallery, Edinburgh), and his brother John had also shown him desperate and neglectful in his studio in Italy (FIG. 84).[33] Runciman's later self-portrait with Brown presents the two conversing, dressed 'of slovenly regardless', with the painter, in the draughtsman's words, 'rather irascible, and impatient of reproof . . . making a damnable face' (FIG. 85).[34] This is to take the image of the artist a long way away from that 'Lad of great honour' that had been perceived in Gavin Hamilton at the start of his career, or the well-groomed, well-adjusted young man presented in David Allan's image of himself in 1770.

Within the larger panorama of late eighteenth-century cultural politics, a studied neglect of personal hygiene or being short-tempered may not seem of tremendous importance. But it does represent the development of an antisocial artistic stance that, in the hands of Runciman's friend in Rome, Henry Fuseli, was to become an art form in itself. In the Edinburgh of the 1770s it took on quite particular political significance. The Select Society was a profoundly Anglocentric organization in that it projected the nationalistic project of cultural and social reform within Scotland as a process insisting on the supreme linguistic model of correct English at the expense of the Scots dialect and of Gaelic. To be 'original' in this context was to strike out against Anglo-British cultural imperialism and to become vulnerable to material, professional, even mental bankruptcy.

The Ossianic cult had been forged originally by an ambitious Gaelic-speaking Highlander and cultivated by an Edinburgh elite in search of a national heritage at once compelling and compliant to the exigencies of the post-Jacobite polity. But the primitive also served as a resource for the professional aspirations of a marginal class, comprising the working and trading sector of Scottish society with a disenfranchised group of cultural commentators and producers whose position within Edinburgh society was far from assured. For Runciman, an artisanally trained craftsman with no great advantages of birth or education, the hall at Penicuik was an unexampled opportunity for professional display, but also, exploiting the unsteady common ground opened up by the cult of primitivism in Scotland, an assertion of a more confrontational identity. Runciman's turning to a Highland subject might be seen as closer to the politically radical reclamation of Scots balladry by his Cape Club fellow David Herd than to the polite and rela-

85 Alexander Runciman, self-portrait with John Brown, 1784. Oil on canvas, 63.6 × 76.5 cm. National Museums of Scotland, Edinburgh.

tively Anglicized accommodation of Highland barbarity into a more fully assimilated Scottish identity by the Poker Club member Hugh Blair.

These claims might be clarified and adjusted by the commentary published to mark the completion of the hall, Walter Ross's, *A Description of the Paintings in the Hall of Ossian at Pennycuik near Edinburgh* (1773).[35] The author, acting to some extent at least as the mouthpiece of the painter, set the project in the context of the old *ut pictura poesis* debate, with the claim that the painter must possess a 'poetical imagination' and poets a 'painterly' capacity to conjure images. Ross claims, though, that the Ossianic texts mark the historical and formal limits of this argument:

> The Celtic Bard uses little or no machinery, knows no religious ceremonies, is familiar only with a small number of natural objects, depends not upon ornament, and dwells in a continued wildness of landscape. Homer, on the contrary, not only invents, but disposes his figures. The artist has little to do but to follow his poet, and express at leisure those circumstances and images offered him from all the variety to be found in the universe, physical or moral.
>
> Invention, therefore, the prime quality of the painter, is indispensable in Ossian's artist. He must not only seize the strongest impressions even in the rapidity of the poet, but supply upon the canvas what the other omits in the description. From Ossian he can have no more than one blaze of light upon the principal figures in the piece, and is left to his own imagination for all the other necessary circumstances of the actors. These too must be conceived in the very spirit of the bard himself. They must stand their own ground upon the canvas, otherwise the painter's work will figure as ill in the picture, as a weak or ignorant interpolation would do in the poem.
>
> From the beginning to the end of Ossian, a deep melancholy is preserved, often perhaps varied, but never remitted; no action or event is admitted, but such as are of an interesting and tragic nature. The Poet never forsakes his principal aim merely to please or to delight the imagination: he hastens to give the 'joy of grief'; he aims at the heart by sublimity and tenderness of sentiment. Hence the painter is deprived of numberless advantages generally offered by the Muses. He can expect no support from gay or smiling scenery, no play of imagination is to be depended upon. . . .
>
> Confined therefore to the simple pathetic, the painter must succeed by the *action alone*: his figures must realize the ideas of the Poet; he must speak their language to the eye; in fine, he must occupy the vantage ground of his art, or drop all pretence to the character of poetical painting.[36]

To this discussion Ross attaches the general principle that the painter should tackle only those subjects 'best suited to the pencil, which consist of motion, attitude and expression alone'.[37] If this is a conventional statement within the *ut pictura poesis* debate, comparing text and image, Ross seeks to attach it specifically to Ossianic imagery. The 'motion, attitude and expression' of such imagery are not simply an obligation of painting as a mode of representation but rather the characteristics of a new mode in which narrative convention is undermined in favour of a novel form of physicality. As *muta poesis*, painting demands that the viewer is familiar with the narrative depicted so that he or she may supply what is necessarily left out in visual representation (words, sentiments). Adam Smith had landed on this point as a means of prohibiting connected narrative series in visual art:

Painters have represented the different transactions of an Heroick Poem. This is surely a very pretty fancy and may have a very good effect; but nothing equal to what the Poem itself would have. The Painting can only represent one moment or Point of time and the situation things were in at that time; Betwixt one moment and another there must have been a very considerable time, a great number of moments must have passed; The actions of all these are unknown and can only be conjectured. Severall Painters have emulated the Poets in giving a Suit of Actions but these labour under a defect for want of Connection; when we turn from one Picture to look at another we do not know the Persons which act there till we have studied the piece nor do we know what hath happened intermediate and preparatory to this action.[38]

86 Alexander Runciman, *The Death of Oscar*, 1772. Pencil, pen and wash 34.3 × 49.2 cm. National Galleries of Scotland, Edinburgh.

Smith questions the capacity of visual art to sustain the 'Unity of the Hero'; according to Blair, Ossianic poetry amplified this as an issue. But for Ross, Ossian's poetry is unusually dependent on 'sentiment' rather than 'imagery or depiction'. What, then, is Ossian's painter to depict? Certainly not a continuous narrative. Considering the continuous narrative adopted by Annibale Carracci in his *Aeneid* cycle at the Palazzo Fava in Bologna, Ross did not initially 'see any reason why Fingal or Temora might not have been executed in the same manner'.[39] But he concluded that Runciman was right 'in chusing from the works of his poet in general, such subjects as could best be told by the pencil, without regard to connection', paralleling Blair's rejection of 'artfully connected narration'.

In place of properly developed narrative comes a charged physicality. Ross dwells on the physique of the figures depicted by Runciman, the 'deep insertions of the large muscles' and the 'bold contour and high swelling muscles'. The author is preoccupied with the immediate visual experience, carried by a kind of breathless impressionism that halts to dwell on a heroic form

or moment of high drama, as in the scene of *Cairbar murders Cormac*: 'It is impossible to imagine a more terrific figure than that of Cairbar. The bold contour and high swelling muscles; the red hair, dreadful visage, and horror of the action, and wonderfully heightened and contrasted by the youth, beauty, and well expressed innocence of Cormac. The painter here has only the chance of a moment, and one stroke to produce his effect.'[40] The scene of the *Death of Oscar*, documented in a drawing by Runciman (FIG. 86), offers Ross a primal simplicity of costume and dramatic posturing:

> 'We saw Oscar on his shield; we saw his blood around; silence darkens every face; each turns his face and weeps; the King strives to hide his tears.' This piece seems to be executed in the spirit of the poet; Oscar lyes upon his shield, where he had thrown himself to save it from the enemy, and his favourite dog Bran howls at his feet; his friends are crowding around; Ossian the father has covered his head in an agony of grief; Fingal is distinguished by the grandeur of his deportment. The expression is noble, and suits the elevation of his character; 'He strives to hide his tears'. Before Oscar stands a *Culdee*, who seems to view him with a mixture of pity and horror; pity to his virtues, and horror at his expiring in infidelity. A soldier behind, stands astonished to see his leader on the ground. Oscar seems to have forgot himself, and sees for his friends. The 'melting of the soul' is pathetically expressed, and forms altogether a most affecting, and deeply tragic scene.[41]

The twisted figure to the right, identified by Ross as Ossian, Oscar's Father, seems to have been lifted from that of Agamemnon, the father of Iphigenia, in the painting of her sacrifice represented on the easel of the ancient artist Timanthes in Adam Friedrich Oeser's etched title vignette for the German editions of Johann Winckelmann's *Gedanken über die Nachahmung der griechischen Werke in der Mahlerey und Bildhauer-Kunst* (1755). Timanthes' decision to mask the features of the grieving father was described in a number of well-known ancient texts and had long been deployed by modern writers on art as a rhetorical example signalling the limits of art's expressive powers or the importance of the viewer's imagination in making a painting complete. The gesture of shielding the eyes from horror had been recommended by Renaissance theorists, though the French theory of expression had raised the challenge of depicting such extremes of emotion, which had been met by painters in recent years. Accompanied by quotations from Euripides and Horace, Timanthes' image was deployed by Winckelmann to reassert the propriety of the ancient painter as the absolute model for modern painters, contrary to the recommendation of complete expressive lucidity in French academic theory and recent pictorial tradition.[42] The painter's approach is thus made to match Ross's claims that the proper province of visual art was the representation of dramatic action through primal, almost hieroglyphic bodies. Runciman is entirely neglectful of the niceties of anatomy, and, despite his vocation as landscape painter, offers only perfunctory renderings of the landscapes within which the action is meant to be taking place.

The Scottish artist's exaggerated, stylized drawing manner could, still, be described in more conventional terms as the 'charged' style discussed by Roger de Piles and defined contemporaneously by Matthew Pilkington: 'Charged, is a term used by artists, to signify any thing that exceeds; such as exaggerating the outlines, in order to shew a superior degree of skill, and by that means exceeding the bounds of a regular simplicity', but which may please 'because they are above the lowliness of ordinary nature, and carry with them an air of freedom, with an idea of a great taste' in contrast to the correctness of the antique and work of 'Raphael, Domenichino, Nicolo Poussin'.[43] Permission for imperfection was provided in theory by Longinus' *On the Sublime*, Chapter 33, which asked whether it was better to be perfect but mediocre or imper-

fect but Sublime, and promptly and certainly concluded that the latter was the case.[44] So Ross could claim:

> Faults in the drawing may, in several places, be pointed out, though I acknowledge some of them, upon examination, seem rather to carry the appearance of poetical licence. In general this artist possesses a bold, flowing and masterly line, suited to subjects of grandeur and effect. Contrary to modern practice, he seems fond of the *naked*, and loves to dwell upon masculine figures, where bold and strong expressions are required. 'Tis to be hoped he will guard against this stile, in softer subjects, and eazel pictures; if not, it will give them a hardness to any eye, but especially to such as are accustomed to the 'touches moelueux' of the Dutch and Flemish.[45]

The few instances in British art of Ossian being taken up as a subject by other artists

87 Angelica Kauffman, *Trenmor and Imbaca, the Moment of her Discovery to Trenmor*, dated and exhibited 1773. Oil on canvas, 127 × 101.6 cm. Private collection, Scotland.

sees the source-matter cast into the formal language of international classicism, taking Raphael, Domenichino and Poussin as the primary reference points, tempered with allusions to Correggio and the Venetians. An example is the painting of Ossianic cross-dressing, *Trenmor and Imbaca*, by Angelica Kauffman, shown at the Royal Academy in 1773 (FIG. 87). Here, the 'noble disorder' and artlessness that were appreciated in the original texts are suppressed in favour of a pictorial language that speaks more clearly of the cosmopolitan polish and genteel correctness of the proven tastes of the Anglo-British establishment and a civilizing process that could accommodate a degree of gender play.[46]

Runciman's interpreter shared with him a social trajectory that distanced him somewhat from this project. Ross was a close contemporary, a fellow member of the Cape Club and, arguably, shared a sense of social isolation or at least vulnerability. While Ross's occupation as a lawyer gave him a place within the Edinburgh social establishment, as a Writer to the Signet (comparable to the modern solicitor) he did not accrue enormous social or financial status. Both were trained by way of apprenticeship into the 'mechanical' branches of their trades. Both also found their positions within the Edinburgh establishment troublesome. The lawyer argued in print for a systematic, practical training in land law and conveyance (which was only available from private tuition), assailed the Faculty of Advocates for its complacency and conservatism, and lamented the corruption and lack of public spirit among the Scots gentry.[47]

Runciman was similarly employed within, but resistant to, the Edinburgh establishment. After the production of the decorations at Penicuik, he never again had the opportunity to work on a large scale. Aside from a few commissions, he settled into a career as an art teacher, succeeding William Delacour as Master of the Trustees' Academy in Edinburgh in 1772, presumably on the recommendation of Sir James Clerk to his brother, George Maxwell-Clerk, a trustee and a prime mover behind the academy.[48] Although the salary of £120 a year secured him a degree

of financial security, Runciman was employed by the Trustees in November 1772 only 'as the properest person that could be got for so small a Salary as the Board allow to a Drawing Master' and was expected to leave after a year or two. Hardly an auspicious beginning, and it is not perhaps surprising that Runciman seems to have been viewed with, at best, caution, by the Board of Trustees. In 1773 his offer of painting the ceiling of their offices was accepted but never followed up, and in the following year Runciman was being instructed to draw up a list of students, suggesting that there was concern that all was not well: things only went downhill from there.[49]

Runciman, Ross and Fergusson each in their own way stand in antagonistic but unresolved resistance to the emerging divide between the elite of advocates, political agents, professors and gentlemen and the artisanal and working classes in Edinburgh. This rift threatened to reach a dramatic finale in the construction of the new town, the plans for which had gained passage in 1767.[50] Runciman's charged style could be set against contemporaneous works by West and Dance or even Hamilton, who he had taken as an initial model, the latter representing that urbane, cosmopolitan and polished style taken up by the Hanoverian establishment, and the former the awkward, incomplete rebellious attitude of Edinburgh's disenfranchised classes. Still, the nature of the commission for Ossian's Hall complicated the situation further, somewhat obscuring the potentially stark confrontation between the expectations and aspirations of the patron and of the artist. In the most immediately visible way, the decorative properties of the scheme countered the more abrasive qualities of Runciman's painting style. What Clerk had wanted was a decorative scheme and Ross's text laments on behalf of the painter the initially distracting effect of the setting for his friend's paintings – a setting that had been completed while he was away in Italy:

> The moment I entered the apartment now termed *the Hall of Ossian*: the eye is at once dazzled by the splendor of gold and colour, reflected from the bright frames of the other paintings round the sides of the room, and by the rich ornaments covering the divisions of the ceiling; all which, by means of a strong light, renders the whole smiling and brilliant . . . I soon however learned, that no idea of the paintings since executed, entered into the original design, but had been adopted after the ceiling was finished, and ready for the pencil. After some attention this effect goes off and will leave the spectator in a proper disposition to examine the work itself.[51]

Penicuik was, at the end of the day, a place of comfort and luxury, erected not in the spirit of Highland savagery but modern politeness. Its very location betrayed its status. As Clerk's father had written of the house rebuilt by his son:

> The villa is seven or eight miles from Edinburgh. This distance is particularly pleasant to me, and would be, as I suppose, to all men immersed in public affairs, more agreeable than a retreat nearer to the city. For, as Pliny, the younger, says of his Truscan home, here is the most profound and undisturbed ease, there is no need to sport fine clothes, no neighbour calls, and all things give rest and quiet.[52]

Runciman's decidedly inarticulate art required a certain suspension of disbelief, a willing submission to delusion. Standing in a newly built classical interior, richly adorned in the latest taste, the spectator had to loose himself to 'enter' the design and be absorbed by its claims. If the account of Runciman's faults as arising from his genius was not accepted, what was left was instead only grotesquerie. Thus this account of Runciman by the politically moderate Scottish writer, Henry Mackenzie (1745–1831):

A sort of Heaven-taught painter, tho' he went to Rome and studied there for some time. He loved the gigantesque, and resembled in that sort of exaggeration the London painter Fuseli. Sir James Clerk, a great encourager of native merit in the arts, employed him to paint in fresco the Hall at Pennycuik House, called, from the subject suggested by Sir James to the painter, Ossian's Hall. Some of the figures (the females) were beautiful, and the composition of some of the Ossianic stories good; but there was in many of them a very disgusting anatomical exaggeration. In truth, even exclusive of his love of that *outré* sort of anatomy, he wrought in too hurried a manner for any great correctness in the drawing.[53]

Mackenzie's use of the term 'Heaven-taught' is, of course, far from accidental. He had invented the celebrated term in a 1786 review of Fergusson, and in turn, and with a political turn, Robert Burns lavished praise on that poet as 'Heaven-taught'.[54] To be 'Heaven-taught' meant being the kind of original genius that had been celebrated by the reformist writers of the 1750s and 1760s. It also, by this time, meant something more radical: resistance to the cultural hegemony of the educated bourgeoisie and the supposedly effete Anglicized gentry class, the degenerate Highland lairds who bought into the English state establishment and its industrial–capitalist project and sold out their countrymen.[55] Runciman's art was cast as being fuelled by a spontaneous, dishevelled, manic creativity that stood against the politeness of the Anglicized Scot, and indeed the Italianate cosmopolitanism of Hamilton, identified by Mackenzie in an adjoining passage as 'a native of Scotland, but from his long residence in Italy an Italian rather than a Scots painter'.[56] Runciman was aligned with a native, organic conception of 'genius', apparent in an early biographical account that claimed he was compelled to discard an early training in architecture as 'the fertile pencil of Alexander would not long remain contented with drawing straight lines, and plans of elevation. The mutilated, moss-grown trunk, the rifted rock, and the foaming waterfall, were better suited to his romantic genius.'[57]

In Runciman's Ossian scheme, as in Macpherson's poetry, heroic masculinity would seem to have been reduced to single moments of drama, action and violence. In Runciman's career, the effort towards the creation of a heroic imagery was frustrated and fragmented by force of social circumstance and the prescriptions of the intellectual elite. The two years after his return from Italy represented the high point of his career, with the decorations at Penicuik, work at the new Theatre Royal, and the large-scale painted installation at the Episcopal Church on Cowgate. Even so, if his work for Clerk brought Runciman into direct contact with the higher echelons of Scots society, his work for the theatre emerged instead from Edinburgh's convivial society, and his contributions to the Episcopal Church were, in Presbyterian Scotland, liable to be considered controversial.[58] Further commissions for subject paintings did not emerge. Runciman's fractious relationship with the board of trustees at the Trustees' Academy, his affiliation with the Cape Club, and perhaps even his private conduct (he was characterized as 'a dissolute, blasphemous fellow'[59] and had a son outside marriage, apparently with a former mistress of Walter Ross) indicate the degree to which the artist's ambitions were necessarily to come into conflict with the establishment, and his lifestyle to compromise his relationship with patrons.

The choice Runciman made between Achilles and Ossian was not just between the classical and the national but also between the hero whose virtues were staked on a commonly understood narrative and heroes whose virtues subsisted in certain spectacular effects, in the heroic character of their physique and the exhibiting of that physique in a single extravagant action. Runciman's decorations at Penicuik, read in relation to Barry's contemporaneous work, signal the emergence of a new kind of heroic physicality in art, which superseded the greater concern with narrative apparent in the history paintings of the earlier 1760s. Hamilton, West and Dance had each in turn demonstrated that some form of reconciliation between reformed art and

genteel professionalism was possible, if only for the few who had the material and symbolic resources to ingratiate themselves with the established social elite. Runciman and Barry, ill equipped for that task, nonetheless pursued the project of reform. The antisocial destructiveness each demonstrated was perhaps an inevitable consequence of this and one that could now be reconciled with a revised notion of the artist as a counter-cultural figure. It was the extravagant physical conception of heroism and the antisocial artistic stance that Barry and Runciman were exhibiting at the end of the 1760s that came to define the most innovative art of the next decade.

7

HENRY FUSELI
AND THOMAS BANKS
IN ROME

At the beginning of 1774 the Rome-based Jesuit priest and art agent John Thorpe (1726–92) reported to his client, the Eighth Earl of Arundell, that 'the place begins to fill with young English Artists, & more are upon the road'.[1] By then it could be reported that there were over forty British artists in the city; perhaps more than thirty of these had come to Italy since the beginning of the decade.[2] In the following year, Thorpe told the same correspondent: 'The town is full of English Artists, who have all very high pretensions, declame against the old masters, whom not one of them can equal, & would persuade noblemen rather to purchase their performances at extravagant prices, than for less money get a fine piece of Guido, Guercino, Domenichino, or even Raphael himself.'[3] As the Roman art market appeared to be entering a boom phase and the period saw the arrival in the city of several British Grand Tourists reckoned to be willing patrons to their countrymen, Thorpe claimed that none of the leading Roman painters would be tempted away from the city as his client wished while 'the present universal taste for paintings is in vogue'.[4]

It was at this time that William Chambers advised a young architect who had travelled to Italy 'that unless a man does much better than his neighbours, he will have but an indifferent chance of making his way'.[5] Chamber's suggestion is that British students in Rome had to buckle down to serious study. But, given the optimistic rhetoric issued from the Royal Academy and new ideals of original genius, there was little incentive for artists to cultivate the kinds of associations with established masters that had been traditional. Neither Anton Raffael Mengs (who had returned to Italy in 1770) nor Pompeo Batoni seem to have taken any English-speaking painters into their studios, and British artists seem to have abandoned the institutional training available in Rome.[6] The stage was set for an ostentatious abandonment of those norms of artistic practice that had, it seemed to many critics, so inhibited the forms of the Grand Manner favoured by Britain's elite classes.

This is the context for the emergence of the Swiss-born painter Henry Fuseli, the dominant figure in Anglo-Roman art in the 1770s and a domineering force in British history painting for the succeeding half-century.[7] Fuseli had travelled to Italy in 1770 under the sponsorship of a circle of British patrons. Basing himself in Rome, the artist appears very quickly to have established an international reputation. Within a few years reports of his 'genius' were circulating

across Europe; for many of his contemporaries Fuseli was the most important living artist at work in the city. He was, reportedly, the 'wild painter', the 'greatest figure' in Rome.[8] Writing to Johann Gottfried Herder (1744–1803), Fuseli's old friend Johan Caspar Lavater (1741–1801) described him thus:

> Fuseli has the greatest imaginative powers in Rome. He is always extreme – always original; Shakespeare's painter – he's no longer a citizen of England and Zurich, he's a poet and a painter . . . He's an intellectual hard-man . . . a whirlwind and a thunderstorm. – Reynolds told him that he'll be the greatest painter of his age. He despises everyone . . . His wit knows no bounds . . . His look is lightening, his word a storm – his jokes, death and his vengeance, hellish. No one comes near him.[9]

The first large-scale painting he exhibited in London, a *Macbeth* including larger-than-life figures shown at the Royal Academy in 1777, was greeted with a mass of press criticism that, though it registered as much alarm and confusion as admiration, established him as a historical painter of considerable public prominence. In the next handful of years he became the most talked-about painter in London, equally lauded and derided, admired and admonished.

Notably, Fuseli does not seem to have ever been involved with any of the art institutions operating in London at that time, and certainly did not enter the Royal Academy schools although, by his own account, he was personally acquainted with Joshua Reynolds by 1768.[10] He had not received any formal artistic training previously; though his father and siblings were professional artists, early biographical accounts stress that the young Fuseli was never taught art, and he was instead sent to Zurich's Caroline College to study to be a Zwinglian minister.[11] There he was taught by and befriended J. J. Bodmer (1698–1782) and J. J. Breitinger (1701–1776), who were 'actively engaged in reforming the German language', and took holy orders, practising as a preacher.[12] Claiming inspiration from Jean Jacques Rousseau and Voltaire, 'who were then endeavouring by their writings to bring about the reform in the political and moral conditions of society', Fuseli became embroiled, with Lavater, in a campaign against a corrupt local magistrate, as a result of which they were advised to leave Switzerland.[13] Fuseli travelled Germany, befriending Sir Andrew Mitchell (1708–71), the English ambassador to the court of Frederick the Great in Berlin, who concocted some sort of plan to send the young Swiss to London as a cultural emissary, compounding the political alliance of Britain and Prussia that had emerged from the Seven Years War. The plan was vague enough to leave Fuseli at a loose end when he arrived in London in the company of Mitchell in the spring of 1764.

Through Mitchell, Fuseli was quickly introduced to 'advanced' literary society, notably the publishers Andrew Millar (1707–68) and Joseph Johnson (1738–1809), with whom he lodged in these years, the banker Thomas Coutts (1735–1822), the Scottish poet and physician (and Fuseli's future travelling companion) Dr John Armstrong (1709–79), and Patrick Murdoch (*d.*1774), another Scot and the friend and former secretary of Mitchell.[14] Fuseli was obliged to work as a travelling tutor to Lord Chewton, an appointment that ended disastrously in a reported brawl.[15] He may have published some articles in 1764–65, but the first firm evidence of his literary work in England was his translation from the German of Johann Wincklemann's *Reflection on the Painting and Sculpture of the Greeks* (1765), the crucial polemical tract promoting the reform of taste along classical ideals. His one original publication from these years was his *Remarks on the Writings and Conduct of J. J. Rousseau* (1767).[16] A rather eccentrically styled philosophical tract – 'wild, scarcely English, and scarcely commonsense' – emerging from the very public argument between the philosophers Jean Jacques Rousseau and David Hume, this was poorly received but at least created a minor literary controversy.[17] The text provided an effusive commentary on the decay of modern culture, which fitted broadly with contempo-

rary reform discourse.[18] The frontispiece, an original design by Fuseli, adds a further dimension to the text by tackling Rousseau's previous disagreement with Voltaire (FIG. 88). The print features the finely dressed Voltaire riding on the back of a wild man who is eating grass: above him the figures of Justice and Liberty hang from a gallows. Rousseau, in the Armenian costume he affected to wear, stands to the side holding the plumb line of truth and gesturing mockingly at the French philosopher.[19] The truth, we are to take from this image, stands aside from the affectations of culture, where freedom is sacrificed and Voltaire's attack on the 'savage' ideals of Rousseau are made to look ludicrous.

Reviewing his own publication in a literary journal, Fuseli cast himself as a genius and, therefore, an outsider: 'He is evidently a gentleman, a scholar, a philosopher, a genius and a man of wit: though by some of his readers his pretension to either of these titles will be called to question; and by others his character in a summary way well be sunk into that of a downright sceptic (perhaps atheist) and libertine.'[20] Still, the sum total of this 'genius' in the 1760s consisted of a few translations, some essays and reviews, some book illustrations and a portfolio of drawings, and a fleeting attempt at literary notoriety with the *Remarks*. His career to date would have to

88 Charles Grignion after Henry Fuseli, engraved frontispiece to Henry Fuseli, *Remarks on the Writings and Conduct of J. J. Rousseau*, London, 1767.

be described as scrappy, opportunistic and largely improvised. In those respects, it was typical of the larger world of cultural production in Britain. The continuing growth of middle-class literate society seemed to promise renewed liberties and the erosion of elite privileges but, necessarily functioning on commercial lines, it did not offer great certainty, either with regard to individual career paths or cultural values more generally. It was therefore no coincidence that the most influential writers and thinkers proposed (if only rhetorically) certainties – the certainties of an authentically emotive poetic voice, the supreme values of ancient art, the incontrovertible power of 'genius' and the 'Sublime'. The position Fuseli moved into in the mid- to late-1760s was the paradoxical one of finding a location within the cultural establishment by proclaiming one's estrangement from that establishment.[21]

More than a generation older than Fuseli, John Armstrong had in the 1750s rehearsed the terms of this reform discourse in his poetry and essays, insisting on the role of the artist 'to improve and correct public taste', dismissing the 'impotent decline of the eighteenth century' and, in his fleeting comments on the visual arts, castigating the highly conventional and insipid treatment of the passions in the tradition of Charles Le Brun and French academic art.[22] Now, in reviewing the state of the arts in 1770, Armstrong could imagine that Fuseli fulfilled that reforming role:

> As to history itself, besides some promising specimens of it at home, perhaps even this barren age has produced a genius, not indeed of British growth; unpatronized, and at present almost unknown; who may live to astonish, to terrify, to delight all Europe. But true genius is such an uncommon production of nature, and is so much superior to all quackish arts of recommending itself, that when it does appear, it is no wonder that a generation of people without taste do not know it.
>
> Genius may shoot up in a land quite inhospitable to it; it may perhaps even blossom in the most ungenial season. But the rose-bush that displays its blushing honours in the face of the surly uncomfortable east wind, must have sprung from a root of no small vigour.[23]

Thus Fuseli was cast in the role of the organic genius touted in reform discourse for so many years, and the stage was set to allow his eccentricities to be taken as signs of the authenticity of this genius. With his thick accent, which, perforce, served to associate him with the 'savage' Rousseau, giving him an exotic, alien aura and his reputation as a 'fanatical admirer' of that author, Fuseli himself must also have fulfilled expectations of what a genius might be as far as the 'advanced' literary circles he associated with were concerned.[24] He also had a predilection for strong language in conversation, which he shared with and was said to have learnt from Armstrong, and which is, in this context, worth taking seriously. Indeed, remarks on the painter's habitual profanity are a consistent feature of his biographies and anecdotes about him, to the extent that Margaret Patrickson, who held the painter in fond memory, claimed that 'There is no giving Fuseli without swearing.'[25] As Janet Sorensen has noted, swearing could signal the adoption of an urbane, specifically masculine identity, connoting a kind of demotic libertarianism that suited the oppositional politics favoured among the London circles Fuseli associated with at this time.[26]

In May 1768, Fuseli could write to Lavater: 'How are things with me? Here is something for my self-regard: Reynolds tells me that I will be the greatest painter of the age, all I have to do is spend a few years in Rome.'[27] Having put together a portfolio of drawings, Fuseli had been able to raise sponsorship from his old Swiss friend Lavater and from associates in London, and in 1770 he set out to Italy. The first part of the journey was with Armstrong but, after rising tensions between the two, they 'finally quarrelled about the pronunciation of an English word;

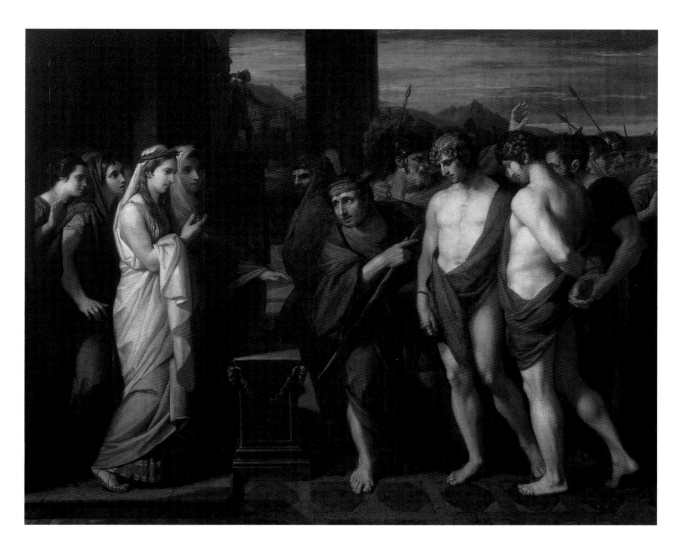

89 Benjamin West, *Orestes and Pylades*, dated and exhibited 1766. Oil on canvas, 100.5 × 126.5, Tate, London.

Fuseli pertinaciously maintaining that a Swiss had as great a right to judge of the correct pro-nunciation of English as a Scotsman', and went their separate ways.[28] Having made fleeting visits to Milan and Florence, Fuseli arrived in Rome by May 1770. He remained there for some eight years, making only short excursions out of the city. According to various independent reports, Fuseli affected an unconventional approach to artistic study. His contemporary in the city, Prince Hoare (1755–1834), recalled:

> After allotting an appropriate time to the examination of the various works of art, which were to be found in the several lesser cities, on his route, he fixed his abode at Rome, then the magnificent depository of all the stores of sculpture and painting. Neither here did he pursue the vulgar track of students, who confine themselves to the servile copying of the works of ancient masters. His ardent imagination, indeed, was little suited to such a task; he felt his mind exalted by the reflection of their copious and enlightened labours, and retiring from intense contemplation of them to his study, while he endeavoured to lift his own ideas to the standard of their excellence, and to assimilate his mind to theirs, he poured out, on

canvas, the glowing conception of his fancy, regardless of any *manner* but that which nature dictated to him. For his subjects he most frequently chose passages of our admired Shakespear and Milton, and sometimes sought them in the stores of his own imagination.[29]

By his own account, the painter spent more time 'among books' than 'applying to the *practise* of his art'.[30] Still an aspiring poet, he penned a piece during his time in Rome that elaborates on the disdainful stance seen before in James Barry. His 'Second Ode on Art' offers an extravagant rejection of normative artistic practice:

> Among the mobs that every northern wind
> Blows into your palaces, oh Rome,
> The mob of Germans, Britons, French,
> The mob of Polish and of Muscovites,
>
> The vermin of art – thus I spent a day
> Wandering with trembling foot among your temples,
> And cursed in furor insensate
> The academies of London and of France.
>
> Contempt, disgust, hope with nocturnal
> Despair wresting – these drove me into solitude,
> To stretch out on my couch rumpled by
> Tossings of agony, and painfully wringing my hands
>
> I exclaimed: 'Is this the way to immortality?
> Did you create, Prime Mover, this, my exalted spirit,
> The sympathies of this, my soul,
> But to count muscles and to mix pigments?'
>
> Did Angelo unlock the gates of heaven
> And bid the gods stride among men
> In order now to arbitrate the quarrel
> Of French and Britons about nature and style?[31]

Only ten years earlier counting muscles and mixing pigments and meeting Rome's international community had been precisely the means considered best for achieving artistic success, as is evident in Samvel Sharp's recommendation of the 'modest and sober' character of art students there (see Chapter 3), the recommendation of social integration and careful study by Benjamin West (see Chapter 2) and Reynolds' more abstract stipulations (see introduction to Part Two). Here, by contrast, the 'stiff-neckedness' claimed by Barry becomes a complete outlook, as the artist assumes a heroic fortitude against the mean interests of Rome's cosmopolitan artistic community. Fuseli suggests, too, an aesthetic correlative to such a stance: the pictorial breadth and uninhibited physicality of Michelangelo. In 1777, he wrote to Lavater to dismiss West's *Orestes and Pylades* (which Fuseli could have seen at the Society of Artists' exhibition in 1766; FIG. 89), which Lavater had proposed as a model for a plate in his forthcoming treatise on physiognomy:

> God knows what you are thinking of with West's Pylades and Orestes. How can anyone who's seen the Raphael Cartoons and thinks they understand the Antinous and Apollo consider describing and analysing these, tame, inexpressive, characterless puppets with derivative heads, which even he'd admit, are worthless? What were you thinking of putting our names together? He has the very, very greatest advantages over me in experience and in the han-

dling of paint, and in the enormous load of figures that he's cooked up, that come smoking daily onto the market from his kitchen, there are a couple of good things – but he has no intellect and he has absolutely no soul.[32]

In a general sense, this recalls Barry's damning commentary on contemporary restorations and also the doubts about the Virgilian polish and refinement of Batoni and Nathaniel Dance expressed by some of their peers. West's picture was exhibited with his *Venus and Cupid* (FIG. 36), and was, he said, similarly painted 'while His mind was full of Corregio'.[33] More particularly, a claim is made for an alternative form of artistic authority, more expressive, characterful and original. It should be remembered how simply outrageous such assertions were. As evident in the portraits of Fuseli by his friend, the Swedish sculptor Johan Tobias Sergel (or Sergell, 1740–1814), such sheer arrogance was readily lampooned even by those who supported him in his claims: Fuseli the self-proclaimed artistic giant, walking among pygmies and driven by furious inspiration, was also Fuseli the five-foot-nothing would-be poet and would-be painter making a spectacle of himself (FIG. 90).

In fact, Fuseli appears to have courted Grand Tourists with some devotion, for at least at the beginning of his stay he enjoyed some distinguished company, and he kept in with the influential dealer and antiquarian James Byres.[34] It appears he may have supplemented his income with work as a guide for a nobleman.[35] He also had some employment as a painter, taking commissions from Thomas Coutts, Sir Robert Smyth (1744–1802), and others, as yet unidentified.[36] By the end of his stay in Italy, Fuseli had certainly finished an enormous (and now lost) canvas of *The Witches show Macbeth Banquo's Descendants*, commissioned by an unknown patron, which was sent back for exhibition in London.[37] However idiosyncratic his behaviour, in some

90 Johan Tobias Sergel, caricature portrait of Henry Fuseli, *c.*1770–78. Pen and ink and wash on paper, 23.4 × 19.4 cm. Nationalmuseum, Stockholm.

91 Henry Fuseli, *The Death of Cardinal Beaufort*, dated 1772, exhibited 1774. Pen and ink and wash over pencil on paper, 64.5 × 80 cm. National Museums, Liverpool (The Walker).

important respects he maintained a conventional professional practice, even if it was not enormously financially rewarding at this point (Fuseli's funds appear to have been insufficient, since he repeatedly asked for money from Lavater).[38] In his *Lives of the Most Eminent British Painters* of 1829–33, Allan Cunningham made the suggestive claim that, given that 'his family were respectable, not opulent; his attempts with the pen had enabled him to live without making his purse overflow, and as his paintings were few' the greater part of his income was secured by 'his winning way in conversation'.[39]

His first notable attempt at a public work while still in Rome was a drawing, *The Death of Cardinal Beaufort*, dated 1772 and shown at the Royal Academy exhibition of 1774 (FIG. 91). The composition of this work bears an obvious resemblance to Gavin Hamilton's *Andromache Bewailing the Death of Hector* (FIG. 21) and through him Nicolas Poussin and the antique. Like John Hamilton Mortimer, Fuseli's sources for his graphic style and corporeal mannerisms were sixteenth and seventeenth-century Italian masters: the drawing shows a general debt to Michelangelo in its conception of vast, swollen heroic bodies, but more especially to mannerist models, particularly Pellegrino Tibaldi (1527–96; FIG. 92).[40] Fuseli has eroticized the heroic physicality of his figures' bodies to a high degree, underscoring their muscular properties and introducing a number of obviously phallic elements. But it would be difficult to read the virile bodies

on show in the image as purposeful in the terms dominant in the sentimental painting of the previous decade. Though composed into the general form of a conventional classical deathbed scene, the central, dying figure is definitively not a canonical hero.

The narrative has at its heart Beaufort, whose utter villainy was proven when he failed to repent on his deathbed – a scene that constituted for contemporaries one of the highlights of Shakespeare's works.[41] It is the cardinal's failure to signal his repentance that Fuseli has dramatized, organizing the composition in terms of stark, almost geometric areas of light and shade pointing towards his contorted form. Perverting his pictorial models, Fuseli presents a scene evacuated of the moral and physical perfection that should be at its compositional and thematic heart. Accordingly, the one sustained critical response to the image focused on its spectacular features: 'There is evidently an Originality of Genius in this Sketch (for it is by no means a finished Drawing) which displays itself by Extravagance in the Ideas, Wildness in the Expression, and Violence in the Actions of his Figures; the Light and Shadow is disposed in broad Masses, and the *tout ensemble* is well composed.'[42] It is the 'originality' of the artist that commands attention, not the emotional content of the scene itself.

In its relatively careful finish and the quite conventional deathbed format, the *Death of Cardinal Beaufort* was uncharacteristic of Fuseli's work of the 1770s and was clearly intended as

92 Pellegrino Tibaldi, design for *St Ambrose Receives the Consular Insignia for the Governership of Liguria and Emilia, c.*1567–74. Pen, sepia wash and black chalk on prepared paper, 48.8 × 30.8 cm. Biblioteca Ambrosia, Milan.

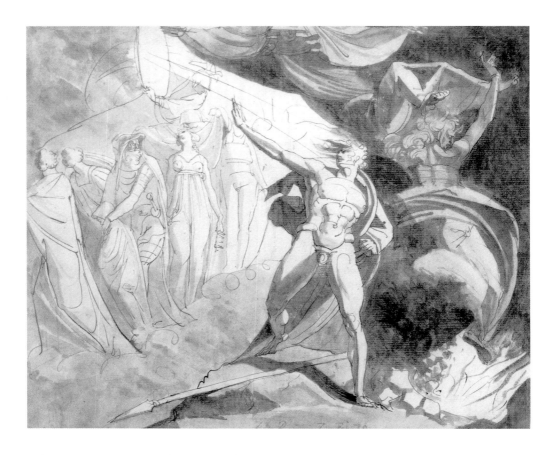

93 Henry Fuseli, *The Witches Show Macbeth Banquo's Descendants*, dated 1773 and 1779. Pen and ink and wash on paper, 36 × 42 cm. Kunsthaus, Zurich.

a showpiece in its own right. Nevertheless, in selecting a subject from Shakespeare as his first Roman work to be viewed by a London audience, Fuseli was signalling his preoccupations as an artist. During 1774 he apparently undertook a series of large-scale canvases on Shakespearean themes. Though these are lost, his graphic work of the period includes numerous Shakespearean subjects, some so fully articulated and large as to suggest that they were preparatory studies for paintings. Moreover, these were predominantly, like the *Death of Cardinal Beaufort*, tragic subjects. While William Hogarth and Francis Hayman had treated Shakespearean subjects earlier in the century and there was a tradition of pictorial illustration, this was the first attempt to produce an extended body of independent imagery based on the plays. Still, in 1781, Robert Edge Pine, launching his own series of paintings from the bard, could claim that they had 'hitherto been unattended to, but for frontispieces of the plays'.[43]

 This search for novel subject matter was significant in a number of different respects. One conclusion to be drawn is that Fuseli was responding to mounting criticism of the stagnation of modern art around a small number of themes. Furthermore, new subjects served to distinguish Fuseli from his contemporaries simply by virtue of his novelty. As Chambers suggested in the letter quoted above, the artistic community was now 'swarming' and it demanded huge efforts to be recognized. But far from simply being an attention-seeking device, Fuseli's extensive exploration of the pictorial potential of Shakespeare's plays should also be seen as embodying a search for new sources of artistic authority prompted by current discourse on originality and the Sublime. Later eighteenth-century criticism of Shakespeare drew on notions of the

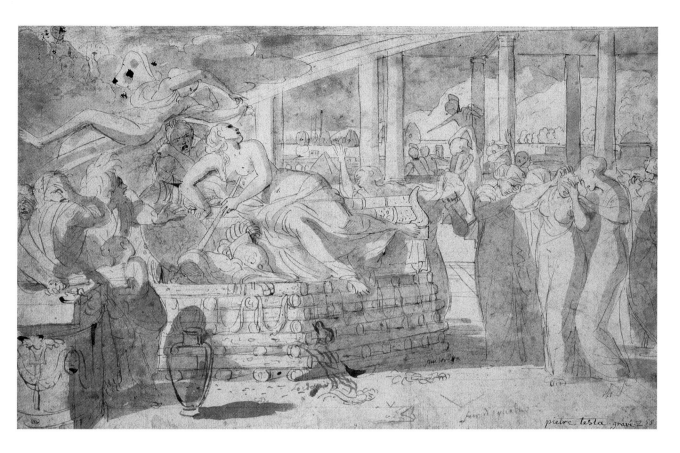

Sublime in order to restate his greatness despite his apparent failure to accord to classical liter-
ary rules. If the Sublime operated as a mode of artistic performance placed rhetorically outside
normative culture, Fuseli doubled up the Sublime resonance of Shakespeare. Not only were the
subjects, in their literary form, beyond the norm; so, too, was their pictorial representation.

Fuseli's approach to his Shakespearean subjects is typified in the drawn composition *The
Witches Show Macbeth Banquo's Descendants*, executed in 1773 and subsequently reworked
(FIG. 93). The choice of subject alone is noteworthy: in depicting the encounter between Macbeth
and the witches when the Scottish hero is presented with a ghostly vision of Banquo's descen-
dants, Fuseli highlighted a moment of supernatural terror. Indeed, Shakespeare's *Macbeth* was
praised as exemplifying the author's Sublime genius precisely because it included such scenes.[44]
Fuseli endeavoured to accentuate the Sublime character of the image with a series of devices.
The viewing point is low, so that the massiveness of Macbeth's form is exaggerated and the
viewer's relative insignificance underscored, while the stacking of the witches adds to the effect
of vertiginous verticality. The witches, defined through areas of dark wash and delimiting an
area of solid tone, function as a kind of curtain or gateway that Macbeth stands astride. Thus,
the image comments on the claim that Shakespeare's sublimity lay in his ability to 'burst the
barriers of a separate state, and disclose the land of Apparitions, Shadows, and Dreams'.[45]
Finally, by setting the figure of Macbeth and the spectral procession on contrasting planes, Fuseli
absolutely denies the theatrical, perspectival space conventional not only in representations of
Shakespearean scenes, but also in classical deathbed scenes of the 1760s. Rather than organiz-

94 Pietro Testa,
study for *The
Suicide of Dido*,
c.1648–50. Pen and
brown ink and light
brown wash over
red chalk with
greyish light brown
wash on paper, 26.9
× 41.5 cm. Musée
du Louvre, Paris.

ing his composition into a stable and unified pictorial space, Fuseli produces a deliberately illog-
ical and disconcerting effect.

As well as giving figural expression to the passage between real and un- or super-real that
was posited as a characteristic of the Shakespearean Sublime, the figure of Macbeth is presented
as embodying the Sublime through his very physicality. Macbeth's posture and physique are
derived from the monumental *Dioscuri* of Monte Cavallo in Rome, figures Fuseli drew on several
occasions during his Roman stay and whose proportions were 'the basis of his style'.[46] As in
Hamilton's *Achilles Vents his Rage on Hector*, this model served as the basis for a massive and
heroic figure intended to dominate the composition. But where Hamilton used only a pose from
the *Dioscuri*, reworking his figure with the addition of historic costume, Fuseli employed also
the abstracted treatment of anatomy apparent in the original and endeavoured to formulate a
graphic language with schematic pictorial qualities that mimic rather than describe their styl-
ized contours and silhouettes. The musculature of Fuseli's figure is characterized as a set of dia-
grammatic forms defined by contour, supplemented with lozenges of wash suggesting volume
only in the most basic way. This style is closely evocative of the work of Luca Cambiaso
(1527–85) and Baccio Bandinelli (1493–1560) and moves, like their work, towards decorative
rather than strictly descriptive effects.[47] Fuseli's particular treatment of the elongated, spectral
figures offers a distinct echo of Pietro Testa's more delicate designs, with fine lines tracing inexact
outlines over otherwise abstract sectors of plain, pale wash (FIG. 94).

This stylistic mannerism – signifying a mode of artistic virtuosity that, while it aspired to strin-
gent classical ideals, tended towards 'wild extravagance' – was anchored by Fuseli to subject
matter and themes that reinforced the association with wildness and excess. There is a sense of
reflexivity in Fuseli's designs that is absent from works by many contemporaries. His unswerv-
ing dedication to violently tragic, supernatural and weird subjects meant that he could hardly
be viewed as adaptable or amenable in his choice of themes; his notorious arrogance and bel-
ligerence would not endear him personally; his consistently mannered graphic style associated
him with eccentric, awkward pictorial traditions. Yet the cumulative effect of these different
levels of antisocial risk-taking was to secure for the artist a peculiar, and peculiarly defined,
identity. What made sense of this identity and of the art was the concept of the Sublime; and it
is here that the losses involved in this risk-taking are revealed.

Macbeth's body, dramatically positioned before a horrifying spectacle, manifests the muscu-
lar exertion that, in Burke's theory, came with the Sublime experience. Such is the schematiza-
tion of Macbeth's body that it virtually takes on the characteristics of armour, appearing as a
moulded representation of the male form rather than a particularized anatomy based on a living
model. Simultaneously, the image asserts an overwhelming masculine presence by figuring the
male body as impenetrable and sheer surface, and underscores the distant, abstracted and unreal
nature of that presence. In fabricating a masculine body that absolutely denied, as in Barry's
paintings, the dissolution of the ideal, and further suppressed the gendered ambiguities of the
sentimental hero, Fuseli highlighted the very artificiality of this ideal and refused to anchor the
narrative action to any ethical point. His Macbeth is caught in a moment of spectacle and the
figure's body becomes part of that spectacle. The gigantic physical efforts of this figure are exces-
sive to the narrative; the classical perfection of his body irrelevant to the story. Fuseli's hero rep-
resents ideal masculinity moving away from exact narrative utility at precisely the point at which
it achieves what must be called phallic fulfilment.[48]

That there is a sexual dimension to be detected in Fuseli's conception of the heroic male body
can be inferred from his association with an international circle of artists gathered in Rome since
the very end of the 1760s and centred on the Swedish sculptor Sergel. A comic drawing by the

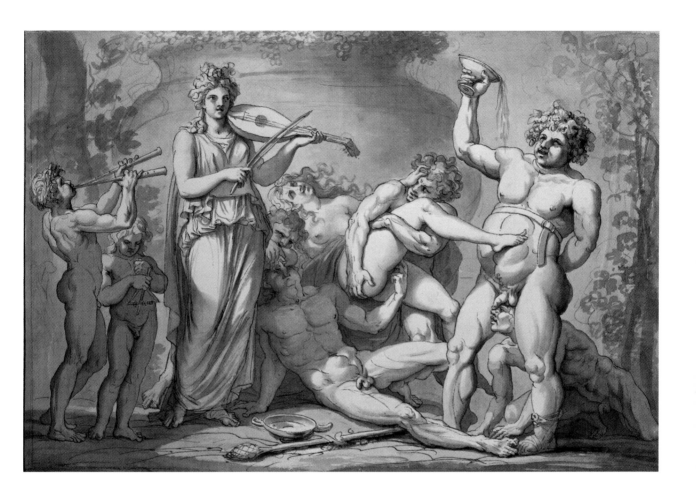

French artist Antoine-Esprit Gibelin (1739–1813) of a Bacchanalian scene involving Sergel (the heavy figure on the right holding up a cup of wine), the painter John Francis Rigaud, who later worked in England (poking his head through his legs), the French artist Vincenzo Valdré (1742?–1814) and Gibelin (grappling with the young woman), incorporates classical and art-historical references even as it insists on figuring the artists' community in terms of bawdy homosociality (FIG. 95).[49] The evidence is that there was a degree of sexual non-conformity current among this group, and what can be gathered from the suppressed evidence suggests that the Grand Tour as a whole was an opportunity for sexual experience and experimentation among Europe's male elite. What Gibelin's drawing suggests is the way that this could be resolved into a novel image of the artist as libertine.

For this, there was intellectual support at hand. In the writings of Richard Payne Knight (1751–1824) in particular, there was a new interest in the specifically masculine and sexual origins of the creative act in primal society, in opposition to the frigid materialism and degeneracy that characterized the modern age.[50] According to Payne Knight, the highest form of creativity, represented by the phallus, was pre-eminently masculine; female creativity was subordinate to it and was a matter simply of natural reproduction. As Ann Bermingham has surmised, the phallic antiquarianism current in these circles asserted that 'religion and civiliza-

95 Antoine-Esprit Gibelin, *Bacchanal in a house in Strada Gregoriana, named after Cinthius Manzonius. Those taking part were Serg . . . Gib . . . Vald . . . Rig . . . accompanied by a woman of pleasure and some hired musicians from Calabria,* c.1769–71. Pen and ink and wash on paper, 23 × 32.2 cm. National-museum, Stockholm.

96 Thomas Banks, *The Death of Germanicus*, commissioned 1773. Marble, 73.7 × 106.7 cm. Holkham Hall, Norfolk.

tion originated in the imposition of sexual difference, a difference that constituted femininity as nature and masculinity as divine, and that associated women's creative power with procreation and men's with the artistic originality of the Creator'.[51]

The political freedom represented in the classical world was thus related not to an actual political system (as in conventional Whig discourse), but to the erotic freedom of the male individual. Just as this strident restatement of Whiggish liberty could slip, in fact, towards libertinism of no clear social or political purpose, so Fuseli's renovation of the classical hero marked a shift away from social signification.[52] Arguably, after being channelled into an attempt to fabricate an imagery of broad social significance in the 1760s and early 1770s, the male hero took on the prime function in Fuseli's work of demonstrating masculine virility at the cost of narrative sense, content and exemplarity. What makes him remarkable was that he found the means of making such heroes pay their way beyond such rarefied contexts as the self-consciously progressive cultural circles of Rome.

The extreme stylization of the male form exhibited in Fuseli's work was taken still further by the Swiss artist's closest British associate, the sculptor Thomas Banks, who had been awarded the first of the Royal Academy's Rome prizes.[53] Although one of the first students at the Royal Academy schools, Banks had experienced a traditional sculptural workman's training. The son of a builder employed on the estate of the Duke of Beaufort, Banks came from a comparable social rank to Alexander Runciman and, like him, had access through the building trades to the realm of artistic production. He followed a full seven-year apprenticeship to the woodcarver and ornamental sculptor William Barlow (d.1765). He also worked for or studied under the sculptors Richard Hayward (1728–1800) and Peter Scheemakers . This constituted a preparation for a subordinate role in a workshop and, perhaps, eventually the establishment of an independent studio to provide decorative and architectural sculptural pieces and, just possibly,

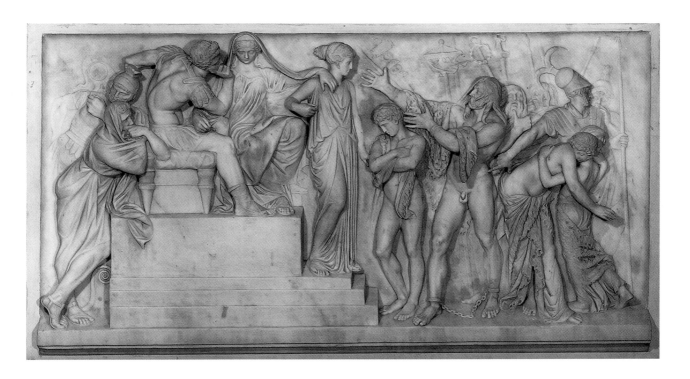

memorial works.[54] It did not, though, provide him with entry into polite society as anything other than a workman.

John Flaxman, in his admiring obituary lecture, claimed that it was Banks' isolation from the mainstream of sculptural practitioners that left him free to develop his own manner, not 'tinctured with the predominant manners of their work', thereby making his biography conform to the ideal of the self-possessed artist freed from the mechanisms of institutional preferment.[55] But there was a social dimension to this as well. As James Northcote (1746–1831), a friend in Rome, recalled, Banks was 'blunt even to rudeness . . . he was quite uneducated nor had be seen much of cultivated life during the time of his youth, or acquired much of the manners afterwards'.[56] The Society of Arts offered one alternative to personal patronage, and he won premium competitions with reliefs of ideal classical subjects and a life-size model of *Prometheus and the Vulture* (lost), bringing him in the years between 1763 and 1769 over £100 in prizes. The *Prometheus*, in particular, would be impossible to reconcile with the kind of skills and material expertise demanded by the market in reality. What direct use could there be in memorial tomb sculpture or architectural decoration for a life-size figure of a titan in eternal torture? Banks' entrance into the academy schools was a further, definitive deviation from the professional course set by his apprenticeship, an acknowledgement that the symbolic capital granted by association with the royal body could take precedence over skills that had already been acquired outside. His passage to Italy with that body's financial support marked the point of no return.

Banks arrived in Rome under the academy's sponsorship by 22 September 1772 and appears rapidly to have acquired commissions in the subsequent months, for in December 1773 he wrote an apologetic letter to Reynolds explaining that he was too busy to send a work to the next exhibition – an obligation that came with the grant.[57] He had probably already received an important commission from Thomas Coke (1784–1842) for the relief of *The Death of Ger-*

97 Thomas Banks, *Caractacus Pleading before the Emperor Claudius in Rome*, commissioned 1774, installed 1777. Marble, 91.5 × 192.4 cm. Stowe Park, Buckinghamshire.

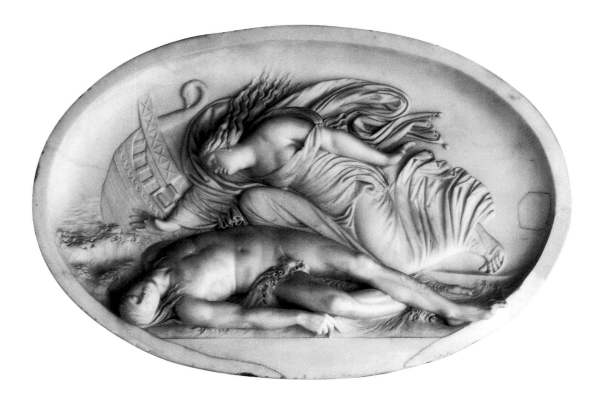

98 Thomas Banks, *Alcyone Discovering the Body of her Husband Ceyx who was Shipwreck'd & driv'n on shore on the Coast of Trachinia*, exhibited 1775. Marble, 77.5 × 112 cm. Lotherton Hall (Leeds Art Gallery).

manicus (FIG. 96) and shortly after would have started work on George Grenville's relief of *Caractacus Before Pleading the Emperor Claudius in Rome* (FIG. 97), both works intended for their patrons' country houses.[58] Coke and Grenville (1753–1813) had been contemporaries at Eton and as men in their very early twenties were of the traditional caste of Grand Tourists. Formally, the works Banks produced for them are explicit in their indebtedness to the classical tradition. Both are lucidly organized around the central male protagonist, whose actions are the focus of attention of the other figures in the relief. Thematically, they deal with heroic male figures drawn from classical sources engaged in noble actions. The Roman general Germanicus is represented at the moment of his death while in effective exile from Rome; from his dying commands proceed the noble actions of his wife Agrippina, who returned to Rome to revenge his death. The Briton Caractacus is shown before his captor Claudius, speaking with such eloquence and power that his life is spared.

With these works Banks was clearly drawing on the discursive resources established in the previous decade for the reconfiguration of the hero in narrative art. Germanicus is readily identified as a sentimental suffering hero; Caractacus as an orator whose rhetorical powers overwhelm his enemies and cause a revolution in his fate – an orator who thus embodies the powers of the Sublime in a specifically national context. Banks effectively situated these alternative masculine ideals within a classical pictorial framework that was of direct appeal to Grand Tour patrons. In effect, he had translated the formal and thematic conventions of Hamilton and West and the thematic concerns exhibited at the Society of Arts into sculptural form, answering the demands of the Grand Tourist for works of art that embodied ennobling themes in an explicitly classical visual form. As a reviewer wrote of Banks in response to the exhibition of the *Car-*

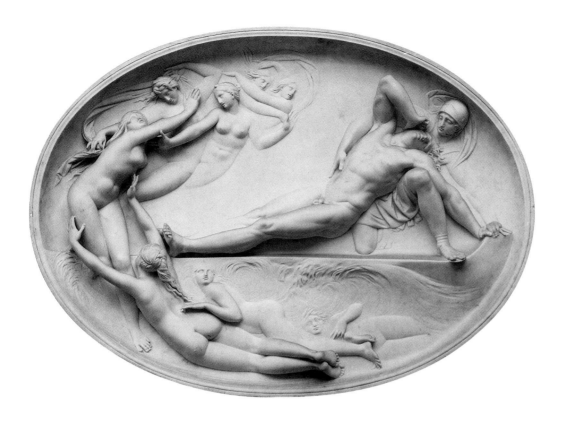

actacus in 1780: 'This man unites the Painter's composition with much of the sculptor's power.'[59]

As he had promised in his letter to Reynolds of December 1773, Banks also sent a work to the exhibition of 1775. This was the bas-relief the sculptor described in a letter to the Academy's council as 'Alcyone discovering the Body of her Husband Ceyx who was Shipwreck'd & driv'n on shore on the Coast of Trachinia' (FIG. 98).[60] Although there has been some confusion over the purposes of the work, the correspondence recorded in the council minutes shows that it was sent to the Royal Academy in fulfilment of the requirements attached to the Rome prize. It can thus be interpreted as an attempt to demonstrate to his sponsors the skills earned in Italy at their expense. In this respect it is significant that the *Ceyx and Alcyone* is in white marble, despite the cost of sending a non-commissioned work like this back to London. Obviously the execution of a finished marble was more time-consuming and expensive than a model in clay or plaster; Banks would not generally even begin work in marble until he had secured a commission (in this confirming the concerns of the anonymous writer of the *Present States of England* (1772) that painters enjoyed a distinct advantage in this respect). The *Ceyx and Alcyone* was also meant to display skills available only outside the Royal Academy: during the early years of his stay Banks was training under G. P. Capitsoldi (1723–1810), an established Italian sculptor who the artist considered to have far greater technical skills that any English master.[61]

More dramatically, the work suggests a concern with the use of contour seen in Fuseli's graphic works of the time and, in the contortion of Alcyone's body, the schematic treatment of draperies and the bizarrely compressed composition, it marks a similar desire to find a distinctive visual language. Just as Fuseli's painted work is marked by characteristics developed in the private media of drawing, where greater formal and thematic licence was conventionally granted,

99 Thomas Banks, *Thetis and her Nymphs Rising from the Sea to Console Achilles for the Loss of Patroclus*, *c.*1777–78, completed posthumously, *c.*1805–7. Marble, 91.4 × 118.7 cm. Victoria and Albert Museum, London.

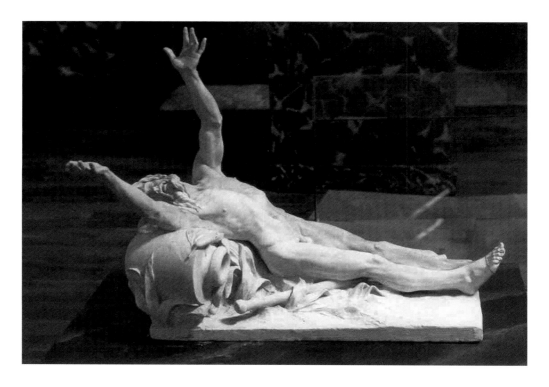

100 Clodion, *The River Scamadre*, c.1762. Plaster, 69 × 90 × 5.6 cm. Musée Dumont, Semur-en-Auxois (Cote d'Or) inv. 885.s.1.

so Banks' relief bears the character of ancient gems in its oval format and tight decorative composition.[62] The intimacy and formal simplification of such small-scale work is translated into the public medium of the relief – a form conventionally intended (as Banks would have known from working in Barlow's studio) as architectural decoration.

Banks' relief depicts the moment in Ovid's narrative when Alcyone discovers the body of her husband Ceyx, who has drowned while in search of the Delphic Oracle – a journey Alcyone had begged him not to take. The image thus fits a pattern of imagery developed by British artists since the 1760s: that of sentimental suffering, where a hero's death is the object of a communal sympathetic response that fabricates an imaginative continuum between an idealized representational audience and the actual audience. Read in those terms, Alcyone gives full vent to the feelings of the sentimental community through her figuration of a powerful feminine presence.

Banks has figured the body of Ceyx as consummately phallic, smooth, complete, integrated, and in its expressionless features and athletic form, unified and impenetrable. Yet it is also, as compared with the hirsute and erect Caractacus, inert and thus feminized, in accordance with the complex erotic dynamic surrounding the appreciation of classical bodies.[63] The most widespread ideal of classical masculine beauty promulgated by eighteenth-century travel literature and art writing suggested a bodily type 'that can easily be classified as feminised', while aesthetic pleasure in male bodies evoked an eroticized mode of looking that potentially cast the viewer in an unmanly role.[64] Traditionally, the ideal male form was imagined as a compromise between 'feminine' softness and smoothness, which ensured the unity of the body, and 'masculine' muscularity, which disturbed bodily integrity while signifying manliness unequivocally.[65] Notably, the narrative of *Ceyx and Alcyone* turns on the meaningless self-sacrifice of the hero and the highly emotional response of a female character. What moral value there may be to draw from the subject subsists in the perfected physicality of the protagonists, conveyed in tech-

101 Thomas Banks, *Design for a National Monument to the Memory of Captain Cook*, 1780. Etching, 32.5 × 22.6 cm. The British Museum, London.

nically consummate carved marble. Such a work does not insist on being considered anything more than decoration, ultimately.

Perhaps more awkward, in its formal daring and its presentation of the heroic body, is the succeeding work by Banks, *Thetis and Her Nymphs Rising from the Sea to Console Achilles for the Loss of Patroclus* (FIG. 99). This appears to have been commissioned and rejected by Frederick Augustus Hervey, bishop of Derry and later earl of Bristol (1730–1803), a notoriously unreliable patron.[66] Banks depicts Achilles, in emotional torment on receiving the news of Patroclus's death, collapsing on the seashore supported by his companion. From the sea rises his mother, Thetis, to console him, accompanied by sea nymphs. Eighteenth-century commentators were troubled by the highly emotional behaviour of Achilles; his tears were seen as inappropriate in a hero. More significantly, his passivity at such points was read as a wholly unmanly retreat from responsibility.[67] As one critic put it, Achilles could be 'a great lubberly school-boy, whimpering to his mother'.[68] Yet Banks' relief gives Achilles' torment full expression. The figure's form is stretched across the composition with complete disregard for naturalistic space, in stark contrast to more conventionally illusionistic reliefs. His bizarrely taut body dominates the composition and is presented as an almost geometric sign of grief.

This work has been associated with that of Sergel, who in the same period was creating comparably expressive classical pieces, including an *Achilles on the Shore* (Nationalmuseum, Stockholm).[69] The particular strained angularity of Banks' Achilles is quite unlike the Swede's work, though. It can be found in antique gems and reliefs, in Enea Vico's engraving from Raphael's *The Lamentation* (1548; copied by Fuseli around this time) and, perhaps, Clodion's figure of *The River Scamadre* (FIG. 100). But the extreme stylization apparent in this relief was, on this scale, without precedent. As in Fuseli's *Macbeth*, the central protagonist is an emphatically phallic presence yet stands as an exemplum of little but masculine physicality. In each case, the

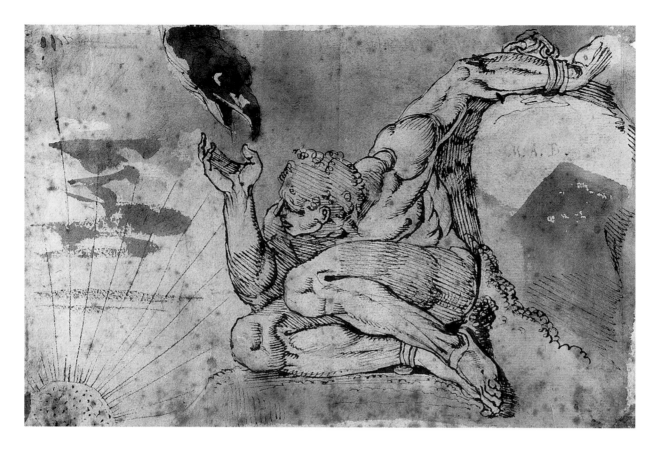

102 Henry Fuseli, 'five-point' drawing representing *Prometheus*, c.1770–71. Pen on paper, 15 × 22.6 cm. Öffentliche Kunstsammlung, Basle.

masculine body is presented as a form of hieroglyph, the graphic embodiment of the 'exertion of the contracting power of the muscles' Burke had identified as the effect of the Sublime, or the phallic fulfilment that promised a return to primal authenticity.[70]

The counter-narrational properties of the heroic body once recast in these terms are most apparent in the playful approach to figurative draughtsmanship assumed by Fuseli and Banks, notably in the 'five-point' drawings that they created together. In these exercises the artists would place five dots on a blank sheet of paper and attempt to connect them by drawing in the extremities of a single figure. A number of examples of the results of the game, with the points still visible, survive (FIG. 102).[71] None of Banks' designs seems to have survived; something of their character can perhaps be gathered from the nude included in the autograph etching of a monument to Captain Cook executed by Banks immediately after his return from Rome (FIG. 101). The nature of the game meant that the figure was conceived through the kind of hasty linear techniques associated with the virtuosity of Cambiaso and Bandinelli (FIG. 103) (the latter is particularly recalled by Fuseli's drawing shown in figure 102) and that it was, naturally, made to assume extraordinary poses.

In itself, the game was not novel: art theorists had advised that it was a most useful practice for an art student to take up in their spare time, encouraging visual ingenuity and facility in the depiction of the body.[72] But with Fuseli the game was not simply an aid to the acquisition of skills as a figurative draughtsman or a prompt to invention. To judge from the extraordinary variety of bizarre, illogical poses apparent in his works the game would seem to have contributed to the formulation of finished works by such designs being liberally grafted into a composition.

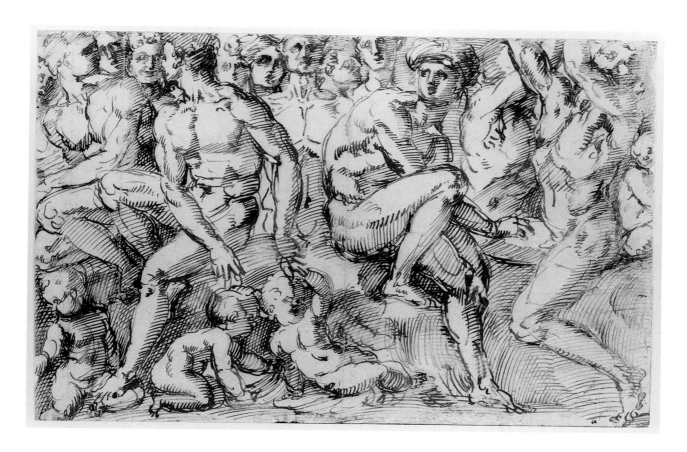

The five-point drawing by Fuseli shown in figure 102 has itself been transformed into a narrative subject by the simple addition of chains and an eagle; and the nude figure on the Cook monument by Banks can be read as a product of the five-point game refigured as an element in funerary iconography.

In this respect the practice represents a radical departure from the concept of the figurative act proposed in academic tradition and by Reynolds, which insisted that the artist approached the ideal through a close attention to natural forms. In this approach the final work of art might be thoroughly abstracted from the natural world, either through the purification of given forms with reference to the antique or the imaginative combination of a range of perceived elements, but its initial formulation depended on direct perception, if only mnemonically. In the 'five-point' games, the figure instead emerged out of a geometrical scheme that bore no resemblance to a natural form. The drawings could almost be used to illustrate the 'dazzling excellencies' that Reynolds warned against, the danger as he saw it of the artist 'presuming on his own sense' rather than looking closely to nature and the established standards of art. In place of the ponderous intellectual and practical exercise of design as a way of understanding the world through observation, the five-point method established a constructionist approach to the body. Thus the exclamation attributed to Giovanni Battista Piranesi on seeing Fuseli at work: 'This is not called *designing*, but *building* a man.'[73]

The draughtsmanship of Fuseli in the 1770s represents two contradictory tendencies. On the one hand, there was a concerted effort to go beyond the standards set by Hamilton and West in expression and drama, which served to draw attention to Fuseli's identity as an artist and

103 Baccio Bandinelli, sheet of figure studies. 28 × 42.7 cm. The British Museum, London.

104 Henry Fuseli,
figure study
(derived from
Andrea del Sarto's
*Beheading of John
the Baptist*,
Monastario dello
Scalzo, Florence),
*c.*1777–78. Pen and
ink on paper, 47.5
× 48.8 cm. The
British Museum,
London.

make him stand out from the crowd. That tendency involved an overblown assertiveness, ensuring that every subject was the most dramatic and violent that could be found, that his draughtsmanship was as expressive and individual as possible, that his heroes were superhuman and gigantic. On the other hand, the process of achieving that aim raised uncertainties with regard to the moral content of his subject matter and the narrative coherence of the bodies he represented. Such works bear description in the terms developed by the film theorist Linda Williams to discuss the 'body genres' of contemporary pornography, melodrama and horror (the three genres in which Fuseli came to specialise in this decade), which establish in their representation of excessive bodies a challenge to 'efficient action-centred, goal-oriented linear narratives driven by the desire of a single protagonist, involving one or two lines of action, and leading to a definitive closure'.[74]

In Fuseli's graphic work, the ostentatious effort to distinguish and delineate every muscle as a sign of a specifically masculine physicality leads to the disintegration of the body as a whole. The male form is reduced to a collection of notational marks that are not necessarily directly descriptive; rather, any individual mark could represent either the cleavage of a muscle formation, the outline of an individual muscle, or a contour defining the surface of a form (FIG. 104). This overdetermined graphic individualism was in violent contradistinction to Charles Dufresnoy's stipulation that the muscles of a figure should not be too visible, 'to avoid the multiplicity of lines'.[75] According to Albertian conceptions of the body, the delineation of every muscle of a figure was meant to contribute to its purpose within the narrative of the whole image.

Within Fuseli's graphic works, the creation of a figure was potentially much more an end in itself, its significance resting in the iconic demonstration of artistic expertise.

The use of drawing as a medium by Fuseli and his circle thereby confounded distinctions between the public and private functions of graphic art, denying the conventional proprieties that dictated the proper use of media.[76] In academic terms, presented in Reynolds' *Discourses*, drawing (as a medium, rather than in its ideal role as 'design') preceded painting, setting the forms and images that colour and painterly substance only enhanced in a supplementary fashion. Insofar as there were great pleasures to be drawn from unfinished sketches, these were properly private delights to be enjoyed with some degree of guilt. Yet with something like Fuseli's enormous drawing of *King Lear Supported by Kent and the Fool Meeting Edgar on the Heath* the technical latitude and formal extravagance associated with the sketch are maintained in a work some 3-feet across (FIG. 105). Neither a sketch nor a finished, elaborated cartoon, on an indeterminate scale that puts it beyond the portfolio, this design and others like it sit uneasily within the accepted categories of graphic production.

James Jefferys (1751–84) produced large drawings in the same vein (FIG. 106) when in Rome in this decade, and George Romney made a series of large and impressive designs shorty after arriving back in England after a period in Italy in the mid-1770s.[77] His version of the *Prometheus* theme offers a vivid demonstration of the anatomical latitude permitted in this mode (FIG. 107). The suffering figure's legs are dislocated from his torso, abandoning that systematic joining of part to part, the careful bounding of a form without outline, so central to academic artistic practice. His torso and arms are in place, but if the viewer tries to follow his body down, beyond the occlusion of the foreground figure, there is, instead of a carefully plotted continuation of his form, a range of alternative markings that lead to the more legible lower portion of his left leg. The gestures of the two figures on the left remain extravagant and unclear. And none of this seems to be only a matter of the design being incomplete, but rather of the composition being worked out as the artist has gone along. The 'Cartoons' seem to have been largely improvised on the support itself, not enlarged (at least in any very calculated way) from smaller studies. So although there is a smaller sketch of the *Prometheus* of the same date (private collection), it may as easily post-date as precede the large design: it has certainly not been scaled up, nor have the problems apparent in the larger work been resolved or even very effectively addressed in the small piece.

The Sublime and original genius gave licence to a careless, visibly rushed, risk-taking graphicity, a way of securing what has been termed in another context 'short-cuts to greatness'.[78] Comparing the Roman drawings of Runciman and Fuseli, Cunningham wrote 'they are distinguished by the same splendid freedom of outline, – the same dashing mode of treatment – the same immoderate length of body and limb, and the resolution of never doing a gentle action with ease, nor an heroic one without perilous straining and toiling'.[79] Works like these, and Romney's *Prometheus* more than most, are susceptible to interpretation as expressive of the artist's 'personality'.[80] Yet to emphasise the spontaneous, expressionistic qualities of such drawings still leads to frustration. Fuseli's style of draughtsmanship was taken up and adapted by artists of diverse backgrounds, experiences and ambitions, including most notably Runciman's friend and pupil, the draughtsman John Brown (1749–87); the painters Romney and Henry Tresham (1751–1814); and the Royal Academy's Rome scholar Jefferys. James Northcote and Prince Hoare literally copied his works, arguably undermining their status as expressive, individualistic sketches. Fuseli's *Death of Cardinal Beaufort* was shown in exhibition, though 'it is by no means a finished Drawing'. Romney's large designs were seen and admired by contemporaries and at one point they were recommended to William Blake as appropriate subjects for reproductive engravings. Massively expressive of artistic ego but fragmented and awkward, original

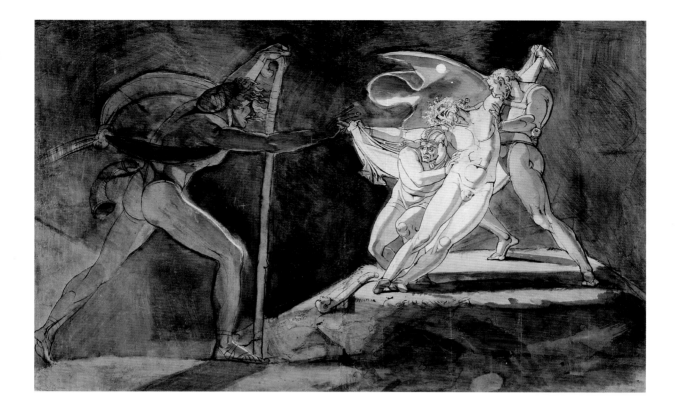

105 Henry Fuseli, *King Lear Supported by Kent and the Fool Meeting Edgar on the Heath*, 1772. Pen and sepia wash over traces of pencil, 61 × 97.5 CM. Birmingham Museums and Art Gallery.

but imitated, public and private, the drawings of the Fuseli circle exhibit contradictions that unsettled the narrative and exemplary functions of heroic art and the heroic body. Assessed by the standards of 'scrupulous exactness' recommended by Reynolds in his early discourses, these designs could be interpreted as an affront to academic practice and perhaps the academy itself.

Some of the questions raised here were addressed directly when Fuseli and Banks' work was given public exposure in London at the end of the 1770s. When Banks showed his design for the Cook monument at the Royal Academy in 1780, a critic complained that 'a most extravagant Design, for an ungainly Figure, representing Capt. Cook, is thrown over a Globe, which he nearly encircles.'[81] Cook represented a new form of national hero – 'the explorer's "man of feeling" who died on the altar of national service with more blood brothers than bloodshed to his credit' as Kathleen Wilson has put it[82] – and in these qualities stood as the opposite of those imperialist conquistadors whose actions had been so much in question over the previous decade. Yet Banks sought to represent him in an inappropriately heroic physical form that neither fitted the accepted image of the dead man nor was fully realizable in a practical form nor entirely congruent with the prevalent tendency to compromise the classical content of public monuments to modern heroes.

Accusations of extravagance were standard in responses to Fuseli. After the single review of the *Death of Cardinal Beaufort* in 1774, a great wave of critical response accompanied a picture Fuseli exhibited at the Royal Academy in 1777. The catalogue identified Fuseli's painting simply as 'No. 127. A Scene from Macbeth', but the evidence is that this was a very large canvas, showing the witches conjuring the ghostly procession of Banquo's descendants.[83] The *Morning Chronicle* referred to the large size of the figures and hinted at the picture's composition and

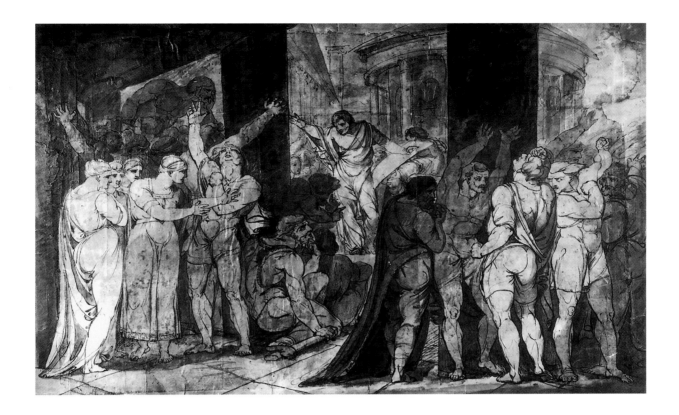

subject matter in a way that suggests the exhibited painting may have been based on the drawing of this scene from 1773:

> MR FUSOLE's scene of Macbeth shews a fine poetical imagination, although the enormous size of the figures and the disposition of the Witches over Macbeth's head, rather serve to prove that such a scene never existed in nature than to give the coinage of the brain currency. The vision of the Ghosts and Kings *that shall be*, is finely conceived and expressed.[84]

Although reviewers were generally favourable to the picture, there were concerns that, in exercising his imagination too freely, Fuseli had exceeded the bounds of good or conventional taste. The material appearance of the picture was criticized, with 'Gaudenzio' ('an Italian Artist in London') complementing the high aspirations of the artist but quipping 'it may be said there is too much Poetry, and not enough Painting in this Piece'.[85] Another commentator in the *General Advertiser* took up a negative viewpoint that reinforces the reading of Fuseli's treatment of the body given above:

> Of all the scenes yet taken from our immortal Poet, perhaps this is the most extravagant. – The portrait of Macbeth is infinitely larger than the life & from the attitude puts one in mind of a gigantic Quixot fighting the windmills – In short it plainly appears, the painter aimed at something great, & we must confess he has succeeded – in point of size.[86]

Fuseli's ambition is here comically deflated. His overblown hero and his own ambitions as an artist could be seen as having Quixotic qualities, offering up a timeless vision of superheroic strength and ghostly spectres in an age of self-conscious reason, science and fashionable frip-

106 James Jefferys, unidentified scene (perhaps *The Body of Lucretia Exposed to the Romans*), c.1777–78. Pen and brown ink, brush and grey wash on joined sheets of tracing paper, varnished, 59.5 × 91 CM. Royal Academy of Arts, London.

107 George
Romney,
Prometheus Bound,
c.1779–80. Black
chalk on six sheets
of laid paper, 100.5
× 126 cm. National
Museums, Liverpool
(The Walker).

peries. If the *Macbeth* drawing of 1773/79 can properly be considered a summation of all Fuseli's ambitions in the 1770s, the writer in the *General Advertiser* might properly be considered as his most acute critic. In landing on the Quixotic analogy, this critic acknowledged what was to become the key truth about the image of the hero in the modern age: that to be heroic now was to risk becoming absurd.

Fuseli perhaps knew something of this sort when he produced a set of drawings towards the end of his stay in Rome casting Shakespearean characters as figures in a Michelangeloesque ceiling scheme (FIG. 108).[87] Are these caricatures or serious suggestions for a pictorial programme? There is a wilful grotesquerie at play in the conception of the figures, a comical extravagance of gesture and expression that is not found elsewhere in Fuseli's designs. Can the disembodied hand that hovers above the body of Duncan in the right-hand lunette really be taken seriously? If these designs are to be taken as a straightforward proposal for a pictorial scheme, it must still be acknowledged that what they propose is architecturally impossible. The abrupt juxtaposition of fragmented scenes makes a further nonsense of art's narrative function. Even Shakespeare, the greatest writer in the English language, the embodiment of the powers of Sublime genius for German and English writers and a most promising resource for artists seeking to create an original heroic imagery, might look simply silly poured into the pictorial mould provided by Michelangelo. These designs might be seen as hopelessly aspirational or self-mocking; either way, they register a sense of historical alienation that is, as the reviewer of 1777 spotted, wholly Quixotic.

Twenty years earlier, a conglomerate of British artists had formed in Rome that were to introduce into Britain a reformist classical aesthetic and were to take a central role in the institu-

tionalization of the arts and the promotion of royal cultural authority. Chambers, Joseph Wilton, Reynolds and their peers had overseen the establishment of a Royal Academy. While plans for such an academy became fixed, West and then Dance, Runciman and Barry had taken the trip to Italy in the hope that it would form the catalyst that would launch their careers as artists in the heroic mode. Now, in the 1770s, a further, rather motley group gathered in Europe's cultural capital. But even since the arrival of Runciman and Barry only five years or so earlier, the definition of the Grand Manner had become fraught. And where they had had only a few competitors, there was now a whole generation competing for attention, expecting reward and demanding approbation.

Though the foundation of the academy had rekindled hopes of a revival of the arts, the terms on which that revival might realistically take place had become utterly confused. Romney failed in his ambitions. John Brown returned to Edinburgh and was occupied as a portrait draughtsman. Northcote struggled on his return, as will be seen. James Jefferys died young. Prince Hoare never had to paint for a living and came into his own as a playwright and later as the foreign secretary of the academy at the beginning of the nineteenth century. Henry Tresham became more fully occupied as an art dealer than as a painter. Banks returned to England in 1779, sick and exhausted, and ended up going to Russia in 1781 in pursuit of patronage, having failed in his native country. Not one of his contemporaries in Rome was able to launch themselves so dramatically and successfully as Fuseli.

In this regard, it seems fair to take seriously Fuseli's extravagant posturing, given quite literal graphic form in a caricature drawing sent by him on his journey back to England to Northcote, then travelling himself through northern Italy (FIG. 109).[88] A gigantic, heroic figure is shown

108 (left)
Henry Fuseli, design for a 'Shakespeare Fresco': *Macbeth*, c.1777–78. Pen and ink and brown wash on paper, 27.3 × 19.6 cm. The British Museum, London.

109 (right)
Henry Fuseli, caricature of the artist leaving Italy, 1778. Pen and sepia ink on paper, 24.5 × 19.3 cm. Kunsthaus, Zurich.

straddling a schematic map of Europe. To the top left a phallic bird, representing the artist's desire, flies towards Italy. At the bottom of the image is 'England', occupied by three mice named 'Humphry' (the portrait painter Ozias Humphry; 1742–1810), 'Romney' and 'B. West'. In the accompanying letter, Fuseli warned Northcote to 'Take heed of the mice'. Meanwhile, Fuseli's heroic figure shits into a pot labelled 'Switzerland'. If the figure is interpreted as a representation of Fuseli himself, his hopes and desires fly back towards Italy, while only artistic 'mice' await him in England. His views on his native Switzerland should be self-explanatory, highlighting once more the artist's inclination to profanity.

Such posturing has a place in a private correspondence, but what may be most remarkable about Fuseli's career is that he translated it into the public sphere, with works that confrontationally set out to establish forms of masculinity that were strident and uncouth, simultaneously comical and passionately serious. As hopes for the revival of the arts in Britain plunged to new lows, such extravagance and absurdity was, if not inevitable, recuperated as signifying novel forms of cultural capital.

PART THREE

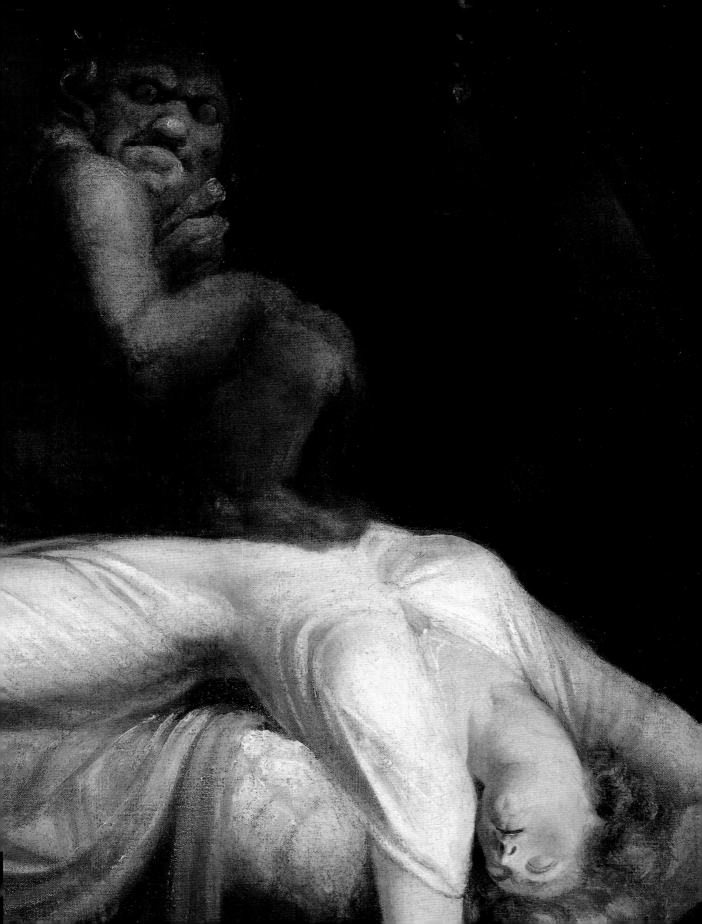

'A WEAK DISJOINTED AGE'

THE STATE OF THE ARTS 1775–1785

The first volleys of the war for American independence in the spring of 1775 marked the beginning of the most arduous testing and ultimate breakdown of the Hanoverian imperial state, and with it classical ideals of virtuous masculine heroism. As bloody conflict loomed, Horace Walpole wrote that 'We are given up to profusion, extravagance and pleasure – Heroism is not at all in fashion.'[1] The gender anxieties that had crystallized around the Macaroni persisted and perhaps deepened in the war years: 'the whole order of nature is inverted, night & day have chang'd places, the men are effeminate & altho the women are not in all points masculin, yet unless they are belyed in some very essential ones they take upon them the duty of men.'[2] Popular riots, particularly the almost unbelievable anti-Catholic violence of 1780, as well as political commotion (peaking around the manifestly opportunistic Fox–North alliance of 1783–84) and ongoing unrest in Ireland compounded a sense of unease. The impeachment and trial of Warren Hastings (1732–1818), governor-general of Bengal, for the purported abuse of imperial authority in India represented the climax of anti-imperialist misgivings that had seen Britain's overseas interests characterized in terms of tyranny and vice.

Aggravating all of these issues, the 1780s saw an unprecedented growth of press commentary, gossip, scandal, puffing and libel that was perceived as overwhelming efforts at reform: 'a busy, bustling time . . . when party rage runs strong / and mightier madness checks the flowing song'.[3] Attacks on luxury became a sustained feature of novels and social criticism, now detached from the context of classical debate on virtue and commerce and fixed firmly on the favoured targets of contemporary fashion and metropolitan manners, which were evoked with precision and in detail.[4]

Many observers believed the war had a material impact on the arts. While the press criticism of the early 1770s suggested that the tendency of painters to treat the same themes would not long be accepted by the public, in the later part of the decade there was evidence that such works would simply not find a market in London. Removed from the privileged context of personal artist–patron relationships as they had emerged in Rome, even the most highly esteemed productions of the classical revival were subject to drastic depreciation. When it appeared for sale at Christie's in 1776, Gavin Hamilton's *Andromache Bewailing the Death of Hector* (FIG. 21) sold for thirty-five pounds. Less than twenty years earlier the picture had cost its original patron three hundred pounds. The price fetched was considered so small that for several days after the auction the painting remained on show in Christie's rooms as a public spectacle.[5] The sale and exportation in 1779 of the spectacular art collection of the former primer minister and overseer of Britain's commercial ascendancy, Robert Walpole (1476–1745), was taken as 'one of the most

Henry Fuseli, *The Nightmare*, detail of FIG. 135.

striking instances that can be produced of the decline of the empire of Great Britain'.[6] In that year the print publisher William Watts wrote to the Liverpool upholsterer and art enthusiast Matthew Gregson:

> With respect to the Arts & Sciences, I am sorry to say they are but little encouraged in these times of public disturbances, many of the first Painters having little or no employment; you may possibly have heard that the Empress of Russia last month purchased a part of the much admired Houghton Collection for 14,000£, which is interpreted as an unfavourable omen to this Country, in short nothing is heard but the beating of Drums & 'the vile squeaking of the wryneck'd fife' as Shylock phrases it.[7]

Watts' sentiments were widely shared. The war certainly had an immediate effect on the fortunes of artists who had moved to Rome and now planned to return to England to establish themselves. With the possibility of France joining the war beginning to look inevitable in 1777, the stream of artists going to Italy slowed down and the flow of artists returning to Britain increased, further heightening concern that London would become overpopulated with painters and sculptors.[8] After his return from Italy, the painter David Allan wrote that, while he was now in useful employment:

> I wish it was in the invention [of] Groups as I once began at Rome, but has been obliged to give it up for want of incouragmt. It is deplorable to think that great Britain in Generall has not sooner begun to incourage her young ones in the study of History, the nobles part of painting, Sr Joshua Reynolds aims with his pamphlets of academic discourses to correct their tast, this is praiseworthy but a difficult task. If we canot pursue our natural turns for want of encouragement, must have patience & in these times, lay by the antique modles & copy Gothick wigs or copy what object is ordered wether it has expression or none at all but as we are not independent must necessarly do it per Vivere.[9]

For younger artists, the future looked even bleaker. An aspiring young Scottish painter in London in 1777, George Heriot, viewed his prospects with trepidation even though he had letters of recommendation to as influential a figure as Robert Adam. He drew a revealing contrast between the challenges of the real world and the too-easy admission into the hothouse environment of the Royal Academy:

> Few or none of the Artists take apprentices or journeymen. I understand it is very easy to gain admittance into the Academy. The form of admission is only this, to make a drawing from the plaister, and show it to a Gentleman who is appointed for that purpose. The students there have their Instructions *gratis*, but have no allowance or Salary, as in France. Some Gentlemen who are my friends and welwishers, advise me to lay aside the thoughts of following Painting and endeavour to get into a Merchant or Banker's House . . . The number of Painters at present in London, and of young students who are following that Profession, is indeed, inconceivable. There are some men, men of very great merit in that Line, that are complaining for want of employment, and others who are obliged to leave their native Country, and seek it in the most distant parts of the world.[10]

Much the same point was made at the other end of the war, by the musicologist Charles Burney (1726–1810):

> I have long seen and predicted that the polite arts have been fostered, cherished, and are arrived almost at maturity in this ruined country merely to be starved to death! The swarm of young artists who have been students in the Royal Academy has over-stocked the capital

and country so much that I am told many of them are at present in the utmost indigence. Zoffani and Humphreys are gone to the East Indies, and Pine, with several others, to the West.[11]

110 Thomas Malton, *The Strand, with Somerset House and St Mary's Church*, perhaps exhibited as *View of the Royal Academy* in 1781. Pencil, watercolour, pen and ink on paper, 32.7 × 47.8 cm. Victoria and Albert Museum, London.

In the wake of Britain's defeat and in a period of demilitarization that saw riots and rising levels of criminality around the country, Walpole wrote: 'The town is overrun with painters, as much as with disbanded soldiers, sailors and ministers, and I doubt half of all four classes must be hanged for robbing on the highway, before the rest can get bread, or anybody else eat theirs in quiet.'[12] The reformist efforts of the late 1750s had raised an army and elevated the arts. The prosperity of the first British Empire, established through victory against France and Spain, promised a new dawn of cultural achievement, spearheaded by the king's artists gathered in his academy. But now, Britain's army had turned into marauders threatening life and property, and her artists into a no less desperate (if not so physically intimidating) crew.

The irony of this state of affairs was sharpened by the ostensible triumphs of the Royal Academy, which achieved a virtual monopoly over artistic training and exhibiting in these years. The competing Free Society of Artists held its final exhibition in 1783, while the Society of Artists' show of that year was the last for seven years. In 1780 the Royal Academy had moved into purpose-built rooms at the newly constructed Somerset House on the Strand, the largest and most architecturally distinguished public building of late eighteenth-century London, designed in a sophisticated classical style by William Chambers and elaborately decorated by a number of his colleagues. Included in the design were rooms specifically for council meetings, a large

space for the plaster schools, a residence for the keeper, and a specially designed exhibition hall – the 'Great Room' (FIG. 110).

The problem, as Heriot knew at first hand, was not that there was anything lacking in the degree of prestige attached to the Royal Academy but rather that it was simply too easy to get into the academy schools. James Barry once even complained that parents sent their sons to the academy simply because it was free, while an apprenticeship could cost them twenty pounds a year.[13] Between 1769 and December 1784, the date of Burney's observations, 465 young men had enrolled as students at the academy. Among the students in painting and sculpture, some twenty-two had received gold medals, a prestigious but non-pecuniary award, and only four had been given the more tangible honour of being sent to Rome.

For contemporary commentators, it was obvious that the academy had failed to provide for its students, and, as Burney suggests, the example of many professional artists seemed to show that much greater opportunities lay outside the country altogether. Quite simply, the metropolis was becoming overrun with young artists who could not look forward to sustained institutional sponsorship, nor, given the economic situation, much attention from private patrons. At the beginning of the 1760s, it appeared to many commentators that high art would have a vital role in the progress of commercial society and empire, not only in representing Britain's power and providing memorials and models for heroes, but also in contributing directly to the economy. Now that very optimism could itself aggravate the perilous state of the economy. The sharpened economic debates of the 1770s provided a ready language for accounting for Britain's cultural fate in crisis terms. Discussion about depopulation, overpopulation and migration provided powerful metaphors for the fate of the artistic community. The effective formulation of revolutionary sentiments in America alienated the English state from the language of liberty that had previously underpinned its authority and provided a persuasive and consensual intellectual framework for high art.

The year 1775 saw James Barry's first public intervention into British cultural politics, when he tackled these issues directly. The publication that year of *An Inquiry into the Real and Imaginary Obstructions to the Acquisition of the Arts in England* marked the beginning of an idiosyncratic campaign of cultural reform that won him only enemies and made mostly enemies of his few friends. The book rebuffs the claim associated with the Abbé Dubos, Baron de Montesquieu and Johann Joachim Winckelmann that the visual arts could never flourish in the north, campaigns for the most stringent kind of Grand Manner art. Combative and digressive, Barry's text, considered in the context of the prevailing cultural pessimism, looked at the very least reckless and perhaps utterly misguided. Where Joshua Reynolds was moving towards conceiving an economy of artistic skill that saw the genres and manners of art distributed between individuals of different temperaments, Barry insisted on the absolute union of art in the figure of the single Grand Manner artist of comprehensive intellect and vision, so that the traffic between the genres was entirely one way:

> The prime object of study to a history-painter being the entire man, body and mind, he can occasionally confine himself to any part of this subject, and carry a meaning, a dignity, and a propriety into his work, which a mere portrait-painter must be a stranger to, who has no ideas of looking further than the likeness and in its moments of still life. As to the notion that a portrait-painter can also, when called upon, paint history, and that he can, merely from his acquaintance with the map of the face, travel with security over the other regions of the body, every part of which has a peculiar and difficult geography of its own; this would be too palpably absurd to need any refutation.[14]

It was the absence of such a comprehensive artist, whose work would be a continuation of the Catholic tradition temporarily interrupted by the Reformation, that was the cause of the present crisis in the arts:

> Instead of expanding our minds so as to take in such an enlarged noble idea of art as was worthy a great and learned nation; our practice, until lately, has been rather to contract the art itself, to split into pieces, and to portion it out into small lots, fitted to the narrow capacities of mechanical uneducated people. We have looked upon the arts, as we do upon trades, which may be carried on separately, and in which seven years apprenticeship was the best title.[15]

A cultural economy thus so closely modelled on the industrial economy as to share its intellectual scope and moral values was almost beyond redemption. The marriage of arts, manufactures and commerce that the merchants and gentry of the Society of Arts had staked their hopes on, or even that realistic acknowledgement made by Reynolds that in the modern state the pursuit of the ideal had to be a cooperative, piecemeal effort, were rejected by Barry.

Exceptionally, Barry made the opportunity to practice what he preached. As noted in the introduction to Part Two, the proposal that a group of academicians decorate the Great Room of the Society of Arts' new building in the Adelphi had collapsed in 1774. In 1777, Barry's offer to complete the scheme single-handedly was taken up by the society.[16] What Alexander Runciman had undertaken in the private house of Penicuik, what John Hamilton Mortimer and Joseph Wright of Derby had produced on a relatively domestic scale at Radburne Hall, and what Henry Fuseli had imagined only half-mockingly with his designs for a Shakespeare ceiling, Barry was now able to undertake in reality in a public building in the metropolis. Between 1777 and 1782 Barry worked relentlessly on the scheme, consisting of six huge canvases on the theme of 'The Progress of Culture' (FIG. 111). These constituted an attempt at the commemoration of the role of the arts in public life in pagan and secular terms: refining man in his historical infancy; then as an honoured part of life in ancient Greece – an age characterized by moral and physical perfection; in modern Britain, as exemplified by the activities of the Society of Arts itself; and in the afterlife, in the Elysium of genius. In Barry's own words, his aim was:

> To illustrate the one great maxim of moral truth, viz. that the obtaining of happiness, as well individual as public, depends upon cultivating the human faculties. We begin with man in a savage state, full of inconveniences, imperfection and misery; and we follow him through several gradations of culture and happiness, which, after our probationary state here, are finally attended with beatitude or misery. The first is the Story of Orpheus, the second a Harvest-Home, or Thanksgiving to Ceres and Bacchus; the third, the Victors at Olympia; the fourth, Navigation, or the Triumph of the Thames; the fifth, the Distribution of Premiums in the Society of Arts, &c; and the sixth, Elisium, or the state of final Retribution; three of these subjects are poetical, and the others historical.[17]

As a large-scale cycle of paintings on a theme of public interest, Barry's decorations were a uniquely ambitious expression of the Grand Manner ideal of the heroic artist. Yet he assumed that role only by becoming impoverished and desperate as a person. The agreement between Barry and the society was on the basis that they would pay only for materials and the hire of models. As a journalist noted at the time, in reporting on the scheme, 'the pursuit of fame, and the acquisition of wealth, in his profession, are almost incompatible'.[18]

Barry attempted to derive some income from his imagery by the production of prints. As with Hamilton's *Iliad* series, this meant dividing a cycle of paintings (in this case literally brought together in a single space) into single commodities and floating these in a market in which artis-

tic intention and pictorial integrity could be entirely discarded by anonymous consumers. Formally, there seems even to be some kind of recognition of this fragmentation and dissection in Barry's prints. The compositions, a number on abnormally long, thin formats with abrupt margins cutting across the most prominent figures (FIG. 112), cannot easily be reconciled with academic standards of narrative and formal clarity.

Instead, the prints drew attention to themselves as commodified units derived from a larger product – the Great Room itself. The heroic artist was thus effectively transformed by circumstances into a purveyor of fragments, divided parts of a whole. Yet in place of a heroic unity of form and narrative, a certain authorial emphasis re-emerges with added vigour. In drawing attention to their fragmentary character, such prints resist interpretation as effective surrogates for the original. Barry's eccentric and innovative deployment of a variety of printmaking techniques achieves relatively coarse graphic effects, which draw attention to the process of their production. He eschews the mechanical, industrialized character of commercial reproductions that, arguably, served the publisher (and perhaps the engraver) better than the artist. His already fragmented images insist on being taken on their own terms, as original prints deriving from, rather than duplicating, a scheme that can only be appreciated in its entirety *in situ*.

The awkward status of these prints may be inferred from this anecdote about one of Barry's customers: 'When they [the prints] were pronounced finished, he called to pay the remainder, and receive his prints; but, upon his expressing himself with some surprise as to their coarseness of execution, Barry asked him if he knew what it was he did expect? – "More finished engravings", replied Mr Young.'[19] Putting their challenging character into the light the artist presumably hoped for, a newspaper, by contrast, reported: 'They are not calculated for *Fan mounts*, but considered with a regard to the force, spirit and correctness of drawing, are a very valuable addition to the Porte Folio of the *Connoisseur*.'[20] (*Morning Chronicle*, 29 May 1792).

Even standing before the original scheme, it might be argued that the viewer's experience is necessarily fragmented and obscured when the iconography slips into more idiosyncratic realms. As William Pressly has concluded, the Adelphi scheme may be the most wholehearted exercise in the Grand Manner, but it is 'also symptomatic of the breakdown of the very tradition on which it sought to build . . . in the final analysis the paintings are more private than public, developing a personal iconography out of traditional materials'.[21] Accordingly, the artist felt obliged to provide lengthy textual explanations for the scenes, in the form of his weighty

Account of a Series of Pictures, in the Great Room (1783). Comprising over a hundred pages of highly digressive and sometimes intimidatingly dense text explaining each element of the iconography, this provided as much in the way of obfuscation as guidance for the confused visitor to the Great Room. It also included what was interpreted at the time as signs of paranoid anxiety, with fleeting but notable references to the perceived harassment of the author. A rather illuminating response to this publication is recorded in a letter by one baffled reader at the time, the classicist and Anglican priest, Thomas Twining (1734–1804):

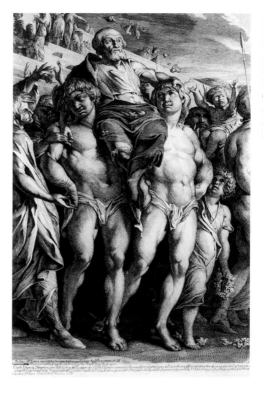

112 James Barry, *Detail of Diagorades Victors*, published by James Barry, 1 May 1795. Etching and engraving, 74.3 × 47.4 cm. The British Museum, London.

> I read Mr Barry's wild book, & was entertained by it in spite of its failings. Surely he is a very Rousseau-ish being? Is there, can there be, any foundation for his complaints of envy, persecution, &c? – of Sir Joshua Reynolds in particular? There are wildnesses, queerities, &c., in his painting too; & yet, upon the whole, I *do* think it is a work of genius, & I question whether any man but himself cou'd have produced a work of the same kind & of equal merit, in the same space of time. Though he seems romantic & visionary in his views & expectations, there is an appearance of integrity & of a moral & generous way of thinking in him, that, I own, interest me more than his faults offend me.[22]

His correspondent, Charles Burney, could only agree:

> You speak of Barry's book so exactly as I think that I can add nothing on the subject – Sir Jos. Reynolds *jealous* of him! and his persecutor! – downright *madness* & self-over-rating Pride. – But besides this the *Potatoe* often appears elsewhere. – & yet as you say there is spirit & a seeming integrity & indignation in his book that dazzle one.[23]

Twining's association of Barry with Jean-Jacques Rousseau indicates the archetypal role of the Swiss philosopher as the embodiment of the outlandish but sincere social critic – a conception that Fuseli had used extensively. The intimation of madness and paranoia indicates how a commitment to extra-social ideals was typically stigmatized by those who considered themselves better accommodated to established culture.[24] But there was paradox here: Barry had, by this date, been elected unopposed as Professor of Painting at the Royal Academy. Far from being an outsider in relation to the establishment, he was the cultural establishment. Then again, he had not exhibited with them since 1776 despite holding office, so his situation was not simply one of alienation or marginalization but of inexorable contrariness.

In the 'question whether any man but himself cou'd have produced a work of the same kind', there is the implication that Barry's achievements as an artist were not incidentally linked, but predicated on, his social alienation. In social and economic terms, to create a heroic monument like Barry's Great Room decorations was necessarily to isolate oneself from the regular world,

displaying 'that violence and ungovernable rage' for which he was known, that could only be brought into representation as a kind of Quixotic madness.[25] Or, in Barry's case, such rage was seen as a predictable consequence of his Irish Catholic identity as by 'Anthony Pasquin' (John Williams; 1754–1818):

> This is Jemmy O'Blarney, Esq. and perhaps one of the most extraordinary oddities on the face of the creation, for his *actions* and his *heart* are in a continual state of warfare; the *former* being constantly marked by ill manners and uncharitableness and the latter uniformly wedded to *honour* and to *virtue* – his love of singularity is carried to such a pitch of ridiculousness, that he affects to despise hereditary dignity, merely because the rest of mankind concur in the idea that subordination and respect are necessary to the well-being of society.[26]

Barry's attempt at forging a heroic pictorial unity looked all the more heroic for appearing in what was called 'a weak disjointed age' in a poetic tribute to the scheme in 1784.[27] But 'Pasquin' might have been more acute in registering a sense of the internal conflicts that had necessarily to accompany such a project at that time. As the next chapters should demonstrate, heroic art was put into a 'continual state of warfare' not so much against vice and effeminacy, as the cultural commentators of 1760 had imagined, as against itself and its proponents.

8

THE AMERICAN WAR AND THE HEROIC IMAGE

In the early summer of 1784, a young Quaker Irishwoman, Mary Shackleton (1758–1826), paid a visit to London with her father, Richard, an old school friend of Edmund Burke. The official purpose of the journey was to attend the annual Society of Friends' meeting, but her diary records in detail her extensive and enthusiastic sightseeing. She went to the Guildhall in the City of London, 'where I saw Chatham's & Beckford's monuments fine pieces of sculpture' and to the Tower, where 'they first shewed us the wild-beasts'.[1] A week later she went with a group of young friends to Westminster Abbey and recorded her impressions of the sculptures there, including 'a very fine one lately erected to the memory of Lord Chatham wch I think they say cost £6000', Joseph Wilton's monument to 'my favourite General Wolfe, who, supported by his afflicted soldiers, seems to express in his countenance the sentiments which we suppose he felt', Louis François Roubiliac's *Nightingale Monument* (1761), and the various medieval antiquities. Even after all this exhausting activity, 'yet a desire to behold Major André's monument seized us, wch. remained unsatisfied as that was blocked from us by boards. I wonder in what light his death could be placed for tho' we love his character, which was brave & amiable, yet sure the cause in which he fell, a spy, was inglorious.'[2]

Three days later, Shackleton went with her father to have breakfast at Burke's house and from there to the studio of Joshua Reynolds, where she noted 'a picture of Genl. Tarleton, just alighted from his horse, & fastening his boot' which 'had a striking effect'. The president then granted her access to the Great Room of the Royal Academy, where the exhibition was closed but the paintings still installed. She recorded the overwhelming sensation of the great massing of pictures there, the domineering impact of Benjamin West's *Moses Receiving the Laws* (Palace of Westminster, London), as well as taking notice of a number of literary paintings and portraits, a depiction of the death of Captain Cook and a painting of 'The shipwreck of Capt. Inglefield, where some persons in a boat were taking in another' that 'had a deal of expression in it'.[3]

Although the association with Burke secured Shackleton privileged access to the studio of Reynolds and through him to the academy exhibition out of hours, her tour may be taken as a typical piece of metropolitan tourism, following the conventional course from east to west, from St Paul's, the Guildhall and the Tower to Somerset House and Westminster Abbey. But, more particularly, her journal reveals in a pointed if only parenthetical way, the personal experience of a culture traumatised by the recent war. Her diary draws attention to a succession of highly visible works that articulated – or evaded – the awkward historical realities of the recent conflict: the monuments to William Pitt, earl of Chatham, in the Guildhall and Westminster Abbey, the memorial to Major John André in the abbey, Reynolds' portrait of the soldier–adventurer

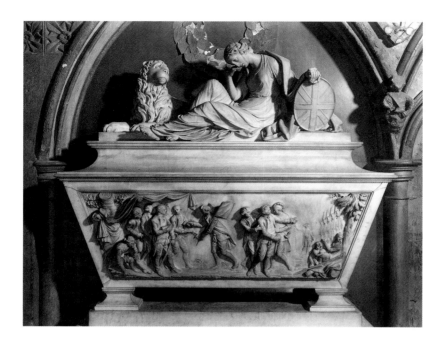

113 Monument to Major John André, designed by Robert Adam and executed by Peter Matthias Vangelder, erected 1783. Westminster Abbey, London.

Banastre Tarleton, and, at the Royal Academy, Johann Heinrich Ramberg's painting of the death of the British explorer James Cook and James Northcote's mammoth picture of Captain Ingle-field escaping from the wreck of his ship, the *Centaur*. Different as these works are in so many respects, they nonetheless all exhibit the complexity and reticence that accompanied attempts at the visual embodiment of heroic virtue in the wake of America's revolution and the crisis of empire.

These tensions were perhaps nowhere more apparent than in the monument that Shackleton sought out with special interest on her visit to the abbey: that designed by Robert Adam and executed by Peter Matthias Vangelder memorializing Major John André (1751–80) and erected late in 1782 under the sponsorship of George III (FIG. 113).[4] The sculpture was boarded up pre-sumably as a remnant of the extensive structures designed by James Wyatt for the Handel fes-tival in May or as a consequence of the damage it so often sustained. Therefore, her question concerning 'in what light his death could be placed' was unanswered, although quite under-standable given the circumstances of the hero's demise and the level of opposition to the war among the dissenting middle class (including the Shackletons).

André was a senior British officer hanged as a spy by the Americans.[5] He had been captured in civilian clothes in September 1780 following a liaison with the turncoat American general Benedict Arnold. Within days of his trial and execution on 1 October, reports of André's death and character were circulating at every level in the British Army in America. A British general reported that 'The death of Major André has been very sincerely and very universally lamented throughout the army, and his behaviour on his trial during his confinement, and in the last scene [was] perfectly manly.'[6] An English private concurred: 'This day [6th October 1780] we hear the melancholly story of poor Major André's death . . . we are told that he behaved through the whole of his tryal, confinement & execution with great fortitude &, Manly Spirit . . . the Genl. much afflicted & the whole army sorry for the untimely death of that promising young man.'[7]

As might be expected, classical prototypes were wheeled out by amateur poets and essayists who commented on the fall of this hero in the great swell of print that answered news of his

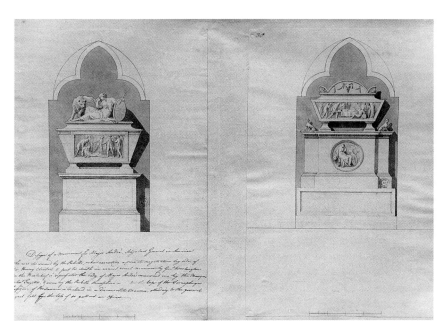

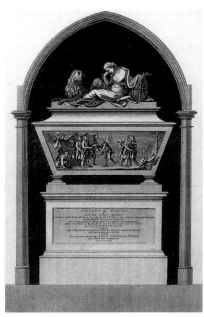

execution. The *Gazetteer* of 15 November 1780 avoided being too specific, and claimed instead that André had 'the undaunted spirit of a Briton, and [the] patriotic resolution of a Citizen of Rome or Athens'. The *Morning Herald* of 18 November 1780 ventured the analogy which was to be most firmly attached to this hero: 'Such is the similitude between kindred virtues, and congenial bravery, that the same confidence, the same strength of mind, and inflexibility of Soul are evident in the hour of detection between the Roman Knight Mutius Scavola, and our ever renowned André.'[8] However, the overwhelming response was one couched in terms of sentimentality, largely eschewing historical reference to classify André as a tragic, helpless figure. Arguably, this British hero emerges as a character who is to be judged not by the exclusive values of masculinist tradition but by the measure of more immediately sensual faculties – even by the yardstick of erotic appeal. As one of the American generals who decided his fate noted of André: 'Had he been tried by a court of ladies, he is so genteel, handsome, polite a gentleman, that I am confident they would have acquitted him.'[9]

The outstanding text in this respect was the enormously successful 'Monody on Major Andre' (1781) by Anna Seward (1744–1809), which must have done much to inspire Mary Shackleton's interest in this figure.[10] One of the central figures of Lichfield's literary circle, Seward was, like many middle-class intellectuals, sympathetic to the American cause and lamented in her poem the years of 'undecesive War' that 'Exhaust my country's treasure, pour her gore / In fruitless conflict on the distant shore.'[11] Her tribute to André focused almost entirely on his tragic romantic life. His death is that of a hopeless lover who went to war to escape the memory of his frustrated passions. His mourning is a scene of universal enervation:

> Lamented Youth! while with inverted spear
> The British Legions pour th'indignant tear!
> Round the dropt arm the funeral scarf entwine,
> And in their heart's deep core thy worth enshrine;
> While my weak Muse, in fond attempt and vain,

114 (left) Robert Adam, two designs for the monument to Major John André in Westminster Abbey, *c*.1781. Sir John Soane's House and Museum, London.

115 (right) Thomas Ravenhill, engraved illustration of the monument to Major John André in Westminster Abbey, *c*.1783. Muniments Room, Westminster Abbey, London.

But feebly pours a perishable strain,
Oh! ye distinguish'd few! whose glowing lays
Bright Phoebus kindles with his purest rays,
Snatch from its radiant source the living fire,
And light with Vestal flame your ANDRE'S HALLOW'D PYRE.[12]

To follow Harriet Guest's important argument about Seward, the radicalization of the political language of virtue in the 1770s and 1780s, combining with the insistent use of familial metaphors as a means of conceptualizing the conflict with America, permitted private relations articulated through the language of sensibility to assume political resonance. It was by this point difficult, perhaps impossible, to posit a stark opposition between private, feminine virtues and masculine, public heroism.[13] The hero, to have public currency, to be understood as a hero, had perhaps to display those private virtues conventionally associated with the feminine realm of the domestic.

Such, then, were the iconographic options available to Adam and Vangelder when they were engaged to produce a monument financed by the king. The most promising and obvious was perhaps the classical option, as pursued in Adam's previous effort in Westminster Abbey in memory of Roger Townshend (FIG. 8). The narrative of Mutius Scaevola might have offered a fitting parallel, and there was always the option, explored by Adam in an alternative design proposal, for a generalized image of the fallen hero (FIG. 114).[14] What Vangelder proceeded with was almost without precedent: a small-scale narrative showing figures in modern dress.[15] Even then, there was promising material available: Anna Seward's poem provided a host of sentimental incidents that might have been exploited imaginatively, while there was an account of André's refusing the hood offered by the executioner in favour of his own handkerchief that might have communicated a sense of both heroically stoical bravery and sentimental graciousness.[16]

Instead, Vangelder's relief presents the moment at which André was led away to his execution. To the left are the American general George Washington and his officers under a tent being approached by a British soldier carrying a flag and holding out a letter. To the right, André is shown being led towards a firing squad by two Continental soldiers. On the far right are a woman and child, sometimes taken as representing Mercy and Innocence but more probably intended as American civilians (playing a role comparable to the American Indian in Benjamin West's *Death of General Wolfe*). The action represented by Vangelder thus corresponds with most accounts of the execution, which claimed that Washington received the flag of truce only once the court-martial report was in his hand, meaning that their decision could not now be overturned.[17] However, while it was widely known that André had been hung – this ignoble form of criminal execution applied since he had been discovered in civilian costume and tried as a spy rather than as a member of the regular army and therefore a prisoner of war – Vangelder represents a firing squad.

André's monument is situated on the north side of the nave of Westminster Abbey, within a sequence of military memorials (FIG. 116), standing, on ground level next to the monument to Sir Palmes Fairborne.[18] The sculpture (or at least George III's patronage of the work) was considered significant enough to displace the existing monument to Major Creed.[19] In its position as well as its form, André's monument is a pendant to that of Colonel Roger Townshend, which sits to the right within the same bay. These three monuments combine to memorialize violent deaths in imperial conflicts across a century, and George III's commissioning of André's memorial might be interpreted as part of the attempt to rehabilitate the royal image in the 1780s, which motivated the 1784 Handel Commemoration in the abbey.[20] In this instance, the remedial effort attempted to bridge the gap between André and the heroes of older, victorious con-

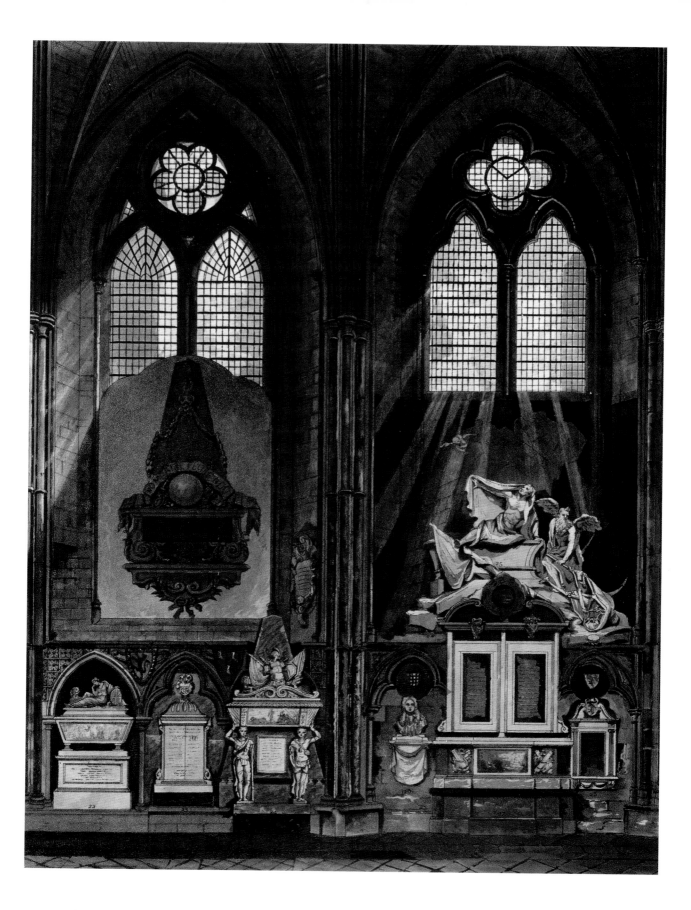

flicts simply by the installation of a memorial to him in the company of their tombs. Thomas Maurice, in a poetic response to the monuments in Westminster Abbey published in 1784, cast the André monument as simultaneously an affective royal response to human tragedy and a contribution to the memorialization of a tradition of national heroism:

> Here too thy warriors, who, from age to age,
> Have spread thy fame thro' all th' astonished world,
> Pointed beneath the line thy awful rage,
> Or at the distant pole thy vengeance hurl'd,
>
> Have nerveless dropt that spear, whose light'ning ray
> Withered the Tyrant's arm in fight;
> Pour'd on the dungeon slave restless day,
> And bade him rise in freedom's sacred light
>
> Where hath not glory wasted Vernon's name?
> Where Wager, Warren – are your deeds unsung?
>
> Where Churchill, Townshend – eldest sons of fame,
> And Wolfe, the theme of ev'ry Briton's tongue?
>
> Immortal spirits of the dauntless Howe,
> Whose triumphs made the western world our own;
> Well may'st thou tear the laurels from thy brow,
> To see thy dear earn'd victories o'erthrown.
>
> Curst civil rage – to glut thy thirsty spear,
> Insatiate fiend, lamented Andre bled:
> In life's gay morn, in glory's full career,
> Low to the Grace descends his youthful head.
>
> His fate, with anguish, smote the royal breast,
> Where worth and valour ever finds a friend;
> The starting tear the monarch's grief confess'd,
> Who bade yon marble to his name ascend.[21]

The first published report of the erection of the monument similarly claimed a tidy parallel between André and Townshend, noting that the new monument was 'close to the equally unfortunate and brave colonel'.[22]

But if there is a certain symbolic coherence in the situation of the three monuments, this served also to underline the historical disruption represented in André's inglorious demise. Overwhelmingly, the response to the specifics of Vangelder's relief was unfavourable. It was 'a strange memorial' and was remembered as 'the most unfortunate monument in the whole Abbey'.[23] A particularly telling account appeared in the *British Magazine* shortly after the unveiling:

> We can by no means approve of the *design*; which, in our opinion, cannot be understood to answer the intended purpose. General Washington is the capital figure, and appears to be employed in the legal exercise of an acknowledged authority; whilst the poor Major is dragged from his presence like a criminal, and scarce seems to attract the notice of any other part of the assembly, but those who have laid violent hands upon him.
>
> If we had been to describe this Monument, without being guided by the inscription, we should have represented it as a trophy to perpetuate the fame of General Washington, in the act of

TIME PAST.
When we beat them ten to one.

TIME PRESENT.
The Case is alter'd.

consigning to due punishment some atrocious offender against the sovereign states of America. Surely the brave, ill-fated Andre, should have been the hero of the tale![24]

Thus the relief is cast as a perversion or inversion of conventional narrative, with the villain playing the part of the hero and the hero impeached. Notably, the prints produced of the monument when it was unveiled show André looking back at Washington rather than facing towards his impending doom as is visible now – giving him a somewhat pleading character (FIG. 115). The head was presumably turned in one of the many restorations that the relief underwent, starting after it was 'wantonly damaged within a short period after it was erected' and continuing through the nineteenth century.[25] What the rotation emphasized was the dominant role played by the figure of Washington in the composition; it is he who occupies the tented area, who stands erect, who assumes the position of authority occupied by Alexander in Charles Le Brun's *Alexander Before the Tent of Darius* (FIG. 13), or General Amherst in Francis Hayman's composition, still on display in Vauxhall Gardens (FIG. 12).

The circumstances of André's death hardly needed such emphasis, suggesting to a distinguished American visitor 'how much degenerated that Nation must be, which can find no fitter Object for so great an honour, than a Spy'.[26] It is in this respect that the proximity of this monument to that of Townshend could become a liability. A German visitor to the abbey in 1786 commented on the juxtaposition:

The memorial to that unlucky Mr André moved me greatly, all the more because it is placed near the one erected by Mrs Thomson [sic] to her son, slain in that tragic American war. André's was presented by the king, but how different the feelings of these two mothers must have been. The latter condemned to hang for a thoughtless action, and Thomson at his post on the battlefield.[27]

117 *Time Past, Time Present*, published by E. Hodges, 20 January 1782. Etching, 24.8 × 34.8 cm. The British Museum, London.

Thus was exhibited in the conjunction of Adam's two monuments a contrast as stark as that presented by the commentators and satirists of the time when they considered the fate of the British Empire. The reversal of fortune between 1760 and 1780 was a frequent theme in published commentary of these years: 'It is not above *twenty years* since this kingdom was the envy of the world. Great in commerce, in arts, in arms, in liberty; universally revered, and held up as a model for surrounding nations: but now alas! how great the change!'[28] In graphic satire, a single print of 1782 makes the same point vividly: in 'Time Past' Britain's imperial effort meant a stout John Bull chasing away effete Frenchmen; in 'Time Present' it was John Bull who was having his backside kicked (FIG. 117).

In these circumstances, the hero André was always less than heroic, either as the object of sympathetic feelings that depended on his vulnerability and feminine grace, or overshadowed by the considerably more heroic and admirable Washington. It might be said that it was the impossibility of fitting André's story into a conventionally heroic mould that made him so useful as a symbol of Britain's fortunes. Sometimes a tragic figure, a victim of war to be placed beside Townshend and General Wolfe, sometimes foolish and vulnerable, sometimes vicious, and sometimes eloquent of the nation's decline, André's symbolic mutability matched the representational instability of the conflict and of the nature of the heroic.

The war itself was a slippery concept, sliding and careering in contemporary perceptions across different definitions as a revolution or rebellion, a civil war, an international conflict or a domestic feud. The cultural representation of the war with America was complicated to the point of near impossibility by two axes of tension that crossed in the figure of André. One involved (as Dror Wahrman has observed of the literary sources) the play of identity and difference in how the enemy could be conceived: the Americans were not the traditional, foreign enemy but ostensibly shared the religion, race and civic values of Britain.[29] So, as much as André was lamented as a tragically misguided hero among the Americans, Washington was held up as an exemplary citizen, soldier and gentleman by the British press.[30] The other axis of tension was historical, apparent in the stark contrast between the tremendous successes of the previous war, which had created a British Empire of unprecedented proportions, and the shameful defeats at the hands of the Americans and their Spanish and French allies. This was manifested in the contrast between André and Townshend.

This historical vulnerability was further exposed in the erection of the memorials to William Pitt, earl of Chatham. The two monuments that Mary Shackleton saw in the Guildhall and in Westminster Abbey were both produced by John Bacon (1740–99) and shared a history. The Westminster monument was the most recently completed, having been unveiled as recently as March 1784 (FIG. 118).[31] That at the Guildhall had been completed in October 1782 (FIG. 119).[32] They had their origin in the rather heated debates in Parliament and in the City about the proper means of memorializing Pitt in the immediate wake of his death in May 1778. The City had lobbied Parliament for the erection of a memorial in St Paul's for the practical reason that the abbey was already overcrowded with monuments and, on a more political note, to memorialize Pitt's association with the commercial cause. This was, however, brushed aside in a move that was interpreted as the latest example of 'the fatal policy of administration to ridicule the first corporation in the world'.[33]

Since his removal from government in 1761, Pitt had developed into a hero for the opposition, identified as the architect of the imperial and martial achievements of the Seven Years' War, which had established Britain's current global supremacy, and as the exemplar of the political virtues of the independent statesman. With limited influence in real terms, Pitt was idealized as representing the stringent alternative to established government; Pitt the patriot minister of 1757–61 was kept alive as Pitt the ideal patriot, friend to the City and scourge of compla-

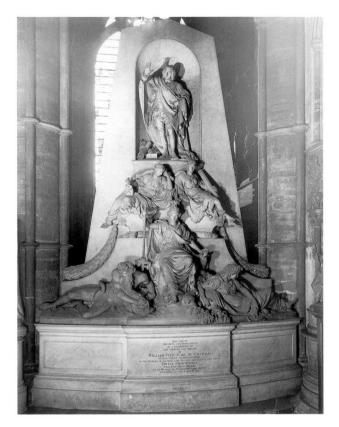

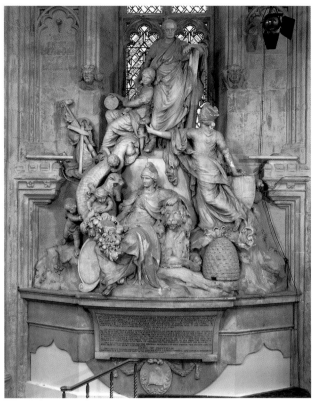

cent courtly power, in the 1770s.[34] Given the sense of impending crisis that accompanied the shaming British defeats in North America and the entry of the French into the war, Pitt's reputation as national saviour was resuscitated. He himself repeatedly drew a contrast between the achievements of the Seven Years War, associated (rightly or wrongly) with his personal leadership, and the 'disgraces of the present'.[35] And, according to a sceptical Horace Walpole, 'All England, that had abandoned him, found out the moment his eyes were closed, that nothing but Lord Chatham could have preserved them – how lucky for him that the experiment cannot be made!'[36]

It had been noted at the time of the initial discussions in Parliament that the proposal was made first by the political opposition rather than the administration, and that the latter's support smacked of insincerity (with the prime minister, Frederick North, rushing to the debate in order to make ostentatious show of his support at the last minute).[37] On the announcement of Pitt's death in the House of Commons on the evening of 11 May, the pro-City member of Parliament Isaac Barré proposed that he have a state-sponsored funeral at Westminster Abbey.[38] It appears that Richard Rigby, opposing the proposal, had tried to trick Barré out of a state funeral by proposing instead that a monument would be more appropriate – a strategy that backfired when Edmund Burke proposed that both a funeral and a monument would be fitting.[39] In this heated debate the antagonism between City interests – laying claim to virtues grounded in severe, classical ideals of martial and civic masculinity – and courtly establishment, was played out in almost caricatured form. Barré had lost an eye at Quebec with Wolfe and was identified in the key to William Woollett's 1776 engraving of West's *Death of General Wolfe* as (in defiance of the facts)

118 (left)
John Bacon,
monument to
William Pitt, Earl
of Chatham,
erected 1783.
Westminster Abbey,
London.

119 (right)
John Bacon,
monument to
William Pitt, Earl
of Chatham,
erected 1782.
Guildhall, London.

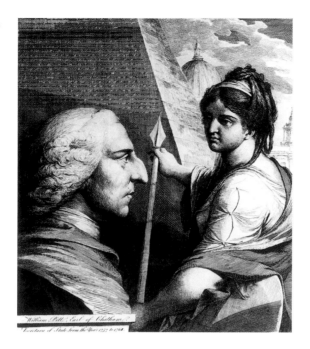

120 James Barry, *William Pitt, Earl of Chatham*, first state published by James Barry, September 1778. Etching and aquatint, 45.5 × 36.7 CM. The British Museum, London.

the figure immediately behind the dying hero. A contemporary account described him as 'robust, and manly in his aspect, but rather severe; it is the countenance of a veteran chief'.[40] Rigby was the most fierce opponent of City causes, closely aligned to the court and, as a modern authority has summarized, 'prominent in defending unpopular measures with maximum provocation to opponents . . . adding as a pastime of his own, gross abuse of the City of London whenever occasion offered'.[41]

If, synchronically, the debate could be cast as a contest between sturdy pro-City interests and courtly affectation, the diachronic question of Pitt's present reputation as opposed to that of Pitt the patriot minister was brought into play. 'Ridens' in the *Morning Post* retorted to criticism of the supposed insincerity of government in supporting the state honours for Pitt that what they agreed to, along with every-one else, was that 'the Earl of Chatham *had been* an able statesman' and that his recent poli-cies – his 'late *Quixotism*' – had been motivated by oppositional politics rather than true patriotic sense.[42] When George III heard of the plans for a monument, he asked that the inscrip-tion 'is worded as a testimony of gratitude for his rousing the Nation at the beginning of the last War, and his conduct whilst at that period he held the Seals of the Secretary of State, or this compliment if payed to his general conduct is rather an offensive measure to me personally'.[43]

This was the context for James Barry's illuminating print memorializing Pitt as a severe clas-sical senator, with an inscription that pointedly discusses his role in founding the empire rather than the awkward fact of his support of the American war (FIG. 120).[44] But instead of displac-ing his reputation wholly into the realm of history, the Irish artist insisted in his inscription on positioning the statesman as the scourge of corruption. Barry depicts St Paul's in the background of his print and has the figure of Britannia direct the viewer's eye to it with her spear, perhaps just to signal Pitt's association with the City but more precisely making a point about the recent debate regarding the proper location for a national monument. Even displaced to the Guildhall, the monument was erected to a statesman who could still be claimed by the City (disregarding the growing discord there over the previous decade) and who was still a germane symbol of political liberties and material progress. Once it was unveiled in October 1782 the monument was immediately covered up again so it would be in pristine condition for the Lord Mayor's day at the beginning of November, the common council clearly hoping that it would form a suitable partner to the newly repaired and cleaned monument to the great City spokesman and mayor, William Beckford.[45]

By contrast, at Westminster Abbey a monument was more quietly and belatedly raised – just before Shackleton's visit – to the hero of another age, and a political opponent of the king and the administration. Two foreign visitors of the time reported separately on the current percep-tion that the administration had wanted to downplay Pitt's achievements by putting the monu-ment in a 'dark recess' in the abbey.[46] In the wake of Britain's disastrous failures in the war with

America – the peace was settled in November 1783 – the official commemoration of Pitt's earlier imperial achievements in the richly historical setting of the abbey could only take on an ironic or tragic tone.

Reflecting poetically on the desperate state of the nation as a whole, William Cowper in 'The Task' (1785) drew out precisely such uncomfortable historical associations by bringing together the figures of Pitt and Wolfe:

> Time was when it was praise and boast enough
> In ev'ry clime, and travel where we might,
> That we were born her [England's] children. Praise enough
> To fill th'ambition of a private man,
> That Chatham's language was his mother tongue,
> And Wolfe's great name compatriot with his own.
> Farewell those honours, and farewell with them
> The hope of such hereafter. They have fall'n
> Each in his field of glory; One in arms,
> And one in council. Wolfe upon the lap
> Of smiling victory that moment won,
> And Chatham, heart-sick of his country's shame.
> They made us many soldiers. Chatham, still
> Consulting England's happiness at home,
> Secured it by an unforgiving frown,
> If any wrong'd her. Wolfe, where'er he fought,
> Put so much of heart into his act,
> That his example had a magnet's force,
> And all were swift to follow whom all loved.
> Those suns are set. Oh rise some other such!
> Or all that we have left, is empty talk
> Of old atchievements, and despair of new.[47]

It may not be unreasonable to claim that Cowper, who at the time of composing 'The Task' remarked 'I have most of the Monuments in the Abbey by heart' and expressed his enthusiasm for Bacon's work at the Guildhall, had the relevant monuments in mind here.[48] Rather more resignedly – and eloquently – than the author of *Time Past, Time Present*, Cowper reflects on a sense of inexorable historical decline that made heroic masculinity the subject only of despair and nostalgia. With André and Pitt the chain of heroic emulation had, it might be claimed, come to an end, and comparisons between modern heroes and the ancient and modern exemplars could now be only a source of shame.

What Shackleton saw at the Royal Academy confirmed that such issues were equally in play in painting. Her account of the visit is worth giving more fully:

The light in the two rooms where the pictures were exhibited was I believe let in at the top, tho' I never thought then how it was admitted, for the walls were lined with paintings. one in the outer room of Iachomo in the chamber of Imogen, I greatly admired – Lear recollecting Cordelia – Capt: Cook's murder – an old Woman; those amid a multitude of others I was gazing at, when the Woman who attended us, desired us to go into the other room I did – it was monstrous large, & Moses receiving the law on Sinai was presented just at entering; almost beside myself with the view of so many beauties I cried out, 'This is too much!' & did not till then perceive some people in the room at which I slunk back abashed till my

Father & Richd. Burke were ready to return with me & then behold one of those in the great room was West a celebrated painter who was once a member of our society. As I had not my wits about me, I made another blunder in taking the catalogue to him, & asking him to find out a picture for me, mistaking him for R: Burke. The shipwreck of Capt. Inglefield, where some persons in a boat were taking in another had a deal of expression in it. A brewer's yard, in which one of the dray horses was wonderfully natural . . . should I attempt to retain the ideas of what perhaps I had better forget & which so overpowered my eyes that I could not, tho' assisted by the catalogue, leisure, &c, see them all much less had I been qualified for it, observe all their beauties.[49]

Even without the crowds that were normally to be encountered while the exhibition was open to the public, Shackleton conveys her sense of the academy show as a space for social performance as much as cultural consumption, as an optically overwhelming experience, and as a site in which the body of the viewer became uncomfortably present in what would ideally be the elevated and disembodied act of aesthetic contemplation. As the generic hierarchies that in principle ordered and ranked individual works were dissolved in the juxtaposition of portraits, subject paintings, landscapes and pictures of common life – a visual 'multitude' – so the eye of the viewer suffered, her sense of balance was upset, a feeling of weakness and disempowerment took hold. And as she blundered, disoriented, into her encounter with Benjamin West, she experienced acute social embarrassment. This may be anecdotal writing, and the expression of these experiences heightened and reorganized for literary effect. But it remains important in giving voice to an experience definitive of cultural modernity, for which the descriptive terms had yet to be fully articulated. Modern culture, as it was manifested in the walls of the academy, escaped classification, ready ordering, the imposition of the clean systems of knowledge imposed by the 'catalogue, leisure, &c'. The direct, exclusive, reflective encounter between the man of taste and the exemplary work of art imagined by the Earl of Shaftesbury was, in such a setting, impossible. In its place came an overridingly spectacular and definitively unstable economy of cultural values.

This is not to say that there was a complete free-for-all. The point is that the academy's hang did not make hieratic values impossible, only that it did not help guarantee them. In fact, this spectacle could facilitate a certain reassertion of technical, thematic and professional hierarchy. In her visit to the Great Room, Shackleton had naturally been most impressed, in sheer visual terms, by West's *Moses Receiving the Laws*. This was intended to be part of the painter's scheme for the chapel at Windsor Castle and, as Edward Burney's watercolour of the show confirms, was the overbearing visual presence of the exhibition (FIG. 121).

West was already at work on first ideas for the royal chapel scheme in 1779 and his extraordinary royal pension of one thousand pounds, presumably intended to support him on the project, had begun in 1780.[50] Over the next twenty years he completed at least eighteen canvases, including the enormous work that formed the centrepiece of the 1784 exhibition, along with a prolific number of drawings or studies. Ostentatiously indebted to elevated pictorial precedents, West's *Moses* was exhibited with a reference to the royal chapel scheme in the catalogue. It proved what was possible with the appropriate level of financial support and a willingness to commit to the political and theological entrenchment that followed on the loss of the American colonies. It prompted an enthusiastic commentary from the *Gazetteer* on 27 April 1784, which led to an uncharacteristically optimistic – perhaps self-deluding – summary of the state of the arts: 'There is no want of encouragement in the country. The numerous wealthy corporations, the public societies, the colleges, the churches, the nobility of the kingdom will be anxious to countenance the efforts of the historical muse, and it is only by this study that the English School can reach celebrity.'

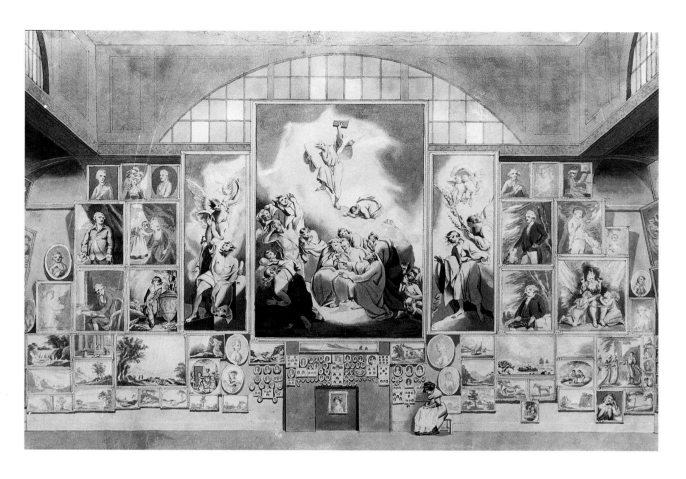

West's achievement was exceptional. He enjoyed a virtual monopoly over royal patronage and the almost unique privilege of pursuing works on this scale with an expectation of financial support. But two further images of a heroic character caught Shackleton's particular attention: 'Capt: Cook's murder' and 'The shipwreck of Capt. Inglefield'. These, in seeking to address the ostensible interests of the academy's existing public and without the financial backing of a powerful patron, offer the more incisive and historically telling image of the fate of heroic art. The first was the subject of two paintings at the Academy that year, a work shown in the ante-room by Charles Grignion (now lost) which is the work Shackleton notes, and a surviving painting by Johann Heinrich Ramberg (1763–1840), a German student of the Royal Academy who was taken under Benjamin West's care. These represented a hero of empire who lost his life while engaged, not in the plunder and conquest, but purportedly peaceable exploration of the Pacific in 1779 (FIG. 122). Ramberg's painting presented a crude confrontation between the bestial racial other and the enlightened white hero. In conformity with the official version of events, given canonical form in 1784 with the publication of James King's Admiralty-sponsored volume on the tragic expedition, Cook, in a pristine white suit, is shown desperately trying to extract himself from the savage horde.[51] He is offered up as an elegant but powerless victim, his gun an impotent prop rather than a weapon, an innocent among degenerates. While there were still fears that empire had turned Britons into savages, his painting offered the reassurance that Britain's most famous explorer remained a gentleman, even though this meant being defence-less against the onslaught of men more able to exercise their brute physical strength. The true

121 Edward Francis Burney, view of the Royal Academy exhibition of 1784 (east wall). Pen, grey ink and wash with watercolour on paper, 33.7 × 49 cm. The British Museum, London.

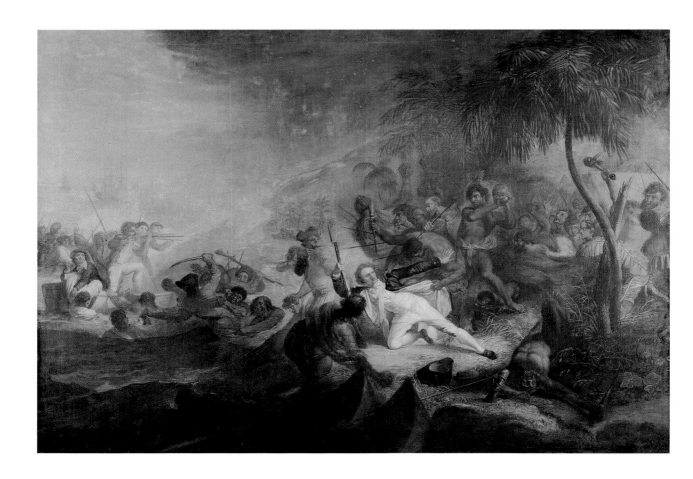

imperial hero – to quote Harriet Guest, 'free from the vices of imperial corruption in its impli-
cations for both the imperial center and the colonized' – might, the picture implies, be a victim,
whose heroic status was secured as much by the emotive visibility of his death, enacted in full
view of his helpless crew, as by the nobility of the cause.[52]

Much more ambitious and, besides West's *Moses*, the dominant narrative painting in the 1784
exhibition, was James Northcote's enormous canvas of *Captain Inglefield Escaping from his
Ship the Centaur* (FIG. 123). This was the 'large composition which should demand the atten-
tion of the publick at the Exhibition of the Royal Academy' that Northcote had planned after
his impecunious return from study in Italy.[53] The sheer scale of the image meant that it had to
be hung centrally on one of the walls of the Great Room, where it would, given the hanging
procedures, be the central work in the composition of the wall, around which all others were
arranged (FIG. 124). Formally, the painting demands attention, with the composition dominated
by the single, striking angle of the lifeboat, lifted impossibly out of the sea, along which the
human drama unfolds as a young, long-haired and fine-looking boy is saved from the water at
the last moment. The figures of the crew are modelled in expressly heroic terms even in their
desperation, and in their variety of posture and expression offer a showcase for the artist's fig-
urative capabilities.

In terms of subject matter, the picture insisted upon the public's attention as well. Captain
John Nicholson Inglefield was a celebrity of the moment. In 1782 he had been crossing the

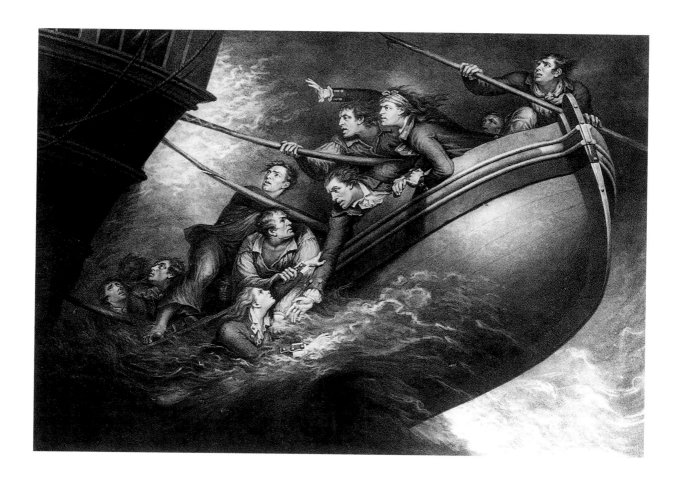

Atlantic in the *Centaur* (1748–1828), loaded with booty, when a hurricane struck. As the ship sank, Inglefield and a number of his crew escaped, leaving the rest of the men to their fate. Though he faced a court-martial on his return for abandoning the vessel, Inglefield was cleared and proclaimed a hero. His dramatic account of the loss of the ship was published and republished in London, scoring a success with the reading public. It did not demur from frankly stating the self-interest involved in his decision:

> There appeared not more than a moment for consideration; to remain and perish with the ship's company, whom I could not be any longer of use to, or seize the opportunity which seemed the only way of escaping, and leave the people who I had been so well satisfied with on a variety of occasions, that I thought I could give my life to preserve them. – This indeed was a painful conflict, and which I believe no man can describe, nor any man have a just idea of, who has not been in a similar situation.

> The love of life prevailed . . .[54]

The old virtues of heroic self-sacrifice have been discarded here. Yet, somehow, the details of Inglefield's account of his self-interest were greeted as providing an exemplary narrative: 'they not only furnish the susceptible mind with one of its most delectable feasts, but frequently supply hints to those brave adventurers who are so valuable in a maritime country, how to act in similar situations.'[55]

123 Thomas Gaugain after James Northcote, *Portraits of the Officers and Men who were Preserv'd from the Wreck of the Centaure*, published by Thomas Gaugain, October 1784. Stipple engraving, 52.3 × 64.3 cm. The British Museum, London.

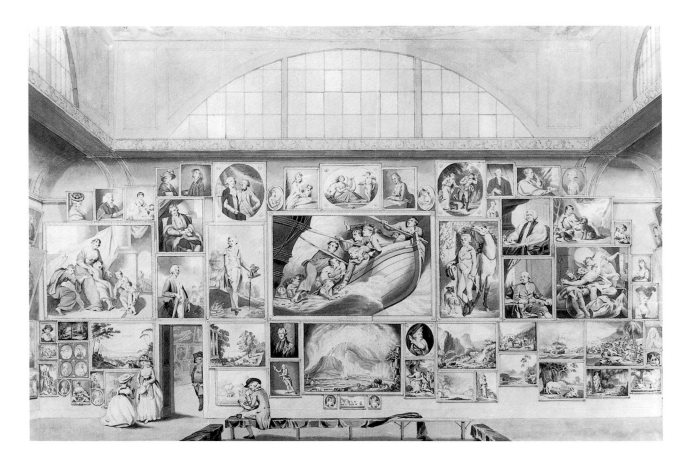

124 Edward Francis Burney, view of the Royal Academy exhibition of 1784 (west wall). Pen, grey ink and wash with watercolour on paper, 33.7 × 49 cm. The British Museum, London.

Northcote tried to match such claims in his canvas, which evokes pictorial tradition in a concerted fashion. The composition alludes to a whole body of paintings of Christ in the sea of Galilee, among the most celebrated of which was Rembrandt's, then in the collection of John Hope in Amsterdam (1633; Isabella Stewart Gardner Museum, Boston), which had been engraved. Viewed in this light, Inglefield displays a distinctly un-Christ-like degree of expressive desperation in the midst of his storm: the theme of his picture is, rather, 'Distress and Terror'.[56] Indeed, compositionally Northcote perhaps takes a further cue from the tradition of Jonah being cast to the whale, exemplified by Dirck Barendsz.'s design of 1582, engraved and published by Jan Sadeler (FIG. 125).[57] By concentrating on the incident where a fifteen-year-old boy from the ship's crew made a final, desperate leap onto the lifeboat once it had been launched, Northcote forces the viewer's attention onto a moment of salvation that derives from John Singleton Copley's celebrated *Watson and the Shark*, exhibited at the Royal Academy in 1778 (FIG. 126).[58]

In thus taking up a subject that focused on the contest between man and nature in circumstances rather removed from the war itself, Northcote was able proffer a narrative of physical heroism and fortitude, but one that sidestepped the issue of military achievement (or, more to the point, the absence thereof). The contemporary response that survives suggests that he succeeded in this respect. The report in the *Morning Chronicle* of 27 April 1784 remarked that the picture 'holds out great promise, and is a wonderful performance for so young an artist, whose better experience will correct his errors, and improve at once his judgement and his ability'. The same paper was to return to this theme in a second account on 4 May 1784: 'A painter, like a

Theodor. Bernard. Amst. figuraut I *Ioan. Sadler fealps. et excud.*

Ionas puppe cadens, Ceto forbente voratus, Ne moreretur habens, tandemqʒ e ventre ferino
Jn pelago non fenfit aquas, vitale fepulcrum Venit ad ignotas tutus fine remige terras.

poet, is to be praised, or blamed, for his choice of subject, this before us is of the former kind, the choice is happy. As to the treatment of it, all reasonable allowances are to be made to the youth of the artist, and then the opinion on it cannot but be favourable.'

It is worth glancing forwards, here, to Northcote's follow-up picture, a painting of the death of Leopold, Prince of Brunswick, shown in 1786, that went still further in removing the figure of the hero completely from any martial context (FIG. 127). Here, finally, is the point of no return for the domesticated hero of sensibility pioneered by the modern-life history paintings of Hayman and West: the death of such heroes by misadventure, not in the service of empire or

125 Jan Sadeler after Dirk Barendsz., *Jonah Swallowed by the Whale*, c.1582. Engraving, 23.3 × 19.5 cm. The British Museum, London.

126 John Singleton Copley, *Watson and the Shark*, dated and exhibited 1778. Oil on canvas, 182.1 × 229.7 cm. National Gallery of Art, Washington. Ferdinand Lammot Belin Fund.

nation or even family, but in the cause of a sentimental attachment to humanity. The prince had drowned trying to save victims of the flooding river of Oder in spring 1785 – an incident reported in the *Leiden Gazette* and reprinted in the *Times* and the *Gentleman's Magazine*.[59] When his companions had tried to dissuade him from this dangerous and, as it proved, fatal act, he was reported to have said 'What am I more than either of you or they? I am a man like yourselves, and nothing more ought to be attended to here but the voice of humanity.' Immediately before the exhibition of Northcote's painting at the Royal Academy, with prior knowledge of the work and perhaps even the artist's active collusion, the *European Magazine* for March 1786 printed the report again, this time with an introductory text claiming: 'The heroic achievements of Warriors have too long been the objects celebrated by painters and poets. The milder virtues of private life, the nobler acts of humanity, compassion, tenderness, and benevolence, have been too often neglected.'[60]

 Such pictures as this mark the abandonment of the epic mode in art – its associations with conquest and violence now distasteful to what was being defined as a cultured modern public – in favour of epically proportioned tragedy that was not predicated on the gender of the consumer. Such pictures helped to create an effectively feminized space of cultural consumption and, it might be suggested, needed to do so to secure material success for their painter. The pressures

of historical and social change had buckled the architecture of difference upon which the struc-tures of moral virtue and heroic exemplarity were mounted. Northcote's pictures lead not to more narrative art centred on an heroic protagonist but only perhaps to the Sublime landscape of the early nineteenth century, where human figures are dwarfed by the forces of nature. The more immediate point to be made is that to restate less equivocal forms of masculine heroism than the salvational and sacrificial figures of Cook, Inglefield or Prince Leopold was a tricky business. To uphold a more stridently aggressive imagery of masculinity in an era of retreat, political entrenchment and defeat – an era in which dominant tastes seemed to demand the con-solations of sentiment rather than revenge or conquest – was to risk appearing wilfully crimi-nal, foolhardy or even mad.

While in London, Mary Shackleton did see one image celebratory of uninhibited physical heroism in a British soldier, which may confirm exactly this point: Reynolds' painting of Banas-tre Tarleton (1754–1833; FIG. 128). The grandiose full-length portrait, painted on the sitter's return from military service in America, had first been shown at the academy in 1782 but had remained in Reynolds's studio.[61] When Shackleton saw it, it was awaiting transportation to an exhibition in Liverpool – a circumstance that Reynolds hoped would mean that the picture would finally be picked up by the sitter's family. The picture shows Tarleton as a monumental

127 James Northcote, *The Death of Prince Leopold of Brunswick*, exhibited 1786. Oil on canvas, 181.8 × 238 cm. Hunterian Museum, Glasgow.

figure in the midst of battle, in the costume of the irregular regiment he had led, until its destruction, through a string of notoriously bloody guerrilla raids and skirmishes, and his wounding in battle at Cowpens, South Carolina, in January 1781. His dynamic pose may have a number of pictorial origins but seems primarily to have been taken from the celebrated antique figure conventionally identified at the time as *Cincinnatus* (Louvre, Paris), the Roman who was famously taken from the fields to lead his people in war and, having served heroically and triumphed, promptly returned to his fields. He thus stood as the archetype of the patriotic citizen who serves the national interest in both war and in peace with equal nobility and vigour.

In the most generalized way, the reference would have been entirely apposite to a soldier returning home from war. But, with the war in America effectively over by the time Tarleton returned to England in 1781, it was perhaps rather more pointed. It was precisely this patriot ideal that had been claimed so emphatically and effectively by the Americans. 'Cincinnatus' appears as pseudonym for pro-American writers in the 1770s, and in 1783 the Order of the Cincinatti was instituted to perpetuate the friendship of American and French veterans.[62] The arrival of an American representative of the order in Paris early in 1784 was reported in the British press and, pointedly, the American painter John Trumbull (1756–1843, of whom more below) exhibited in that year a picture of *The Deputation of the Senate Presenting to Cincinattus the Command of the Roman Armies*, in which the Roman hero was said to be depicted bearing Washington's features.[63] The painting of Tarleton might be said, then, to offer an aggressive reclamation of the sort of heroic patriot masculinity associated with classical narrative. Even if the legibility of the specific reference to Cincinattus in Reynolds' portrait is refuted, it must still be acknowledged that, by the time Shackleton saw the painting, the fact that the Americans had demonstrated themselves the more effective patriots and heroes in the classical mould was unavoidable.

The notion of masculine heroism that Reynolds recuperates in the sheer visual drama and physical dignity of his painting, Tarleton himself recovered in social practice on considerably less stable terms.[64] Known for his ruthlessness as a war hero, Tarleton became a notorious adventurer in civilian society. He relished his reputation for recklessness in both arenas, writing in a private letter to his sister before his return to London:

> Pray have you any handsome Faces of great Fortunes now in Town let me know express; I may come home & marry such a one – None but the brave deserve the Fair – I shall try when I have lost an Arm, an Eye, & a Leg – But . . . my Lady must have a swinging Fortune for I still have a taste for every pleasure – & my imagination is a good deal heightened by all my fighting and Quixotism.[65]

Tarleton was good to his word and launched himself upon London society in such an uninhibited fashion that his reputation as the leading libertine of the age was secured. Walpole dismissed him as a reckless adventurer, who 'boasts of having butchered more men, and lain with more women, than anybody', reporting that the playwright Richard Brinsley Sheridan had retorted with the comment 'Lain with . . . what a weak expression; he should have said, *ravished* – rapes are the relaxation of murderers.'[66] This marriage of military and sexual conquest and of conquest with criminal plunder should be familiar from the anti-imperialist diatribes of mid-century and from the critiques of stern classical virtues by writers announcing their commitment to modern, sentimental values. The threat posed by such authors – that the virtues of the hero and the vices of the savage criminal might shade imperceptibly into one another – was realized in the figure of Tarleton. Reynolds' image, for all its painterly grandeur, was subject to a revision that reflected this threat. James Gillray's print, executed in the graphic style he had learnt from John Hamilton Mortimer, presents Tarleton as a criminal figure, his swelling form an expression of a barely bridled primal manhood inevitably resonant of the *banditti* (FIG. 129).

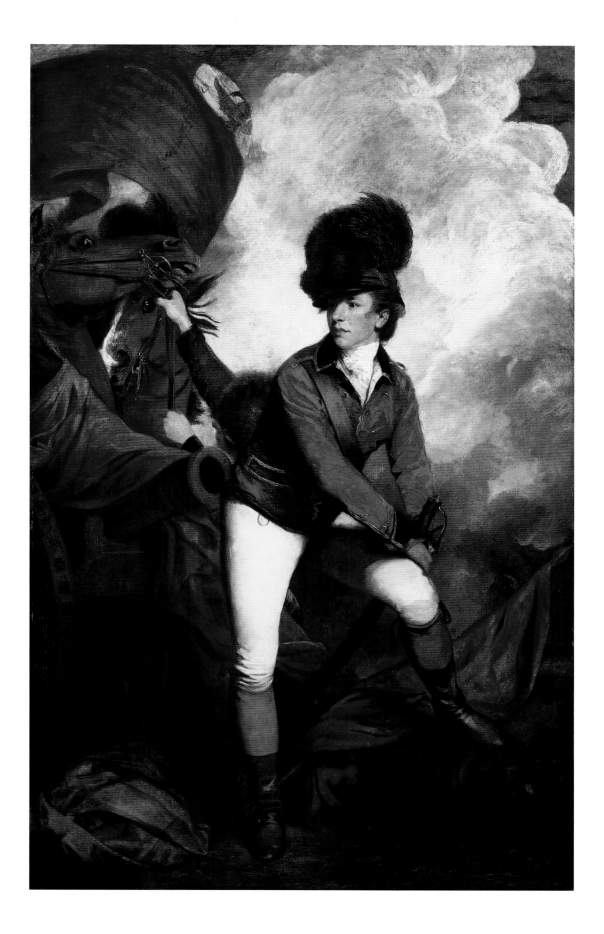

The THUNDERER.

Vide; Every Man in his Humour. alterd from Ben Johnson.

In the wake of the American war, such an uninhibitedly physical image of masculine heroism as was presented in Reynolds' portrait of Tarleton was forced to occupy that unstable borderline between criminality and heroism, virtue and vice, that Mortimer had explored with his *banditti* and that social critics had played with in their commentaries on the Mohawks and Macaronis.

The inversion of British heroism enacted in the André memorial and the embarrassment surrounding the Chatham monuments were, it must be concluded, unintended: the criminalization of the hero in the figure of Tarleton was perhaps unavoidable. Whether vital and active or passive victims, each of these figures helped, to quote Horace Walpole's comment on the death of Pitt, to 'draw the line between our prosperity and adversity.'[67] And this may have been, to judge from contemporary responses, enough in itself. Northcote's pictures were well-received, Tarleton's misdemeanours were the stuff of gossip rather than more serious debate, and Shackleton made her thorough tour of the sights with only her question about André registering any sense of unease. What Shackleton's journal may reveal ultimately is that, in the wake of the American war, the hero was perhaps less of a problem than an irrelevance.

But the vulnerabilities in the representation of the conflict could be, and had been, exploited to effect, and were to generate some of the more ambitious heroic images of this era from James Barry and Trumbull, which are worth considering in this context. Barry's support of the American cause is well documented and found expression in graphic satire. Considerably more oblique, even obscure, was his major painterly response to the war: his revision of West's *Death of General Wolfe* (fig. 130), exhibited at the Royal Academy in 1776 only months after the publication of Woollett's famously money-making reproduction of the original painting.[68] As a known supporter of the cause of American independence, Barry timed his picture to be a riposte to the royal favourite's conception of the hero of the last, more noble war, and to be a comment – albeit a rather unclear one – on Britain's now oppressive assertion of imperial authority over its colonial subjects. Barry went out of his way to check the known facts about the circumstances of Wolfe's death, representing his fading general in an isolated spot, accompanied only by the anonymous grenadiers noted in contemporary reports. In this the Irish painter had his supporters, as a contemporary reviewer praised 'the ingenious and pathetic Manner in which this heroic Fact is painted, though the Truth of History is not in the least departed from'.[69]

Yet this is not simply a 'realist' reworking of West's painting that attends more closely to written documentation. The real force of Barry's painting comes from his attention to detail, which exploded the myth of a sentimentally unified multi-ethnic British imperial project prom-

130 James Barry, *The Death of General Wolfe*, exhibited 1776. Oil on canvas, 148.6 × 236.2 cm. John Clarence Webster Canadiana Collection, New Brunswick Museum, Saint John, New Brunswick.

ulgated by the American painter. While West had presented representative figures from the British nations and colonies and – in complete defiance of fact or probability – went to the greatest efforts to distinguish them individually one from the other in their costumes, Barry presents all his soldiers in British military costume and included an oversized figure of a dead American Indian in the low foreground. This gratuitous presence, which seems to play no clear narrative role other than as a companion to the dead French soldier and thus an embodiment of the enemy – and its scale is even then hardly explained – seems to be a response specifically to West's painting. If not intended as an open critique of heroism in general or of Wolfe, Barry's picture nonetheless presents a harder-nosed image of empire as an affair of conquest with a potentially brutal effect on local populations. Wolfe's Indian served to present Britain's conquering heroes as the purveyors of a civilizing influence, taming savage America by their personal qualities; Barry's Indian is a victim of imperial war. Like the young engraver and poet William Blake in 'King Edward the Third', printed in his *Poetical Sketches* at the end of the American war, Barry 'parodies the organizing theme of the English imperial tradition: namely the equation of commercial expansion with the peaceful spread of liberty and culture'.[70]

Barry's *Death of Wolfe* was the last painting he exhibited at the Royal Academy and his only documented effort in the direction of 'heroic Fact' as a means of revealing the illusory nature of the civilizing effects of Britain's imperial project. But the task was taken up a few years later by the American painter John Trumbull. While he was in London in the 1780s, Trumbull sketched a succession of canvases depicting scenes from the American war that reworked the Wolfe prototype thoroughly.[71] Such a scheme of pictures displaying the course of the war had initially been imagined by Benjamin West, who went so far as to sketch one or two scenes.[72] Yet

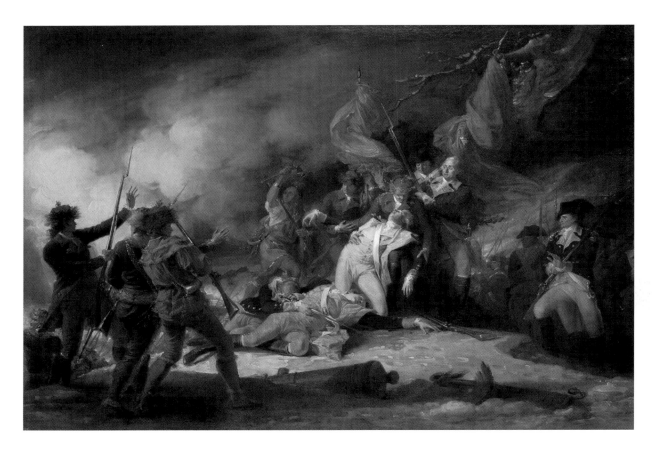

131 John Trumbull, *The Death of General Montgomery in the Attack on Quebec, 31 December 1775*, *c*.1786. Oil on canvas, 62.5 × 94 cm. Trumbull Collection, Yale University Art Gallery, New Haven.

he was swiftly to abandon this project and hand it over to his compatriot, who had joined his studio in 1781.

The dynamic, richly painterly scenes that the younger painter created develop a vigorous imagery of conflict that, perforce, undermines more simply one-sided notions of British heroism. The key image in this respect is the death of Richard Montgomery (1738–75), the most complete reworking of West's *Wolfe* (FIG. 131).[73] Montgomery had died in the American assault on British-held Quebec in December 1775 and Trumbull took the opportunity to represent his fall as an incident that could unite the regular American Army, an American Indian and Rangers as surely as Wolfe's death brought together the full range of British subjects in West's painting. But where West had represented the death of a British hero as the catalyst for an imperial identity, here the British are the enemy and a brutal enemy at that.

The viciousness of British imperial force, in doubt since 1768 and a major issue since the early 1770s, was made the central motif of Trumbull's series of paintings. David Bindman traces in these images an assertion of chivalric, officer-class values that transcend national boundaries, and the concomitant derogation of the actions of the uncultivated ordinary soldier, but the sheer brutality of the latter remains startlingly emphatic.[74] A Briton threatens to issue a final, cruel blow to the fallen General Warren in the Bunker's Hill painting (Trumbull Collection, Yale University Art Gallery). Britons descend upon General Mercer at the Battle of Princeton even though he is on his knees, playing the role taken by Cook in Ramberg's painting, implying that the British grenadiers are as savage as the inhabitants of Hawaii and making a mockery of the 'mod-

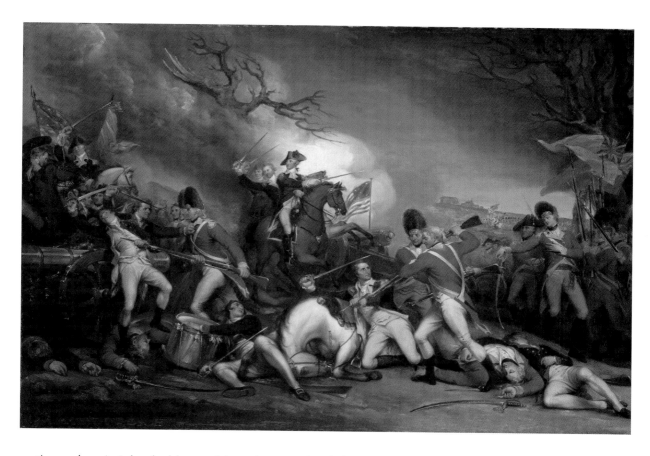

132 John Trumbull, *The Death of General Mercer at the Battle of Princeton, 3 January 1777*, c.1789 – c.1831. Oil on canvas, 51.1 × 75.9 cm. Trumbull Collection, Yale University Art Gallery, New Haven.

eration and equity' that had been celebrated as a national characteristic by Hayman at Vaux-hall Gardens (FIG. 132).[75]

Born into a wealthy background, Trumbull was, perhaps, at liberty to take risks that others were unable or unwilling to venture. That he could, while in the studio of George III's painter Benjamin West, even conceive of such a series may be further testament to the deep and wide-spread uncertainty regarding the British role in America, and the confusion of roles that the conflict entailed: America's heroes could sometimes be Britain's and vice versa. Just as André's death was widely received with sympathy in America, so the American general Montgomery's death was received with respect and admiration among the British press.[76]

If the anxieties and instabilities that characterized representation of the war with America derived from the play of resemblance and difference that accompanied the depiction of the Americans, Trumbull knew this at first-hand. His arrest in the winter of 1780 was a direct conse-quence of André's execution. Trumbull had been an adjunct general in the American Army, the same rank held by André in the British Army, and he was 'therefore thought a proper person to retaliate upon'.[77] As the artist put it in his autobiography, he was considered by loyalists as a '*pendant*' to André.[78]

In the event Trumbull decided not to pursue his project as a commercial prospect in Britain. If he intended to communicate some kind of subtle argument about the common values of the English-speaking elite, the evidence is that he did not expect such subtleties to be appreciated by a British audience. He removed himself to Paris, partly with the aim of publishing a series

of prints reproducing his American scenes, which according to Thomas Jefferson he was forced to do as 'they are too true to suit the English palate'.[79]

The period of the American war had brought heroic virtue, masculinity and the Grand Manner into radically altered relationships, the interplay between them signalling now criminality or Quixotism as much as exemplary civic values. What Mary Shackleton saw in London in the summer of 1784 registered the instabilities surrounding the representation of the heroic in the contemporary context and, rather incidentally, the potential irrelevance of this problem. The huge popularity of Seward's poetry and the critical success of Northcote's heroes testifies to the progress of a 'feminized' culture in which differences of gender and the stringent distinction between private and public values were neither serviceable nor desirable. The problems of bringing André into sculptural representation and the political complexities surrounding the memorialization of Pitt reveal the awkward status of questions of history, public virtue and exemplarity at the time. On the other hand, the 'truth' represented by Barry and by Trumbull in their different ways rather undermined the identity of the British hero. Yet an imagery of the hero did persist, not so much 'despite' the evident foolhardiness and absurdity that this entailed but rather by incorporating foolhardiness and absurdity as central features, and throwing 'heroic Fact' to the winds.

9

GOTHIC ROMANCE AND QUIXOTIC HEROISM

FUSELI IN THE 1780S

In the summer of 1783, the Derbyshire gentleman Brooke Boothby (1743–1824), famously pictured as the quintessential man of sensibility by Joseph Wright of Derby (FIG. 133), organized a Gothic pageant for Henry Fuseli in the woods behind a house somewhere in England belonging to one Colonel St George. Involving costume, elaborate stage effects, poetry (penned by the struggling Irish writer Elizabeth Ryves) and an all-singing all-dancing finale, this midnight entertainment was intended to 'suprize & amuse the great Wizard painter, who had no suspicion of ye scheme'.[1] Boothby, Fuseli and the poet Anna Seward all took key roles in the pageant, dressing up, delivering their lines, taking part in the carefully plotted action in different spots in the wood. Their family and friends took up supporting roles, adopting costumes as fairies, monsters, knights and ladies, singing and dancing, and interacting with the lead players on cue.

Curious and amusing as the details of the pageant are, its significance does not lie in the mere fact of its happening. Private theatricals were popular among the well off in the later eighteenth century and could take on elaborate forms. In its use of Gothic fantasy imagery the event had a precedent in the tradition of courtly masques revived most recently at the 'Fairy Temple' set up at Fonthill in Wiltshire for the twenty-first birthday celebrations in 1781 of William Beckford (1760–1844). And it was in that same year that a theatrical version of Horace Walpole's *Castle of Otranto* was staged in London under the title *The Count of Narbonne*, anticipating the full-blown Gothic theatricals of the 1790s.[2] Boothby's pageant has quite exceptional significance, however, in addressing the emergent heroic artist of the era, Fuseli. It also makes it possible to relate his art with unusual directness to the wider issues in the transformation of heroic art in the 1780s: namely, the catastrophic effects on masculine exemplarity produced by imperial crisis.

Fuseli had travelled back to England in 1778–79 and for a while after his return remained preoccupied with completing the commissions he had gained during his short stay in Switzerland. As noted in chapter 7, his exhibition in 1777 of a large-scale painting of *Macbeth* had already marked him out as an 'extravagant' artist. From 1779 he resumed his exhibiting career, showing a series of works based on subjects from English literature and the classics, and sub-

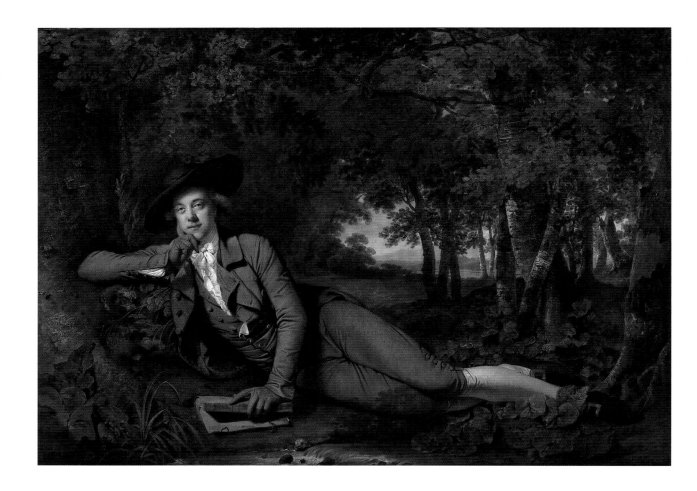

133 Joseph Wright of Derby, portrait of Brooke Boothby, dated and exhibited 1781. Oil on canvas, 148 × 206.4 cm. Tate, London.

jects of his own invention. He pitched himself against Benjamin West in a 1780 Royal Academy exhibition – the first in the new Great Room at Somerset House – with a varied group of canvases including the thoroughly epic (in scale and theme) *Satan Starting at the Touch of Ithuriel's Spear* (FIG. 134). In 1781 he confronted Joshua Reynolds more directly by showing a competing version of the *Death of Dido* (Yale Center for British Art, New Haven) – a subject he knew the president of the academy was planning to exhibit – before consolidating his reputation with a single, strikingly original work, *The Nightmare*, in 1782 (FIG. 135).[3] These canvases swiftly confirmed his reputation as a painter of the horrible, fantastic and perverse, himself a kind of enchanter or magician.

Fuseli's association with the magical was taken quite literally during that night in St George's woods. The text describing the evening states that at the end of dinner Boothby excused himself while the host invited Fuseli to take a walk with him. After a while strolling among the trees, Boothby reappeared, now resplendent in full medieval armour – 'Armed at all points in complete steel'. St George 'slunk away & left the Painter alone to the encounter, whom ye Knight accosts as a Magician, who was to aid him in feats of high adventure casting over him a Magician's robe, & delivering to him a white wand.' Boothby told Fuseli, in rhymed verse penned by Ryves, that they were going on an adventure together. St George joined the company who had been instructed 'to keep back among the trees & not interrupt the solemn ceremonies'.[4]

What followed was a sequence of events organized according to the well-worn conventions of Gothic romance – tales of knights and monsters, wizards and castles and the maidens trapped inside them, derived from medieval and renaissance literature and given widespread new cur-

rency in the late eighteenth-century Gothic novel and popular magazines.[5] Boothby and Fuseli were first confronted by knights who proclaimed that they fought in the name of 'Urma'. Boothby got into a bit of a scuffle with one of them, forcing himself and Fuseli onwards where they came to a mausoleum. Within this structure was a skull containing a scroll explaining (in verse) that they were in the presence of the remains of an evil wizard, the aforementioned Urma, who had set a curse that only the knight and magician (Boothby and Fuseli) could break. 'Pursuing the sound of mournful shrieks' they travelled further on, and discovered a monster gnawing on 'a bleeding head'. Boothby heroically despatched the creature, and claimed the magic sword it was defending. Finally they came upon a 'Knight and lovely lady' in an enchanted sleep. Waving the magic sword over their bodies, Boothby awakened them. In triumph, Boothby and fuseli entered a brightly lit glade, where 'they are met by a troop of splendid fairies, who dancing round the valorous knight & magician crown them with laurel wreathes' and sing the praises of the two 'heroes':

> Hail thee Valorous favoured Son
> Now is past ye fateful hour
> Thou ye magic sword has won
> That bursts Enchantments dreaded power
>
> Hail bright Fancy's favour'd Child
> Born in Zurich's mountains wild
> Whom thy immortal Mother bore
> High o'er ye Surge to Albion's shore[6]

The climax of the evening came when the Anna Seward descended among the fairies as 'the Muse of Elegiac Verse'. The fairies exhorted her to stop lamenting that most famous victim of the American war, Major John André:

> On thy much lov'd Andre's beir
> Trophies of thy friendship stand
> Wreaths that shall for ever bloom
> Wove by thy immortal hand
>
> That Duty paid O Lady turn
> From his Laurel shaded Hearse!
> Nor o'er the cold insensate Urn
> Waste ye music of thy verse

The 'fairies' implored Seward to use her poetic powers instead to praise one more immediately present, who had suffered in the war with America hardly less: their host, St George. As a note to the account of the pageant explains, he was invalided in the conflict, and 'now lives with half his head shot away':

> The Knight who here requires thy lays
> Like that brave youth for Britain fought
> And wears Alas! the shining bays
> Of Glory all too dearly bought[7]

The account of this pageant is significant on a number of fronts. It serves to confirm Fuseli's association with and status among the intellectual circles of the Midlands and north-west that were to provide his most reliable sources of support, in common with Wright of Derby (who

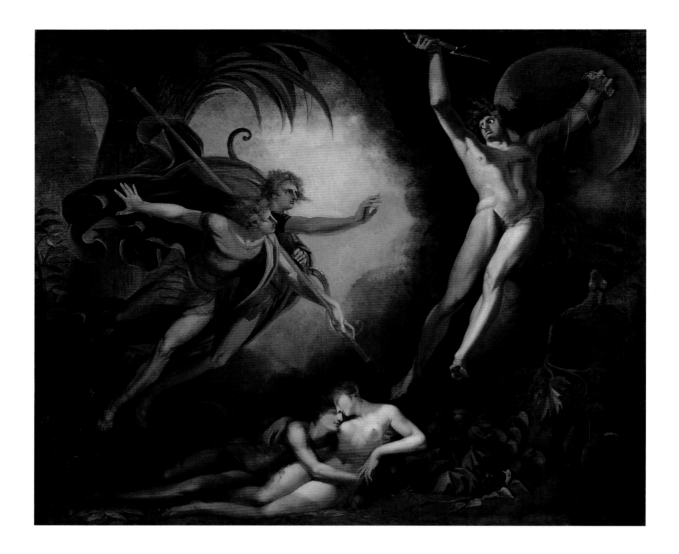

134 Henry Fuseli, *Satan Starting at the Touch of Ithuriel's Spear*, exhibited 1780. Oil on canvas, 230.5 × 276.3 cm. Staatsgalerie, Stuttgart.

had painted Boothby) and George Romney (who had started his portrait of Seward the previous summer in 1782).[8] It also emphasizes that Fuseli was as an artist whose work was richly involved in a specific cultural moment where the status of Gothic fantasy and attendant issues about the nature of cultural representation, the national past and the formation of gender identity, underwent significant transformations. Gothic romance, in literature, in performance and in Fuseli's art, was emerging as a cultural form whose debased and absurd qualities were acknowledged even by its supporters. Yet it was a form that – as might be suggested by the pageant, which transformed a tribute to the wizard painter into a lament for a man literally wounded by the fate of Britain's imperial project – was profoundly linked to very real and urgent anxieties.

Fuseli was implicated in this pageant not just because he was there, nor even just because a fantasy pageant was seen as a suitable way to pay tribute to him, but because the pageant itself was formed in part out of his imagery. The evil wizard Urma who cast a spell over the woods is not to be found in any established literary source, nor in any original medieval romance, nor in the later poetic revisions of romance convention in Edmund Spenser or John Milton or James Thomson, nor even, as far as can be ascertained, in any contemporary Gothic novel. The character is, rather, an invention unique to Fuseli. In 1782 he had painted two pictures dealing with

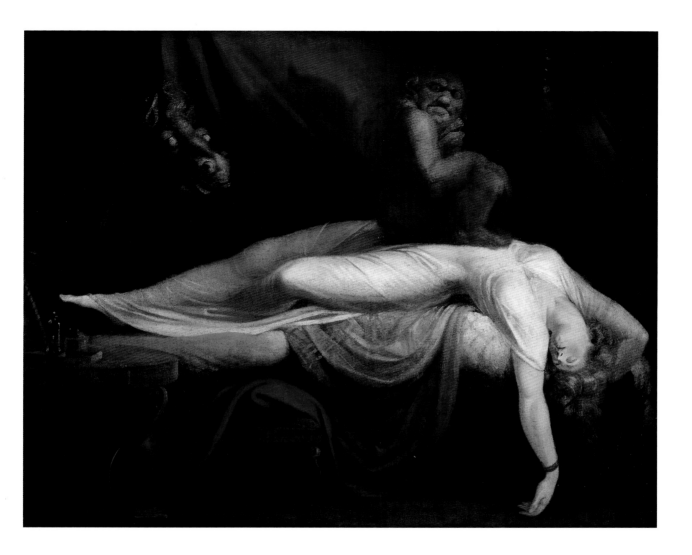

this character. One, known from a mezzotint, showed a sulky-looking Urma with a knight, 'Perceval', and a lady, 'Belisane', under his enchantment (FIG. 137). The second, exhibited at the Royal Academy in the spring of 1783 (immediately prior to the pageant), showed Perceval sprung to life and about to despatch the wizard (FIG. 136).[9]

In the print and in the catalogue of the exhibition, Fuseli claimed that the source of his subject was the 'Provencal Tales of Kyot'. This was identified by Wolfram Von Essenbach as the source of his Arthurian romance, *Parzival*, written ca.1200–10 and first published in 1477.[10] But, there is no documented Kyot, no real literary work authored by or even attributed to him. Instead, the source was an invention of Wolfram. And there is a further layer of deceit, for Wolfram claimed that Kyot's text was itself a translation from an Arabic manuscript discovered in Toledo. So in claiming the 'Provencal Tales of Kyot' as the source of his 'Urma' pictures, Fuseli proposed that his picture showed a subject taken from a text that never existed, that was in turn meant to be a translation of a further text that never existed either. Still the deceit does not end, since the character of Urma named in the images Fuseli claimed to derive from Wolfram's literary sources does not appear in Wolfram's text. It does sound appropriately 'Gothic': the closest parallel in literature is, perhaps, Urganda, the good enchantress in *Amadis the Gaul*, one of the most famous early romances.[11]

135 Henry Fuseli, *The Nightmare*, exhibited 1782. Oil on canvas, 101.6 × 127 cm. Detroit Institute of Arts, Detroit. Founders Society Purchase with funds from Mr and Mrs Bert L. Smokler and Mr and Mrs Lawrence A. Fleischman.

There are similar problems with the other characters. There is a 'Belacane' in Wolfram's text, but she was a Moorish princess, so could hardly be taken as the model for Fuseli's figure. There is also a 'Belisent' who appears in a number of English Arthurian romances, although not as Perceval's lover. There is more certainty with regard to the figure of Perceval, who was a stock character in Arthurian romance. He was the archetypal Saxon hero who became a knight without belonging to courtly culture and who could thus stand within Anglo-British political discourse as a demotic, patriotic hero in opposition to the more highly cultivated notions of knighthood associated with later Norman rule. The latter represented a foreign, French heritage, sometimes associated further with Scots–Jacobite tendencies, rather than a supposedly 'native' Anglo-German heritage aligned with the Hanoverian state or, among more radical political factions, with Anglo-Saxon legal and cultural institutions that preceded that state and needed to be defended against it.

So, source hunting is a confusing and inconclusive activity here that could be pursued further but with little hope of greater certainty. Writing to his patron William Roscoe at a later date, Fuseli noted that 'Situations as I have Combined Such as Ezelin, Belisane &c; Philosophical Ideas made intuitive, or Sentiment personified, suit, in my opinion, Small Canvases eminently'.[12] So it was that Byron was frustrated in his search for Byron, the source of Fuseli's painting of *Ezzelin and Meduna* in the annals of medieval literature; it was similarly invented along lines that evoked historical and literary precedents (in this case, medieval Italy) without referring to specific sources (FIG. 138).[13]

With their dramatic action, heroically conceived figures, historically distant settings and painterly gloom, these paintings invite interpretation as works in the highest pictorial mode. But, considered in relation to the regulations of literary epic that provided the first points of reference for the Grand Manner, the absence of a secure literary source presented a serious issue. Quite how far Fuseli had departed from the norms of epic composition might be apparent in comparing what he did with the Perceval pictures or the *Ezzelin and Meduna* to the ironic 'Receit' (recipe) for the production of epic outlined by Alexander Pope:

> Take out of any old Poem, History-books, Romance, or Legend, (for instance Geffry of Monmouth or Don Belianis of Greece) those Parts of Story which afford the most Scope for long Descriptions: Put these Pieces together, and throw all the Adventures you fancy into one Tale. Then take a Hero, whom you may chuse for the Sound of his Name, and put him into the midst of these Adventures . . . For the Moral and Allegory. These you may Extract out of the Fable afterwards at your Leisure.[14]

Pope's immediate targets are writers who would work by formulae. But his lampooning of the arbitrary nature of their choices, their attention to superficial appearances and impressions rather than structure, and their lack of concern with moral content, chimes with the approach apparent in Fuseli's 'Urma' canvases. His protagonists are given names that just sound right, his characters are equally formulaic, his concern is with making an impression rather than providing a moral lesson. Considering the compulsion to originality and invention fashioned in the 1760s and critical concerns about the regression of British art into repetitive staleness in the 1770s, it should be obvious how the stage was set for such dramatic artistic posturing. Alexander Runciman and John Hamilton Mortimer had each in their way taken advantage of the situation. Fuseli was to do so much more fully by exploiting the intrinsically unstable discursive territory identified with the Gothic and more particularly the Gothic Romance as a body of literary, historical and critical writings concerned with a real or imagined medieval past, a heroic era of chivalry, supernaturalism and adventure.

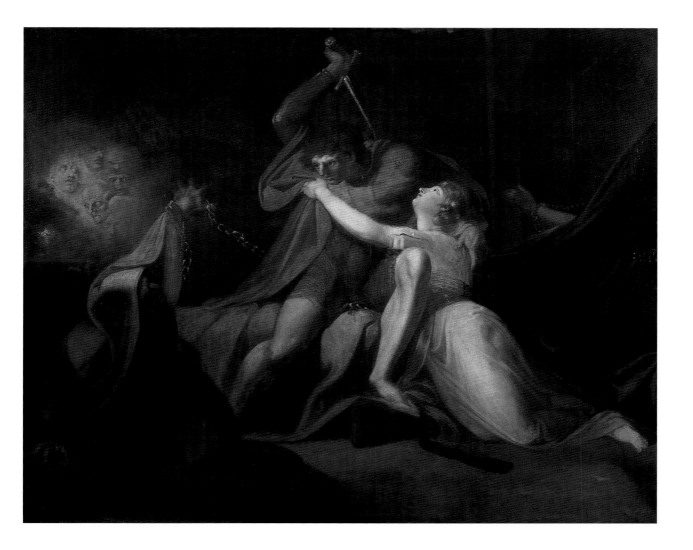

The resurgence of Gothic romance in the later 1770s and 1780s can be interpreted in relation to the radicalized political situation and increasingly prevalent concerns about the ineffectiveness of modern men, the feminization of culture, and the perceived estrangement of a heroic past. [15] In contrast to historical realities, the Gothic provided a repository of much more certain values, real men and real women instead of the fribbles, effeminates and viragos of the modern day. The medieval in a general sense supplied a discursive resource for a whole variety of groups; but how that past was imagined, and how far the issue was one of historical rather than imaginative representation, opened up the contestation of political power between the state establishment and its adherents on the one hand, and more stridently middle-class and radical tendencies on the other. Was the romantic Gothic past to be a source only for thrilling images of sexual affirmation in an era of gender doubt, or did it provide historical precedents and a sense of heritage? Were the institutions and traditions rooted in medieval history a reality, and if so did they sustain or counter the claims of the Hanoverian state to political and moral authority?

Earlier eighteenth-century commentaries on Gothic romance had been quite consistent in claiming that their appeal had been effectively diminished by Miguel de Cervantes. [16] In his preface to a 1742 translation of *Don Quixote*, the scholar William Warburton (1698–1729) had

137 Henry Fuseli, *Perceval Delivers Belisane from the Enchantment of Urma*, exhibited 1783. Oil on canvas, 99.1 × 125.7 cm. Tate, London.

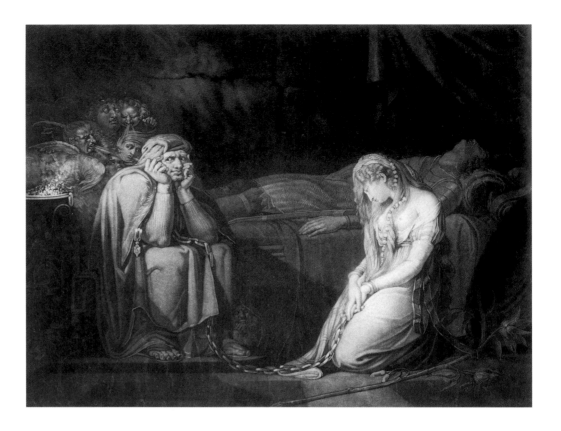

136 John Raphael Smith after Henry Fuseli, *Belisane & Perceval under the Enchantment of Urma, from the Provenzal tale of Kyot*, published by John Raphael Smith, 25 August 1782. Mezzotint, 43.5 × 55.1 cm (image size). The British Museum, London.

set the Spanish author's literary efforts against the tradition of debased romance. This point was elaborated by Tobias Smollett in the preface to his novel *Roderick Random* (1748), where he famously claimed that Cervantes had revealed the fundamentally anachronistic absurdity of romance, which could now be superseded by the modern novel: 'Cervantes, by an inimitable piece of ridicule, reformed the taste of mankind, representing chivalry in the right point of view, and converting romance to purposes far more useful and entertaining, by making it assume the sock, and point out the follies of ordinary life.'[17] Warburton, in turn, took this as a rationale for the modern novel. His 1748 preface to Samuel Richardson's *Pamela* (1740) provided a synoptic account of romance literature that placed the modern English epistolary novel at the head of a reformation of romance, correcting the excesses of the original 'barbarous *Romances*', the Spanish novel, and the French '*Heroical romances*' of the seventeenth century and their successors, the 'little amatory *Novels*' of modern France. Where they had been, by turn, barbaric, extravagant, unreal and amoral, modern English writers like Richardson presented instead 'a faithful and chaste copy of real *Life and Manners*'.[18] Thus by 1750 a rationale for the modern novel had become established, based on a contrast between romance fancy and the socially mimetic, and thus purportedly morally secure, qualities of the novel.

The possibility of a re-evaluation of romance was opened up by the historicizing literary criticism of the 1760s and 1770s, as the boundaries between 'romance', 'history' and 'epic' were exposed as especially porous or unclear. The alignment of epic – conventionally the repository of heroic virtues that should be emulated by modern men – with romance raised the possibility that epic art could itself be no more than entertainment. Thomas Leland (1722–85) had pursued this possibility in the introduction to his historical romance *Longsword* (1762):

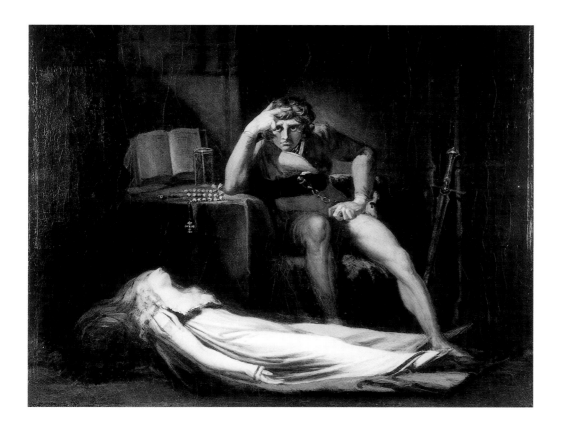

It is generally expected that pieces of this kind should convey some one useful moral: which moral, not always perhaps, the most valuable or refined, is sometimes made to float on the surface of the narrative; or is plucked up at proper intervals, and presented to the view of the reader, with great solemnity. But the author of these sheets hath too high an opinion of the judgment and penetration of his readers, to pursue this method. Although he cannot claim to be very *deep*, yet he hopes he is *clear*.[19]

Influentially, Richard Hurd (1720–1808) had aligned Homer and Gothic romance, suggesting that, while there is no doubt a qualitative difference between them, they are fundamentally the same literary creature and, if the historically specific terms on which they operate as literature are acknowledged, they could be equally appreciated. He perceived in medieval romance the same primitive appeal as was to be found in (the almost universally acclaimed) Homer: both were the products of a feudal culture 'whose turbulent genius breathed nothing but war, and was fierce and military even in its amusements'.[20] The opposition between exemplary history and debased popular forms proposed by the *artes historicae* and maintained in modulated form in the modernist critical theories of mid-century could then be collapsed. 'To read of kings, generals and statesmen; of wars, battles, and the intrigues of politics; is delightful to the bulk of mankind, for the same reasons that romances were once so bewitching: because they are above their level, and therefore answer the same purposes with giants and enchanted castles.'[21] Similarly, Homer's 'heroes quarrelling, and his gods meeting gods in combat, are sure to transport the greater part of his readers, who, it must be confessed, would hang over any extravagant and romantic novel, where preternatural exertions are described.'[22]

138 Henry Fuseli, *Ezzelin Bracciaferro Musing Beside the Body of his Wife Meduna, Slain by Him for her Infidelity During his Absence on a Crusade*, exhibited 1780. Oil on canvas, 45.7 × 50.8 cm. Sir John Soane's House and Museum, London.

The proximity of serious epic and debased, infantile or feminine literary forms was meant to be policed by taste – the socialized capacity to judge that overruled physiological responses that might disassociate aesthetic judgement from social hierarchy altogether. But such statements indicate that romance and epic could occupy the same cultural space. In fact there is documentary evidence that educated elite men enjoyed chapbook romances – and not just ironically – during this period.[23] In the context of the renewed luxury debates of the 1770s, romance could even offer models of masculine virtue in place of epic, as Richard Graves (1215–1804) proposed, somewhat wryly, in his *Spiritual Quixote* (1773):

> Though the profession of chivalry has been exhibited to us by Cervantes, as an object of ridicule; we must not imagine that it was in itself, and in its original, really ridiculous. Knight-errantry took its rise from true heroism, and the most generous principles of honour and public spirit. The most celebrated heroes of antiquity were in reality knights-errant: who wandered about, to subdue monsters or to deliver men from oppression; to protect the innocent, or chastise the insolent; and, in short, to redress those grievances which were not sufficiently provided against by established laws, in the ruder ages of the world.[24]

The value of Gothic romance was elaborated most fully by the writer Clara Reeve (1729–1807), in her lengthy *Progress of Romance* (1785). An entrenched Old Whig, Reeve sought to revise the decadent, aristocratic Gothic of Horace Walpole and stressed instead the instructive value of romance literature in the formation of the virtuous citizen.[25] While some commentators had cast real history and romance in opposition, the *Progress of Romance* posits that romance and epic can be equated. Reeve has her mouthpiece, Euphrasia, state that romance is 'an *Heroic fable*, – a fabulous Story of such actions as are commonly ascribed to heroes, or men of extraordinary courage and abilities. – Or if you would allow it, I would say an Epic in prose.'[26] Reeve claims that history, romance and epics have a single origin in the 'traditional stories of their most eminent persons, that is of their *Heroes*'. Therefore Homer's heroes and Sinbad are the same; indeed, inverting Smollett's arguments, romances are better than modern novels in providing in their heroes 'patterns of courage, truth, generosity'.[27]

The adherence to Gothic romance amounted to, in effect, an ironic rejection of the 'middle state' valorized by temperate versions of civic discourse since the early eighteenth century and revitalized in the 1780s and 1790s as fundamental to a middle-class social identity.[28] Thomas Gordon's 'Essay on Heroes' from *Cato's Letters* had ended, after all, by proposing that a better model of modern manhood lay in the bumbling but ironically detached figure of Sancho than in the ludicrously questing and conquering Don Quixote:

> I will conclude with wishing, that all nations learn the wisdom of the prudent Sancho, who, when the hero his master madly attacked the wind-mills and the lions, stood at a safe distance in a whole skin. If their governing Don Quixotes will fight, right or wrong, let them fight by themselves, and not sit at home and wantonly sacrifice their people against wind-mills and fulling-mills.[29]

An imaginary dialogue between Robinson Crusoe and Amadis the Gaul – that is, between the representative characters of the modern 'realistic' novel and the romance – published in 1782 draws out the imperialist connotations of romance: 'As for the crusade heroes, those *knight-martyrs*, or whatever you please to call them, they had much better have respited their valour to defend their own respective countries, than to have waged an unprovoked war with people who never injured them.'[30] Given the anti-imperialist stance of the social circle represented at Boothby's pageant, it may be surprising that romance could have such appeal, even to the extent of providing a proper form for a tribute to a friend.[31]

There may be some explanation provided in the details of the disabled friend who played host that night. The 'Col. St George' who hosted the event was Richard St George Mansergh St George (1756–98), a member of the Irish landed gentry. Born Richard St George Mansergh, he assumed the additional 'St George' on inheriting property from his maternal uncle, Richard Mansergh St George. This was around 1771 while he was a student at Trinity College, Cambridge. Having been previously a student at Temple Bar, his education qualified him as a member of the Anglo-Irish landed gentry who, arguably, viewed themselves as a kind of colonial elite rather than united to their workers and tenants by a common sense of Irishness.[32] Like his countryman and peer Archibald Hamilton Rowan, St George spent the early 1770s in London, but without, as far as is known, any similar level of disrepute attaching itself to him. During these years he produced a number of designs for caricatures satirizing contemporary fashionable life. Noteworthy among them is the print titled *Refined Taste*, which shows an effete and fashionable old fop eyeing up an enormous and very butch grenadier (FIG. 139). In an unusually explicit way, the accompanying epithet, drawn from Smollett's *Roderick Random*, makes clear that this covetous gaze was sexual in nature:

> Eternal Infamy, that wretch Confound,
> Who Planted first this Vice on English Ground
> A Crime that spite of Sense and Nature reigns,
> And Poisons Genial Love & Manhood stains.[33]

St George's own military career began as an ensign in the fourth Regiment of Foot in 1776, although he transferred to the fifty-second Regiment of Foot within a year, first as a volunteer and subsequently purchasing a lieutenancy.[34] Before leaving for America, St George had himself painted in a full-length portrait by Thomas Gainsborough, which presents him as the epitome of the man of feeling, leaning mournfully within a coastal scene as the ship that will take him to the unfortunate war across the Atlantic sets sail, his dog looking up at his master patheti-

139 After Richard St George Mansergh St George, *Refin'd Taste*, first published Robert Sayer, c.1772, reprinted by Laurie & Whittle c.1792. Etching, 17.6 × 25 CM. The British Museum, London.

140 Thomas
Gainsborough,
portrait of an officer
of the Forth
Regiment of Foot
(here identified as
Richard St George
Mansergh St
George), c.1775–76.
Oil on canvas, 230.2
× 156.1 cm.
National Gallery of
Victoria, Melbourne.

cally (FIG. 140).[35] It was as a lieutenant in the fifty-second that he received the injury referred to in the account of Boothby's pageant, being shot in the head and trepanned at the Battle of Germantown in October 1777. The injury was disfiguring and debilitating, and St George took to wearing a silk cap to cover up the visible metal plate, and lived mainly on the Continent to avoid the damp and cold of the British Isles. In her 'Epistle to Colonel St George, Written April 1783' Anna Seward recounted that he 'had nobly distinguished himself in the late disastrous war with America. He now lives with a considerable part of his head shot away, and though feeble, emaciated, and in almost constant pain, his imagination and his virtues have lost nothing of their vigour.'[36]

More is known about St George than might be expected, because a fellow officer in the fifty-second at Germantown, Martin Hunter, left an extensive memoir, and the dramatic circumstances of his death prompted biographical reminiscences on the part of a number of acquaintances. St George was murdered by Irish rebels on his estate in Cork in February 1798.[37] Accounts variously suggest that he was killed in cold blood, either beaten or stabbed to death, or that he put up a brave defence, these variations explicable with reference to political alignment. What most of the biographical accounts that emerged after this tragedy testify to was a man who, like Don Quixote, was an obsessive reader of romances, to the point of trying to live like a hero of chivalry. Hunter's account also claims that St George 'was quite military mad' and was followed by a Sancho Panza-like Irish servant who 'copied his master in everything . . . He wore one of his master's old regimental jackets, a set of American accoutrements, a long rifle and sword, with a brace of horse pistols.'[38] Responding to news of his death, Anna Seward even claimed that he must have been the model for the chivalric character of Orlando Falkland in William Godwin's novel *Caleb Williams* (1794), 'so exactly do we find the portrait of St George's person, genius, virtues, and singularities, in the description of Falkland'.[39] Characterizing St George as 'a man of genius', an obituary writer stated that 'his distinguishing trait, and what gave something of an eccentric cast to his conduct throughout life, was *romance* . . . his whole deportment and style of acting seemed formed upon the ideas of chivalresque ages'. The writer further noted that this romantic patriotism formed his motivation both for joining the army, and his activities as an amateur artist, where 'his constant subjects were knights, halls, battlements, feats of arms, with store of ladies, &c &c'.[40]

Claiming St George as a chivalric hero made his death seem especially poignant. An alternative account might present him as the victim of his own injustices, an absentee landlord who had allowed his estates to fall into disarray while he led a life of cultured leisure in England and the Continent. In either case, the legends of romance facilitated a representation of this man in terms that removed him somewhat from political and military responsibilities. Hunter claimed that St George made an odd sort of soldier, going out of his way to be wounded rather than do the wounding: 'On a shot being fired at any of the advanced posts, master and man set off immediately . . . I often thought that St George wished to be wounded, as he frequently said, "It is very extraordinary that I don't get a clink, for I am certain I go as much in the way of it as anybody." '[41] A letter from St George to his fiancée of September 1777 gave an account of the massacre at Paoli, a particularly vicious engagement where the actions of the fifty-second Regiment against the enemy were so cruel as to fuel American aggression at the subsequent engagement at Germantown.[42] Despite his role as an officer, the account is that of a horrified bystander, a man of sensibility who looks in disgust at the terrors of war but does not perpetuate those terrors (as he was employed to do).[43] Patriotic heroism, recast as a romance in this way, could be a fantasy that appeared harmless (at least harmless to others).

St George's use of Gothic themes as a means of managing contemporary realities found expression following the death of his wife in the early 1790s. He then wrote to Fuseli, asking him to

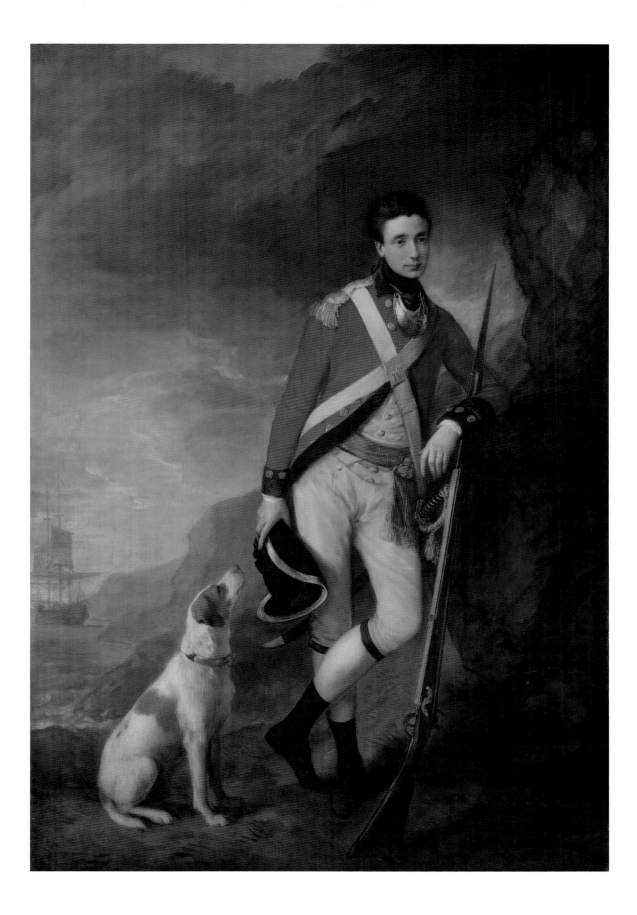

create an allegorical picture that would be hidden away until his own death, when it would be discovered by his sons – itself a sort of Gothic plot line.[44] The painting, it seems, was never created, but he did commission a portrait from Hugh Douglas Hamilton (FIG. 141). Fintan Cullen has interpreted this as an expression of specifically Anglo-Irish Protestant Gothic melancholy, a response to the current political troubles in which St George was to lose his life.[45] More generally, it is a depiction of the modern man as a dreamer, as disengaged from the world even when he is in uniform – arguably, an image of the emotional and sometimes physical masochism that may be a defining feature of modern masculinity. In his cultivated tastes, his patronage of literature and art and his dedication to the highest principles of chivalry, St George conformed to the image of the genteel hero (mapped out originally in the figure of General James Wolfe and resuscitated in relation to André). But in his case, those qualities were articulated through a passion for Gothic romance, a passion that was necessarily absurd in the context of the modern world.

The absurdity of Fuseli's art, the themes of supernaturalism and improbable heroism, the forging of literary sources and the inflated pictorial language match this absurdity. As the *General Advertiser's* critic had recognized in 1777 of Fuseli's first large-scale exhibited painting (see Chapter 7, n. 86), his art and the values it represented were necessarily Quixotic. And as James Beattie was to note in an essay published in 1783: 'the authors of the Old Romance, resemble Michael Angelo, in exalting their champions, not into heroes, but into giants and monsters'.[46] The Gothic demands a way of reading that meants the question of exemplary masculine action is almost irrelevant.[47] The whole story cannot be known, so it is a momentary action conveyed in a semantic vacuum that defines the hero. The obvious signs – chains and dungeons, witches and knights – seem trivial and playful – they are merely a dressing to the event, setting up associations but not limiting the depicted scene to the narrative scope of an established literary precedent. According to Andrea Henderson, the Gothic represents a world 'emptied of content': that is, defined through the shifting processes of personal interaction and exchange that typify commercial society rather than the fixed certainties of 'genealogy' (the personal origins of the individual character, which in conventional narrative imagery, with its cast of established heroes, would be known to the reader).[48] Fuseli's fantasy paintings can similarly be interpreted as severed from the inheritance of subject matter that had underpinned the processes of artistic emulation. His heroes and heroines have discrete identities only insofar as the broad genre of each painting can be gressed; they do not have relationships that the viewer can know, other than those revealed pictorially by the artist.

One document suggests Fuseli's active encouragement of the interpretative speculation allowed by Gothic romance as a genre. Frederica Lock recorded in a long letter how, when visiting the Lock family home in December 1789, Fuseli, waiting till darkness fell, told the story of the Knight of Navarre, 'from an ancient German ballad', which he had recently painted. According to the letter, the Lock sisters immediately suggested how the story could be changed to make it less 'odious'. Frederica recommended the theme to the poet Fanny Burney, and Fuseli encouraged the amateur artist William Lock to depict some scene from the story. A Sublime subject extracted from an obscure medieval source thus represented a mechanism for initiating personal and subjective adaptations: Fuseli's depiction of the subject became, through domestic conversation and play, only an initial representational act, which rapidly became elaborated and transformed into multiple versions.[49] Far from being definitive and authoritative, Fuseli's image was the object of divergent subjective projections on the part of his audience of women and youths.

A masculine ideal remains in Fuseli's work but is reinvested into the sheer physicality of his figures: as with the Gothic romance, a sense of 'realness' is recovered not through reference to the social and familial origins of the individual character but through the immediate physical-

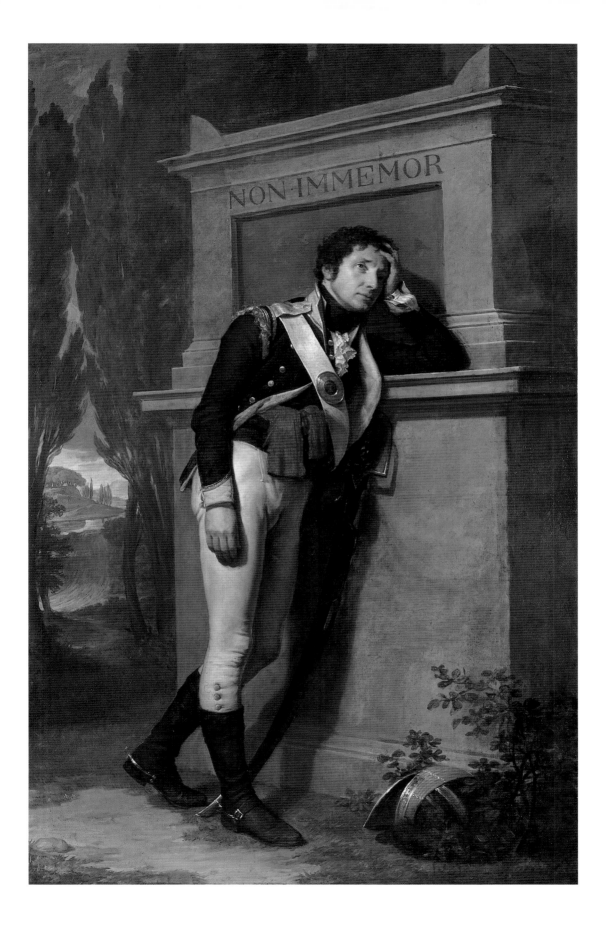

ity of their bodies. In the words of Harriet Guest: 'In the feminized territory of Gothic fantasy, as in the feminized discourses of political embourgeoisification, a more immediately physical manliness is privileged in the place of the chaste masculine definition of the discourses of public power.'[50] Hence there is a sharp gendered dichotomy of visual form in Fuseli's imagery, where all the heroes are supermen with elongated limbs, pronounced muscles, armour and absurdly phallic weaponry, and all the young women are fleshy and curvaceous, caricatured signs of life-less or soft femininity (FIG. 142). The figures in the *Perceval Delivers Belisane* – the old hag, the beautiful young woman and the muscular hero – are ciphers expressing in virtually schematic fashion the differentiation of sexual identity.

Such a schematic distinction between and within the sexes was an operational feature of the physiognomic system of Fuseli's friend Johan Caspor Lavater; like physiognomic theory, Fuseli's pictures seemed to offer simple, visible signs for reading sexual status in an era of shifting iden-tities.[51] But this stark differentiation of visual form was equally open to the accusation that it represented a kind of caricature and removed the body from the schema of ethical value. The observation of Fuseli's erstwhile acolyte Benjamin Robert Haydon (1786–1846) – 'The Engines in Fuzeli's Mind are Blasphemy, Lechery, and blood. His women are all whores, and men all *banditti*' – gives voice to the moral vacuity of Fuseli's art, the sense that his men demonstrate their manliness and his women their femininity without regard to moral quality.[52] The very rigour of the painter's differentiation of gendered physical forms marks, from this perspective, an anxiety about the potential for the collapse of difference in a commercial society, a society in which men of business are thieves and women sell their bodies.

The peculiar values of Fuseli's art did, though, coincide with the interests of particular social groups, represented by the Midlands gentry and literati who attended the party at St George's in 1783. Most importantly, it was during the early 1780s that Fuseli established links with the circle of provincial men centred on the Liverpool lawyer and banker William Roscoe (1753–1831) who were to prove his most constant patrons.[53] Their landing on Fuseli as a central focus of their cultural investment marks the culmination of a collective effort to establish Liverpool as an alter-native centre of cultural authority. During the 1770s and early 1780s Roscoe, in association with his brother-in-law, the banker Daniel Daulby (1746–98), and the upholsterer Matthew Gregson (1749–1824) among others, made several attempts to establish an academy and exhibiting society in their native city, and enthusiastically visited the exhibitions and artists' studios in London.

The cultural activities of the 1770s and 1780s in Liverpool can be considered as the inter-twining and occasional co-ordination of the diverse efforts towards cultural reform on the part of professional artists, art enthusiasts and patrons. Here the commercial nature of modern cul-tural patronage was more frankly acknowledged than elsewhere. The admittedly rather dissolute medical student David Samwell could write cynically to Matthew Gregson in 1773: 'Religion seems to flourish among you as well as Commerce in whose train all the fine arts follow as well as the art of going to Heaven. all arts are subservient to one, and that is the art of getting Money.'[55] Roscoe himself was aware of the corutradictions manifest in cultivating high art in a city whose financial promise rested on the cruel exploitations of the slave trade: 'Ah! why ye Sons of Wealth, with ceaseless toil, / Add gold to gold, and swell the shining pile.'[56] He was ulti-mately to pursue consolations for the hardships of the present situation in history, writing a badly received but nonetheless significant history of sixteenth-century Florence, the exemplar of a cultured mercantile society. It was, as Nanora Sweet has suggested, by reference to an idol-ized Renaissance that Liverpool's merchant class was able to impose a distinctly bourgeois turn on the narrative of national cultural history.[57] Roscoe steered a course away from the strident radicalism associated with the dissenting academies (which offered formal education to those

outside of the established Church and therefore barred from the universities), but unencumbered by the conservatism bred by a traditional public-school education. Freed from the extreme prejudices of either, Roscoe was most pioneering in his vision of a civilizing education very specifically appropriate to Liverpool's business and professional class.

Fuseli's art could operate so effectively in this context because it represented almost hyperbolic distance both from commercial society and from established aristocratic taste, the artist performing as a representative of the Grand Manner tradition who, by political and religious affiliations and his own alien status, could sit aside from the Westminster establishment. Fuseli's art offered the formalities of heroic form – indeed, an amplified physical heroism – with little in the way of the encumbrance of heroic exemplarity. So his life-scale *Dispute Between Hotspur, Glendower, Mortimer and Worcester About the Division of England*, shown at the Liverpool exhibition in 1784 and sold to Daniel Daulby, puts forward a scene of verbal exchange from Shakespeare as an extravagantly physical activity (FIG. 143). At the same time, his prices were far from extravagant. In 1785 he was selling small pictures for twenty-five guineas a canvas, and it seems he asked little more for larger works: he sold this Shakespearean painting to Daniel Daulby for only forty guineas.[59] Though Daulby was the most extensive collector in this circle, the Fuseli picture was one of the most highly priced in his collection and by some degree the largest canvas.[60] When Roscoe first became actively involved with Fuseli, he was skimping even on the purchase of prints and when, in a fit of enthusiasm, he purchased a picture at auction for eight guineas, he hoped that he would be able to sell it on to Daulby rather than bear the expense himself.[61]

Fuseli's achievement was to play the demand for (or perhaps necessity of) a relatively modest kind of pictorial product against an honorific discourse of artistic value that still accommodated a combative and specifically masculine artistic identity adjudged by the reformed standard of 'original genius'. Fuseli and Roscoe followed a tricky path between pragmatic commercialism and outrageous idealism hand in hand. In a letter to Roscoe written in 1791, as the artist was embarking on his ill-fated Milton Gallery, Fuseli claimed that he was utterly confident that he could support himself by 'painting Small pictures to make the large ones go on'. He represented himself as capable of producing such works with great facility: 'there is hardly an interesting Subject, I may well say, from Homer to Shakespeare – or, in the records of History – that at one time or other I have not bestowed at least a cursory thought on so that my Stock will not be easily exhausted.'[62] Even a few years later, when it became increasingly evident that the gallery was heading for disaster, he was still hoping that 'small pictures or finished drawings at my option, none for more than twenty and none for less than ten Guineas a piece' could support him. He believed these would be easy to produce, as 'I am always Sketching and finishing Small Subjects independent of the great work I have in hand – and Such has been the unremitting exertion of my fancy during every period of my life, that, were I to invent no more, the Matterials I have at my command might furnish at Least ten Painters with Ideas Sufficient for a pretty Long Life.'[63]

Fuseli's statements can be located within a pattern of reformist discourse that had underpinned the heroic ideal of the artist since the late 1750s. Yet despite situating himself as a kind of hyper-productive 'genius', Fuseli was also quite transparently mercenary (and in this aspect perhaps sits more happily with the bourgeois–capitalist values of Roscoe's circle). In his private correspondence, the heroic paradigm of the endlessly creative and adventurous artist was forced into coalescence with an alternative ideal of the artist as the provider of commercial goods for the home – now more than ever defined as the realm of the feminine. In 1800 he wrote that he had ten or twenty pictures for sale, 'from Milton, Shakespeare, Spenser, Sophocles – highly fin-

142 Johann
Heinrich Lips after
Henry Fuseli, plate
from Johann Caspar
Lavater, *Essai sur la
Physiognomie*, La
Haye, 1781–86.

ished, portable, fit for any room, and most of them interesting and not too deep Subjects'.[64] In
a single sentence, Fuseli moves from naming the canonical greats of literature, the fountainheads
of the Sublime, as the sources of his imagery, to a description of paintings as domestic artefacts
that do not place many intellectual demands on their owners. That shift represents the repack-
aging of the Sublime into a saleable format and the fabrication of an imaginary bridge between
the esteemed canon of literary greats and the ethically indeterminate responses invited by the
privatized spectacle of art.

It was the indeterminacy of Fuseli's Gothic that made his art available to and useful for patrons
and supporters unwilling to commit to the harsher ideals of classical exemplarity or the politi-
cally awkward associations of national history. The revaluation of romance and the interplay
of this genre with epic and heroic values made this possible, but equally opened up a field of
active argument that could radically devalue the Swiss painter's strategies. The years following
the American war saw the emergence of what James Watt calls the loyalist Gothic romance,
where the political associations of the medieval were brought to the fore and the opposition of
imagination and truth re-emphasized.[65] As early as 1771, when David Garrick revived Gilbert
West's *The Institution of the Order of the Garter* (1742) – a play forming the high point of the
romantic patriotic chivalry that had currency in Prince Frederick's circle – George III's reclama-
tion of the medieval past to counter the radicalization of Anglo-Saxon political heritage was
taking shape.[66] In the historical novels of the 1780s the chivalric past was presented as the locus
of certainty and virtue against the corruption of modernity, although not on the grounds that
such a past held within it the precedents of political institutions that ensured personal liberties
(that is, ancient constitutionalism), but because it represented a world of social hierarchy and
of sharpened social distinctions. Equally, the loyalist version of the Gothic sought to counter
the libertarian aspect of fantasy literature, denying the frivolous and playful aspects of the form.
It has already been noted in Chapter 5 that, in critics' comments on Mortimer's art, doubts were

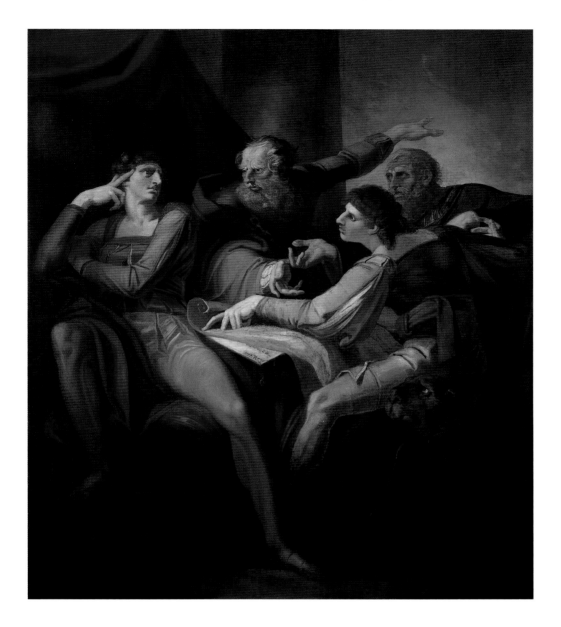

being raised about the appropriate level of imaginative liberty to be allowed to the modern artist. To bring art into the service of emulation, the present tendency to fantasy needed to be reigned in by referring to historical fact or canonical literature. Gothic Romance as a loyalist form was to stake its authority on precisely such claims to authenticity.

While Watt traces this development in literature, it found expression in painting, too. West's vast canvas of *Alexander, the Third King of Scotland, Rescued from the Fury of a Stag by the Intrepidity of Colin Fitzgerald*, exhibited at the Royal Academy in 1786, proffered a vision of the medieval past as the locus of heroic physicality (FIG. 144). Commissioned by Francis Humberston Mackenzie of the clan Mackenzie, whose founding father, Colin Fitzgerald, was said to be the hero of this painting the elaborates the theme of loyalism into an overwhelming salvational drama secured in history and in family history: 'Men, horses and dogs in action; a stag pressed hard, and the life of a King at stake – A romantic country too – what a field for Painting to effect magic in!'[67] In the next year Benjamin West began a series of paintings for George

143 Henry Fuseli, *The Dispute Between Hotspur, Glendower, Mortimer and Worcester About the Division of England*, exhibited 1784. Oil on canvas, 211 × 180 cm. Birmingham Museums and Art Gallery, Birmingham.

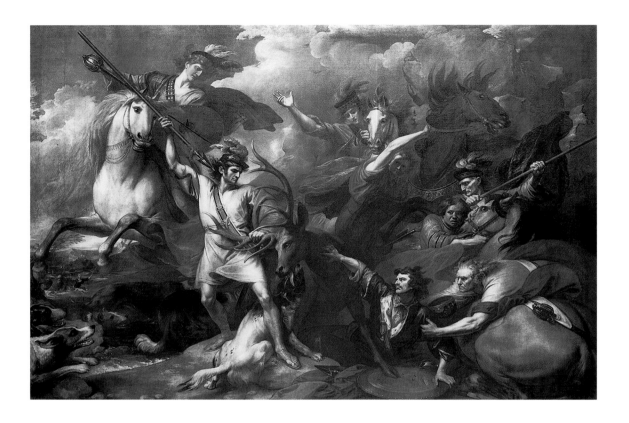

144 Benjamin West, *Alexander, the Third King of Scotland, Rescued from the Fury of a Stag by the Intrepidity of Colin Fitzgerald, the Ancestor of the Present Mackenzie Family*, dated and exhibited 1786. Oil on canvas, 366 × 521 cm. National Galleries of Scotland, Edinburgh.

III relating to Edward III's wars with France.[68] In their novel attention to historical facts of costume and setting, taken from antiquarian literature, these images seek to establish an authoritative version of medieval history that could be recruited in support of the modern monarchy.

This is most telling in West's treatment of the subject of Edward III and the burghers of Calais (exhibited first as a finished study in 1788; FIG. 145). Potentially, this is a subject about royal tyranny and had been treated as such by Robert Edge Pine in the 1760s (see Chapter 1). Where Pine – who by this time had abandoned the country of his birth for America and, he hoped, liberty – had showed Edward as a vile tyrant and his queen as desperately pleading, West represents a scene that speaks instead of royal dignity and wisdom.[69] His Edward III is erect and noble; his queen stands and gestures gracefully towards the French prisoners. The American painter's picture effectively reworks Pine's image in loyalist terms, presenting a scene of royal benevolence where the queen acts as a gently persuasive advisor rather than as a desperately emotional pleading figure.[70] Thus the conjugation of civilization and empire was restated by West in a painting that, with its massing of historical detail, sought to provide a persuasive view of a past defined by its tangible physical remains.

Early commentators were at pains to point out how carefully researched West's paintings were: prompted by the burghers of Calais painting, one critic remarked that 'he is generally destitute of the Poetry of Painting, and tells his Tale in plain Prose'.[71] His debt to current antiquarian research was much in evidence in the details of armour and heraldry paraded over the series as a whole.[72] One early commentator on West's series claimed that the artist 'had found it necessary to depart from the first plans, as he obtained new historical facts, particularly in

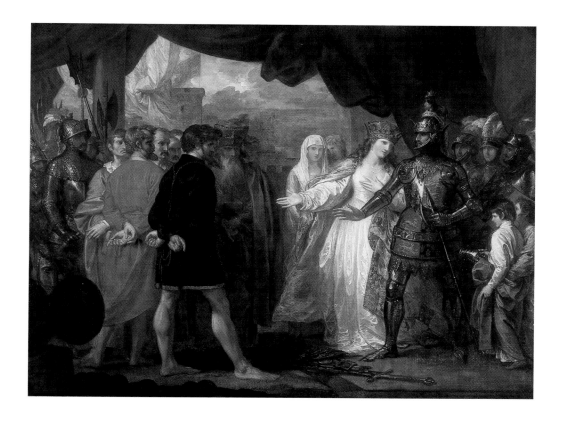

the armorial bearings'.[73] This suggests that what was at stake was less the imaginative interpretation of history in a form dictated by artistic will and formal exigencies than the re-presentation of extant physical remains and documentary materials in pictorial form. The free passage of ideas, the exploratory, often incorrect expression of form that characterized the draughtsmanship and paintings of Fuseli and his associates, were anathema here, as too, arguably, was that attention to generalities upon which the Reynoldsian definition of the Grand Manner was predicated. For West, in the employ of George III, the pursuit of pictorial historicism took precedence over making manifest the workings of the imagination or, even, the dynamic compositional possibilities of narrative historical painting that the painter had explored with his *Alexander* or his earlier depictions of Protestant empire-building for Lord Grosvenor.

The purging of historical romance of the oppositional associations forged in mid-century patriotism and maintained in the Wilkesite agitation and ancient constitutionalism of the 1760s and 1770s was not inevitable or uncontested. Such an assiduous approach to the making of images as was manifested in West's historical scenes had its detractors, even when the subject was not loaded with loyalist political import. Writing to Matthew Gregson in 1781 about a West painting of *Saul and the Witch of Endor* (1777; Wadsworth Athenaeum, Connecticut) then in the collection of Daniel Daulby, the draughtsman John Stringer noted of West's work more generally that: 'I must observe if Mr West had not been a living Artist, it might have been remarked, he is generally too tame & deficient in that fiery Spirit & masterly rapid execution, essentially requisite to the truly Sublime one Spark of fire, is worth twenty Degrees of cool Correctness.'[74] Daulby himself had admitted that he much preferred Mortimer, and his support of

145 Benjamin West, *Queen Philippa Soliciting her Husband Edward the Third to Save the Lives of the Brave Burghers of Calais*, dated and exhibited 1788. Oil on canvas, 100.5 × 132.5 cm. Detroit Institute of Arts, Detroit. Gift of James E. Scripps.

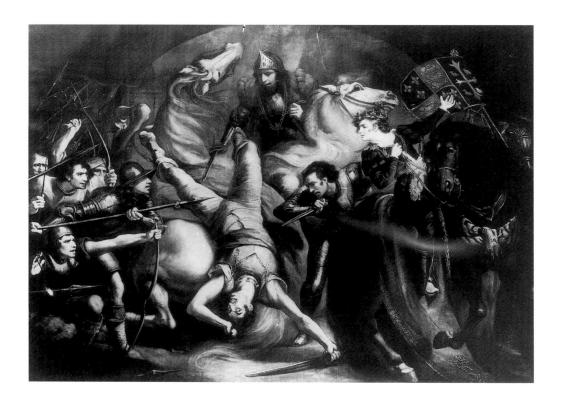

146 James North-
cote, *The Death of
Wat Tyler*, exhibited
1787. Formerly
Guildhall, London
(destroyed).

Fuseli has been noted already.[75] These were, for their supporters, artists of 'fiery Spirit' rather than 'cool Correctness'.

In the same spirit, the radical, republican associations of the Gothic past were put to use in fictions by Clare Reeve, William Godwin and others, and in the visual arts there were politically oppositional uses of the medieval past.[76] At the end of the 1770s William Blake projected a series of designs representing scenes from ancient and medieval history from a radical political perspective.[77] The image of the ancient Briton persisted in the imagery of Blake as a symbol of ancient liberties and a focus for resistance to Hanoverian hegemony, and active counter-claims to loyalist interpretations of the national past were made with the radical antiquarianism of the scholars Edward Williams and Joseph Ritson and the circles around the publisher Joseph Johnson.[78] In a much more public way, the publisher John Boydell's purchase of large-scale medieval subjects from John Opie (1761–1807) and James Northcote in the later 1780s should be interpreted, perhaps, as a counter to the aristocratic and royal patronage of large-scale historical narratives. Opie's *Death of Rizzio* (1785; Guildhall Art Gallery, London) and *Death of James I of Scotland* (1786; destroyed 1940) and Northcote's *Death of Wat Tyler* (FIG. 146) offer extravagantly dramatic scenes of national history that turn, thematically, on the theme of the abuse of power, recalling the anti-royalist undercurrent of the national history paintings entered into the premium competitions of the Society of Arts in the early 1760s. Rizzio and James I are getting their just desserts for their tyrannical and corrupt behaviour, while Wat Tyler is a martyr to the cause of political liberty, the boyish figure of Richard III a symbol of pampered and sexually suspect monarchy, 'one of our modern smock-faced, effeminate youths'.[79]

The dominant presence of these latter works on the walls of the Royal Academy in 1787 (FIG. 147) signalled the abiding cultural authority of the City of London against the court and the

147 Pietro Antonio Martini after Johann Heinrich Ramberg, *The Exhibition of the Royal Academy, 1787*, published by A. C. de Poggi, 1 July 1787. Etching and engraving, 36 × 52.7 cm. The British Museum, London.

possibility of drawing anti-monarchical lessons from history, even as the political authority of the monarchy was becoming entrenched and the more historically immediate traumas of the loss of America being swept under the carpet in favour of an intensive identification with a chivalric past. When Boydell presented these works, with others (including a painting by West), to the Corporation of London in 1794 he took the opportunity to elaborate in print the demotic patriotism that had motivated them.[80]

Still, it was West who was the most prominent and successful painter, who enjoyed the greatest privileges in the academy and at court. So when the Revd Bromley sought to belittle Fuseli in his *Philosophical and Critical History of the Fine Arts* of 1793, it was by pitching him against Benjamin West's vision of the heroic, anchored in 'heroic fact' and politically secure. Where West sought out subjects from 'real history' and depicted them with close attention to historical detail, Fuseli was a mere fantasist and, in this, like the purveyors of cheap literature:

The *night-mare*, *little red riding hood*, *the shepherd's dream*, or any dream that is not marked in authentic history as combined with the important dispensations of Providence, and many other pieces of a visionary and fanciful nature, are speculations of as exalted a stretch in the contemplation of such a mind as the finest lessons that ever were drawn from religion, or morals, or useful history. And yet the painter, who should employ his time on such subjects, would certainly amuse the intelligent no more than the man who should make those subjects the topics of a serious discourse. But what good has the world, or what honour has the art, at any time derived from such light and fantastic speculations?[81]

The extreme stylization of Fuseli's art meant that it was not to be judged by rules and was instead to be considered in relation to less tangible or certain values:

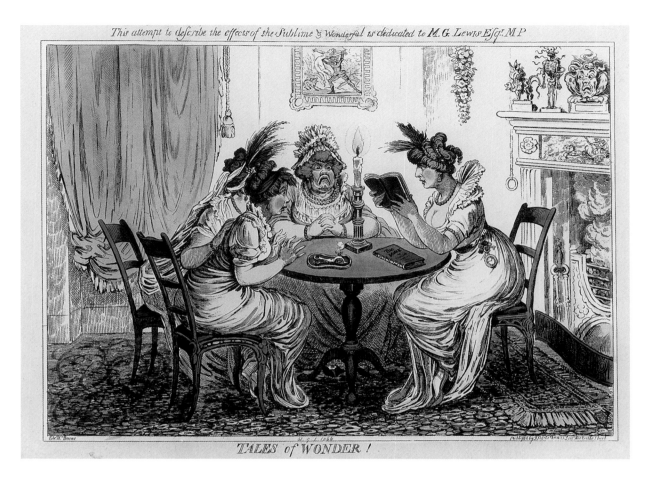

This attempt to describe the effects of the Sublime & Wonderful is dedicated to M. G. Lewis Esqr. M.P.

TALES of WONDER !

148 James Gillray, *Tales of Wonder!*, published by Hannah Humphrey, 1 February 1802. Hand-coloured etching, 25.5 × 35.4 cm. The British Museum, London.

It is a difficult task to estimate the merits of this artist's work, by any rule or criterion by which we judge of others. Pictures are, or ought to be, a representation of natural objects, delineated with taste and precision. Mr *Fuseli* gives us the human figure, from the recollection of its form, and not from the form itself; he seems to be painting every thing from fancy, which renders his work almost incomprehensible, and leaves no criterion to judge of them by, but the imagination.[82]

Critics held that his imagination was rooted in pathology, in sickness or delusion, and thus was decisively extra-social. It is the extra-social properties of his art that gave rise to the resilient rumours of Fuseli's using opium or eating raw pork in order to conjure up dream visions – rumours that are as absurd as they are ill founded.[83] More significant is the unstable gender dynamic that was put into play around such a notion of creativity. Contemporary critiques of supernatural fiction posited the genre as the province of non-masculine audiences. As E. J. Clery has argued, the 'irrational plots and blatant appeal to the passions' of the genre caused it to be 'classed among the corrupting agencies of feminine luxury, intimately, physically identified with the reading subject constructed as feminine'.[84] When James Gillray sought to satirize the vogue for fantasy literature in 1802 – by which time the fashion for fantasy had reached fever pitch with a new kind of cheap and lurid paperback novel – he featured the telling detail of a painting on the wall that, with its athletic hero in a skin-tight costume and limp maiden, would imme-

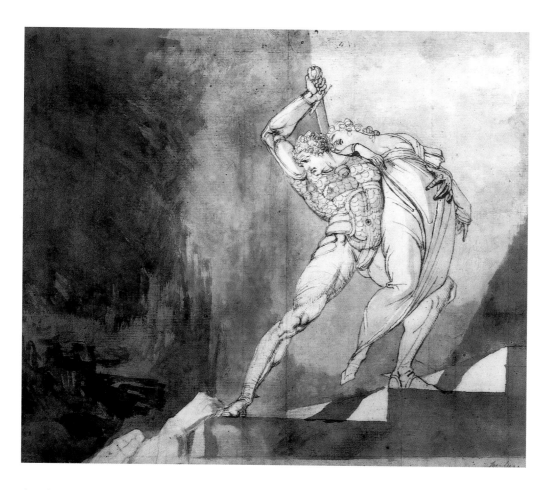

diately be identified as Fuseli or at least Fuselian, recalling the physical extravagance of such designs as his heroic figure saving a woman from a giant (FIGS 148 AND 149).

West, in a draft autobiography put together a few years later, cast himself as a reformer working against the corrupt traditions of 'Legantary Fables', painting instead 'pictures exhibiting famanine conjugal affections to departed Greatness, patronism for love of country, Heroism, and a rectitude of justice . . . those subjects being real facts founded in history'.[85] Fuseli, in turn, was to counter such claims in his oft-quoted comments regarding the state of the arts by 1805, which aligned this sort of facticity with the lesser genres: 'Fuseli has little hope of *Poetical* Painting finding encouragements in England. The people are not prepared for it. Portrait with them is everything. – Their taste & feelings all goes to *realities*, – The Ideal does not operate on their minds. – *Historical painting*, viz: matter of fact, they may encourage.'[86] Moreover, that compounding of virtue and artistic excellence attempted by Bromley, and by West in his presidential lectures, was persistently refuted by the Swiss artist in print and in private.[87]

Fuseli's art was thus positioned in different ways by the artist himself as much as his critics at the crux of the issue of artistic authority and authenticity and at a point of slippage between masculine virtue and its others, whether 'feminine' consumerism or a kind of vice. The absurdity and extravagance of his art revealed the moral vacuum that could now exist at the heart of heroic representation.

149 Henry Fuseli, unidentified scene (perhaps *Othar Rescuing Siritha from the Giant*), dated January 1781. Pen and wash on paper, 30.5 × 37.1 cm. Cecil Higgins Art Gallery, Bedford.

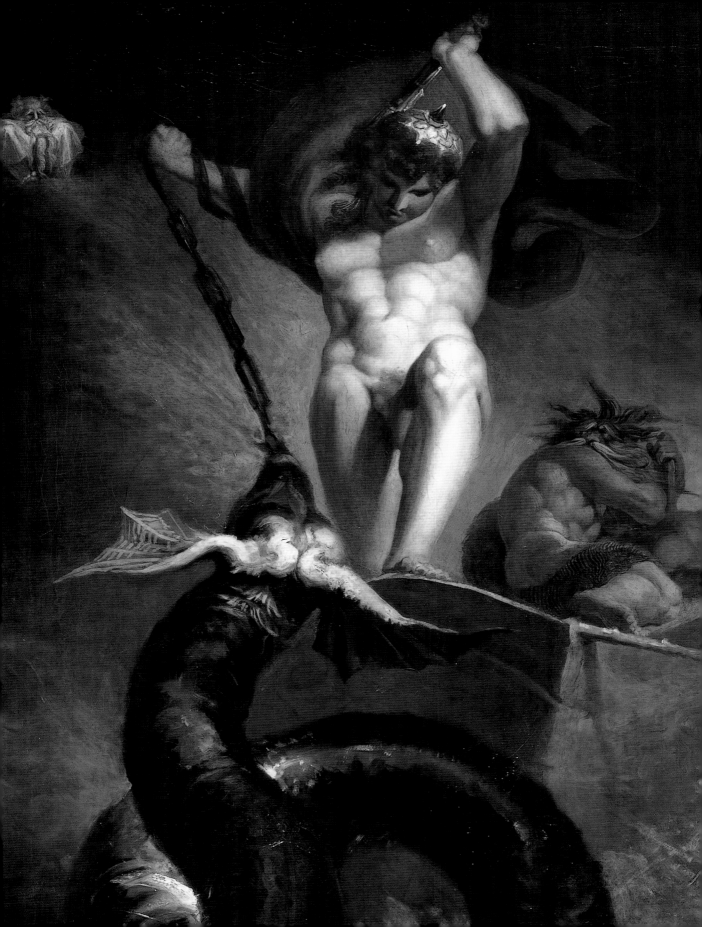

10

THE MALE NUDE AT THE
ROYAL ACADEMY

This study has not sought to find in the representation of heroic bodies simple projections of the personality and self-image of the artist: the relationship between the internal formation of the work of art and the 'external' realm of the social performance of artistic identity is not claimed here as necessarily one of mimetic resemblance or direct reference. But in certain, highly prescribed, circumstances, the heroic image could be invested with this sort of significance. The Diploma Works that John Francis Rigaud, Thomas Banks and Henry Fuseli presented to the Royal Academy in the later 1780s are a case in point, as each can be interpreted as giving dramatic expression to the complex position of the heroic artist at this juncture. Working aside from the exigencies of the market and away from direct patronal demands, each of these artists was able temporarily to indulge the most rarefied fantasy of heroic art. But none could erase from sight the reality of their circumstances, and each of these works comments in some way on the very vulnerability of the ideals they set out to demonstrate. Fuseli's diploma work in particular is a peculiarly self-aware experiment, both embodying and commenting on the gendered conflict between commercial luxury and the classically heroic body.

The convention of the Diploma Work had been established early in the academy's history, with the regulation passed in 1771 that each newly appointed academician be obliged to present an example of his work to be kept by the academy. The work in question was meant to be exemplary of the skills of the particular practitioner, but – unlike France, where new academicians were given subjects to execute and were entered into the institution as a distinct class of artist – there was no ruling about the exact character of the diploma work. Later, rather improvised rulings indicate that portraits were generally not acceptable and that any offered work had to be complete and framed.[1]

The very existence of such stipulations is an indication of the half-heartedness of many new academicians as they approached the task of the diploma work. Made unavailable for sale or even convenient reproduction and not guaranteed a place in the public eye, the Diploma Work offered little reason beyond the symbolic for the artist to invest greatly. Many artists clearly viewed the production of these works as tiresome. In 1794, Richard Westall and Thomas Lawrence (1769–1830) had their diploma works returned to them as unfinished, and it was presumably the prevarication of many academicians in presenting their works that prompted the resolution of 1795 forcing newly elected academicians to send in their diploma works within a year of their election.[2] With this in mind, it should not perhaps be surprising that very few attempted the potentially complex and demanding task of producing historical compositions, and even fewer undertook subjects that involved the male nude – the exemplum of academic

(Facing page)
Henry Fuseli, *Thor Battering the Midgard Serpent.* Detail of fig. 157.

skills. The three artists under consideration here are exceptional in the degree of imaginative and practical investment they put into their diploma works and in the mere fact that they treated the male nude as a subject. In fact, in each case it may be that the resulting productions represent a degree of overinvestment in the Grand Manner that unsettled rather than confirmed academic ideals.

Chronologically the first work to be considered here, John Francis Rigaud's *Samson Breaking his Bonds* was presented to the academy in 1784 (FIG. 150).³ Rigaud had been elected an associate of the Royal Academy in 1772, only a year after he had come to Britain from his native Italy with James Barry.⁴ At that time he appears to have been intent on presenting himself as a painter of the heroic male nude and he had brought with him a large-scale painting of a *Hercules Resting from his Labours* (now lost). It was, in the words of the extensive memoir of the artist put together by his son, 'a finely composed figure, larger than the life, the drawing admirably correct, displaying a thorough knowledge of the human figure, and in the grandest style – completely of the Roman school'.⁵ Be that as it may, Rigaud made a living in Britain out of decorative painting, variously for architect-designed interiors and more lowly locations, including popular sideshows, and by producing literary and historical narrative painting of a sentimental or antiquarian character. The artist became moderately successful and was elected a full member of the academy in February 1784. His diploma work was received by December of that year, and the royal approbation of his election issued in February 1785.⁶

The painting shows Rigaud returning to the type of subject that he had executed immediately before his arrival in Britain: the heroic male nude. William Pressly has termed the work 'an inflated academy study' developed, ultimately, from painted studies undertaken at the Accademia Clementia in Bologna.⁷ The figure of Samson, rather over life-size, dominates the canvas. His form is intended as a virtuoso display of the artist's ability to evoke flesh in paint, from the yellow pallor of the figure's torso through to the more vivid reds of his extremities and face. His hugely muscled form is evoked in the painterly terms of seventeenth-century Flemish art, emphasizing his fleshiness, the weight of individual limbs and a high level of corpuscular energy. Indeed, the image makes a theme of the assumption of full masculine physical potential: it shows the moment when the still hirsute Samson breaks his bonds. At this point in the narrative, neither the treacherous woman who stands beside him, nor the feeble bonds around his wrists and ankles, nor even the Philistines visible to the right, present any challenge to the biblical hero. As an embodiment of a fantasy of superheroic strength, Rigaud's Samson seems complete.

While the figure's physique is properly described as hyper-masculine in the Michelangeloesque mode, the composition also evokes the theme of the reclining female nude. Samson's body functions both as an emblem of masculine power and as an object occupying a role that could be erotically charged – one conventionally occupied by a female body. The viewer's knowledge of the narrative would suggest that the figure should be seen as imminently triumphant rather than suffering, and the now commonplace terms of the Sublime an imply that the 'contracting power of the muscles' affirms rather than undermines a masculine identity. But the sexual dimension of this figure should not be disregarded. While in Italy, Rigaud associated with an international circle of artists including Johan Tobias Sergel, and indeed he featured in Antoine-Esprit Gibelin's drawing of the group of around 1769–71, his head appearing from between the sculptor's thighs (FIG. 95). As noted in Chapter 7, within this circle male sexuality offered both a metaphor for and the purported origin of creative energy. In a caricature from around the same date, Sergel showed Rigaud standing amused in juxtaposition with an impressively endowed priapic herm (FIG. 151). The facial resemblance between the sculpture and the painter and the latter's cocky expression imply an identification that, viewed in light of sexualized ideals of creative genera-

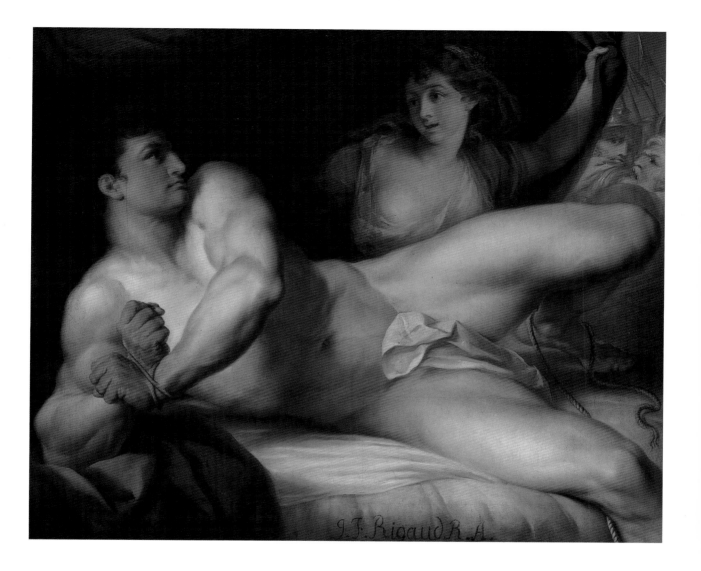

tion, might be more than a flippantly bawdy comment. The general swelling of Samson's body might then be read as referring back ultimately to the swelling and fulfilment of the phallus itself, which can define a moment at which a full masculine identity is assumed. Read in these terms, Rigaud's painting takes on resonance as an allegory of the creative process, the whole of the figure's body acting as a gigantic masculine member whose potency is not undermined by the visible presence of a relatively diminutive penis.

Rigaud's diploma work was unusual in that it received a considerable amount of press attention when it was first on show in the Council Room during the academy's exhibition of 1785; generally diploma works were overlooked completely in favour of the pictures on show in the Great Room. According to Rigaud's son the painting was kept in the Council Room where 'for many years it was annually seen by the public at the time of the exhibition'.[8] One piece of criticism even suggests that the reading of the image as a heroic allegory of the creative act has currency: 'Mr *Rigaud's* picture of *Samson*, has over-come all the rival pieces in the Council room. His brother artists may *rail* on, but they will not equal him in power, although some of them are furnished with the *jaw-bone* of an *ass*!'[9] Thus as Samson overcomes the Philistines, Rigaud overcomes his opponents, who have only words, through the performance of his art.

150 John Francis Rigaud, *Samson Breaking his Bonds*, presented to the Royal Academy in December 1784. Oil on canvas, 130.3 × 156.2 cm. Royal Academy of Arts, London.

In painting a large-scale male nude Rigaud fulfilled the key expectations of the academy and received general approbation in the press. The picture was clearly considered a success by the artist, who used it as a showpiece in later years. In 1788 he borrowed the painting to make a copy from it, and two years later borrowed it again. In 1792 a subscription for an engraving was opened, and the copy put on show in the artist's studio in order to cultivate subscribers,[10] prompting one critic of the annual exhibition to highlight the contrast between that exceptional work and the kinds of product Rigaud executed as the substance of his professional practice:

> We cannot but express our regret, to see the abilities of this Artist employed on subjects so insignificant to which his name is prefixed, in the present exhibition. We viewed them with indifference, and passed into the Council Chamber, to meditate on the vigorous efforts of his pencil, at the time when he solicited *Academical Honours*, and to lament, that the Artist who produced the *Samson*, should have degenerated into so very a trifler, as to amuse himself with *Portraits* and *Processions*.[11]

The mention of the artist's 'vigorous efforts' again reveals the virile character of the creative act. This is contrasted with the self-interest that led Rigaud to produce 'trifles', here characterized as amusements for himself but also, by implication, for the market place. The picture was something of a millstone hanging around the painter's neck, as critics returned to its example year after year to regret that Rigaud was taken up with less heroic subjects. The *Samson*, like Rigaud's *Hercules*, contributed to the creation of a specifically heroic and masculine artistic identity that could, in practice, exist only exterior to the norms of professional practice with their commercial imperatives.

Rigaud himself was quite aware of the exceptional and exemplary character of his *Samson*. In a letter of 1807, written in response to the decision of his artist son to abandon history painting in favour of watercolour, he stated how painting the male nude was a sure means of gaining attention and respect:

> If I had never painted my Hercules, at Rome, I should never have been considered by my fellow students but as a good natured jovial fellow, but not as a good painter. To that picture I owe the opinion they formed of me; for I had no patron, no protector, and I was spending the little money I had. That opinion has followed me, and supported me ever since, under Providence; though not without many vicissitudes. That reputation which Hercules begun, was, sixteen years after confirmed, strengthened or renewed by the Samson.[12]

The diploma work was a chance for the artist to reclaim the long-neglected ambitions of his earlier life, but this was achieved, according to Rigaud, only by neglecting any attention to immediate financial necessity. He continues: 'In such a picture as I suggest, I would banish all idea of fashion, and all thoughts of profit. The Art alone should be the guide, and morality the sentiment.' The overdetermination of Samson's masculinity, suggesting a feminine, narcissistic presence, was a sign of a Quixotic nostalgia for an integrated masculinity that could exist outside modernity.

An analogous instance of the incompatibility of the incentives offered by the academy and the actualities of the market place is found in the case of Thomas Banks. The sculptor was elected an associate of the academy in 1784, on his second attempt, and a full academician as early as February 1785.[13] His diploma work, the marble *Falling Titan*, was submitted about a year later, since the royal approbation was issued in April 1786 (FIG. 152).[14] These events came on the heels of a series of traumatic professional setbacks: in 1782 Banks had returned from Russia, having failed to receive the patronage he had hoped to find at the court of Catherine II.[15] As Allan Cunningham exclaimed of this period:

Military pageants, balls, reviews, interposed between the sculptor and the success which he merited; and it is further said, that the religious feelings of this grave and good man were not a little shocked at the gross and profligate debauchery of a most licentious court . . . Catharine could not but see that he felt disappointed; but it was perhaps no alleviation to his feelings that she gave him an historic subject to do into stone; – and such a subject – The Armed Neutrality! How he acquitted himself in this imperial puzzle cannot at present be known; he made his escape, I believe, in allegory, and explained with words what the marble failed to convey. This was a far different occupation from that of embodying the heroes of Homer.[16]

The Declaration of Armed Neutrality existed to preserve international commerce in the midst of war and was against Britain's interests so, aside from the question of the accuracy of this statement, Cunningham's report inventively underscores the idea of Banks existing in conflict with political and material reality. Whatever the truth of his circumstances in Russia, Banks was clearly unable to attract much financial support, for in the year of his return to England from Russia he put up a collection of casts and terracottas anonymously for sale at Christie's.[17] He had, back in England, no great monumental projects lined up – aside from a memorial to Sir Eyre Coote for Westminster Abbey that he took on in 1783 – no sustained source of patronage and no professional office. As a supporter noted: 'he has produced but few works but these of a quality to recom'd and endear him to real judges, yet his Patrons have hitherto been people of little influence, his employment has been proportionately small.'[18]

The sculptor's response to his situation was, to be cynical, far from pragmatic, and represents, like Rigaud's *Samson*, a pointed return to youthful ambitions. During 1783 and 1784 he worked on a larger-than-life plaster model of *Achilles Mourning*, which, after being severely damaged on the way to the academy exhibition of 1784, was eventually shown to tremendous critical acclaim in that year.[19] In a sense this was a repetition of the student exercise that had won him acclaim at the Society of Arts at the end of the 1760s: the life-scale clay figure of *Prometheus and the Vulture* – an ambitiously scaled model on a classical theme that involved a hero in distress. It was also an amplification of that effort, achieving, in the context of a now middle-aged artist in need of employment, absurd proportions. The figure was over 8 feet tall, raised on a pedestal 3 feet high, created without a commission or any certain promise of a commission, and in the most vulnerable of materials. In these respects, the model represents a gratuitously risky strategy. But, exceptionally, it worked – to a point. To take Cunningham's retrospective summary of responses to the model:

> The heroic beauty and natural vigour of this poetic statue have been noticed by many; in fine action and noble proportions nothing here has yet excelled it. Praise was poured upon the artist from all quarters; some loved it because it was classic – others because it was natural, and more because the sentiment of sorrow was largely diffused from the face over the figure.[20]

Given the conflicts of value and form between sentimental versions of masculinity and the heroic, the beautiful and the vigorous, the Sublime and the beautiful, evident in the high art of the previous decades, Cunningham's terms are telling. The claim is here that Banks had in this figure brought together the contradictory forces and interests surrounding the heroic male body: he had succeeded in pleasing everybody. However, this effort did not immediately translate into material success. A monumental marble version was commissioned by Thomas Johnes of Hafod, who patronized Banks on a number of occasions, but the project was abandoned and the repaired model remained in the sculptor's studio until his death. Eventually it entered the collection of the Royal Academy, where it was destroyed in the 1920s.[21]

Without a detailed visual record of the work, the form of the *Achilles Mourning* is a matter of speculation. From the textual accounts that survive it seems that it was a figure displaying extravagant gestures in a complex pose, kneeling and partly resting on its shield, leaning forward with the head thrown back violently and the left arm extended, the face contorted with expression. As noted in relation to Banks' sculpted works of the 1770s, such physical and expressive extravagance were traditionally located in the private realm of small-scale works and sketches, and this work should be considered as a massive but direct magnification of the Homeric subjects that the sculptor created. Cunningham knew of, and apparently had seen, a succession of works by Banks representing such themes: 'Andromache lamenting with her handmaidens over the body of Hector – his Venus rising from the sea . . . A Venus bearing aeneas wounded from the battle . . . Achilles arming against his Myrmidons . . . that angry parle between Agamemnon and Achilles in the opening of the Iliad'. These were, though, only 'sketches – rough it is true, and somewhat repulsive to those fastidious about delicacy of finish, but full of heroic feeling'.[22]

Unfinished, perhaps unfinishable, such designs languished in a studio that was to be preoccupied with memorial sculptures, becoming unavoidably poignant symbols of a lost conception of the heroic artist. The *Achilles Mourning* could gain meaning primarily as a means of demonstrating artistic ambition, and it was presumably not coincidental that Banks was elected into the academic body following on from the display of this work. For John Flaxman, in his admiring posthumous tribute to the sculptor (1805), the *Achilles* represented the standard of a kind of artistic excellence that could be best acknowledged away from the political squabbling and posturing that characterized the wider cultural field:

Prime merit and moral worth are the only claims which this Society [the Academy] can listen to; the Laws have wisely & positively declared, 'that the Academicians shall be men of fair moral characters, & of distinguished merit in their professions, as Painters, Sculptors or Architects'; it frequently happens that the most active & boisterous in proffering his pretensions, has the least merit to support them; & it is equally true, that he who is most desirous of office or honors, is seldom the person that ought to have them: – let the Candidate upon the present occasion who is most solicitous to be chosen, follow the generous example of our departed friend; produce a work in the Exhibition the merits of which shall be decided, as to leave the Academy no choice, & make the members unanimous in his election.[23]

152 Thomas Banks, *Falling Titan*, 1785–86, presented to the Royal Academy in April 1786. Marble. Royal Academy of Arts, London.

What re-emerges at the beginning of the nineteenth century in texts like this – and this happened in the case of the younger artist Thomas Procter, too, as will be discussed – is the idea that the values of the realm of heroic excellence are inverted in relation to those of artistic production. Insofar as the academy was able, in Flaxman's judgement, truly to acknowledge superior talent, it gave representation to a world turned upside down, where poverty and neglect had the greatest value, and quietude spoke most loudly. In this lies the alibi for the cultural poverty of bourgeois capitalism, brought into being by its opponents as much as (perhaps more than) its advocates – but of this, more is to come.

What Banks presented to the academy after his election as a full member in 1785 was to become another symbol of this lost cause of pursuing the representation of 'heroic feeling'. In materializing such aspirations, this exercise in heroic art further undoes itself and reveals the illusory character of the corresponding virtues despite the highly rarefied circumstances of its production. On one level, Banks' *Falling Titan* would appear to be entirely conventional, judged by Continental standards at least. In terms of its physical material (highly finished white marble), scale (about two-thirds life), and treatment of the male form, the *Falling Titan* relates closely to a tradition of sculpted figure studies presented to the French *Académie* as *morceaux de réception*, including François Dumont's *Titan* (1711; FIG. 153), Pierre Ambrose Slodtz's *Fall of Icarus* (1743) and E.-M. Falconet's *Milo of Crotona* (1754).[24] As a demonstration of technical skill and imagination, each of these treats a single nude male figure disposed into a posture that demands considerable understanding of anatomy and a high level of technical competence in the cutting of marble into structurally feasible three-dimensional forms.

Insofar as Banks' sculpture can be read in terms of a formal exercise in the same manner as these French precedents, it was coherent, accomplished, even a triumph. Although sculpture usually received scant attention at the annual exhibitions, one reviewer in 1786 made a point of turning from the main show to Banks' diploma work: 'The figure in marble of one of the

Titans (a donation to the Academy by Mr Banks) is admirably conceived, and the anatomy well understood. In short, for correctness of design, and masterly stile of execution, it seems to be superior to any thing in that line that has yet been presented to the Academy.'[25]

Banks' *Titan* can also be read, however, in the specific terms of the late eighteenth-century Sublime, with its emphasis not on the objective mastery of artistic materials and anatomy represented in the French precedents, so much as subjective dissolution, dislocations of scale and disorientation:

> In form, expression, anatomical accuracy, and adaption, this statue approaches perfection: it is one of those works, that in a small compass, and with simplicity of parts, may be called Sublime. The mind of the spectator is imperceptibly hurried away from the object to the subject, from the marble personification of a human figure to the poetical tales of the ancients, from a small statue to the imaginary display of super-human power and gigantic mightiness.[26]

In its relatively small-scale evocation of an enormous figure, its fantastic subject matter and disconcerting contrast between the gigantic Titan and the minute shepherds at its base, Banks' sculpture seems calculated to invite a reading as Sublime. In this it depends to a degree on effects that are pictorial, deriving from perspective effects set up through a specific positioning of the

154 Henry Fuseli, *Prometheus Rescued by Hercules*, *c*.1781–85. Pen and brown ink and wash touched with white over graphite on paper, 56.5 × 66.9 CM. The British Museum, London.

155 Thomas Banks, *Falling Titan*, after 1786. Etching, 27.6 × 37.5 cm. The British Museum, London.

viewer: the figure's head is disproportionately small, suggesting that the work should be viewed from below. The extravagant physicality of the figure, sprawling and strained, relates to the 'five-point' exercises banks had worked on with Fuseli, and close comparisons can be found in the painter's designs (FIG. 154).[27] Banks' undated etching of the sculpture – one of only two prints executed by the artist – emphasized these qualities (FIG. 155). Rather than simply describing the work in a graphic medium, Banks has reworked the subject in a specifically pictorial register that evokes Hendrick Goltzius' bizarrely foreshortened figures and the etching of *The Fall of the Giants* by Salvator Rosa (FIG. 156) – the definitively Sublime artist. The artist's etching technique creates a degree of furious movement and visual agitation only hinted at in the original sculpture, while his rejection of a clear sense of any spatial setting for the sculpture as an object and the compressed arrangement of the figure and his surroundings within the pictorial frame ensure that the disconcerting conjunction of scale is underscored.

The pictorial nature of Banks' etching, which by flattening out the composition and detaching the figure from the falling rocks that in three dimensions lend it physical support, barely concedes that it was based on a sculpture at all, and indicates a need to resolve or clarify the characteristics of his diploma work.

As an exercise in the Sublime, the sculpture of the *Falling Titan* sends out contradictory messages about the male body in representation. On the one hand, it is a relatively small-scale, finely

156 Salvator Rosa, *The Fall of the Giants*, 1663. Etching and drypoint, 72 × 47.5 cm. Witt Print Collection, Courtauld Institute of Art, London.

executed study of the male nude, arranged to facilitate close attention to the cadences and subtle undulations of an athletic masculine body as a beautiful object. On the other, it is presented as the object of a potentially overwhelming emotional response that must depend for its effect not on close attention but on a general impression that stretches and exercises the eye and the imagination. In that aspect, the beauty of finish, the treatment of anatomy, the details and narrative content should be irrelevant, even inimical to its effects. The *Falling Titan* thus occupies the loophole at the heart of the theory of the Sublime, where simply by entering representation the awesomely unmanageable Sublime object is transformed into its antithesis, the Beautiful.[28] Banks felt impelled, as on no other occasion, to extend the work's life and revise its meanings through an experimental graphic work where the sublimity and masculine musculature of the figure could be more deeply and certainly registered.[29]

A later commentator certainly felt that the sculpture as it existed appeared incomplete in its meanings. According to Cunningham, the composition originated in a relief representing the battle between Jupiter and the Titans, with the god seated in heaven alongside the other gods and goddesses – a small oval composition 'ten or twelve inches long' yet incorporating a heavenly scene with Jupiter enthroned and 'a sea of gigantic forms' writhing in agony, some preparing to hurl rocks.[30] Cunningham claims that for the *Falling Titan* to be 'fully felt' it must be imagined in relation to that smaller relief – a work apparently of densely communicated narra-

157 Henry Fuseli,
*Thor Battering the
Midgard Serpent*,
presented to the
Royal Academy in
November 1790. Oil
on canvas, 133 ×
94.6 cm. Royal
Academy of Arts,
London.

tive content – and once 'felt', the effect was perforce tragic in its emotional implications: 'Looking at both, we cannot refrain from lamenting, that a man capable of such things should have mourned away three-fourths of his life over disappointed hopes.'[31] Thus the *Falling Titan* highlights both the priority of the Sublime as a vehicle for artistic ambition and the potential tensions between Sublime aesthetics and normative academic practice.

Before the end of the eighteenth century only a single further newly appointed academician undertook a heroic male nude as the subject of his diploma work: Henry Fuseli. While members of his Roman 'circle', including Banks and James Northcote, had more quickly sought academic recognition after returning to London, Fuseli did not even present himself as a candidate associate until 1788, when he was immediately elected. Within four months he was presented as a possible academician, but lost out decisively in the first round of voting. Exactly a year later he was voted in as an academician in 'A contest of unusual violence' that prompted Joshua Reynolds' (temporary) resignation.[32] Fuseli's diploma work, *Thor Battering the Midgard Serpent* (FIG. 157), was underway by September 1790, and in November Reynolds, now back in his post as president, was able to report that 'His Majesty had been graciously pleased to Approve his [Fuseli's] Election and Sign his Diploma.'[33]

Although a relatively small painting, produced perhaps in a couple of months while the artist was busy with work for John Boydell, Fuseli's diploma work is another example of a male nude invested with considerable artistic significance but indeterminate in its precise meaning. But reference to Fuseli's writings on art will help to suggest that the piece embodies, by way of an acutely self-aware engagement with the Sublime, precisely the contest between an elevated notion of classical masculinity and the threat of commercial society that was a preoccupation of the age.

Fuseli's immediate source was the second volume of Paul-Henri Mallet's popular *Northern Antiquities* (translated 1770), which includes a translation of the Twenty-seventh Fable of the prose version of the ancient Icelandic mythic cycle, the *Edda*.[34] This is not a self-enclosed text, but forms the conclusion to a narrative that begins in the Twenty-third Fable. This tells how Thor – 'the strongest and bravest of Gods and Men' – is defeated by magic and deceit in a series of challenges from the giants of Utgard, resulting in his banishment from the city.[35] As an act of revenge the Icelandic hero attacks the Midgard Serpent, the female monster that had participated in one of the giants' epic challenges. Having deceived the giant Eymer into taking him out in his boat to the domain of the serpent, he successfully fishes for the monster but fails to kill it. But then, he is frustrated. At the crucial moment, when Thor is ready to strike the serpent, Eymer cuts the line that holds it fast to the boat. But in Fuseli's picture, there is not the slightest indication that Thor will do anything but strike the serpent successfully: his mace is raised high, the creature seems surely held, and Eymer cowers at the far end of the boat.

By turning to this source, Fuseli was fulfilling perceptions of his predilection for the obscure in the most complete manner. The *Edda* did not receive serious attention as a piece of literature, and Nordic myths and legends were 'almost totally neglected' throughout this period.[36] There is only a single other Eddaic subject by a British artist of this period now known, attributed to Prince Hoare.[37] The revaluation of this literary source formed part of the cult of primitivism that found popular expression in the 1760s and 1770s. In this context, the obscurity and mystery of this some were appreciated as authenticating characteristics, revelatory of a primal state of freedom that a modern reader could hardly appreciate except at a knowing distance. Like Ossian and Homer, the *Edda* thus enjoyed associations with an ideal of political liberty that was historically estranged from modern society, unrealizable, even undesirable, in real terms.[38] Certainly more than the Greek poet and perhaps even more than Ossian, these connections with political freedom allowed a high degree of mythographic and narrative licence. Contemplating the translation of Nordic verse in 1758, Thomas Gray (1716–71) had given some

revealing reflections about the status of the *Edda*: 'I told you before, that, in time of dearth, I would venture to borrow from the Edda without entering too minutely on particulars; but, if I did so, I would make each image so clear, that it might be fully understood by itself, for in this obscure mythology we must not hint at things, as we do with the Greek fables, that every body is supposed to know at school.'[39]

Nordic myth, unfamiliar to the public and to critics, is described here as the source of Sublime images that would not, even could not, be immediately comprehensible however vividly presented. Potentially, this incomplete comprehension could be taken as enhancing the very sublimity of the representation while also fitting the professional and personal requirements of an artist in search of novel and distinctive subjects. As Fuseli explained in comments written in 1799, with reference to gray's transliteration of the Nordic *Descent of Odin*: 'Of the specimens imitated from the Norse and Welsh Poetry, the Descent of Odin is undoubtedly the most Sublime, and owes perhaps some of that sublimity to its being a fragment . . . the abruptness with which the English poet hurries into the midst of his subject, forcibly seizes the reader, and ensures restless curiosity.'[40]

With the *Edda* designated a 'singular and Sublime mythology', it can be seen how the source matter matched Fuseli's image as an artist.[41] The viewer is, in effect, 'hurried into the midst' of the image, and there is evidence that Fuseli's pictures were received on these terms by contemporaries: 'while he neglects the little parts that might captivate the Flemish student, he arrests the attention by a burst of imagery'.[42] Fuseli's *Thor* is organized so that the viewer is presented with a moment of high drama to the exclusion of almost everything else, even to the extent that the central action appears as a virtual cameo, fading into black at the edges of the canvas. In this respect, the picture epitomizes the undermining of narrative initiated in visual form in the work of James Barry and Alexander Runciman around 1770 and characteristic of the Gothic literature and art of the 1780s. The sheer physical presence stands in for, and may even obscure, more elaborate narrative values. The obscure subject is transformed (as per Gray) into a vividly immediate image.

This strategy or effect was rationalized by Fuseli by his reworking of the category of 'epic painting', extracted from the genre of 'history painting' and meant to occupy a still higher rung in the hierarchy of genres. Developing an idiosyncratic approach to genre in his writings, the Revd Bromley's disparagement of Fuseli in favour of Benjamin West in his *Philosophical and Critical History of the Fine Arts* (1793; see chapter 9), Fuseli was to claim that history painting, as redefined by him, was simply concerned with fact and with narrative. A still greater artistic achievement was that of the epic painter in aiming to 'impress one general idea, one great quality of nature or mode of society, some great maxim' – a heroic endeavour for which Michelangelo was the absolute model and which required no elaborate literary narrative or reference to fact to achieve its effect but only the powerful presence of idealized bodies.[43] The old fault line within epic discourse, formed by the incomplete correspondence between objectified, narrated heroic exemplarity and the subjective appreciation of heroic formal effects, is taken up by Fuseli to describe a separate visual mode elevated above socially functional ideas of virtue. The narrative of the picture might even be seen in purely formal terms, linking it to Fuseli's statements about the gendered properties of visual shapes: 'The forms of virtue are erect, the forms of pleasure undulate.'[44] Such statements reveal the essentializing rhetoric of the emerging regime of gender difference, ushered in by the stereotypes of Gothic literature, by the gendered polarities of the Sublime, by Johan Caspar Lavater and physiognomic theory, and by – overlapping with each of these phenomena – Fuseli's images of superheroic men, monstrous women and feminine monsters.

158 Thomas Rowlandson, *The Champion of the People*, published by William Humphreys, 11 March 1784. Etching, 21.9 × 32.6 cm. The British Museum, London.

The further interest of Fuseli's picture lies in the extent to which the viewers is expected to suspend scepticism about both the superheroic body he represents and his abilities to represent that body. The figure of Thor is composed in defiance of the established standards of figurative art. The right arm is heavily cloaked, the raised left leg obscures its own movement and the left ankle is hidden from view entirely, leaving the toes propped up on the side of the boat without visible support. Charles Dufresnoy had emphasized that, even where drapery appeared at such points, it should uncover rather than occlude the joins and movements of the body:

> *The Extremities of the Joints must be seldom hidden and the Extremities or End of the Feet never, &c.* These Extremities of the Joints are as it were the Hafts or Handles of the Members; for example, the Shoulders, the Elbows, the Thighs, and the Knees. And if a Drapery should be found on these ends of the Joints, 'tis the duty of Science and Decorum, to mark them by Folds, but with great discretion; for what concerns the Feet, though they should be hidden by some part of the Drapery; nevertheless, if they are mark'd by Folds, and their shape be distinguish'd, they are supposed to be seen.[45]

Instead, Fuseli fudges the matter entirely, and this in the context of what was meant to be an exemplary academic figure. In occluding what would conventionally be signs of artistic authority, the painter was restating his position outside normal cultural practice, either as a madman and junkie or as a Sublime genius. As was recognized in the art journalism of the 1780s, Fuseli thus produced figures that demanded to be read in terms of the artist's 'genius' rather than the established conventions of pictorial figuration. But while the figure of Thor has little to recommend it according to the conventional criteria of life drawing, it is nonetheless fully redolent of the Grand Manner tradition. The figure's proportions are Michelangeloesque, the pose being

modelled quite closely on the figure of Christ in the *Last Judgement* in the Sistine Chapel. On a more general level and taking into account the theme, a number of precedents on the subject of St Michael defeating Satan could also be suggested as models. In Giorgio Vasari's account of the revival of the arts, the subjects of *Hercules Slaying the Hydra* and *St Michael and the Dragon* represented the epitome of heroic energy, and these images had underpinned the literary tradition of brute masculine physicality to the point of deliberately trite repetition in the field of visual satire (FIG. 158).[46] Of course, what this last image points to is the comical associations of such ideals of physical heroism at that time – the historical distance between the gigantic efforts of the ancients or the knights of chivalry and the indirect, prudential, delegated activities of modern leaders, even as both might claim demotic favour. Fuseli's painting represents quite the reverse, a hedonistic indulgence in a fantasy of masculine physical supremacy pursued in no particular political cause.

Fuseli's *Thor* is an especially rich image in the ways that this rhetoric of masculine supremacist fantasies extends to its material characterization. Thor's body is represented in a highly restricted, unpainterly fashion. Areas of light and shade are firmly marked and generally delimited by firm contours. The paint itself has been applied to the canvas in thin, controlled layers, whereas the serpent and the sea are characterized in a quite different way. Where the coiling form of the serpent crosses over itself there are no clear linear boundaries and thick slabs of paint cut across pictorial space. Thus the conventional opposition between the masculine painterly mode, with its emphasis on linear precision and control, and its feminine other – paint itself, with its emphatically material and unpredictable character – is literally pictorialized. In effect, the image represents a heroic struggle with paint itself, with what Fuseli termed the 'gulph of colours' that came with an unrestricted painterly technique.[47]

Since the late 1760s, Fuseli had capitalized on the revised standards of artistic expertise that accompanied reforming cultural discourse. For friends and admirers such as John Armstrong and Thomas Coutts, Johan Caspar Lavater and Johann Gottfried Herder, his manifest shortcomings as a draughtsman and technical painter were all to be excused as signs of his peculiar genius. In the correspondence from his Roman years and in his 'Second Ode on Art' from the same period, Fuseli pivoted his identity as an artist around his opposition to corrupting civilization, with its moderated, technically accomplished modes of visual representation exemplified by West. He pursued instead a primal, masculine artistic energy neglectful of niceties. That the works that he presented to the public in the late 1770s and through the 1780s were sometimes accepted as examples of this latter among critics is testament to the currency of such ideas. The fact of Fuseli's sustained support from among the provincial, intellectual and generally Dissenting middle class was, meanwhile, an indication of the social specificity of such themes, inasmuch as they were a spur to material investment.

In the 1780s, Henry Fuseli mobilized the theme of cultural reform in written form again, taking a swing against his contemporaries in his 'Dunciad of Painting' (1783–85):

> Where London pours her motley Myriads, Trade
> With fell Luxuriance the Printshop spread:
> There as the wedded elm and tendril'd vine
> Angelica and Bartolozzi twine.
> Blazoned in Crystal, crowned with sculptured gold,
> Imperious Fashion's central seat they hold:
> Love without Fire; Smiles without Mirth; bright Tears
> To Grief unknown; and without Beauty, Airs;
> Celestial Harlots; Graces dressed by France;
> Rosy Despair and Passions taught to dance

> Irradiate the gay leaf – the charm struck crowd
> Devoutly gaze, then burst in raptures loud.[48]

Fuseli uses the now entrenched terms of the attack on luxury in the arts in a specific rebuke to Angelica Kauffman and the engraver Francesco Bartolozzi that recalls Thomas Robinson's dismissal of 'il Signor Ettore, la Signora Andromache' in Pompeo Batoni's art, and after that the slights made against Nathaniel Dance and Benjamin West in the later 1760s (see Chapter 2).[49] In his formal writings on art as Professor of Painting at the academy from 1800 to 1804 and again from 1810, Fuseli was to consolidate this reforming rhetoric with the more technical concerns of academic discourse. These writings provide not so much a retrospective 'explanation' of the pictorial dynamic of the *Thor* as a means of marking out textually the discursive space the painting occupied and within which it gained meaning.

At the beginning of his 'Eighth Lecture on Painting' (1810), Fuseli presents his audience with a simple moral choice. He tells them that art can do two things: reach the intellect and heart through the senses, or simply amuse the senses:

> In the first light, the senses, like the rest of its materials, are only a vehicle; in the second, they are the principal object and the ultimate aim of its endeavours ... Nature, and the masters of Art, who pronounce the verdicts of Nature in Poetry and Painting, have decided, that they neither can attain their highest degree of accomplishment, nor can be considered as useful assistants to society, unless they subordinate the vehicle, whatever it be, to the real object, and make sense the minister of mind.[50]

It is colour, he is sure, that determines art's function in society. It can be a valuable tool for the artist, lending power and definition to 'character', but there is also 'the usurping, the ambitious principle inseparable from colour ... if it divert the public eye from higher beauties to be absorbed by its lures – then the art is degraded to a mere vehicle of sensual pleasure, an implement of luxury, a beautiful, *but trifling* bauble, or a splendid fault'.[51]

In the wake of the French Revolution, the notion of a 'usurping' and dangerous sensible force could, no doubt, carry particularly forceful connotations, but in essence Fuseli is operating within the conceptual framework of the old Shaftesburian discourse on art – what John Barrell terms 'Spartan civic humanism'.[52] Fuseli's invocation of a 'public eye' whose line of sight is distracted or obscured by sensual, base and trivial 'luxury' directly echoes the 'judicious Eye' driven to 'Confusion' and 'Oppugnancy' by a lurid 'Riot of Colours' noted by Anthony Ashley Cooper, third earl of Shaftesbury.[53] According to the principles of Shaftesburian discourse, which Fuseli reproduces with the greatest elaboration in his history of modern painting, art could be revealed to the 'public eye' as a means of expressive communication that bound men together through 'sympathy'. It could also, however, be a debased commodity intended for private consumption, driving men apart, as was evident in the art of Venice:

> The centre of commerce ... the splendid toy-shop of the time: its chief inhabitants princely merchants, or a patrician race elevated to rank by accumulation from trade or naval prowess; the bulk of the people mechanics or artisans, administering the means, and, in their turn, fed by the produce of luxury. Of such a system, what could the Art be more than the parasite? Religion itself had exchanged its gravity for the allurements of ear and eye, and even sanctity disgusted, unless arrayed by the gorgeous hand of fashion. Such was, such will always be the birth place and the theatre of colour.[54]

Thus Fuseli posits colourism as the inevitable partner of unchecked opulence in sixteenth-century Venice, but surely also in the commercial society of modern Britain. During the eighteenth century the argument against luxury had been inflected in order to provide a legitimization of

the painter as a citizen. If warnings against excessive colouring were a commonplace of eighteenth-century critical literature, those warnings paradoxically allowed a valid place for the artist in society to be imagined. This was effected by equating the painter with the rhetorician or poet.[55] Drawing on the authority of classical criticism, colour was equated with poetic ornament, which, if pleasing, had still to be employed cautiously.[56] The Shaftesburian writer George Turnbull (1698–1748) provided a summary of this argument:

> Whatever is said against the gaudy, the pompous, the florid, and luxuriant on the one hand; or in praise of the chaste, the pure, the subdued, and unaffected on the other, doth equally agree to colouring and discourse . . . The painter, as well as the poet, of a rich imagination, must therefore learn to deny himself, and to be able to reject fine embellishments and decorations, when the subject does not require them; or when they would not be in their place: more especially in representing those subjects, which, the more simply they are conceived, and the more plainly they are expressed, give the soul proportionally the more pleasing emotions: other embellishments added to them, as it is well said by some author, serve only to hide beauty; however gracefully they are put on, and are thrown away like paint on a fine complexion.[57]

Turnbull places the responsibility for the internal propriety of the work of art (what the subject 'requires', the 'decorum') with the artist. That internal order is analogous to the order of society as a whole: 'What is beautiful is harmonious and proportion'd, what is harmonious and proportion'd is true; and what is at once both beautiful and true, is as consequence agreeable and good. And accordingly, Affections, Manners, and all the Arts are to be judged by this Rule.'[58] Within the admonition against excess is a circumscribed endorsement of the artist's agency: condemning colour as a supplementary ornament meant concurrently conceptualizing and legitimizing a 'plain style' that lacked ornament.[59] The possibility was imagined that art, like rhetoric, could please and persuade without debasing itself, so long as certain rules were obeyed. If the artist successfully internalized those rules, successfully regulated his natural desires, learnt to 'deny himself', he qualified for a place in society. By figuring transgression, Turnbull figured the potentiality of inclusion. The same terms recur, of course, in Joshua Reynolds' 'First Discourse', where, as noted in the introduction to Part Two, a sense of authoritative and authentic masculine artistry was forged out of a censuring of unregulated technical display.

The issues of artistic propriety and the artist's public responsibilities are certainly present in Fuseli's lectures. If the terms he employed in his engagement with those issues were, in essence, those of the sternest civic humanism of the early eighteenth century, it can be argued that, by this date, these arguments were of diminished relevance. Although Fuseli may confidently set 'luxury' against the interests of the 'public' in order to define the regulating principles of painting, the meanings of those terms were no longer self-evident. The idea of a 'public' had been radically redefined over the eighteenth century, and within the contemporary discourses of political economy 'luxury' could readily be conceived as socially beneficial – indeed, Fuseli recognizes its 'lures' and registers that it might be 'beautiful'. Still, Fuseli does achieve a high degree of moral certainty not in those passages where he rehearses conventional civic humanist arguments, but in the intense evocations of the plastic properties of paint that punctuate the lectures. In these the politically bankrupt vocabulary of civic humanism is revitalized through a kind of fevered ecphrasis that effectively wipes out, or at least complicates, the positive associations of colour that had previously been imagined. The specific properties of oil paint – in his own words, 'its glow, its juice, its richness, its pulp' – are evoked with precision and at length.[60] A sense of the intensity of Fuseli's language, and the basic features of his denunciation

of painterly matter can be drawn from this one rhetorical outburst from his first lecture on colour:

> But of Colour, when equally it overwhelms the forms of infancy, the milky germ of life, and the defined lines of manhood and of beauty with lumpy pulp; when from the dresser of the Graces it becomes the handmaid of deformity, and with their spoils decks her limbs – shakes hands with meanness, or haunts the recesses of loathsomeness and horror – when it exchanges flesh for roses, and vigour for vulgarity – absorbs character and truth in hues and flattery, or changes the tone demanded by sublimity and pathos into a mannered medium of playful tints; – of Colour, the slave of fashion and usurper of propriety, if still its charms retain our eye, what mind unseduced by prejudice or habit can forbear to lament the abuse?[61]

This is a complex passage. There is still a trace of Shaftesbury and Turnbull here, with the talk of a clear 'eye' and artistic 'propriety', and a hint of Burkean conservatism in the implicit alignment of 'prejudice' with revolution – the rise of a 'slave' that no unprejudiced citizen could suffer in silence.[62] A classical reference to Euphranor's objection that his rival Parrhasius' *Theseus* had fed on roses rather than flesh is thrown in without comment.[63] Parrhasius was admired for 'the Softness and Elegance of his *Out-lines*' and Euphranor for his 'masculine and bold' style – it was he who was 'the first who signaliz'd himself, by representing the Majesty of *Heroes*'.[64] This fleeting allusion therefore puts into play the opposition of the heroic and the luxurious that resonated through Fuseli's account of contemporary British art. But the dominant message, driven home with more passion than sense, is that paint is a fluid and corrupting force that threatens to render art a trivial luxury through its cosmetic effects.

Turnbull warned against excessive ornament in art or literature, claiming that unless properly regulated it is 'thrown away like paint on a fine complexion'. The figuring of feminine vanity to define principles of artistic propriety had been current since antiquity; Turnbull virtually paraphrases the ancient dictum reported by Junius: 'Adorn any thing properly and soberly . . . and it shall grow better and better; daube it over on the contrary with the painting colour of women, and it shall resemble a jugglers delusion.'[65] Such an association between representation and cosmetic deceit was a convention of Platonic criticism of art and literature, still widely current in eighteenth-century Britain and indeed revived during Fuseli's time.[66] The fear that a means of expression might obscure the express meaning of a representation has been a persistent feature of Western discourse on representation.[67] For Fuseli, the 'vile crust' formed by painterliness makes the representational body unnatural and abnormal, as exemplified in the work of the prime colourist Peter Paul Rubens: 'His male forms, generally the brawny pulp of slaughtermen; his females, hillocks of roses in overwhelmed muscles, grotesque attitudes, and distorted joints, are swept along in a gulph of colours, as herbage, trees and shrubs are whirled, tossed, and absorbed by inundation.'[68] The essence of painterly colour is rot (the 'pulp of slaughtermen') and flood ('inundation'). Both present immediate, sensible dangers to the body, inviting a purportedly spontaneous, visceral reaction.

These grand symbols link the matter of paint to broader processes of cultural change. Quoting Reynolds' commentary on Dufresnoy, Fuseli noted that the Greek word for the process of mixing different coloured paints meant corruption in the sense of decay.[69] Junius had noted this also and his modern editors have offered an explanation for the connection by referring to Plutarch.[70] The latter had commented that sailors refused to drink from the Nile when the traffic of people and animals soiled the water, as 'mixing produces conflict, conflict produces alteration, and putrefaction is a kind of change'; as mixing paint causes change, so it too is a form of corruption.[71] These associations of mixing with infection and pollution were generally passed over by

writers on art. For colourists from Lodovico Dolce to Roger de Piles it was, echoing Cicero, the mixing of paint that signified the progress of artistic skill – paint in its raw state was simply 'colour' and could not produce harmony. For Reynolds it was exactly the 'corruption' of paint that effected the harmony of Bolognese painting.[72] But for Fuseli the sense of 'corruption' as decline is restated. The mixing and hybridization of paint was inevitably to result in a *morally* corrupt style – the style of the school of Venice, a city 'fed by the produce of luxury'.

If the connection between 'corruption' as an archaic technical term and 'corruption' as the source of cultural decline still seems tenuous, it should be noted that it had already been mapped out by Daniel Webb in his *Inquiry into the Beauties of Painting* (1760). Citing Dionysius, he noted that the best painters were those of early antiquity who 'were simple and unvaried in their colouring'. Art declined as more and more painters relied on 'the multitude of their colours' for effect. Webb comments: 'You will observe, that this boasted science of the moderns, was, to the ancients, a symptom of *the decay of paint*' [emphasis added]. Webb's interpretation is not supported by the standard modern translation, where the passage is rendered: 'There are many old paintings which are worked in simple colours without any subtle blendings of tints but clear in their outline, and thereby possessing great charm; whereas the later paintings are less well-drawn but contain greater detail and a subtle interplay of light and shade, and are effective because of the many nuances they contain.'[73] Pliny, also, had identified the expansion of the painter's palette as the reason for the degeneration of art. Where art had once been simple and great: 'Now on the contrary is there never a noble picture made, though purple settleth it self upon our walls, though India bringeth in the mud of her rivers, as also the corrupt bloud of Dragons and Elephants'.[74]

Hybridization and expansion corrupted society and, according to Fuseli, the artist's palette: 'When you are told that *simplicity and keeping* are the basis of purity and harmony, that *one* colour has a greater power than a combination of two, that a mixture of these three impairs that power still more, you are in possession of the great elemental principles necessary for the economy of your palette.'[75] Thus paint is bound inextricably to commerce, luxury, corruption and dirt not only through a historical process but through its inherent properties as matter. In short, paint as matter is figured as a monstrous, polluting other, the enemy of a securely retentive symbolic economy. But it must now be noted that, even at his harshest, Fuseli did not condemn the medium of paint in its totality. He does admit a mode of visual representation that brackets out all vile materiality – fresco:

The tones fit for Poetic painting are like its styles of design, generic and characteristic. The former is called negative, or composed of little more than chiaroscuro; the second admits, though not ambitiously, a greater variety and subdivision of tint. The first is the tone of M. Angelo, the second that of Raffaelo. The sovereign instrument of both is undoubtedly the simple, broad, pure, fresh, and limpid vehicle of Fresco. Fresco, which does not admit of that refined variety of tints that are the privilege of oil painting, and from the rapidity with which the earths, its chief materials, are absorbed, requires nearly immediate termination, is for those very reasons the immediate minister and the aptest vehicle of a grand design. Its element is purity and breadth of tint. In no other style of painting could the generic forms of M. Angelo have been divided, like night and day, into that breadth of light and shade which stamps their character. The silver purity of Corregio is the offspring of Fresco; his oil paintings are faint and tainted emanations of the freshness and 'limpidezza' in his Frescoes. Oil, which rounds and conglutinates, spreads less than the sheety medium of Fresco, and if stretched into breadth beyond its natural tone, as the spirits which are used to extenuate its glue escape, returns upon itself, and oftener forms surfaces of dough, or wood, or crust, than fleshy fibre. Oil

impeded the breadth even of the elemental colours of Tiziano in the Salute. The minute process inseparable from oil, is the reason why M. Angelo declared oil painting to be a woman's method, or of idle men.[76]

Opening his subsequent comments on colour in oil painting, Fuseli acknowledges the irony in recommending the supremacy of fresco, 'a method of painting almost as much out of use as public encouragement, and perhaps better fitted for the serene Italian than the moist air of more northern climates'.[77] But, he still sets limits on oil as a medium: it can achieve only 'Historic effects', rather than the 'Poetic' that represented the highest achievements. Or at least, that is the case when oil paint is allowed to behave like oil paint: oil colouring becomes more acceptable when 'reducing colour frequently to little more than chiaroscuro'.[78] Fuseli was, in fact, understood by contemporaries to have followed this dictum, adapting oil paint to mimic the effects of fresco. He painted, according to his acolyte William Young Ottley, 'in that solemn tone of colouring which we admire in the works of the greatest fresco-painters, and which Sir Joshua Reynolds observes to be so well adapted to the higher kind of pictorial representation'.[79]

Fuseli's was not a new argument; the failure of Raphael and Michelangelo in oil painting was a commonplace of art historical writing and, as mentioned by Ottley, Reynolds had noted that fresco was the greatest medium, though he conceded that great things were also possible in oil.[80] But the distinction between oil and fresco was axiomatic with Fuseli. It structured his two lectures on colour, one on fresco, the other on oil. It can also be read as structuring his elaborate semiotics of artistic production; if he presents the act of painting in heightened dramatic terms, it is these alternative materials of painting that determine the tone of the script – as inspirational epic or bleak tragedy. The matter of paint serves Fuseli as the means of locating himself at a critical point in the history of art, at a moment of crisis in which the performance of gender is deeply implicated. The alienation of the heroic artist from consumer society is thereby inscribed into the act of painting itself in a gesture that can lead nowhere in practice other than into the idiosyncratic innovation of William Blake, whose condemnation of oil painting as a medium takes off where Fuseli ends.[81]

In *Thor Battering the Midgard Serpent* this sense of threat is dramatized on a number of levels. The contrast between the tightly controlled painted surface that describes Thor's form and the formless and highly textured painterly evocation of the serpent and sea has already been noted. Thor's body is articulated as an exaggeratedly masculine form not only in its physique but in the very way it is painted, the contrast between the restrained characterization of the hero and the sloppy materiality of the Midgard Serpent constituting a scene of Sublime struggle. As James Beattie noted, in his 1783 essay on the Sublime, the very word 'Sublime' was 'derived from *supra* and *limus*; and so denotes literally the circumstance of being raised *above* the *slime*, the *mud*, or the *mould*, of this world'.[82] Hence Thor is legible as a sublime hero because he is literally raised above (and threatening to destroy) the monstrous and muddy form beneath him, and Fuseli is legible as a sublimely heroic painter, because he shows himself to have produced a figure of classical unity by overcoming and transforming the mess of paint.

Thor Battering the Midgard Serpent is, in effect, a painting that comments upon the act of painting itself to underscore its gendered properties. Indeed, it is as a commentary of this sort that the picture is most full of meaning. The image clearly cannot be read as a biblical or classical theme in a simple sense, though oblique reference is made to each. By inference, some kind of ethical message could be extracted, perhaps with contemporary political resonance.[83] But in choosing an arcane subject, Fuseli was not making such associations lucid or direct. Without speculative interpretation, the image presents nothing but a pagan hero engaged in an act of brutal violence with no clear purpose other than a destructive one. Thor's actions are legible

only as a proof of heroism itself, just as Fuseli's picture is best read not as a belaboured effort to demonstrate specific recognized skills, but as a demonstration of ambition itself. Pursuing a possibility that had been opened up by Reynolds in his early *Discourses on Art*, the painting is thus an acutely self-conscious demonstration of masculine authority in specifically, even exclusively, artistic terms; the individual – even individualistic – act of painting itself has come to stand in for and perhaps even replace a more broadly socialized performance of masculinity.

I I

THREE YOUNG
SCULPTORS
OF THE 1790S

In his invaluable if incorrigibly bitchy *Nollekens and his Times* (1828), John Thomas Smith (1766–1833) remarked that during the time of his subject's visitorship at the Royal Academy, there were 'three young Sculptors, who drew remarkably well, Flaxman, Proctor, and Deare, whose abilities were so much noticed by their fellow-students, that Nollekens gave up his practice of drawing for that of modelling the figure in basso-relievo'.[1] Smith highlights a moment of emulation in which the student becomes an equal to the teacher and the teacher may even start to learn from the pupil. His purpose may have been only to issue yet another slight on his subject – *Nollekens and his Times* is defamatory to the point of comic excess – but he tellingly brings together the names of three men whose professional fates bring the present study to some form of conclusion.

Of the artists named by Smith, only the first, John Flaxman, has an established historical reputation. The third, John Deare, is now seen as a presence in the history of British art, especially after the rediscovery of the marble version of his enormous bas-relief *The Judgement of Jupiter* (FIG. 164). However, Thomas Procter is almost forgotten. Yet as Smith highlights, all were highly regarded, and this at a moment when Grand Manner sculpture proper in the form of large-scale gallery works was beginning to attract material support from British patrons. More significantly, the divergent courses of their careers make peculiarly clear both the opportunities and frustrations of the Grand Manner in the last decades of the eighteenth century. The complete failure of Procter, the limited successes of Deare and the professional triumph of Flaxman demonstrate a number of specific points about artistic practice in London and Rome and illuminate a more general point about the commercial status of heroic art and the heroic male body at the close of the century.

These three artists were of the first generation that could come as students to an academy entrenched as a part of the cultural establishment. Importantly, they were the recipients of a newly articulated reforming agenda for sculpture issued from the head of the academy. Until Flaxman became the professor as late as 1810, the academy did not have a separate lecturer on sculpture. Although individual sculpture in the form of the casts that made up the teaching collection had a highly significant role to play in the institution's pedagogic programme, Joshua Reynolds' 'Tenth Discourse' delivered in 1780 and dedicated to the topic of sculpture, provided the most complete statement about the practice of sculpture. Procter, a student at the academy

since 1777, was likely to have heard it. Deare certainly did, as he was a prizewinner at the cer-
emony where it was first delivered. Flaxman knew it at least in published form, as he later
opined that 'Sir Joshua R. had written admirably on painting, but occasionally *nonsense* abt.
Sculpture.'[2] This last estimation has become orthodox. The 'Tenth Discourse' has been quite
uniformly estimated as 'inadequate', 'incoherent' and the 'weakest' of all Reynolds' lectures, and
has been taken as exhibiting much of his own ignorance of the medium and little of real inter-
est to the art historian.[3] Still, the '*nonsense*' elements of the 'Tenth Discourse' are the most reveal-
ing, illuminating the necessarily perplexing status of ideal sculpture in late eighteenth-century
Britain.

Throughout the 'Tenth Discourse', Reynolds is preoccupied with describing the sculptural
object in the most restrictive terms. Sculpture, he says, 'has but one style' and 'cannot with pro-
priety and the best effect be applied to many subjects'. It has, it appears, a single 'essential char-
acter' that cannot be changed. Painting by contrast can be categorized into a multiplicity of
schools – 'The Roman, Lombard, Florentine, Venetian, and Flemish'.[4] He provides a catalogue
of prohibitions that the modern sculptor must attend to, lest he offend this 'essential character'.
The costumes of sculpted figures have to be classical; in clothing their figures in contemporary
dress, sculptors irrevocably mark their work with 'a fashion of which the longest existence scarce
exceeds a year' – that is, they reduce art to the status of being itself an item of fashionable taste.[5]
Colour is labelled a cosmetic addition, 'rendering the work more natural' to the senses but
'incompatible' with the sense of nature gained through the intellect; it provides only 'pleasure
to ignorance, or mere entertainment to the sense'.[6]

These remarks were pointed. In commenting on the use of modern dress, Reynolds alludes
to, though he does not name, Sir Henry Cheere's equestrian portrait of the Duke of Cumber-
land in Cavendish Square, 'which may be sufficient to deter future artists from any such
attempt'.[7] But his comments stand as a more general condemnation of portrait sculpture, which
was, of course, an important source of income. His dismissal of applied colour, hardly a common
practice among the generality of eighteenth-century sculptors, was directed more particularly.
Among the most popular attractions in London at that moment were the wholly naturalistic
coloured waxworks by the American Patience Wright, whose productions were anathema to
academic practice and whose political affiliations offered a further challenge to that authority
of the academy.[8]

Reynolds' opposition to the sensually appealing aspects of the sculpted object led him also to
condemn two of the features of post-Renaissance sculpture that had been posited as the main
claims to the superiority of moderns over the ancients: perspective and flying drapery.[9] Accord-
ing to Reynolds the introduction of illusionistic spatial effects into sculpture causes confusion.
'The Ancients', he asserts 'with great judgment, represented only the elevation of whatever archi-
tecture they introduced into their bas-reliefs, which is composed of little more than horizontal
or perpendicular lines; whereas the interruption of crossed lines or whatever causes a multi-
plicity of subordinate parts, destroys that regularity and firmness of effect on which grandeur
of style so much depends.'[10]

The prime offender in these respects was, according to Reynolds (following Johann Joachim
Winckelmann), Gian Lorenzo Bernini. Reynolds made his point with reference to a cast housed
in the academy of the head of that artist's *Neptune* (FIG. 159):

> This will be sufficient to serve us for an example of the mischief produced by this attempt of
> representing the effects of the wind. The locks of the hair are flying abroad in all directions,
> insomuch that it is not a superficial view that can discover what the object is which is rep-
> resented, or distinguish those flying locks from the features, as they are all of the same colour,
> of equal solidity, and consequently project with equal force.

The same entangled confusion which is here occasioned by the hair, is produced by drapery flying off; which the eye must, for the same reason, inevitably mingle and confound with the principal parts of the figure.[11]

In short, perspective and the representation of fluttering movement render the work of sculpture difficult to view comprehensively; they distract the eye and so confuse the mind. The transgressive properties of illusionistic sculpture are all the greater since, by its nature, sculpture intrudes upon the space of the viewer: the confusions it entails are not merely pictorial (for Reynolds allows such improprieties in paintings, or even pictorial reliefs) but spatial and tangible.[12] The sculpture itself becomes not a representation of a head but a mere meaningless concoction of forms. The classical body with its secured boundaries has been exploded and made

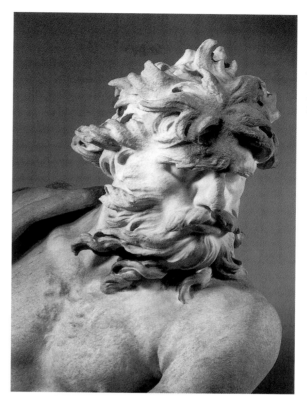

159 Detail of the head of Neptune from Gian Lorenzo Bernini, *Neptune and Glaucus*, *c.*1622. Victoria and Albert Museum, London.

monstrous; the subject whose wholeness was confirmed by identification with that classical whole is disturbed.

In the formalism of his prescriptions, Reynolds draws close to arguing that sculpture is in essence an abstract art, suggesting that 'the beauty of form alone, without the assistance of any other quality, makes of itself a great work, and justly claims our esteem and admiration'.[13] As such, the practice of sculpture, which Reynolds introduces as the lesser art to painting because of its formal restrictions, provides, at the end of the 'Tenth Discourse' a compelling model of stoical self-restraint:

> There is no circumstance which more distinguishes a well regulated and sound taste, than a settled uniformity of design, where all the parts are compact, and fitted to each other, everything to be of a piece. This principle extends itself to all habits of life, as well as to all works of art. Upon this general ground therefore we may safely venture to pronounce, that the uniformity and simplicity of the materials on which the Sculptor labours, (which are only white marble,) prescribes bounds to his art, and teaches him to confine himself to a proportionable simplicity of design.[14]

Reynolds' evocation of the sculptural object in terms of its integrity, wholeness, veracity and clarity, richly articulates gendered distinctions. His sculptural object is the very model of idealized masculinity in formal as well as mimetic terms – a claim that was all the more pointed given what was happening in the wider world. The period saw the deregulation of social hierarchies through rampant consumerism, military defeat and the imminent attenuation of the central, patriarchal authority embodied by the king. But in the realm of the aesthetic and in the context of an institution within which Reynolds occupied a securely paternal role it could seem that

160 (left)
Louis Marie
Normand after
Thomas Procter,
Ixion, engraved
plate from G.
Hamilton, *The
English School*,
London, 1831–32.

some order might still be asserted. Facing assault by the cosmetic, dissembling, corrupting forces of (conventionally feminized) consumer society and the utter confusion surrounding classical ideals of virtue, this emblem of masculine integrity is forced to constrict itself, form itself into an impermeable, compacted, bounded unity, a model for phallic selfhood. In an echo of James Barry's comments on his 'contracting' of his studies so that his art could more closely resemble ancient Greek sculpture, Reynolds, for once, becomes the uncompromising artistic reformer, casting the work of sculpture as something that, in its very formal properties, can come into service in transforming the self and society.[15]

Reynolds' stipulations define a defiantly anti-commercial mode of sculptural practice, directed almost point by point against the realities of the market place and the display of art. Modern dress was prevalent in public sculpture and in memorials; it was colour that made contemporary waxworks so hugely popular with the general public; and the technical accomplishments of perspective and flying drapery that had traditionally been definitive of sculptural expertise were hardly to be so easily cast aside. But each of the 'three young sculptors' explored, in their different ways, the possibility that the ostensibly anti-commercial sculptural virtues manifested in Reynolds' *nonsense* could be put into practice.

This was most dramatically the case in the career of Thomas Procter. Although now entirely forgotten, from the mid-1780s when his work first came to public attention and for three decades after his death in 1794, Procter was held up as a model academic practitioner. He was the artist who most completely lived up to the expectation that a modern British sculptor could lead the reform of culture with the pursuit of a stringently classical idealism.[16] At the Royal Academy, Benjamin West, in his capacity as the second president, praised him in the highest; John Opie as professor of painting put him with William Hogarth, Richard Wilson and James Barry as one of the 'injured, but immortal' geniuses of the eighteenth century; and Richard Westmacott displayed his works to the students as exemplary.[17] Yet, the course of his career illustrates in painful detail the untenability of the Grand Manner and, in particular, of the Grand Manner version of the heroic male body. Moreover, if his career highlights in a general way the incompatibility of Grand Manner ideals of masculinity with commercial reality, it more specifically illustrates the fashion in which the Royal Academy as a pedagogic institution actively fostered and lent value to that incompatibility.

Procter was born in Settle, Yorkshire, in 1753, the son of a local innkeeper. Although early biographies stressed the humble character of his background, his father was a successful businessman and property owner, and Procter was educated at the ancient grammar school at Giggleswick.[18] His youthful career was that of a dutiful son of the business class rather than an outsider. After working at a tobacconist in Manchester, he moved at the age of twenty to London to take up a post in a clerks' office.[19] Supposedly inspired by the sight of Barry's *Venus* (1772; National Gallery of Ireland, Dublin), Procter decided to turn to a career in art and entered the academy schools in the autumn of 1777, terming himself a painter.[20] In fact, his decision may

have been more truly motivated by the degree of financial independence allowed him by the death of his father, from whom he inherited the inn and a number of income-generating proper-ties at the end of 1776.[21] Whatever the motivation, Procter pursued a career in art entirely in relation to the academy, where he became a perfect student. He was awarded a prize for life drawing in 1782, a silver medal for a model after the life in 1783 and in the following year, at the end of his term at the schools, the academy's top

161 (right) Louis Marie Normand after Thomas Procter, *Pirithous*, engraved plate from G. Hamilton, *The English School*, London, 1831–32.

prize of a gold medal for history painting – the prerequisite for being sent to Rome at the insti-tution's expense.[22] There is no record of the young artist having engaged himself under any master at any point over these years, so his only training would have been that offered at the academy in drawing and modelling. For an artist who then went on to establish himself as one of the most promising sculptors of his generation, the absence of any technical training in the art proved decisive.

The terracotta model of *Ixion* that Procter exhibited at the academy in 1785, established his critical reputation (FIG. 160). The *Morning Herald* said it 'deserves to be distinguished' from all the other sculptures in the show while the *Artist's Repository* claimed 'it would not disgrace the best of our sculptors'.[23] Horace Walpole called Procter 'marvellous' and his model 'a prodigy of anatomy with all the freedom of nature'.[24] One newspaper even claimed (erroneously) that the king was so impressed with Procter that he had arranged for the artist to be sent immedi-ately to Rome, and that the academy was to buy the work.[25] The following year Procter exhib-ited what seems to have been a much larger model, of the *Death of Diomedes*. The *European Magazine* received this work with the highest praise: 'The death of Diomedes, by Mr Proctor, is evidently a work of great genius: bold, energetic, and sublime; and is a full confirmation of the high opinion which the Public conceived of him last year, from his model of *Ixion*' while the *Artist's Repository* also recommended it as 'one of the boldest attempts we ever saw', severe doubts were expressed about its practicability as a model for sculpture, and its diffuse compo-sition was criticized.[26] Biographers subsequently stated that Procter destroyed the work after failing to find a purchaser. Certainly, he did not exhibit another sculpture until 1792, when he showed his model of *Pirithous, the Son of Ixion, Destroyed by Cerberus* (FIG. 161). His return to sculpture was announced widely and warmly in the press, and at least one critic pronounced the work a triumph:

> Mr Proctor's model is very properly exhibited in the centre of the Academy . . . such a model, perhaps, no man in this country, or any other, could have executed. The anatomy is in every point accurate, the lines in a most eminent degree beautiful, and the grouping in a style that sets modern art at defiance. It has the spirit, vigour and chastity of Grecian art.[27]

Procter's critical status had certainly been raised high enough for him to be awarded the academy's Rome prize in December 1793, with a significant majority of votes.[28] The circum-stances of this event were heavily romanticized in the early literature. It was suggested that the Rome prize was given impetuously as an act of charity by West, and that Procter, unable to clear his debts, died in abject poverty only a few days after the decision was made.[29] This account

was mythical on a number of points. Although certainly not wealthy, Procter was unlikely to be in such a financial crisis, and he had returned to Yorkshire on business, dying from a fever caught on the journey back to London. Early accounts that he was resident in the notorious slum of Clare Market can be discounted.[30] With regard to West's supposed impetuosity, in fact Procter had been soliciting the votes of the academicians assiduously since at least October and the competition followed the usual course of a two-stage ballot.[31] Also, although he certainly did not go to Rome, neither did he die immediately after the election; Procter exhibited at the 1794 exhibition and had been in communication with the academy council in March fixing his date of departure as May.[32]

The diligent Farington did not note his death until 19 July, when he reported it had occurred 'in England a few days ago'.[33] A second note of three days later indicates that, even by that date, a myth about Procter's decline had been developing: 'Poor Procter is supposed to have been overcome by anxiety of mind on acct. of his circumstances being deranged – so Rossi told Smirke – I afterwards learnt that He broke a Blood Vessel in the night, and only lived a few hours.'[34] Less than five months later West, in his presidential discourse, was proclaiming Procter one of the best of the moderns, 'whose recent death is a misfortune to the British School, for ever to be lamented'.[35]

Although Procter exhibited several history paintings on Ovidian and biblical themes, these seem never to have received any critical attention; his reputation was to rest solely on the *Ixion* and the *Pirithous*. These two works, together with a painting of *The Accusers of Daniel Thrown in the Lion's Den*, were in the collection of Sir Abraham Hume by 1794.[36] Procter's works remained in Hume's possession until the latter's death in 1838 and have since been lost.[37] They were, though, engraved in 1832 for G. Hamilton's *The English School*, and the prints from these volumes constitute their only known visual record.[38]

In their formal properties, Procter's models of *Ixion* and *Pirithous* conformed to the stringent 'simplicity of design' advocated by Reynolds. They are pointedly pictorial works that appear to have been contained within a single dominant plane, with the figures stretched flatly in continuation of the objects of their destruction. The figures are naked; there is no flying drapery or perspectival effect. There appears to be nothing that would obtrude beyond the footprint of the figures' bases, nothing that would suggest spaces inside or beyond the surface of the work. They are, in the tradition of Thomas Banks' *Falling Titan* (FIG. 152) and the *morceaux de réception* that work recalls, demonstrations of artistic facility with the heroic male body placed under extreme pressure – formal exercises in the representation of physical submission that articulate the mastery of their author.

Yet the gendered values embodied in Procter's work were not, in their symbolic operations, either simple or direct. Each of Procter's most acclaimed works depicted a far from exemplary male figure undergoing extreme physical sensation, suffering horribly. Ixion was the cruel, deceitful and hated king of Thessaly who, having been saved from his people's antipathy by Jupiter, abused the god and was punished by being tied to an ever-turning wheel. Pirithous, his son, was a friend of the hero Theseus, but also a rapist whose punishment was to be devoured by Cerberus. It is this final torture that Procter represented. Diomedes was a tyrant who fed his horses human flesh and who was in turn fed to the beasts by Hercules. None of these characters conformed to any ideal of heroic and virtuous masculinity; they could not be expected to excite sympathetic pity from an audience. Further, these figures may not effectively represent the theme of infamy punished, since Procter was intent on preserving their physical beauty. Ixion and Pirithous are father and son, yet appear equally youthful. Their Apollonian bodies and beardless, oval features identify them as ideal physical types on the Grecian model – and this physical type was meant to be the product of a perfect society. Procter sets signifying physical-

ity in conflict with the thematic content of his pieces: physically, these characters invite a flat-
tering self-identification, but thematically they offer themselves up as a repellent spectacle. As
the critic of the *Morning Herald* wrote on 3 May 1792 in response to the model of Pirithous:
'If we cannot admire the subject the Artist has chosen, we are compelled to applaud his execu-
tion.'

What could the function of such works have been apart from academic exercises, demon-
strations of artistic facility? Could they serve to qualify the artist for monumental work, when
their closest precedent was Banks' design for the Cook monument (FIG. 102), so ungenerously
received a few years before (see chapter 7)? Procter's early death prevented any of these ques-
tions being explored in practice and made him available instead to the prevailing hagiography,
which could accommodate the contradictions and complexities of his work under the theme of
romantic martyrdom.

The fullest early commentary on Procter was Sir Thomas Bernard's article in the *Director* for
7 March 1807. The philanthropist Bernard (1750–1818) was at that moment taking a leading
role in the newly founded British Institution, which provided a gallery space for modern British
art in the hope that a 'British school' could still be raised by the efforts of wealthy laymen,
where the professional efforts of the Royal Academy had failed.[39] For Bernard, Procter exem-
plified the high potential of modern British artists and the failure of artistic societies and earlier
patrons to promote that potential to date:

> When the period arrived for his quitting the Academy, Proctor found himself in those cir-
> cumstances, which have, in so many instances, thwarted and impeded the progress of British
> talent. Habituated to the sublime and intellectual branches of art, he possessed neither dis-
> position nor talent for portrait painting; he could not sketch for the publisher, nor pencil for
> the manufacturer. Having quitted an advantageous situation, in order to devote himself to his
> favourite pursuits, he found himself, at the close of his academical studies, without any defect
> in prudential or moral conduct, absolutely in want of bread.[40]

Bernard thus mobilizes a set of established biographical tropes that emerged with reform dis-
course. The artist, isolated from commercial society by his genius, is left to suffer and is con-
demned to personal failure. If only, Bernard claims, the British Institution, with all the patrician
powers invested in it, had been around to save the tragic young artist from this fate.[41] Still,
Bernard allows that it was the personally taxing material conditions of Procter's existence that
proved a spur to his art:

> It may be proper to submit a few words of explanation with regard to the subjects of his
> choice, – all in their nature *pathetic* and *terrible*. – He did not want a taste for physical or
> moral beauty . . . But the condition of Proctor was not that of an artist, systematically pur-
> suing his profession, in comfort and independence; – he never attained so desirable a situa-
> tion. It was that of a youth, feeling extraordinary energy of mind, and selecting difficult and
> sublime subjects, capable of exercising and displaying that extraordinary energy. In the calm
> period of middle life, the same artist would have directed his attention to the objects of the
> softer and more delightful sensations; – to beauty intellectual and corporeal, and to the pleas-
> ing display of female tenderness, of the gentle emotions of the mind, and of the domestic sym-
> pathies and affections.[42]

Procter's purported youthfulness – he was actually over forty when he died but Bernard gives
his birth date as 1765 – is brought into play in order to understand the peculiar nature of his
works and to explain his lack of appeal among patrons. His works, by this account, were violent
and difficult because he was young and ambitious, and because his works were violent and dif-

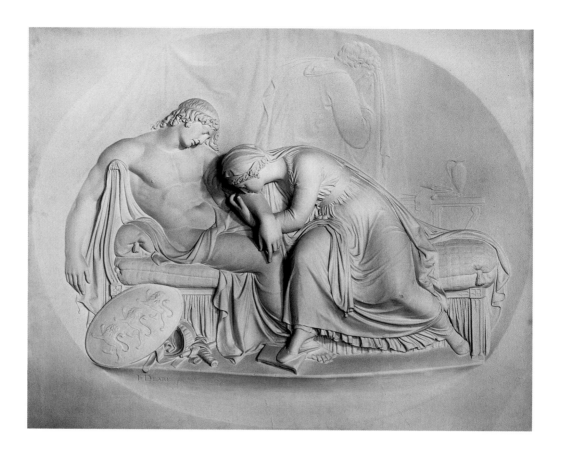

ficult they did not easily conform to established taste. In short, Procter's artistic supremacy and his financial misery are identified as resulting from the incompatibility of his pure masculine nature with the effeminate and corrupt modernity that had been allowed to prosper. Significantly, the protagonist of this narrative is displaced, temporally. Procter's death, the termination of his life's narrative, secured his biography as a historical artefact like the writings of Homer and Ossian or the knights of chivalric romance, rather than as an ongoing process. Through hagiography, the dead sculptor could readily be severed from all the shifting debates and actions of the contemporary cultural scene, and be situated rhetorically outside them. If the modern cultural scene as envisioned by Bernard was characterized by transient processes of commodification and exchange, Procter was imagined in death as a timeless *exemplum* of the heroic artist.

 Ultimately, it may be most revealing to explain Procter's professional failure by referring to material factors. He did not come from an artistic family and did not undergo any kind of apprenticeship in a workshop or studio. At the academy he would have been trained in draughtsmanship and modelling but not in the practical skills necessary to produce finished sculpture or make a material contribution to a workshop production. Predictably, Procter failed utterly to get the private commissions for sculpted work that, in the absence of financial support from an institution, were an absolute necessity. Unlike many of his contemporaries, Procter lacked the more prosaic skills that could prove a means of support for a student sculptor: without knowledge of marble cutting, polishing or inscription cutting, he could not pick up the piecework that could be a lucrative source of income. In this, he is a familiar kind of modern artist, detached quite entirely from the familial and formal networks of artisanal culture. While the critical tools

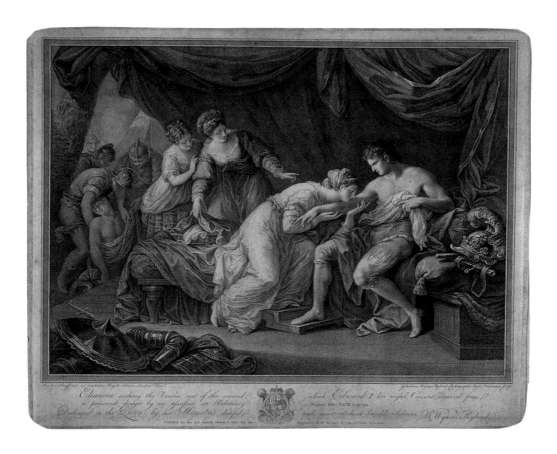

163 William Wynne Ryland after Angelica Kauffman, *Eleanora Sucking the Venom out of the Wound which Edward I, her Royal Consort, Received from a Poisoned Dagger by an Assassin in Palestine*, published by William Wynne Ryland, 1 March 1780. Stipple engraving, 32.5 × 39.2 cm. The Wellcome Library, London.

were in place to assess the works of such an artist highly, the material basis that could support his activities was lacking. As pointed out by critics of his model of *Diomedes*, it was of a form that could not have actually been made up in marble. In Procter, the academy had, in effect, created an 'artist' on the model of the supremely imaginative masculine creator, who could not achieve any kind of viable professional status. In other words, it had led to the existence of an individual whose resource of cultural capital was entirely separated from his fund of economic capital and even somewhat dependent on his inability to accumulate such a fund.

If Procter represents the extreme of an artist who attempted to create himself through exclusive reference to the academy, John Deare demonstrates, by contrast, the level of sustenance available to an artist of a more pragmatic disposition. Deare was the son of a jeweller and tax collector in Liverpool, but moved in his teenage years to London to train as a sculptor in the studio of Thomas Carter (d.1795).[43] Carter ran a successful business specializing in chimney pieces, for which Deare produced ornamental carvings. Contrasting monuments and chimney pieces, an anonymous but well-informed commentator had stated: 'The former are generally executed by artists of great note, and whose fame is fixt; the latter are under the direction of mechanicks, mere marble cutters.'[44] Like many of Carter's apprentices and assistants, Deare simultaneously undertook work of a more esteemed, high-art character and entered the academy schools. During the early 1780s he progressed rapidly in both his academic and professional careers; he had won a silver medal in 1779 and a gold medal for a narrative relief in 1780. At the same time he was drawing a lucrative income from his work with Carter and as a modeller for the high-class clockmaker Vulliamy.[45] In 1785 he was appointed the Rome scholar along

with another sculptor, John Charles Felix Rossi (1762–1839).[46] By that time he had also received private commissions for ambitious relief sculptures on biblical and mythological themes.[47] The artist who reached Rome in the summer of 1785 was thus experienced in the more prosaic aspects of the business of sculpture, and demonstrably capable of executing Grand Manner works that fulfilled the expectations of the academy.

Within a few months of their arrival in Rome, Deare and Rossi were sent a letter by the council of the academy in which they were 'acquainted that they must send a Performance to the Exhibition 1787'.[48] Rossi certainly submitted a work on time, but on such a scale that he went to the council to defray the costs of its transport to England.[49] The secretary of the academy, Francis Milner Newton, sent a rather severe letter to Rossi and Deare informing them that the academy had decided that 'your Time will be more properly employed in Modeling than in working in Marble. That They receive only Models; if of a Figure, that it do not exceed *three* Feet in height, and if a Bas-relief, the size not to exceed *four* feet by *three* feet.'[50] While guided by economic considerations, the academy's decision could be rationalized with reference to the institution's high-minded policy of retarding its pupils' technical skills in favour of the non-manual, 'intellectual' aspects of art. Whatever the explanation, the academy did not think it important that its students in Rome should occupy themselves with cutting marble – the very reason why British sculptors like Banks had gone there in the past.

In the event, Rossi sent no further works for exhibition, while the sculpture eventually sent by Deare was a version of his relief design showing the medieval subject of *Edward I and Eleanor of Castille*, exhibited in 1788 (FIG. 162).[51] The treatment of the subject is patently indebted to the classical art of the previous two decades: the restrained but lucid posturing, bulky physical types, deeply incised drapery and anatomy, and 'archaeological' details are reminiscent of Gavin Hamilton. The focus on the suffering male figure also relates the work to recent pictorial tradition. The figure of *Edward* – like Hamilton's *Hector* or, more pertinently, Banks' *Germanicus* – is at once the embodiment of a long-standing and widespread ideal of masculine physical beauty and a visual statement of the feminized notions of heroism specific to British culture at the time. The most complete visual precedent was the version of the subject by Angelica Kauffman, and the resemblance was noted – and criticized – at the time of its exhibition (FIG. 163).[52] Edward thus fits the model of the 'sentimental' hero, well established as a means of making the Grand Manner relevant in contemporary terms. Significantly, the subject had been included on the initial list of set topics for the history painting competition of the Society of Arts. While in all these aspects the *Edward and Eleanor* was old-fashioned, even conservative, it was considered as relevant and worthwhile by patrons, for Deare had to produce a number of versions of this design to satisfy demand. In looking in this instance to the sentimental imagery of the 1760s and 1770s rather than the more severely idealist work of Banks' *Ceyx and Alcyone* (FIG. 98), the artist made a sound career move. The further, even more dramatic, contrast to the suffering male bodies conceived contemporaneously by Procter need hardly be emphasized.

While working on the *Edward and Eleanor*, Deare was also completing the first version in plaster of his most ambitious single sculpture, the large relief of the *Judgement of Jupiter*, depicting the divine events from the *Iliad* that led to the start of the Trojan War (FIG. 164).[53] This work had originally been intended for the academy but was replaced by the *Edward and Eleanor*, presumably after the problems with the size of Rossi's work.[54] As such, Deare's relief can be assessed as a self-conscious demonstration of artistic skill to be judged from an academic perspective.

As an affirmation of the comprehensive capacities of the academic artist, the work is a triumph that asked to be placed in relation to an esteemed tradition of picture making. There were a number of important Renaissance precedents for the 'council of the gods' scene. Deare depicts

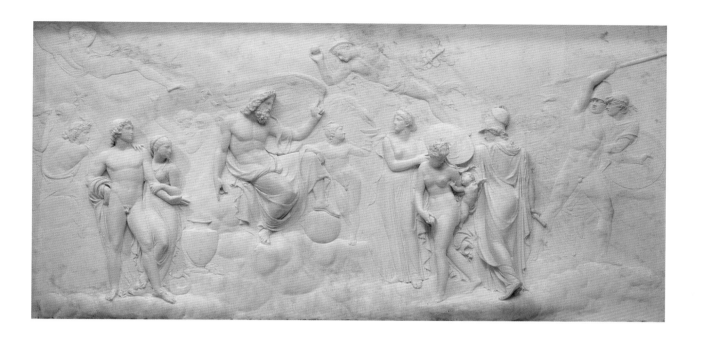

a council of the gods as a range of physical types, demonstrating his abilities to describe a wide variety of human forms. These include representatives of the various ideals of physical beauty: the masculine figures are the ephebic Ganymede, the emphatically muscular Mars and the heavy but graceful figure of Jupiter; the feminine are the three goddesses Juno, Venus and Minerva, each embodying a version of idealized womanhood. In each case, Deare took his cue from classical models. Thus the sculptor fulfilled the expectation that the artist would be able to treat a variety of human types with reference to the ancient heritage, and to communicate a complex iconography through the visual means of posture, dress and bodily form.

164 John Deare, *Judgement of Jupiter*, c.1786–87. Marble, approx. 148 × 298 × 25.4 cm. Los Angeles County Museum of Art, Gift of Anna Bing Arnold.

In terms of sculptural technique, too, Deare set out to show a range of skills in the presentation of these figures through a variety of relief levels, from the barely modelled figures in the background to the foreground figures, which are virtually detached, necessitating a plinth-like protrusion to support the feet of Venus and Minerva. By these means Deare integrated emphatically sculpted form with pictorial effects in a fashion considered by influential French theorists as a means of associating the manual practice of sculpture with the 'intellectual' techniques of picture making. With less lucidity than his French predecessors, Reynolds had hinted at such an advantage in relief sculpture in his 'Tenth Discourse'. It may be difficult, though, to match the sheer pictorial sophistication demonstrated in Deare's relief to the president's stipulations.

Edward and Eleanor and the *Judgement of Jupiter* were ventured as exercises in the Grand Manner that could be taken only as such; it would be hard to imagine a function for these designs aside from the sculpture gallery or the hybrid or intermediate space of the academy exhibition. But where Procter's attempts in this line – his perhaps unrealizable free-standing models for figures expressively tortured – languished, Deare in Rome was able to capture the attention and support of influential patrons. Although the *Judgement* was never sent for display at the academy, it was exhibited in the artist's studio in Rome alongside a version of the *Edward and Eleanor*, and there attracted positive attention.[55] By the beginning of the 1790s, Deare had established a name for himself and obtained a number of important commissions, including the execution in marble of a full-scale version of the *Judgement*.[56]

However, the bulk of his practice was taken up with highly commercial work as a producer of architectural and decorative sculpted wares. His time in Rome can be read as an extension of his work in Carter's studio in London. As there, Deare provided decorative elements for chimney decoration and now oversaw the construction of whole chimney pieces from the highly valued marbles that were available in Italy. The sculptor began acting as the master of a work-shop, buying in designs from other artists.[57] These could be works of considerable prestige: a large piece for the prince of Wales was so ornately decorated that it seems to have had the status of a gallery work rather than a practical architectural fitting.[58] But these were still not sculptures that could be assessed highly according to academic standards of artistic performance and quality, worked out around the representation of the human figure. In the line of work that brought him financial security, Deare acted as a businessman rather than as an artist in the academic sense, and he was subject to rumours of sharp practice and, at the end of his life, actual litigation.[59]

Although celebrated posthumously as a martyr to high art, in real terms Deare's career was highly diversified. It was founded on practical skills and capabilities that were alien to the academic economy, and the successful implementation of risk-taking strategies in the highly privileged circumstances of Rome. These were combined with a choice of subjects for his Grand Manner productions that tended towards myth and romance rather than the more savage or stern values associated with the Sublime.

Tellingly, this last was more apparent in the sculptor's graphic works. Deare was a dedicated draughtsman and many of his studies, mainly from the antique, survive. These tend to a severe linearity, generally in bare penned line with some rough hatching added. Their effect is economical, even schematic. Between the figure studies on one such sheet, Deare wrote: 'That figures in the grand style should be broad & square in the body head arms thighs & legs. In short the reverse of soft & round figures, not to break the masses by small divisions of them & to leave out all small parts but such as serve to contrast the large ones'[60] Beside line drawings showing details from the gigantic figures of the antique *Dioscuri* on another sheet (FIG. 165), he noted:

> The eyes of the figures of monte cavallo have a peculiar force from being much opened & particularly from being cut suddenly from the forehead to the cheek. In Ideal figures the ancients dont admit of hollows at all. in the f[igures] of monte cavallo the muscles swell very much but they run quick or sharp against each other with great attention to contrast such as small nipples & navel. the sides full or small muscles . . . To the large masses of the breast small knees, long threads of drapery oppos to the mass of the body or limbs.[61]

Despite their fragmentary nature, these statements establish a highly dramatized corporeal aesthetic. With the sharp contrasts and sudden changes of direction remarked upon in his texts and given visible expression in the abrupt linearity of his designs, the heroic body is inscribed with a degree of imaginative weight in excess of mere description. In simplifying the masculine form into a network of bare lines delineating, alternatively, silhouette and a minimal number of surface contours, Deare presents an image whose simplicity and abstraction is nonetheless visually dramatic (FIG. 166). While the artist was clearly concerned to describe the forms of these sculptures, the drawing itself was a kind of graphic experiment, a minimalistic game using line in its most direct expression through pen and ink. The modulation and correction allowed by softer media is absent and even the tonal weighting that is gained simply when the pen stops and leaves the paper is employed.

For all their casualness, Deare's designs are rich in associations. Their dramatic conception of the masculine body and scratchy, open graphicity recall the work of Henry Fuseli and his peers. They embody the rushed, abrupt style that Reynolds had warned against and, in marking

the musculature of the masculine body so deeply, defy the standards of smoothness and polish set up as the academic ideal in the past and elaborated by Winckelmann. The very casualness of these graphic statements testifies to the absorption of a reformed idea of the masculine artist, operating – regardless of the conventional task of copying the antique – less within the terms of academic tradition than in relation to the extravagantly gendered rhetoric of the Sublime and of social criticism. The latter provides a more meaningful context for Deare's remarks against 'soft & round figures', and the attention to 'contrast', suddenness and massiveness in his comments on the *Dioscuri*. It also offers a rationale for the execution of such strident pen-and-ink designs rather than the plodding pursuit of minutely finished chalk studies after the life and the antique.

It is in the work of the third of Smith's 'young Sculptors', John Flaxman, that the influence of the market on the very possibility of ideal art found its most dramatic expression. Flaxman was the son of a plaster maker who created casts for some of the leading statuaries of the period, including Louis François Roubiliac and Henry Cheere, and for the manufacturer Josiah Wedgwood.[62] By privilege of his birth, Flaxman was thus as a youth exposed to classical exemplars in the form of manufactured reproductions after the antique – the fundamental equipment of art education.[63]

Flaxman's move from his artisanal roots into fine art practice can be seen as another instance of the transformative cultural optimism prevalent at the end of the 1760s. The artist was a teenager when the Royal Academy was founded and became one of the first students to enter

165 (left)
John Deare, sheet of pen and ink drawings and annotations, titled 'Antique', *c*.1786–93, Victoria and Albert Museum, London.

166 (right)
John Deare, sheet of figure studies, inscribed 'Mercury Stealing Apollo's Cattle', 1786–93. Pen and brown ink on paper, 8 × 12 cm. The British Museum, London.

the academy schools. Here he was a recipient in the first round of silver medals, and in 1772 entered the gold medal competition for sculpture. This he controversially lost to Thomas Engleheart.[64] Without a gold medal, the artist was unable to apply to be a Rome scholar at a time when travel to Italy was trusted to be the best means of becoming a successful artist in the highest genres. There was, in fact, no reason why Flaxman could not have entered the competition again, though he does not seem to have done so. Instead, the young artist apparently took his loss as a personal affront; as Wedgwood wrote at the beginning of 1775, the competition had made him quite a 'Coxcomb'.[65]

Failed by the academy, Flaxman turned to the potter – one of his father's most important clients – for support. Wedgwood employed the younger Flaxman to provide designs and models in the severely linear style that his manufacturing procedures – and public taste as shaped by the antiquarian publications of the 1760s and 1770s – demanded.[66] Although Flaxman received occasional commissions for memorial works in the 1780s, and for a number of modest ideal works from the Worcestershire gentleman Edward Knight (indicating that he had learnt to cut marble at some point), Wedgwood remained Flaxman's most important patron until his eventual departure for Rome in 1787.[67] In the intervening years Flaxman exhibited a number of models at the academy, mainly of portraits and of Grand Manner subjects, and continued in his effort to obtain academic recognition by standing for election as an associate academician, though without success.[68]

At the beginning of 1787 Dr Benjamin Bates (c.1736–1828), formerly a patron of Joseph Wright of Derby and John Hamilton Mortimer, wrote that Flaxman, like the ancients, believed that the essence of beauty lay in straight lines, unlike 'Reynoldus – Gainsbrogus Westo – Petersis & not to mention Cartereu Copleybo & others of less note, who all maintain that Beauty is composed of Plump – Round – Flowing dimpled Rosey – Peachey – Transparent – Simpering sleek Fast oily Men – Women & Children'.[69] The gendered dynamic expressed in this opposition should be very evident, for an opposition of 'masculine' classical art to a repulsive and feminized modernity was long established as a critical trope. The specific line of argument recalls the opposition between the principles of Giles Hussey, which were based on abstracted geometry, and the curvaceous 'line of beauty' of William Hogarth, derived from nature, which had been the source of debate in the 1750s. Of course, here Bates is implicitly attacking the academy itself by naming its president and three of its members as among the leading exponents of a grossly sensual style of painting. Like other more forthright critics of the academy, Bates identifies the institution with corrupted artistic principles by evoking the old opposition of classical and intellectual line to base painterliness. Insofar as this opposition was fundamental to the predominant modes of discourse on art both within and without the academy, even the artists he criticizes would not readily have disputed the terms of his argument. But as a form of rhetoric, Bates' comments suggest that Flaxman's apparent isolation from the academy at this point could serve to give his adherence to a linear style a peculiar advantage.

When Flaxman set out for Rome late in 1787 with letters of introduction from Wedgwood, his reputation was sufficiently well established for the fact to be announced in the press: he was, according to the *World*, 'an artist whose art promises everything'.[70] He was in his mid-thirties, with a wife and an established career as a modeller and designer, and this must have given him a degree of self-sufficiency that was unusual among art students in Rome. Flaxman certainly felt confident enough to affect a distance from the Roman community at large. Where John Deare once casually referred to 'we Romans' and married an Italian, Flaxman made sure he kept away from the locals, viewing them as a threat to the moral character of Englishmen.[71] This aloofness extended to his relations with his countrymen. Only a few months after his arrival he wrote: 'I never go to the English Coffee House, this place is the rendez-vous of the Artists.

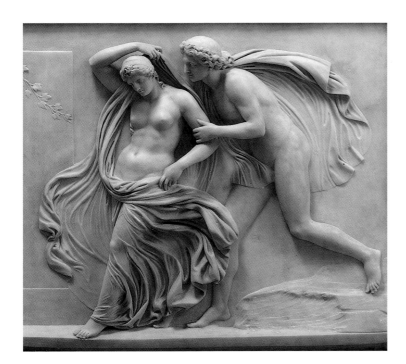

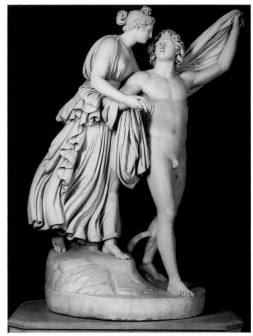

here is always some party, some disagreement & the flame is continually kept up, when winter comes & the people of Quality come here, they are then ready to tear each other in pieces for business.'[72] To a degree this must have been mere pretence: Flaxman was prepared to present himself as part of the British community in Rome for business purposes, for his name was entered in all the 'Rome lists' which circulated to keep Grand Tourists informed of which British artists were in the city, and he even kept one example himself. Furthermore, it is known that he was occupied as a guide for Grand Tourists.[73] However, as a rhetorical construct as much as a practical fact, Flaxman's isolationism served him well. For his patrons, some of the most important of whom were themselves isolated from Deare and his circle, it served to lend his work a sense of exclusivity. In a sense, Flaxman was replaying the strategy employed by James Barry twenty years previously, though to much greater effect.

Still, during his first two years in Rome Flaxman received only a handful of relatively minor new commissions for drawings and sculptural copies. In this time he produced models for show in his studio, presumably in the hope that these would attract patrons.[74] *Apollo and Marpassa*, started in 1790 on a speculative basis, may provide an indication of the character of the works in his studio at this period (FIG. 167).[75] Like Banks in his *Ceyx and Alcyone* and Deare in his *Judgement of Jupiter*, Flaxman was concerned to demonstrate an ability to cut marble in a sophisticated fashion, whether to represent the most delicate folds of drapery or to evoke youthful and beautiful flesh. A tendency to ornamental abstraction is evident in all these works, apparent in the way that figures are placed on a plain surface with the minimal suggestion of a setting. But while Banks had used this effect to emphasize the emotional content of his piece, in Flaxman's relief it serves only to lend decorative clarity, very much on the model of his work for Wedgwood. Flaxman's theme was taken from an obscure source and thus gave some suggestion of intellectual capacity, though this obscurity, combined with the absence of obvious iconographical clues, arguably renders the relief chiefly of interest as an exhibition of the nude.

167 (left)
John Flaxman,
Apollo and Marpessa,
c.1790–94, exhibited
and presented to the
Royal Academy in
1800. Marble, 49.8
× 54 × 6.3 cm.
Royal Academy of
Arts, London.

168 (right)
John Flaxman,
Aurora Visiting Cephalus on Mount Ida, 1789–90.
Marble, height 184
cm. National
Museums, Liverpool
(Lady Lever Art
Gallery, Port
Sunlight).

In its decorative qualities and its subject, the work does not strive to assert clear gender distinctions; a degree of feminine delicacy was usual in the representation of Apollo, the most physically beautiful of the ancient gods, and Flaxman has deliberately emphasized this quality. The figure's musculature is suppressed and his coiffure is markedly similar to that of *Marpassa*. The relief can be said actively to play with the slippage between masculinist identification and eroticized objectification typical in the aesthetic reception of ideal sculpture.

These characteristics were carried into three dimensions in one of the first of the large-scale commissions Flaxman received in Rome, the Ovidian *Aurora Visiting Cephalus on Mount Ida*, made for Thomas Hope (1769–1831) in 1789–90 (FIG. 168).[76] Here, the sculptor again treated a love theme from mythology and made little attempt to differentiate masculine and feminine forms, but rather played with the resemblance between them. Though this sculpture was available for viewing in Flaxman's studio in Rome, its ultimate destination was the private home of the young heir to an immense banking fortune, the architect and collector Hope. Thus it was never meant to be a public emblem of virtue but the private property of a non-aristocratic individual. The 'loves of the gods' theme was entirely appropriate in such a context, where the work could function as, above all, a gallery work. Hope arranged for a whole room to be designed around it, domesticating the sculpture thoroughly, and his other commission from the sculptor, a *Hercules and Hebe* (plaster at University College, London), extended the theme.[77] Ultimately, the sculpture is a belated exercise in three dimensions in the Virgilian mode of technical grace promulgated by Benjamin West and Nathaniel Dance in the 1760s.

However, in the most important work produced by Flaxman in Rome he attempted to treat a more complex theme in a self-consciously 'Sublime' fashion. This was a larger-than-life group of the *Fury of Athamas* for Frederick Augustus Hervey, earl of Bristol (FIG. 169). Flaxman gave an account of the commission in a letter written at the time:

> One morning Lord Bristol called to see what I have done here & ordered me to carve in marble for him, a bas relief I have modelled here between 8 & 9 feet & near 5 feet high, representing Amphion & Zethus delivering their Mother Antiope from the fury of Dirce & Lycus. it is my own composition taken from a different point of time but the same story as Group of the Torso Farnese which you well know. I refused the work notwithstanding the price would have been 500 guineas, & I informed his Lordship I could not possibly remain here unless I should be employed to execute a work that might establish my reputation as a Sculptor his Lordship applauded my resolution, & immediately ordered me to execute a group in marble the figures as large as the Gladiator, from a Sketch in Clay which I had made the subject of which is the Madness of Athamas.[78]

Clearly, Flaxman regarded the *Fury of Athamas* as the piece that would bring him fame as a sculptor. The sculpture was to occupy Flaxman for the next three years. In 1790–92 he produced a full-scale clay model of the composition, and the larger-than-life scale marble was completed by assistants – a product of the academy, for Flaxman had no great skills as a carver – in 1793.[79] Although the finished work did not reach England until some years later because of the French invasion of Rome, the original model and the marble were shown in the artist's studio and won Flaxman considerable celebrity. The earl of Bristol reckoned that the piece would establish Flaxman as the greatest sculptor in Europe, while a friend of the artist claimed that Flaxman could now return to England in triumph.[80] Flaxman himself was quite aware of the exceptional nature of the *Athamas* – both in its physical qualities and the circumstances of its production. In a letter to his parents, sent while the work was nearing completion, he wrote:

> My Sister tells me Sr W. Fordyce & my other friends think if I had returned at the appointed time I might have been employed in works as honourable & profitable in my own country –

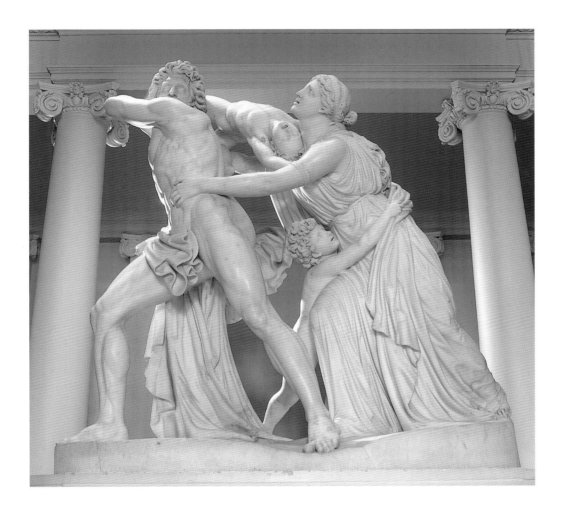

I might have had works much more profitable, for I expect to get but little by my present work, but who would have employed me in England to make a group 7 feet high of a man, a woman, an infant & a larger child, I have never yet heard of an English sculptor being employed in such a work either here or in his own country & besides if I ever expect to be employed on great works, it is reasonable that I should show the world some proof of my abilities.[81]

169 John Flaxman, *The Fury of Athamas*, 1790–94. Marble, height 208.5 cm. National Trust, Ickworth, Suffolk.

Like Banks' *Ceyx and Alcyone* and Deare's *Judgement of Jupiter* and *Edward and Eleanor*, the *Fury of Athamas* was a demonstration piece. In scale and ambition, its only precedent was Thomas Banks' *Achilles Mourning*. Yet none of these artists had to date had the opportunity to produce a free-standing work of such elevated aspirations in marble. The very cost of the marble was huge, famously exceeding the apparently generous payment agreed with the earl of Bristol. The time spent on it was also excessive, permitted, it would appear, only by the extreme frugality of the artist and his wife. According to a later account 'Flaxman had recd. 600£ for the composition of Athamas & Io – but the marble time & expences had cost so much more to Flaxman that this work 'had beggared him' (his own phrase).'[82]

But most noteworthy, as Flaxman recognized, was the nature of its subject matter. The story from Ovid's *Metamorphosis* tells how Athamas, the king of Thebes, was driven mad by the

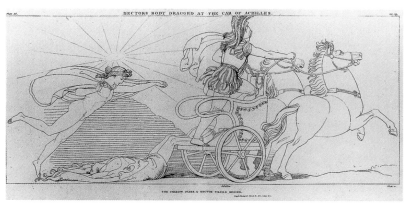

170 (left)
John Flaxman, *The Binding of Prometheus*, c.1792. Pen and ink and pencil on paper, 23.6 × 33.2 cm. The British Museum, London.

171 (right)
Tomaso Piroli after John Flaxman, *Hector's Body Dragged at the Car of Achilles*, first printed 1793, published London, 1805.

jealous gods and attacked his wife, Ino, and children in the delusion that they were lions. The particular moment selected by Flaxman shows Athamas preparing to hurl his child through the air and kill him. In its character the theme is tragic and, in its horrifying and magical aspects, Sublime – with its utter perversion of domestic family norms, even Gothic. In Laurence Eusden's translation Athamas was, in his murderous state: 'A Father no more . . . quite insensible to Nature's Call'.[83] Moreover, Flaxman conceived of the figure of Athamas as a physically over-whelming and horrifying and so Sublime masculine presence. The high tone is maintained in the work's formal references to ancient models: the posture of Athamas reproduces that of the male figure in the *Paetus and Arria* group (Museo Nazionale Romano, Rome), the figure of Ino is taken from *Niobe and her Daughter* (Uffizi, Florence), and the composition as a whole was considered at the time comparable to the *Laocoon* (Vatican Museum, Rome) in tone and ambi-tion.

Yet the *Fury of Athamas* has troubled modern commentators. W. G. Constable and Margaret Whinney felt this to be a deeply unsuccessful, formally awkward work, while David Irwin has complained that the 'movement is cramped and seems to be still contained within the cube of marble'.[84] While these observations have substance, a different reading of the work can be pro-posed that encompasses these criticisms. In part the apparent awkwardness of Flaxman's group must derive from its unwieldy collision of figures imitated from quite separate ancient works, signalling the overinvestment in high-cultural references that is typical of the late eighteenth-century British Grand Manner. This in turn represents an overinvestment in the individual work on the part of artists (already seen in the case of the diploma works) – a consequence of the self-consciousness that accompanied the all too rare opportunity to produce such a piece.

More significantly, the awkwardness observed in the sculpture in modern times served a purpose in terms of late eighteenth-century sculptural aesthetics. The planar quality of the *Athamas* fixes the composition in space, forcing the viewer to take up a specific position in rela-tion to the work. Although it is not known whether the sculpture was originally to be provided with a tailor-made architectural setting, the rear side of the composition offers little interest to the viewer, suggesting that it was always intended to be seen (as it is now) from the front. From that position the lines of drapery lead ineluctably up to the main drama at the top of the com-position and the whole group is legible 'at the first glance of the eye' the spectator thus seeing the piece as a pictorial unity in accordance with the strictly delimited formal character of sculp-ture prescribed by Reynolds at the Royal Academy.

If the sculpture does render its original form as a block visible in its constrained lines of move-ment, it may do so to a purpose: to elide the disconcerting and emasculating effects of sculp-

tural spatiality. The fact that the sculptor's cube of marble 'prescribes bounds to his art' was, for Reynolds, a reason to value the art greatly. *The Fury of Athamas* is a sculpture that is designed, despite its monumental proportions and dense referencing of sculptural tradition, according to an expressly pictorial paradigm: Flaxman has attempted to convey in three dimensions the formal severity and compressed, diagrammatic dynamism of Fuseli's painting. Like Procter's figures of monstrous masculine heroes, the sculpture shares the moral vacuity of the Swiss artist's work.

With his brute physique and horrifying actions, Athamas could not have been representative of a conventionally exemplary masculinity. Alternatively, considered through the framework of the Sublime, the figure of Athamas, by undertaking an act of supernaturally inspired and shocking violence, could have a potentially masculinizing effect on its viewer. If the discourse on the Sublime provided the most persuasive masculinist ideals of the period, Flaxman's *Fury of Athamas* suggests the impossibility of composing a Sublime masculinity in figurative form without complicating the procedures of subjective identification that underlay traditional notions of the Grand Manner as the source of masculine self-affirmation.

Flaxman's major mythological works of the early 1790s suggest that fully sculptural Grand Manner works could not unequivocally embody masculinity because of the ways in which the visual pleasures of sculptural space were associated with effeminacy in late eighteenth-century aesthetics and criticism. On the one hand, the sculptor produced works that were highly unified as objects but embodied feminized forms of masculinity most appropriate to private consumption. On the other hand, with the *Fury of Athamas*, he created a representation of a most brutally assertive masculinity that consequently lacked obvious social currency, in a form that accorded so closely with the demand that the sculptural object be wholly integrated visually that it lost some of its three-dimensional character.

In fact the most influential works produced by Flaxman in Rome were not sculptures at all, but graphic. A series of line drawings of scenes from the *Iliad* and the *Odyssey* (1792–93) and the *Tragedies of Aeschylus* (1794) secured him an international reputation (FIG. 170).[85] The drawings from Homer were sponsored by the Rome-based gentlewoman Mrs Georgina Hare-Naylor (c.1755–1806), the series from Aeschylus were for Georgina, dowager Countess Spencer (1737–1814), and a further set illustrating Dante was created for Thomas Hope. Although distinguished, these patrons were rather different in one respect or another from the young, male, aristocratic characters who had patronized Hamilton and West in an earlier decade.

In 1793 the original Homeric illustrations were published as a series of engravings by Tomaso Piroli (FIG. 171). Quickly disseminated in their engraved form in official and pirate versions from 1794, Flaxman's linear designs immediately gained the admiration of fellow artists and became the object of widespread emulation. They were hungrily consumed across Europe, with ten editions of the *Odyssey* plates and eleven of the *Iliad* being produced in the next forty years, while Flaxman's further series of designs from Dante and Aeschylus scored a similar success. Their appeal was thus cosmopolitan and extensive, if not certainly financially rewarding for the sculptor: Thomas Hope retained the copyright on the series he commissioned, and the sculptor sold on the plates for the Homer series, meaning that when they were republished it was for the profit of others.[86]

From a purely formal point of view, Flaxman's outlines could be understood as fulfilling the most radical proposals for ideal art that had emerged in the previous three decades. In their severe linearity, denying the sensuality of colour or textural effects and renouncing any attempt at illusionism, they take Reynolds' strictures to their logical end and go beyond what even Deare was producing at this point. It could appear to contemporaries that Flaxman had overcome the historical distance that stood between the modern artist and the classical past – a historical dis-

tance traversed by the corrupting forces of commercialization and feminization, which blocked a view onto the ideal. As Thomas Lawrence told Farington on seeing the designs from Homer in 1794: 'they are very fine and have so much of the true spirit of the antique that they appear as if they had been designed when the book was written.'[87]

From a more localized perspective, the series saw Flaxman returning to subjects that had pre-occupied artists endeavouring to operate in a Grand Manner mode over the previous three decades. When the sculptor delineated his refined versions of the death of Hector, or Priam pleading for Hector's body, or Prometheus, he necessarily evoked the phantom presence of his predecessors and the heritage of cultural reform they represented. The breadth and extent of the sale of the outline compositions was testimony to the wide recognition of the appeal of reformist aesthetics at the end of the eighteenth century. But Flaxman's failure to follow up what he perceived as preparatory studies with finished works was further evidence that there was still no practical direction for that reform. Without the cultural leadership required to authorize the production of substantial works of art, the line engravings stood in as a conveniently packaged version of the ideal proffered for private consumption in the home. Executed in a technique that was infinitely reproducible, they were resonant as much of mass-produced design as of the antique, and not necessarily rewarding to their author. Fuseli and Banks had brought the more eccentric and personalized mannerisms of linear draughtsmanship into public works. With Flaxman's line engravings such idiosyncracies were effectively returned to the private sphere as commodities. The publishers were the mediators between the two realms, profiting most highly from the relationship.

Pure line, the symbol of reformed artistic practice since the 1760s, could also function as a sign of fashionable grace, the effective reproduction of which effectively removed the artist from the patronal relationship altogether. To the connoisseurs and artists, Flaxman's linear designs spoke of chaste, heroic ideals; they could equally be taken as luxurious fripperies. At a later date, the sculptor facetiously acknowledged as much in a private letter regarding his self-published outline engravings illustrating Hesiod: 'I am going to publish – not a patent medicine – nor elastic whiskers – nor I was going to say, Youth & Beauty restored, but yet it is something of this latter kind because the Graces, the Muses aye & Venus will come into the compositions.'[88]

Flaxman's time in Rome marks the end of a phase in heroic art in more tangible ways. By the time he left Italy in the autumn of 1794, the first rumours of a French invasion were already circulating. The cost of living in Rome increased dramatically, and the prevalence of malaria in 1795 worsened living conditions still further.[89] In the course of the following year Rome was virtually emptied of British artists and their patrons. As the architect C. H. Tatham wrote in January 1796: 'There is scarce an individual now at Rome who comes under the Class of an amateur, a Dilettanti, or a Purchaser, and would you think that but for the travelling Earl of Bristol I myself am second in the rank of making acquisitions – this will give you a good idea of the dearth of foreign Travellers.'[90]

The French entered Rome in March 1797 and immediately set about pillaging the city. The studios of British artists as well as the museums were ransacked, Deare suffering especially badly.[91] As Flaxman reported from back in London, by 1800 the community in Italy had disintegrated completely: 'Several of the English are dead in consequence of the blessings of French Liberty being spread over Italy. Hamilton, Hewetson, Deare & some others have been its martyrs, & some of those still living have been so pillaged & harassed that their lives must have been burthensome.'[92] An era of heroic ambition based on the practical and imaginative benefits of Rome and encompassing Gavin Hamilton in the 1760s, Fuseli and Banks in the 1770s, Flaxman and Deare in the 1780s and 1790s, had most definitely come to an end.

'I NEVER PRESUM'D TO CLASS THE PAINTERS'

THE STATE OF THE ARTS 1785-1800

Writing of 'The State of Arts in England' in 1786, the German travel writer Gerhard Frederick Augustus Wendeborn (1742–1811) could remark on their generally healthy state. He was reporting on a metropolitan art scene that had been transformed out of all recognition from that prospected by André Rouquet thirty years earlier. Dismissing the old arguments of the Abbé Dubos, the Baron de Montesquieu and Johan Winckelmann about the influence of the national climate, Wendeborn insisted that: 'There are at present among the English eminent painters, some very good engravers, and other ingenious artists.'[1] The Royal Academy, he claimed, had had 'many good effects, towards reforming the taste of the English with regard to the polite arts', and even the Society of Arts seemed to be recovering, when only 'a few years ago it was apprehended, that these times of luxury and dissipation, when patriotism is rather sickly, had thrown it into decline.' Painting was in a flourishing state, as was evident from the crowds who attended the annual exhibitions at Somerset House, although portraits 'constitute the greater part in the exhibitions of the Royal Academy' and 'before the American, Mr West, England had nobody who could be styled an eminent historical painter'. Sculpture, whose taste had only recently been reformed by Michael Rybsrack and latterly by the 'addition of scenical representations' was also doing well: 'There are sculptors and statuaries enough in England, and particularly in London.'[2]

With regard to the general state of the arts, Wendeborn was justified in his claims. The academy had weathered the recent economic depression and political travails and was mounting exhibitions that were ever more popular, to the point that visiting the annual show could be a physically uncomfortable experience, as likely to result in a fainting fit as aesthetic elevation. The success of William Woollett's 1776 engraving of Beniamin West's *Death of General Wolfe*, as well as a range of technical innovations, helped propel an escalating spiral of print production with a truly international scope, leading Horace Walpole to claim in 1786 that 'a brighter era has dawned on the manufacture of prints'.[3] In fact, what concerns there were about the print market and public exhibitions were most often about their luxuriance and degeneracy, focusing attention on the excesses of contemporary cultural consumption rather than its paucity. As a newspaper writer of the time quipped: 'If we cannot succeed in reforming the morals of the people, or the constitution of government, we have at any rate the satisfaction of seeing abundance

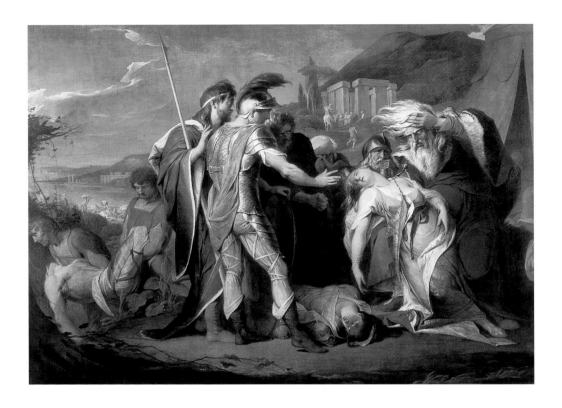

172 James Barry, *Lear and Cordelia*, 1786–87, first exhibited 1789. Oil on canvas, 269 × 367 cm. Tate, London.

of *vertu* in the metropolis.'[4] As a spectacle, profiting entrepreneurs and generating journalistic commentary, British art had never been in such good shape.

Nevertheless, as Wendeborn had to note, artists themselves were in as precarious a position as ever:

> Liberty is most favourable to trade and commerce. Of this the English nation affords the strongest evidence. The spirit of gambling and commerce are nearly related; to gain riches by means of genius and enthusiasm for the arts, is exceedingly precarious. It is far more easy to obtain a fortune as a tradesman or merchant, assisted with the good luck of a gambler, and his not always very honest maxims. No wonder, therefore, if the greatest part of the English, whose *summum bonum* is money, are tasteless in the arts, and treat them with neglect, or even look upon them with a kind of disdain; no wonder if a tradesman or merchant, favoured by liberty, regards the accumulation of money above all, and considers a man of talents and learning, or an artist endowed with excellent genius, as being far below him.[5]

A decade earlier, George Heriot had been advised as much by his friends. This was an age of business, inhospitable to the artist, and a young man had better head to the counting house or clerk's office than the Royal Academy if he sought financial security and a place in society. But as the account of Thomas Procter has shown – and here was an artist who quite literally left the clerk's office to pursue a penniless career as an artist, while one of his peers went on to become 'an opulent and respectable merchant in the city of London' – the situation could be simply inverted and the social isolation of the artist taken as a way of demonstrating his value.[6] It was, it might be claimed, even necessary to be deserted by society and personally negligent of the practicalities of art to become accepted as truly an artist in the heroic mode. The academy's dis-

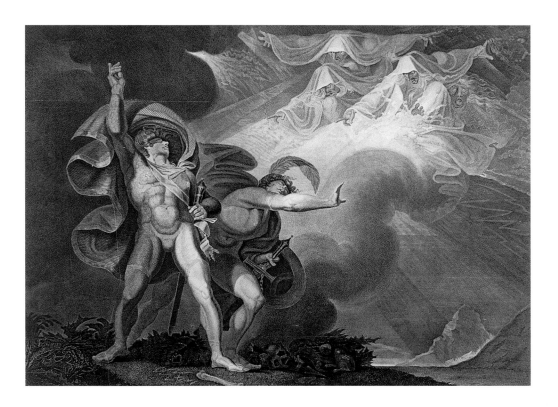

regard for the practical training of its students, particularly in the field of sculpture, implied as much. In practice, John Flaxman affected to stand apart from the artistic community in Rome, and the unrelentingly antisocial behaviour of Henry Fuseli served to demonstrate his genius among his friends and supporters. An artist who did not struggle, who catered too readily to the market, tended to be viewed with suspicion among the middle-class literati who dominated cultural discourse and had an influential role to play as patrons.

Wendeborn was, though, writing on the eve of a set of transformations within British culture that were to revolutionize further the relations between heroic exemplarity and artistic practice, commerce, virtue and genre in historically decisive ways. In 1786, the print publisher John Boydell initiated a scheme that involved commissioning a succession of paintings from British artists on set themes from Shakespeare, exhibiting these in a specially created showroom in London and marketing prints reproducing the paintings as a portfolio of plates or as part of a luxury edition of the plays.[7] The 'Shakespeare Gallery' opened in Pall Mall in the summer of 1789. Initially featuring thirty-four canvases, the gallery opened annually with additions, until it was closed by its owner, dismantled and disposed of by lottery in 1805. By that time it included a collection of 167 pictures by thirty-three artists. Boydell's scheme was joined by several other projects run along the same lines. Thomas Macklin's 'Poet's Gallery', which actually opened before Boydell's, in 1788, featured paintings from a range of writers. Robert Bowyer's 'Historic Gallery' drew on David Hume's *History of England*, and James Woodmason made an ill-fated attempt to set up a Shakespeare Gallery in Dublin.[8]

Between them, the commercial galleries provided well-paid work for almost every painter considered in the present study, from the now aged Gavin Hamilton, Nathaniel Dance and Benjamin West, to James Barry (FIG. 172), Thomas Banks (who sculpted a figure of the play-

173 James Caldwell after Henry Fuseli, *The Witches Appear to Macbeth and Banquo*, published by John and Josiah Boydell, 23 April 1798. Engraving, 44.5 × 59.9 cm (image size). Witt Print Collection, Courtauld Institute of Art, London.

wright for the front of the Shakespeare Gallery) and, most extensively of all, Henry Fuseli (FIG. 173). Academic artists were well represented: of the thirty-three artists employed by Boydell, some two-thirds were members of the academy.[9] Younger painters were also involved (particularly in Macklin's 'Poet's Gallery'), including such frank imitators of Fuseli as Richard Westall (1765–1836), Thomas Stothard (1755–1834) and William Hamilton (1751–1801).[10] The artists were well rewarded for their efforts, with individual payments from Boydell rising to three hundred pounds, with exceptional payments of and over five hundred pounds: for Barry and Fuseli these were the greatest commissions they ever received. While by their nature these projects did not focus on heroic exemplarity as a theme, among the subjects were images of extravagant physicality and raw emotion. These were distinguished by most critics from the 'meretricious foppery' of presenting these scenes as theatrical performances and located instead in relation to the specifically pictorial traditions of the Grand Manner.[11]

As speculative enterprises providing artists with a succession of important commissions, the commercial galleries of the 1790s have considerable significance in the history of art patronage. As explorations of the potential of literary themes as the subject of art that in scale and form emulated the Grand Manner tradition, the commissioned paintings mark the climactic stage of one of the most significant iconographic innovations of the later eighteenth century – an innovation orientated to the expanding and socially diversified market. However, coinciding with and dynamically involved in responses to the French Revolution and the succeeding wars with France, the commercial galleries were to become of still greater consequence. Even as they constituted the most complete collaborative effort towards realizing a modern British Grand Manner on terms that lent heroic art social currency, they were received and sustained in a way that was to render even the pursuit of heroic artistic idealism anachronistic.

The French Revolution had been generally received warmly in Britain in its earliest stages, but the polarized political debate that opened up in late 1790 gave way, in the mid-1790s, to outright political oppression and counter-revolution.[12] Through brute force, coercion and legislation, political opposition was largely silenced. In the realm of culture, counter-revolutionary commentators appropriated the terms of reform discourse and put them to use to define a new and powerful cultural conservatism, delineating hegemonic gender norms and social hierarchy.[13] In the face of the threat of revolutionary democracy, the regulatory possibilities of absolute sexual difference were mobilized with new force, the possibility that liberty could become libertinism condemned, and political and moral debate devolved into the more insidious compulsion of normative social behaviour. The old opposition of feminine commerce and masculine virtue was superseded and the commercial nature of modern Britain was generally conceded by progressives and conservatives, the bourgeois and landed classes, radically reorienting the debates that had fuelled and shaped cultural reform.[14] If the debate on democracy, political representation and social hierarchy was far from over, the place of commerce in the modern world was now largely unchallenged as the consumer values of a nascent bourgeois culture were recruited in defence of the social establishment.

The peculiar achievement of the owners of the literary galleries, and of Boydell especially, was to formulate a clear role (in principle at least) for their commercial enterprises in a national context.[15] Applying to parliament for the right to dispose of the Shakespeare Gallery by lottery in the wake of its collapse, John Boydell reflected on the achievements of his gallery in the context of the history of the 'English School of History Painting':

> I had observed, with indignation, that the want of such a School had been long made a favourite topic of opprobrium against this country, among foreign writers on National Taste.

No subject, therefore, could be more appropriate for such a national attempt, than England's inspired Poet, and great Painter of Nature, Shakespeare; and I flatter myself the most prejudiced foreigner must allow, that Englishmen want nothing but the fostering hand of encouragement, to bring forth genius in this line of art. I might go further, and defy any of the Italian, Flemish, or French Schools, to show, in so short a space of time, such an exertion as the Shakespeare Gallery; and if they could have made such an exertion in so short a period, the pictures would have been marked with all that monotonous sameness which distinguishes these different Schools. Whereas, in the Shakespeare Gallery, every Artist, partaking of the freedom of his country, and endowed with that originality of thinking, so peculiar to its natives, has chosen his own road, to what he conceived to be excellence, unshackled by the slavish imitation and uniformity that pervades all the foreign schools.[16]

The eccentricity and faults of Shakespeare's writings had long been posited as the source of his greatness. This made him incomprehensible to foreigners who stuck to the rules, as Horace Walpole had noted proudly: 'What French criticism can wound the ghosts of Hamlet or Banquo? Scorn rules, Sir, that cramp genius, and substitute delicacy to imagination in a barren language. Shall not we soar, because the French dare not rise from the ground?'[17] Such statements employed a familiar theme of reformist aesthetics: foreign artists and writers are denigrated for their 'sameness', their lack of originality and novelty. They are consequently insipid, weak, lacking in individuality – the very characteristics of the effeminate modern man to whom the reformers of the 1760s had attached. The Shakespeare Gallery, in contrast, was characterized as novel, various and the product of great exertions, and in this resembled and equalled the achievements of the bard, the interplay of the two constituting a vision of a distinctly national culture.

If the reform aesthetics focused on concepts of the Sublime and original genius had attracted oppositional and then radical political associations in the previous decades, by the 1790s the same discourse was redeployed to reactionary ends. Edmund Burke, the prime theorist of the counter-revolution, summed this up in a letter to the Shakespeare scholar Edmund Malone in 1796: 'Your admiration of Shakespeare would be ill sorted indeed, if your Taste (to talk of nothing else) did not lead you to a perfect abhorrence of the French Revolution, and all its works.'[18] As Gary Taylor has argued, after 1790 the 'openness' of Shakespeare (his freedom from critical rules) 'embodied – indeed, proved – the openness of English society'.[19] In his notes on Shakespeare penned around 1790, Joshua Reynolds drew up the terms of the analogy between literature and art in this respect:

Art has a wonderful propensity to insipidity. A regular system is not so pleasant as a desultory observation, a regular built city or house as a chance city or improvised house. *Cato* is cold; Shakespeare the contrary. Art in its most perfect state is when it possesses those accidents which do not belong to the cold laws for that art. Poussin is too artificial in his draperies, perhaps in the whole. Carlo Maratti the same. Raphael's right taste makes him introduce accidental folds, &c.[20]

In other words, precision and regulation are foreign; faults are to be prized as the evidence of a superior genius bred in a free society. Much the same point had been made by the cultural reformers of the 1760s. In the following decade, Barry and Fuseli had made their reputations out of creating works that seemed the opposite of 'insipidity', even though, in both cases, what resulted was controversially unpredictable and sometimes unacceptable. Now, in the 1790s, the cultural establishment fostered an attachment to 'accidents' as expressive of a national genius that, quite spontaneously, opposed reform and gave sustenance to the status quo.

The dominant reading of the Boydell Gallery and its imitators was that they embodied an ideal of a diversified and libertarian national genius fostered by the authentically democratic political principles developed organically in Britain. The artistic diversity they fostered had the aesthetic quality of 'variety', even picturesque variety, as was hinted at by Humphrey Repton in his review of the Shakespeare Gallery; the economy of genius is various because 'one man will have excellence unattainable by another; and each will have faults of a different kind to counter-balance any degree of merit'.[21] The principles of aesthetic variety were followed through by Macklin in describing the Poet's Gallery:

> I did not confine my views to any particular author, because I conceived that, by embracing them all, a more extensive field presented itself for the exertions of fancy, and afforded room for a more diversified display of excellence. The sublime and superhuman descriptions of Milton, the enchanted regions of Spenser, the pathos and humour of Shakespeare, and the rustic scenery of Thomson, presented an inexhaustible source of all that could astonish, interest or entertain.[22]

This had important repercussions for the construction of a now national rather than civic masculinity. Britishness was defined as inherently individualistic: each artist had his own identity, his own manner, and would thereby find his right place in the aesthetic hierarchy. In the same way, in reactionary political theory, each man would find his proper place in the social hierarchy without reference to the abstract political principles of classical republican theory – principles effectively appropriated by the revolutionaries in America and then France. An idea of genius was shackled to a nationalist and conservative rhetoric dedicated to the rationalization and naturalization of social inequality.

A critical space was opened up in these years, not so much for artists as for the middlemen who would direct and disseminate the artists' multifarious productions. These by definition, could not be directed and disseminated along the more restrictive routes of Continental-style academic practice according to the hierarchies of value that prevailed in those contexts. A critic in 1787 had remarked that 'The present improved state of painting in this country . . . is more indebted to the *Engraver* than the encouragement of *the Great*.'[23] This implies a positively demotic turn to the nation's cultural economy, but within this equation lies a more invidious possibility. Answering Joseph Wright of Derby's accusation that he had actively ranked artists in his payments to them, Boydell replied: 'Now Sir, I never presum'd to class the Painters. I leave that to the Public, to whose opinion & Judgment, I bow with great reverence & respect.'[24] The idea of the 'nation' thus served a further purpose: it provided a get-out clause for the entrepreneur. The 'inexhaustible' variety of moods, subjects and pictorial manners exhibited at the commercial galleries was meant to answer, mimetically, the variety of this cultural public, answering the individualism of Britons with artistic individualism. The paradox is that the individual artist had, then, to be considered as part of a community, his work gaining significance in the context of a collective effort that in its internal diversity manifested a national character. It was the named entrepreneurs – Boydell, Macklin, Bowyer – who brought this community together and organized the artists' efforts, who became all the more visible (and financially rewarded), rather than the artist.

There is an irony, of course, in the fact that Boydell articulated the nationalist rationale for his project most clearly in the context of a letter asking for government support for his plans to dismantle the Shakespeare Gallery. All the commercial galleries suffered from the economic hardships of the years of conflict with France, which stymied the international print market. As much as the prints were admired and talked about, that did not secure their commercial viability in itself. The galleries were the most visible product of the developing consumerism of late

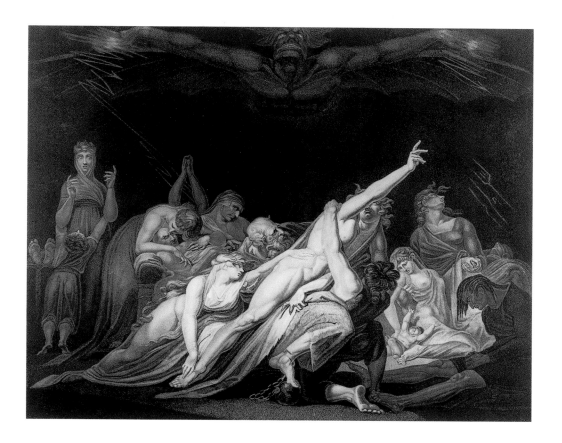

eighteenth-century culture, and stood or fell on entirely commercial foundations. The counter-revolutionary cultural discourse of the 1790s offered a way of rationalizing these projects as having national import, but only insofar as the 'nation' was defined as a mass of individual economic units functioning separately to achieve, organically, a reactionary consensus. The abiding fuzziness surrounding the idea of 'encouragement' could allow, still, a degree of honour to be attached even to this cynical and almost definitively unmanageable set-up.

The limits of this artistic individualism and the illusory nature of the encouragement of heroic art were exposed by the fate of a further gallery of literary paintings created in the 1790s: Henry Fuseli's 'Milton Gallery'. The painter had conceived of such a project as early as 1790, when he wrote to William Roscoe of his planned response to the success of the Boydell scheme, in a letter that acknowledges the conflicting claims to possession between artist and entrepreneur:

> Notwithstanding the Success of my election at the Academy, and of the Pictures I have painted for the Shakespeare-Gallery – my Situation continues to be extremely precarious. I have and am Contributing to make the Public drop their gold in purses not my own, and though I am and probably Shall be fully employed for Some time to come, the Scheme is hastening with rapidity towards its Conclusion. There are, says Mr West but two ways of working Successfully, that is Lastingly, in this Country for an Artist; the one is to paint for the king, the other to meditate a Scheme of Your own. The first he has monopolized, in the Second he is not idle; witness the prints from English History and the Late advertisement of Allegorical

174 Moses Haughton after Henry Fuseli, *The Vision of the Lazar House*, published 10 October 1813 by Henry Fuseli and Moses Haughton. Stipple engraving, 54 × 66. The British Museum, London.

prints to be published from his designs by Bartolozzi. In imitation of So Great a Man, I am determined to lay, hatch and Crack an egg *for myself* too – if I can. What it Shall be – I am not yet ready to tell with Certainty – but the Sum of it is, a Series of Pictures for *Exhibition*, Such as Boydells and Macklins.[25]

Initially conceived as a stand-alone gallery to be supported by a small circle of investors close to the artist, the scheme developed to encompass the publication by Joseph Johnson of a lavish illustrated edition of Milton's works, edited by William Cowper.[26] Although the original plan to publish an illustrated edition of Milton collapsed with the mental health of Cowper, and the scheme of print publication was faltering even by 1792, Fuseli persisted. Such was his dedication to the project that he put aside other work, abjuring from the exhibitions and depending primarily on financial support from a number of middle-class friends, notably the lawyer William Roscoe, the banker Thomas Coutts, the writers William Seward (1747–99) and George Steevens (1736–1800), and the wealthy young amateur artist William Lock (1767–1847).[27]

Widely considered as Britain's greatest epic poet, John Milton provided, according to Fuseli, a wide range of potential subject matter, from the 'Sublime and Pathetic' to the 'Whimsical and phantastic'.[28] What he produced with the support of his friends was a series of some forty or so canvases showing scenes primarily from *Paradise Lost* but also from Milton's other poetical writings and from the life of the poet. Some of these were enormous works, on a par with the paintings Fuseli produced for Boydell. In subject and theme these range from the Satanic and 'Sublime' *Sin, Pursued by Death* through sweetly conceived scenes of Milton's boyhood, the overwrought physical drama of the naked Adam and Eve, and the 'phantastic' of fairy scenes (FIG. 174). Reviewing the surviving images, there is a sense of tumultuous visual drama, as gigantic figures vault, fly and fight in a fantastical arena of suffocating blackness relieved only by storm clouds and rocky precipices. Fuseli's interpretation of *Paradise Lost* presents a pessimistic vision of intensely physical conflict, with the rebellious Satan the vigorous hero of the piece and no real hope of salvation. In their themes and colossal physicality, the pictures make inflated claims for the artist as a kind of Miltonic Satan.

In theory, the Milton Gallery should have been Fuseli's greatest moment, the fullest expression of his aim to be a great painter of an expansive pictorial scheme, in line with Raphael and Michelangelo. As the painter had acknowledged to Roscoe, this was to be a risky undertaking, but one seemingly necessary given economic realities if the painter was to do anything other than 'make the Public drop their gold in purses not my own'. Joseph Farington reported: 'On this Exhibition He totally depends, should it fail all is over with Him.'[29]

The gallery finally opened in Pall Mall in London in May 1799 with forty pictures. It was immediately clear that the project was a non-starter. In its first season the gallery was very sparsely attended. By June Fuseli had accumulated £117 from entrance fees and the sale of catalogues, but in July 1799 the gallery had still taken only £170 and he was forced to close it down: the annual rent alone was £210.[30] The gallery opened again in the spring of 1800 with the addition of seven more pictures. Despite a special dinner held by the Royal Academy to support it, the gallery again failed to raise public interest and was this time to close permanently. A retrospective scheme of larger prints reproducing the paintings was taken up, but only intermittently, over the next decade or so. The scheme as a whole had been a complete flop.

The failure of the gallery can be explained in a number of ways. The decline in print exports, which hit the other commercial galleries, is one explanation, though this would not explain the public's lack of interest in the exhibition itself. This may reflect the ambivalent status of Milton. He was viewed as a difficult, challenging poet, read for educational purposes rather than enter-

tainment. Fuseli was moved to write an emphatic 'I DO NOT' in the margins of his copy of
Samuel Johnson's *Lives of the Poets*,' where he found the opinion that 'we read Milton for
instruction, retire harassed and overburdened, and look elsewhere for recreation'.[31] The poet's
association with republicanism made him politically suspect, and Fuseli himself was sometimes
accused of political dissidence.[32] Yet, in the summer of 1798, as various members of the Royal
Academy were patriotically taking up arms against France in the militia, Fuseli told Joseph
Farington of his worries that he might appear unpatriotic if he did not join, which elicited the
reply from the arch-conservative: 'I told him no necessity to do anything. His situation perfect-
ly safe as He always appeared as to Politicks prudent.'[33] 'Moreover, Milton's writings remained
open to conflicting readings. They were by no means secured as sources of radical thought; in
the course of the eighteenth century, the work of Milton had been largely reconciled to the polit-
ical mainstream. His republicanism could be made out to be an acceptable dimension of British
political tradition, or, alternatively, as more threatening to the establishment. Such distinctions
could come into play among contemporaries, allowing them to distinguish between the politi-
cally equivocal Fuseli and the stridently radical publisher Johnson, despite these two men's com-
mon interest in the Milton project.' Still further, the very mechanics of creating a gallery of this
kind involved the extraction of short texts from the greater narrative of Milton's poems and the
illustration of individual dramatic scenes for spectacular effect. This conformed to the 'denarra-
tivized and decontextualized' reading of Milton that had stripped his works of political and the-
ological reference and made them amenable to the conservative mainstream of British culture as
objects of affective response and sensibility.[35]

More than anything, perhaps, the plan to produce a gallery of some forty pictures single-
handedly was simply a bad idea viewed from the perspective of commercial practice as legiti-
mated by the discourse of British nationalism. The other commercial galleries were marketed on
the basis of the diversity and range of works on show, reflecting patriotic arguments about mod-
ern British art and embodying the law of consumer choice. The same could not be said of the
Milton Gallery, authored solely by Fuseli, who rebuffed offers of assistance from John Opie and
the up-and-coming Thomas Lawrence.[36] John Knowles' gloss on this incident rather betrays
Fuseli's lack of interest in making the gallery appealing to visitors in the manner of the com-
mercial galleries:

> These offers Fuseli politely but prudently declined, being determined not to have any assis-
> tance whatever in a work, which he wished should be a monument of himself, and feeling,
> perhaps, that contrarieties of style would not be beneficial to the exhibition as a whole; for
> his aim was more to give the sublime, quiescent, and playful imagery of the poet in his own
> powerful manner, than to engage attention by colour or a brilliant execution of pictures.[37]

The gallery did not become the 'fashionable Rage' it needed to be, as Joseph Farington realized
when he advised Fuseli to 'get some ladies to attend his Exhibition to make it more general'.[38]
Fuseli had ultimately to concede that he could not compete with Robert Ker Porter's panorama
of the 'Storming and Capture of Seringapatam' at the Lyceum Theatre, or the 'Portraits and
Kinckknacks of Sommerset-House'.[39] Such diverse artistic productions could be accommodated
to an emerging vision of a culture founded upon variety, and lent value as manifestations of a
national genius: Fuseli's singular (in every sense) Milton Gallery could not.

But then again, within a few years neither could the commercial galleries. The French
Revolution provided a short-lived rationale for heroic art as the expression of the national
genius, where there were entrepreneurs who gambled that the values associated with the genre
could still have some currency among the wider literate public. But the conservative consensus

ushered in during the 1790s did not actively require heroic representation, and could, in due course, disregard the hierarchy of the genres as a means of enforcing its most important social, political and gendered values. The cultural work of shaping the subjective and objective structures of masculinity could be done elsewhere, without attempting to bring into play the vast historical perspectives assumed by the Grand Manner. The attempt to anchor heroic images in meaningful social contexts, taken up with vigour around 1760, pursued in many, often strange and fruitless directions since, was virtually abandoned.

CONCLUSION:

GENIUS, MADNESS
AND THE FATE
OF HEROIC ART

BLAKE AND FUSELI IN THE NINETEENTH CENTURY

Around 1810, William Blake produced one of the more esoteric symbols of the disintegration of the ideals of heroic art. The print of *Joseph of Arimathea among the Rocks of Albion* (FIG. 175) was originally engraved as a student exercise dated by the artist to 1773, while he was still an apprentice with the antiquarian engraver James Basire. It encapsulates in its content and in the circumstances of its production something of the broader history of the heroic ideal.[1]

The figure was first copied from a print reproducing Michelangelo's *Crucifixion of St Peter* in the Pauline Chapel in the Vatican. The apprentice engraver adapted the original in a number of details, most importantly by casting this heroically proportioned character into a rocky coastal landscape, retained, although further changed and with added text, in the print of around 1810. The figure in question was conventionally identified as a melancholic self-portrait by Michelangelo, so Blake was transforming a student exercise into an announcement of artistic allegiance to the exemplar of the more extravagant forms of heroic art – the very model of a kind of 'charged' style being taken up so vigorously and variously only at that moment by John Hamilton Mortimer and James Barry, Alexander Runciman and Henry Fuseli.

Joshua Reynolds, in his 'Fifth Discourse' of 1772, had recommended that Michelangelo's works be taken as a model by students only with the utmost caution, claiming that his works bear such a 'strong, peculiar and marked character' that they can be appreciated only in relation to the technical and formal latitude permitted by the Sublime.[2] What Reynolds presented as an option – one way of making art among several – was, to many, by this time felt as a compulsion. It might be by pursuing such extremes that a form of heroic art could be forged that would proffer assurances of vital and vigorous forms of masculinity in an era of increasing gender doubt and secure for the artist a socially meaningful and financially rewarding place in the world.

Blake's career since 1773 had encompassed a studentship at the Royal Academy during the era of the American wars and a political radicalization, given form first rather inarticulately with the attempt to create cycles of heroic art on a small scale in watercolour. At the end of the 1770s, Blake conceived a series of subjects from national history, full of that spirit of political opposition that had dominated the Society of Arts' premium competitions in the early 1760s but that

175 William
Blake, *Joseph of
Arimathea among
the Rocks of
Albion*, engraved
1773, reworked
*c.*1810. Engraving
with some grey
wash, 25.6 × 14
cm. The British
Museum, London.

now, with the effective reclamation of national history by the forces of conservatism, could hard-ly be brought to very effective fruition.

The young Blake's efforts in watercolour and in poetry brought him the attention and admi-ration of a few supporters. In 1784 John Flaxman reported that 'Mr Romney thinks his histor-ical drawings rank with those of Ml Angelo' and noted that he planned to go to Rome.[3] This was not to be. The death of his father provided Blake with enough capital to establish himself as an independent print publisher. This did not go well and, continuing to support himself as a com-mercial illustrator working for booksellers and publishers, Blake in 1792–93 embarked on a his-toric phase of technical and iconographic innovation, focusing on the illumination in a wholly original printmaking technique of small books of prophetic poetry.[4] The vastly complex and nuanced nature of these works is well beyond the scope of this study. But what can be noted in this context is that they inverted the heroic model of art perpetuated by Fuseli, taking it down in scale to the point of complete, precious intimacy. The striding figure who appears at the end of *Europe: A Prophecy* (FIG. 176) resonates with the heroic conceptions of Fuseli and his circle, Flaxman and, ultimately, Gavin Hamilton's furious Achilles dragging the body of Hector behind him (FIG. 27). Yet even the semblance of narrative that clings to Fuseli has been abandoned for a more complex and unstable relationship between literary text and visual image.[5] And the fig-ure in question is hardly the height of a hand outstretched. These illuminations are images removed from the realm of socialized iconography so completely as to become almost illegible, produced in editions so small that there can be no guarantee that they circulated beyond Blake's immediate circle, and so confrontational in their political implications that, in an age of reac-tionary paranoia, their author would have risked imprisonment if they had been made more widely available.[6]

In 1805 the opportunity for a more public exposition of his peculiar talents emerged when the publisher R. H. Cromek (1770–1812) commissioned Blake to design and engrave illustrations for a luxurious new edition of Robert Blair's poem *The Grave* (1743).[7] This was to be a presti-gious and well-publicized project, and would have been an important source of income for Blake. In November of that year a 'Prospectus' was issued with an endorsement by Fuseli that cast the younger man as a heroic reformer able to offer artistic innovation and thus definite val-ues in 'an Age of equal Refinement and Corruption of Manners, when Systems of Education and Seduction go hand in hand; when Religion itself compounds with Fashion; when in the Pursuit of present Enjoyments, all Consideration of Futurity vanishes, and the real Object of Life is lost'.[8] In the event, Blake was to engrave only one of his own designs, and even this was not included in the final publication, the whole being executed by the reproductive engraver Louis Schiavonetti and published in 1808.

The course of events and the nature of what was clearly a rather sharp disagreement between publisher and artist remains a little muddy. Blake scholars have been quick to leap to their sub-ject's defence and have assumed that Cromek became anxious about Blake's unconventional techniques and was seeking to exploit the artist commercially. But Blake does seem to have over-stepped the mark when, buoyed by the approval of Queen Charlotte for his initial designs, he demanded a pay rise. Cromek's response – considered in relation to the contradictions around heroic art and the characteristic self-destructiveness of artists in that mode traced in this study – may be more reasonable than has generally been allowed: 'When I first called on you I found you without reputation; I *imposed* on myself the labour, and an Herculean one it has been, to create and establish a reputation for you. I say the labour was Herculean, because I had not only the public to contend with, but I had to battle with a man who had predetermined not to be served.'[9]

After the disappointment over the engraved illustrations for *The Grave* came a disastrous effort by Blake to establish himself as a painter in the heroic mode with the exhibition of his

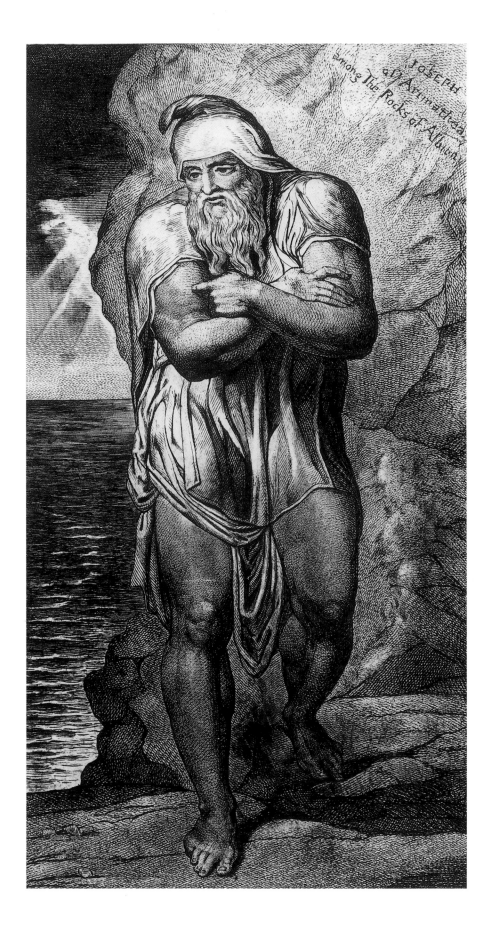

paintings at his family shop in Golden Square from 1809.[10] Involving sixteen of his paintings in watercolour and the invented medium of 'Fresco', including his single largest work – a picture of *Ancient Britons* over 3 metres long (lost) – and allegorical pictures of Admiral Nelson and William Pitt (both Tate) intended to tap into popular nationalism, the show was designed, like Fuseli's Milton Gallery, to be an exhibition of individual talent that could make a career. In the event, the display was greeted with a wall of indifference, punctuated only by a single published review that damned the project completely.

Blake had expected some disapproval of his designs as 'unscientific and irregular Eccentricity, a Madman's Scrawls' but must still have been little prepared for the vituperative response the exhibition elicited.[11] Proclaiming that the show represented 'The Grand Style of Art restored; in FRESCO, or Water-colour Painting, and England protected from the too just imputation of being the Seat and Protectoress of bad (that is blotting and blurring) Art', Blake proposed a project of strenuous cultural reform.[12] Like Fuseli, he surrogated the very technique of making pictures for the heroic struggle of the artist to establish the clarity and truth of his vision against the invidiously liquid forces of consumer society. Unlike Fuseli, Blake was to pursue this in technical fact, with his invented 'fresco' technique and watercolours and through a contrived iconography of such density and opacity that its interpretation motivates a scholarly industry today. The exhibition in Golden Square was the occasion of an infamous denouncement of the artist by Robert Hunt, the otherwise obscure brother of the poet and journalist Leigh Hunt (1784–1859):

> If beside the stupid and mad-brained projects of their rulers, the sane part of the people of England required fresh proofs of the alarming increase of the efforts of insanity, they will be too well convinced from its having been spread into the hitherto sober regions of Art. I say hitherto, because I cannot think with many, that the vigorous genius of the present worthy Keeper of the Royal Academy is touched, though no one can deny that his Muse has been on the verge of insanity, since it has brought forth, with more legitimate offspring, the furious and distorted beings of an extravagant imagination. But, when the ebullitions of a distempered brain are mistaken for the sallies of genius by those whose works have exhibited the soundest thinking in art, the malady has indeed attained a pernicious height, and it becomes a duty to endeavour to arrest its development. Such is the case with the productions and admirers of WILLIAM BLAKE, an unfortunate lunatic, whose personal inoffensiveness secures him from confinement, and, consequently, of whom no public notice would have been taken, if it was not forced on the notice and animadversion of the EXAMINER, in having been held up to public admiration by many esteemed amateurs and professors as a genius in some respect original and legitimate. The praises which these gentlemen bestowed last year on this unfortunate man's illustrations of *Blair's Grave*, have, in feeding his vanity, stimulated him to publish his madness more largely . . . Thus encouraged, the poor man fancies himself a great master, and has painted a few wretched pictures, some of which are unintelligible allegory, others an attempt at sober character by caricature representation, and the whole 'blotted and blurred' and very badly drawn. These he calls an Exhibition, of which he has published a Catalogue, or rather a farrago of nonsense, unintelligibleness, and egregious vanity, the wild effusions of a distempered brain.[13]

As Morris Eaves has discussed, the liberal Hunt thus distanced the artistic radicalism of Blake and Fuseli from the present project of political reform, anticipating in some respects that allegiance to industry and intellectual clarity that was to define the specifically bourgeois reform project of the early nineteenth century.[14] Hunt's anxiety was, fundamentally, that the idiosyncrasy and illegibility of the kind of art pursued by Fuseli and more wholeheartedly by Blake might

compromise the formation of a demotic public for art. The people, then, needed to be protected from such artists, and even from the art establishment that was deluded enough to foster them.

This was the context for the *Joseph of Arimathea* – his student exercise transformed into a figure of pessimism and neglect intended to exemplify the travails of the committed artist. The rather mechanical cross-hatching of the original print was replaced with a more vigorous variety of graphic markings and completely new inscriptions were introduced.[15] These identified the figure as 'Joseph of Arimathea', who Blake described as 'One of the Gothic Artists who Built the Cathedrals in what we call the Dark Ages'. According to legend, Joseph brought Christianity to England and built a cathedral in Glastonbury within decades of Christ's death. Blake presents him both as a founding figure of the Christian faith in Britain and as a model artist, whose creativity was fused with his faith. The inscription continues, suggesting that, as a Christian and as a true 'Gothic' artist, Joseph is isolated from society: 'Wandering about in sheep skins & goat skins of whom the World was not worthy / such were the Christians / in all Ages'.

Around the same date as he reworked Michelangelo's melancholy self-image, Blake was to annotate his copy of Reynolds, *Discourses on Art* with a comment that deals more concretely with the question of the social trajectory of the artist in the modern age:

> Having spent the Vigour of my Youth & Genius under the Oppression of Sr Joshua & his Gang of Cunning Hired Knaves Without Employment & as much as could possibly be Without Bread, The Reader must Expect to Read in all my Remarks on these Books Nothing but Indignation & Resentment. While Sr Joshua was rolling in Riches Barry was Poor & Unemployed except by his own Energy. Mortimer was calld a Madman & only Portrait Painting applauded & rewarded by the Rich & Great. Reynolds & Gainsborough Blotted & Blurred One against the other & Divided all the English World between them. Fuseli Indignant almost hid himself – I am hid.[16]

So, while Blake was 'hid', Fuseli was 'almost hid', even after the debacle of the Milton Gallery – with Blake perhaps rather ingeniously excusing the Swiss painter from the stigmatic association with commerce that prevailed in his comments on Boydell and the other literary galleries.[17] Even Hunt in all his fury excused Fuseli in part from the condemnation he levelled at Blake. The answer why might lie with Blake himself and his bitter little poetic panegyric on the Swiss artist:

> The only man that eer I knew
> Who did not make me almost spew
> Was Fuseli he was both Turk and Jew
> And so dear Christian Friends how do you do[18]

Fuseli was all contradiction: he was to Joseph Farington 'prudent' in his politics, to William Godwin and Wollstonecraft an ally, to some an heir to Michelangelo, to others a crude caricaturist, to his supporters an intellectual far above the common herd, to his critics a pretentious fool peddling childish fantasies. He was heroically disdainful of the institutions and persons that could support him and a career strategist of some skill. His social alienation – that facet of the artistic personality that had become the leading sign of a form of heroic authority unsustainable in the modern age – had become with him a kind of pantomime. This kind of artist played out his role in the uncertain discursive territories placed, rhetorically, beyond the reach of social surveillance and conjured by the various and variously loaded terms 'genius', 'madness' and the 'Sublime', sickness and aberration, eccentricity and inspiration.

This point is worth dwelling on a little further. For his supporters, Fuseli's very faults could be proof of his genius, exploiting the fault line that emerged within anti- or extra-social forma-

tions of genius and value that emerged from 1760.[19] But, for his enemies, his crimes against art, as represented in his crimes against the 'natural' body, were unforgivable. In a typical comment of this sort Edward Dayes (1763–1804) directly linked the harm done to the representational body to an excess of artistic singularity:

> Enthusiasm in the arts is often mistaken for genius, which, if not directed by sound judgement, will answer little purpose, and often end in error: this is precisely the case of Fuseli, whose heat is not tempered with the coolness and judgement necessary to an artist. His figures are meagre and poor, and the articulations of the joints are so hardly marked, as to appear without flesh on them.[20]

Fuseli's enthusiasm thus leads to bodies that are abnormal, lacking in flesh. They are extranatural, anatomized yet active: 'his men', wrote the painter Benjamin Robert Haydon (1786–1846), 'looked like surgical preparations who had burst, skinned as they were, out of bottles in Surgeons' Hall'.[21] The metaphors of monstrosity, torture and the unnatural were applied liberally to Blake and Fuseli, separately and in combination: 'Blakes's figures are as if, like Procrustes' men, they had been stretched on a bed of iron; as if one person had laid hold on the head and another on the legs, & pulled them longer. Nor are some of the figures by Stothard, Flaxman & Fuseli exempt from this fault.'[22] As Paul Youngquist has stated of the monstrous in literature, such grotesque imagery serves 'in a cultural context of nationalist ideology and normative discourse . . . the double function of transgressing and affirming the proprieties that make it possible'.[23]

Fuseli's very rise through the ranks of the profession, assuming the role of keeper at the Royal Academy and then also professor of painting, seemed to some to have been facilitated only by this kind of monstrous rhetorical performance. Haydon claimed of him, 'Weak minds he destroyed. They mistook his wit for reason, his indelicacy for breeding, his swearing for manliness, and his infidelity for strength of mind.'[24] The journalist John Taylor complained that his role of cultural authority had been gained only by personal intimidation, 'wondering . . . as an artist or a wit, he could ever have been the subject either of fear or panegyric; though he certainly was the subject of fear on account of his sarcastic disposition, and to that probably, as I have said, he was indebted for admission into the Royal Academy, and for the situations in it that were conferred on him.'[25] Similarly, a later account insisted that 'Conscious of not having all the strength he wished, he endeavoured to make out for it by violence and pretension.'[26] Haydon, initially an acolyte of the old artist, underwent dramatic conversions in his view towards him later in life, and his *Autobiography* exhibits a profound scepticism. His bathetic account of his first encounter with the old painter is worth giving in full:

> Fuseli had a great reputation for the terrible. His sublime conception of Uriel and Satan had impressed me when a boy. I had mysterious awe of him. Prince Hoare's apprehensions lest he might injure my taste or hurt my morals, excited in my mind a notion that he was a sort of gifted wild beast . . .
>
> This sort of preparation made everything worse, and I was quite nervous when the day arrived. I walked away with my drawings up Wardour Street. I remembered that Berners Street had a golden lion on the right corner house and blundered on, till without knowing how or remembering why, I found myself at Fuseli's door! I deliberated a minute or two, and at last making up my mind to see the enchanter, I jerked up the knocker so nervously that it stuck in the air. I looked at it, as much as to say: 'Is this fair?' and then drove it down with such a devil of a blow that the door rang again. The maid came rushing up in astonishment.

I followed her into a gallery or showroom, enough to frighten anybody at twilight. Galvanised devils – malicious witches brewing their incantations. – Satan bridging Chaos, and springing upwards like a pyramid of fire – Lady Macbeth – Paolo and Francesca – Falstaff and Mrs Quickly – humour, pathos, terror, blood, and murder met one at every look! I expected the floor to give way – I fancied Fuseli himself to be a giant. I heard his footsteps and saw a little bony hand around the edge of the door, followed by a little white-headed lion-faced old man in an old flannel dressing-gown, tied round his waist with a piece of rope, and upon his head the bottom of Mrs Fuseli's work-basket.[27]

The master of the grandest art of the age, the purveyor of an extravagantly heroic image of the male body intended to reform public taste and re-establish sexual norms in a world of gender ambiguity and anxiety, was thus revealed as a wizened old man with a propensity to swear.

Haydon's account not only registers personal disillusion but also encapsulates a sense in which the heroic ideal reached a terminal point with the man who was to dominate the teaching of a whole generation of artists who passed through the academy in the first two decades of the nineteenth century. Recalling his attendance at Fuseli's academic drawing lessons in 1812, the American painter Charles Robert Leslie (1794–1859) wrote an account that equally establishes the reach and eminence of Fuseli's fame as a history painter and his indifference to the matter of perpetuating any artistic principles that could sustain history painting:

I was now admitted a student in the Antique Academy of which Fuseli was the keeper. I had been impressed with the greatest respect for his genius, both as a painter and a writer, before I left America. The engraving from his 'Hamlet and the Ghost' had scared me from the window of a print shop in Philadelphia, and I still contemplate that matchless spectre with something of the same awe it then inspired. I hoped for much advantage from studying under such a master, but he said little in the Academy. He generally came into the room once in the course of every evening, and rarely without a book in his hand. He would take any vacant place among the students, and sit reading nearly the whole time he stayed with us. I believe he was right. For those students who are born with powers that will make them eminent, it is sufficient to place fine works of art before them. They do not want instruction, and those that do are not worth it. Art may be *learnt* but can't be *taught*. Under Fuseli's wise neglect, Wilkie, Mulready, Etty, Landseer, and Haydon distinguished themselves, and were the better for not being made all alike by teaching, if indeed that could have been done.[28]

Drawing on the nascent ideals of British national variety formed around the commercial gallery projects of the 1790s, the scene was set to recuperate the effects of this 'wise neglect' as a healthy expression of the national character. The careers of David Wilkie (1785–1841), William Mulready (1786–1863) and Edwin Henry Landseer (1802–73) ensured the triumph of the moderated artistic ambitions that had to be cultivated in a capitalist state. Each worked predominantly in lesser genres, producing paintings of ordinary life, the landscape and the animal kingdom that, despite their technical accomplishment and sometimes grandeur, are not the be judged by the standards of the Grand Manner that had prevailed in the eighteenth century. The pursuit of a fleshy revision of the Grand Manner by William Etty (1787–1849) is a different story and would need to be told separately, but his career saw him locked into an idealistic student identity to the point of pathology. Haydon, of course, followed the older conception of the Grand Manner but his continuing advocacy of a heroic art based on classical virtues and Christian ethics brought in a literal way his final destruction by suicide, in the face of utter public neglect.[29] His pitiful death exemplified the way that, in the words of John Barrell, 'the classical

republican version of heroic masculinity was coming to seem more and more the sign of an inse-
cure, not a confident masculinity'.[30]

Other virtues had come to the fore – domestic, bourgeois and diminished. Referring to the
younger generation of subject painters, the reforming art critic William Carey complained that
all were practitioners 'In the *private style* of art, that is, in easel, or cabinet pictures, for *private
houses*, we have artists whose pictures abound in beauty, and are an honour to their country.'
There was, Carey lamented, no such thing as public art in Britain, Benjamin West excepted, and
excluding even the 'pagan' Fuseli.[31] A foreign observer of the Royal Academy exhibition of
1802–03 noted the paucity of history paintings, and that those that were present were 'mostly,
however, very small and insignificant; and those of a larger size only contained two, and rarely
three figures. On an enlarged scale, there were none', while sculpture was 'admired, but not
patronised.'[32]

The old arguments about the British being naturally disinclined from encouraging intellectu-
ally strenuous heroic art were revived and revised:

> In general the English artists seek in their figures agreeableness in flesh and form rather than
> the beauty and character of the forms. Their figures are wholly and entirely national, not only
> in their beauties, but also in their blemishes; accordingly one commonly sees large feet and
> hands on their women, in drawing as in nature. Both poetry and painting in this country
> revolve round what is here called comfort. The proportion of landscape painting and paint-
> ing of domestic scenes is greatly in excess of other ingredients.[33]

As Henry Brooke's 'Friend' might have anticipated and as Blake knew all too well, to make state-
ments about the heroic in this context was to risk becoming utterly ludicrous.

The 'British School' that gained definition around 1800 was staked not on the hierarchy of
the genres and the supremacy of epic and heroic narrative and form – a hierarchy closely relat-
ed to conventional gender distinctions – but on an analogy between visual form and a social
polity that licensed a degree of variety. In fabricating a British school based on diversity, a school
of painting was created that had necessarily to disintegrate in terms of its potential to sustain
gendered meanings, insofar as those meanings were projected onto exemplary figures. There
was, consequently, a fundamental shift in values regarding the subjects proper for ambitious art.
In the sphere of the visual arts what emerged were the characteristics of a modern capitalist state,
based on recourse to fuzzy notions of 'tradition' and 'empiricism' and fiercely opposed to the
systematic intellectual practices that could reveal that state's own inequities.[34] As Kay Dian Kriz
has shown in detail, this fundamental shift in values permitted the reconstruction of artistic
genius around the formerly denigrated genre of naturalistic landscape painting.[35]

With regard to sculpture, the patriotic state patronage of the 1790s and 1800s ensured that
the funerary monument, long the prime occupation of the most successful sculptors, was
affirmed as the most truly public form of art. The compromised classicism of Flaxman, John
Charles Felix Rossi and others, displayed at Westminster Abbey and St Paul's at the beginning
of the nineteenth century, marks in some ways the triumph of the sculptor – always able, as
André Rouquet had identified a half-century before, to marry high ambitions to the highly per-
sonalized interests of the market place more effectively than compatriots working in paint. When
Flaxman came to deliver his lectures as the newly appointed professor of sculpture at the Royal
Academy in 1810, he did so on the rationale that it was precisely this form of commission that
had belatedly ensured the emergence of a British school of sculpture.[36]

The rise of genre painting and the landscape genre, of naturalism as a pictorial mode (brought
to bear, latterly, on history painting as well) and of the mixed-mode of monumental sculpture,

are all to be described as among those 'empirical, piecemeal intellectual disciplines [which] corresponded to humble, circumscribed social action'.[37] The notion of singularity as expressive of artistic genius was effectively sanctioned as a 'national' characteristic, so long as it was not pursued to the point of compromising the artist's role according to middle-class ideals of temperate sociability. This 'measured disorder' meant that the coherent ideal of the Grand Manner as a professional undertaking collapsed.[38]

The half-century of British art after about 1760 witnessed a sort of experiment in the Grand Manner, a testing of the possibilities of the heroic genre as a means of managing gender difference and articulating distinctions of taste and status among social groups competing for sovereignty over the cultural field. Grand Manner art was displaced from the institutional and socioeconomic contexts that could sustain it in its most rarefied and coherent form. It was forced to respond to the competing agendas issued by the dominant class and state establishment, the public at large (acting as a body of consumers in the exhibitions and print shops) and self-elected arbiters of taste from different social spheres. In these circumstances it began to embody masculinities variously brutal or feminized, overbearingly physical or disembodied, narcissistic or spectacular. The private passions and personal interests that Rouquet had identified as the future foundation of British art won the day, and the resulting work could now be articulated as a spontaneous consequence of the human condition as modulated by national circumstance, rather than as the product of historical forces and the economic and social divisions these brought. The elevated artistic identities that, unsupported materially or practically, might indict the cultural values of the dominant classes, were recuperated as simply eccentric and marginal, subjected to nostalgia and to the kinds of rhetorical claim to cultural greatness that did not require matching material investment.

The dehistoricizing rationale that emerged in discourse on the 'British School' and that helped shape modern masculinity was the sanctioning of the individual and the stigmatization of the individualism that could offer even symbolic resistance to capitalism – the redaction of selfhood to contained and manageable units, duty-bound to contradiction and the fuzziness of common sense. Always now temporally, spatially and socially displaced, the heroic artist could be a figure of fun or of romance, but always of little or no direct social utility. The heroes who formed the proper subject of the work of such artists art now looked inescapably irrelevant. A fundamentally complacent form of bourgeois social dominance triumphed that required neither moral virtues nor historical exemplars to manage the gender differences and economic inequalities that sustained it.

The uncertainties and contradictions that have been exposed in the Grand Manner art of the late eighteenth century are also, in part and inexactly, the uncertainties and contradictions of modern masculinity in the making. Displaced from the schema of exemplarity and imaginative identification that had temporarily been sought by the various proponents of cultural reform, man was now primarily, even exclusively, an economic creature. 'His fate would be determined by his willingness to comply with an existing, deeply stratified social order, in which he had to find his exact place in relation to others – from within and beyond British society – if he was to find any value or meaning in life. The contradictions and conflicts of this subtly oppressive social order could all too readily to dismissed with reference to a cultural heritage that would always be mysterious, as its machinations would be always, it seemed, beyond formal analysis. We might, in the kind of vainly romantic gesture this situation compels, leave the last word to Blake: since the French Revolution Englishmen are all Intermeasurable One by Another Certainly a happy state of Agreement to which I for One do not Agree. God keep me from the Divinity of Yes & No too.[39]

176 (following page) William Blake, *Shot from the Heights of Enitharmon*, plate 15 from *Europe a Prophecy* (Copy B), 1794. Relief etching with white-line engraving, colour printed with added watercolour, 23 × 16.5 cm. University of Glasgow, Glasgow.

Shot from the heights of Enitharmon;
And in the vineyards of red France appear'd the light of his fury.

The sun glow'd fiery red;
The furious terrors flew around!
On golden chariots raging, with red wheels dropping with blood;
The Lions lash their wrathful tails!
The Tigers couch upon the prey & suck the ruddy tide:
And Enitharmon groans & cries in anguish and dismay.

Then Los arose his head he reard in snaky thunders clad:
And with a cry that shook all nature to the utmost pole,
Call'd all his sons to the strife of blood.

FINIS

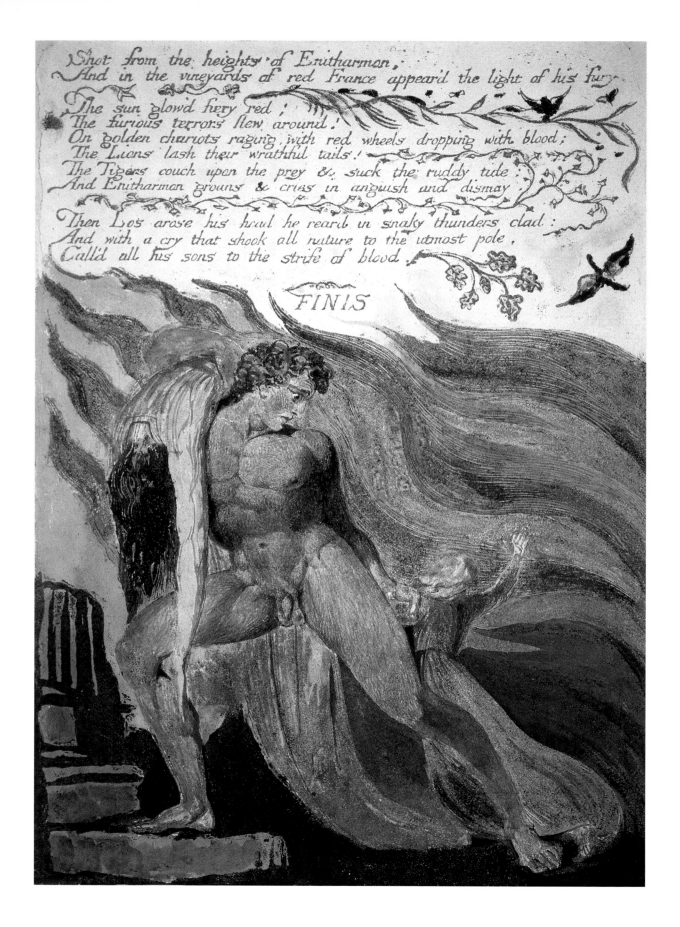

NOTES

INTRODUCTION

1. Henry Brooke, *The Fool of Quality: Or, The History of Henry Earl of Moreland*, 5 vols, London, 1765–70, vol. 1, pp. 149–50.
2. Tobias Smollett, 'The Life of Cervantes', preface to his translation of Miguel De Cervantes, *The History and Adventures of the Renowned Don Quixote*, New York, 2001, p. 18.
3. Brooke, *Fool of Quality*, vol. 1, p. 153.
4. J. G. A. Pocock, *Barbarism and Religion*, vol. 1: *The Enlightenments of Edward Gibbon, 1737–1764*, Cambridge, 1999, p. 97.
5. Pocock, *Barbarism and Religion*, vol. 1, p. 98.
6. Pocock, *Barbarism and Religion*, vol. 1, p. 106.
7. See J. G. A. Pocock, *The Machiavellian Moment: Florentine Political Thought and the Atlantic Republican Tradition*, Princeton, 1975, pp. 465–505; J. G. A. Pocock, *Virtue, Commerce and History: Essays on Political Thought and History, Chiefly in the Eighteenth Century*, Cambridge, 1985, esp. pp. 234–53. See also Shelley Burtt, *Virtue Transformed: Political Argument in England, 1688–1740*, Cambridge, 1992; Paul A. Rahe, 'Antiquity Surpassed: The Repudiation of Classical Republicanism', in *Republicanism, Liberty and Commercial Society*, ed. David Wootton, Stanford, 1994, pp. 233–69.
8. Cf. Pierre Bourdieu, *The Rules of Art: Genesis and Structure of the Literary Field*, trans. Susan Emanuel, Oxford, 1996, pp. 214–15:

 The science of cultural works presupposes three operations which are as necessary and necessarily linked as the three levels of social reality that they apprehend. First, one must analyse the position of the literary (etc.) field within the field of power, and its evolution in time. Second, one must analyse the internal structure of the literary (etc.) field, a universe obeying its own laws of functioning and transformation, meaning the structure of objective relations between positions occupied by individuals and groups placed in a situation of competition for legitimacy. And finally, the analysis involves the genesis of the habitus of occupants of these positions, that is, the systems of dispositions which, being the product of a social trajectory and of a position within the literary (etc.) field, find in this position a more or less favourable opportunity to be realized (the construction of the field is the logical preamble for the construction of the social trajectory as a series of positions successively occupied in this field). Readers may, throughout this chapter, replace *writer* with *painter, philosopher, scholar*, etc., and *literary* with *artistic, philosophical, scientific*, etc. . . . Thus the real hierarchy of explanatory factors requires a reversal of the approach ordinarily adopted by analysts. On no account do we ask how such and such a writer came to be what he was – at the risk of falling into the retrospective illusion of a reconstructed coherence. Rather we must ask how, given his social origin and the socially constituted properties he derived from it, that writer has managed to occupy or, in certain cases, produce the positions which the determined state of the literary (etc.) field offered (already there or still to be made), and thus how that writer managed to give a more or less complete and coherent expression to the position-takings inscribed in a potential state within these positions.

9. William Warner, 'Spectacular Action: Rambo and the Popular Pleasures of Pain', in *Cultural Studies*, ed. Lawrence Grossberg, Cary Nelson and Paula A. Treicher, New York and London, 1992, p. 672.
10. John Barrell, *The Political Theory of Painting from Reynolds to Hazlitt: 'The Body of the Public'*, New Haven and London, 1986.
11. On exemplary history see Joseph M. Levine, *The Battle of the Books: History and Literature in the Augustan Age*, Ithaca and London, 1991, pp. 267–90; J. H. M. Salmon, 'Precept, Example, and Truth: Degory Wheare and the *ars historica*', in *The Historical Imagination in Early Modern Britain: History, Rhetoric, and Fiction, 1500–1800*, ed. Donald R. Kelley and David Harris Sacks, Cambridge, 1997, pp. 11–36; D. R. Woolf, 'A Feminine Past? Gender, Genre, and Historical Knowledge in England, 1500–1800',

in *American Historical Review* 102 (1997), pp. 645–79; Mark Salber Phillips, *Society and Sentiment: Genres of Historical Writing in Britain, 1740–1820*, Princeton, 2000, pp. 105–6; also, Geoffrey Cubitt and Allen Warren, eds, *Heroic Reputations and Exemplary Lives*, Manchester and New York, 2000.

12 Barrell, *Political Theory of Painting*, pp. 19–20. On the theory of epic, see H. T. Swedenberg, *The Theory of Epic in England 1650–1800*, Berkeley and Los Angeles, 1944.

13 André Félibien, *Seven Conferences on Painting*, trans. Henri Testelin, London, 1740, pp. xxvi–xxvii. See Mark Ledbury, *Sedaine, Greuze and the Boundaries of Genre*, Studies in Voltaire and the Eighteenth Century, no. 380, Oxford, 2000, pp. 17–26.

14 Charles Dufresnoy, *De Arte Graphica*, trans. John Dryden, in *The Works of John Dryden*, ed. Edward Niles Hooker, H. T. Swedenberg et al. Berkeley, Los Angeles and London, 1956–89, vol. 20, pp. 89–91 and p. 102. This disgust at the porous, incomplete or fragmented body must, perforce, recall Mikhail Bakhtin's influential argument about the 'new bodily canon' and the social division and ordering represented through and implemented by that body, in *Rabelais and his World*, trans. Helene Iswolsky, Bloomington, 1984, esp. p. 320. For the pertinence of Bakhtin's arguments for eighteenth century aesthetic discourse see John Barrell, 'The Birth of Pandora and the Origin of Painting', in *The Birth of Pandora and the Division of Knowledge*, Basingstoke, 1992, p. 150, and, more generally, Peter Stallybrass and Allon White, *The Politics and Poetics of Transgression*, London, 1986.

15 See Reed Behamou, 'Public and Private Art Education in France, 1648–1793', in *Studies in Voltaire and the Eighteenth Century*, 308 (1993), pp. 1–183, p. 80. On the use of the term 'emulation' in the context of English literature see Howard D. Weinbrot, ' "An Ambition to Excell": The Aesthetics of Emulation in the Seventeenth and Eighteenth Centuries', *Huntington Library Quarterly* 48 (1985), pp. 121–39. For the gendered dynamic of emulative artistic practices in an eighteenth-century French context see Thomas Crow, *Emulation: Making Artists for Revolutionary France*, New Haven and London, 1995; Abigail Solomon-Godeau, *Male Trouble: A Crisis in Representation*, London, 1997, esp. pp. 46–61.

16 Barrell, *Political Theory of Painting*; John Barrell, ed., *Painting and the Politics of Culture: New Essays on British Art, 1700–1850*, Oxford, 1992; David Solkin, *Painting for Money: The Visual Arts and the Public Sphere in Eighteenth-Century England*, New Haven and London, 1993; John Brewer, *The Pleasures of the Imagination: English Culture in the Eighteenth Century*, London, 1997; also Robert W. Jones, *Gender and the Formation of Taste in Eighteenth-Century Britain: The Analysis of Beauty*, Cambridge, 1998; Harriet Guest, *Small Change: Women, Learning, Patriotism, 1750–1810*, Chicago and London, 2000.

17 Steven N. Zwicker, *Lines of Authority: Politics and English Literary Culture, 1649–1689*, Ithaca and London, 1993, p. 198. For a wider perspective on this 'crisis in representations', see Peter Burke, 'The Demise of Royal Mythologies', in *Iconography, Propaganda, and Legitima-*

tion, ed. Allen Ellenius, Oxford, 1998, pp. 245–54.

18 See Howard Caygill, *Art of Judgement*, Oxford, 1989, pp. 41–2.

19 Renee le Bossu, 'A General View of the Epick Poem and of the Illiad and Odyssey', in *The Odyssey of Homer*, trans. Alexander Pope ed. Maynard Mack, London and New Haven, 1967, vol. 2, p. 21.

20 John Dryden, 'The Dedication of the AEneis', in *The Works of John Dryden*, vol. 5, p. 271. On the politics of Dryden's *Virgil*, see Zwicker, *Lines of Authority*, pp. 197–9. See also John M. Steadman, *Milton and the Paradoxes of Renaissance Heroism*, Baston Rouge and London, 1987, pp. 3–25.

21 See Swedenberg, *Theory of Epic*, p. 195.

22 See Stephen Copley, 'The Fine Arts in Eighteenth-Century Polite Culture', in *Painting and the Politics of Culture*, ed. Barrell, pp. 13–37.

23 *Spectator* 226 (19 November 1711), in *The Spectator*, ed. Donald F. Bond, 5, Oxford, 1965, vol. 2, pp. 378–9.

24 See Ronald Paulson, *Hogarth*, New Brunswick and London, 1991–93, vol. 1, pp. 124–34. See also Arline Meyer, *Apostles in England: Sir James Thornhill and the Legacy of Raphael's Tapestry Cartoons*, exhibition catalogue, Miriam & Ira D. Wallach Art Gallery, Columbia University, New York, 1996.

25 William Hogarth, *The Analysis of Beauty*, ed. Ronald Paulson, New Haven and London, 1997, p. 59. On modulations of the hierarchy of the genres, see Michael Podro, 'The Drawn Line from Hogarth to Schiller', in *'Sind Briten hier?': Relations Between British and Continental Art, 1680–1880*, Munich, 1981, pp. 45–56; Ronald Paulson, *The Beautiful, Novel and Strange: Aesthetics and Heterodoxy*, Baltimore and London, 1996; Carol Gibson-Wood, *Jonathan Richardson: Art Theorist of the English Enlightenment*, New Haven and London, 2000, esp. pp. 143–78.

26 Richard Steele, untitled, *The Spectator* 248 (14 December 1711), in *The Spectator*, ed. Bond, vol. 2, pp. 462–3.

27 Samuel Johnson, untitled, *The Rambler*, 60 (13 October 1750), in *The Rambler*, ed. W. J. Bate and Albrecht B. Strauss, New Haven and London, 1969, vol. 1, p. 320.

28 Oliver Goldsmith, *The Citizen of the World*, in *Collected Works of Oliver Goldsmith*, ed. Arthur Friedman, Oxford, 1966, vol. 2, p. 162. On the waning of the epic hero, see Peter Hägin's still fascinating *The Epic Hero and the Decline of Heroic Poetry: A Study of the English Neoclassical Epic with Special Reference to Milton's 'Paradise Lost'*, Berne, 1964; see also Bruce W. Wardropper, 'The Epic Hero Superseded', in *Concepts of the Hero in the Middle Ages and the Renaissance*, ed. Norman T. Burns and Christopher Reagan, London, 1976, pp. 197–221; Frans de Bruyn, 'Hooking the Leviathan: The Eclipse of the Heroic and the Emergence of the Sublime in Eighteenth-Century British Literature', *The Eighteenth Century: Theory and Interpretation* 28 (1987), pp. 193–215; Laura L. Runge, *Gender and Language in British Literary Criticism 1660–1790*, Cambridge, 1997, esp. pp. 182–4.

29 The literature on eighteenth-century sensibility is considerable: the most important studies in the present context include Janet Todd, *Sensibility: An Introduction*, London and New York, 1986; John Mullan, *Sentiment and Socia-*

bility: The Language of Feeling in the Eighteenth Century, Oxford, 1988; G. J. Barker-Benfield, The Culture of Sensibility: Sex and Society in Eighteenth-Century Britain, Chicago and London, 1992.

30 Recent, major historical accounts that have given the Seven Years' War a central role include Linda Colley, Britons: Forging the Nation 1708–1837, 2nd ed., London, 1994; Kathleen Wilson, The Sense of the People: Politics, Culture and Imperialism in England 1715–1785, Cambridge, 1995; Eliga H. Gould, The Persistence of Empire: British Political Culture in the Age of the American Revolution, Chapel Hill and London, 2000.

31 John Brown, An Estimate of the Manners and Principles of the Times, 2 vols, London, 1757–58. See Robert D. Spector, English Literary Periodicals and the Climate of Opinion During the Seven Years' War, The Hague, 1966, pp. 62–5; John Sekora, Luxury: The Concept in Western Thought, Eden to Smollett, Baltimore and London, 1977, pp. 93–100; Peter N. Miller, Defining the Common Good: Empire, Religion and Philosophy in Eighteenth-Century Britain, Cambridge, 1994, pp. 105–11; Philip Carter, 'An "Effeminate" or "Efficient" Nation? Masculinity and Eighteenth-Century Social Documentary', Textual Practice 11 (1997), pp. 429–43; Gerald Newman, The Rise of English Nationalism: A Cultural History 1740–1830, Basingstoke and London, 1997, pp. 80–4 and passim. For the biographical context, see William Roberts, A Dawn of Imaginative Feeling: The Contribution of John Brown (1715–66) to Eighteenth-Century Thought and Literature, Carlisle, 1996.

32 Brown, Estimate, vol. 1, p. 51.

33 Brown, Estimate, vol. 1, pp. 29, 210.

34 Bonnell Thornton, 'Letter, remonstrating against the Use of Paint among Men – Description of a Male Toilet. Characters of John Hardman, and Mr Jessamy', Connoisseur 65 (24 April 1755), in The Connoisseur, ed. Bonnell Thornton and George Colman, 2nd ed., London, 1757, vol. 2, pp. 218–35.

35 See Nicholas Phillipson, 'Politeness and Politics in the Reigns of Anne and the Early Hanoverians', in The Varieties of British Political Thought, 1500–1800, ed. J. G. A. Pocock, Cambridge, 1993, pp. 211–45, esp. pp. 223–37.

36 Brown, Estimate, vol. 1, p. 219.

37 Brown, Estimate, vol. 2, p. 74.

38 Peter de Bolla, The Discourse of the Sublime: Readings in History, Aesthetics and the Subject, Oxford, 1989.

39 See Pocock, Barbarism and Religion, vol. 1, pp. 117–20. For the political context of this queasy ambivalence around heroism and virtue, see also J. G. A. Pocock, '1776: The Revolution Against Parliament', in Three British Revolutions: 1641, 1688, 1776, ed. J. G. A. Pocock, Princeton, 1980, pp. 265–88; J. G. A. Pocock, 'Political Thought in the English-Speaking Atlantic, 1760–1790, Part I: The Imperial Crisis', in Varieties of British Political Thought, ed. Pocock, pp. 246–82, esp. pp. 259–61; Miller, Defining the Common Good, esp. pp. 169–79.

40 Edmund Burke, A Philosophical Enquiry into the Origin of Our Ideas of the Sublime and the Beautiful, ed. James T. Boulton, Oxford, 1987. Walter J. Hipple, The Beautiful, the Sublime, and the Picturesque, Carbondale,

1957, and Samuel H. Monk, The Sublime: A Study of Critical Theories in XVIII-Century England, Michigan, 1960, remain fundamental for the consideration of Burke's text, its context and influence. The most important recent studies for the present argument include de Bolla, The Discourse of the Sublime; Frances Ferguson, Solitude and the Sublime: Romanticism and the Aesthetics of Individuation, New York and London, 1992; Tom Furniss, Edmund Burke's Aesthetic Ideology: Language, Gender, and Political Economy in Revolution, Cambridge, 1993; E. J. Clery, 'The Pleasure of Terror: Paradox in Edmund Burke's Theory of the Sublime', in Pleasure in the Eighteenth Century, ed. Roy Porter and Marie Mulvey Roberts, Basingstoke and London, 1996, pp. 164–81.

41 The key section here is titled 'How pain can be a cause of delight', from which these quotes are taken; Burke, Philosophical Enquiry, pp. 134–35.

42 Arguably, Burke's evocation of the effects of the Beautiful describes precisely the 'disaffection and negligence' so much under debate when the Philosophical Enquiry was published, even as it was also rooted in the travails of Anglo-Irish political life as experienced by the writer through the 1740s (when the Enquiry was begun as a student) and the 1750s. Significantly, his other preoccupation at that time was an essay periodical called the Reformer. The very first paragraph of this journal presented its author's intentions: 'There is a certain Period when Dulness being arrived to its full Growth, and spreading over a Nation becomes so insolent that it forces men of Genius and Spirit to rise up, in spite of their natural Modesty, and work that Destruction it is ripe for . . .'; Reformer 1 (28 January 1748), in Arthur P. I. Samuels, The Early Life, Correspondence and Writings of The Rt. Hon. Edmund Burke LL.D, Cambridge, 1928, p. 297. This lays out the very same sort of cultural project embodied by the Enquiry. In 1748, as in 1757 and 1759, there were pressing concerns about military virtue; the ease with which Highland troops had penetrated deep into the English Midlands had alarmed authorities and revealed the insufficiencies of the standing army, provoking the first calls for a militia. Thus Opposition debates about the militia and national virtue were current throughout the writing of the Enquiry, although especially pronounced at the time it was first published. The Anglo-Irish context and content of Burke's Sublime are explored in Michel Fuchs, Edmund Burke, Ireland, and the Fashioning of Self (Studies in Voltaire and the Eighteenth Century, 343) Oxford, 1996.

43 See Ferguson, Solitude and the Sublime, pp. 46–7; Dafydd Moore, Enlightenment and Romance in James Macpherson's The Poems of Ossian: Myth, Genre and Cultural Change, Aldershot, 2003, pp. 114–18.

44 Dror Wahrman, The Making of the Modern Self: Identity and Culture in Eighteenth-Century England, New Haven and London, 2004, p. 21. For accounts of gender play in the early modern period, see Diane Dugaw, Warrior Women and Popular Balladry, 1650–1850, Cambridge, 1989; Mary Beth Rose, Gender and Heroism in Early Modern Literature, Chicago and London, 2002. Wahrman's is the latest, perhaps most closely historicized elaboration of the argument deriving from Foucault

around the 'disciplining' or normalization of sexuality in the course of the eighteenth century. The polarization of sex roles and the concomitant stigmatization of effeminate behaviours and sexual activity between men are explored in Michael McKeon, 'Historicizing Patriarchy: The Emergence of Gender Difference in England, 1660–1760', *Eighteenth Century Studies* 28 (1995), pp. 295–322; Tim Hitchcock, 'Redefining Sex in Eighteenth-Century England', *History Workshop Journal* 41 (1996), pp. 73–90. Further important commentaries on the historical relationships between masculinity, effeminacy and sexuality are included in Michèle Cohen, *Fashioning Masculinity: National Identity and Language in the Eighteenth Century*, London and New York, 1996; Cath Sharrock, 'Reviewing "the Spirit of Man-hood": Sodomy, Masturbation, and the Body (Politic) in Eighteenth-Century England', *Textual Practice* 11 (1997), pp. 417–28; Harriet Guest, '"These Neutar Somethings": Gender Difference and Commercial Culture in Mid-Eighteenth-Century England', in *Refiguring Revolutions: Aesthetics and Politics from the English Revolution to the Romantic Revolution*, ed. Kevin Sharpe and Steven N. Zwicker, Berkeley, Los Angeles and London, 1998, pp. 172–94; Tim Hitchcock and Michèle Cohen, eds, *English Masculinities 1660–1800*, London and New York, 1999; Conrad Brunstrom, '"Be Male and Female Still": An ABC of Hyperbolic Masculinity in the Eighteenth Century' in *Presenting Gender: Changing Sex in Early Modern Culture*, London, ed. Chris Mounsey, 2001, pp. 29–49; Philip Carter, *Men and the Emergence of Polite Society, 1660–1800*, Harlow, 2001; Clare A. Lyons, 'Mapping an Atlantic Sexual Culture: Homoeroticism in Eighteenth-Century Philadelphia', *William and Mary Quarterly* 60 (2003), pp. 119–54. See also R. W. Connell's account of the decline of 'gentry masculinity' and the rise with capitalism of compulsory heterosexuality in *Masculinities*, Berkeley, 1995, pp. 186–88; also George L. Mosse, *The Image of Man: The Creation of Modern Masculinity*, New York and Oxford, 1996; Alan Peterson, *Unmasking the Masculine: 'Men' and 'Identity' in a Skeptical Age*, London, Thousand Oaks, New Delhi, 1998, esp. pp. 42–4.

45 Chris Holmlund, *Impossible Bodies: Femininity and Masculinity at the Movies*, London, 2002.

46 See Bourdieu, *Rules of Art*; Pierre Bourdieu, *Distinction: A Social Critique of the Judgement of Taste*, trans. Richard Nice, London, 1986, pp. 316–17. Tensions between the centralized state and the various nations of Britain have been explored most fully in the context of language studies and literary history. See Olivia Smith, *The Politics of Language 1791–1819*, Oxford, 1984; Robert Crawford, *Devolving English Literature*, 2nd ed., Edinburgh, 2000; Janet Sorensen, *The Grammar of Empire in Eighteenth-Century British Writing*, Cambridge, 2000. On the project of 'British' history and its challenges see J. G. A. Pocock, 'British History: A Plea for a New Subject', *Journal of Modern History* 47 (1975), pp. 601–28; J. G. A. Pocock, 'The Limits and Divisions of British History: In Search of an Unknown Subject', *American Historical Review* 87 (1982), pp. 311–36; J. G. A. Pocock, 'The New British

History in Atlantic Perspective: An Antipodean Commentary', *American Historical Review* 104 (1999), pp. 490–500; Nancy C. Curtin, '"Varieties of Irishness": Historical Revisionism, Irish Style', *Journal of British Studies* 35 (1996), pp. 195–219; Leith Davis, *Acts of Union: Scotland and the Literary Negotiation of the British Nation, 1707–1830*, Stanford, 1998; Colin Kidd, *Subverting Scotland's Past: Scottish Whig Historians and the Creation of an Anglo-British Identity, 1689–c. 1830*, Cambridge, 1993; Colin Kidd, *British Identities Before Nationalism: Ethnicity and Nationhood in the Atlantic World, 1600–1800*, Cambridge, 1999. It is from Kidd that the present study takes the term 'Anglo-British' to refer to the Anglo-centric and metropolitan bias implicit in the emerging cultural formations of 'Britain' and 'Britishness'.

PART ONE

'OUT ARTS MAY HOPE FOR NEW ADVANCES': THE STATE OF THE ARTS, 1755–65

1 André Rouquet, *The Present State of the Arts in England*, London, 1755; facsimile reprint with an introduction by R. W. Lightbown, London, 1970. Sixty years earlier, Richard Graham had included brief lives of Sir Peter Lely, John Greenhill and John Riley in his, 'A Short Account of the Most Eminent Painters, Both Ancient and Modern', in Charles Dufresnoy, *The Art of Painting*, trans. John Dryden, 2nd ed., London, 1716. A first attempt at a more comprehensive account of modern art in England appeared only in the form of a compendium of biographies, Bainbrigg Buckeridge's 'Essay towards and English School of Painting', appended to the 1706 translation of Roger de Piles, *Abreegee de la vie des Peintres*, facsimile reprint with an introduction by R. W. Lightbown, London, 1969. In the absence of anything better, this had been republished as recently as 1754. Meanwhile, George Vertue's assiduous compilation of notes on British artists past and present promised a more analytical and comprehensive account from the perspective of a professionally active engraver with extensive connections in the metropolitan art scene, but this had seen the light of day only in a few slim publications of an antiquarian nature. On Vertue, see Ilaria Bignamini, 'George Vertue, Art Historian and Art Institutions in London, 1689–1768', *Walpole Society* 54 (1988), pp. 1–148. What Rouquet succeeded in publishing in 1755 was, by contrast, the first full survey of the manual and oral arts in contemporary London. For the state of patronage and the art market in the period that produced these writings see Iain Pears, *The Discovery of Painting: The Growth of Interest in the Arts in England, 1680–1768*, New Haven and London, 1988.

2 Rouquet, *Present State of the Arts*, p. 136.

3 Rouquet, *Present State of the Arts*, pp. 21–2.

4 See Brian Allen, *Francis Hayman*, New Haven and London, 1987.

5 William Aglionby, preface to *Painting Illustrated in Three Dialogues: Containing Some Choice Observations Upon*

the Art, London, 1685, unpaginated.

6 Anthony Ashley Cooper, third earl of Shaftesbury, *Second Characters or the Language of Forms*, ed. Benjamin Rand, Cambridge, 1914, p. 20.

7 Michael Kitson, 'Hogarth's "Apology for Painters"', *Walpole Society* 49 (1966–68), pp. 96–7.

8 See Lawrence E. Klein, *Shaftesbury and the Culture of Politeness: Moral Discourse and Cultural Politics in Early Eighteenth-Century England*, Cambridge, 1994, pp. 178–83; Christine Gerrard, *The Patriot Opposition to Walpole: Politics, Poetry, and National Myth 1725–1742*, Oxford, 1994, p. 48–51; Suvir Kaul, *Poems of Nation, Anthems of Empire: English Verse in the Long Eighteenth Century*, Charlottesville and London, 2000, esp. pp. 92–110, pp. 167–76.

9 Joseph Addison, 'Letter from Italy', in *The Miscellaneous Works of Joseph Addison*, ed. A. C. Guthkelch, London, 1914, vol. 1, p. 59.

10 James Thomson, 'Liberty, A Poem', in *Liberty, The Castle of Indolence and Other Poems*, ed. James Sambrook, Oxford, 1986, p. 139.

11 James Thomson, 'Liberty, A Poem', in *Liberty*, ed. Sambrook, p. 126.

12 James Thomson, 'Liberty, A Poem', in *Liberty*, ed. sambrook, p. 141.

13 Rouquet, *Present State of the Arts*, pp. 24–6.

14 On developments in London Ilaria Bignamini, 'The Accompaniment to Patronage: A Study in the Origins, Rise and Development of an Institutional System for the Arts in Britain, 1692–1768', 2 vols, (Ph. D. diss., University of London, 1988); see Ronald Paulson, *Hogarth*, New Brunswick and London 1991–93 vol. 3, pp. 9–16, pp. 185–96. See also William T. Whitley, *Artists and Their Friends in England 1700–1799*, 2 vols, London and Boston, 1928; Kimberly Rorschach, 'Frederick Prince of Wales (1707–1751) as Collector and Patron', *Walpole Society* 55 (1989–90), pp. 1–76; Joan Coutu, '"A Very Grand and Seigneurial Design": The Duke of Richmond's Academy in Whitehall', *The British Art Journal* 1:2 (2000), pp. 47–54.

15 John Gwynn, *An Essay on Design: Including Proposals for Erecting a Public Academy*, London, 1749, p. 78.

16 On Dublin see R. Raley, 'Beyond all Expectations: The Dublin Society's Drawing-School in the 18th Century' in *Academies of Art Between Renaissance and Romanticism*, ed. Anton W. A. Boschloo et al., The Hague 1989, pp. 493–505; John Turpin, *A School of Art in Dublin Since the Eighteenth Century: A History of the National College of Art and Design*, Dublin, 1995. On Glasgow see George Fairfull-Smith, *The Foulis Press and Foulis Academy: Glasgow's Eighteenth-Century School of Art and Design*, Glasgow, 2001. On Edinburgh see Duncan Macmillan, *Painting in Scotland: The Golden Age*, Oxford, 1986; James Holloway, *Patrons and Painters: Art in Scotland 1650–1760*, Edinburgh, 1989, pp. 105–21.

17 *London Gazette* (6–10 January 1761); the author may be Samuel Johnson and the passage is quoted and discussed in James L. Clifford, 'Johnson and the Society of Artists', in *The Augustan Milieu: Essays Presented to Louis A.*

Landa, ed. Henry Knight Miller, Eric Rothstein and G. S. Rousseau, Oxford, 1970, pp. 340–1.

18 Henry Home, Lord Kames, 'Dedication', dated December 1761, in *Elements of Criticism*, 2nd ed., Edinburgh, 1763, vol. 1, p. v.

19 Versions of this narrative are found in Robert Strange, *An Inquiry into the Rise and Establishment of the Royal Academy of Arts*, London, 1775; John Pye, *Patronage of British Art: An Historical Sketch*, London, 1845; and, in modern times, Ellis Waterhouse's influential *Three Decades of British Art*, Philadelphia, 1965.

1 REFORMING THE HERO: LONDON IN THE EARLY 1760s

1 'H. C.', *Royal Magazine* 4 (1761), pp. 66–7.

2 See Michael Snodin, ed., *Rococo: Art and Design in Hogarth's England*, exhibition catalogue, Victoria and Albert Museum, London, 1984, no. S21.

3 Joseph Addison, *Spectator* 26 (30 March 1711) in *The Spectator*, ed. Donald F-Bond, Oxford, 1965, vol. 1, pp. 108–11.

4 See Geoffrey Beard, *The Work of Grinling Gibbons*, London, 1989, pp. 78–9.

5 Referring to the Cornwall monument: 'I fancy he is the first that ever had such an honour decreed him by a British senate.' André Rouquet, *The Present State of the Arts in England*, London, 1755; facsimile reprint with an introduction by R. W. Lightbown, London, 1970, p. 65.

6 The abbey authorities who reported to the Select Committee on the Preservation of Public Monuments in 1841 listed seven 'state' or 'national' monuments in the church, the earliest being General Wolfe's of 1773 (Westminster Abbey Muniments Room).

7 Rouquet, *Present State of the Arts*, pp. 63–4.

8 See David Bindman and Malcolm Baker, *Roubiliac and the Eighteenth-Century Monument: Sculpture as Theatre*, New Haven and London, 1995, pp. 11–23.

9 Bindman and Baker, *Roubiliac*, pp. 147–72.

10 Oliver Goldsmith, *The Citizen of the World*, in *Collected Works of Oliver Goldsmith*, ed. Arthur Friedman, Oxford, 1966, vol. 2, pp. 58–9.

11 See Joan Coutu, 'Eighteenth-Century British Monuments and the Politics of Empire' Ph.D. diss., University College, London, 1993, pp. 25–66; Bindman and Baker, *Roubiliac*, pp. 170–2, pp. 336–9; Malcolm Baker, *Figured in Marble: The Making and Viewing of Eighteenth-Century Sculpture*, London, 2000, pp. 11–15, pp. 45–7 and pp. 85–6.

12 The following rests on Coutu's detailed discussion in 'Eighteenth-Century British Monuments': *British Political Culture in the Age of the American Revolution*, Chapel Hill and London, 2000, pp. 25–66. On Pitt's policy see Gould, *The Persistence of Empire*, pp. 53–71.

13 See Kathleen Wilson, 'Empire, Trade and Popular Politics in Mid-Hanoverian Britain: The Case of Admiral Vernon', *Past and Present* 121 (1988), pp. 74–109; also Gerald Jordan and Nicholas Rogers, 'Admirals as Heroes: Patriotism and Liberty in Hanoverian England', *Journal*

14 The first notice of a monument, in the *Public Advertiser* as early as the 1 November 1759, reported that the king was to pay for it out of the privy purse. Although this report does not appear to have been repeated (on the contrary, the same newspaper subsequently noted (13 November 1759) that the monument would be raised at 'public Expence'), the idea that the monument could be interpreted as an expression of George III's personal gratitude had wide currency. The *London Evening-Post*, 1–3 November 1759, reported that 'a magnificent funeral will be bestowed, by a grateful nation', and the poem 'On General Wolfe' in the *London Chronicle for 1759*, 15–17 November 1759, p. 480, includes the line 'When Britain mourns, and George erects the bust'. 'Quebec: An Hero-Elegiac Poem on the Conquest of that Place, and the Death of General Wolfe' in the *Royal Magazine* 1 (1759), pp. 370–1 features the line 'Now see! a monument by George prepar'd'.

15 On the image of Wolfe see Alan McNairn, *Behold the Hero: General Wolfe and the Arts in the Eighteenth Century*, Quebec, 1997. On the mythology of the demotic hero in Dutch memorial art see Cynthia Lawrence, 'Henrick de Keyser's Heemskerk Monument: The Origins of the Cult and Iconography of Dutch Naval Heroes', *Simiolus: Netherlands Quarterly for the History of Art* 21 (1992), pp. 265–93.

16 The use of 'medley' as a derogatory term here may gain force by the association with the satiric genre of the medley print, 'an imagery that demanded and enforced a constant oscillation, optical as well as interpretative, between a range of competing, overlapping graphic materials'; see Mark Hallett, *The Spectacle of Difference: Graphic Satire in the Age of Hogarth*, New Haven and London, 1999, p. 55.

17 'Of the present Taste in Monuments – Flattery of *Epitaphs* – *Heathen Gods* improper Decorations for *Christian Monuments*', *Connoisseur* (19 June 1755), in *The Connoisseur*, ed. Bonnell Thornton and George Colman, 2nd ed., London, 1757, vol. 3, pp. 15–21.

18 Charles Churchill, 'On the Monuments in Westminster Abbey', in *The Poetical Works of Charles Churchill*, ed. Douglas Grant, Oxford, 1956, p. 452.

19 The sculptor John Baptist Locatelli claimed that the design was drawn up by Giovanni Battista Cipriani whose close association with the architect would reinforce the suggestion that Chambers was involved; see his letter to the *World*, 1 July 1788.

20 See Joan Coutu, 'William Chambers and Joseph Wilton', in *Sir William Chambers: Architect to George III*, ed. John Harris and Michael Snodin, New Haven and London, 1997, pp. 175–85; Jonathan Marsden and John Hardy, ' "O fair Britannia Hail!: The 'most superb' State Coach", *Apollo* 153 (February 2001), pp. 3–12.

21 A drawing, now untraced, is taken as a record of the original in Baker, *Figured in Marble*, p. 46, although this varies from the design proposed by Pierre-Jean Grosley's written account given here and by Baker. It is almost certainly the drawing of the finished monument by Charles Reuben Ryley (1752–98) commissioned for Robert

Bowyer's Historic Gallery in the early 1790s.

22 Pierre-Jean Grosley, *A Tour to London; Or, New Observations on England and its Inhabitants*, trans. Thomas Nugent, London, 1772, vol. 2, pp. 102–3.

23 Even Roubiliac, whose design showed Wolfe in modern dress before a tent represented in perspective, included only allegorical figures besides the general: see Bindman and Baker, *Roubiliac*, p. 169. Rysbrack's design proposal, which exists in three variations in the collection of the Victoria and Albert Museum, with further related drawings in the Art Institute of Chicago, is firmly identified. The design from the Soane Collection in figure 6 is more speculatively attributed to Carlini.

24 'Epigraph for Maj. Gen. Wolfe', *London Evening-Post* 8–10 (November 1760). Cf., for instance, 'On the Death of General Wolfe', *Boston Evening Post* (15 October 1759); 'On the Death of the Much Lamented General Wolfe', *Virginia Gazette* (30 November 1759); 'Epitaph on General Wolfe', *New Hampshire Gazette* (1 February 1760).

25 *Imperial Magazine* 1 (1760), p. 247.

26 Horace Walpole, *Memoirs of King George II*, ed. John Brooke, New Haven and London, 1985, vol. 3, p. 80.

27 See Allan Cunningham, *The Lives of the Most Eminent British Painters, Sculptors and Architects*, London, 1829–33, vol. 3, p. 74.

28 Anon., *Letters Concerning the Present State of England: Particularly Respecting the Politics, Arts, Manners, and Literature of the Times*, London, 1772, p. 271.

29 John Fleming, 'Luis-François Breton and the Townshend Monument in Westminster Abbey', *Connoisseur* (July 1962), pp. 163–71.

30 See Westminster Abbey Muniments Room, chapter book 10 (1750–68), 5 February 1760. Lady Townshend had presumably been considering a memorial in the autumn of the previous year, when Walpole wrote to her with a design; Horace Walpole to Lady Townshend, 21 September 1759, in *The Yale Edition of Horace Walpole's Correspondence*, ed. W. S. Lewis, Oxford and New Haven, 1937–83, vol. 40, pp. 166–7. Adam's design was evidently in an advanced stage because by July 1760 he was considering having both the Wolfe and Townshend designs engraved (and proofs of the latter are recorded). See Robert Adam to James Adam, 24 July 1760, National Archives of Scotland GD18/4866, f. 32v; Eileen Harris and Nicholas Savage, *British Architectural Books and Writers 1556–1785*, Cambridge, 1990, p. 91n.

31 See *London Chronicle* (2–4 November 1762); also *Dublin Magazine* 1 (1762), p. 706; Betty Adam to James Adam, 23 November 1762, National Archives of Scotland GD18/4948, f. 48.

32 See Eileen Harris, *The Genius of Robert Adam: His Interiors*, New Haven and London, 2001, p. 26.

33 'Journeys from Dublin to London, 1761, 1772', British Library Add. MS 27,951, f. 110v (16 August 1772). 'Our Ld Lietant' was George, fourth viscount Townshend, Lord Lieutenant of Ireland 1767–72.

34 'Characters of the Greatest Generals of the Age', *Dublin Magazine* 2 (1763), p. 37.

35 'A. B.', *London Magazine* 32 (1763), p. 492. On the Howe

of British Studies 28 (1989), pp. 201–24.

monument see Ingrid Roscoe, 'James "Athenian" Stuart and the Scheemakers Family: A Lucrative Partnership between Architect and Sculptors', *Apollo* 126 (1987), pp. 178–84.

36 See Brian Allen, *Francis Hayman*, New Haven and London, 1987, pp. 62–70.

37 David Solkin, *Painting for Money: The Visual Arts and the Public Sphere in Eighteenth-Century England*, New Haven and London, 1993, pp. 190–99; Miles Ogborn, *Spaces of Modernity: London's Geographies, 1680–1780*, New York and London, 1998, pp. 142–50; Peter de Bolla, *The Education of the Eye: Painting, Landscape, and Architecture in Eighteenth-Century Britain*, Stanford, 2003, pp. 94–103.

38 André Félibien, *The Tent of Darius Explain'd; or the Queens of Persia at the Feet of Alexander*, trans. William Parsons, London, 1703.

39 James Marriott, *Political Considerations; being a few thoughts of a candid man at the present crisis*, London, 1762, quoted in Gould, *Persistence of Empire*, p. 102, who discusses the appearance of this theme in pamphlet literature in detail. On essayists' comparable discussion of the peace see Robert Donald Spector, *English Literary Periodicals and the Climate of Opinion During the Seven Years' War*, The Hague, 1966, pp. 88–129.

40 McNairn, *Behold the Hero*, pp. 91–100; Alex Kidson, *George Romney 1734–1802*, exhibition catalogue, National Portrait Gallery, London, 2002, pp. 13–16.

41 For the history of the society see: Derek Hudson and Kenneth W. Luckhurst, *The Royal Society of Arts 1754–1954*, London, 1954; D. G. C. Allan, *William Shipley: Founder of the Royal Society of Arts*, rev. ed. London, 1979; and the essays from the *RSA Journal* collected in *The Virtuoso Tribe of Arts & Sciences: Studies in the Eighteenth-Century Work and Membership of the London Society of Arts*, ed. D. G. C. Allan and J. L. Abbott, Athens, Georgia, and London, 1992.

42 See D. G. C. Allan, 'The Laudable Association of Antigallicans', *RSA Journal* 137 (1989), pp. 623–8. See Linda Colley, *Britons: Forging the Nation 1708–1837*, 2nd ed., London, 1994, pp. 88–91, for a discussion of the nationalist aspect of such projects.

43 On the relationship between the Dublin and London societies see D. G. C. Allan, ' "In the Manner of One in Ireland": The Society of Arts and the Dublin Society, from the Earliest Years to 1801', *RSA Journal* 138 (1989–90), pp. 835–7. For the Dublin Society's political role, see the materials taken from the Revd Samuel Madden's publications on 'encouragement' as a means of buttressing Anglo-Irish society and the established (Anglican) Church against the threat of Catholicism and dissent in *Sources in Irish Art: A Reader*, ed. Fintan Cullen, Cork, 2000, pp. 163–7.

44 For selective overviews of the art premiums see Robert Dossie, *Memoirs of Agriculture and Other Oeconomical Arts*, London, 1768–82, vol. 3, pp. 391–443; Henry Trueman Wood, *A History of the Royal Society of Arts*, London, 1913, pp. 162–212. See John Sunderland, 'Mortimer, Pine and Some Political Aspects of English History Painting', *Burlington Magazine* 116 (1974), pp. 217–26 for an important account of the history-painting premiums.

45 The premium was initially offered for paintings based on set subjects but this was swiftly abandoned. The stipulation was initially for paintings 'out of English history', changing to 'British history' and 'British or Irish history'; see Library of the Royal Society of Arts, London, Minutes of the Society, vol. 2, p. 166 (28 February 1759); Minutes of the Committee of Polite Arts, 1758–60, p. xv (4 April 1760) and 1762–63, p. 59 (1 April 1763).

46 See Richard Cumberland, 'Memoirs of Mr George Romney', *The European Magazine* 43 (1803), p. 420. See also William Hayley, *Life of George Romney*, London, 1809, pp. 39–40, John Romney, *Memoirs of the Life and Works of George Romney*, London, 1830, pp. 47–9.

47 Henry Home, Lord Kames, *Elements of Criticism*, 2nd ed., Edinburgh, 1763, vol. 3, pp. 261–2. Voltaire's *Henriade*, set in the sixteenth century, had been published in English in 1728; a new edition was issued in 1764 as part of Thomas Francklin and Tobias Smollett's *Works of M. De Voltaire*, 25 vols, London, 1761–65. Intriguingly, for the 1763 premium, the society had first contemplated setting as a subject 'viz. The Account in the Duke de Sally's Memoir of Henry the 4th of France revealing his Contract of Marriage with his Mistress Henrietta d'Estranger' but this was rejected; Library of the Royal Society of Arts, Minutes of the Committee of Polite Arts, 1761–62, p. 41 (30 May 1762).

48 For the following see D. G. C. Allan, 'Artists and the Society in the Eighteenth Century', in *The Virtuoso Tribe*, ed. Allan and Abbott, pp. 91–119; Ilaria Bignamini, The Accompaniment to Patronage: 'A Study in the Origins, Rise and Development of an Institutional System for the Arts in Britain', 1692–1768 (Ph.D. diss., University of London, 1988), vol. 2, pp. 423–43.

49 Michael Kitson, ed., 'Hogarth's "Apology for Painters" ', *Walpole Society* 49 (1966–68), pp. 87–8. By contrast, in Dublin specialists from the artistic professions were brought in to assess premiums from the outset (John Turpin, *A School of Art in Dublin Since the Eighteenth Century: A History of the National College of Art and Design*, Dublin, 1995, pp. 12–14).

50 See David Irwin, 'Art Versus Design: The Debate 1760–1860', *Journal of Design History* 4 (1991), pp. 219–20; Jules Lubbock, *The Tyranny of Taste: The Politics of Architecture and Design in Britain 1550–1960*, New Haven and London, 1995, pp. 115–43, pp. 209–25; Anne Puetz, 'Design Instruction for Artisans in Eighteenth-Century Britain', *Journal of Design History* 12 (1999), pp. 217–39.

51 Samuel Johnson, *Idler* 45 (24 February 1759), in *The Idler and Adventurer*, ed. W. J. Bate, John M. Bullitt and L. F. Powell, New Haven and London, 1963, pp. 140–1. On this essay see John Sunderland, 'Samuel Johnson and History Painting' in *The Virtuoso Tribe*, ed. Allan and Abbot, pp. 183–94; Morris R. Brownell, *Samuel Johnson's Attitude to the Arts*, Oxford, 1989, pp. 72–8.

52 J. G. A. Pocock, *Barbarism and Religion*, Cambridge, 1999, vol. 2, pp. 165–6.

53 For this reading of Hume, see Mark Salber Phillips, *Society and Sentiment: Genres of Historical Writing is Britain, 1740–1820*, Princeton, 2000; also Philip Hicks, *Neoclassi-*

cal History and English Culture: From Clarendon to Hume, London, 1996. On the issues surrounding female readers of history see also D. R. Woolf, 'A Feminine Past? Gender, Genre and Historical Knowledge in England, 1500–1800', in *American Historical Review* 102 (1997), pp. 645–79.

54 See Pocock, *Barbarism and Religion*, vol. 2, p. 173. See also Philip Hicks, 'Catherine Macaulay's Civil War: Gender, History and Republicanism in Georgian Britain', *Journal of British Studies* 41 (2002), pp. 170–98.

55 Library of the Royal Society of Arts, Minutes of the Committee of Polite Arts, 1758–60, p. 86 (31 March 1760) and p. 95 (9 April 1760). The painting came into the possession of the Corporation of Newbury, who gave it as a lottery prize in 1773, and it is now lost. See Sunderland, 'Mortimer, Pine and Some Political Aspects', p. 225; also John Sunderland, 'Les Bourgeois de Calais dans l'art britannique au XVIIIe siècle', in *Les Bourgeois de Calais: Fortunes d'un Mythe*, exhibition catalogue, Museee des Beaux-Arts et de la Dentelle, Calais, 1995, pp. 47–51. For the narrative see: Rapin de Thoyras, *The History of England*, trans. John Kelly and Joseph Morgan, London, 1732–37, vol. 1, p. 480; David Hume, *The History of England*, Indianapolis, 1983, vol. 2, pp. 237–8.

56 'G. L.', *Imperial Magazine* 1 (1760), p. 207.

57 Phillips, *Society and Sentiment*, pp. 40–5.

58 Charles Denis, *The Siege of Calais: A Tragedy from the French of M. de Belloy, With Historical Notes*, London, 1765, pp. vi–vii. The play was seen by Thomas Pennant in Paris in March 1765, who noted 'the story is strangely perverted from the historic truth. Our Queen is not introduced, but the merit of the saving of the six Gallant Citizens is given to the Mayor of Calais's Daughter': *Tour on the Continent 1765 by Thomas Pennant*, ed. G. R. de Beer, London, 1948, p. 21. Presumably because of de Belloy's play, Pine's image was reproduced and the Whig account of the siege by Rapin de Thoyras reprinted in *The Universal Museum and Complete Magazine* 1 (1765), pp. 116–18 (March 1765).

59 G. A. Rosso, 'Empire of the Sea: "King Edward the Third" and English Imperial Policy', in *Blake, Politics and History*, ed. Jackie DiSalvo, G. A. Rosso and Christopher Z. Hobson, New York and London, 1998, pp. 251–72. See also Christine Gerrard, *The Patriot Opposition to Walpole: Politics, Poetry, and National Myth 1725–42*, Oxford, 1994, pp. 228–9.

60 See Sunderland, 'Mortimer, Pine and Some Political Aspects'.

61 *Imperial Magazine* 1 (1760), pp. 203–4.

62 The disappearance of almost all the pictures and sculptures submitted for the premiums suggests as much. The documented exceptions are few enough to note. Pine's *Canute* entered the collection of Sir John Taylor at some point, whence it sold for only £23.2.0 at Christie's on 26 April 1787 (first day's sale, lot no. 66; price taken from annotated copy of the catalogue in Christie's Archive). *The Morning Herald* (28 April 1787) noted that this low price, 'was owing to its being of a size not admissable in any building, save a public hall, for which it was well calculated'. George Romney sold one premium work for twenty-five guineas (less than the prize itself) and destroyed the other when it failed to find a buyer; see Hayley, *Life of George Romney*, pp. 39–40. John Vandermeulen's winning bas-reliefs of 1765 and 1767 were in the collection of Lord Montfort by 1776, and Andrea Casali succeeded in selling his premium paintings to William Beckford of Fonthill, where they hung as a suite. For Vandermeulen see Christie's, 16–17 February 1776, first day's sale, lots 20–2; on Casali see Philip Hewat-Jaboor, 'Fonthill House: "One of the Most Princely Edifices in the Kingdom"' in *William Beckford, 1760–1844: An Eye for the Magnificent*, ed. Derek E. Ostergord, New Haven and London, 2002, p. 58. There is evidence that some works entered the collection of the society, whether they were presented by the artists themselves or by individual members. A list of the society's possessions drawn up in 1779 included five bas-reliefs in plaster and an unidentified marble bas-relief in a glass case. The plaster bas-reliefs include a version of *Jepthah's Rash Vow*, the subject of a premium in 1760 won by Joseph Nollekens and John Bacon. The society at this time certainly had prints after Pine's winning pictures. Additionally, the society now holds three plaster roundels that may formerly have been the property of the society's secretary, Samuel More. One of these shows *Priam Pleading with Achilles for Hector's Body*, the subject of a premium-winning relief in marble by Thomas Banks in 1765. For the bas-reliefs see Library of the Royal Society of Arts, *A Catalogue of the Books, Manuscripts, Medals, Basso-Relievo's . . . belonging to the Society for the Encouragement of the Arts, Manufactures and Commerce Adelphi Building Strand taken May 1779*; on Banks see D. G. C. Allan, 'Bas-relief Plaques in the Society's House: An Inquiry', *RSA Journal* 119 (1970–71), pp. 44–6, who misidentifies the subject.

63 See the observations about the Salon in France as a hybrid public–private space filled 'with truant works temporarily separated from their duties but idling in the company of phantom uses': Katie Scott, *The Rococo Interior: Decoration and Social Spaces in Early Eighteenth-Century Paris*, New Haven and London, 1995, pp. 252–3.

64 Library of the Royal Society of Arts, Minutes of the Committee of Polite Arts, 1763–64, pp. 64–5 (26 March 1764) and p. 72 (21 April 1764). See John Sunderland, 'John Hamilton Mortimer: His Life and Works', *Walpole Society* 52 (1986), pp. 19–22; Sam Smiles, *The Image of Antiquity: Ancient Britain and the Romantic Imagination*, New Haven and London, 1994, pp. 98–101. The following reading takes further points from Sam Smiles, 'J. H. Mortimer and Ancient Britain: An Unrecorded Project and a New Identification', in *Apollo* 142 (November 1995), pp. 42–6 and Arline Mayer, *Apostles in England: Sir James Thornhill and the Legacy of Raphael's Tapestry Cartoons*, exhibition catalogue, Miriam & Ira D. Wallach Art Gallery, Columbia University, New York, 1996, pp. 67–9.

65 John Parker, *Early History and Antiquities of Wycombe* (1878), quoted in Sunderland 'John Hamilton Mortimer', p. 20.

66 Evan Lloyd, *Conversation: A Poem*, London, 1767, pp. 48–9. On Lloyd see E. Alfred Jones, *Two Welsh Correspondents of John Wilkes*, London, 1919; Cecil Price,

'David Garrick and Evan Lloyd', *Review of English Studies* 9 (1952), pp. 28–38; Cecil Price, 'The Unpublished Letters of Evan Lloyd', *Cylchgrawn Llyfrgell Genedlaethol Cymru – The National Library of Wales Journal* 8 (1953–54), pp. 264–305, 426–48. Mortimer was to provide the etched frontispieces to the poet's 'Powers of the Pen' (1768) and 'An Epistle to David Garrick, Esq.' (1773), and painted his portrait: see Sunderland, 'John Hamilton Mortimer', pp. 85–7.

67 On the gendered characteristics of the language of Wilkesite politics see Anna Clark, 'The Chevalier D'Eon and Wilkes: Masculinity and Politics in the Eighteenth Century', *Eighteenth-Century Studies* 32 (1998), pp. 19–48.

68 Library of the Royal Society of Arts, Minutes of the Committee of Polite Arts, 1763–64, p. 65 (26 March 1764) and 1766–67, pp. 2–3 (21 November 1766); *Gazetteer* (27 March 1765). See Allan, 'Artists and the Society', pp. 105–6; James Taylor, 'Sea Pieces and Scandal: the Society of Arts' Encouragement of Marine Art, 1764–70', *RSA Journal* 144 (1996), pp. 32–4; Sarah Monks, 'Marine Art and the Public Sphere in Britain, 1739–95' (Ph.D. diss., Courtauld Institute of Art, University of London, 2002), vol. 1, pp. 70–114.

69 On the vocabulary of patronage see Dustin Griffin, *Literary Patronage in England, 1650–1800*, Cambridge, 1996, pp. 12–44.

70 John Gwynn, *London and Westminster Improved*, London, 1766, pp. 57–9.

2 GAVIN HAMILTON AND ROME IN THE 1760S

1 On Hamilton and his work see: David Irwin, 'Gavin Hamilton: Archaeologist, Painter, and Dealer', *Art Bulletin* 44 (1962), pp. 87–102; David and Francina Irwin, *Scottish Painters at Home and Abroad 1700–1900*, London, 1975, pp. 49–50, pp. 101–3; Nicola Kalinsky, 'Gavin Hamilton and the Genesis of Neo-Classical History Painting' (master's thesis, Courtauld Institute of Art, University of London, 1985); Duncan Macmillan, *Painting in Scotland: The Golden Age*, Oxford, 1986, pp. 31–42; Julia Lloyd Williams, *Gavin Hamilton 1723–1798*, Edinburgh, 1994. On the revival of the arts in Italy see Robert Rosenblum, *Transformations in Late Eighteenth-Century Art*, Princeton, 1967; Hugh Honour, *Neoclassicism*, Harmondsworth, 1968; *The Age of Neo-Classicism*, exhibition catalogue, Arts Council of Great Britain, 1972. For an account that stresses economic factors see Albert Boime, *Art in an Age of Revolutions 1750–1800*, Chicago and London, 1987, pp. 55–183. The major accounts of British cultural activity in Rome in the 1750s and 1760s are Ellis Waterhouse, 'The British Contribution to the Neoclassical Style in Painting', in *Proceedings of the British Academy*, London, 1954, pp. 57–74; John Fleming, *Robert Adam and His Circle in Edinburgh and Rome*, London, 1962; David Irwin, *English Neoclassical Art: Studies in Inspiration and Taste*, London, 1966.

2 On Batoni see Edgar Peters Bowron, *Pompeo Batoni and His British Patrons*, exhibition catalogue, Iveagh Bequest,

Kenwood, London, 1982; Edgar Peters Bowron, *Pompeo Batoni: A Complete Catalogue of His Works*, ed. Anthony M. Clark, Oxford, 1985. On Mengs see Thomas O. Pelzel, *Anton Raphael Mengs and Neoclassicism: His Art, His Influence and his Reputation*, New York and London, 1979; Steffi Roettgen, *Anton Raphael Mengs 1728–1779 and his British Patrons*, exhibition catalogue, Iveagh Bequest, Kenwood, London, 1993; Steffi Roettgen, *Anton Raphael Mengs 1728–1779*, 2 vols, Munich, 1999–2003.

3 Jonathan Skelton to William Herring, 20 July 1758, in Brinsley Ford, 'The Letters of Jonathan Skelton Written in Rome and Tivoli in 1758; Together with Correspondence Relating to his Death on 19 January 1759', *Walpole Society* 36 (1956–58), p. 51.

4 See Jeremy Black, *The British Abroad: The Grand Tour in the Eighteenth Century*, Stroud, 1992; Jeremy Black, *France and the Grand Tour*, Basingstoke, 2003; Jeremy Black, *Italy and the Grand Tour*, New Haven and London, 2003. John Ingamells, ed., *A Dictionary of British and Irish Travellers in Italy 1701–1800*, New Haven and London, 1997, is the essential reference work, which has transformed the state of knowledge about the Grand Tour. More critical and analytical perspectives are available in Bruce Redford, *Venice and the Grand Tour*, New Haven and London, 1996; Jeffrey Morrison, *Winckelmann and the Notion of Aesthetic Education*, Oxford, 1996, pp. 1–19; Kay Dian Kriz, 'The Grand Tour', *Eighteenth-Century Studies* 31 (1997–98), pp. 87–9; Dana Arnold, 'The Illusion of Grandeur? Antiquity, Grand Tourism and the Country House', in Dana Arnold et al., *The Georgian Country House: Architecture, Landscape and Society*, Stroud, 1998, pp. 100–16; Chloe Chard, *Pleasure and Guilt on the Grand Tour: Travel Writing and Imaginative Geography 1600–1830*, Manchester and New York, 1999; Clare Hornsby, *The Impact of Italy: The Grand Tour and Beyond*, London, 2000.

5 The role of public schools in the formation of upper-class masculine identity has been most intensively considered as a Victorian phenomenon. See particularly, J. A. Mangan, *Athleticism in the Victorian and Edwardian Public School: The Emergence and Consolidation of an Educational Ideology*, London, 2000. The pre-Victorian era is considered in Anthony Fletcher, *Gender, Sex and Subordination in England 1500–1800*, New Haven and London, 1995, pp. 297–321. The role of public schools in the reproduction of political power is amply demonstrated by M. V. Wallbank, 'Eighteenth-Century Public Schools and the Education of the Governing Elite', *History of Education* 8 (1979), pp. 1–19.

6 John, Lord Sheffield, ed., *Edward Gibbon: Memoirs of my Life and Writings*, 1796; reprint, edited by A. Cockshut, J. Cockshut and Stephen Constantine, Keele University Press, 1996, p. 145.

7 See Richard S. Tompson, *Classics or Charity: The Dilemma of the 18th-Century Grammar School*, Manchester, 1971, pp. 36–48; Robert Donald Spector, 'The *Connoisseur*: A Study of the Functions of a Persona', in *English Writers of the Eighteenth Century*, ed. John H. Middendorf, New York and London, 1971, pp. 109–21; Lance Bertelsen, *The Nonsense Club: Literature and*

Popular Culture 1749–1764, Oxford, 1986; Gerald Newman, *The Rise of English Nationalism: A Cultural History 1740–1830*, Basingstoke and London, 1997, pp. 21–47, and pp. 63–80.

8 Richard Hurd, *Dialogues on the Uses of Foreign Travel: Considered as Part of an English Gentleman's Education: Between Lord Shaftesbury and Mr Locke*, London, 1764, pp. 43–6, p. 71; see Michèle Cohen, *Fashioning Masculinity: National Identity and Language in the Eighteenth Century*, London and New York, 1996, pp. 58–63.

9 For the conventions of Grand Tour portraiture, see the important study by Sabrina Norlander, *Claiming Rome: Portraiture and Social Identity in the Eighteenth Century*, Uppsala 2003, esp. pp. 138–70.

10 Thomas Robinson to Frederick Robinson, 14 October 1759, West Yorkshire Archive Service, Leeds, WYL 150/6032 (12307).

11 Thomas Robinson to Thomas Robinson, first baron Grantham, 9 August 1760, West Yorkshire Archive Service, Leeds, WYL 150/6032 (12325). This important letter is printed and discussed in 'Batoni and Mengs', *Leeds Art Calendar* 44 (1960), pp. 23–24. See also Thomas Robinson to Thomas Robinson, first baron Grantham, 21 June 1760, on first encountering the work of Mengs and Batoni and contrasting the 'very strong & chaste' qualities of the German with the 'more glaring' and less forceful work of the Italian, WYL 150/6032 (12322). The context for these comments is discussed more fully in Martin Myrone, 'Taste, Travel and the Reform of Culture in the 1760s', in *Drawing from the Past: William Weddell and the Transformation of Newby Hall*, Leeds Museums & Galleries (City Art Gallery), 2004, pp. 41–55.

12 See Bowron, *Pompeo Batoni: A Complete Catalogue*, no. D45; Roettgen, *Anton Raphael Mengs (1728–79)*, no. 105, also no. QU 70, where the author notes the suspicious absence of any corroborating evidence for Robinson's account of Mengs' having painted a version of *Hector and Andromache*.

13 Joshua Reynolds, *Idler* 79 (20 October 1759), in *The Idler and the Adventurer*, ed. W. J. Bate, John M. Bullitt and L. F. Powell, New Haven and London, 1963, pp. 246–9.

14 Thomas Robinson to Thomas Robinson, first baron Grantham, 15 May 1763, West Yorkshire Archives Service, Leeds, WYL 150/6032 (12296).

15 L.-A. de Caraccioli, *Voyage de la raison en Europe* (1771), quoted in Frances Acomb, *Anglophobia in France 1763–1789: An Essay in the History of Constitutionalism and Nationalism*, Durham, NC, 1950, p. 11.

16 Notably Baron de Grimm, *Correspondence littéraire*, 1 May 1763, in *Early Neo-Classicism in France: The Creation of the Louis Seize Style in Architectural Decoration, Furniture and Ormolu, Gold and Silver, and Sèvres Porcelain in the Mid-Eighteenth Century*, ed. Peter Thornton, trans. Svend Erikson, London, 1974, pp. 48–51 and pp. 264–5.

17 See Cohen, *Fashioning Masculinity*, pp. 54–63; Redford, *Venice and the Grand Tour*, pp. 14–15. Robin Eagles, *Francophilia in English Society, 1748–1815*, Basingstoke, 2000, pp. 120–1; Katherine Turner, *British Travel Writers in Europe: Authorship, Gender and National Identity*,

Aldershot, 2001, pp. 2–3; Jean Viviès, *English Travel Narratives in the Eighteenth Century: Exploring Genres*, trans. Claire Davison, Aldershot, 2002, pp. 25–6.

18 Sheffield, ed., *Edward Gibbon*, p. 172. Gibbon's comments can be read in relation to his membership of the 'Roman Club', made up of men who shared the experience of the Grand Tour in the early 1760s; see Myrone, 'Taste, Travel and the Reform of Culture'.

19 Matthew William Peters to William Oram, 6 May 1762, in William Oram, *Precepts and Observations on the Art of Colouring in Landscape Painting*, ed. Charles Clarke, London, 1810, pp. 82–3.

20 Alexander Carlyle, *Anecdotes and Characters of the Times*, ed. James Kingsley, London, 1973, pp. 38–9. On Glasgow University see W. M. Mathew, 'The Origins and Occupations of Glasgow Students, 1740–1839', *Past and Present* 33 (1966), pp. 74–94. Mathew's analysis of the student membership for 1740–49 situates Hamilton as a typical student of the period, part of the 31.9% who were sons of the nobility or landed class and the 42.7% who were from Scotland's west central counties. From the same decade, 26.2% of enrolled students were sons of fathers operating in the industrial or commercial fields. As a painter and art dealer, Hamilton can be considered as part of that 1.4% minority of students from landed families who went into 'miscellaneous' professions, as opposed to the 37.3% majority who went into the Church. For the matriculation records of Hamilton and his brothers, and the marriage of Isabella Hamilton to Patrick Bogle of Hamilton Farm, 'merchant in Glasgow', see W. Innes Addison, ed., *Matriculation Albums of the University of Glasgow*, Glasgow, 1913. See also Andrew Hook and Richard B. Sher, eds, *The Glasgow Enlightenment*, East Linton, 1995, particularly the editors' introduction, 'Glasgow and the Enlightenment', pp. 1–17, and Roger L. Emerson, 'Politics and the Glasgow Professors, 1690–1800', pp. 21–39.

21 See N. T. Phillipson, 'Lawyers, Landowners, and the Civic Leadership of Post-Union Scotland', in *Lawyers in their Social Setting: Wilson Memorial Lectures University of Edinburgh*, ed. D. N. MacCormick, Edinburgh, 1976, pp. 171–94; Duncan Forbes, 'Artists, Patrons and the Power of Association: The Emergence of a Bourgeois Artistic Field in Edinburgh, c.1775–c.1840' (Ph.D., diss., University of St Andrews, 1996), pp. 18–67.

22 See Anthony M. Clark, 'Agostino Masucci: A Conclusion and a Reformation of the Roman Baroque', in *Essays in the History of Art Presented to Rudolf Wittkower*, ed. Douglas Fraser, Howard Hibbard and Milton J. Lewine, London, 1967, pp. 259–64. That Hamilton may have had Jacobite sympathies is suggested by his friendship with the exiled Jacobites William Hamilton of Bangour (the poet, whose portrait he painted in 1750) and James Byres.

23 Andrew Stuart to 'Dr F', 2 July 1751, National Library of Scotland MS.8250, f.1v-2. According to Reynolds, who had returned from his own Italian trip in triumph, 'Mr Hambleton's business is very nearly entirely gone from him he is in a very melancholy situation having engaged a house for three years at 120£ a year', and he and his contemporary, the portrait painter John Astley, were 'obliged to dis-

patch their Pictures as fast as they could in order to received the cash so that their first Pictures which were exposed and by which their reputation was to stand or fall were very slight indigested and incorrect things'; Joshua Reynolds to Joseph Wilton, 5 June 1753, in *The Letters of Sir Joshua Reynolds*, ed. John Ingamells and John Edgcumbe, Guildford and King's Lynn, 2000, p. 14.

24 Gavin Hamilton to Lord Tweeddale, 24 September 1755, National Library of Scotland, MS 17,552. See Serena Q. Hutton, ' "A Historical Painter": Gavin Hamilton in 1755', *Burlington Magazine* 120 (1978), pp. 25–7. On the development of the interiors at Yester House, see the three-part article by Alastair Rowan, 'Yester House, East Lothian', in *Country Life* 154 (1973), pp. 358–61, pp. 430–3, pp. 490–3.

25 Gavin Hamilton to Lord Tweeddale, 30 July 1756, National Library of Scotland MS 17,552, quoted in Hutton, ' "A Historical Painter" ', p. 27.

26 See C. Pace, 'Gavin Hamilton's *Wood and Dawkins Discovering Palmyra*: The Dilettante as Hero', *Art History* 4 (1981), pp. 271–90.

27 Robert Adam to Janet Adam, Rome, 30 March 1757, National Archives of Scotland, GD 18/4833.

28 Thomas Spence, *Polymetis: Or, An Inquiry Concerning the Agreement Between the Works of the Roman Poets and the Remains of the Antient Artists*, London, 1747.

29 William Cole to Horace Walpole, 14 May 1780, in *The Yale Edition of Horace Walpole's Correspondence*, ed. W. S. Lewis, Oxford and New Haven, 1937–83, vol. 2, pp. 214–15. The 'Westminster Method' is a term used by the contemporaries at Westminster, Richard Cumberland (*Memoirs of Richard Cumberland*, 2 vols. London, 1807, vol. 1, pp. 22–3, referring to the 'system of Westminster' in employ at his first school at Bury St Edmunds) and William Cowper, who wanted in 1776 to provide private tuition on 'the Westminster Method of instruction' (James King and Charles Ryskamp, eds, *The Letters and Prose Writings of William Cowper*, Oxford, 1979–86, vol. 1, pp. 262–3). On classical learning and gender norms see Penelope Wilson, 'Classical Poetry and the Eighteenth-Century Reader', in *Books and their Readers in Eighteenth-Century England*, ed. Isabel Rivers, Leicester, 1982, pp. 69–96; Carolyn D. Williams, *Pope, Homer and Manliness: Some Aspects of Eighteenth-Century Learning*, London and New York, 1993; Dror Wahrman, 'Gender in Translation: How the English Wrote their Juvenal, 1644–1815', *Representations* 65 (1999), pp. 1–41. Also relevant are: Shearer West, 'Libertinism and Male Friendship in the Portraits of the Society of Dilettanti', *Eighteenth-Century Life* 16 (1992), pp. 76–104; Ann Bermingham, 'The Aesthetics of Ignorance: The Accomplished Woman in the Culture of Connoisseurship', *Oxford Art Journal* 16:2 (1993), pp. 3–20; Viccy Coltman, 'Classicism in the English Library: Reading Classical Culture in the Late Eighteenth and Early Nineteenth Centuries', *Journal of the History of Collections* 11 (1999), pp. 35–50.

30 See David Hancock, *Citizens of the World: London Merchants and the Integration of the British Atlantic Community, 1735–1785*, Cambridge, 1995, pp. 437–43. Further patrons of Hamilton's subject paintings included James

Boswell (1740–95), who came from a gentrified background and was educated at the universities of Edinburgh and Glasgow, and Charles, Lord Hope (1740–66) and John, Lord Spencer (1734–83), who appear to have been privately educated.

31 This may be contrary to the claims made by, for instance, Redford, *Venice & the Grand Tour*, p. 15; Arnold, 'The Illusion of Grandeur?', p. 103, and Turner, *British Travel Writers in Europe*, pp. 58–9, who each argue that the Grand Tour functioned as a kind of substitute for university education.

32 [Thomas Maurice], *The Schoolboy: A Poem, in Imitation of Mr Phillip's Splendid Shilling*, Oxford, 1775, pp. 10–11. See also [Thomas Maurice], *Memoirs of the Author of Indian Antiquities*, London, 1819, part 2, pp. 3–5 and passim.

33 'Tiroconium' (1785), ll.222–31, in *The Poems of William Cowper*, ed. John D. Baird and Charles Ryskamp, Oxford, 1980–95, vol. 2, pp. 276–7. See Charles Ryskamp, *William Cowper of the Inner Temple, Esq.: A Study of his Life and Works to the Year 1768*, Cambridge, 1959, pp. 14–35, for an account of Cowper's time at Westminster, which concludes, however, that it was generally positive.

34 On the reappraisal of Homer, see John L. Myres, *Homer and His Critics*, ed. Dorothy Gray, London, 1958; Margaret Mary Rubel, *Savage and Barbarian: Historical Attitudes in the Criticism of Homer and Ossian in Britain, 1760–1800*, Amsterdam, Oxford and New York, 1978; Kirsti Simonsuuri, *Homer's Original Genius: Eighteenth-Century Notions of the Early Greek Epic (1688–1798)*, Cambridge, 1979; Howard D. Weinbrot, *Britannia's Issue: The Rise of British Literature From Dryden to Ossian*, Cambridge, 1993, pp. 193–236. On Blackwell, see Duane Coltharp, 'History and the Primitive: Homer, Blackwell, and the Scottish Enlightenment', in *Eighteenth-Century Life* 19 (1995), pp. 57–69.

35 Coltharp, 'History and the Primitive', p. 62.

36 See Peter McKay, 'A Patron of Promise: Charles, 7th Earl of Northampton', in *Northamptonshire Past and Present* 8 (1992–93), pp. 263–73. On the commission, see also Gert-Rudolf Flick, 'Missing Masterpieces: *Hector's Farewell to Andromache* by Batoni and *Andromache Bewailing the Death of Hector* by Hamilton', *The British Art Journal* 4 (2003), pp. 83–7.

37 Johann Joachim Winckelmann to Wilhelm Musel-Stosch, 3 January 1761, translated in Flick, 'Missing Masterpieces', p. 83.

38 The painting had been despatched by February 1761. See Abbé Peter Grant to Sir James Grant, 7 February 1761, in William Fraser, *The Chiefs of Grant*, Edinburgh, 1883, vol. 2, p. 534.

39 See Flick, 'Missing Masterpieces'.

40 For Hamilton as a painter of sentiment, see Lindsay Errington, 'Gavin Hamilton's Sentimental Iliad', *Burlington Magazine* 120 (1978), pp. 11–13; Duncan Macmillan, 'Woman as Hero: Gavin Hamilton's Radical Alternative', in *Femininity and Masculinity in Eighteenth-Century Art and Culture*, ed. Gill Perry and Michael Rossington, Manchester and New York, 1994, pp. 78–98; Duncan Macmillan, 'The Iconography of Moral Sense: Gavin

Hamilton's Sentimental Heroines', *The British Art Journal* 1 (2000), pp. 46–55.

41 Gavin Hamilton to Sir James Grant, 9 January 1765, National Archives of Scotland, GD 248/178/2/51. The progress of the work had been traced in letters from the Abbé Peter Grant in Rome to Sir James Grant of Grant, printed in Fraser, *The Chiefs of Grant*, vol. 2, p. 534 (7 February 1761: 'He is now at work makeing studys for your Patroclus'); p. 536 (6 February 1762: 'Hamilton will have your picture finish'd by the end of May'); and 12 September 1763: 'Mr Hamilton has at last finish'd the great work he undertook for you'. Within a few months the picture was being puffed in the London press (*Public Advertiser*, 4 May 1764).

42 See the letter from London of James, sixth earl of Findlater and third earl of Seafield, to Sir James Grant, 18 March 1765, requesting that the recipient instruct Sir Alexander Grant and persuade him to allow its display (in Fraser, *Chiefs of Grant*, vol. 2, pp. 444–5).

43 Alexander Cozens to James Grant, 15 April 1765, National Archives of Scotland, GD 248/49/3.

44 James Inglis Hamilton to Andrew Stuart, 27 January 1768, National Library of Scotland MS.5391, 'Andrew Stuart Correspondence', f.25.

45 For an interpretation of the public reception of Hamilton's paintings see Solkin, *Painting for Money: The Visual Arts and the Public Sphere in Eighteenth-Century England*, New Haven and London, 1993, pp. 255–7.

46 See Richard Kedington, *Critical Dissertations on the Iliad of Homer*, London, 1759, pp. 174–5n; Robert Wood, *Essay on the Original Genius of Homer*, London, 1769, p. xvii.

47 'Cursory Thoughts on Various Subjects by a Society of Gentlemen', *Town and Country Magazine* 8 (1776), p. 519; Alexander Pope, trans. *The Iliad of Homer*, ed. Maynard Mack, New Haven, 1967, vol. 2, pp. 476–7n.

48 Letter from D. Crespin to James Grant at his house in Leicestershire, 11 March 1763, National Archives of Scotland, GD 248/49/2/38–39.

49 The body of Hector drew attention for its classical qualities; see Seymour Howard, 'A Model of Early Romantic Necrophilia', in *Stil und Überlieferung in der Kunst des Abendlandes: Akten des 21. Internationalen Kongresses für Kunstgeschichte in Bonn 1964*, Berlin, 1967, vol. 1, pp. 217–25, p. 218, citing the opinions of Charles-Joseph Natoire, Giovanni Gaetano Bottari and James Boswell.

50 A letter from Hamilton to John Fitzpatrick second earl of Ossory, ca.1767 (National Library of Ireland MS 8012 (iii) Fitzpatrick MSS) conveys the painter's thanks for the latter's purchase of the picture after the death of Tavistock:

> I am more than ever under obligations to your Lordship for the honour you have done me, in purchasing my picture of Achilles & Hector wh. on account of the subject I am told was become disagreable to Lady Tavistock, the reasons I am affraid were too good, the loss of my best friend & patron is so affecting to me that I can say no more on that melancholy incident, the continuance of your Lordships countenance & protection will in a great measure make up for this loss.

As Ossory and Tavistock were cousins, and as the Irish peer was a patron of the artist of several years standing, this is perhaps a matter of Hamilton's account being cleared rather than the painting changing possession. The biography of Hamilton in John Anderson, *The Bee*, 10 July 1793, pp. 1–8, suggests that the painting was commissioned by Tavistock's father, the fourth duke of Bedford, who sold it 'at a very moderate price' to a 'Mr Scot', whose widow now had the painting on display at her house near Edinburgh. The original painting is untraced: small painted versions in the National Gallery in Warsaw and on the Italian art market in 1973 may be either working *modelli* by the painter, transcriptions for reproduction from his studio or copies after the engraving.

51 Gavin Hamilton to Lord Palmerston, 2 August 1765, Hartley Library, University of Southampton, BR Box 1/2.

52 Gavin Hamilton to Lord Palmerston, 2 August 1765, Hartley Library, University of Southampton, BR Box 1/2; Gavin Hamilton to Sir James Grant of Grant, 9 January 1765, National Archives of Scotland, GD 248/178/2/51.

53 An advertisement dated 1765 for the *Andromache Bewailing the Death of Hector* states that it was available with 'J. Boydell, in Cheapside; Ryland and Bryer in Cornhill; W. Austin in Bond-street; and the Print-warehouse, in Pall-mall; and D. Wilson, bookseller in the Strand'. The print was puffed as the first in a series: 'A companion to the above out of Homer will be published same time next year.' A later, widely issued advertisement of 1769 is worth quoting in full, since it gives an indication of the extensive distribution of Hamilton's prints in the metropolis:

> *This Day is Published*
> Three prints, finely engraved by Cunego, from the Paintings of Mr Hamilton at Rome. viz. Brutus, or, The Death of Lucretia, Price 6s. L'Allegro, Il Penseroso, from Milton, Price 5s each.
>
> Sold by Boydell, in Cheapside; Ryland and Bryer in Cornhill; Jeffreys in St Martin's Lane; Webley, in Holborn; Wilson and Nicol, in the Strand; and J. Murray, Number 32, Fleet-street.
>
> Where may be had, Andromache bewailing the Death of Hector, Price 10s 6d. Achilles venting his Rage on Hector, Price 10s 6d. Achilles lamenting the death of Patrocule, Price 10s 6d. Innocence, Price 5s. Juno, Price 5s. Hebe, Price 5s. All engraved by Cunego, from the Paintings of Mr Hamilton

54 On the purchase of a set of Hamilton's prints see John Thorpe to the eighth earl of Arundell, 2 February 1771 and March 1771, Wiltshire County record Office, Trowbridge, 2667/20, Box 3. Only partial sets came onto the market from individuals' collections. See the sales of prints at Christie & Ansell's, 4–7 April 1781, second day's sale, lot 94 ('4, the death of Hector, &c by G. Hamilton'), and Christie's, 20 January 1795 (published with the date given as 19 January, a corrected copy at the Christie's Archive), lot 2 ('Three, the anger of Achilles for the loss of Briseis, Achilles vents his rage in Helen and Priam redeems the dead body of Hector'). William Cowper for instance had a single print from the *Iliad* series, which he hung isolated above his fireplace. See William Cowper to Lady Hesketh,

23 June 1788, in King and Ryskamp, *The Letters and Prose Writings of William Cowper*, vol. 3, pp. 183–5. James Byres had a full set of prints, but only two of them seem to have been hung in the hallway of his house in Rome (see the inventory in National Library of Scotland, DEP.184/1).

55 Henry Temple, Lord Palmerston, 'Extract of a letter from Venice', 22 June 1764, Hartley Library, University of Southampton, BR 11/3.

56 On Hamilton's account of the history of art, see Quatrèmere de Quincy, *Canova et ses Ouvrages*, Paris, 1834, pp. 25–6.

57 Robert Foulis to Mr Yorke, January 1763, quoted in *Notices and Documents illustrative of the Literary History of Glasgow during the Greater Part of the Last Century*, Glasgow, 1886, p. 86.

58 See Basil Skinner, *The Indefatigable Mr Allan*, exhibition catalogue, Scottish Arts Council, 1973.

59 See David Goodreau, *Nathaniel Dance 1735–1811*, exhibition catalogue, Iveagh Bequest, Kenwood, London, 1977; David Goodreau, 'Nathaniel Dance, RA (1735–1811)' (Ph.D. diss., University of California, Los Angeles, 1977).

60 References to George Dance sen.'s financial contributions are scattered throughout the correspondence of the Dance family, in the British Architectural Library, RIBA, London, DA Fam/1/1. At the end of 1762, Dance was reporting that he had spent £200 a year in Rome, far in excess of the £50 a year generally reckoned sufficient to support a student in the city. See Nathaniel Dance to George Dance sen., 4 December 1762, in DA. Fam/1/1, xvi *verso*.

61 Recorded in the description and drawing contained in Nathaniel Dance to George Dance sen., 28 July 1759, in David Goodreau, 'Nathaniel Dance: An Unpublished Letter', *Burlington Magazine* 114 (1972), p. 712; see also Goodreau, *Nathaniel Dance, RA*, pp. 24–55.

62 See Roettgen, *Anton Raphael Mengs (1728–1779)*, no. Z121; also, Steffi Roettgen, ed., *Mengs: La Scoperta del Neoclassico*, exhibition catalogue, Palazzo Zabaralla, Padua, 2001, no. 46.

63 The quote is taken from the full title of the picture as given in the Society of Artists' exhibition catalogue, 1761, no. 25. The source of the narrative was René Aubert de Vertot D'Aubeuf, *The History of the Revolutions that Happened in the Government of the Roman Republic*, trans. John Ozell, 2nd ed., London, 1750, vol. 2, p. 295.

64 David Hume, 'Letter to the Authors of the Critical Review Concerning the Epigoniad of Wilkie', in *Essays Moral, Political, and Literary*, ed. T. H. Green and T. H. Grose, London, 1875, vol. 1, p. 434. Aeneas' status as a model of moderated masculinity fitting for the post-Stuart state was set by John Dryden's translation of the *Aeneid*; see Steven N. Zwicker, *Lines of Authority: Politics and English Literary Culture, 1649–1689*, Ithaca and London, 1993, pp. 197–9; Richard Morton, *John Dryden's Aeneas: A Hero in Enlightenment Mode*, Victoria, BC, 2000.

65 Richard Steele, *Spectator* 279 (12 January 1712) in *The Spectator*, ed, Donald F. Bond, Oxford, 1965, vol. 1, p. 587.

66 Morton, *John Dryden's Aeneas*, pp. 83–4, referring to

Dryden's translation which, Morton argues, puts the scene into domestic and psychological terms, playing down the role of the gods. Dance's presentation of the scene conforms to this domestication by focusing on the exchange of glances between Dido and Aeneas.

67 'An Impartial Hand', in *The Exhibition, or a Candid Display of the Genius and Merits of the Several Masters whose Works are now Offered to the Public at Spring Gardens*, London, 1766, p. 5

68 See *Public Advertiser*, 13 July 1767; Dorothy Stroud, *George Dance: Architect 1741–1825*, London, 1971, pp. 74–77; Goodreau, 'Nathaniel Dance, RA', p. 12.

69 Roger de Piles, *The Art of Painting with the Lives and Characters of Above 300 of the Most Eminent Painters*, 3rd ed., London, 1706, pp. 155–6.

70 Matthew Pilkington, *The Gentleman's and Connoisseur's Dictionary of Painters*, London, 1770, s.v. 'Pietro Berretini da Cortona'.

71 Thomas Robinson to Thomas Robinson first baron Grantham, 24 January 1760, West Yorkshire Archive Service, Leeds, WYL 150/6032 (12314).

72 On West see Ann Uhry Abrams, *The Valiant Hero: Benjamin West and Grand-Style History Painting*, Washington, 1985; Helmut von Erffa and Allen Staley, *The Paintings of Benjamin West*, New Haven and London, 1986. West's Italian experience is further documented in E. P. Richardson 'West's Voyage to Italy, 1760, and William Allen', *The Pennsylvania Magazine of History and Biography* 102 (1978), pp. 3–26.

73 William Allen to Barclay & Son, 10 October 1762, in Richardson 'West's Voyage to Italy', p. 20.

74 William Allen to Benjamin Chew, 7 October 1763, in David A. Kimball and Miriam Quinn, 'William Allen–Benjamin Chew Correspondence, 1763–1764', *The Pennsylvania Magazine of History and Biography* 90 (1966), pp. 202–26 (p. 221).

75 The degraded dignity of the art in France was more deplorable than in Italy, for there it was humiliated to luscious passions and the gayeties of frivolity and shew. That was the degraded state to which the professors of the art in general then reduced to with a few exception – in a Mengs and Hamilton at Rome – Verney and a few others at Paris, and the manly exertions of a Reynold and Wilson in London.

Benjamin West Autographed Mss. Autobiography, ca.1805, Charles Allen Munn Collection, Fordham University Library, n.p. (Archives of American Art, N68-20, fr.286).

76 See Solkin, *Painting for Money*, pp. 181–3. West's actual copies of old masters for William Allen are catalogued in von Erffa and Staley, *Paintings of Benjamin West*, nos 504 (thought to be by Annibale Carracci), 506 (Domenichino), 510–11 (both Mengs), 516 (Reni), 520 (Titian); also dating from these years are no. 505 (Correggio) and no. 507 (van Dyck).

77 Quoted are West's comments on the *Venus and Cupid* recorded in *The Diary of Joseph Farington*, ed. Kenneth Garlick et al., New Haven and London, 1978–98, vol. 9, pp. 3207–8 (26 January 1808).

78 Copley's experience of Italy is documented in Jules David Prown, *John Singleton Copley*, Harvard, 1966, vol. 1, pp. 49–51, vol. 2, pp. 249–57. For a later body of advice from West, see Fransisca Forster-Hahn, 'The Sources of True Taste: Benjamin West's Instructions to a Young Painter for his Studies in Italy', *Journal of the Warburg and Courtauld Institutes* 30 (1967), pp. 367–82.

79 Benjamin West to John Singleton Copley, 6 January 1773, in *Letters and Papers of John Singleton Copley and Henry Pelham, Massachusetts Historical Society Collections* 71 (1914), pp. 194–5.

80 Copley's attempts to redefine himself as an artist of gentility are discussed in compelling detail by Susan Rather, 'Carpenter, Tailor, Shoemaker, Artist: Copley and Portrait Painting around 1770', *Art Bulletin* 79 (1997), pp. 269–90; also Emily Ballew Neff, 'John Singleton Copley: The Artist as 'Realist' and London Impresario' (Ph.D. diss., University of Texas at Austin, 1998), esp. pp. 1–63.

81 'Lines to an English Painter', quoted in William T. Whitley, *Artists and Their Friends in England 1700–1799*, London and Boston, 1928, vol. 1, p. 199.

3 JAMES BARRY IN THE FRANCE AND ITALY

1 Samuel Sharp, *Letters from Italy*, London, 1767, pp. 216–17. See also Pierre-Jean Grosley, *New Observations on Italy and Its Inhabitants*, trans. Thomas Nugent, London, 1769, vol. 1, pp. 144–60, esp. p. 158; Lady Ann Miller, *Letters from Italy*, London, 1776, vol. 3, pp. 167–8; Francis Haskell and Nicholas Penny, *Taste and the Antique: The Lure of Classical Sculpture 1500–1900*, New Haven and London, 1981, esp. pp. 79–91; Seymour Howard, *Antiquity Restored: Essays on the Afterlife of the Antique*, Vienna, 1990.

2 For Barry see Edward Fryer, *The Works of James Barry*, 2 vols, London, 1809; William L. Pressly, *The Life and Art of James Barry*, New Haven and London, 1981; *James Barry: The Artist as Hero*, exhibition catalogue, Tate Gallery, London, 1983.

3 Though Fryer himself doubted that the Barry family could be linked by documentary proof to the earls of Barrymore, there is no reason to prefer the account of Antony Pasquin that 'his father was a bricklayer in Cork; and the professor of painting was wont to carry the hod' (*An Authentic History of the Professors of Painting, Sculpture, & Architecture, who have Practised in Ireland*, London, 1795, p. 48; see Pressly, *Life and Art of James Barry*, p. 205, n.3). The decline of the Catholic gentry under the penal laws is a fact of eighteenth-century Irish history generally accepted, and the respectful terms on which friends of Barry such as Edmund Burke and Dr Joseph Fenn Sleigh made mention of Barry's father in their correspondence (and the fact that the former received a letter from the man he called 'the old Gentleman' and the latter was early acquainted with him) would hardly suggest a completely debased social character.

4 See David Dickson, 'Catholics and Trade in Eighteenth-Century Ireland: An Old Debate Revisited', in *Endurance and Emergence: Catholics in Ireland in the Eighteenth Century*, ed. T. P. Power and Kevin Wheelon, Dublin, 1990, pp. 85–100; and, more generally, Thomas Bartlett, *The Fall and Rise of the Irish Nation: The Catholic Question 1690–1830*, Dublin, 1992.

5 Fryer, *Works of James Barry*, vol. 1, pp. 5–6.

6 See John Turpin, *A School of Art in Dublin Since the Eighteenth Century: A History of the National College of Art and Design*, Dublin, 1995, pp. 19, 24–6.

7 See Luke Gibbons, ' "A Shadowy Narrator": History, Art and Romantic Nationalism in Ireland 1750–1850', in *Ideology and the Historians (Historical Studies XVII: Papers Read Before the Irish Conference of Historians Held at Trinity College, Dublin 8–10 June 1989)*, ed. Ciarin Brady, Dublin, 1991, pp. 99–127. The cultural representation of the relationship between Catholic insurgents and the Hanoverian state in the 1760s is a fraught and incomplete area of enquiry: see Vincent Morley, 'George III, Queen Sadhbh and the Historians', *Eighteenth-Century Ireland – Iris an dá chultúr* 17 (2002), pp. 112–20.

8 See Conor Cruise O'Brien, *The Great Melody: A Thematic Biography and Commented Anthology of Edmund Burke*, London, 1992, pp. 3–71; Eamonn O'Flaherty, 'Burke and the Catholic Question', *Eighteenth-Century Ireland – Iris an dá chultúr* 12 (1997), pp. 7–27; Katherine O'Donnell, 'The Image of a Relationship in Blood: Párliament ma mBan and Burke's Jacobite Politics', *Eighteenth-Century Ireland – Iris an dá chultúr* 15 (2000), pp. 98–119. Barry was himself very conscious of the distinction between Cork (with its Catholic and rural associations) and Dublin (Protestant and urbane), as is evident in his comments on his former tutor, the landscape painter John Butts, in a letter to Joseph Fenn Sleigh around 1763: 'His being bred in Cork excluded him from many advantages; this he made evident by the surprising change of his manner on his going to Dublin'; Fryer, *Works of James Barry*, vol. 1, pp. 21–22. His further comment prophesies his own fate: 'A great many of those unmanly disingenuous actions, which his friends had but too much reason to accuse him, arose more, I am persuaded, from his perplexed situation, than from his dispositions, which upon the least emancipation were of quite another tendency.'

9 See O'Brien, *Great Melody*, p. 55–7.

10 Fryer, *Works of James Barry*, vol. 1, pp. 332–3.

11 On polarities in Burke's thought see Tom Furniss, *Edmund Burke's Aesthetic Ideology: Language, Gender and Political Economy in Revolution*, Cambridge, 1993; Margot Gayle Backus, *The Gothic Family Romance: Heterosexuality, Child Sacrifice, and the Anglo-Irish Colonial Order*, Durham and London, 1999, pp. 89–96.

12 See Fintan Cullen, *Visual Politics: The Representation of Ireland 1750–1830*, Cork, 1997, pp. 26–41. Pertinent here are Michel Fuchs' comments about Burke's contemporaneous, self-dramatizing account of education as a means to his self-realization in *Edmund Burke, Ireland, and the Fashioning of Self*, Oxford, 1996, p. 13. Fuchs rejects claims such as O'Brien's that Burke needs to be considered as personally tending to Catholicism.

13 Fryer, *Works of James Barry*, vol. 1, p. 14.

14 James Barry to Dr Joseph Fenn Sleigh, early 1765, in Fryer, *Works of James Barry*, vol. 1, pp. 15–16.

15 James Barry to Dr Joseph Fenn Sleigh, *c.*May 1765, in Fryer, *Works of James Barry*, vol. 1, p. 22.

16 See Thomas Crow, *Painters and Public Life in Eighteenth-Century Paris*, New Haven and London, 1985, pp. 153–63; John Goodman, trans. and ed., with an introduction by Thomas Crow, *Diderot on Art*, 2 vols, New Haven and London, 1995.

17 James Barry to Dr Joseph Fenn Sleigh, undated (Paris, 1766), in Fryer, *Works of James Barry*, vol. 1, pp. 39–40. See also Barry's *Inquiry*, in Fryer, *Works of James Barry*, vol. 2, p. 229, where he remarks that an 'unaffected manly plainess' is finally finding its way into French manners. Diderot's views were given written form only in the ultra-exclusive manuscript *Correspondence littéraire*, and his essay on the 1765 Salon was not even begun until October, outside Paris. But he had discussed the exhibition with a number of artists and, as an habitué of the capital's art collections and a student at the Académie de san Luc and probably the Académie Royale, Barry would almost certainly have been exposed to such current debates. His arguments resemble West's recollections of his time in Paris and in Italy, immediately before that of Barry; Benjamin West, Autographed Mss. Autobiography, a.1805, Charles Allen Munn Collection, Fordham University Library, n.p., Archives of American Art, N68–20, fr.286.

18 Thomas Campbell, *An Essay on Perfecting the Fine Arts*, Dublin, 1767, quoted in Fintan Cullen, *Sources in Irish Art: A Reader*, Cork, 2000, p. 178.

19 Anthony Pasquin [John Williams], *An Authentic History of the Professors of Painting, Sculpture, & Architecture who have Practised in Ireland*, London, 1796, p. 17. See also Turpin, *A School of Art in Dublin*, pp. 70–1. Turpin also notes (p. 9) that the other drawing masters in Dublin were (or pretended to be) French. On the red chalk manner see James Henry Rubin and David Levine, *Eighteenth-Century French Life Drawing*, exhibition catalogue, Princeton University Art Museum, 1977, esp. pp. 32–5.

20 Diderot wrote: 'We have three painters who are skilful, prolific, and studious observers of nature, who begin nothing, finish nothing without having consulted the model several times, and they are Lagrenée, Greuze, and Vernet'; *Diderot on Art*, vol. 1, p. 97. The first-mentioned artist was the history painter Jean-Jacques Lagrenée (1739–1821).

21 James Barry to Edmund Burke, undated (Rome, 1767), in Fryer, *Works of James Barry*, vol. 1, pp. 70–1. The Barry–Burkes correspondence is reprinted in part, with annotations, in Thomas W. Copeland et al., eds, *The Correspondence of Edmund Burke*, 10 vols, Chicago 1958–78. A version of this letter, with some variations and dated 23 May 1767, appears in *Correspondence of the Right Honourable Edmund Burke*, ed. Charles William, Earl Fitzwilliam, and Sir Sidney Bourke, London, 1844, vol. 1, pp. 116–29. This is apparently a finished version as sent (for which possibility see ibid., p. 86n), and is quoted in part in Pressly, *Life and Art of James Barry*, p. 11. Among the variations, the forceful and absurdist 'gods and monsters . . . fairies and graces' is rendered as the more polished and logical 'fragments of gods and senators, are jumbled together into the same figure of furies and graces,

till out a monster, like that which rose from the hide the three deities pissed into'; pp. 122–3.

22 Giovanni Battista Piranesi, 'Thoughts on Architecture', trans. M. Norris and M. Epstein, in *Oppositions* 26 (spring 1984), pp. 21–2; Giovanni Battista Casanova, *Discorso sopra gl'antichi*, quoted and trans. in Adolf Michaelis, *Ancient Marbles in Great Britain*, Cambridge, 1882, pp. 83–4.

23 On the grotesque see Mikhail Bakhtin, *Rabelais and his World*, trans. Helene Iswolsky, Bloomington, 1984, pp. 317–18.

24 James Barry to Edmund Burke, undated (Rome, 1767), in Fryer, *Works of James Barry*, vol. 1, pp. 72–3.

25 William and Bourke, eds, *Correspondence of the Right Honourable Edmund Burke*, vol. 1, p. 125; see Pressly, *Life and Art of James Barry*, pp. 206–7, n. 46.

26 Fryer, *Works of James Barry*, vol. 2, pp. 43–4.

27 See Gibbons, ' "A Shadowy Narrator" '; Cullen, *Sources in Irish Art*, pp. 295–302.

28 James Barry to the Burkes, 13 February 1767, in Fryer, *Works of James Barry*, vol. 1, pp. 80–1.

29 Cf. Alexander Pope's comment on 'Poetical Fire' in Homer and in Virgil: 'This *Fire* is discern'd in *Virgil*, but discern'd as through a Glass, reflected from *Homer*, more shining than fierce, but every where equal and constant'; preface to Alexander Pope, trans., *The Iliad of Homer*, ed. Maynard Mack, London and New Haven, 1967, vol. 1, pp. 4–5.

30 A later inscription in pen states that the drawing was made in '1763' and anachronistically refers to Barry as 'Professor of Painting'. The accompanying lines, presumably also inscribed at a later date, attack him for hypocrisy:

On his coming to Rome Barry swore with a Frown
Every Man who oppos'd him he'd kick or knock down
Having found his mistake wth. the few that he try'd
Now rather than Quarrel he'll kiss your Backside.

These lines were also given with slight variations by Ozias Humphry to Joseph Farington, claiming that they 'were written on Barry while he was in Rome'; *The Diary of Joseph Farington*, ed. Kenneth Garlick et al., New Haven and London, 1978–98, vol. 4, p. 1172 (15 March 1799).

31 Edmund Burke to James Barry, 24 August 1767, in Fryer, *Works of James Barry*, vol. 1, pp. 94–5.

32 Nicola Figgis and Brendan Rooney, *Irish Paintings in the National Gallery of Ireland*, Dublin, 2001–, vol. 1, pp. 69–70.

33 Adam's physique recalls Herculean types, not least the celebrated *Belvedere Torso* in the Vatican, while his posture derives from the *Germanicus* (Louvre, Paris). The posture of Eve evokes various examples of the *Venus Pudica* type – although with the significant turning of her palm in a deliberately indiscreet fashion – and her torso the *Venus de Milo* (Louvre, Paris). Given the clear visual relationship between Barry's Eve and classical Venuses, the iconographic detail of the apple is given added significance; according to Bernard de Montfaucon, an apple was a usual attribute of the Venuses represented as victorious in the Judgement of Paris (Bernard de Montfaucon, *The Supplement to Antiquity Explained and Represented in Sculp-*

tures, trans. David Humphrey, London, 1725, vol. 1, p. 70). Adam's Eve is thus represented as a triumphantly beautiful woman, here enjoying a further triumph over Adam.

34 Barry could have known either the original, life-size canvas of Lemoyne's *Adorn and Eve*, the engraving (by Laurent Cars) reproducing that work, or the small version in a Paris private collection, which is illustrated by an engraving here (FIG. 38).

35 Johann Joachim Winckelmann, *Reflections on the Painting and Sculpture of the Greeks*, trans. Henry Fuseli, London, 1765, p. 22. For a highly nuanced account of Winckelmann, which draws out the contradictions apparent in this fantasy of wholeness, see Alex Potts, *Flesh and the Ideal: Winckelmann and the Origins of Art History*, New Haven and London, 1994, pp. 167–73.

36 See Robert Rosenblum, *Transformations in Late Eighteenth-Century Art*, Princeton, 1967; also, Seymour Howard, *Sacrifice of the Hero: A Classical Frieze by Jacques Louis David*, Sacramento, 1975, pp. 72–3; Dorothy Johnson, *Jacques-Louis David: Art in Metamorphosis*, Princeton, 1993, esp. pp. 36–7.

37 Notebook of Ozias Humphry, British Library, Add.MSS. 22,949.

38 James Barry to Edmund Burke, 8 April 1769, in Fryer, *Works of James Barry*, vol. 1, p. 160.

39 James Barry to the Burkes, undated, in Fryer, *Works of James Barry*, vol. 1, p. 190.

40 See Carlo Cesare Malvasia, *Felsina pittrice, Vite de'pittori bolognesi*, quoted and translated in Robert Enggass and Jonathan Brown, *Italy and Spain 1600–1750: Sources and Documents*, New Jersey, 1970, pp. 88–91. See also Giovanni Pietro Bellori, *The Lives of Annibale and Agostino Carracci*, trans. Catherine Enggass, Pennsylvania, 1968. On the increasing prevalence of the idea of the Bolognese reform of art in the eighteenth century, see Denis Mahon, *Studies in Seicento Art and Theory* London, 1947, pp. 212–17; on Reni's reputation see D. Stephen Pepper, *Guido Reni: A Complete Catalogue of his Works with an Introductory Text*, Oxford, 1984, pp. 45–9.

41 Although it is important that in his notes on Italian art Barry was to disavow the eclecticism of the Carracci. See James Barry to the Burkes, Bologna, ca. 1770, in Fryer, *Works of James Barry*, vol. 1, p. 198; also 'Observations on Different Works of art in France and Italy, By Mr Barry, During his Residence in those Countries', in Fryer, *Works of James Barry*, vol. 2, p. 30: 'The three Carraches are top men, and deserve the highest praise for what they have done; but they are not models for me.' On his favourable comments on Guido Reni see ibid., pp. 13–14. Here Barry praises Guido for exemplifying the way that great pictures 'have only great and essential particulars in view', that is, have each a single dominant character, in conformity with Barry's idea of the 'contracted' style. His further comments on the 'white, hard manner' of Guido in the distinction of masculine and feminine 'carnation' (treatment of flesh) are pertinent also to the painter's formulation of his own pictorial manner (ibid., p. 59).

42 See Charles Dempsey, 'The Greek Style and the Prehistory of Neoclassicism', in Elizabeth Cropper et al., *Pietro Testa*

1612–1650: Prints and Drawings, exhibition catalogue, Philadelphia Museum of Art, 1988, pp. xxxvii–lxv.

43 Charlotte Lennox trans., *The Greek Theatre of Father Brumoy*, London, 1759, vol. 1, pp. 199, 251, 254. Also, Thomas Warton, *An Essay on the Genius and Writings of Pope*, 2nd ed., London, 1762, p. 71n: 'The subject and scene of this tragedy, so romantic and uncommon, are highly pleasing to the imagination . . . One may observe by the way, that the ancients thought bodily pains, and wounds, &c proper subjects to be represented on the stage.'

44 'To Sir Richard Blackmore, on the Moral and Conclusion of an Epick Poem', in *The Critical Works of John Dennis*, ed. Edward Niles Hooker, Baltimore, 1943, vol. 2, pp. 113–14.

45 Adam Smith, *The Theory of Moral Sentiments*, ed. D. D. Raphael and A. L. Macfie, 1976; reprint, Indianapolis, 1984, p. 30.

46 Adam Smith, *Lectures on Rhetoric and Belles Lettres*, ed. J. C. Bryce, Oxford, 1983, pp. 126–7.

47 Samuel Johnson *Idler* 45 (24 February 1759), in *The Idler and the Adventurer*, ed. W. J. Bate, John M. Bullitt and L. F. Powell, New Haven and London, 1963, p. 141.

48 Henry Home, Lord Kames, *Elements of Criticism*, 2nd ed., Edinburgh, 1763, vol. 1, pp. 122–3.

49 Cf. John Barrell, 'The Dangerous Goddess' in *The Birth of Pandora and the Division of Knowledge*, Basingstoke 1992; Jeffrey A. Brown, 'The Tortures of Mel Gibson: Masochism and the Sexy Male Body', *Men and Masculinities* 5 (2002), pp. 123–43.

50 See Winckelmann, *Reflections* pp. 30–2; Johann Joachim Winchelmann, *Historie de l'art chez les Anciens*, Amsterdam, 1766, vol. 2, pp. 276–8. See the discussion in Potts, *Flesh and the Ideal*, pp. 136–44.

51 See Daniel Webb, *An Inquiry into the Beauties of Painting*, London 1760, pp. 161–2; Pressly, *Life and Art of James Barry*, p. 22; Philostratus the Younger, *Imagines*, 17, in *Philostratus the Elder: Imagines, Philostratus the Younger: Imagines, Callistratus: Descriptions*, trans. A Fairbanhs, London and New York, 1931, p. 365. Barry referred only to the epigram recording Parrhasius' painting as a source for his work (undated letter to the Burkes, ca.1770, in Fryer, *Works of James Barry*, vol. 1, pp. 189–90), although he could have known Philostratus' text, if only in its French translation (*Les Images ou Tableaux de Platte Peinture des Deux Philostrates Sophistes Grecs et les Statues de Callistrate*, trans. Blasse de Vigenere, Paris, 1637, pp. 747–8).

52 See Potts, *Flesh and the Ideal*, p. 143.

53 On Hussey see John Hutchins, *The History and Antiquities of the County of Dorset*, 3rd ed., London, 1861–70, vol. 4, pp. 307–11; John Britton, *The Beauties of Wiltshire*, London, 1801–25, vol. 1, pp. 286–303; Edward Edwards, *Anecdotes of Painters*, London 1808 pp. 150–7. See also J. J. Foster, 'Giles Hussey, a Dorset Artist', *Connoisseur* 65 (1923), pp. 134–9; John Shackleton, *Giles Hussey*, privately printed, 2000. His art theory is considered in Sheila O'Connell, 'An Explanation of Hogarth's "Analysis of Beauty", Pl. I, Fig. 66', *Burlington Magazine* 126 (1984), pp. 33–4.

54 *St James's Chronicle* (9–12 May 1761). See also Anon. ('T. B.', sometimes improbably identified as Barry, more likely Bonnell Thornton), *A Call to the Connoisseurs: Or, Decisions of Sense with Respect to the Present State of Painting And Sculpture*, London, 1761, p. 37.

55 In February 1773 Ozias Humphry noted in his 'Memorandum Book': 'I went wth. Romney & Paine &c to see Mr Duane's collection of Hussey's drawings', British Library Add.MSS. 22, 949, f.105v. The 'Paine' was presumably the architect James Paine who was in Italy 1766–69 and who was included in the 1767 self-portrait by Barry. On Duane see D. G. C. Allan, 'Matthew Duane FRS, FSA (1707–85): Gold Medallist and Active Member of the Society', *RSA Journal* 144 (1996), pp. 35–7.

56 James Barry, *Account of the Pictures in the Great Room of the Society of Arts*, in Fryer, *Works of James Barry*, vol. 2, p. 391.

57 James Barry to Edmund Burke, 8 July 1769, in Fryer, *Works of James Barry*, vol. 1, p. 171. When Barry wrote to the Burkes asking if Hussey was still alive, the reply must have been negative, as in a subsequent undated letter Barry wrote to Edmund Burke lamenting Hussey's death and stating that 'Hussey's fate is before me' (p. 178). Hussey had, in fact, simply retired into the country for his health: his genteel social status and material resources provided a cushion for the iniquities and hardships his vocational choice and profession of faith may otherwise have brought.

58 Pressly, *Life and Art of James Barry*, pp. 38–41; William T. Whitley, *Artists and Their Friends in England 1700–1799*, London and Boston, 1928, vol. 1, pp. 287–93.

59 Pressly, *James Barry: The Artist as Hero*, p. 33, points to the sole historical precedent of Christ in scenes of the Passion.

60 See F. P. Lock, *Edmund Burke*, Oxford, 1998–, vol. 1, pp. 364–8; cf. Pressly, *Life and Art of James Barry*, pp. 75–8.

PART TWO

'OVER-STOCKED WITH ARTISTS OF ALL SORTS': THE STATE OF THE ARTS 1765–75

1 Accounts of the king's librarian Richard Dalton handing out commissions at this early date to Nathaniel Dance and Benjamin West in Rome cannot be confirmed; see Oliver Millar, *The Later Georgian Pictures in the Collection of Her Majesty the Queen*, London, 1969, vol. 1, pp. 23–4; David Goodreau, 'Nathaniel Dance, RA (1735–1811)' (Ph. D. diss., University of California, Los Angeles, 1973), pp. 106–7; Helmut von Erffa and Allen Staley, *The Paintings of Benjamin West*, New Haven and London, 1986, no. 195.

2 The 1767 Society of Artists catalogue lists the picture as 'Timon of Athens, from Shakespear, Act iv. scene iv.'. The play is referred to as a 'domestick tragedy' in Samuel Johnson, *The Plays of William Shakespeare*, in *Johnson on Shakespeare*, ed. Arthur Sherbo, New Haven and London, 1968, vol. 2, p. 745. See also Goodreau, 'Nathaniel Dance, RA', pp. 142–5.

3 Quoted in anon., *Le Pour et le Contre*, London, 1767 p. 8.

4 There is the option of interpreting the picture's subject as more closely aligned to George III's image as a patron of the arts. The story of Timon had been referred to as an allegory of a wise patron who refuses to distribute mere material bounty and seeks to encourage the pursuit of virtue. See Aaron Hill, 'A Dialogue, between Damon and Philomen, concerning the Preference of Riches to Poverty', in *The Works of the Late Aaron Hill, Esq.*, 2nd ed., London, 1754, vol. 3, p. 289. Hill was associated with the patriot circles around Prince Frederick, whose ideals were revived and revised in relation to George III. See Christine Gerrard, *The Patriot Opposition to Walpole: Politics, Poetry, and National Myth 1725–1742*, Oxford, 1994, pp. 51–4 for comments on the politics of Hill's poetry.

5 *Timon of Athens, as it is Acted at the Theatre-Royal on Richmond-Green, Altered from Shakespear and Shadwell*, London, 1768, p. 68.

6 Benjamin West, Autographed Mss. Autobiography, ca. 1805, Charles Allen Munn Collection, Fordham University Library, pp. 7–9, Archives of American Art, N68–20, fr. 279–80.

7 Von Erffa and Staley, *Paintings of Benjamin West*, no. 33.

8 Von Erffa and Staley, *Paintings of Benjamin West*, no. 10. The 'Wolfe' is the *Death of General Wolfe*, painted for Lord Grosvenor and then for George III, as discussed below, Chapter 4; the 'Hanibal' is *The Oath of Hannibal* painted for the king around 1769–70; (Royal Collection) and the 'Penn' is *William Penn's Treatment with the Indians*, for Thomas Penn of 1771–72; (Pennsylvania Academy of the Fine Arts, Philadelphia). See Von Erffa and Staley, *Paintings of Benjamin West*, no. 17 and no. 85.

9 *Whitehall Evening Post* (4–6 May 1769). In fact, documentation points to the king paying only £420 (Von Erffa and Staley, *Paintings of Benjamin West*, cat. no. 10). For the rumour of knighthood see *Whitehall Evening Post* (25–27 May 1769) and *Public Advertiser* (28 May 1769).

10 See Sidney C. Hutchison, *The History of the Royal Academy of Arts 1768–1986*, 2nd ed., London, 1986. Much useful information is still to be found in John Pye, *Patronage of British Art: An Historical Sketch*, London, 1845; William Sandby, *History of the Royal Academy of Arts*, 2 vols, London, 1862; J. E. Hodgson and Frederick A. Eaton, *The Royal Academy and Its Members 1768–1830*, London, 1905. These earlier studies are now complemented by Holger Hoock, *The King's Artists: The Royal Academy of Arts and the Politics of British Culture, 1760–1840*, Oxford, 2003.

11 Joshua Reynolds, *Discourses on Art*, ed. Robert R. Wark, New Haven and London, 1975, p. 21.

12 Thomas Francklin, 'THE PATRONS a Song', National Library of Ireland MS 5672/9.

13 Thus, similarly, the *Public Advertiser* (3 July 1769) explained: 'Now, as Travellers promote the circulation of Money, in the Places frequented by them, I imagine it is to be a good Policy, in us, to prepare as many Magnets (if I may so speak) as possible.' The writer identified the academy as such a 'Magnet', declaring that now: 'We . . . shall probably export our own Works, if not to that

Country [Italy], at least to Others, which would be a considerable Saving to this Nation.'

14 The best account of this remains George Rudé, *Wilkes & Liberty: A Social Study of 1763 to 1774*, Oxford, 1962. See also John Sainsbury, *Disaffected Patriots: London Supporters of Revolutionary America 1769–1782*, Kingston, 1987, pp. 31–54.

15 Benjamin West to John Green, 10 September 1771, Archives of American Art, Misc. MSS, reel 3480, fr. 1279–91. William Hoare, another founder member of the academy, could write similarly: 'there is now so much encouragement, and the King himself patronises the Art with so much affection and attention, I make no doubt but there will be young men who will exert themselves, and do honour to this Country. I think his Majesty's turn to the Arts must spread a general regard and esteem for them'; William Hoare to William Chambers, 29 May 1770, British Architectural Library, RIBA, CHA/2/36.

16 Reynolds, *Discourses*, pp. 43–4.

17 Reynolds, *Discourses*, p. 17.

18 Reynolds, *Discourses*, p. 19.

19 Reynolds, *Discourses*, pp. 17–18.

20 Reynolds, *Discourses*, p. 20.

21 Reynolds, *Discourses*, p. 37.

22 Reynolds, *Discourses*, p. 52.

23 [Robert Baker], *Reflections on the English Language*, London, 1770, pp. xxiii–xxiv.

24 *Letters Concerning the Present State of England*, London, 1772, pp. 68–71.

25 See David Solkin, *Painting for Money: The Visual Arts and the Public Sphere Eighteenth Century England*, New Haven and London, 1993, pp. 259–76.

26 Pierre-Jean Grosley, *A Tour to London; Or, New Observations on England and its Inhabitants*, trans. Thomas Nugent, London, 1772, vol. 2, p. 60. See also John Gwynn, *London and Westminster Improved*, London, 1766, pp. 26–7.

27 Joshua Reynolds to Thomas Robinson, second Baron Grantham, 20 July 1773, in *The Letters of Sir Joshua Reynolds*, ed. John Ingamells and John Edgcumbe, Guildford and King's Lynn, 2000, p. 45.

28 See Ozias Humphry to Charles Rainsford, ca. 1773, Library of the Royal Academy of Arts, London, HU/1/137.

29 William Chambers to Thomas Robinson, second Boron Granthan, April 1774, British Library, Add. MSS 41,135, f. 22v.

30 See William L. Pressly, *The Life and Art of James Barry*, New Haven and London, 1981, p. 86.

31 *Public Advertiser* (4 May 1764).

32 *Middlesex Journal* (19–21 May 1772).

33 *London Chronicle* (13–15 May 1773)

34 The reviewer in The *Middlesex Journal* of 6–8 May 1773 also noted that Nevay had treated a 'subject much hacknied by the painters of late'. Besides West's *Agrippina Landing at Brundisium with the Ashes of Germanicus*, shown twice in 1768, Gavin Hamilton had shown an *Agrippina Weeping* at the academy in 1770 and *Agrippina Landing at Brundisium* in 1772, James Paine showed a sketch of a bas-relief of *Agrippina Mourning* with the Society of Artists in 1770, and James Durno an *Agrippina*

and her two Children Mourning with the same group in 1772.

35 *St James's Chronicle* (11–14 May 1765). The reviewer also attacked Andrea Casali on the same grounds. See also *Gazetteer* (23 May 1768); [Robert Baker], *Observations on the Pictures Now in the Exhibition at the Royal Academy, Spring Gardens, and Mr Christie's*, London, 1771, p. 15; Horace Walpole, annotation to 1771 Royal Academy catalogue, regarding West's 'very bricky colouring' (formerly collection of the Dowager Countess Rosebery; photographic record in the Witt Library, Courtauld Institute of Art); *Le Pour et le Contre*, p. 9, on 'A dusky grey' of Dance's *Timon of Athens*. These anticipate criticism of Jacques-Louis David's 'bricky' colouring that William Vaughan has read as reflecting politically motivated attacks on French artifice: ' "David's Brickdust" and the Rise of the British School' in *Reflections of Revolution: Images of Romanticism*, ed. Alison Yarrington and Kelvin Everest, London, 1993, pp. 134–58. In addition to the associations with dryness and artifice, these references to brickdust may evoke a sense of ceramic impermeableness: brickdust was traditionally used to scour ceramics.

4 GENERAL WOLFE AMONG THE MACARONIS

1 Westminster Abbey Muniments Room, chapter book (1768–77), 14 May 1771, recording the fine for the monument to Earl Ligonier, states that it will be positioned 'opposite to that which is now erecting for General Wolfe'. See also David Samwell to Matthew Gregson, 26 September 1772, Liverpool Record Office GRO 2/17: 'Wolfe's Moment is almost finished'; 'Crito' in *Gentleman's Magazine* 42 (1772), pp. 517–18. *Edinburgh Advertiser* (2 April 1773) describes the whole design in some detail; *London Magazine* 42 (1773), p. 514, records that, as of 4 October 1773, the inscription was visible. The monument was unveiled fully on 30 November; see *Gentleman's Magazine* 43 (1773) p. 616.

2 According to Joseph Farington, the long delay in opening Joseph Nollekens' later monument to the naval commanders Blair, Bayne and Manners was due to changes in the administration since the original commission, and there is no reason to doubt that through the turbulent 1760s, with the factional contests around William Pitt the Elder and his legacy, the momentum behind the project would be easily lost. See John Kenworthy-Browne, 'A Monument to Three Captains', *Country Life* 161 (1977), pp. 180–1; *The Diary of Joseph Farington*, ed. Kenneth Garlick et al., New Haven and London, 1978–98, vol. 1, pp. 4–5, 26 July 1793.

3 On the older Highland regiment as *banditti* see Harold William Thompson, ed., *The Anecdotes and Egotisms of Henry Mackenzie 1745–1831*, 1927; facsimile edition with an introduction by John Dwyer, Bristol, 1996, p. 130.

4 In May 1771, as work on the erection of the monument was advancing, 'A. C.' wrote to Edinburgh's *Weekly Magazine*: 'The news-papers lately abounded with accounts of the frequent migrations, from different parts of this country, particularly the Highlands of Scotland to

America'; *Weekly Magazine* (30 May 1771). See also, for example, 'Luxury the Cause of Emigration', *Weekly Magazine* (25 November 1773); [Edward Topham], *Letters from Edinburgh; Written in the Years 1774 and 1775*, London, 1776, pp. 163–71.

5 See Alan McNairn, *Behold the Hero: General Wolfe and the Arts in the Eighteenth Century*, Quebec, 1997, pp. 81–90.

6 David Samwell to Matthew Gregson, 25 March 1774, Liverpool Record Office, 920 GRE 2/17.

7 David Garrick to Peter Fountain, after 7 October 1772, in *The Letters of David Garrick*, ed. David M. Little and George M. Kahrl, London, 1963, vol. 2, p. 821. Parallels between theatrical and visual art in the era are explored fully in Shearer West *The Image of the Actor: Verbal and Visual Representation in the Age of Garrick and Kemble*, London, 1991.

8 Horst W. Janson, 'Observations on Nudity in Neoclassical Art', in *Stil und Überlieferung in der Kunst des Abendlandes* 3 vols, Berlin 1967, vol. 1, pp. 202–3.

9 Anon., *Constantia and her Daughter Julia, an Italian History, with a Discourse on Romances*, London, 1769, vol. 1, pp. xi–xii.

10 'To the Publick: The History of Gallantry', *London Magazine* 40 (1771), pp. 477–8.

11 See David Solkin, *Painting for Money: The Visual Arts and the Public Sphere in Eighteenth-Century England*, New Haven and London, 1993, pp. 207–13.

12 See McNairn, *Behold the Hero*, pp. 127–8.

13 See Emily Ballew Neff, 'The History Theater: Production and Spectatorship in Copley's *The Death of Major Peirson*', in *John Singleton Copley in England*, London, 1995, pp. 61–90, nos 18–32.

14 This was a departure from previous efforts to represent the scene by George Romney (as is evident from the surviving fragments of his painting) and from Edward Penny, who both represented Wolfe accompanied by only three or four other figures.

15 The following is derived from Helmut von Erffa and Allen Staley, *The Paintings of Benjamin West*, New Haven and London, 1986, no. 93.

16 Robert Bromley's comments on the American Indian are discussed in Solkin, *Painting for Money*, p. 212; see also Vivien Green Fryd, 'Reading the Indian in Benjamin West's *Death of General Wolfe*', *American Art* 9:1 (1995), pp. 73–85, who elaborates Bromley's comments into an anticipation of the image of the tragic American Indian of the nineteenth century. The position proposed here corresponds more closely with comments made by Matthew Craske, *Art in Europe 1700–1830: A History of the Visual Arts in an Era of Unprecedented Urban Economic Growth*, Oxford and New York, 1997, p. 265.

17 See William B. Hart, 'Black 'Go-Betweens' and the Mutability of 'Race,' Status, and Identity on New York's Pre-Revolutionary Frontier', in *Contact Points: American Frontiers from the Mohawk Valley to the Mississippi, 1750–1830*, ed. Andrew R. L. Cayton and Fredrika J. Teute, Chapel Hill and London, 1998, pp. 88–113.

18 George Cockings, *The Conquest of Canada; Or The Siege of Quebec. An Historical Tragedy*, London, 1766. See

McNairn, *Behold the Hero*, pp. 56–9.

19 See James T. Boulton, *The Language of Politics in the Age of Wilkes and Burke*, Westport, 1963, pp. 11–72.

20 See James Raven, *Judging New Wealth: Popular Publishing and Responses to Commerce in England, 1750–1800*, Oxford, 1992, pp. 157–82.

21 'To the Editor', *Oxford Magazine* 9 (1772), p. 125.

22 'Modern Manners', *London Magazine* 42 (1773), p. 30.

23 'Lively Portrait of the Fashion Luxuries', *London Magazine* 42 (1773), p. 70; 'Modern Manners: A Sketch', *London Magazine* 42 (1773), p. 331.

24 'Socrates', *Town and Country Magazine* 5 (July 1773), pp. 410–11. The history of the conquistadors was used contemporaneously by Jean-François Marmontel as a means of critiquing European imperialism. See T. M. Pratt, 'Of Exploration and Exploitation: The New World in Later Enlightenment Epic', *Studies in Voltaire and the Eighteenth Century* 267 (1989), pp. 291–319; John Renwick, 'Marmontel, *Les Incas* et L'Expansion de L'Europe', in *Jean-François Marmontel (1732–1799): Dix études*, Paris, 2001, pp. 245–63. Marmontel's *The Incas* was published in English translation immediately after its French edition in 1777. This year also saw William Robertson's *History of America*, which detailed the conquest of South America.

25 On the Macaroni phenomenon in London see Diana Donald, *The Age of Caricature: Satirical Prints in the Age of George III*, New Haven and London, 1996; Miles Ogborn, *Spaces of Modernity: London's Geographies, 1680–1780*, New York and London, 1998, pp. 133–42; Peter McNeil, ' "That Doubtful Gender": Macaroni Dress and Male Sexualities', *Fashion Theory: A Journal of Dress, Body & Culture* 3 (1999), pp. 411–47; Peter McNeil, 'Macaroni Masculinities', *Fashion Theory: A Journal of Dress, Body & Culture* 4 (2000), pp. 373–404.

26 'Character of a Macaroni', *Town and Country Magazine* 4 (1772), pp. 242–3. See also McNeil, ' "That Doubtful Gender" ', p. 432.

27 See McNeil, 'Macaroni Masculinities', pp. 381–2.

28 'An Account of the Reigning, Ridiculous Character in Genteel Life, called a Maccaroni', *London Magazine* 41 (1772), p. 193.

29 [Henry Home, Lord Kames], *Sketches of the History of Man*, Edinburgh, 1774, vol. 1, p. 435. Reviewing the crime statistics of the previous two decades, Stephen Jannsen concluded in his *Table of Death Sentences* (1772):

> When we turn adrift so many thousand Men, great Numbers fall heedlessly to thieving as soon as their Pockets are empty, and are at once brought to the Gallows; the Wiser ones survive a while by listing with experienced Associates, by which means in a few Years, those numerous and desperate Gangs of Murderers, House-breakers, and Highway-men have been formed, which have of late struck such a Terror within the Metropolis and 20 Miles around.

Quoted in J. M. Beattie, *Crime and the Courts in England 1660–1800*, Oxford, 1986, p. 227. See also Peter King, 'War as a Judicial Resource: Press Gangs and Prosecution Rates, 1740–1830', in *Law, Crime and English Society, 1660–1830*, ed. Norma Landau, Cambridge, 2002.

30 Samuel Johnson, quoted in Rudlof Freiburg, '*Cuncta Prius Tentanda*: The Treatment of War in Samuel Johnson's *Thoughts on the Late Transactions Respecting Falkland's Islands* (1771)', in *Guerres et Paix: la Grand-Bretagne au XVIIIe siècle*, ed. Paul-Gabriel Boucé, Paris, 1998, vol. 2, pp. 325–40; see also Jeremy Black, '*Thoughts on the Late Transactions respecting Falkland's Islands* and the Tory Tradition in Foreign Policy', in *Samuel Johnson in Historical Context* ed. Jonathan Clark and Howard Erskine-Hill Basingstoke, 2002, pp. 169–83.

31 See John Sainsbury, *Disaffected Patriots: London Supporters of Revolutionary America 1769–1782*, Gloucester, 1987, pp. 39–41.

32 Letter from Henry Bate to the *Morning Post*, 30 July 1773, in *The Vauxhall Affray; Or, The Macaronies Defeated: Being a Compilation of Letters, Squibs, &c. on Both Sides of that Dispute, With an Introductory Dedication to the Hon. Tho. Lyttelton, Esq*, London, 3rd ed., 1773, pp. 11, 13.

33 See: Kristina Straub, *Sexual Suspects: Eighteenth-Century Players and Sexual Ideology*, Princeton, 1992, pp. 16–23; Ogborn, *Spaces of Modernity*, pp. 116–57; Peter de Bolla, *Education of the Eye: Painting, Landscape and Architecture in Eighteenth-Century Britain*, Stanford, 2003, pp. 89–93.

34 David Erskine Baker, *Biographia Dramatica: Or, A Companion to the Playhouse*, London, 1782, vol. 1, p. 15. On Bate see John Fyvie, *Noble Dames and Notable Men of the Georgian Era*, London, 1910, pp. 79–104; William T. Whitley, 'An Eighteenth-Century Art Chronicler: Sir Henry Bate Dudley, Bart', *Walpole Society* 13 (1924–25), pp. 25–66.

35 See David Mannings with Martin Postle, *Sir Joshua Reynolds: A Complete Catalogue of his Paintings*, New Haven and London, 2000, no. 856.

36 For Colman's anti-Semitism see Lance Bertelsen, *The Nonsense Club: Literature and Popular Culture 1749–1764*, Oxford, 1986, pp. 48–9; for his stereoyping of the Irish, see G. C. Duggan, *The Stage Irishman: A History of the Irish Play and Stage Characters from the Earliest Times*, Dublin and Cork, 1937, pp. 274–6; also, Paul Goring, ' "John Bull, pit, box, and gallery, said No!": Charles Macklin and the Limits of Ethnic Resistance on the Eighteenth-Century London, Stage', *Representations* 79 (2002), pp. 61–81.

37 The letter from Dawes to the *Morning Post* that appears in the Appendix to *The Vauxhall Affray* is signed 'M. Dawes'; see *The Vauxhall Affray* London, 1773, p. 94.

38 Horace Walpole, *Memoirs of the Reign of King George the Third*, ed. G. F. Russell Barker London, 1894, vol. 3, p. 146.

39 See Henry Graham, *History of the Sixteenth, The Queen's, Light Dragoons (Lancers), 1759 to 1912*, Devizes, 1912–26, vol. 1, pp. 274–5. According to Reginald Blunt, *Lord Lyttelton: Portrait of a Rake*, London, 1936, p. 114, Crofts went to India, where he was killed in a duel.

40 *The Life and Times of George Robert Fitzgerald, Commonly Called Fighting Fitzgerald*, Dublin, 1852; Mary MacCarthy, *Fighting Fitzgerald and Other Papers*, London, 1930. The former source offers a correction to the more familiar image of Fitzgerald as only a reckless youth and roots his belligerent disposition precisely in the political and economic travails of the late eighteenth-century Irish gentry.

41 William H. Drummond, ed., *The Autobiography of Archibald Hamilton Rowan*, 1840; facsimile reprint with an introduction by R. B. McDowell, Shannon, 1972, pp. 51–2. O'Byrne is mentioned by name as a thug hired by Bate's enemies, along with an O'Fagan, in a letter by 'Amateur de Marionettes' published in the *Morning Post* and included in *The Vauxhall Affray*, p. 79, and as a companion of Rowan in H. Lavers Smith, ed., *The Reminiscences of Henry Angelo*, London, 1904, vol. 1, pp. 117–18.

42 Unable to hold commissions in the British Army, many Irish Catholics served in Continental armies. See John McGurk, 'Wild Geese: The Irish in European Armies (Sixteenth to Eighteenth Centuries)', in *Patterns of Migrations (The Irish World Wide: History, Heritage, Identity)*, ed. Patrick O'Sullivan, vol. 1, Leicester, 1992, pp. 36–62.

43 In Samuel Foote's *The Devil Upon Two Sticks* (1768) the contrast between 'native' Irish and Anglo-Irish is played out when the character of Dr Sligo says of the Anglo-Irish Dr Oasafaras 'he is not a Milesian, I am sure. The family, I suppose, came over t'other day with Strongbow, not above seven or eight hundred years ago'; quoted in J. O. Bartley, *Teague, Shenkin and Sawney: Being an Historical Study of the Earliest Irish, Welsh and Scottish Characters in English Plays*, Cork, 1954, p. 173. A few years later Isaac Jackman's play centring on the Irish sailor Captain Cornelius O'Gallagher was titled *The Milesian* (1777). See Duggan, *The Stage Irishman*, pp. 215–17.

44 'A Milesian' to *The Morning Post*, in *The Vauxhall Affray*, p. 60

45 *The Vauxhall Affray*, p. 105.

46 'T. P' to Bate, from *The Morning Post*, in *The Vauxhall Affray*, p. 110.

47 'The Macaroniad, Or, Priest Triumphant', from the *Whitehall Evening Post*, in *The Vauxhall Affray*, p. 59.

48 See Bartley, *Teague, Shenkin and Sawney*, pp. 190–1; Joseph Theodoor Leerssen, *'Mere Irish & Fío Ghael': Studies in the Idea of Irish Nationality, Its Development and Literary Expression Prior to the Nineteenth Century*, Amsterdam, 1986; Claus-Ulrich Viol, *Eighteenth-Century (Sub)Versions of Stage Irishness: Prevalent Anti-Irish Stereotypes and their Dramatic Functionalism*, Trier, 1998, for accounts of Irish stereotypes that draw out the ambiguities involved and the positive reclamation of such identities in the later eighteenth century. The actions of Bate and Colman are a matter of actively defending Anglo-British values against the increasing acceptance of such supposedly disruptive 'external' presences by delimiting and disciplining Irish identities. Colman's *Oxonian in Town* appeared in a context where 'serious exception was taken to a negative representation of Irish characters' (Leerssen, *Mere Irish*, p. 140). As Leerssen further notes (p. 465), Colman's view of the Irish is not simply negative but disciplinary: 'In Colman's plays, a "good" Irishman is an Anglicized one'.

49 'Amico', *Town and Country Magazine* 3 (June 1771), p.

322.

50 See Don Herzog, *Poisoning the Minds of the Lower Orders*, Princeton, 1998, p. 463.

51 See Von Erffa and Staley, *Paintings of Benjamin West*, no. 93; Ellen G. Miles et al., *American Paintings of the Eighteenth Century: The Collections of the National Gallery of Art Systematic Catalogue*, Washington, 1995, pp. 329–34.

52 See Von Erffa and Staley, *Paintings of Benjamin West*, no. 94.

53 Solkin, *Painting for Money*, pp. 212–13.

5 OUTLAW MASCULINITY: JOHN HAMILTON MORTIMER IN THE 1770S

1 'Character of the Emperor Justinian, and his General Belisarius', *Oxford Magazine* 9 (1772), pp. 176–7.

2 *Gentleman's Magazine* 40 (1770), p. 500. See John Renwick, *Marmontel, Voltaire, and the Beelisaire Affair* (*Studies in Voltaire and the Eighteenth Century*, 121) Banbury, 1974. For the popularity of Marmontel in England see Josephine Grieder, *Translations of French Sentimental Prose in Late Eighteenth-Century England: The History of a Literary Vogue*, Durham, NC, 1975, pp. 55–8. On the uses of Belisarius as a reformist figure elsewhere, see Albert Boime, 'Marmontel's *Belisaire* and the Pre-Revolutionary Progressivism of David', *Art History* 3 (1980), pp. 81–101; Thomas Crow, *Painters and Public Life in Eighteenth-Century Paris*, New Haven and London, 1985, pp. 198–209; also John Renwick, '*Bélisaire* in South Carolina, 1768', in *Jean-François Marmontel (1732–1799): Dix études*, Paris, 2001, pp. 222–43.

3 [Edward Thompson], *The Soldier: A Poem, Inscribed to the Honourable General Conway*, London, 1764, p. 19. Thompson (1738?–86) was a naval officer and a member of the same social circle as George Colman, David Garrick and Charles Churchill.

4 Sarah Osborn to John Osborn, 14 October 1766, in *Political and Social Letters of a Lady of the Eighteenth Century 1721–1771*, ed. Emily F. D. Osborn, London, 1890, p. 154.

5 *Belisarius by M. Marmontel*, London, 1767, pp. iv–v.

6 John Sunderland, 'John Hamilton Mortimer: His Life and Works', *Walpole Society* 52 (1986), pp. 70–3.

7 See L. Eardley-Simpson, *Derby and the Forty-Five*, London, 1933, pp. 123–30, to be considered in conjunction with R. E. E. Chambers, 'The Pole Family and the Forty-Five', *Derbyshire Archaeological and Natural History Society* 55 (1934), pp. 1–10; L. Eardley-Simpson, 'Radburne and the Forty-Five', *Derbyshire Archaeological and Natural History Society* 56 (1935), pp. 18–28. On Radburne Hall see Maxwell Craven and Michael Stanley, *The Derbyshire Country House*, Derby, 1991, pp. 167–9.

8 See Benedict Nicholson, *Joseph Wright of Derby: Painter of Light*, London and New York, 1968, nos 122–3 and 201–4; vol. 1, pp. 48–50 and 108–10. The relationship between this scheme and Wright's own, highly developed design of *Belisarius* from a couple of years later (Derby Art Gallery) is not clear. See Judy Egerton, *Wright of Derby*, exhibition catalogue, Tate Gallery, London, 1990, no. 89.

9 Thomas Otway, 'The History and Fall of Caius Marius', in *The Works of Mr Thomas Otway*, London, 1768, vol. 3, p. 189. On the history and interpretation of the play see Michael Dobson, *The Making of the National Poet: Shakespeare, Adaptation and Authorship, 1660–1769*, Oxford, 1992, pp. 76–80; Jessica Munns, *Restoration Politics and Drama: The Plays of Thomas Otway, 1675–1683*, Newark and London, 1995, pp. 95–128.

10 [Robert Baker], *Observations on the Pictures now in the Exhibition at the Royal Academy, Spring Gardens, and Mr Christie's*, London, 1771, p. 18. On Baker as a language reformer see Sterling Andrus Leonard, *The Doctrine of Correctness in English Usage 1700–1800*, Madison 1929, pp. 35–41 and passim. The points about Baker's political allegiances and personal origins are to be gleaned from his *Reflections on the English Language*, London 1770, and the second edition of this book, published as *Remarks on the English Language*, London 1779.

11 On Kauffman and androgyny, see Angela Rosenthal, *Angelika Kauffmann: Bildnismalerei im 18. Jahrhundert*, Berlin, 1996, pp. 258–74.

12 [Cuthbert Shaw], *Corruption: A Satire. Inscribed to the Right Honourable Richard Grenville, Earl Temple*, London, 1768, pp. 12–13. Grenville was a Pittite politician who had resigned with Pitt in 1761 and lost his post as lord chamberlain for his support of John Wilkes in 1763.

13 [Cuthbert Shaw] *Corruption*, p. 14. For later uses of Belisarius to voice the disappointment of veterans see 'Harlequin, No. XXI', *London Magazine* 44 (1775), pp. 159–61. In pictorial form, see Henry Walton's veteran in *The Ballad-Singer* (ca.1776, Tate) as interpreted by Mark L. Evans, 'Painting, Prints and Politics During the American War: Henry Walton's *A Girl Buying a Ballad*', *Print Quarterly* 19 (2002), pp. 12–24, and John Trumbull's version of Rosa's composition, for which see Richard W. Wallace, *Salvator Rosa in America*, exhibition catalogue, The Wellesley College Museum, Wellesley, Mass., 1979, p. 105.

14 Quoting Alexander Pope's praise of Oglethorpe in his *Imitations of Horace* (1733), James Boswell claimed that his '"strong benevolence of soul" was unabated during the course of a very long life; though it is painful to think, that he had but too much reason to become cold and callous, and discontented with the world, from the neglect he experienced of his publick and private worth, by those in whose power it was to gratify so gallant a veteran with marks of distinction'; *Boswell's Life of Johnson*, ed. George Birkbeck Hill and L. F. Oxford, 1934–50, vol. 1, pp. 127–8. On Oglethorpe and his reputation see Amos Aschbach Ettinger, *James Edward Oglethorpe: Imperial Idealist*, Oxford, 1936, esp. pp. 290–330.

15 [Cuthbert Shaw] *Corruption*, p. 15.

16 In the event the consolations of the home were to prove transient in more literal terms. Having been a patient of the Lichfield medical doctor and poet Erasmus Darwin during the early 1770s, Elizabeth was romantically involved with the doctor by 1775 at the latest and was very swiftly to marry him after Pole's death. See Desmond King-Hele, *Erasmus Darwin: A Life of Unparalleled Achievement*, London, 1999; also Desmond King-Hele,

ed., *The Letters of Erasmus Darwin*, Cambridge, 1981, pp. 77–8, a 'Speech of a Wood-nymph', addressed to Mrs Pole and dated to ca.1775, and pp. 91–4, a 'Platonic Epistle to a married Lady' of ca.1778, which succeeds in being, as King-Hele notes, 'quite saucy'. Darwin had lost his first wife in 1770 and had conducted a relationship with a Mary Parker that resulted in two children being born, in 1772 and 1774. It is charitably assumed that the relationship with Mrs Pole was not consummated before 1775, to which date the first romantic epistle is ascribed by King-Hele.

17 See Sunderland, 'John Hamilton Mortimer', pp. 90–1; also Michelle Hetherington, 'John Hamilton Mortimer and the Discovery of Captain Cook', *British Art Journal* 4 (2003), p. 70.

18 See Sunderland, 'John Hamilton Mortimer', no. 34, who discusses the picture and the identification of the sitters in some detail. Besides Mortimer, the painting may include likenesses of G. B. Cipriani, Joseph Wright of Derby, Richard Wilson, Laurence Sterne and John Armstrong.

19 Sunderland, 'John Hamilton Mortimer', nos 65–67, 140.7–8.

20 Allan Cunningham, 'Mortimer – Portrait in Character', *The Cabinet Gallery of Pictures* 2 (1834), pp. 49–50; see Sunderland, 'John Hamilton Mortimer', pp. 54–6.

21 See Sunderland, 'John Hamilton Mortimer', pp. 55–8 and 97–8; also David Solkin, '"Conquest, Usurption, Wealth, Luxury, Famine": Mortimer's Banditti and the Anxieties of Empire', in Art and the British Empire', ed. Tim Barringer, Douglas Fordham and Geoff Quilley (forthcoming), for an important discussion of these designs in relation to the imperial politics of the 1770s and 1780s. I would like to thank David Solkin for allowing me toread the text of the conference paper on which this forthcoming essay is based.

22 Michael Mangan, *Staging Masculinities: History, Gender, Performance*, Basingstoke, 2003, pp. 136–51. See also Patricia Vettel Tom, 'Bad Boys: Bruce Davison's Gang Photographs and Outlaw Masculinity', *Art Journal* 56:2 (1997), pp. 69–74, for a discussion of an 'active model of masculinity' intended as a means of reforming gender roles in quite another context.

23 On Rosa's reputation and imitators see Elizabeth Wheeler Manwaring, *Italian Landscape in Eighteenth-Century England: A Study Chiefly of the Influence of Claude Lorrain and Salvator Rosa on English Taste 1700–1800*, New York, 1925, pp. 44–54; *Salvator Rosa*, exhibition catalogue, Arts Council, London, 1973. A more immediate prompt for Mortimer was the arrival in London in 1771 of the successful French painter of landscapes and theatre designer Phillip James de Loutherbourg. He had published his own adaptation of Rosa's *Figurine* in Paris in the 1760s, and specialized in Salvatorian landscapes, sometimes incorporating banditti figures. In these pictorial precedents the bandits and soldiers are presented as character studies or as *staffage*. Mortimer's innovation was to make such figures play the central role in narrative scenes that could not be so easily dismissed as belonging to a lesser genre. See Sunderland, 'John Hamilton Mortimer', p. 57; Matthias Ruediger Joppien, *Philippe Jacques de Loutherbourg, RA, 1740–1812*, exhibition catalogue, Iveagh

Bequest, Kenwood, London, 1973.

24 Matthew Pilkington, *The Gentleman's and Connoisseur's Dictionary of Painters*, London, 1770, s.v. 'Salvator Rosa'.

25 Joshva Reynolds, *Discourses on Art*, ed. Robert R. Wark, New Haven and London, 1975, p. 85.

26 [William Young], *A Journal of a Summer's Excursion by the Road of Montecasino to Naples, and from Thence all over the Southern Parts of Italy, Sicily, and Malta; in the Year MDCCLXXII* [London, ca.1773], p. 119.

27 Peter Brydone, *A Tour Through Sicily and Malta. In a Series of Letters to William Beckford, Esq.*, London, 1773, vol. 1, pp. 68–73. Brydone's account of the *banditti* was also published separately in the *Oxford Magazine* 10 (1773), pp. 158–60 and elsewhere.

28 See Scott, *Salvator Rosa: His Life and Times*, New Haven and London 1995, pp. 110–15 and p. 246n.11.

29 The literature on eighteenth-century Orientalism remains somewhat diffuse. M. P. Conant, *The Oriental Tale in England in the Eighteenth Century*, New York, 1908, still provides the fullest overview. For more contemporary perspectives see Robert L. Mack, ed., *Oriental Tales*, Oxford and New York, 1992; C. C. Barfoot, 'English Romantic Poets and the "Free-Floating Orient"', in *Oriental Prospects: Western Literature and the Lure of the East*, ed. C. C. Barfoot and Theo D'haen, Amsterdam and Atlanta, 1998, pp. 65–96; Diego Saglia, 'William Beckford's "Sparks of Orientalism" and the Mental-Discursive Orient of British Romanticism', in *Textual Practice* 16 (2002), pp. 75–92. Mortimer's *banditti* have been related to issues around Britain's eastern empire in an important discussion by David Solkin, '"Conquest, Usurption, Wealth, Luxury, Famine"'.

30 Tobias Smollett, *Humphrey Clinker*, ed. Thomas R. Preston, London, 1990, p. 91.

31 See Robert M. Ryley, *William Warburton*, Boston, 1984, pp. 46–8. Also Thomas Warton, *History of English Poetry*, ed. David Fairer, London, 1998, vol. 1, 'Dissertation I: Of the Origin of Romantic Fiction in Europe' (n.p.).

32 Thomas Percy trans., 'The Moor's Equipment', in *Ancient Songs Chiefly on Moorish Subjects*, ed. David Nichol Smith, Oxford, 1932, p. 5. Percy had been collecting the Spanish songs included in this volume as early as 1759 as accompaniment to his effort to re-create the library of romances owned by Don Quixote in Cervantes' novel. The text was prepared for publication in 1775 but not issued.

33 [Henry Home, Lord Kames], *Sketches of the History of Man*, Edinburgh, 1774, vol. 1, p. 133n. See also Luiz de Camoens, *The Lusiad: Or, The Discovery of India*, trans. William Julius Mickle, London, 1776, p. cxlvii, where the translator indicates that conventional wisdom dictated that firearms could not properly be represented in epic mode. On the historiographical issues around gunpowder see J. G. A. Pocock, *The Machiavellian Moment: florentine Political Thought and the Atlantic Republican Tradition*, Princeton, 1975, pp. 429–31.

34 See Robert Shoemaker, 'Male Honour and the Decline of Public Violence in Eighteenth-Century London', *Social History* 26 (2001), pp. 190–208; Robert Shoemaker, 'The Taming of the Duel: Masculinity, Honour and Ritual Violence in London, 1660–1800', *The Historical Journal*

45 (2002), pp. 525–45.

35 John Knowles, *The Life and Writings of Henry Fuseli*, London, 1830, vol. 2, pp. 102–3.

36 These came to a head with the renewal of the militia in 1778–80. Writing of the inefficacy of the Military Associations an essayist in the *Westminster Magazine* (February 1781, p. 70) complained: 'We frequently saw, in the course of last summer, many a pretty little hero sweating and broiling under the weight of a musket, who but a little before carried nothing more tremendous with him than a supple-jack [walking stick] or a macaroni cane.' See Gillian Russell, *The Theatres of War: Performance, Politics, and Society, 1793–1815*, Oxford, 1995, pp. 33–48; Robert W. Jones, 'Notes on *The Camp*: Women, Effeminacy and the Military in Late Eighteenth-Century Literature', *Textual Practice* 11 (1997), pp. 463–76; Stephen Conway, *The British Isles and the War of American Independence*, Oxford, 2000, pp. 118–28.

37 *The Adventurer* 47 (17 April 1753), in *The Adventurer*, 2nd ed., London, 1754, vol. 2, pp. 95–6.

38 Henry Brooke, *The Fool of Quality: Or, The History of Henry Earl of Moreland*, London, 1765–70, vol. 1, pp. 153–7.

39 Thomas Gordon 'An Essay upon Heroes', in John Trenchard and Thomas Gordon, *Cato's Letters: Or, Essays on Liberty, Civil and Religious, and other Important Subjects*, ed. Ronald Hamowy, Indianapolis, 1995, vol. 2, pp. 662–3.

40 See Kathleen Wilson, *The Sense of the People: Politics, Culture and Inperialism in England 1715–1785*, Cambridge, 1995, pp. 274–5; Kathleen, Wilson, *The Island Race: Englishness, Empire and Gender in the Eighteenth Century*, London and New York, 2003, pp. 50–1.

41 *Boston Gazette* (12 March 1770).

42 Evan Lloyd to John Wilkes, 13 September 1770, in E. Alfred Jones, *Two Welsh Correspondents of John Wilkes*, London, 1919, p. 127.

43 [Henry Home, Lord Kames], *Sketches of the History of Man*, Edinburgh, 1774, vol. 1, p. 427.

44 'Probus', 'Injustice of the Proceedings at St Vincent Represented', *Scots Magazine* 34 (1772), quoted in Peter Hulme, *Colonial Encounters: Europe and the Native Caribbean, 1492–1797*, London and New York, 1986, p. 248. See also Barlow Trecothick's speech in parliament, quoted in Wilson, *Sense of the People*, p. 275: 'you are exercising the barbarities of the Spaniards against the Mexicans'.

45 Horace Walpole to Horace Mann, 21 January 1773, in *Yale Edition of Horace Walpole's Correspondence*, ed. W. S. Lewis, Oxford and New Haven, 1937–83, vol. 23, pp. 454–5.

46 *Connecticut Journal* (25 October 1775); *Connecticut Courant* (30 October 1775). On the other hand, the distinction between the formal militia and bandits in the American war was from any perspective blurred; the American forces were often characterized as *banditti* by loyalist commentators. See Harry M. Ward, *Between the Lines: Banditti of the American Revolution*, Westport, CT, and London 2002.

47 It is also important to note local inflections of the Macaroni phenomenon. In Edinburgh, the term 'Macaroni'; was attached particularly to Highland lairds who affected English manners, as featured in the poetry of Robert Fergusson. In the context of America, the trappings of the Macaroni were regarded as signs of dissolute youth rather than jaundiced effeminacy, with criminals and runaways being marked out for their adoption of the ribbons and long hair associated with the fashion. An apprentice on the run from his master was described as having 'long black hair' which he often dressed 'into the macaroni taste'; *Boston Evening Post* (15 August 1774). An indentured Irish servant, William Keims aka Taylor, 'took with him macaroni hatt' when he made his escape; *Pennsylvania Servant* (19 July 1775). One thief was described as having 'black hair, very long and clubbed like a macaroni', *Virginia Gazette* (18 August 1774). Another was described as having 'a macaroni hat'; *Virginia Gazette* (10 January 1776).

48 Elizabeth Carter to Mrs Vesey, 17 April 1772, in *A Series of Letters Between Mrs Elizabeth Carter and Miss Catherine Talbot, from the Year 1741 to 1770, to which are added, Letters from Mrs Elizabeth Carter to Mrs Vesey, Between the Years 1763 and 1787*, London, 1809, vol. 4, pp. 57–8.

49 Willian Hickey in Alfred Spencer, ed., *Memoirs of William Hickey (1749–1775)*, London, 1913–1925, vol. 1, pp. 273–4. 'Mohawk' or 'Mohock' was a conventional term for upper-class ruffians in the eighteenth century, first coming into use with the notorious 'Mohock' gang of Spring 1712, for the history and questionable reality of which see Daniel Statt, 'The Case of the Mohocks: Rake Violence in Augustan London', in *Social History* 20 (1995), pp. 179–99; Neil Guthrie, ' "No Truth or very little in the whole Story"? – A Reassessment of the Mohock Scare of 1712', in *Eighteenth-Century Life* 20 (1996), pp. 33–56.

50 *Memoirs of William Hickey*, vol. 1, pp. 308–9. Frederick was remembered as 'a very elegant young man' by John Taylor, *Records of my Life*, London, 1832, vol. 2, p. 222. A Thomas Hayter 'banker' died at Salisbury in 1779; *Gentleman's Magazine* 49 (1779), p. 317. This may be the father of the Hayter in consideration here. Osborne has proved impossible to identify.

51 See William H. Drummond, ed., *The Autobiography of Archibald Hamilton Rowan*, 1840; facsimile reprint with an introduction by R. B. McDowell, Shannon, 1972.

52 On associations of the Irish (and Scottish and Welsh) with the savage see Murray G. H. Pittock, *Celtic Identity and the British Image*, Manchester and New York, 1999, pp. 20–60. Note that these were self-identifications as opposed to identification of Americans (and subsequently Irish) as 'savages' (see Drohr Wahrman, 'The English Problem of Identity in the American Revolution', *American Historical Review* 106 (2001) pp. 1245–8). A few years later in Aberdeen there was a further gang of Scottish 'Mohocks', whom George Colman junior and two other English students, each wearing a specially tailored coat 'of the newest London fashion' to distinguish them from the soberly attired local populace, took it upon themselves to chastise. A clearer instance of English imperial barbarity on the scale of gang violence could hardly be desired. See Richard

Brinsley Peake, ed., *Memoirs of the Colman Family*, London, 1841, vol. 2, pp. 92–5.

53 James Beattie, *Essays on Poetry and Music*, Edinburgh 1776, pp. 71–6.

54 Beattie, *Essays on Poetry and Music*, p. 93.

55 James Beattie, *Dissertations Moral and Critical*, London, 1783, pp. 612–13.

56 Beattie, *Dissertations*, p. 639.

57 Beattie, *Dissertations*, p. 650. The ambiguities in Beattie's construction of epic heroism were drawn out in his commentary on Gothic romance, which implies, as Harriet Guest has summarized in an important essay, that such fantasies 'promote both heroic self-denial and a more-than-extravagant criminality, both chaste frugality and promiscuous luxury'; 'The Wanton Muse: Politics and Gender in Gothic Theory After 1760', in *Beyond Romanticism: New Approaches to Texts and Contexts 1780–1832*, ed. Stephen Copley and John Whale, London and New York, 1992, p. 133.

58 *Middlesex Journal* (6–8 May 1773).

59 [Robert Baker], *Observations on the Pictures now in Exhibition at the Royal Academy, Spring Gardens, and Mr Christie's*, London, 1771, p. 27.

60 Sunderland, 'John Hamilton Mortimer', pp. 58–60.

61 *Morning Chronicle* (29 April 1775).

62 Sunderland, 'John Hamilton Mortimer', nos 61.1–4.

63 This contrasts with the continuous characters appearing in, for instance, the group of six designs the artist showed in 1773; see Sunderland 'John Hamilton Mortimer', nos 71.1–6.

64 Sunderland, 'John Hamilton Mortimer', nos 102–3.

65 *St James's Chronicle* (10–13) May 1777.

66 Sunderland, 'John Hamilton Mortimer', pp. 73–5.

67 Ignatius Sancho to Mr Stevenson, 11 March 1779, in *The Letters of Ignatius Sancho*, ed. Paul Edwards and Polly Rewt, Edinburgh, 1994, p. 163.

6 ALEXANDER RUNCIMAN IN ROME AND EDINBURGH

1 See Linda Colley, *Britons: Forging the Nation 1708–1837*, 2nd ed., London, 1994, pp. 180–1.

2 On Runciman see John Duncan Macmillan's comprehensively documented, 'The Earlier Career of Alexander Runciman and the Influences that Shaped his Style' (Ph.D. diss., University of Edinburgh, 1973). See also Susan Booth, 'The Early Career of Alexander Runciman and his Relations with Sir James Clerk of Penicuik', *Journal of the Warburg and Courtauld Institutes* 32 (1969), pp. 332–43; Duncan Macmillan, 'Alexander Runciman in Rome', *Burlington Magazine* 112 (1970), pp. 22–31.

3 The apprenticeship is recorded in Charles B. Boog Watson, *Register of Edinburgh Apprentices, 1701–1755*, Edinburgh, 1929, p. 75. Runciman's father is here identified as 'James R., freeman wright in Portsburgh', and can presumably be identified with the James Runciman who was competing with John Baxter for the commission for building a new house for Lord Aberdeen in 1731. See James Runciman to Alexander, second earl of Marchmont,

Edinburgh, 22 July 1731, where the writer says he doubts he'll get the job, as 'ther is another man of my busnes who is setting up for it who imploys evry on he knows to recemend him'; National Archives of Scotland, GD 158/1381, quoted in James Macauley, *The Classical Country House in Scotland 1660–1800*, London, 1987 p. 84n111. James Runciman's work for the Breadalbane family at Taymouth, including making boxes and chests, mending windows and furniture, and room alterations, is documented in the National Archives of Scotland, GD 112/15/ 302, 309, GD 112/51/96, 275 and GD 112/74/743. On the role of carpenters and joiners within the building trades see James Ayres, *Building the Georgian City*, New Haven and London, 1998, pp. 131–56; on the Incorporation of Mary's Chapel see James Colston, *The Incorporated Trades of Edinburgh*, Edinburgh, 1891, pp. 65–75.

4 See Charles B. Boog Watson, *Roll of Edinburgh Burgesses and Guild Brethren 1761–1841*, Edinburgh, 1933. On the Norie firm see James Holloway, *The Norie Family*, Edinburgh, 1994.

5 See Ian Gordon Brown, *The Clerks of Penicuik: Portraits of Taste and Talent*, Edinburgh, 1987; Sir John Clerk of Penicuik, *History of the Union of Scotland and England*, trans. and ed. Douglas Duncan, Edinburgh, 1993.

6 See Macmillan, 'Earlier Career', pp. 78–9.

7 Walter Ross to Sir James Clerk, 24 August 1768, in Macmillan, 'Earlier Career', pp. 288–9.

8 Andrew Lumisden to Alexander Runciman, 3 February 1769, National Library of Scotland MS.14,262, 'Lumisden Letters 1769–1770', f. 7–7v. See also Robert Strange to Andrew Lumisden, 13 January 1769, recommending the Runcimans as 'Mr Alexander's friends'; James Dennistoun, *Memoirs of Sir Robert Strange, Knt., Engraver . . . And of his Brother-in-Law Andrew Lumisden, Private Secretary to the Stuart Princes*, London, 1855, vol. 2, p. 116.

9 Macmillan, 'Alexander Runciman in Rome', pp. 27–30.

10 Alexander Runciman to Sir James Clerk, 16 May 1770, National Archive of Scotland GD18/4680.

11 See Elizabeth Cropper et al., *Pietro Testa 1612–1630: Prints and Drawings*, exhibition catalogue, Philadelphia Museum of Art, 1988, nos 118–22. In his conception of the scheme, Runciman may also have had in mind the example of Peter Paul Rubens, who made the first attempt to depict a complete cycle of Achilles' life since antiquity. The sketches for the cycle had been in the Richard Mead's collection in London earlier in the century and were engraved while in that collection. See Edgar Haverkamp Begemann, *The Achilles Series (Corpus Rubenianum Ludwig Burchard Vol. X)*, London, 1975.

12 Richard Graham, 'A Short Account of the Most Eminent Painters, Both Ancient and Modern', in Charles Dufresnoy, *The Art of Painting*, trans. John Dryden, 2nd ed., London, 1716, p. 379; see, similarly, Roger de Piles, *The Art of Painting with the Lives and Characters of Above 300 of the Most Eminent Painters*, 3rd ed., London, 1706, p. 154; Matthew Pilkington, *The Gentleman's and Connoisseur's Dictionary of Painters*, London, 1770, s.v. 'Pietro Testa'; William Gilpin, *An Essay on Prints*, London, 1768, pp. 88–91.

13 See John M. Gray, *Notes on the Art Treasures at Penicuik*

House Midlothian, privately printed, 1889, pp. 60–3; John Duncan Macmillan, ' "Truly National Designs": Runciman's Scottish Themes at Penicuik', *Art History* 1 (1978), pp. 90–8. On Ossian and the visual arts more generally see Henry Okun, 'Ossian in Painting', *Journal of the Warburg and Courtauld Institutes* 30 (1967), pp. 327–66.

14 The Ossianic phenomenon has attracted a still-swelling body of analysis from cultural and literary historians and more recently folklorists. Among the contributions relevant to the present arguments are Fiona J. Stafford, *The Sublime Savage: A Study of James Macpherson and the Poems of Ossian*, Edinburgh, 1988; Clare O'Halloran, 'Irish Re-Creations of the Gaelic Past: The Challenge of Macpherson's Ossian', in *Past and Present* 124 (1989), pp. 69–95; Howard Gaskill, ed., *Ossian Revisited*, Edinburgh, 1991; David Hill Radcliffe, 'Ossian and the Genres of Culture', *Studies in Romanticism* 31 (1992), pp. 213–32; Howard D. Weinbrot, *Britannia's Issue: The Rise of British Literature From Dryden to Ossian*, Cambridge, 1993, pp. 526–56; Adam Potkay, *The Fate of Eloquence in the Age of Hume*, Ithaca and London, 1994, pp. 189–225; Katie Trumpener, *Bardic Nationalism: The Romantic Novel and the British Empire*, Princeton, 1997, pp. 67–127; Fiona Stafford and Howard Gaskill, eds, *From Gaelic to Romantic: Ossianic Translations*, Amsterdam and Atlanta, 1998; Corinna Laughlin, 'The Lawless Language of Macpherson's *Ossian*', *Studies in English Literature* 40 (2000), pp. 511–37; James Porter, ' "Bring me the Head of James Macpherson": The Execution of Ossian and the Wellsprings of Folkloristic Discourse', *Journal of American Folklore* 114 (2001) pp. 396–435; Dafydd Moore, *Enlightenment and Romance in James Macpherson's The Poems of Ossian: Myth, Genre and Cultural Change*, Aldershot, 2003. The significance of the Ossianic texts in the Scottish intellectual culture of the period was most influentially explored in John Robertson, *The Scottish Enlightenment and the Militia Issue*, Edinburgh, 1985, pp. 98–127; Richard Sher, *Church and University in the Scottish Enlightenment: The Moderate Literati of Edinburgh*, Edinburgh, 1985, pp. 242–61. The texts themselves are available in a modern critical edition, Howard Gaskill, ed., *The Poems of Ossian and Related Works*, Edinburgh, 1996.

15 Hugh Blair, 'A Critical Dissertation on the Poems of Ossian', in *Poems of Ossian*, ed. Gaskill, pp. 343–99.

16 Blair, 'Critical Dissertation', pp. 345–6. Cf. Adam Smith, *Lectures on Rhetoric and Belles Lettres*, ed. J. C. Bryce, Oxford, 1983, pp. 136–7; and for a parallel 'British' view John Brown, *A Dissertation on the Rise, Union, and Power, The Progressions, Separations, and Corruptions, of Poetry and Music*, London, 1763. On linguistic primitivism see Olivia Smith, *The Politics of Language 1791–1819*, Oxford, 1984, pp. 26–8; on English reticence about such primitivism see Robert Donald Spector, *English Literary Periodicals and the Climate of Opinion During the Seven Years' War*, The Hague, 1966, pp. 265–309.

17 John Gregory, *A Comparative View of the State and Faculties of Man with those of the Animal World*, 6th ed., London, 1774, vol. 1, p. x.

18 Moore, *Enlightenment and Romance*, p. 113.

19 Renee le Bossu, 'A General View of the Epick Poem and of the Illiad and Odyssey', in *The Odyssey of Homer*, trans. Alexander Pope, ed. Maynard Mack, London and New Haven, 1967, vol. 2, p. 21. Le Bossu quotes Aristotle's warning to poets about making their heroes too perfect; Blair claimed Ossian's Fingal refutes that principle ('Critical Dissertation', pp. 364–5).

20 Trumpener, *Bardic Nationalism*, pp. 74–6; Potkay, *The Fate of Eloquence*, pp. 189–225.

21 Blair, 'Critical Dissertation', p. 359.

22 Blair, 'Critical Dissertation', pp. 394–6.

23 Cf. Trumpener's discussions of the 'unevenness of character, and of textuality' in Ossian as being taken as 'historical testimony, as an inadvertent record of historical upheavals and endurance, survivals and extinction'; *Bardic Nationalism*, p. 117.

24 Horace Walpole to David Dalrymple, 20 June 1760, in *The Yale Edition of Horace Walpole's Correspondence*, ed. W. S. Lewis, Oxford and New Haven, 1937–83, vol. 15, p. 69.

25 Stuart Piggott, 'Sir John Clerk and "The Country Seat" ', in *The Country Seat: Studies in the History of the British Country House Presented to Sir John Summerson*, ed. Howard Colvin and John Harris, London, 1970, pp. 110–16. The political content of Clerk's scheme would need to be considered in relation to his account of the *fata Britannica* in his 'De Imperio Britannico', published as Clerk, *History of the Union*. On the younger Clerk's interpretation of these principles at Penicuik see Macauley, *The Classical Country House in Scotland*, pp. 169–72; Ian Gordon Brown, 'A Bibliophile's Bagnio: Sir James Clerk's Pantheon for Penicuik', in Ian Gow and Alistair Rowan, *Scottish Country Houses 1600–1914*, Edinburgh, 1995, pp. 135–49. For pertinent critical comments about the Scots subscription to an assimilationist 'British' imperialism see Kidd, *British Identities Before Nationalism*, pp. 200–4.

26 For the Select Society see Roger L. Emerson, 'The Social Composition of Enlightened Scotland: the Select Society of Edinburgh, 1754–1764', *Studies on Voltaire and the Eighteenth Century* 114 (1973), pp. 291–329; also N. T. Phillipson, 'Lawyers, Landowners, and the Civic Leadership of Post-Union Scotland', in *Lawyers in their Social Setting: Wilson Memorial Lectures, University of Edinburgh*, ed. D. N. MacCormick, Edinburgh, 1976, pp. 171–94. See also Robert Crawford, *Devolving English Literature*, 2nd ed., Edinburgh, 2000, pp. 16–44. The Cape Club's papers are at the National Library of Scotland, Ms2000-2045. A brief early history of the Club by David Herd appears at MS 2004, pp. 3–5; the list cited here is at MS 2044, ff. 214–15. 'C.F.D.' was the Club's motto: 'Concordia Fratrum Decus'.

27 On Edinburgh's clubs, including the Cape, see Harry A. Cockburn, 'An Account of the Friday Club, Written by Lord Cockburn, Together with Notes on Certain other Social Clubs in Edinburgh', *The Book of the Old Edinburgh Club* 3 (1910), pp. 105–78; Davis D. McElroy, *Scotland's Age of Improvement: A Survey of Eighteenth-Century Literary Clubs and Societies*, Washington, 1969. Further pertinent notices of the Cape Club appear in the literature on Robert Fergusson (see below, n.28); Hans

Hecht, *Songs from David Herds Manuscripts*, Edinburgh, 1904, pp. 34–51. On the role of clubs more generally, see Peter Clark, 'Sociability and Urbanity: Clubs and Societies in the Eighteenth-Century City', (*The H. J. Dyos Memorial Lecture*, 23 April 1986, Victorian Studies Centre, University of Leicester 1986); Peter Clark *British Clubs and Societies 1580–1800: The Origins of an Associational World*, Oxford, 2000. The politics of Edinburgh's developing cultural scene in this era are considered in Duncan Forbes, 'Artists, Patrons and the Power of Association: The Emergence of a Bourgeois Artistic Field in Edinburgh, c.1775–c.1840' (Ph.D. diss., University of St Andrews, 1996); Nick Prior, *Museums and Modernity: Art Galleries and the Making of Modern Culture*, Oxford and New York, 2002, pp. 109–34.

28 Matthew P. McDiarmid, *The Poems of Robert Fergusson*, 2 vols, Edinburgh and London, 1954–56; F. W. Freeman, *Robert Fergusson and the Scots Humanist Compromise*, Edinburgh, 1984; Robert Crawford, ed., *'Heaven-Taught Fergusson': Robert Burns's Favourite Scottish Poet: Poems and Essays*, East Linton, 2003. For a critical account of the modernization of Edinburgh see R. A. Houston, *Social Change in the Age of Enlightenment: Edinburgh, 1660–1760*, Oxford, 1994; Paul Henderson Scott, 'The Eighteenth-Century Revival and the Nature of Scottish Nationalism', *Scottish Studies Review* 3:2 (2002), pp. 9–19. A telling contemporary account of the physical reorganization of the city that discusses the 'English' character of the new town is [Edward Topham], *Letters from Edinburgh; Written in the Years 1774 and 1775*, London, 1776, pp. 9–12 and passim.

29 'Auld Reikie, A Poem', ll. 153–60, in McDiarmid, *Poems of Robert Fegusson*, vol. 2, pp. 113–14.

30 See Edwin Morgan, 'A Scottish Trawl', in Christopher Whyte, *Gendering the Nation: Studies in Modern Scottish Literature*, Edinburgh, 1995, pp. 207–10, who notes (in a confessedly speculative fashion) the homoerotic undercurrent apparent in the passionate admiration of the Macaronis for the burly bully in 'Auld Reikie'. Morgan wonders whether Fergusson could have been associated with the Edinburgh branch of the Beggar's Benison Club, where initiation rites reputedly included genital contact between the 'Knights' and masturbating openly (albeit as an accompaniment to a sexual exhibition involving women). Whether there is anything to this or not, the existence of such clubs at all highlights the potential slippage between displays of heterosexual virility in homosocial environments and homoeroticism – a threat that, as in Thomas Maurice's 'Schoolboy', became acute around the figure of the ultra-masculine brutish hero. Morgan's further comments on texts from Walter Scott suggest that the culture of masculine conviviality remained more readily physical in Scotland than it was in England. See also David Stevenson, *The Beggar's Benison: Sex Clubs of Enlightenment Scotland and their Rituals*, East Linton, 2001. Although there can be no intimation that the Cape Club was a sex club, the homosocial conviviality it fostered could encompass sexual elements. The petitions of new members were inscribed on the verso with a drawing relating to their assumed name within the society: Roger McGowan was 'Sir Merrypin', so his petition was decorated with a drawing of an impressively tumescent ('merry') penis ('pin'); petition of 25 September 1775; National Library of Scotland, MS 2041, Cape Club Petitions, vol. 1, f. 142.

31 The full name appears over Runciman's contribution to the Cape Club songbook, 'THE CAPEIAD', University of Edinburgh Library, La.III.464. Runciman's 'New Song', to the tune of 'Push about the jorum' (a 'jorum' being a large punch bowl), tells of the different knights from '*King Arthur*' to '*New Scotia*' via '*City*' and '*Country*', who are all superseded by the harmonious knights of the Cape. The 'Capeiad' itself has been mutilated and only the first canto survives, but it is perhaps to be identified with the literary work providing 'a catalogue of the knights, in imitation of Homer's catalogue of warriors' described by 'A.Z.' in a letter to David Herd of the 8 November 1769 (La.II.82, printed in Hecht, *Songs*, pp. 42–3).

The rational Modern knight was a Masonic theme, as witnessed in Cape Club member Gavin Wilson's 'Song VIII: Let others sing, and for their theme. . .' in his *A Collection of Masonic Songs and Entertaining Anecdotes, for the Use of all the Lodges*, Edinburgh, 1788, p. 9. Noteworthy here, also, is Wilson's bawdy reclamation of the 'Sawney' character from within the sexual economy of English imperialism (p. 89):

Anec. XXXIII: Epigram

Says Richard to Sawny, ye son of a w—e,
You Scots are our bastard in the days of yore,
When Edward spread conquest all over Scotland,
Your wives and your daughters were at our
 command.

Troth that've very true man, quoth Sawny to Dick,
The best of your countrymen serv'd us that trick,
But the worst staid at home, and your breed did
 confound,
Hence buffons and coxcombs among you abound.

Wilson's poetry, collected in 1788, includes pieces dating back to 1771. His simultaneous membership of the Cape Club and the Masonic Lodge of St David in Edinburgh, and the intertwining of the themes of his poetry and songs with those apparent in the literary records of the Cape, is suggestive of a degree of concordance between the groups that could be more fully explored.

32 'Philanthropus', 'A Character, Addressed to a Friend', *The Weekly Magazine* (10 December 1773), in McDiarmid, *Poems of Robert Fergusson*, vol. 1, p. 47. A relatively reliable early source suggests that it was Fergusson's sumptuary carelessness that cost him any chance of preferment with his mother's family, the well-connected Forbes; see McDiarmid, *Poems of Robert Fergusson*, vol. 1, pp. 21–2.

33 The haggard figure of Runciman in Brown's drawing corresponds, perhaps more than incidentally, to the representation of Fergusson as 'Sir Precenter' in the Cape Club papers (National Library of Scotland, MS 2041, Cape Club Petitions, vol. 1, f. 62), a drawing sometimes attributed to Runciman, although more likely to be by James Cummings. Runciman painted Fergusson in a small oil portrait (Scottish National Portrait Gallery, Edinburgh) and was

said to have represented the poet as the 'Prodigal Son' in his versions of that scene in the Episcopal Chapel, Cowgate (now St Andrew's Catholic Church) and on canvas (formerly collection of Sir Steven Runciman; photograph at Scottish National Portrait Gallery, Edinburgh). Although the likeness is inconclusive, such a convivial gesture seems quite probable. Fergusson repaid the compliment with his 'On Seeing a Collection of Pictures Painted by Mr Runciman'; see McDiarmid, vol. 1, pp. 110-17 and vol. 2, p. 172.

34 John Brown to the Earl of Buchan, August 1784, quoted in Duncan Macmillan, *Painting in Scotland: The Golden Age*, Oxford, 1986, p. 61.

35 [Walter Ross], *A Description of the Paintings in the Hall of Ossian at Pennycuik near Edinburgh*, Edinburgh, 1773. For the authorship, see David Laing to Allan Cunningham, 27 May 1831, National Library of Scotland, MS 830, f.94v: 'The tract describing Ossian's Hall at Pennycuick is now very scarce, the Greater part of the copies having, as David Laing was informed, been disposed of to a Tobacconist. It was written by one Walter Ross WS under instructions from Runciman.'

36 Ross, *Description*, pp. 8-10. Ross quotes from Blair, 'Critical Dissertation', p. 354: 'The manner of composition bears all the marks of the greatest antiquity. No artful transitions; nor full and extended connection of parts; such as we find among the poets of later times, when order and regularity were more studied and known; but a style always rapid and vehement; in narration concise even to abruptness, and leaving several circumstances to be supplied by the reader's imagination.' The quoted 'joys of grief' was cited by Blair, 'Critical Dissertation', pp. 381-2, as a frequently appearing Ossianic phrase demonstrating 'a clear idea of that gratification which a virtuous heart often feels in the indulgence of a tender melancholy'.

37 Ross, *Description*, p. 13.

38 Smith, *Lectures on Rhetoric and Belles Lettres*, pp. 122-3.

39 Ross, *Description*, p. 20. Ross in fact refers to Annibale Carracci's 'Ænid in the palace of Farneze' but this must simply be an error. There is no evidence that Ross had travelled to Italy.

40 Ross, *Description*, p. 39.

41 Ross, *Description*, pp. 28-9. Ross notes that the relevant passages were supplied by Runciman himself (p. 22n) and that the 'culdees' were 'the first Christians in Scotland' (p. 29n).

42 See H. Fullenwider, '"The Sacrifice of Iphigenia" in French and German Art Criticism, 1755-1757', *Zeitschrift für Kunstgeschichte* 52 (1989), pp. 539-49.

43 Pilkington, *Gentleman's and Connoisseur's Dictionary of Painters*, p. xv.

44 Longinus, *Dionysius Longinus on the Sublime*, London, trans. William Smith, 1739, Sect. XXXIII, 'That the Sublime with some Faults is better than what is correct and faultless without being Sublime', pp. 79-81, esp. p. 79: 'it is almost impossible for a low and grov'ling Genius to be guilty of Error, since he never endangers himself by soaring on high, or aiming at Eminence, but still goes on in the same uniform secure Track, whilst its very Height and Grandeur exposes the Sublime to sudden Falls.'

45 Ross, *Description*, pp. 47-8.

46 See Angela Rosenthal, *Angelika Kauffmann: Bildnismalerei in 18. Jahrhvndert*, Berlin, 1996, pp. 258-74; also Angela Rosenthal 'Angelica Kauffman Ma(s)king Claims', *Art History* 15 (1992), pp. 38-59.

47 [Walter Ross], *An Historical Account of the Privileges of the College of Justice*, Edinburgh, 1785; Walter Ross, 'To the Members of the Court of Justice' and 'Essay on the Removing of Tenants', in *Lectures on the Practice of the Law in Scotland*, 2nd ed., 2 vols, Edinburgh, 1822. These lectures were originally delivered in 1782-84. On Ross see David M. Walker, *A Legal History of Scotland: Volume V, The Eighteenth Century*, Edinburgh, 1998, p. 354. On the social composition of the Faculty of Advocates and the Society of Writers to his Majesty's Signet, see John Stuart Shaw, *The Management of Scottish Society 1707-1764: Power, Nobles, Lawyers, Edinburgh Agents and English Influences*, Edinburgh, 1983, pp. 18-36. On the Faculty of Advocates' mistreatment of Ross (albeit coming to a head over a matter of library access), see Angus Stewart, ed., *The Minute Book of the Faculty of Advocates, Volume 3: 1751-1783* (The Stair Society 46), Edinburgh, 1999, p. xxii and pp. 339-40.

48 See David Laing, 'Of the Supposed "Missing School of Design in the University of Edinburgh", 1784', *Proceedings of the Society of Antiquaries of Scotland* 8 (1871), p. 39.

49 The papers of the Board of Trustees for Fisheries, Manufactures and Improvements in Scotland are at the National Archives of Scotland, NG 1. For the present references: NG 1/1/20, pp. 4-5, p. 16, p. 165. The friction between Runciman and the Board of Trustees is worth documenting as evidence of the conflicting cultural aims of Edinburgh's social elite and a professional artist of less distinguished social origin. By 1783 the school seems to have been in disarray, with the Edinburgh clerk John MacGowan taking responsibility for presenting student drawings to the trustees. In late 1784 and 1785 Runciman was being severely reprimanded for mismanagement and was forced to take extra pupils to make up the allotted number. His death in October 1785 was reported with only a perfunctory notice, with immediate consideration given to his potential successor. His executor's request for the recovery of his due salary and payment for a large painting left with the trustees 'as he has left a son, and a nephew quite unprovided for' was treated coolly. See National Archives of Scotland, NG 1/1/20, p. 265; NG 1/1/25, p. 80. While this might be simply a consequence of the painter's personality, it is clear that there was a more serious element of discord between his expectations about what an art school was for and the demands of the trustees. Runciman's commitment to a liberal rather than mechanic art instruction flatly contradicted the academy's purpose as an aid to the Select Society's promotion of trade and manufactures. The secretary, reviewing the state of the academy in the wake of Runciman's death and its success in fulfilling its remit to teach, as described in a letter to Robert Adam, 'the stile of Drawing calculated to diffuse and elegant taste among the Ornamental Manufacturers', could only report: 'With regard to the good effects that have arisen from the

academy, I find it difficult to speak with any degree of certainty ... Several *artists* of very considerable merit Received the Rudiments of their education at the academy ... Runciman confessedly posest genius, but he was indolent and inattentive to a great degree'; copy letter to Robert Adam, 28 November 1785, National Archives of Scotland, NG 1/3/14, p. 296; Robert Arbuthnot, Secretary to the Board of Trustees, report on the drawing academy, 23 January 1786, National Archives of Scotland, NG 1/1/25, pp. 109–10.

50 For an account of resistance to urbane, urban, London-centred Whig values in literature see Murray G. H. Pittock, *Poetry and Jacobite Politics in Eighteenth-Century Britain and Ireland*, Cambridge, 1994, pp. 133–86. More particularly regarding Fergusson, see Ian Duncan, 'Fergusson's Edinburgh', in *'Heaven-Taught Fergusson'*, ed. Robert Crawford, pp. 65–83. For Edinburgh's civic politics of this era, which saw heightened criticism of the Set (the civil establishment), see Alexander Murdoch, 'The Importance of Being Edinburgh: Management and Opposition in Edinburgh Politics, 1746–1784', *The Scottish Historical Review* 62 (1983), pp. 1–16.

51 Ross, *Description*, p. 21. See also John J. Wilson, *The Annals of Penicuik: Being a History of the Parish and of the Village*, Edinburgh, 1891, pp. 6, 156, which uses the term 'rich' when referring to Runciman's decorations. Gray, *Notes on the Art Treasures*, p. 61, suggests that the paintings were lost amidst the decorations of the room as a whole: 'If we were to criticise the ceiling purely as an example of decorative art, we might well object that the elaboration and wealth of detail in the work is hardly suitable to its position, that designs so placed should have been simpler and more salient in their component parts, and executed in a lighter and more airy scheme of colouring, so as to carry the eye freely upwards.'

52 Letter from Sir John Clerk to Hermann Boerhave, 1740, in John M. Gray ed., *Memoirs of the Life of Sir John Clerk*, ed. John M. Gray, London, 1895, p. 236.

53 Harold William Thompson, ed., *The Anecdotes and Egotisms of Henry Mackenzie 1745–1831*, 1927; facsimile edition with an introduction by John Dwyer, Bristol, 1996, p. 213. See also the opinions expressed in John Gibson Lockhart, *Peter's Letters to his Kinsfolk*, ed. William Ruddick, Edinburgh, 1977, pp. 121–2:

> The only two Scottish painters of former times, of whom any of the Scotch connoisseurs, with whom I have conversed, seem to speak with much exultation, are Gavin Hamilton and Runciman. The latter, although he was far inferior in the practice of art – although he knew nothing of colouring, and very little of drawing – yet, in my opinion, possessed much more of the true soul of the painter than the former. There is about his often miserably drawn figures, and as often miserably arranged groupes, a certain rude character of grandeur, a certain indescribable majesty and originality of conception, which shows at once, that had he been better educated, he might have been a princely painter. The other possessed in perfection all the manual part of his art – he made no mistakes – he was sure so far as he went – he had the complete mastery of his tools. The subjects

which he chose, too, were admirable, and in his treatment of many of them altogether, he has displayed a union of talents, which even few of the very first artists the world has produced could ever equal. But Gavin Hamilton was not a great painter. Nature never meant him to be one. He wanted soul to conceive, and therefore his hands, so ready and so skilful to execute, were of little avail.

54 The cultural politics of Mackenzie's and Burns' use of the term 'Heaven-taught' are explored in Robert Crawford, 'Robert Fergusson's Robert Burns', in *Robert Burns and Cultural Authority*, ed. Robert Crawford, Edinburgh, 1997, pp. 1–22.

55 See in particular the essay by 'Somebody', 'Luxury the Cause of Emigration', the *Weekly Magazine* 22 (25 November 1773), pp. 261–2, which laid the blame for the Highland clearances apparent since 1768 at the feet of the gentry class. While the linen industry was seen to introduce the corruptions of commerce and affected manners among the working people of the Highlands:

> The laird is prompted to have a finger in the pye of administration, by standing candidate for a seat in parliament ... He must have a French cook to dress his turtle – an English – to manage his tea-table – a valet de chambre to dress his hair – and a contemptuous (I do not say contemptible) Londoner to lay the cloth. The laird, with his new levied retinue, returns with splendor from London to his country-seat among the hills, the sight of which distorts his eye; the air of the mountains chills his blood, the approach of his hardy Highlanders disgusts his refinement and delicacy; and, losing his patience, he calls for his chamberlain, receives his rents, sets his lands and then disappears.

For this theme in social criticism see Eric Richards, *The Highland Clearances: People, Landlords and Rural Turmoil*, Edinburgh, 2000, esp. pp. 62–4; Alex Murdoch, 'Emigration from the Scottish Highlands in the Eighteenth Century', *British Journal for Eighteenth Century Studies* 21 (1998), pp. 161–74.

56 *Anecdotes and Egotisms of Henry Mackenzie*, ed. Thompson, p. 212.

57 'Biographical Sketch of Alexander Runciman, History Painter', *Scots Magazine* 64 (1802), p. 620.

58 'Not many years ago, that form of worship, in all its ceremonies, would not have been tolerated. The organ and the paintings would have been downright idolatry, and the chapel would have fallen a sacrifice to the mob'; Hugo Arnot, *The History of Edinburgh*, Edinburgh and London, 1779, p. 286. Runciman's decorations at the theatre were described as part of the account of a musical gathering considered contrary to the lessons of 'Presbyterianism and the Kirk, those formidable enemies to Mirth and Jollity'; in Topham, *Letters from Edinburgh*, p. 246.

59 Unidentified correspondent, quoted in Allan Cunningham, *The Lives of the Most Eminent British Painters Sculptors and Architects*, London, 1829–33, vol. 5, p. 158. Cunningham also quotes (p. 159) a contrary account of Runciman as a sober character who was 'courted' by Edinburgh's literary and social elite, represented by 'Hume, Robertson,

Kames, and Monboddo'. For the woman with whom Runciman had a son, see the note of a letter from David Laing to Allan Cunningham, 27 May 1831, National Library of Scotland, MS 830, f. 94v: 'Mr Ross was at least as remarkable for profligacy as for talent, and, among other things, passed on one of his cast-off mistresses to the Painter. Runciman lived with her openly, and had a child by her, and is said to have lost many of his early patrons on this account.'

7 HENRY FUSELI AND THOMAS BANKS IN ROME

1 John Thorpe to the eighth earl of Arundell, 5 January 1774, Wiltshire County Record Office, Trowbridge, 2667/20 Box 3.

2 John Thorpe to eighth earl of Arundell, 12 February 1774, Wiltshire County Record Office, Trowbridge, 2667/20 Box 3; Joseph Wright to Nancy Wright, 13 April 1774, in William Bemrose, *The Life and Works of Joseph Wright, ARA, Commonly Called 'Wright of Derby'*, London, 1885, p. 31. See also Ozias Humphry to Revd William Humphry, 14 September 1774, Centre for Kentish Studies, Maidstone, U1050, C29/11.

3 John Thorpe to the eighth earl of Arundell, 4 January 1775, Wiltshire County Record Office, Trowbridge, 2667/20 Box 3.

4 John Thorpe to the eighth earl of Arundell, 30 September [1769], photocopy at Wiltshire County Record Office, Trowbridge, 2667/20 Box 3. The duke of Gloucester's patronage was noticed in the London Press (*London Chronicle*, 30 April–2 May 1772), and the arrival of Robert, Lord Clive was much anticipated, as Thorpe noted: 'The Artists as well as the dealers are in great expectations of the immense Sums to be left among them.' The artists, at least, were disappointed, as a month later the same writer reported: 'Lord Clive & his company are going away tomorrow, without leaving any of the great Sums among the Artists, who expected them. He declared that he would only purchase the works of the old masters'; John Thorpe to the eighth earl of Arundell, 19 February 1774 and 19 March 1774, Wiltshire County Record Office, Trowbridge, 2667/20 Box 3.

5 William Chambers to Edward Stevens, 5 August 1774, British Library Add. MSS 41,136, f.8.

6 Johann Gottlieb Puhlmann, whose letters give an extremely full account of Batoni's studio in the 1770s, noted the presence of only one English student there. See Puhlmann to his parents, 14 February, in *Ein Potsdamer Maler in Rom: Briefe des Batoni-Schülers Johann Gottlieb Puhlmann aus den Jahren 1774 bis 1787*, ed. Götz Eckardt, Berlin, 1979, p. 104. Puhlmann does not name the artist involved: it may have been Ozias Humphry. In a letter datable on internal evidence to late 1775, Alexander Day wrote to Humphry stating that James Nevay could offer him a place in Batoni's studio (Library of the Royal Academy of Arts, London HU/2/16). For some of the students of Batoni and Mengs from the 1750s and 1760s, including James Byres, James Nevay and Colin Morison, see Basil Skinner, 'Scottish Pupils of Batoni and Mengs'

(unpublished paper read at the Scottish Society of Art Historians, 1989, typescript at The Paul Mellon Centre, London). M. F. MacDonald has noted that no British students attended the Accademia del Nudo in Rome after 1769; see his 'British Artists at the Accademia del Nudo in Rome', *Leids Kunsthistorisch Jaarboek* 5–6 (1986–87), p. 94.

7 John Knowles, *The Life and Writings of Henry Fuseli*, 3 vols, London, 1831; facsimile reprint edited by David Weinglass, Millwood, NY, 1982, is still a vital source on the artist's biography and writings. Gert Schiff, *Johann Heinrich Füssli*, 2 vols, Zurich and Munich, 1973, provides the standard documentation of his art; the long-anticipated translation and updating by David H. Weinglass is represented in draft form at the Paul Mellon Centre, London. Weinglass is the editor of the indispensable *The Collected English Letters of Henry Fuseli*, Millwood, NY, 1982 (referred to hereafter as *Fuseli Letters*). Fuseli's period in Rome is the special focus of Nancy Pressly, *The Fuseli Circle in Rome: Early Romantic Art of the 1770s*, exhibition catalogue, Yale Center for British Art, New Haven, 1979.

8 John Cartwright to A. K. Dashwood, 12 May 1772, in *Fuseli Letters*, p. 13; Thomas Banks to Nathaniel Smith, 31 July 1773, in C. F. Bell, *Annals of Thomas Banks: Sculptor, Royal Academician*, Cambridge, 1938, pp. 16–17; R. C. Whalley to T. S. Whalley, 3 September 1773, in *Fuseli Letters*, p. 15; J. C. Lavater to Johann Gottfried Herder, 4 November 1773, in Walter Muschg ed, *Heinrich Füssli: Briefe*, ed. Walter Muschg, Basel, 1942, p. 168; Johann Jakob Bodmer to Johann Georg Sulzer, 12 March 1773, in Arnold Federmann, *Johann Heinrich Füssli: Dichter und Maler 1741–1825*, Zurich and Leipzig, 1927, p. 41.

9 'Füßli in Rom ist eine de größten Imaginationen. Er is in allem Extrem – immer Original; Shakespeares Maler – nichts als Engländer und Zürcher, Poet und Maler . . . Ein Hartmannischer Geist . . . Sein Witz ist grensenlos . . . Windsturm und Ungewitter. – Reynolds weissagt ihn zum größten Maler seiner Zeit. Er verachtet alles . . . Sein Blick ist Blitz, sein Wort is Wetter – sein Scherz Tod und seine Rache Hölle. In der Nähe ist er nicht zu ertragen'; J. C. Lavater to Johann Gottfried Herder, 4 November 1773, in *Briefe*, ed. Muschg, p. 168. Lavater's comments may contain an echo of Jean-Jacques Rousseau: by casting Fuseli as 'nichts als Engländer und Zürcher' Lavater situates him as the antithesis of the bourgeois as imagined by that philosopher: 'He who in the civil order wishes to preserve the primacy of the sentiments of nature does not know what he wants. Always in contradiction with himself, always floating between his wishes and his duties, he will be neither a man nor a citizen. He will be good neither for himself nor for others. He will be a man of our days: a Frenchman, an Englishman, a bourgeois. He will be nothing'; from *Émile, Ou, de L'Education* (1762), quoted and discussed in Werner J. Dannhauser, 'The Problem of the Bourgeois', in *The Legacy of Rousseau*, ed., Clifford Orwin and Nathan Tarcov, Chicago and London, 1997, pp. 3–19.

10 Fuseli told his biographer, John Knowles, that he had not touched oil paint until he was twenty-five (around 1765);

Knowles, *Life and Writings of Henry Fuseli*, vol. 1, p. 397.

11 See Knowles, *Life and Writings of Henry Fuseli*, vol. 1, p. 9, where it is claimed that Fuseli became ambidextrous when forced secretly to draw with his left hand to avoid his father's admonition, and Knowles, *Life and Writings of Henry Fuseli*, vol. 1, pp. 405–6. A contemporary account (Kenneth Garlick et al., eds, *The Diary of Joseph Farington*, New Haven and London, 1978–98, vol. 14, p. 4924; referred to hereafter as Farington Diary) and the material evidence of Fuseli's drawings indicate that he was generally left-handed rather than fully ambidextrous.

12 Knowles, *Life and Writings of Henry Fuseli*, vol. 1, p. 12.

13 Knowles, *Life and Writings of Henry Fuseli*, vol. 1, pp. 18–20.

14 On Mitchell see Patrick Francis Doran, *Andrew Mitchell and Anglo-Prussian Diplomatic Relations During the Seven Years' War* New York and London, 1986. On Armstrong see William J. Maloney, *George and John Armstrong of Castleton: Two Eighteenth-Century Medical Pioneers*, Edinburgh and London, 1954; Lewis M. Knapp, 'Dr John Armstrong, Littérateur, and Associate of Smollett, Thomson, Wilkes, and Other Celebrities', *Publications of the Modern Language Association of America* 59 (1944), pp. 1019–58.

15 See Knowles, *Life and Writings of Henry Fuseli*, vol. 1, pp. 40–1; also James Northcote, 'Autobiography', vol. 2, British Library, Add. MSS 47,791, ff.71–2.

16 Henry Fuseli, *Remarks on the Writings and Conduct of J. J. Rousseau*, ed. Eudo C. Mason, Zurich, 1962.

17 William Godwin to John Knowles, 28 September 1826, in *Fuseli Letters*, p. 509; also Knowles, *Life and Writings of Henry Fuseli*, vol. 1, p. 44: 'in style, it cannot be considered strictly English'. Although minor, the controversy around the essay lingered in some quarters: in 1799, as Fuseli was being considered for the post of professor of painting at the Royal Academy, Thomas Banks reported Thomas Sandby's opposition, on the grounds 'that Fuseli was said not to draw well, nor compose &c & that He had written a book on Manners (30 yrs ago by the way) which was not approved'; *Farington Diary*, vol. 4, p. 1240 (17 June 1799).

18 See also the letters to Dälliker, November 1765, and to Johann Jakob Bodmer, 7 February 1766, in Eudo C. Mason, *The Mind of Henry Fuseli: Selections from his Writings with an Introductory Study*, London, 1951, pp. 110–11.

19 See S. S. B. Taylor, 'Public Awareness of the Voltaire-Rousseau Quarrel: The Iconographical and Biographical Evidence', in *Rousseau and The Eighteenth Century: Essays in Memory of R. A. Leigh*, ed. Marian Hobson, J. T. A. Leigh and Robert Wokler, Oxford, 1992, pp. 217–20; Weinglass, *Prints and Engraved Illustrations By and After Henry Fuseli: A Catalogue Raisonné*, Aldershot 1994, no. 11.

20 From Fuseli's own, anonymous review of the *Remarks on Rousseau*, *Critical Review* (May 1767), in Mason, *Mind of Henry Fuseli*, p. 134. Cf. Fuseli's remarks on Rousseau's character, in *Remarks on Rousseau*, pp. 68–9.

21 Fuseli's emerging persona finds a German context in the literature of the Sturm und Drang movement: see Mason, *Mind of Henry Fuseli*, pp. 30–2. For relevant studies of the Sturm und Drang see David Hill, ' "Die schönsten Träume von Freiheit werden ja im Keker geträumt": The Rhetoric of Freedom in the Sturm und Drang', in *Literature of the Sturm und Drang*, ed. David Hill, Rochester, NY, 2003, pp. 159–84; also, Larry Vaughan, *The Historical Constellation of the Sturm und Drang*, New York, Berne and Frankfurt, 1985, esp. pp. 49–62, who coordinates the theme of alienation and such emancipatory rhetoric with economic and social shifts (the contradictions of civil society, the ascendance of capitalist modes of production) in a way broadly consonant with the arguments of the present study. Also pertinent are the comments on the paradox of the counter-cultural positions taken up within the Sturm und Drang in Gustave Frank, '*Sturm und Drang*: Towards a New Logic of Passion and the Logic of German Counter-Cultures', in *Counter-Cultures in Germany and Central Europe: From Sturm und Drang to Baader-Meinhof*, ed. Steven Giles and Maike Oergel, Oxford, 2003, pp. 25–42.

22 John Armstrong, 'Of Writing to the Taste of the Age', first published 1758, reprinted in his *Miscellanies*, vol. 1, pp. 169–70. For Armstrong on Le Brun see 'Taste: An Epistle to a Young Critic', in *Miscellanies*, vol. 1, p. 139, complaining of the 'passions drily copied from Le Brun' and satirizing (p. 139n) that painter's treatment of expression as the work of a timid copyist or portraitist: 'Our sovereign lords the passions, Love, Rage, Despair, &, were graciously pleased to sit to him in their turns for their portraits.' Armstrong had associated with reforming circles in London, remaining a friend of John Wilkes through the 1750s and possibly attending the Sublime Society of Beefsteaks. He had broken from the then virulently anti-Scottish Wilkes by 1763. See also David Hume to Andrew Millar, 28 March 1763, in *The Letters of David Hume*, ed. J. Y. T. Grieg, Oxford, 1932, vol. 1, pp. 382–3: 'I hear Dr Armstrong has sent you over a most violent Renounciation of Wilkes's Friendship. Wilkes is indeed very blameable in indulging himself so much in national Reflections, which are low, vulgar & ungenerous, and come with a bad Grace from him, who conversed so much with our Countrymen.'

23 John Armstrong, 'The Influence of Climate Upon Genius', in Armstrong, *Miscellanies*, vol. 2, p. 236. J. T. Smith, relying on James Northcote's recollections, claimed that Armstrong puffed Fuseli in the papers, and recalled an article reading 'Parry may learn from Reynolds, but there is one now unknown and unpatronized, who will astonish, terrify, and delight all Europe'. See John Thomas Smith, *Nollekens and his Times* ed. Wilfred Whitten, London and New York, 1920, vol. 2, p. 341.

24 See David Hume to Hugh Blair, 20 May 1767, in *Letters of David Hume*, ed. Grieg, vol. 2, pp. 135–6: 'You may perhaps have heard, that Rousseau has elop'd . . . He is plainly mad; tho I believe not more so, than he has been all his Life. The Pamphlet you mention was wrote by one as mad as himself, and it was believed at first to be Tristram Shandy, but proves to be one Fuseli, an Engraver. He is a fanatical admirer of Rousseau'. On perceptions of Rousseau to this point, see Edward Duffy, *Rousseau in England: The Context for Shelley's Critique of Enlighten-*

ment, Berkeley and Los Angeles, 1979, pp. 9–31; also the sampling of opinion in James H. Warner, 'The Basis of J. J. Rousseau's Contemporaneous Reputation in England', *Modern Language Notes* 55 (1940), pp. 270–80.

25 Margaret Patrickson to Allan Cunningham, 14 September 1830, in *Fuseli Letters*, p. 519. On Armstrong's use of strong language and his influence on the painter, see J. E. Morpurgo, ed., *The Autobiography of Leigh Hunt*, London, 1948, p. 194: 'The poet condescended to be a great swearer, and Fuseli through it energetic to swear like him'; Thomas Taylor, ed., *The Autobiography and Memoirs of Benjamin Robert Haydon (1786–1846)*, London, 1926, vol. 1, p. 25: 'He swore roundly, a habit which he told me he contracted from Dr Armstrong.' For further accounts of Fuseli's habitual use of strong language, see G. E. Bentley, ed., *Blake Records*, 2nd ed., New Haven and London, 2002, p. 72.

26 Janet Sorensen, 'Vulgar Tongues: Canting Dictionaries and the Language of the People in Eighteenth-Century Britain', *Eighteenth-Century Studies* 37 (2004), p. 450.

27 'Etwas von mir? Komm, hier ist etwas trockne Eitelkeit: um der größte Maler meiner Zeit zu sein, habe ich, sagt Reynolds, nichts zu tun, als für ein paar Jahre nach Italien zu gehn'; Henry Fuseli to J. C. Lavater, 6 May 1768, in *Briefe*, ed. Muschg, pp. 143–4.

28 Knowles, *Life and Writings of Henry Fuseli*, vol. 1, p. 47. The matter of their disagreement was, given the anxieties around linguistic reform and the vulnerable social status of Scots in English society, a good deal more serious than Knowles allows. Armstrong's break with Wilkes had been over the latter's 'national Reflections' (see above, n. 22). Maloney, *George and John Armstrong*, gives a full account of the degree of social exclusion experienced by Armstrong, who as a Scot could not legally practise medicine in London and took up literary activities as an additional means of income. For the social alienation of Scots within Anglocentric culture, including a discussion of Armstrong's friend Tobias Smollett, see James G. Basker, 'Scottisms and the Problem of Cultural Identity in Eighteenth-Century Britain', *Eighteenth-Century Life* 15:1–2 (1991), pp. 81–95.

29 [Prince Hoare], 'Biographical Sketch of Henry Fuseli, Esq. RA', *The Monthly Mirror* 11 (1801), p. 7. See *Fuseli Letters*, p. 230 for the authorship of this essay. For similar comments see Knowles, *Life and Writings of Henry Fuseli*, vol. 1, pp. 47–8; see also the review of Knowles' biography in *Edinburgh Review* 54 (1831), p. 163; Allan Cunningham, *The Lives of the Most Eminent British Painters, Sculptors and Architects*, London, 1829–33, vol. 2, pp. 274–5.

30 Henry Fuseli, quoted in *Farington Diary*, vol. 2, p. 416 (27 November 1795); Farington later interpreted this as an admission that the painter lacked technical skills; see *Farington Diary*, vol. 5, p. 1894 (1 October 1802).

31 Henry Fuseli, 'Second Ode on Art', trans. in A. M. Atkins, '"Both Turk and Jew": Notes on the Poetry of Henry Fuseli, with Some Translations', *Blake: An Illustrated Quarterly* 16 (1983), pp. 209–10.

32 'Was du mit Wests Pylades und Orestes meinest, weißGott. Ist es denn möglich, daß der, welcher die Cartone von

Raphael geshen und den Anitnous und Apollo zu kenne denkt, daß der sich mit Beschreibung und Zerliederung dieser zahmen, ausdrucklosen, uncharakertistischen Marionette abgebe und Köpfe kopiere, von denen er endlich selber gesteht, daß sie nights taugen? Warum sezest du meinen Namen zu dem seinigen? Er hat viel, viel, sehr viel Praxis und Pinselgriff mehr als ich, und in der ungeheuren Menge von Figurenkocherei, die aus seiner Garküche zu Markte gekommen und täglich rauchend kommen, sind zwei oder dreo gute Dinge – aber gedacht hat er beinahe nie und Seele hat er nicht'; Henry Fuseli to J. C. Lavater, 14 June 1777, in *Briefe*, ed. Muschg, pp. 176–7. See also Helmut von Erffa and Allen Staley, *The Paintings of Benjamin West*, New Haven and London, 1986, no. 186.

33 *Farington Diary*, vol. 9, pp. 3207–8 (26 January 1808), quoted in von Erffa and Staley, *Paintings of Benjamin West*, p. 232.

34 In September 1770 the musicologist Charles Burney noted that he visited St Peters as part of a group of Grand Tourists including the historian William Beckford and Fuseli, and dined shortly after with Fuseli, Beckford, James Nevay and James Byres. See H. Edmund Poole, ed., *Music, Men, and Manners in France and Italy: Being the Journal Written by Charles Burney, Mus. D., During a Tour Through Those Countries*, London, 1969, p. 131 (journal for 22 September 1770); p. 132 (journal for 24 September 1770). It was customary for British artists to present an example of their work to either Byres or the banker or dealer Thomas Jenkins with a view to courting their friendship and support. Fuseli's gift may have been the drawing of an unspecified subject that was hanging, in a gilt frame, in Byres' waiting room in 1790. See the 'Inventory of the Furniture in the House of Mr James Byres at Rome', compiled ca. 1790 by Patrick Home, National Library of Scotland, DEP 181/1.

35 In 1808 Farington reported that George Pitt, Lord Rivers, was 'in his youth . . . a sort of pupil to Fuseli in Italy', which suggests some sort of role as a *cicerone*: see *Farington Diary*, vol. 9, p. 3196 (12 January 1808). Knowles notes only that they 'became very intimate' in Italy; *Life and Writings of Henry Fuseli*, vol. 1, p. 53.

36 Knowles attests that 'he got much employment from those Englishmen who resided at or visited Rome', naming Sir Robert Smyth (*Life and Writings of Henry Fuseli*, vol. 1, p. 50). On Coutts see Henry Fuseli to Thomas Coutts, Rome, November 1778; letters on the London market in the late 1920s, recorded in the papers of William T. Whitley, Department of Prints and Drawings, British Museum, vol. 5, no. 562. The letters are untraced and so it is difficult to demonstrate their authenticity. Fuseli is believed to have left Rome before November 1778. However, Fuseli reported to Farington in 1795 that Coutts had commissioned paintings from him 'which was a genteel way' of supporting his studies in Rome; *Farington Diary*, vol. 2, p. 416 (27 November 1795). In 1773 it was reported that he had turned down a commission for 1,500 guineas to copy 'a capital picture', and a year later Thomas Banks stated that 'he had pictures bespoke to the amount of £1,300'; John Cartwright to A. K. Dashwood, 12 May 1772, in *Fuseli Letters*, pp. 13–14; Thomas Banks to James

Northcote, 31 July 1771, in *Fuseli Letters*, p. 14. Such a price for a copy was not unknown: James Durno was expecting £1,000 for a copy after Raphael's *Transfiguration* that he completed in 1779; see Nicola Figgis, 'Raphael's "Transfiguration": Some Irish Grand Tour Associations', *Irish Arts Review* 14 (1998), pp. 53–6. In 1774 John Thorpe had reported that 'the English artists expect to make mountains of gold by their copies of it [the *Transfiguration*]'. He noted that George Romney was working on a copy, and that William Parry had sold one of his versions of the painting for as much as 400 guineas; John Thorpe to the eighth earl of Arundell, 16 November 1774, 30 July 1774 and (photocopy) 15 October 1774, Wiltshire County Record Office, Trowbridge, 2667/20 Box 3. In January 1774, Thorpe reported that 'A Mr Fusily is preparing to paint Several principal Scenes in Shakespear.' These seem to have been underway by June of that year, when Thorpe reported that Fuseli 'is painting scenes from Shakespear in figures as large as life'. These may be the '16 Shakespearstücke' that the artist mentioned as sold for 8,000 florins in a letter to Lavater in February of that year; John Thorpe to the eighth earl of Arundell, 15 January 1774, 4 June 1774, Wiltshire County Record Office, Trowbridge, 2667/20 Box 3; Henry Fuseli to J. C. Lavater, 4 February 1774, in Federmann, *Füssli*, p. 152. As £100 was reckoned to be worth 833 German florins in 1770, it can be estimated that Fuseli sold these works for around £960, or an average of £60 a piece, thus suggesting he must have been referring to paintings rather than drawings. For the exchange rate see Louis Dutens, *Journal of Travels Made Through the Principal Cities of Europe*, trans. John Highmore, London, 1782, p.xxii.

37 The *Macbeth* is recorded in letters to the patron by Ozias Humphry (apparently acting as an agent) (letters of ca.1776 and 1777, Library of the Royal Academy of Arts, London, HU/2/9, 93; *Fuseli Letters*, pp. 15–16). The name of the recipient is not noted, though it may have been Sir Harry Fetherstonhaugh, who was known to have been spending freely on art at the time and had previously acquired works through Humphry. See Library of the Royal Academy of Arts, London HU/2/43–44.

38 See the letters from Fuseli to Lavater, 4 November 1773, 'Zu Schrieben ist er nicht zu bringen, wenn ich ihm nicht Geld schicken muß', and from J. C. Lavater to Herder, 16 November 1774, in *Briefe*, ed. Muschg, p. 171.

39 Cunningham, *Lives of the Most Eminent British Painters*, vol. 2, p. 175.

40 See Frederick Antal, *Fuseli Studies*, London, 1956, esp. pp. 95–8.

41 For example, Samuel Johnson: 'This is one of the scenes which have been applauded by the criticks, and which will continue to be admired when prejudice shall cease, and bigotry give way to impartial examination'; *Johnson on Shakespeare*, ed. Arthur Sherbo, New Haven and London, 1968, vol. 2, p. 591. See also *Bell's Edition of Shakespeare's Plays*, ed. Francis Gentleman, London, 1774, vol. 7, p. 237; Edward Capell in *Notes and Various Readings to Shakespeare*, ed. John Collins, London, 1779–80, vol. 1, part 2, p. 47.

42 *General Advertiser*, clipping in the files of eighteenth-century exhibition reviews at the Witt Library, Courtauld Institute of Art, London, inscribed 'April 1777'.

43 Robert Edge Pine, *London Courant* (5 May 1781). On Shakespeare an illustration in the eighteenth century see T. S. R. Boase, 'Illustrations of Shakespeare's Plays in the Seventeenth and Eighteenth Centuries', *Journal of the Warburg and Courtauld Institutes* 10 (1947), pp. 83–108; W. Moelwyn Merchant, *Shakespeare and the Artist*, London, 1959, pp. 35–94; Colin Franklin, *Shakespeare Domesticated: The Eighteenth-Century Editions*, Aldershot, 1991, pp. 198–223.

44 Anonymous ('T. W.'), 'Observations upon the Tragedy of Macbeth', *British Magazine* 8 (1767), pp. 514–16; Elizabeth Montagu, *An Essay on the Writings and Genius of Shakespeare*, London, 1770, pp. 173–4; William Duff, *Critical Observations on the Writings of the Most Celebrated Original Geniuses in Poetry*, London, 1770, p. 189.

45 William Duff, *An Essay on Original Genius*, London, 1767, p. 141.

46 William Young Ottley, 'On the Character of Fuseli as an Artist', in Knowles, *Life and Writings of Henry Fuseli*, vol. 1, p. 425. See also Knowles, *Life and Writings of Henry Fuseli*, vol. 1, p. 399: 'these [the *Dioscuri*] chiefly regulated his proportions and influenced his style, although it must be acknowledged that, in the length of limbs, he frequently exceeded them.'

47 See Antal, *Fuseli Studies*, pp. 38–46 and passim.

48 See Petra Maisak, 'Henry Fuseli – "Shakespeare's Painter"', in *The Boydell Shakespeare Gallery*, ed. Walter Pape and Frederick Burwick, Bottrop, 1996, pp. 57–74 for comparable conclusions about Fuseli's rejection of exemplary narrative. There are important parallels here between Fuseli's pictorial methods and Lavater's developing physiognomic thought, which will 'have us focus on the human body so closely, yet with such a supposedly universal scope, that all narrative, discourse, and symbol are shut out, and we end up with a register of physical characteristics shorn of every specific context'; Alan C. Leidner, *The Impatient Muse: Germany and the Sturm und Drang*, Chapel Hill and London, 1994, p. 17.

49 Ulf Cederlöf, 'On an Unearthed Roman Group Portrait with Sergel, by Esprit Gibelin', in *Nationalmuseum Bulletin* 3 (1979), pp. 169–78. See also Matthew Craske, *Art in Europe 1700–1830: A History of the Visual Arts in an Era of Unprecedented Urban Economic Growth*, Oxford and New York, 1997, pp. 239–50; Jøregen Anderson, *De År i Rom: Abildgaard, Sergel, Füssli*, Copenhagen, 1989. It has been suggested that Rigaud actually served as the model for Sergel's model of a faun, which was the basis of the naked male figure lying down in the centre of this composition; see *Sergel*, exhibition catalogue, Nationalmuseum, Stockholm, 1990, p. 311. The identification of the modern-day artist as a satyr-like figure reappears with Fuseli's self-portrait drawing in that guise (undated; Tate) and, more tenuously, John Runciman's portrait of Alexander Runciman in profile in juxtaposition with a satyr (c. 1767–68; National Galleries of Scotland, Edinburgh). The sexualized image of the artist is a theme apparent in Sergel's portrait of John Francis Rigaud with a priapic sculpture (FIG. 151) and Fuseli's well-known drawing of the sculp-

50 See Michael Clark and Nicholas Penny, eds, *The Arrogant Connoisseur: Richard Payne Knight*, Manchester, 1982; Andrew Ballatyne, *Architecture, Landscape and Liberty: Richard Payne Knight and the Picturesque*, Cambridge, 1997, esp. pp. 86–109.

51 Ann Bermingham, 'Elegant Females and Gentleman Connoisseurs: The Commerce of Culture and Self-Image in Eighteenth-Century England', in *The Consumption of Culture 1600–1800: Image, Object, Text*, ed. Ann Bermingham and John Brewer, London and New York, 1995, p. 506.

52 On the slippage between political and sexual ideas of liberty in the eighteenth century see Randolph Trumbach, 'Erotic Fantasy and Male Libertinism in Enlightenment England', in *The Invention of Pornography: Obscenity and the Origins of Modernity*, ed. Lynn Hunt, New York, 1993, pp. 253–82; John Sainsbury, 'Wilkes and Libertinism', *Studies in Eighteenth Century Culture* 26 (1998), pp. 151–74; also Kathleen Wilson, *The Sense of the People: Politics, Culture and Imperialism in England 1715–1785*, Cambridge, 1995, pp. 219–25.

53 The election was held on 2 June 1772 (Library of the Royal Academy of Arts, London GA/1/64); he received fifteen votes, with only a single vote going to one of the other candidates, William Bell.

54 Although Barlow was generally referred to as a woodcarver in the early literature on Banks, his workshop was also employed in producing marble chimneypieces and carved ornaments, notably at the Mansion House around the time that the younger sculptor started his apprenticeship. See Sally Jeffery, *The Mansion House*, Chichester, 1993, p. 299 and pp. 126–7.

55 John Flaxman, 'An Address to the President and Members of the Royal Academy on the Death of Thomas Banks, Sculptor', in *Lectures on Sculpture*, London, 1865, p. 295; see also Cunningham, *Lives of the Most Eminent British Painters*, vol. 3, p. 85.

56 James Northcote, 'Autobiography', vol. 2, British Library, Add. MSS 47,791, f.80.

57 Thomas Banks to Sir Joshua Reynolds, 11 December 1773, copy at Library of the Royal Academy of Arts, London, CM/1/171 (17 January 1774); Thomas Banks to Sir William Chambers, 26 September 1772, reported in Library of the Royal Academy of Arts, London, CM/1/150 (31 December 1772). The council complied with Banks' request to delay sending a work until 1775 (Library of the Royal Academy of Arts, London CM/1/172, 17 January 1774; letter sent 21 March 1774, Library of the Royal Academy of Arts, London CM/1/173).

58 See Bell, *Annals of Thomas Banks*, pp. 39–40, 43–5; Pressly, *Fuseli Circle in Rome*, nos 50 and 51; W. O. Hassall and Nicholas Penny, 'Political Sculpture at Holkham', in *Connoisseur* 195 (1977), pp. 207–11; David Bindman, 'Thomas Banks's "Caractacus before Claudius"', *Burlington Magazine* 142 (2000), pp. 769–72.

59 *London Courant* (13 May 1780).

60 Though Banks states the work was despatched late in December 1774 (letter to Francis Milner Newton, 8 February 1775, copy at Library of the Royal Academy of Arts, London, CM/1/191 [6 March 1775]), it may have arrived late to the exhibition, as it is included among the omitted works at the end of the main catalogue. Banks failed to sell the work, which was acquired via lottery by Sir Thomas Gascoigne; see Terry F. Friedman, 'Sir Thomas Gascoigne and His Friends in Italy', *Leeds Art Calendar* 78 (1976), pp. 17–23.

61 See Thomas Banks to Nathaniel Smith, 4 February 1774, in Smith, *Nollekens and his Times*, vol. 2, p. 124; also Cunningham, *Lives of the Most Eminent British Painters*, vol. 3, pp. 90–1.

62 In general, accounts of ancient gems stressed their craftsmanship, authorial integrity and denial of illusionistic effects in favour of the core values of 'design'. In these respects, they conform to Reynolds' strictures on the character of ideal sculpture. See George Ogle, *Antiquities Explained: Being a Collection of Figured Gems Illustrated by Similar Descriptions Taken from the Classics*, London, 1737, vol. 1, pp. xviii–xix; P. J. Mariette, *Traité des Pierres Gravées*, Paris, 1750, vol. 1, pp. 35–40; Laurentius Natter, *A Treatise on the Ancient Method of Engraving on Precious Stones Compared with the Modern*, London, 1754, pp. x–xi.

63 See Alex Potts, *Flesh and the Ideal: Winckelmann and the Origins of Art History*, New Haven and London, 1994; also Chloe Chard, 'Effeminacy, Pleasure and the Classical Body', in *Femininity and Masculinity in Eighteenth-Century Art and Culture*, ed. Gill Perry and Michael Rossington Manchester, 1994, pp. 142–61.

64 See Chard, 'Effeminacy, Pleasure and the Classical Body', p. 154.

65 The exemplar in this respect was the antique relief of Antinous; see Claudia Tusch, "*Man muß mit ihnen, wie mit seinem Freund, bekannt geworden seyn . . .*": *Zum Bildnes Johann Joachim Winckelmanns von Anton von Maron*, Mainz, 1995, pp. 59–73.

66 Bell, *Annals of Thomas Banks*, pp. 40–1; Pressly, *Fuseli Circle in Rome*, no. 53.

67 See Carolyn D. Williams, 'Breaking Decorums: Belinda, Bays and Epic Effeminacy', in *Pope: New Contexts*, ed. David Fairer, Hemel Hempstead, 1990, pp. 59–79; Carolyn D. Williams, *Pope, Homer and Manliness: Some Aspects of Eighteenth-Century Learning*, London and New York, 1993. See also Yvonne Noble, 'Sex and Gender in Gay's *Achilles*', in *John Gay and the Scriblerians*, ed. P. Lewis and N. Woods, London, 1988, pp. 184–215.

68 [John Gordon], *Occasional Thoughts on the Study and Character of Classical Authors*, London, 1762, p. 92n.

69 On Sergel in Rome see Elly Setterqvist O'Brien, *Johan Tobias Sergell (1740–1814) and Neoclassicism: Sculpture of Sergell's Years Abroad, 1767–1779*, Ann Arbor, 1991; Magnus Olaussen, 'The Launching of Johan Tobias Sergel in Sweden', *Nationalmuseum Bulletin* 14 (1990), pp. 77–87.

70 On the hieroglyph in the discourse of primitivism, see Frances S. Connelly, *The Sleep of Reason: Primitivism in Modern European Art and Aesthetics, 1725–1907*, University Park, 1995, pp. 37–54.

71 See Schiff, *Johann Heinrich Füssli*, nos 618–29.

72 For example, Francesco Algarotti refers to 'the five points,

in which the head, hands and feet of a figure are to be placed,' as the 'most useful' of the traditional exercises that could be recommended as 'The Recreations of a Painter'; *An Essay on Painting*, London, 1764, p. 175.

73 [Hoare], 'Biographical Sketch of Henry Fuseli, Esq. RA', p. 7.

74 Linda Williams, 'Film Bodies: Gender, Genre, and Excess', in *Film Theory and Criticism: Introductory Readings*, ed. Leo Braudy and Marshall Cohen, 5th ed., New York and Oxford, 1999, p. 702.

75 Charles Dufresnoy, *De Arte Graphica*, trans. John Dryden, in *The Works of John Dryden*, ed. Edward Niles Hooker, H. T. Swedenberg et al., Berkeley, Los Angeles and London, 1956–89, vol. 20, p. 271.

76 See Michael Rosenthal, *The Art of Thomas Gainsborough: 'a little business for the eye'*, New Haven and London, 1999, pp. 249–70, whose discussion of Gainsborough's disregard for 'the propriety of media' is suggestive in this context. On drawing as a private medium see John Barrell, 'The Private Comedy of Thomas Rowlandson', in *The Birth of Pandora and the Division of Knowledge*, Basingstoke, 1992, pp. 1–24.

77 On Jefferys see Timothy Clifford and Susan Legouix, 'James Jefferys, Historical Draughtsman (1751–84)', *Burlington Magazine* 118 (1976), pp. 148–57; *The Rediscovery of an Artist: The Drawings of James Jefferys (1751–84)*, exhibition catalogue, Victoria and Albert Museum, London, 1976. For Romney's drawings see Alex Kidson, *George Romney, 1734–1802*, exhibition catalogue, National Portrait Gallery, London, 2002, nos 59–76.

78 Leidner, *The Impatient Muse*, pp. 4–5, in relation to the Sturm und Drang in Germany; see also Leidner's comments on a generation 'more interested in effectiveness than the truth' (p. 8).

79 Cunningham, *Lives of the Most Eminent British Painters*, vol. 5, pp. 148–9.

80 See particularly David A. Cross, ' "The Admiral of the Blues": Romney, Depression and Creativity', in *Those Delightful Regions of the Imagination: Essays on George Romney*, ed. Alex Kidson, New Haven and London, 2002, p. 19; and, in the same volume, William L. Pressly, 'Romney's "Peculiar Powers for Historical and Ideal Painting" ', p. 124.

81 *St James's Chronicle* (9–11 May 1780).

82 Kathleen Wilson, *The Island Race: Englishness, Empire and Gender in the Eighteenth Century*, London and New York, pp. 58–62.

83 In his authoritative monograph, Gert Schiff has tentatively claimed that this must be the extant *Macbeth and the Armed Head*, a rather small painting, chosen presumably on the grounds that it was the only extant oil painting of a Macbeth subject that Schiff felt confident dating to the 1770s; Schiff, *Johann Heinrich Füssli*, no. 363. This canvas measures only 94 × 118. The painting is not in Stratford, as stated by Schiff, but in the Fabrizio Apollari, Rome. See David H. Weinglass, 'Preliminary Renumbered and Revised Fuseli Catalogue Raissoné', typescript 1992, copy at the Paul Mellon Centre for British Art, London, no. 486. However, the *London Chronicle* (24–26 April 1777) and

the *General Advertiser* (clipping dated 1777, as n. 42) both remarked that the figure of Macbeth was larger than life-size – so the overall size of the canvas must have been enormous. This makes sense of Ozias Humphry's claim to the unidentified patron that it was 'one of the most considerable productions of the present age'; Humphry to an unknown correspondent, ca.1777, Library of the Royal Academy of Arts, London, HU/2/93. It also explains Edmund Garvey's recollection of seeing, with Gainsborough, Fuseli's 'Large picture of Macbeth' at the academy; *Farington Diary*, vol. 6, p. 2245 (15 February 1804). As Gainsborough died in 1788, the only other Macbeth paintings by Fuseli he could have seen at the Royal Academy do not qualify as 'large'. Listed among Byres' paintings was 'Macbeth & the Witches by Fuseli'; 'A Note of the Property of James Byres Esqr of Tonley left by Patrick Moir in the Scotch College at Rome to the Care of the Revd Mr Paul Macpherson', National Library of Scotland DEP 184/1. A note 'got X' indicates that the painting was shipped eventually back to Britain, although there is no information about the scale of this work.

84 *Morning Chronicle* (28 April 1777).

85 'Gaudenzio', *St James's Chronicle* (24–26 April 1777).

86 *General Advertiser* (clipping dated 1777, as n. 42).

87 Schiff, *Johann Heinrich Füssli*, nos 475–8. For alternative accounts of the Shakespeare frescoes as statements about artistic expression and method, see Irene H. Chayes, 'Between Reynolds and Blake: Eclecticism and Expression in Fuseli's Shakespeare Frescoes', *BRH: Bulletin of Research in the Humanities* 85 (1982), pp. 140–68; Karen Junod, 'Henry Fuseli's Pragmatic Use of Aesthetics: His Epic Illustrations of *Macbeth*', *Word and Image* 19 (2003), pp. 148–9.

88 See Peter Tomory, *The Life and Art of Henry Fuseli*, London, 1972, p. 50, for an interpretation of the iconography of this image and *Fuseli Letters*, pp. 17–19, for the letter to Northcote, dated 29 September 1778.

PART THREE

'A WEAK DISJOINTED AGE': THE STATE OF THE ARTS, 1775–85

1 Horace Walpole to Horace Mann, 20 March 1775, in *Yale Edition of Horace Walpole's Correspondence*, ed. W. S. Lewis, Oxford and New Haven, 1937–83, vol. 24, p. 86.

2 John Harris, first earl of Malmesbury, to Thomas Robinson, second lord Grantham, 14 February 1777, Bedfordshire and Luton Archives and Records Service, L 30/15/26/8.

3 George Crabbe, 'The News-Paper', ll.1–4, in *George Crabbe: The Complete Poetical Works*, eds. Norma Dalrymple-Champneys and Arthur Pollard, Oxford, 1988, vol. 1, p. 181. See also the editors' notes, p. 671, quoting a professional report of 1820: 'By a strong competition for public fervour (which commenced prior to the termination of the American war, and from the years 1785–93) the Journals underwent a most material change . . . Information from all quarters was eagerly sought, and as readily

given to the Editors of the daily Journals, among whom, as with their readers, party spirit rose to the utmost height.'

4 See James Raven, *Judging New Wealth: Popular Publishing and Responses to Commerce in England, 1750–1800*, Oxford, 1992, pp. 176–8; Joanna Innes, 'Politics and Morals: The Reformation of Manners Movement in Later Eighteenth-Century England', in *The Transformation of Political Culture: England and Germany in the Late Eighteenth Century*, ed. Eckhart Hellmuth, Oxford, 1990, pp. 57–118.

5 See Christie and Ansell, 3–4 April 1776, first day's sale, lot 70 (annotated copy in Christie's Archive); James Cummings to Sir James Grant, 8 April 1776, in William Fraser, *The Chiefs of Grant*, Edinburgh, 1883, vol. 1, p. 445. The picture was subsequently sold for £100 to Sir John Dalrymple, having been declined for a higher price by a 'Lord F.'. See James Cummings to Sir James Grant, 31 October 1784, National Archives of Scotland, GD 248/229/11/17; Sir John Dalrymple to Sir James Grant, November 1784, National Archives of Scotland, GD 248/229/2/33. The following year James Nevay's painting of *Agrippina* went up for auction and, despite being catalogued erroneously as a work by Gavin Hamilton, sold for the trifling sum of three pounds; Christie and Ansell, 24–25 January 1777, second day's sale, lot 91. The actual identity of the picture is revealed in William Parsons to Isabella Hadfield, 4 February 1777, Library of the Royal Academy of Arts, London, HU/2/51, and James Irvine to George Cumberland, 10 February 1781, British Library, Add. MSS 36,493, f.128. It should be noted, also, that Pompeo Batoni's picture of *Hector's Farewell to Andromache*, which had been commissioned with Hamilton's *Adromache*, sold in London for a reported seventy pounds in the mid-1770s; see Edgar Peters Bowron, *Pompeo Batoni: A Complete Catalogue of His Works*, ed. Anthony M. Clark, Oxford, 1985, no. 222.

6 *European Magazine* 1 (1782), p. 95.

7 William Watts to Matthew Gregson, 17 October 1779, Liverpool Record Office, GRE 2/20/6. Watts is quoting Shakespeare's *The Merchant of Venice*, Act II, Scene V, Shylock to Launcelot, on hearing there may be masques approaching: 'Hear you me, Lock up my doors; and when you hear the drum, And the vile squeaking of the wry-necked fife . . . stop my house's ears.' See, similarly, Joseph Wright of Derby to Daniel Daulby, 31 December 1779, complaining of the low prices for paintings: 'the scarcity of money of late lowerd the value of art & we must do as we can, when we cant do as we wish'; Derbyshire Local Studies Library, Ms. 8962. On the context of the Watts–Gregson correspondence see H. A. Taylor, 'Matthew Gregson and the Pursuit of Taste', *Transactions of the Historic Society of Lancashire and Cheshire* 110 (1959), pp. 157–76.

8 In July of that year the Grand Tourist Thomas Pelham reported that all the English were leaving Rome so that soon he would have the Piazza de Espagna 'quite to myself'; Thomas Pelham to Thomas, Lord Pelham, 12 July 1777, British Library, Add. MSS 33,127, f.275. At the beginning of 1778 the bishop of Derry, a very significant patron of the arts in Italy, noted that 'there seems to be no possibility of escaping a French war' and that consequently the English and French were fleeing; Frederick Augustus Hervey, earl of Bristol and bishop of Derry, to Mrs J. Thomas Foster, 28 January 1778, in *The Two Duchesses: Georgiana Duchess of Devonshire, Elizabeth Duchess of Devonshire, Family Correspondence 1777–1859*, ed. Vere Foster, London, 1898, pp. 33–4. Soon afterwards Lady Phillipina Knight reported that 'we have very few English here except artists'; Lady Phillipina Knight to Mrs Drake, 8 August 1778, in *Lady Knight's Letters from France and Italy 1776–1795*, ed. Lady Eliott-Drake, London, 1905, p. 64. See also Horace Mann to Horace Walpole, 7 July 1779, in *Walpole Correspondence*, vol. 24, p. 497: 'The concourse of English must surely recede, especially now the French are interdicted.'

9 David Allan to the earl of Buchan, 3 December 1780, University of Edinburgh Library, La.IV.26 (1).

10 George Heriot to Sir James Grant, 14 September 1777, National Archives of Scotland, GD 248/54/5/63.

11 Charles Burney to Thomas Twining, 25 December 1784, in *The Letters of Dr Charles Burney*, ed. Alvaro Ribeiro, Oxford, 1991–, vol. 1, p. 458.

12 Horace Walpole to Horace Mason, 7 May 1783, in *Walpole Correspondence*, vol. 29, p. 299. Cf. Elizabeth Carter to Elizabeth Montagu, 22 September 1783, in *Letters from Mrs Elizabeth Carter to Mrs Montagu, Between the Years 1755 and 1800*, London, 1817, vol. 3, p. 203:

> We have now pretty well got rid of the foreign troops from America, which for some time crowded our streets, and devoured our provisions. Indeed, I am on many accounts glad they are gone. I could not help shuddering at the sight of such a number of soldiers, just arrived from the lawless region of violence, rapine, and bloodshed. May we never more, I pray, have any national connection with it!

The impact of disbanded soldiers on the social order was a widely discussed issue in 1783–84 and formed one of the plagues visited on modern England in the metaphorically and literally harsh winter recorded by William Cowper in 'The Task', Part II, ll.652–8, in *The Poems of William Cowper*, ed. John D. Baird and Charles Ryskamp, Oxford, 1980–95, vol. 2, p. 202:

> To swear, to game, to drink, to shew at home
> By lewdness, idelness, and sabbath-breach,
> The great proficiency he made abroad,
> T'astonish and to grieve his gazing friends,
> To break some maiden's and his mother's heart,
> To be a pest where he was useful once,
> Are his sole aim, and all his glory now.

Statistical research suggests that such fears were well founded. Crime levels did rise considerably during times of peace in the eighteenth century, with the situation becoming particularly dire in the wake of the American war. See J. M. Beattie, *Crime and the Courts in England*, Oxford, 1986, esp. pp. 223–5 and 582–92.

13 Kenneth Garlick et al., eds, *The Diary of Joseph Farington*, New Haven and London, 1978–98, vol. 4, p. 1124 (1 January 1799).

14 Edward Fryer, *The Works of James Barry*, London, 1809, vol. 2, p. 248.

15 Fryer, *Works of James Barry*, vol. 2, p. 252. See John Barrell, *The Political Theory of Painting from Reynolds to Hazlitt: 'The Body of the Public'*, New Haven and London, 1986, pp. 163–221 for a full discussion of these points.

16 See William L. Pressly, *The Life and Art of James Barry*, New Haven and London, 1981, pp. 86–122; D. G. C. Allan, 'The Chronology of James Barry's Works for the Society's Great Rooms', in *The Virtuoso Tribe of Arts and Sciences: Studies in the Eighteenth-Century Work and Membership of the London Society of Arts*, ed. D. G. C. Allan and J. L. Abbott, Athens, Georgia and London, 1992, pp. 336–58.

17 Fryer, *Works of James Barry*, vol. 2, p. 323.

18 *General Advertiser* (15 January 1778).

19 John Thomas Smith, *Nollekens and his Times*, ed. Wilfred Whitten, London and New York, 1920, vol. 2, pp. 280–1; quoted in David Alexander and Richard T. Godfrey, *Painters and Engraving: The Reproductive Print from Hogarth to Wilkie*, exhibition catalogue, Yale Center for British Art, New Haven, 1980, p. 48. On Barry's resistance to the commercial function of engraving, see Saree Makdisi, *William Blake and the Impossible History of the 1790s*, Chicago and London, 2003, pp. 147–8, and the wider discussion in Morris Eaves, *The Counter-Arts Conspiracy: Art and Industry in the Age of Blake*, Ithaca, New York, and London, 1992.

20 *Morning Chronicle* (29 May 1792).

21 Pressly, *Life and Art of James Barry*, p. 122.

22 Thomas Twining to Charles Burney, 5 July 1783, in *A Selection of Thomas Twining's Letters 1734–1804: The Record of a Tranquil Life*, ed. Ralph S. Walker, Lewiston, Queenston, Lampeter, 1991, vol. 1, pp. 250–1.

23 Charles Burney to Thomas Twining, 6 September 1783, in *The Letters of Dr Charles Burney*, ed. Ribeiro, vol. 1, pp. 379–80.

24 The first six books of Rousseau's *Confessions* were published in English in 1782 to general disdain, compounding his image as an eccentric and outsider. See Edward Duffy, *Rousseau in England: The Context for Shelley's Critique of Enlightenment*, Berkeley and Los Angeles, 1979, pp. 32–4.

25 Fanny Burney to Susanna Elizabeth Burney, 11 November 1781, in *The Early Journals and Letters of Fanny Burney*, ed. Lars E. Troide, Oxford 1988, vol. 4, part 2, p. 502, Although 'potatoe' was a generally pejorative term, its use by Charles Burney in the letter quoted above may be racially motivated, as the term certainly was put in use against the Irish; see J. O. Bartley, *Teague, Shenkin and Sawney: Being on Historical Study of the Earliest Irish, Welsh and Scottish Characters in English Plays*, Cork, 1984, p. 194. On stereotypes of the Irish as belligerent, see particularly Joseph Theodoor Leerssen, *'Mere Irish & Fio Ghael': Studies in the Idea of Irish Nationality. Its Development and Literary Expression Prior to the Nineteenth Century*, Amsterdam, 1986, pp. 160–6, who pertinently points to the queasy acceptance of Irish quick-temperedness as a sign of noble feeling after about 1775.

26 John Williams (as 'Anthony Pasquin'), *The Royal Academicians: A Farce, as it Was Performed, to the Astonishment of Mankind, by His Majesty's Servants, at the Stone House, in Utopia, in the Summer of 1786*, London, 1786, pp. 23–4.

27 Ann Hunter, 'Lines addressed to James Barry, Esq, Professor of Historical Painting in the Royal Academy, London, on the Subject of his Series of Pictures on Human Culture; painted for the Society of Arts and Sciences', *Morning Post*, (22 May 1784); reprinted as 'To James Barry, Esq., On the Design of his Series of Pictures Painted for the Society Instituted for the Promoting Arts and Manufactures', in Ann Hunter, *Poems, by Mrs John Hunter*, 2nd ed., London, 1803, p. 70.

8 THE AMERICAN WAR AND THE HEROIC IMAGE

1 Mary Shackleton, 'The Journal & Diary of Mary Shackleton 1784 Ballitore', p. 90, National Library of Ireland MS 9310, published as 'A Tour Through Part of England, by Mary Shackleton, in the Year 1784', *Pennsylvania Magazine of History and Biography* 40:2 (1916), pp. 144–5. On Shackleton see Mary Leadbeater, *The Leadbeater Papers*, with a new introduction by Maria Luddy, 2 vols, London, 1998.

2 Mary Shackleton, National Library of Ireland, MS 9310, pp. 100, 102.

3 Mary Shackleton, National Library of Ireland, MS 9310, pp. 106–11.

4 Permission for its erection being granted in February 1782; Westminster Abbey Muniments Room, chapter book (1777–90), 26 February 1782. The fine was paid by Vangelder on 23 September; Westminster Abbey Muniments Room, 'Funeral Fees'.

5 On the circumstances of André's arrest and execution and interpretations of his cultural representation see Sarah Knott, 'Sensibility and the American War for Independence', *American Historical Review* 109 (2004), pp. 19–40; Harry M. Ward, *Between the Lines: Banditti of the American Revolution*, Westport, CT, and London, 2002, pp. 27–9; Larry J. Reynolds, 'Patriots and Criminals, Criminals and Patriots: Representations of the Case of Major André', *South Central Review* 9 (1992), pp. 57–84; Andy Tees, 'Benedict Arnold, John André and his Three Yeoman Captors: A Sentimental Journey or American Virtue Defined', *Early American Literature* 35 (2000), pp. 246–73.

6 Hon. George Damer to Lord George Germain, 13 October 1780, in *Report on the Manuscripts of Mrs Stopford-Sackville of Drayton House, Northamptonshire*, Historical Manuscripts Commission 49, vol. 2, 1910, p. 184.

7 Ira D. Gruber, ed., *John Peebles' American War: The Diary of a Scottish Grenadier, 1776–1782*, Stroud, 1998, p. 411.

8 On the Mutius analogy, see also Winthrop Sargent, *The Life and Career of Major André*, ed. William Abbatt, New York, 1902, p. 455. Mutius was 'famous in Roman history for his courage and intrepidity'. While Rome was besieged by Porsenna, king of Etruria, Mutius disguised himself and entered the enemy camp. Captured in a bungled attempt to

kill the king, he was brought before Porsenna: 'He disdained to answer the enquiries of the courtiers, but told them he was a Roman, and to give them a proof of his fortitude, he laid his right hand on an altar of burning coals, and sternly looking at the king, and without uttering a groan, he boldly informed him, that 300 young Romans like himself had conspired against his life, and entered his camp in disguise, determined either to destroy him, or perish in the attempt'; John Lemprière, *Bibliotheca Classica; Or, A Classical Dictionary*, 2nd ed., London, 1792.

9 Letter of Major Tallmadge, 1 October 1780, quoted in *Andreana: Containing the Trial, Execution and Various Matter Connected with the History of Major John Andre*, Philadelphia, 1865, p. 65.

10 Shackleton had bought her copy in November 1782. See National Library of Ireland MS 9308, 'The Ladies Most elegant and Convenient Pocket Book for the Year 1782', p. 108, where a page of accounts includes 'Elegy on Major André 1.1'.

11 Anna Seward, 'Monody on Major Andre', in *The Poetical Works of Anna Seward*, ed. Walter Scott, Edinburgh, 1810, vol. 2, p. 84.

12 Anna Seward, 'Monody on Major Andre', in *Poetical Works of Anna Seward*, ed. Scott, vol. 2, p. 88.

13 Harriet Guest, *Small Change: Women, Learning, Patriotism, 1750–1810*, Chicago and London, 2000, p. 261.

14 There were even immediate sculptural precedents for the subject of Mutius before Porsenna. It had been the set topic of the competition for clay bas-reliefs at the Society of Arts in 1764 (Library of the Royal Society of Arts, London, MC62/63, pp. 33–4, 17 February 1763) and Joseph Wilton had exhibited a model for the subject at the Royal Academy in 1773 that was said to express 'all that firmness of soul in the face which one is led to expect must mark so great a character'; *Middlesex Journal* (1–4 May 1773).

15 The prosaic, modern-dress features of Vangelder's Monument find comparison in the monument to Cornet Francis Geary in St Nicholas, Great Bookham, Surrey, showing him being shot down by American troops. See Henry Graham, *History of the Sixteenth, The Queen's Light Dragoons (Lancers), 1759 to 1912*, Devizes, 1912–26, vol. 1, p. 330. A further example of this prosaic, even anti-heroic mode is Roubiliac's monument to Lieutenant Stapleton, St Peter's Church, Port Royal, Jamaica; see David Bindman and Malcolm Baker, *Roubiliac and the Eighteenth-Century Monument: Sculpture as Theatre*, New Haven and London, 1995, pp. 168–9.

16 *Morning Herald* (16 November 1780).

17 This is the version given in *An Historical Description of Westminster Abbey, its Monuments and Curiosities*, London, 1783, p. 98; *Gentleman's Magazine* 52 (1782), p. 514; *Universal Magazine* 71 (1782), p. 329. An alternative reading of the time suggested that the scene showed Washington with a letter from André requesting that he be shot rather than hung: see James Ralph, *A Critical Review of the Public Buildings, Statues, and Ornaments, in and About London and Westminster*, rev. ed., London, 1783, p. 115.

18 See John Dryden, 'An Epitaph, On Sir Palmes Fairborne's

Tomb in Westminster Abbey', in *The Poems of John Dryden*, ed. James Kinsley, Oxford, 1958, vol. 2, pp. 845–6.

19 Arthur Penrhyn Stanley, *Historical Memorials of Westminster Abbey*, 8th ed., London, 1924, pp. 223–4.

20 On the cultural aspects of George III's attempts to rehabilitate the image of monarchy see William Weber, 'The 1784 Handel Commemoration as Political Ritual', *Journal of British Studies* 28 (1989), pp. 43–69.

21 Thomas Maurice, *Westminster-Abbey: An Elegiac Poem*, London, 1784, pp. 8–9.

22 *Lady's Magazine* 13 (1782), p. 558.

22 Ruth Michaelis-Jena and Willy Mersor, *A Lady Travels: Journeys through England and Scotland from the Diaries of Joanna Schopenhauer*, London, 1988, p. 222; Peter Cunningham, *Westminster Abbey; its Art, Architecture, and Associations: A Handbook for Visitors*, London, 1842, p. 68.

24 *British Magazine and Review* 1 (November 1782), pp. 331–2.

25 Edward Wedlake Brayley and John Preston Neale, *The History and Antiquities of the Abbey Church of St Peter, Westminster*, London, 1818–23, vol. 2, p. 241. See also John Thomas Smith, *Nollekens and his Times*, ed. Wilfred Whitten, London and New York, 1920, vol. 1, pp. 146, 150; B. Lambert, *The History and Survey of London and its Environs*, London, 1806, vol. 3, p. 413; 'C.B.', *Gentleman's Magazine* 71 (1801), p. 623; James Peller Malcolm, *Londinium Redivivus: Or, An Antient History and Modern Description of London*, London, 1802–7, vol. 1, p. 167. By 1884 it was reported that the heads of Washington and André had each been replaced three times, and this time the damage was blamed on American tourists 'taking home samples of what they see in the "old country"'; *Times* (9 June 1884) p. 9.

26 John Quincy Adams to Elizabeth Cranch, 18 April 1784, in *Adams Family Correspondence*, ed. Richard Alan Ryerson et al., Cambridge, Mass., and London, 1963–93, vol. 5, p. 323.

27 Sophie La Roche, *Sophie in London, 1786: Being the Diary of Sophie V. La Roche*, trans. Clare Williams, London and Toronto, 1936, pp. 116–17 (8 September 1786).

28 'An Anglo-Saxon', *The Duty of a Freeman, addressed to the electors of Great Britain*, London, ca.1780, quoted in Eliga H. Gould, *The Persistence of Empire: British Political Culture in the Age of the American Revolution*, Chapel Hill and London, 2000, p. 179.

29 See Dror Wahrman, 'The English Problem of Identity in the American Revolution', *American Historical Review* 106 (2001), pp. 1236–62; Dror Wahrman, *The Making of the Modern Self: Identity and Culture in Eighteenth-Century England*, New Haven and London, 2004, esp. pp. 221–7. See also Stephen Conway, 'From Fellow-Nationals to Foreigners: British Perceptions of the Americans, circa 1739–1783', *William and Mary Quarterly* 59 (2002), pp. 64–100.

30 See Troy A. Bickham, 'Sympathizing with Sedition? George Washington, the British Press, and British Attitudes during the American War of Independence', *William and*

Mary Quarterly 59 (2002), pp. 101–22.

31 *European Magazine* 5 (April 1784), p. 248.

32 *Gentleman's Magazine* 52 (October and November 1782), pp. 464, 500. The monument is documented in Philip Ward-Jackson, *Public Sculpture of the City of London*, Liverpool, 2003, pp. 166–9.

33 [Court of Common Council, City of London], *City Petitions, Addresses, and Remonstrances &c &c*, London, 1778, pp. iii–iv; the petitions regarding the burial of Pitt and the king's reply are presented at the end of the volume, pp. 202–6. See Ward-Jackson, *Public Sculpture of the City of London*, pp. 166–9.

34 See Marie Peters, *The Elder Pitt*, London and New York, 1998, pp. 216–27.

35 William Pitt, first earl of Chatham, in Parliament, 5 December 1777, cited, together with a series of similar statements, in Marie Peters, 'The Myth of William Pitt, Earl of Chatham, Great Imperialist. Part II: Chatham and Imperial Reorganisation 1763–78', *Journal of Imperial and Commonwealth History* 21 (1993), p. 410.

36 Horace Walpole to Horace Mann, 31 May 1778, in *Yale Edition of Horace Walpole's Correspondence*, ed. W. S. Lewis, Oxford and New Haven, 1937–83, vol. 24, p. 382 (referred to henceforth as *Walpole Correspondence*). On Pitt's reputation at the time of his death see Peters, *The Elder Pitt*, pp. 216–27.

37 *Morning Post* (13 May 1778); *St James's Chronicle* (26–28 May 1778); *Morning Chronicle* (10 June 1778). See also Horace Walpole to Horace Mann, 7 July 1778, in *Walpole Correspondence*, vol. 24, p. 393.

38 *The Parliamentary Register*, London, 1802, vol. 8 (for 1778), pp. 285–6.

39 See William Stanhope Taylor and John Henry Pringle, eds, *Correspondence of William Pitt, Earl of Chatham*, London, 1838–40, vol. 4, p. 524n.

40 'Some Account of Colonel Barré', *London Magazine* 49 (1780), pp. 195–6. See also Horace Walpole, *Memoirs of the Reign of King George the Third*, ed. G. F. Russell Barker, London, 1894, vol. 1, p. 86.

41 Lewis Namier and John Brooke, *The History of Parliament: The House of Commons 1754–1790*, London, 1964, vol. 2, pp. 356–57.

42 'Ridens', *Morning Post* (20 May 1778).

43 George III to Lord Frederick North, 12 May 1778, in *The Correspondence of King George the Third from 1760 to December 1783*, ed. John Fortescue, London, 1927–28, vol. 4, pp. 139–40.

44 See William L. Pressly, *The Life and Art of James Barry*, New Haven and London, 1981, 'Catalogue of Prints', no. 14 and p. 82.

45 *European Magazine* 2 (1782), p. 317; *Gazetteer and New Daily Advertiser* (12 October 1782) (18 October 1782).

46 Sophie La Roche, *Sophie in London*, pp. 124–5; see also D'Archenholz, *A Picture of England*, London, 1789, vol. 1, pp. 138–9.

47 William Cowper, 'The Task', Part II, ll. 233–54, in *The Poems of William Cowper*, ed. John D. Baird and Charles Ryskamp, Oxford, 1980–95, vol. 2, p. 145.

48 William Cowper to John Newton, 22 October 1783, in *The Letters and Prose Writings of William Cowper*, ed.

James King and Charles Ryskamp, Oxford, 1979–86, vol. 2, p. 174.

49 Mary Shackleton, National Library of Ireland, MS 9310, pp. 106–11.

50 See Nancy L. Pressly, *Revealed Religion: Benjamin West's Commissions for Windsor Castle and Fonthill Abbey*, exhibition catalogue, San Antonio Museum of Art, 1983; Helmut von Erffa and Allen Staley, *The Paintings of Benjamin West*, New Haven and London, 1986, pp. 577–81.

51 The painting therefore contrasts with George Carter's version of the subject of 1781, privately exhibited 1785 (Bishop Museum Library, Honolulu), which Edward Parkinson has aligned with 'unofficial' accounts of the tragedy, which emphasized Cook's more aggressive role. Zoffany's painting of around 1795 emphasized the physical dignity of both the English hero and his assailants (National Maritime Museum, London). See Edward Parkinson, 'Explorations and that Dangerous "Other": The Deaths of Captain Cook and Franklin', in John Rieder and Larry E. Smith, *Multiculturalism and Representation*, Honolulu, 1996, pp. 25–42. On Zoffany's painting see Bernard Smith, *European Vision and the South Pacific*, 2nd ed. New Haven and London, 1985, pp. 119–23.

52 Guest, *Small Change*, pp. 258–9. See also Kathleen Wilson, *The Island Race: Englishness, Empire and Gender in the Eighteenth Century*, London and New York, 2003, esp. pp. 54–91. The importance of Cook's death as a 'public spectacle' viewed by his crew and by the islanders is stressed by Parkinson, 'Explorations and that Dangerous "Other"'.

53 James Northcote, British Library, Add. MSS 47,792 f.14v.

54 Captain Inglefield, *Capt. Inglefield's Narrative Concerning the Loss of His Majesty's Ship the Centaur*, London, 1783, pp. 25–6.

55 *British Magazine and Review* 2 (1783), p. 50.

56 *General Evening Post* (24–27 April 1784).

57 For the pictorial tradition of the shipwreck see Laurence Otto Goedde, *Tempest and Shipwreck in Dutch and Flemish Art: Convention, Rhetoric, and Interpretation*, Pennsylvania and London, 1989, pp. 47–100; T. S. R. Boase, 'Shipwrecks in English Romantic Painting', *Journal of the Warburg and Courtauld Institutes* 22 (1959), pp. 332–46.

58 See Emily Ballew Neff, *John Singleton Copley in England*, London, 1995, no. 4; see also Goedde, *Tempest and Shipwreck*, pp. 199–201.

59 The description from the *Leiden Gazette* was printed in *Gentleman's Magazine* 55 (1785), p. 403, and *Times* (16 May 1785). The latter is quoted and discussed in Martin Hopkinson's documentation of the painting, 'James Northcote's *The Death of Prince Maximillian Leopold of Brunswick*', *British Art Journal* 4 (2003), pp. 29–36.

60 *European Magazine* 9 (1786), pp. 210–11. Northcote's choice of subject and his treatment of the theme were subject to criticism though, an amusing and telling report appearing in the *Morning Post* of 3 May 1786: 'This picture is, like the general run of this gentleman's performances, an effort of insipidity. The moment is ill chosen – The Prince should have been represented in the attitude of extending his benevolence to those unhappy creatures,

whose impending fate he commiserated; and not in the character of a dead Mackrel.'

61 See Judy Egerton, *The British School (National Gallery Catalogues)*, London, 1998, pp. 218–27; David Mannings with Martin Postle, *Sir Joshua Reynolds: A Complete Catalogue of his Paintings*, New Haven and London, 2000, no. 1733; also, importantly, John Bonehill, 'Reynolds' *Portrait of Lieutenant-Colonel Banastre Tarleton* and the Fashion for War', *British Journal for Eighteenth-Century Studies* 24 (2001), pp. 123–44; Mark Hallett, 'Reading the Walls: Pictorial Dialogue at the British Royal Academy', *Eighteenth-Century Studies* 37 (2004), pp. 600–1.

62 Asa Bird Gardiner, *The Order of the Cincinnati in France: Its Organisation and History*, Rhode Island, 1905.

63 *European Magazine* 5 (1784), p. 72; also *European Magazine* 6 (1784), pp. 77–8; see Irma B. Jaffe, *John Trumbull: Patriot-Artist of the American Revolution*, Boston, 1975, p. 60.

64 On the formal grandeur of portraits as providing a kind of compensatory exemplarity, see David H. Solkin, 'Great Pictures or Great Men? Reynolds, Male Portraiture, and the Power of Art', *Oxford Art Journal* 9:2 (1986), pp. 42–9.

65 Banastre Tarleton to Bridget Tarleton, 15 April 1781, in Egerton, *The British School*, p. 222.

66 Horace Walpole to William Mason, 23 February 1782, in *Walpole Correspondence*, vol. 29, p. 189.

67 Horace Walpole to Horace Mann, 15 May 1778, in *Walpole Correspondence*, vol. 28, p. 394.

68 See Pressly, *Life and Art of James Barry*, pp. 58–62.

69 *Public Advertiser* (4 May 1776), quoted in Pressly, *Life and Art of James Barry*, p. 81.

70 G. A. Rosso, 'Empire of the Sea: "King Edward the Third" and English Imperial Policy', in *Blake, Politics and History*, ed. Jackie DiSalvo, G. A. Rosso and Chistopher Z. Hobson, New York and London, 1998, p. 268.

71 See Jaffe, *John Trumbull*; also, Helen A. Cooper et al., *John Trumbull: The Hand and Spirit of a Painter*, exhibition catalogue, Yale University Art Gallery, New Haven, 1982.

72 I wrote you by Mr Vaughan my intentions of composing a set of pictures containing the great events which have affected the revolution of America . . . I mean the arrangement of the subjects most expressive and most painted, as for instance – the cause of the Quarrel, the commencement of it, the carrying it on, the Battle, alliances &c &c – to form one work, to be given in eligent engravings – call'd, the American revolution – this work I mean to do at my own expence, and to imploy the first engravers in Europe to carry them into execution, not having the least dout, as the subject has engaged all the powers of Europe, all will be interested in seeing the event so portraid.

Benjamin West to Charles Willson Peale, 4 August 1783: Charles Robert Autograph Collection, Haverford College Library, Haverford, Pennsylvania (Archives of American Art, P88, fr.317). See von Erffa and Staley, *Paintings of Benjamin West*, nos 105–6; Arthur S. Marks, 'Benjamin West and the American Revolution', *American Art Journal* 6 (1974), pp. 15–35.

73 Cooper, *John Trumbull*, nos 7–9.

74 See David Bindman, 'Americans in London: Contemporary History Painting Revisited', in *English Accents: Interactions with British Art, c.1776–1855*, ed. Christiana Payne and William Vaughan, Aldershot, 2004, pp. 9–22.

75 Cooper, *John Trumbull*, nos 4–6 and 14–22.

76 See Bickman, 'Sympathizing with Sedition', p. 114.

77 Thomas Digges to Benjamin Franklin, 21 November [1780], in Leonard W. Labaree et al., eds, *The Papers of Benjamin Franklin*, New Haven and London, 1959–, vol. 34, pp. 39–40.

78 John Trumbull, *Autobiography, Reminiscences and Letters of John Trumbull from 1756 to 1841*, New York and London, 1841, p. 69.

79 Thomas Jefferson to Francis Hopkinson, 14 August 1786, in Julian P. Boyd et al., eds, *The Papers of Thomas Jefferson*, Princeton, 1950–, vol. 10, p. 250. Trumbull's own retrospective account makes nothing of the politically charged nature of the series and notes the admiration these pictures received from West and Reynolds; see Trumbull, *Autobiography*, pp. 93–5. Moreover, the prints were marketed in London; see the advertisement for the Montgomery and Bunker's Hill engravings in the *World*, 17 May 1792.

9 GOTHIC ROMANCE AND QUIXOTIC HEROISM: FUSELI IN THE 1780S

1 Brooke Boothby, 'Mr Boothby's description of a Midnight & poetic Pageant contrived & performed in Col. St George's woods this summer 1783 at an emmense expence of machinery &c to surprize & amuse the great Wizard Painter, Fuseley; who had no suspicion of ye scheme, so secret had been ye preparations. The rest of the Company, which was not large, had their cue to keep back among ye trees, & not interrupt the solemn ceremonies'; British Library, Add. MSS 61,842 ff.164v–166v. This handwritten description appears among a collection of manuscript and published poems and reviews relating to the literary circle of Lichfield. On Ryves see E. Owens Blackburne, *Illustrious Irishwomen: Being the Memoirs of Some of the Most Noted Irishwomen from the Earliest Ages to the Present Century*, London, 1877, vol. 2, pp. 225–31.

2 See Timothy Mowl, 'William Beckford: A Biographical Perspective', in *William Beckford, 1760–1844: An Eye for the Magnificent*, ed. Derek E. Ostergord, New Haven and London, 2002, pp. 25–6; more generally, Sybil Rosenfield, *Temples of Thespis: Some Private Theatres and Theatricals in England and Wales, 1700–1820*, London, 1978. On Gothic theatricals see also Jeffrey N. Cox, 'English Gothic Theatre', in *The Cambridge Companion to Gothic Fiction*, ed. Jerrold E. Hogle, Cambridge, 2002, pp. 125–44; Paula R. Backscheider, *Theatrical Power and Mass Culture in Early Modern England*, Baltimore and London, 1993, pp. 148–233.

3 According to John Knowles, the 1780 exhibits were 'to show what he could do' in invention and 'boldness of drawing', the qualities he perceived as lacking in West's

work; *The Life and Writings of Henry Fuseli*, London, 1831, vol. 1, pp. 62–3. For Fuseli's challenge to Reynolds in 1781 see Martin Myrone, 'The Sublime as Spectacle: The Transformation of Ideal Art at Somerset House', in *Art on the Line: The Royal Academy Exhibitions at Somerset House 1780–1836*, ed. David Solkin, New Haven and London, 2001, pp. 77–91.

4 Boothby, 'Mr Boothby's description of a Midnight & peotic Pageant . . .', British Library, Add. MSS 61,842, f.164v.

5 On the conventions of romance as understood from eighteenth-century perspectives see Eithne Henson, *"The Fictions of Romantick Chivalry": Samuel Johnson and Romance*, London and Toronto, 1992, pp. 19–52.

6 Boothby, 'Mr Boothby's description of a Midnight & poetic Pageant . . .', British Library, Add. MSS 61,842, f.165v.

7 Boothby, 'Mr Boothby's description of a Midnight & poetic Pageant . . .', British Library, Add. MSS 61,842, f.166.

8 Boothby had commissioned at least two paintings from Fuseli by 1785; a decade later, the painter still had savings from his 'employments' for that gentleman. See Henry Fuseli to Brooke Boothby, 15 January 1785, and Henry Fuseli to William Roscoe, 16 February 1795, in *The Collected English Letters of Henry Fuseli*, ed. David H. Weinglass, Millwood, NY, 1982 (referred to hereafter as *Fuseli Letters*), pp. 24–5 and p. 127.

9 David H. Weinglass posits that *Prints and Engraved Illustrations by and After Henry Fuseli: A Catelogue Raisonné*, Aldershot 1994, no. 70, was the picture exhibited in 1783, but the description of the exhibited painting in *Public Advertiser*, 10 May 1783, confirms that it was the Tate picture that was put on show.

10 See Adrian Stevens, 'Fiction, Plot and Discourse: Wolfram's *Parzival* and its Narrative Sources', in *A Companion to Wolfram's Parzival*, ed. Will Hasty, Drawer, 1999, esp. pp. 99–123.

11 See the relevant articles in Christopher W. Bruce, *The Arthurian Name Dictionary*, New York and London, 1999; Willem P. Gerritsen and Anthony G. van Melle, *A Dictionary of Medieval Heroes*, trans. Tanis Gant, Woodbridge, 1998.

12 Henry Fuseli to William Roscoe, 22 October, 1791, in *Fuseli Letters*, p. 74; also Knowles, *Life and Writings of Henry Fuseli*, vol. 1, p. 403. See Peter Tomory, *The Life and Art of Henry Fuseli*, London, 1972, pp. 92–5, for some suggested points of reference for Fuseli's characters. It is conceivable that Ezzelin and Meduna, Perceval and Belisane, Urma and Mona, as they appear in Fuseli's paintings of the early 1780s, may derive from some specific literary source; the point to be made is that, if so, that source is entirely obscure, and further that this obscurity was maintained by Fuseli.

13 See Lord Byron to Annabella Milbanke, 25 August 1814, and 'Journal', 20 March 1814, in *Byron's Letters and Journals*, ed. Leslie A. Marchand, London, 1973–94, vol. 4, pp. 161–2, and vol. 3, pp. 253–4.

14 Alexander Pope, *Guardian* 78 (10 June 1713), in *The Guardian*, ed. John Calhoun Stephens, Lexington, 1982, p.

288. The *Guardian* itself was frequently republished in the eighteenth century, and the 'Receit' also appeared in Pope's *Peri Bethous; or the Art of Sinking in Poetry* (1727).

15 See E. J. Clery, *The Rise of Supernatural Fiction 1762–1800*, Cambridge, 1995; James Watt, *Contesting the Gothic: Fiction, Genre and Cultural Conflict, 1764–1832*, Cambridge, 1999. Also Harriet Guest, 'The Wanton Muse: Politics and Gender in Gothic Theory After 1760', in *Beyond Romanticism: New Approaches to Texts and Contexts 1780–1832*, ed. Stephen Copley and John Whale, London and New York, 1992, pp. 118–39; Andrea K. Henderson, *Romantic Identities: Varieties of Subjectivity 1774–1830*, Cambridge, 1996; E. J. Clery and Robert Miles, eds, *Gothic Documents: A Sourcebook 1700–1820*, Manchester and New York, 2000; Gary Kelly, ed., *Varieties of Female Gothic*, 6 vols, London, 2002.

16 On aspects of Quixotism in eighteenth-century Britain see Henson, *"The Fictions of Romantick Chivalry"*; Lennard J. Davis, *Factual Fictions: The Origins of the English Novel*, Philadelphia, 1996; Wendy Motooka, *The Age of Reasons: Quixotism, Sentimentalism and Political Economy in Eighteenth-Century Britain*, London and New York, 1998; Ronald Paulson, *Don Quixote in England: The Aesthetics of Laughter*, Baltimore and London, 1998.

17 Tobias Smollett, *Roderick Random*, ed. David Blewett, London, 1995, p. 4.

18 William Warburton, 'The Editor to the Reader', in Thomas Keymer et al., *Samuel Richardson's Published Commentary on Clarissa 1747–65*, London, 1998, vol. 1, pp. 33–8.

19 [Thomas Leland], *Longsword, Earl of Salisbury: An Historical Romance*, London, 1762, vol. 1, 'Advertisement'. 'A New Edition' appeared in 1775.

20 Richard Hurd, *Letters on Chivalry and Romance*, London, 1762, pp. 10, 26–7.

21 Thomas Martyn, *Dissertations upon the Æneids of Virgil*, London, 1770, pp. i–ii.

22 Edward Burnaby Greene, *Critical Essays*, London, 1770, p. 138.

23 On the regulating role of taste see Tom Furniss, *Edmund Burke's Aesthetic Ideology: Language, Gender, and Political Economy in Revolution*, Cambridge, 1993, pp. 68–88. On male readers of Gothic romance see Henson, *"The Fictions of Romantick Chivalry"*; John Mullan and Christopher Reid, eds, *Eighteenth-Century Popular Culture: A Selection*, Oxford, 2000, pp. 7–10; also Clery, *Rise of Supernatural Fiction*, pp. 98–9.

24 Richard Graves, *The Spiritual Quixote*, ed. Clarence Tracy, London, 1967, p. 39.

25 See Gary Kelly, 'Clara Reeve, Provincial Bluestocking: From the Old Whigs to the Modern Liberal State', *Huntington Library Quarterly* 65 (2002), pp. 105–25; Kelly, *Varieties of Female Gothic*, vol. 1, pp. lxi–lxxx.

26 [Clara Reeve], *The Progress of Romance*, Colchester, 1785, vol. 1, p. 13.

27 Reeve, *Progress of Romance*, vol. 1 pp. 14, 22; vol. 2, pp. 86–7.

28 See Dror Wahrman, *Imagining the Middle Class: The Political Representation of Class in Britain, c.1780–1840*, Cambridge, 1995, pp. 60–73; also Dror Wahrman, *The Making of the Modern Self: Identity and Culture in Eigh-*

teenth-Century England, New Haven and London, 2004, pp. 146–53, with its adjustments to this argument.

29 John Trenchard and Thomas Gordon, *Cato's Letters: Or, Essays on Liberty, Civil and Religious, and other Important Subjects*, ed. Ronald Hamowy, Indianapolis, 1995, vol. 2, pp. 668–9.

30 'Umbra's Dialogues No. 1: Amadis de Gaule, Robinson Crusoe', *London Magazine* 51 (1782), p. 117. This is, perhaps, also to figure a clash between the middle-class and the aristocratic class: on Crusoe as representative figure of the 'middle' see Wahrman, *Imagining the Middle Class*, p. 61.

31 See Peter Rowland, *The Life and Times of Thomas Day, 1748–1789: English Philanthropist and Author: Virtue almost Personified*, New York, 1996; John Brewer, *The Pleasures of the Imagination: English Culture in the Eighteenth Century*, London, 1997, pp. 573–612; Harriet Guest, *Small Change: Women, Learning, Patriotism, 1750–1810*, Chicago and London, 2000; Kelly, *Varieties of Female Gothic*, vol. 2, pp. xvii–xviii, who comments on the apparent paradox of the appeal of Gothic romance within middle-class, Dissenting circles.

32 For the Anglo-Irish gentry as a 'colonial elite', see Thomas Bartlett, ' "A People Made Rather for Copies than Originals": The Anglo-Irish, 1760–1800', *International History Review* 12 (1990), pp. 11–25. Although St George drew his wealth from extensive estates in Cork, Tipperary and Kilkenny, and had a historic house, Headford in Co. Galway, he spent almost all his adult life away from Ireland. Biographical accounts, and, notably, the manuscript 'Galway in 1798 by R. M. St George: Murder of St George', Trinity College, Dublin, MS 1749/1–2, confirm that he returned to his estates in Ireland only in the 1790s, having lived in Europe and England through the 1780s. In his 'Journal of a Tour through part of Ireland begun Aug 26 – continued from October 1 1787. Part 2d' the Irish traveller Daniel Augustus Beaufort gave a telling account of a visit to St George's Irish house, Headford, which had suffered from long neglect. Evoking the terms of the Gothic, without the heroic associations preferred by St George himself, Beaufort wrote that 'In his strange old house dwells Mr Crampton Man of this parish, with 5 sons & as many daughters. The place has been great, but is now ruins' and reported that the 'primitive manners' of the Cramptons, 'the crowing of rooks, & the whistling of wind thro' the various walls &c had too solemn an appearance for my temper to withstand . . . Nor was I sorry to leave a house which impressed such gloom on my mind' (Trinity College, Dublin, MS 4027, ff.4–5). On the double-edged nature of the Gothic in an Irish context, see Luke Gibbons, *Gaelic Gothic: Race, Colonization, and Irish Culture*, Galway 2004.

33 Cf. Smollett, *Roderick Random*, p. 310, quoting from his poem *Advice* (1746):

> Eternal infamy the wretch confound
> Who planted first that vice on British ground!
> A vice! that 'spite of sense and nature reigns,
> And poisons genial love, and manhood stains.

34 His name appears as an addition in hand in the copies of the *List of the General and Field-Officers as they Rank in the Army . . . For the Year 1776*, London, 1776, held by the British Library (BS 45/136) and the Institute of Historical Research, London. His name is crossed through in the list for 1777. His rapid transfer to the Fifty-Second is noted in James Hunter, ed., *The Journal of Gen. Sir Martin Hunter*, Edinburgh, 1894, p. 16. There is also a typed label on the back of Hugh Douglas Hamilton's portrait of St George in the National Gallery of Ireland that notes: 'Richard St George Mansergh St George, of Headford Castle, Galway, Ensign 4th (King's Own) Regt. 15th April 1776; Lieut. 52nd Regt. Dec 1776', transcribed in Nicola Figgis and Brendan Rooney, *Irish Paintings in the National Gallery of Ireland*, Dublin, 2000, p. 176.

35 See Michael Rosenthal, *The Art of Thomas Gainsborough: 'a little business for the eye'*, New Haven and London, 1999, pp. 148–51. The provenance of this work is not known before 1867, when it was shown in the New Assembly Rooms, Brighton, the owner at that time being Mr Taverner or Tarner. It was acquired by the National Gallery of Victoria, Melbourne, in 1922. In the 1950s Ellis Waterhouse, Joseph Burke and Ursula Hoff corresponded over the identification of the sitter, but their discussions were inconclusive. An existing suggestion, that the sitter was the Hon. John Theophilus Rawdon-Hastings, was rejected, as he was only an officer for three months before losing his leg in the Battle of Brandywine. The identification as St George proceeds on several fronts: in a letter to Henry Fuseli proposing an emblematic portrait commemorating his recently deceased wife, St George suggested that this could be based in part on extant likenesses, including a painting of him done by Gainsborough 'in my youth' (*Fuseli Letters*, pp. 66–71). No portrait of St George by Gainsborough is otherwise known. The sitter in the Melbourne picture bears a strong likeness to the known portraits of St George by Hugh Douglas Hamilton, both the full-length now in the National Gallery of Ireland and, more especially, the small portrait showing the sitter wearing a black silk cap (misidentified as from the 'Circle of Francois Xavier Fabré', Sotheby's, London, 28 November 2001). St George's brief membership of the Fourth Regiment of Foot does not appear in published versions of the Army List, so has not been taken into consideration previously. I am grateful to Ted Gott of the National Gallery of Victoria, who checked the gallery files and provided a number of decisive references in this matter, including the Rawdon-Hastings portrait.

36 Anna Seward, 'Epistle to Colonel St George, Written April 1783, in *The Poetical Works of Anna Seward*, ed. Walter Scott, Edinburgh, 1810, vol. 2, pp. 215–16n. St George's wounding at Germantown was recorded in a painting by the Italian artist Xavier Della Gatta that was almost certainly commissioned by him during the 1780s; illustrated in Thomas J. McGuire, *The Surprise of Germantown, or, the Battle of Cliveden October 4th 1777*, Philadelphia, 1994, p. 63.

37 See Thomas Pakenham, *The Year of Liberty: The Story of the Great Irish Rebellion of 1798*, London, 1972, pp. 40–1; R. B. McDowell, *Ireland in the Age of Imperialism and Revolution 1760–1801*, Oxford, 1979, pp. 536–7.

38 James Hunter, *The Journal of Gen. Sir Martin Hunter*, Edinburgh, 1894, pp. 21–2.

39 Anna Seward to Humphrey Repton, 13 April 1798, in Archibald Constable ed., *Letters of Anna Seward Written Between the Years 1784 and 1807*, Edinburgh, 1811, vol. 5, p. 68. Cf. William Godwin, *Caleb Williams*, ed. David McCracken, Oxford, 1977, p. 10–11, on Falklands's consumption of Gothic romances; also Kelly, *The English Jacobin Novel, 1780–1815*, Oxford 1976, pp. 178–208 and pp. 215–17.

40 'Historical Memoirs of the Late Colonel St George', *Hibernian Magazine* (March 1798), pp. 248–50; a version of this account also appeared as a letter from 'H.O', 23 February 1798, in *Gentleman's Magazine* 68 (1798), pp. 97–9.

41 Hunter, *Journal of Gen. Sir Martin Hunter*, pp. 21–2.

42 See McGuire, *The Surprise of Germantown*, pp. 3–7.

43 'We marched on through a thick wood, and received a smart fire from another unfortunate picket – as the first, instantly massacred. We then saw their wigwams or huts, partly by the almost extinguished light of their fires and partly by the glimmer of a few stars, and the frightened wretches endeavoring to form. We then charged . . . Then followed a dreadful scene of havoc. The light dragoons came on sword in hand. The shrieks, groans, shouting, imprecations, deprecations, the clashing of swords and bayonets, &c &c'; in J. Smith Futhey, 'The Massacre at Paoli', *The Pennsylvania Magazine of History and Biography* 1 (1877), pp. 311–12. The letter is connected with St George in McGuire, *The Surprise of Germantown*, p. 7. The same correspondent had described being wounded at the engagement at Brandywine a few days earlier in a letter quoted by Futhey, pp. 293–4n. This biographical detail further suggests that the author was St George, since Hunter stated that St George had been wounded in the same way at Brandywine.

44 Richard St George Mansergh St George to Henry Fuseli, August 1791, in *Fuseli Letters*, pp. 66–71.

45 See Fintan Cullen, *Visual Politics: The Representation of Ireland 1750–1930*, Cork, 1997, pp. 104–15. The friendly relations between Fuseli and St George are evident in the latter's comments in conversation with the 'Ladies of Llangollen' in 1788, at which time he was living in the area; 'Journal of EB & SP Inhabitants of a Cottage in the Vale of Llangollen N. Wales. Written by EB.', National Library of Wales, Ms 22971C, pp. 33–4, 4 February 1788 (*Ladies of Llangollen: Letters and Journals of Lady Eleanor Butler (1739–1829) and Sarah Ponsonby (1755–1831) from the National Library of Wales*, microfilm, reel 2). There is, then, the distinct possibility that St George was a patron of Fuseli, in the 1780s.

46 James Beattie, *Dissertations Moral and Critical*, London, 1783, p. 620. Similarly, a writer in *La Belle Assemblée* 3 (1811), p. 261, commented: 'The pictures of Fuseli, like the heroes and dwarfs in the old romances, stir up and agitate the mind without impressing the feelings.'

47 See Guest, 'Wanton Muse', pp. 131–2.

48 See Henderson, *Romantic Identities*, pp. 45–59.

49 Frederica Lock to Frances Burney, 15–21 December 1789, in *Fuseli Letters*, pp. 48–51. The work in question was the first version of *Wolfram introducing Bertrand of Navarre to the Place where he had Confined his Wife, with the Skeleton of her Lover* (exhibited 1790, later overpainted by Fuseli). The subject was in fact based on Margeret of Navarre's widely available *Heptamaron* (see Knowles, *Life and Writings of Henry Fuseli*, vol. 1, p. 414). This only enhances the deliberate theatricality of Fuseli's presentation – putting him at the head of a storytelling circle. On the role of communal storytelling in the Gothic see Clery, *Rise of Supernatural Fiction*, pp. 2–5.

50 Guest, 'Wanton Muse', p. 134; see also Henderson, *Romantic Identities*, pp. 53–4.

51 Thus a contemporary review of Lavater's *Aphorisms on Man* (1788) noted: 'These sketches of M. Lavater on the philosophic canvas might be compared to the paintings of his friend Fuseli. Perhaps the drawing is, in general, too bold, and the colouring too strong; but he knew that he painted for beings on whose minds the boldest strokes of the moral pencil are apt to produce the slightest effects'; *Monthly Review* 80 (1789), p. 527. On Lavater and physiognomy see Wahrman, *Making of the Modern Self*, pp. 294–9; Marcia Allentuck, 'Fuseli and Lavater: Physiognomical Theory and the Enlightenment', *Studies on Voltaire and the Eighteenth Century* 55 (1967), pp. 89–112; John Graham, *Lavater's Essays on Physiognomy: A Study in the History of Ideas*, Berne, Frankfurt, Las Vegas, 1979; Roy Porter, 'Making Faces: Physiognomy and Fashion in Eighteenth-Century England', *Études Anglaises* 38 (1985), pp. 385–96; Ellis Shookman, ed., *The Faces of Physiognomy: Interdisciplinary Approaches to Johann Caspar Lavater*, Drawer, 1993.

52 Benjamin Robert Haydon, *The Diary of Benjamin Robert Haydon*, ed. Willard Bissell Pope, Cambridge, Mass., 1960–63, vol. 1, p. 488. Also, p. 232 (27 April 1812), on seeing Raphael's cartoons for the Sistine Chapel tapestries: 'Think of Fuzeli's savage ferocity, his whorish abandoned women, the daughters of the bawds of Hell, engendered by lecherous, dusky demons, and then bring to your fancy this exquisite, graceful, innocent creature dropped from Heaven on a May morning or sprung up from the center of a rose spangled with dew, at the delicate, voluptuous, gentle kiss of a bending, pearly lily. Again think of Fuzeli's men, the sons of *banditti*, and contrast them with the rapturous innocence of St John.' Even Knowles admitted that a degree of gendered exaggeration prevailed in Fuseli's work: *Life and Writings of Henry Fuseli*, vol. 1, pp. 403–4.

53 See Trevor Fawcett, *The Rise of English Provincial Art: Artists, Patrons and Institutions Outside London 1800–1830*, Oxford, 1974, esp. pp. 92–9; C. P. Darcy, *The Encouragement of the Fine Arts in Lancashire 1760–1860*, Manchester, 1976; Arline Wilson, 'The Cultural Identity of Liverpool, 1790–1850: The Early Learned Societies', *Transactions of the Historic Society of Lancashire and Cheshire* 147 (1998), pp. 55–80; Arline Wilson, ' "The Florence of the North"? The Civic Culture of Liverpool in the Early Nineteenth Century', in *Gender, Civic Culture and Consumerism: Middle-Class Identity in Britain, 1800–1940*, ed. Alan Kidd and David Nicholls, Manchester and New York, 1999, pp. 34–46. On Roscoe in particular see George Chandler, *William Roscoe of Liverpool*

1753–1831, London, 1953; Ian Sellars, 'William Roscoe, The Roscoe Circle and Radical Politics in Liverpool, 1789–1807', *Transactions of the Historic Society of Lancashire and Cheshire* 120 (1968), pp. 45–62; Edward Morris, 'William Roscoe and Medici Florence', in *Riches into Art: Liverpool Collectors 1770–1880: Essays in Honour of Margaret T. Gibson*, ed. Pat Starhen, Liverpool, 1993, pp. 7–26; Donald A. Macnaughton, *Roscoe of Liverpool: His Life, Writings and Treasures 1753–1831*, Birkenhead, 1996. For Liverpoool's art institutions see Joseph Mayer, *Early Exhibitions of Art in Liverpool*, Liverpool, 1876; Darcy, *Encouragement of the Fine Arts*, pp. 20–33; Edward Morris and Emma Roberts, *The Liverpool Academy and Other Exhibitions of Contemporary Art in Liverpool 1774–1867: A History and Index of Artists and Works Exhibited*, Liverpool, 1998.

54 In 1783 Samuel Stringer of Knutsford, an aspirant artist, wrote to Matthew Gregson with a plan to bring together the middle-class art enthusiasts of Manchester and Liverpool and professional aritsts into a society. However, Stringer roughly rejected Gregson's suggestion that Henry Blundell of Ince Blundell, the most conspicuous aristocratic collector of classical antiquities in the region, be president of this group: 'You propose Mr Blundell, he is an acknowledged Connoisseur, but we wish not at present I apprehend to have a Gentleman in his line of Life to direct. Under him, or any other Gent'n when arrived to tolerable maturity we may flourish. But let us not at the Setting out be under an Aristocracy, – Let the *Main* stems be of our own planting, and then the more capital the shoots are, the more honor, & Strength will be added'. Samuel Stringer to Matthew Gregson, 18 December 1782, Liverpool Record Office, 920 GRE/2/18/13. In the event, Stringer died unexpectedly, and his plan was overtaken by the group led by Roscoe. See H. A. Taylor, 'Matthew Gregson and the Pursuit of Taste', *Transactions of the Historic Society of Lancashire and Cheshire* 110 (1959), pp. 157–76. Notably, the new academy excluded artists. Thus the establishment of an academy in Liverpool in the early 1780s anticipated the struggles over authority within the field of taste that were to come to the fore in the early nineteenth century, with artists competing with leisured connoisseurs for the leadership of art institutions.

55 David Samwell to Matthew Gregson, 24 June 1773, Liverpool Record Office, 920 GRE 2/17/3. See H. A. Taylor, 'David Samwell: The Letters of David Samwell, Surgeon, to Matthew Gregson of Liverpool, Upholsterer and Antiquarian, Between 1772 and 1798', *The Liverpool Libraries, Museums & Arts Committee Bulletin* 6:1–2 (1956), pp. 33–46.

56 William Roscoe, 'Mount Pleasant' (1777), in Chandler, *William Roscoe*, p. 331.

57 Nanora Sweet, '"Lorenzo's" Liverpool and "Corinne's" Coppet: The Italianate Salon and Romantic Education', in *Lessons of Romanticism: A Critical Companion*, ed. Thomas Pfau and Robert F. Glecker, Durham and London, 1998, pp. 244–60; see also Philip Connell, *Romanticism, Economics and the Question of 'Culture'*, Oxford, 2001, pp. 101–11.

58 See Sweet, '"Lorepool's" Liverpool and "Corinne's"

Coppet', p. 248.

63 Gert Schiff, *Johann Heinrich Füssli*, Zurich and Munich, 1973, no. 723. See Henry Fuseli to William Roscoe, 18 August 1784, in *Fuseli Letters*, p. 24.

60 For the sizes see T. Vernon, *A Catalogue of a Superlatively fine Collection of Capital Pictures . . . The Whole Being the Property of the late Daniel Daulby Esq.*, Liverpool, 27 August 1798 (photostat at Liverpool Record Office, Hq.708.9.DAU). For the prices fetched see William Roscoe to Mrs Daulby, 29 August 1798, Liverpool Record Office, ROS 1142. The full extent of Daulby's collection is recorded in the Ms. 'Catalogue: Books, Prints, Pictures Etc. of Daniel Daulby 1793', Liverpool Record Office, H.091.5.DAU.

61 See William Roscoe to Jane Roscoe, 16 May 1782, Liverpool Record Office, ROS 3486: 'I have laid out about 40s in Prints & find no inclination to any more extravagance in that Article', William Roscoe to Jane Roscoe, 27 May 1782, Liverpool Record Office, ROS 3487.

62 Henry Fuseli to William Roscoe, 22 October 1791, in *Fuseli Letters*, pp. 74–5.

63 Henry Fuseli to William Roscoe, 10 March 1794, in *Fuseli Letters*, pp. 92–3.

64 Henry Fuseli to William Roscoe, 18 June 1800, in *Fuseli Letters*, pp. 212–13.

65 Watt, *Contesting the Gothic*, pp. 42–69. See also Carolyn D. Williams, '"In Albion's Ancient Days": George Richards and the Dilemmas of Patriot Gothic', in *Early Romantics: Perspectives on British Poetry from Pope to Wordsworth*, ed. Thomas Woodman, Basingstoke, 1998, pp. 256–72. For the conservatism of the 1780s more generally see John Sainsbury, *Disaffected Patriots: London Supporters of Revolutionary America 1769–1782*, Kingston and Montreal, 1987, pp. 158–61; J. E. Bradley, 'The Anglican Pulpit, the Social Order, and the Resurgence of Toryism During the American Revolution', *Albion* 21 (1989), pp. 361–88; Robert Hole, *Pulpits, Politics and Public Order in England 1760–1832*, Cambridge, 1989, pp. 44–50.

66 Christine Gerrard, *The Patriot Opposition to Walpole: Politics, Poetry, and National Myth 1725–1742*, Oxford, 1994, pp. 228–9.

67 Newspaper cutting of 1786, quoted in Helmut von Erffa and Allen Staley, *The Paintings of Benjamin West*, New Haven and London, 1986, no. 54.

68 The series was completed and installed by 1796 and all seven paintings dealing with Edward III were exhibited at the Royal Academy in these years. See Von Erffa and Staley, *The Paintings of Benjamin West*, nos 56–76; Wendy Greenhouse, 'Benjamin West and Edward III: A Neoclassical Painter and Medieval History', *Art History* 8 (1985), pp. 178–91.

69 On Pine's American career, see R. G. Stewart, *Robert Edge Pine: A British Portrait Painter in America, 1784–1788*, exhibition catalogue, National Portrait Gallery, Smithsonian Institution, Washington, 1979.

70 Greenhouse, 'Benjamin West and Edward III', p. 181, notes that in this West departs from contemporary representations of the same scene by Robert Smirke and Edward Edwards.

71 *St James's Chronicle* (29 April–1 May 1788).

72 See Roy Strong, *And When Did You Last See Your Father?: The Victorian Painter and British History*, London, 1978, pp. 80–5.

73 Henry Angelo, quoted in Greenhouse, 'Benjamin West and Edward III', p. 180.

74 John Stringer to Matthew Gregson, 31 March 1781, Liverpool Record Office, 920 GRE 2/18/8.

75 Daniel Daulby to Matthew Gregson, 3 June 1779, Liverpool Record Office, 920 GRE 1/18/11.

76 See Watt, *Contesting the Gothic*, pp. 44–46; David Duff, *Romance and Revolution: Shelley and the Politics of Genre*, Cambridge, 1994, for a retrospect over these debates. For a further perspective on the issue of nostalgia and the estrangement of the heroic past, see Robert W. Jones, '"We Proclaim our Darling Son": The Politics of Chatterton's Memory During the War for America', *Review for English Studies* 53 (2002), pp. 373–95.

77 See David Bindman, 'Blake's "Gothicised Imagination" and the History of England', in *William Blake: Essays in Honour of Sir Geoffrey Keynes*, ed. Morton D. Paley and Michael Phillips, Oxford, 1973, pp. 29–49.

78 See Jon Mee, *Dangerous Enthusiasm: William Blake and the Culture of Radicalism in the 1790s*, Oxford, 1992, pp. 75–120; Helen Braithwaite, *Romanticism, Publishing and Dissent: Joseph Johnson and the Cause of Liberty*, Basingstoke, 2003.

79 *Daily Universal Register* (7 May 1787).

80 John Boydell, *A Description of Several Pictures Presented to the Corporation of the City of London*, London, 1794. The most explicitly political comments come in reference to a painting of the battle of Agincourt by Josiah Boydell, which subject demonstrates the 'presence of mind, dexterity, firmness, and precaution' of the common English solider, contrary to the 'confusion and vain confidence' of the French, *and* the weakness of England's monarch, who failed to follow up on the great victory won there; pp. 24–7.

81 Robert Anthony Bromley, *A Philosophical and Critical History of the Fine Arts*, London, 1793–95, vol. 1, pp. 36–7.

82 *Public Advertiser* (22 May 1786).

83 The rumour about Fuseli's opium use was reported and dismissed in *The Diary of Joseph Farington*, ed. Kenneth Garlick et al., New Haven and London, 1978–98, vol. 3, p. 660 (11 September 1796). Later, Fuseli admitted to Farington that he had been using opium to help him sleep – this in the darkest days of his ill-fated Milton Gallery; *Farington Diary* vol. 4, p. 1299 (7 November 1799). The story about raw pork seems to have originated in the *Public Advertiser*, 31 May 1790, and evidence for its sustained circulation can be found in, for instance, Robert Southey to John Rickman, 19 December 1809, in *New Letters of Robert Southey*, ed. Kenneth Curry, New York and London, 1975, vol. 1, pp. 264–5. The story was still being refuted more than half a century later: see Mary Balmanno, *Pen and Pencil*, New York, 1858, p. 204. On the relation of digestion to imagination and dreams in this period, see Jennifer Ford, *Coleridge on Dreaming: Romanticism, Dreams and the Medical Imagination*, Cambridge, 1998, pp. 13–32. For opium use see Virginia Berridge and

Griffith Edwards, *Opium and the People: Opiate Use in Nineteenth-Century England*, London, 1981, pp. 49–61.

84 Clery, *Rise of Supernatural Fiction*, p. 105. The feminization extends to producers of such works – this is implicit in Pope's reduction of the rules of epic to a 'Receit', a device taken up by a critic of female authors of the Gothic in the *Spirit of the Public Journals* 1 (1798), quoted in Kelly, *Female Gothic*, vol. 2, p. xvi.

85 Benjamin West Autographed Mss. Autobiography, ca.1805, Charles Allen Munn Collection, Fordham University Library, p. 9, Archives of American Art, N68–20, fr.280. West was rumoured to have contributed passages to Bromley's text; see *Farington Diary*, vol. 1, p. 1689 (17 May 1794); Knowles, *Life and Writings of Henry Fuseli*, vol. 1, p. 185.

86 Henry Fuseli quoted in *Farington Diary*, vol. 7, p. 2594 (24 July 1805).

87 See, in particular, Fuseli's answer to West's 1792 lecture, in the *Analytical Review* (May 1793), and the response to Bromley's *Philosophical and Critical History* in the *Analytical Review* (July 1793), quoted in Eudo C. Mason, *The Mind of Henry Fuseli: Selections from his Writings with an Introductory Study*, London, 1951, pp. 192–3.

10 THE MALE NUDE AT THE ROYAL ACADEMY

1 See Helen Valentine with Becky McGinnis, *From Reynolds to Lawrence: The First Sixty Years of the Royal Academy of Arts and its Collections*, ed. MaryAnne Stevens, exhibition catalogue, Royal Academy of Arts, London, 1991, pp. 11–12.

2 See Kenneth Garlick et al., eds, *The Diary of Joseph Farington*, New Haven and London, 1978–98, vol. 1, p. 269 (3 December 1794); Library of the Royal Academy of Arts, London, GA/1/342–43.

3 For Rigaud see William L. Pressly, ed., 'Facts and Recollections of the XVIIIth Century in a Memoir of John Francis Rigaud Esq., RA. by Stephen Francis Dutilh Rigaud', *Walpole Society* 50 (1984), pp. 1–164, and on the *Samson*, p. 13.

4 Library of the Royal Academy of Arts, London, GA/1/67, 2 November 1772. See also Pressly, 'Facts and Recollections', pp. 50–3.

5 Pressly, 'Facts and Recollections', p. 48. The painting is recorded only in the background of Rigaud's self-portrait with his family, itself known only by a photographic record, illustrated by Pressly as fig.4.

6 Library of the Royal Academy of Arts, London, GA/1/175, 10 February 1784; Library of the Royal Academy of Arts, London, *RA Royal Book 1768–1802*.

7 Pressly, 'Facts and Recollections', p. 13 and p. 31, n.31.

8 Pressly, 'Facts and Recollections', p. 71,

9 *Morning Herald* (4 June 1785).

10 Library of the Royal Academy of Arts, London, CM/2/60, 27 June 1788 and CM/2/109, 18 June 1790. See the announcement of the publication of the print in the *Public Advertiser* (24 April 1792): 'Subscriptions are received at Mr Rigaud's, No. 71, Great Titchfield-Street, where a duplicate of the original picture may be seen.'

11 *Morning Herald* (9 May 1792).

12 John Francis Rigaud to Stephen Francis Dutilh Rigaud, 11 June 1807, in Pressly, 'Facts and Recollections', p. 132.

13 Library of the Royal Academy of Arts, London, GA/1/137, 5 November 1780; GA/1/180, 8 November 1784; GA/1/187, 15 February 1785.

14 Library of the Royal Academy of Arts, London, CM/2/20, 17 February 1786; CM/2/46, 14 September 1786; *Royal Book*.

15 See C. F. Bell, *Annals of Thomas Banks: Scultor, Royal Academician*, Cambridge, 1927 pp. 49–60.

16 Allan Cunningham, *The Lives of the Most Eminent British Painters, Sculptors and Architects*, London, 1829–33, vol. 3, pp. 96–7.

17 Christie and Ansell, 17–18 May 1782, second day's sale, lots 11–18; annotated copy in Christie's Archive, with the date of the sale corrected from 16–18 May, and Banks' name recorded as the seller of these lots.

18 George Cumberland to Edward Loveden, 19 August 1783, quoted in Bell, *Annals of Thomas Banks*, p. 56.

19 See Bell, *Annals of Thomas Banks*, pp. 60–6. Julius Bryant has identified a cursory record of the sculpture in John Partridge's portrait of the *Fine Art Commissioners*, 1846 (a.1846–53; National Portrait Gallery, London) see his '"Mourning Achilles": A Missing Sculpture by Thomas Banks', *Burlington Magazine* 125 (1983), pp. 742–45. The fullest description is 'Banks's Statue of Achilles', *Director* 1 (1807), pp. 65–78. The article may be authored by Thomas Bernard or the editor Thomas Frognall Dibdin, though the latter attributed it wholly to Lavinia Forster, who certainly provided information whichever is the case; see his *Reminiscences of a Literary Life*, London, 1836, vol. 1, p. 251, also Bell, *Annals of Thomas Banks*, p. 64.

20 Cunningham, *Lives of the Most Eminent British Painters*, vol. 3, pp. 97–8.

21 For Johnes' patronage see Richard J. Moore-Colyer, ed., *A Land of Pure Delight: Selections from the Letters of Thomas Johnes of Hafod, Cardiganshire (1748–1816)*, Llandysul, 1992, p. 17.

22 Cunningham, *Lives of the Most Eminent British Painters*, vol. 3, pp. 109–110 and p. 120.

23 John Flaxman, 'Address on the Death of T. Banks', f.19, among 'Flaxman's Original Manuscript Lectures', Fitzwilliam Museum, Cambridge, shelved at 25B. Cf. Flaxman, 'An Address', p. 280.

24 Banks could have seen such works in person while in Paris on his outward journey to Rome in 1772. See Francis Milner Newton to Thomas Banks, 3 July 1772, copy at Library of the Royal Academy of Arts, London CM/1/138–9. A few years earlier James Barry had noted the 'Hercules tearing off the poisoned shirt, by Girardon; the Milo, by Falconet; and the Hercules chaining Cerburus, by Puget' in 'the rooms of the academy in the Louvre'; Edward Fryer, *The Works of James Barry*, London, 1809, vol. 2, p. 9. Banks' return journey in 1779 was presumably not through France because of the hostilities of the war war American independence. On the format of the *morceaux de réception* see Malcolm Baker, *Figured in Marble: The Making and Viewing of the Eighteenth-Century Sulpture*, London, 2000, pp. 30–1.

25 *European Magazine* 9 (1796), p. 311.

26 John Britton, 'Remarks on the Statue of a Falling Giant Designed, and Executed in Marble, by Thomas Banks Esq. RA', *Fine Arts of the English School*, London, 1812, p. 22.

27 See Elizabeth Forster to Allan Cunningham, 1 March 1830, quoted in Bell, *Annals of Thomas Banks*, p. 68.

28 See Frances Ferguson, *Solitude and the Sublime: Romanticism and the Aesthetics of Individuation*, New York and London, 1992, pp. 46–7.

29 According to the catalogue of the Prints and Drawings Collection, Victoria and Albert Museum, Dyce 2917, the print was published as part of a set entitled: 'Etchings by and from the most esteemed English artists – R. M. Paye'. This is also noted on the verso of the British Museum's copy of the print. Richard Morton Paye (a.1750–1821) was a painter and engraver, active mainly in the 1780s and 1790s. See the biographical account in *Library of the Fine Arts* 3 (1830), pp. 95–101.

30 Cunningham, *Lives of the Most Eminent British Painters*, vol. 3, pp. 101–2.

31 Cunningham, *Lives of the Most Eminent British Painters*, vol. 3, p. 102.

32 *English Chronicle* (11 February 1790). See Library of the Royal Academy of Arts, London, GA/1/213, 3 November 1788; GA/1/222, 10 February 1789; GA/1/230, 10 February 1790. The change of heart may well be attributable to Fuseli's new personal circumstances, for in July 1788 he had married; see John Knowles, *The Life and Writings of Henry Fuseli*, London, 1830, vol. 1, p. 159. On the controversy surrounding the 1790 election, see Holger Hoock, *The King's Artists: The Royal Academy of Arts and the Politics of British Culture, 1760–1840*, Oxford, 2003, pp. 116–17.

33 Letter from Fuseli to the council of the Royal Academy, reported in Library of the Royal Academy of Arts, London, CM/2/114, 6 September 1790 and GA/1/245, 1 November 1790.

34 See Gert Schiff, *Johann Heinrich Füssli*, Zurich and Munich, 1973, no. 716. Cf. Paul Henri Mallet, *Northern Antiquities: Or, A Description of the Manners, Customs, Religion and Laws of the Ancient Danes, and Other Northern Nations . . . With a Translation of the Edda, or System of Runic Mythology*, London, 1770, vol. 2, pp. 134–7. The only other readily available version of the *Edda* – Gudmundus Magnaeus et al., eds, *Edda Saemunder hinns Froda*, Copenhagen, 1787, which Fuseli reviewed for the *Analytical Review* in 1789 – presented a different version of the myth in which Thor attacks the serpent by sending rocks crashing down on its head. For Fuseli's review see *Analytical Review* 2 (1789) pp. 337–44 and 461–71. On Mallet see Frank Edgar Farley, *Scandinavian Influences in the English Romantic Movement*, Boston, 1903; Margaret Omberg, *Scandinavian Themes in English Poetry, 1760–1800*, Uppsala, 1976; Régis Boyer, 'Vikings, Sagas and Wasa Bread', in *Northern Antiquity: The Post-Medieval Reception of Edda and Saga*, ed. Andrew Wawn, Enfield Lock, 1994, pp. 69–81.

35 Mallet, *Northern Antiquities*, vol. 2, p. 65

36 See Oliver Goldsmith's review of Mallet in the *Monthly Review* (1757), in *The Collected Works of Oliver Gold-*

smith, ed. Arthur Friedman, Oxford, 1966 vol. 1, p. 6. For a later text that makes exactly the same point see Charles Butler, *Horae Biblicae*, London, 1797–1802, vol. 2, p. 135.

37 An undated watercolour of *Thor Battering the Midgard Serpent* attributed to Prince Hoare, an imitator of Fuseli, is in the Huntington Collection, San Marino. Another subject from the Edda, again by an imitator of Fuseli, William Lock, is mentioned in a letter from Frederica Lock to Fanny Burney, 15–21 December 1789, in *The Collected English Letters of Henry Fuseli*, ed. David H. Weinglass, Millwood, NY, 1982, p. 49 (referred to hereafter as *Fuseli Letters*).

38 See Omberg, *Scandinavian Themes*, pp. 53–4.

39 Thomas Gray to William Mason, 24 March 1758, in *The Letters of Thomas Gray*, ed. Duncan C. Tovey, London, 1909–12, vol. 2, pp. 27–8.

40 Fuseli to F. I. Du Roveray, c. 1799, printed in *The Poems of Gray* (1800), quoted in *Fuseli Letters*, p. 209.

41 *Gentleman's Magazine* 58, part 2 (1788), p. 137 (from a review of *Edda Saemunder hinns Froda*).

42 *St James's Chronicle* (7–10 April 1792).

43 Cf. Ronald Paulson, *Book and Painting: Shakespeare, Milton and the Bible: Literary Texts and the Emergence of English Painting*, Knoxville, 1982, pp. 129–37; Karen Junod, 'Henry Fuseli's Pragmatic Use of Aesthetics: His Epic Illustrations of *Macbeth*', *Word and Image* 19 (2003), pp. 138–50. The nuances of Fuseli's case about 'epic' are teased out in John Barrell, *The Political Theory of Painting from Reynolds to Hazlitt: 'The Body of the Public*, New Haven and London, 1986, esp. pp. 283–91.

44 Knowles, *Life and Writings of Henry Fuseli*, vol. 3, p. 135.

45 Charles Dufresnoy, *De Arte Graphica*, trans. John Dryden, in *The Works of John Dryden*, ed. Edward Miles Hooker, H. T. Swedenberg et al., Berkeley, Los Angeles and London, 1956–89, vol. 20, p. 145.

46 See Eugene Mersereau Waith, *The Herculean Hero in Marlowe, Chapman, Shakespeare and Dryden*, London, 1962, pp. 46–7.

47 Knowles, *Life and Writings of Henry Fuseli*, vol. 2, p. 369.

48 Henry Fuseli, 'Dunciad of Painting', in *Johann Heinrich Füssli: Sämtliche Gedichte*, ed. Martin Bircher and Karl S. Guthke Zurich, 1973, p. 80.

49 See David Alexander, 'Kauffman and the Print Market in Eighteenth-Century England', in *Angelica Kauffman: A Continental Artist in Georgian England*, ed. Wendy Wassying Roworth, London, 1992, pp. 140–78.

50 Knowles, *Life and Writings of Henry Fuseli*, vol. 2, pp. 331–2.

51 Knowles, *Life and Writings of Henry Fuseli*, vol. 2, p. 333–4.

52 Barrell, *Political Theory of Painting*, pp. 158–62.

53 Anthony Ashley Cooper, third earl of Shaftesbury, *Characteristicks*; quoted and discussed in Barrell, *Political Theory of Painting*, pp. 32–3.

54 Knowles, *Life and Writings of Henry Fuseli*, vol. 2, pp. 103–4.

55 See Rensselaer Lee, 'Ut Pictura Poesis: The Humanistic Theory of Painting', *Art Bulletin* 22 (1940), pp. 197–229; John R. Spencer, 'Ut Rhetorica Pictura: A Study of Quat-trocento Theory of Painting', *Journal of the Warburg and Courtauld Institutes* 20 (1957), pp. 26–44; Niklaus Rudolf Schweizer, *The Ut Pictura Poesis Controversy in Eighteenth-Century England and Germany*, Bern and Frankfurt, 1972.

56 Cicero, *De Inventionae*, I.2.2–3, trans. H. M. Hubbell, London and Cambridge, Mass., 1949, pp. 5–9; Seneca the Younger, *Epistle* 114, in *Ancient Literary Criticism*, ed. D. A. Russell and M. Winterbottom Oxford, 1972, p. 363; Quintilian, *Institutio Oratorio* XII.X.73–6, in ibid., pp. 415–16; Plutarch, *Letter to Marcus Sedatius*, in ibid., p. 510.

57 George Turnbull, *A Treatise on Ancient Painting*, London, 1750, pp. 73, 88.

58 Turnbull, *Treatise*, p. 140.

59 Demetrius, *On Style*, 190–203, in *Ancient Literary Criticism*, ed. Russell and Winterbottom pp. 206–8; Cicero, *Orator*, 75–90, in ibid., pp. 240–3.

60 Knowles, *Life and Writings of Henry Fuseli*, vol. 2, p. 86n.

61 Knowles, *Life and Writings of Henry Fuseli*, vol. 2, pp. 334–5.

62 J. G. A. Pocock, *Virtue, Commerce, and History; Essays an Political Thought and History, Chiefly in the Eighteenth Century*, Cambridge, 1985, pp. 193–212.

63 See Pliny, *Natural History* XXXV.XL.129, in *Natural History*, trans. H. Rackham and D. E. Eicholz, London and Cambridge, Mass., 1938–62, vol. 9, p. 355.

64 Richard Graham, 'A Short Account of the Most Eminent Painters, Both Ancient and Modern', in Charles Dufresnoy, *The Art of Painting*, trans. John Dryden, London, 1716, pp. 254–6.

65 Junius *The Literature of Classical Art*, vol. 1, p. 105.

66 See M. H. Abrams, *The Mirror and the Lamp: Romantic Theory and the Critical Tradition*, Oxford, 1953, pp. 42–6 and passim.

67 Jacqueline Lichtenstein, *The Eloquence of Color: Rhetoric and Painting in the French Classical Age*, trans. Emily McVarish, Berkeley, 1993, pp. 37–54.

68 Knowles, *Life and Writings of Henry Fuseli*, vol. 2, p. 369. On the 'vile crust' see Knowles, *Life and Writings of Henry Fuseli*, vol. 3, p. 130, in reference to Rembrandt, also p. 123 on Rubens.

69 Knowles, *Life and Writings of Henry Fuseli*, vol. 2, p. 356 and 359–60. See Reynolds' note in Charles Dufresnoy, *The Art of Painting*, trans. William Mason, London, 1782, pp. 102–3.

70 Junius, *Literature of Classical Art*, vol. 1, pp. 240–1.

71 Plutarch, *Moralia* 725C–D, as cited in Junius, *Literature of Classical Art*, vol. 1, p. 240n.

72 See Lichtenstein, *Eloquence of Color*, pp. 152–3.

73 Daniel Webb, *Inquiry into the Beauties of Painting*, London 1760, p. 84; cf. *Isaeus*, trans. S. Usher, London and Cambridge, MA, 1974, vol. 2, pp. 179–81.

74 Pliny, *Natural History* XXXV.50, in Junius, *Literature of Classical Art*, vol. 1, p. 105.

75 Knowles, *Life and Writings of Henry Fuseli*, vol. 2, p. 337; cf. Fuseli's, 'Aphorisms on Art', in Knowles, *Life and Writings of Henry Fuseli*, vol. 3, p. 131: 'Clearness, freshness, force of colour, are produced by simplicity; one pure, is more than a mixture of many.'

76 Knowles, *Life and Writings of Henry Fuseli*, vol. 2, pp. 345–6.

77 Knowles, *Life and Writings of Henry Fuseli*, vol. 2, p. 355.

78 Knowles, *Life and Writings of Henry Fuseli*, vol. 2, p. 359.

79 William Young Ottley, 'On the Character of Fuseli as an Artist', in Knowles, *Life and Writings of Henry Fuseli*, vol. 1, pp. 425–6. See also Knowles, *Life and Writings of Henry Fuseli*, vol. 1, p. 397: 'To set a palette, as artists usually do, was with him out of the question; he used many of his colours in a dry, powdered state, and rubbed them up with his pencil only'. And, describing the resulting paintings, p. 408: 'they usually have the sobriety of tone which is more particular to fresco than to oil-painting'. As in their respective written statements on technique, Blake took Fuseli's approach literally and to a further degree, developing his psuedo-'fresco' technique.

80 Joshua Reynolds *Discourses on Art*, ed. Robert R. Wark, New Haven and London, 1975, pp. 81–2.

81 See W. J. T. Mitchell, *Blake's Composite Art: A Study of the Illuminated Poetry*, Princeton, 1978, pp. 44–53, who argues for the polemical rather than practical character of Blake's commentary, which point could be reflected back on Fuseli; also Edward J. Rose, ' "A Most Outrageous Demon": Blake's Case Against Rubens', in *The Visionary Hand: Essays for the Study of Blake's Art and Aesthetics*, ed. Robert N. Essick, Los Angeles, 1973, pp. 310–36.

82 See James Beattie, *Dissertations Moral and Critical*, London, 1783, p. 606.

83 See Peter Tomory, *The Life and Art of Henry Fuseli*, London, 1972, p. 105; David Bindman, *The Shadow of the Guillotine: Britain and the French Revolution*, exhibition catalogue, British Museum, 1989, no. 159.

11 'THREE YOUNG SCULPTORS' OF THE 1790S

1 John Thomas Smith, *Nollekens and his Times*, ed. Wilfred Whitten, London and New York, 1920, vol. 1, p. 346.

2 Kenneth Garlick et al., eds, *The Diary of Joseph Farington*, New Haven and London, 1978–98, vol. 5, p. 1980 (17 February 1803). (Hereafter referred to as *Farington Diary*)

3 For example Joshua Reynolds, *Discourses*, ed. Roger Fry, London, 1905, pp. 265–6; Margaret Whinney, *Sculpture in Britain 1540–1830*, Harmondsworth, 1964, p. 154; Pat Rogers, ed., *Discourses*, Harmondsworth, 1992, p. 21. For an exception, see the view expressed in Katharine A. Esdaile, *English Monumental Sculpture Since the Renaissance*, London, 1927, pp. 64–5, and the sustained analysis of the lecture in Johannes Dobai, *Die Kunstliteratur des Klassizismus und der Romantik in England*, Berne, 1974–84, vol. 2, pp. 770–3.

4 Joshua Reynolds, *Discourses on Art*, ed. Robert R. Work, New Haven and London, 1975, pp. 175–6.

5 Reynolds, *Discourses*, p. 187. Reynolds may also be responding to a tendency found in literature on sculpture at the time to proclaim the memorial sculpture of the modern individual as intrinsically of more value than more abstract, and certainly mythological, work. See John Grattan, 'On Sculpture', in *The Oxford Prize Essays*, Oxford, 1830, vol. 1, pp. 15–33; Vicesmus Knox, 'Essay XL. On Sculpture', in his *Essays Moral and Literary*, London, 1779, pp. 300–19; John Moore, *A View of Society and Manners in Italy*, London, 1782, vol. 2, pp. 1–20.

6 Reynolds, *Discourses*, pp. 176–7.

7 Reynolds, *Discourses*, p. 187.

8 See Charles Coleman Sellers, *Patience Wright: American Artist and Spy in George III's England*, Middletown, 1976. In reiterating Reynolds' argument about sculptural colour, a later commentator more explicitly referred to Mrs Wright's waxworks. See Robert Cullen, 'On Sculpture', *Lounger* 73 (24 June 1786). See also Holger Hoock, *The King's Artists: The Royal Academy of Arts and the Politics of British Culture, 1760–1840*, Oxford, 2003, pp. 157–64.

9 Such comments were commonplace, but the following might be cited as examples: Joseph Addison, *Remarks on Several Parts of Italy*, London, 1726, pp. 176–7; Louis Doisson, *Sculptura: Carmen*, Paris, 1757, part II, pp. 8–9; E.-M. Falconet, 'Reflections on Sculpture', in *Pieces Written by Mons. Falconet, and Mons. Diderot, on Sculpture*, trans. *William Tooke*, London, 1777, p. 25.

10 Reynolds, *Discourses*, p. 186.

11 Reynolds, *Discourses*, pp. 183–4. On the tradition of criticism of Bernini see Charles Avery, *Bernini: Genius of the Baroque*, London, 1997, pp. 273–8. It should be noted that a few years later Reynolds bought Bernini's original sculpture as an investment. See Rudolf Wittkower, *Gian Lorenzo Bernini: The Sculpture of the Roman Baroque*, Oxford, 1981, no. 9.

12 In the latitude Reynolds allows to reliefs, he is following French academic precedent. See Francis H. Dowley, 'Falconet's Attitude Towards Antiquity and his Theory of Reliefs', *Art Quarterly* 31 (1968) pp. 185–204, esp. pp. 185–8.

13 Reynolds, *Discourses*, p. 177.

14 Reynolds, *Discourses*, pp. 187–8.

15 See John Barrell, The *Political Theory of Painting from Reynolds to Hazlitt: 'The Body of the Public'*, New Haven and London, 1986, p. 154.

16 Edward Dayes, *The Works of Edward Dayes*, London, 1805, pp. 58–9 and p. 344; [Thomas Bernard], 'The Life of Mr Thomas Proctor', *Director* 1 (1807), pp. 193–205; Smith, *Nollekens and his Times*, vol. 2, pp. 62–6. See also 'Anthony Pasquin' (John Williams), *Memoirs of the Royal Academicians*, London, 1796, pp. 109–10; John Robert Scott, *A Dissertation on the Progress of the Fine Arts*, London, 1800, p. 32n; Martin Archer Shee, *Rhymes on Art: Or, the Remonstrance of a Painter*, London, 1805, p. 88 and p. 88n; Prince Hoare, *Epochs of the Arts*, London, 1813, pp. 79–84; 'Anser Pen-Drag-on' (William Henry Ireland), *Scribbleomania: Or, The Printer's Devil's Polichronicon. A Sublime Poem*, London, 1815, p. 224; *New Monthly Magazine* 6 (1816), p. 423; William Carey, *Some Memoirs of the Patronage and Progress of the Fine Arts in England*, London, 1826, p. 46. Procter's life and work have been almost completely overlooked in modern accounts. His life has been documented by the current occupiers of the former Spread Eagle Inn in Settle, Peter and Sheila Harling, who very kindly shared their knowl-

edge with me.

17 Benjamin West's comments are recorded contemporane-
ously by a student at the Royal Academy, A. J. Oliver, in
a letter to Henry Thomson, 10 December 1794, British
Library, Add. MSS 50,066, f.14, and in the *Farington
Diary*, vol. 1, p. 273 (11 December 1794). Though I have
not been able to trace a published version of West's lecture,
a transcript must have been in circulation, for the relevant
passage was printed in [Bernard], 'Life of Mr Thomas
Proctor', pp. 199–200n. The comments were not recorded
in John Galt's biography of West, which includes sum-
maries of a number of the president's lectures; *The Life and
Studies of Benjamin West*, London, 1816, and *The Life
and Works of Benjamin West . . . Part 2*, London, 1820.
John Opie's comment appeared in his, 'Lecture III. – On
Chiaroscuro', in *Lectures on Painting by the Royal
Academicians*, ed. Ralph Wornum, London, 1885, p. 293.
Westmacott's lectures were never published in their origi-
nal form and the few portions that survive do not deal with
Procter. His first lecture apparently dealt mainly with
Flaxman. See Mario Busco, *Sir Richard Westmacott:
Sculptor*, Cambridge, 1994, pp. 28–9. However, his views
on Procter were noted in Smith, *Nollekens and his Times*,
vol. 2, p. 66.

18 Thomas Brayshaw and Ralph M. Robinson, *A History of
the Ancient Parish of Giggleswick*, p. 261; London, 1932,
H. L. Mullins, *The Giggleswick School Register 1499 to
1913*, Leeds, 1913, pp. xiv–xv.

19 Smith, *Nollekens and his Times*, vol. 2, p. 62. Brayshaw
and Robinson record Procter's work in a clerk's office, but
not his time in Manchester (*History of the Ancient Parish
of Giggleswick*, p. 261). Although many sources give his
name as 'Proctor', official documents relating to the family
always use the spelling 'Procter', and that is followed here.

20 Smith, *Nollekens and his Times*, vol. 2, p. 62. Barry's
Venus was actually exhibited in 1772, though Valentine
Green's reproductive mezzotint of 1772 would presumably
still have been in circulation in the later 1770s, and John
Boydell published a new engraving in 1778. See William L.
Pressly, *The Life and Art of James Barry*, New Haven and
London, 1981 'Catalogue of Paintings', no. 7.

21 Brayshaw and Robinson, *History of the Ancient Parish of
Giggleswick*, p. 261.

22 Library of the Royal Academy of Arts, London, GA/1/163,
10 December 1782; GA/1/174, 10 December 1783;
GA/1/184, 10 December 1784.

23 *Morning Herald* (28 April 1785); *Artist's Repository* 4,
part 1 (1785). See also *General Evening Post* (26–28 April
1785) and *General Advertiser* (2 May 1785).

24 Horace Walpole to Horace Mann, 7 May 1785, in *Yale
Edition of Horace, Walpole's Correspondence*, ed. W. S.
Lewis, Oxford and New Haven, 1937–83, vol. 25 p. 577.

25 Newspaper clipping dated May 1785, in *Anecdotes of
Painting in England (1760–1795) . . . Collected by Horace
Walpole ('Volume the Fifth and Last')*, ed. Frederick W.
Hilles and Philip B. Daghlian, New Haven and London,
1937, p. 150.

26 *European Magazine*, 9 (1786) pp. 3–11 *Artist's Repository*
4, part 2 (1786), p. 27–8.

27 *General Evening Post* (1–3 May 1792). Prince Hoare

(*Epochs of the Arts*, p. 80) clarifies that the position of the
model was in the centre of the library rather than the Great
Room, and that it was displayed separately from all the
other sculptural work in the exhibition.

28 Library of the Royal Academy of Arts, London,
CM/2/311-12, December 10 1793; GA/2/325, 10 February
1794.

29 Smith, *Nollekens and his Times*, vol. 2, p. 63.

30 Brayshaw and Robinson, *History of the Ancient Parish of
Giggleswick*, p. 263. His London address was demonstra-
bly Maiden Lane rather than the reputed Clare Market (a
slum dominated by the meat trade), although the former
was not particularly salubrious. See 'Maiden-lane, Covent-
Garden', *Builder* 32 (1874), pp. 819–21.

31 Procter called on Joseph Farington on 21 and 27 October
to solicit his vote for the forthcoming election (see
Farington Diary, vol. 1 pp. 73, 75). On 7 November he
called again and gave the diarist an impressive list of aca-
demicians who had already agreed to vote for him, includ-
ing Thomas Banks, Henry Fuseli, William Hodges, Paul
Sandby, Robert Smirke, Francis Wheatley, Garin Hamilton,
Joseph Wilton, Richard Cosway, Francis Bourgeois and
John Singleton Copley. Farington promised to vote for him
also. See *Farington Diary*, vol. 1, p. 90.

32 On 7 February the council had been assured that Procter
was 'Ready to sett off for Rome'; Library of the Royal
Academy of Arts, London, CM/2/202. On 13 March the
council received a letter from the artist that stated he
'would be ready to set out for Rome, the first week of
May'; Library of the Royal Academy of Arts, London,
CM/2/204. In June he collected the £30 grant allowed to
him by the academy for his outward expenses; Library of
the Royal Academy of Arts, London, *RA Cash Book*, p.
60 (12 June 1794).

33 *Farington Diary*, vol. 1, p. 218 (19 July 1794). The rapid
circulation of the news of Procter's death was at least partly
fuelled by the fact that this meant a new Rome scholar
would have to be elected.

34 *Farington Diary*, vol. 1, p. 218 (22 July 1794).

35 Quoted in [Bernard], 'Life of Mr Thomas Proctor',
p. 200n.

36 See *Director*, 1, no. 7, pp. 199–200n, quoting West's 1794
lecture. See also Hoare, *Epochs of the Arts*, pp. 79–84,
who mentions that both models were bought immediately
after their exhibition.

37 *Ixion* and *Pirithous* were included in the catalogue of the
house sale for Ashridge, Berkhamsted, Herts., conducted
by Drivers, Jonas & Co., on 13–15 and 20–22 October
1924. Described here as 'plaster models' they were either
the original terracottas whitewashed or, more likely, plaster
casts of the still more fragile terracotta originals. *The
Accusers of Daniel Thrown in the Lions' Den* was included
in the sale of pictures removed from Ashridge and sold by
Christie, Manson & Woods, London, 4–7 May 1923. The
annotated copy in Christie's Archive indicates that it was
purchased by 'Wolff' – perhaps the art dealer Wolff who
was operating out of a gallery in Tottenham Court Road
at this date. Other works by Procter have not yet been
traced. A painted self-portrait was exhibited and illustrated
in Edward Hailstone, ed., *Portraits of Yorkshire Worthies*

Selected from the National Exhibition of Works of Art at Leeds, 1868, with Biographical Notices, London, 1869, vol. 2, p. 158. At the end of the nineteenth century a local historian noted that 'Some rough sketches of the sculptor's early years were, until lately, to be seen in the dairy of his old home', H. Speight, *The Craven and North-West Yorkshire Highlands*, London, 1892, p. 91. In the 1930s, the self-portrait and a portrait of the artist's father in miniature were in the collection of Thomas Brayshaw; Brayshaw and Robinson, *History of the Ancient Parish of Giggleswick*, p. 264. Phil Hudson of the North Craven Historical Research Group has informed me that Brayshaw's property was dispersed by sale, but this did not include any works by Procter. They may have travelled, with Brayshaw's son, to Canada.

38 G. Hamilton, *The English School: A Series of the Most Approved Productions in Painting and Sculpture Executed by British Artists*, London, 1831–32, vol. 2, nos 162, 204 and 218. The untraced author of these volumes, 'G. Hamilton', is probably a pen-name, meant to evoke, as a distinguished precedent for these volumes, Gavin Hamilton's *Schola Italica Picturae* (1773).

39 See Peter Fullerton, 'Patronage and Pedagogy: The British Institution in the Early Nineteenth Century', *Art History* 5 (1982), pp. 59–72; Peter Funnell, 'The London Art World and its Institutions', in *London: World City 1800–1840*, ed. Celina Fox, New Haven and London, 1992, pp. 155–66, esp. pp. 157–62; Ann Pullan, 'Public Goods or Private Interests? The British Institution in the Early Nineteenth Century', in *Art in Bourgeois Society, 1790–1850*, ed. Andrew Hemingway and William Vaughan Cambridge, 1998, pp. 27–44.

40 [Bernard], 'Life of Mr Thomas Proctor', p. 196.

41 [Bernard], 'Life of Thomas Proctor', pp. 203–4. Citing the life of Procter, Bernard's biographer noted that he 'had become acquainted with some extraordinary instances of young artists of great natural talents, irretrievably lost to the country by want of that patronage which is essential to the existence of the arts'; James Baker, *The Life of Sir Thomas Bernard, Baronet*, London, 1819, pp. 76–7.

42 [Bernard], 'Life of Mr Thomas Proctor', p. 200.

43 Peggy Fogelman, Peter Fusco and Simon Stock, 'John Deare (1759–1798): A British Neo-classical Sculptor in Rome', *Sculpture Journal* 4 (2000), pp. 85–126. This artisanal training did not, of course, provide Deare with the intellectual resources of the 'liberal' artist, as was noted disparagingly by Francis Holden to William Roscoe, 1 May 1781, Liverpool Record Office, ROS 2065. On Carter and his studio see Rupert Gunnis, 'The Carters', *Architectural Review* 123 (1958), p. 334.

44 Anonymous, *Letters Concerning the Present State of England Particularly Respecting the Politics, Arts, Manners, and Literature of the Times*, London, 1772, p. 270.

45 See Timothy Clifford, 'Vulliamy Clocks and British Sculpture', *Apollo* 132 (1990), pp. 226–37. By 1783 Deare was also working as a modeller for the sculptor John Bacon; John Deare to Thomas Deare, 15 September 1783, in Smith, *Nollekens and his Times*, vol. 2, p. 241.

46 The election took place on 15 February 1785; Library of

the Royal Academy of Arts, London, GA/1/189. Though Deare won the highest vote in the first round, in the second round he lost by a single suffrage to Rossi. The general assembly subsequently voted to send both sculptors to Rome; Library of the Royal Academy of Arts, London, CM/2/1, 7 March 1785; Library of the Royal Academy of Arts, London, GA/1/190, 14 March 1785. On 15 May, Reynolds supplied Deare with a letter of introduction to Horace Mann; Deare to his father, 15 May 1785, in Smith, *Nollekens and his Times*, vol. 2, pp. 244–5. Deare was in Paris by 25 May 1785; letter to his father, in Smith, *Nollekens and his Times*, vol. 2, p. 245. On 2 July he sent a letter to the academy to announce his arrival with Rossi in Rome; Library of the Royal Academy of Arts, London, GA/2/11, 14 October 1785; see also James Irvine to George Cumberland, 2 July 1785, British Library, Add.MSS 36,495, f.53. A stipple engraving dated 1786 of Rossi's *Diana and Endymion*, exhibited at the Royal Academy in 1785 (no. 513), shows an oval relief fundamentally similar to Deare's *Eleanor* (FIG. 162) in its characterization of form and decorative composition. A copy of the engraving is in Library of the Royal Academy of Arts, London, AND/6/62.

47 The relief of *The Good Samaritan* at the Old Dispensary in Church Street, Liverpool, was presumably an early commission. The existence of this work was noted by Benjamin Arthur Heywood, who referred to it as the 'only . . . public monument of his art'; *Addresses Delivered to the Meetings of the Proprietors of the Liverpool Royal Institution on the 27th February, 1822, & 13th February, 1824*, Liverpool, 1824, p. 18; see also Henry Smithers, *Liverpool: Its Commerce, Statistics and Institutions*, Liverpool, 1825. The work was destroyed around 1829; see Liverpool Record Office, 942 UND 3, J. G. Underhill MSS, 'The Liver', vol. 3 (1831), p. 75. In 1783 Deare produced a pedimental relief some 6 or 7 metres long for the house of Sir George Gosling in Hounslow; see John Deare to his father, 16 August 1783, in Smith, *Nollekens and his Times*, vol. 2, p. 241; Fogelman, Fusco and Stock, 'John Deare', pp. 89–90.

48 Library of the Royal Academy of Arts, London, CM/2/11, 14 October 1785. The academy's letter to Deare and Rossi, dated 10 November 1785, is printed in Smith, *Nollekens and his Times*, vol. 2, p. 249n.

49 Library of the Royal Academy of Arts, London, CM/2/15, 31 December 1785. The payment does not seem to have been made until 1789; Library of the Royal Academy of Arts, London, CM/2/67, 31 December 1788; Library of the Royal Academy of Arts, London, *RA Cash Book*, p. 50, entry for 1789. The relief was presumably *The Temptation of Ulysses*, exhibited at the academy in 1787, no. 618 (lost).

50 Francis Milner Newton to John Charles Felix Rossi, 22 January 1787, Liverpool Record Office, Hq920 DEA, 'John Deare: Sculptor, Liverpool 1760–1798: Miscellaneous Correspondence and Drawings (Mayer Papers)', f.56.

51 John Deare to the Council of the Royal Academy, 17 May 1787, reported Library of the Royal Academy of Arts, London, CM/2/30, 22 June 1787; see Fogelman, Fusco and Stock, 'John Deare', pp. 92–94 and Charles Avery, 'John

Deare's Marble Reliefs for Sir Andrew Corbet Corbet, Bt.', in *British Art Journal*, 3 (2002), pp. 50–7.

52 *St James's Chronicle* (24–27 May 1788).

53 The full-scale plaster model was in the collection at Northwick Park, Worcestershire. It was *in situ* by 1846; see 'Visits to Private Galleries, No.XVI: The Collection of the Right Honourable Lord Northwick, At Northwick Park, Worcestershire', *Art-Union* 8 (1846), p. 273. John Rushout, second baron Northwick (1770–1859), who was in Italy from 1793 to 1800, is presumed to have acquired it. The marble was rediscovered in a private collection in France and bought by the Los Angeles Museum of Art in 1979; see *Los Angeles County Museum of Art Bulletin* 26 (1980), no. 11. It may be assumed that, like one of the models of the *Edward and Eleanor* and other works by the artist, the marble had been taken from Rome by a French invader; see George Cumberland, 'Sketch of the Biography of Charles Grignion, Esq.', *Monthly Magazine*, (1 January 1809), p. 552; Fogelman, Fusco and Stock, 'John Deare', no. 15.

54 See Deare to his father, 1786, in Smith, *Nollekens and his Times*, vol. 2, p. 250.

55 The two works were described admiringly by Elizabeth Giddes after a visit to the artist's studio in 1790; National Archives, Kew, 30/9/7/11, 21 April 1790. Four years later L. J. de Goujon De Thuisy also visited Deare's studio and noted that these same works were the best examples of his sculpture; 'Voyage en Italie: Rome en 1792–3 et 1794. Tome 1er.', British Library, Add.MSS 64, 100, f.221.

56 In 1791 he was able to report that he had £1,200 of work in hand and employed several assistants and a servant; John Deare to Joseph Deare, 13 July 1791, in Smith, *Nollekens and his Times*, vol. 2, p. 252. The work in hand included a relief of *The Landing of Julius Caesar* for John Penn (Alastair Lang, 'Clubhouse Neo-Classicism', *Country Life* 173 (1983), p. 187) and reliefs, busts and copies for Penn, Sir Richard Worsley and the earl of Bristol; letters to Joseph Deare, 27 June 1788 to 13 July 1791, in Smith, *Nollekens and his Times*, vol. 2, pp. 250–2; James Irvine to George Cumberland, 8 April 1791, British Library, Add.MSS 36,496, f.307v.

57 The architect Joseph Gandy designed chimney pieces and monuments for Deare; see Joseph Gandy to Thomas Gandy, 23 January 1796, British Architectural Library, RIBA, London, GA.FAM/1, ff.121–2. The architect also reported that George Hadfield, the incumbent Royal Academy Rome scholar, had been similarly employed; see Joseph Gandy to Thomas Gandy, 11 August 1796, British Architectural Library, RIBA, London, GA.FAM/1, ff.136–7.

58 C. H. Tatham to Henry Holland, 7 June 1795, Victoria and Albert Museum, D.1479-98-11. See Damie Stillman, 'Chimney-Pieces for the English Market: A Thriving Business in Late Eighteenth-Century Rome', *Art Bulletin* 59 (1977), pp. 85–94.

59 Joseph Gandy brought the case. See Gandy to Thomas Gandy, 7 January 1797, British Architectural Library, GA.FAM/1, f.156.

60 John Deare, Victoria and Albert Museum, London, E.181-1966.

61 John Deare, Victoria and Albert Museum, London, E.189-1966.

62 On Flaxman see David Irwin, *John Flaxman: Sculptor, Illustrator, Designer*, London, 1979; David Bindman, ed., *John Flaxman*, exhibition catalogue, Royal Academy of Arts, London, 1979; David Bindman, ed., *John Flaxman 1755–1826: Master of the Purest Line*, exhibition catalogue, Sir John Soane's Museum and University College, London, 2003. On Flaxman senior see Timothy Clifford, 'The Plaster Shops of the Rococo and Neo-Classical Era in Britain' in the *Journal of the History of Collections* 4 (1992), pp. 53–5.

63 Flaxman senior supplied the short-lived drawing academy in Liverpool and the Royal Academy with collections of teaching casts in 1770; see Joseph Mayer, *Early Exhibitions of Art in Liverpool: With Some Notes for a Memoir of George Stubbs, RA*, Liverpool, 1876, p. 5, and for the Royal Academy, the bill at Library of the Royal Academy of Arts, London, SB/55.

64 Library of the Royal Academy of Arts, London, GA/1/70, 10 December 1772. According to J. T. Smith, Flaxman was expected to win, as Engleheart had not attended the candidate's test; Smith, *Nollekens and his Times*, vol. 2, pp. 356–7. This statement is supported by an early biographical account of Engleheart written by his nephew Nathaniel, quoted in G. C. Williamson and Henry Lewis Dillman Engleheart, *George Engleheart 1750–1829: Miniature Painter to George III*, London, 1902, pp. 4–5.

65 Josiah Wedgwood to Thomas Bentley, 14 January 1775, in Eliza Meteyard, *The Life of Josiah Wedgwood*, London, 1856–66, vol. 2, p. 321.

66 See Bruce Tattersall, 'Flaxman and Wedgwood', in *John Flaxman*, ed. Bindman, pp. 47–9 and nos 19–53. See also David Irwin, 'Neo-Classical Design: Industry Plunders Antiquity', *Apollo* 97 (1972), pp. 288–97; Albert Boime, *Art in an Age of Revolution 1750–1800*, Chicago and London, 1987, pp. 370–82.

67 See Meteyard, *Wedgwood*, vol. 2, pp. 485–6. On Knight's patronage see Ella Hendriks, 'The First Patron of John Flaxman', *Burlington Magazine* 126 (1984), pp. 620–5.

68 Flaxman stood for election in 1784 and 1785; Library of the Royal Academy of Arts, London, GA/1/180, 8 November 1784; Library of the Royal Academy of Arts, London, GA/1/192, 7 November 1785.

69 Benjamin Bates to Mrs Flaxman, 4 January 1787, British Library, Add. MSS 39,781, ff.362–3.

70 Meteyard, *Wedgwood*, vol. 2, p. 504; clipping from the *World*, dated 1787, in Library of the Royal Academy of Arts, London, AND/6/171.

71 John Flaxman to John and Elizabeth Flaxman, Rome, 1789, Fitzwilliam Museum, Cambridge, 'Autograph Letters to William Hayley: Blue Vellum Book', f.62.

72 John Flaxman to John and Elizabeth Flaxman, 30 August 1788, British Library, Add.MSS 39,780, f.45v.

73 John Flaxman to John and Elizabeth Flaxman, 30 August 1788, British Library, Add.MSS 39,780, f.45v; Irwin, *John Flaxman*, pp. 48–52.

74 Particularly a large bas-relief 'in the grand style'; John Flaxman to Mary Flaxman, 9 July 1789, British Library, Add.MSS 39, 780, f.52. This may have been commissioned

by Knight. See Hendriks, 'The First Patron of John Flaxman', p. 623.

75 Flaxman evidently considered this a showpiece, for he presented it to the academy as his diploma work in 1800, though he originally planned to replace it with 'a Figure in Marble'; Library of the Royal Academy of Arts, London, CM/3/52, 19 February 1801.

76 See David Watkins, *Thomas Hope and the Neo-Classical Idea*, London, 1968, p. 31.

77 See Watkins, *Thomas Hope*, pp. 110–13.

78 John Flaxman to George Romney, 15 April 1790, Fitzwilliam Museum Cambridge, 'Autograph Letters to Hayley: Blue Vellum Book', f.63.

79 John Flaxman to John, Elizabeth and Mary Ann Flaxman, 3 March 1792, British Library, Add.MSS 39,780, f.57v. See also Irwin, *John Flaxman*, p. 224 n.10; John Flaxman to John Flaxman senr, 23 November 1793, British Library, Add. MSS 39,780, f.61. On Flaxman's working methods see Mary Webster, 'Flaxman as Sculptor', in *John Flaxman*, ed. Bindman, pp. 100–1.

80 See Mrs Hare-Naylor to Mrs Flaxman, 3 July [1795], British Library, Add. MSS 39,781, f.392; Williams Childe-Pemberton, *The Earl-Bishop*, 2 vols, London 1925, vol. 2, pp. 417–19; Edward Knight to John Flaxman, 23 April 1792, British Library, Add. MSS 39,781, f.8v.

81 John Flaxman to his parents, 7 October 1790, British Library, Add MSS 39, 780, f.50.

82 C. R. Cockerell, diary, 27 November 1824, Cockerell Family Papers, British Architectural Library, RIBA, CoC/9/5, quoted in G. E. Bentley, 'The Unrecognized First Printing of Flaxman's *Iliad*', *Analytical & Enumerative Bibliography* 9 (1995), p. 103.

83 See Laurence Eusden, trans, 'The Transformation of Ino and Melicenta to Sea-Gods', in *Ovid's Metamorphoses in Fifteen Books* trans. John Dryden et al., London, 1751, vol. 1, pp. 132–8, p. 137.

84 Whinney, *Sculpture in Britain*, p. 188; W. G. Constable, *John Flaxman 1755–1826*, London, 1928, p. 41; Irwin, *John Flaxman*, p. 58.

85 See Robert Rosenblum, *Transformations in Late Eighteenth-Century Art*, Princeton, 1967, pp. 158–79; Robert Essick and Jenijoy La Belle, eds, *Flaxman's Illustrations to Homer*, New York, 1977; Julia Sarah Symmons, *Flaxman and Europe: The Outline Illustrations and their Influence*, New York and London, 1984.

86 'Mr Hare Naylor proposed to Flaxman to design the subjects of Homer, for which he paid him 1 Guinea each. there are abt. 40 in each (Iliad & Odyssey.) the plates of Iliad were sold after by H. Naylor to Longmans for twice as much as the engravings & original drawgs. had cost him in Italy. Mr H. Naylor made at least 100£ by the books in Italy before his sale of the Plates of the Iliad. – those of the Odyssey were lost in the voyage'; C. R. Cockerell, diary, 27 November 1824, quoted in Bentley, 'The Unrecognized First Printing of Flaxman's *Iliad*', p. 103.

87 Thomas Lawrence in *Farington Diary*, vol. 1, p. 264 (26 November 1794).

88 John Flaxman to Revd William Gunn, 1 October 1814, British Library, Add.MSS 39,790, f.30.

89 See Joseph Gandy to Thomas Gandy, 6 February 1795, British Architectural Library, RIBA, GA.FAM/1, ff.61-2. At the beginning of the 1790s the academy raised its Rome scholarship from sixty pounds per annum to one hundred pounds; Library of the Royal Academy of Arts, London, GA/1/258, 10 February 1791; Joseph Gandy to Thomas Gandy, 26 August 1795, British Architectural Library, RIBA, GA.FAM/1, ff.97-9.

90 C. H. Tatham to Henry Holland, 30 January 1796, Victoria and Albert Museum, D.1479-98-21.

91 See Joseph Gandy to Thomas Gandy, 16 August 1796, British Architectural Library, RIBA, GA.FAM/1, f.138. See also William Artaud's report on Deare's losses in a letter to John Landseer, 20 November 1797, in A. C. Sewter, *The Life, Work and Letters of William Artaud*, MA report, University of Manchester 1951, vol. 2, p. 263.

92 John Flaxman to Revd William Gunn, 1 July 1800, British Library, Add.MSS 39,790, f.16. 'Hewetson' is the sculptor Christopher Hewetson.

'I NEVER PRESUM'D TO CLASS THE THE PAINTERS': THE STATE OF THE ARTS 1785–1800

1 Frederick August Wendeborn, *A View of England Towards the Close of the Eighteenth Century*, London, 1791, vol. 2, pp. 184–5. The *View* was first published in German in 1786.

2 Wendeborn, *View of England*, vol. 2, pp. 191–2, 201–3 and 219–20.

3 Horace Walpole, postscript to *Catalogue of Engravers* (1762), quoted in David Alexander and Richard T. Godfrey, *Painters and Engraving: The Reproductive Print from Hogarth to Wilkie*, exhibition catalogue, Yale Center for British Art, New Haven, 1980, p. 40.

4 *Morning Post* (10 May 1785).

5 Wendeborn, *View of England*, vol. 2, pp. 180–3.

6 [Thomas Bernard], 'The Life of Thomas Proctor', in *Director* 1 (1807) p. 194n.

7 See Winifred H. Friedman, *Boydell's Shakespeare Gallery*, New York and London, 1976; Sven H. A. Bruntjen, *John Boydell, 1719–1804: A Study of Art Patronage and Publishing in Georgian London*, New York and London, 1985; Richard D. Altick, *Paintings from Books: Art and Literature in Britain, 1760–1900*, Columbus, 1985, pp. 43–55; Walter Pape and Frederick Burwick, eds, *The Boydell Shakespeare Gallery*, Bottrop, 1996.

8 See T. S. R. Boase, 'Macklin and Bowyer', *Journal of the Warburg and Courtauld Institutes* 26 (1963), pp. 148–77; Robin Hamlyn, 'An Irish Shakespeare Gallery', *Burlington Magazine* 120 (1978), pp. 515–29; Richard Wetherill Hutton, 'Robert Bowyer and the Historic Gallery: A Study in the Creation of a Magnificent Work to Promote the Arts in England' (Ph.D. diss., University of Chicago, 1992).

9 Bruntjen, *John Boydell*, p. 74.

10 See *St James's Chronicle* (12–15 April 1788).

11 See the letter pre-empting the exhibition in the *Gentleman's Magazine* 53 (1788), pp. 778–9. Also *Public Advertiser* (6 May 1789).

12 On shifting perceptions of the revolution in Britain, see David Bindman et al., *The Shadow of the Guillotine*:

Britain and the French Revolution, exhibition catalogue, British Museum, London, 1989; Gregory Claeys, introduction to *Political Writings of the 1790s*, London, 1995, vol. 1, pp. xvii–lvi; Stuart Andrews, *The British Periodical Press and the French Revolution, 1789–99*, Basingstoke, 2000. On the conservatism of the 1790s see H. T. Dickinson, 'Popular Conservatism and Militant Loyalsm 1789–1815', in *Britain and the French Revolution, 1789–1815*, ed. H. T. Dickinson, Basingstoke, 1984, pp. 103–25; H. T. Dickinson, 'Popular Loyalism in Britain in the 1790s', in Eckhart, Hellmuth ed., *The Transformation of Political Culture*, Oxford 1990, pp. 503–33; David Eastwood, 'Patriotism and the English State in the 1790s', in *The French Revolution and British Popular Politics*, ed. Mark Philp, Cambridge, 1991, pp. 146–68.

13 On the French Revolution and the compulsion of normative gender roles in the 1790s, see Mitzi Myers, 'Reform or Ruin: "A Revolution in Female Manners"', in *Studies in Eighteenth-Century Culture* 2 (1982), pp. 199–216; Gary Kelly, *Women, Writing, and Revolution 1790–1827*, Oxford, 1993, esp. pp. 173–9; Eleanor Ty, *Unsex'd Revolutionaries: Five Women Novelists of the 1790s*, Toronto, 1993; Paul Keen, *The Crisis in Literature in the 1790s: Print Culture and the Public Sphere*, Cambridge, 1999, esp. pp. 199–205; M. O. Grenby, *The Anti-Jacobin Novel: British Conservatism and the French Revolution*, Cambridge, 2001.

14 Gregory Claeys, 'The French Revolution Debate and British Political Thought', in *History of Political Thought* 11 (1990), pp. 59–80; Gregory Claeys, 'The Origins of the Rights of Labour: Republicanism, Commerce, and the Construction of Modern Social Theory in Britain, 1796–1805', *Journal of Modern History* 66 (1994), pp. 249–90.

15 See Morris Eaves, *The Counter-Arts Conspiracy: Art and Industry in the Age of Blake*, Ithaca, New York, and London, 1992, pp. 41–55.

16 John Boydell to Sir John William Anderson, 4 February 1804, in Josiah Boydell's preface to *Collection of Prints, from Pictures Painted for the Purpose of Illustrating the Dramatic Works of Shakespeare*, London, 1803 [1804]; facsimile reprint with introduction by A. E. Santaniello, *The Boydell Shakespeare Gallery*, New York and London, 1968.

17 Horace Walpole to Robert Jephson, February 1775, in *Yale Edition of Horace Walpole's Correspondence*, Oxford and New Haven, 1937–83, vol. 41, p. 297.

18 Edmund Burke to Edmund Malone, 5 April 1796, in *The Correspondence of Edmund Burke*, ed. Thomas W. Copeland et al., Cambridge and Chicago, 1958–78, vol. 8, p. 456.

19 Gary Taylor, *Reinventing Shakespeare: A Cultural History from the Restoration to the Present*, London, 1990, p. 149.

20 Joshua Reynolds, undated note, printed in *Portraits: By Sir Joshua Reynolds*, ed. Frederick W. Hilles, London, 1952, pp. 108–9. On the mobilization of an ideology of nationalism in Reynolds' writings on art, see, importantly, John Barrell, 'Sir Joshua Reynolds and the Englishness of English Art', in *Nation and Narration*, ed. Homi K. Bhabha, London and New York, 1990, pp. 154–76.

21 [Humphrey Repton], *The Bee: Or, A Companion to the Shakespeare Gallery*, London, 1789, p. 7. Cf. the comments of John Landseer and Charles Lamb quoted by Altick, *Paintings from Books*, pp. 46–8, which make the same point, but in a negative context.

22 Thomas Macklin, *Catalogue of the Third Exhibition of Pictures, Painted for Mr Macklin by the Artists of Britain*, London, 1790, p.v.

23 *Daily Universal Register* (22 May 1787).

24 John Boydell to Joseph Wright, 4 August 1789, Derby Local Studies Library, Ms 8962. Boydell continued his letter with a put-down: 'At the same time I am free to confess, that had I ever presum'd to have class'd the Historical Painters in this Country, perhaps Mr Wright's name would not have stood exactly, where he has been pleased to place it himself. In the line of landscape, I confess it would have been a different consideration.'

25 Henry Fuseli to William Roscoe, 17 August 1790, in *The Collected English Letters of Henry Fuseli*, ed. David H. Weinglass, Millwood, NY, 1982, p. 61 (hereafter referred to as *Fuseli Letters*).

26 The scheme is detailed in Gert Schiff, *Johann Heinrich Füsslis Milton-Galerie*, Zurich, 1963; Christoph Becker with Claudia Hattendorff, *Johann Heinich Füssli: Das Verlorene Paradies*, exhibition catalogue, Staatsgalerie, Stuttgart, 1997; Luisa Calè, 'Henry Fuseli's Milton Gallery: "Turning Readers into Spectators"'. (Ph.D. diss. University of Oxford, 2001).

27 See Kenneth Garlick et al., eds, *The Diary of Joseph Farington*, New Haven and London, 1978–98, vol. 3, p. 830 (29 April 1797), p. 972 (24 January 1798) (hereafter referred to as *Farington Diary*).

28 Henry Fuseli to William Roscoe, 24 May 1799, in *Fuseli Letters*, p. 196.

29 *Farington Diary*, vol. 4, p. 1145 (23 January 1799).

30 See Henry Fuseli to William Roscoe, 20 June 1799, in *Fuseli Letters*, p. 203; *Farington Diary*, vol. 4, p. 1252 (10 July 1799). The rental rate is mentioned in John Knowles, *The Life and Writings of Henry Fuseli*, London, 1830, p. 204 and p. 223.

31 See Knowles, *Life and Writings of Henry Fuseli*, vol. 1, pp. 198–9.

32 With the heightened nervousness about revolutionary tendencies in the 1790s, Fuseli was perhaps rightly upset that William Godwin had 'made a malevolent insinuation against his principles' in his *Life of Mary Wollstonecraft* (1798); see *Farington Diary*, vol. 3, p. 1043 (3 August 1798). Later that year, Farington reported that Fuseli's search for sponsorship was still frustrated, but this was his own fault 'by too free opinions of religion & politicks. That but for this – 2 or 3 yrs ago Burke might have been induced to obtain something of a pension for him'; p. 1115, 20 December 1798.

33 *Farington Diary*, vol. 3, p. 1016 (4 June 1798). Such 'prudency' was characteristic, in fact, of the middle-class intellectual circles to which Fuseli belonged, and this equivocal, contradictory response to the French Revolution can be found in the *Analytical Review*, the literary journal to which the painter contributed extensively. See Brian Rigby, 'Radical Spectators of the Revolution: The Case of the

Analytical Review', in Ceri Crossley and Ian Small, *The French Revolution and British Culture*, Oxford and New York, 1989, pp. 63–83. Fuseli's early withdrawal of his revolutionary sympathies appeared in the *Analytical Review* before the end of 1793; see Eudo C. Mason, *The Mind of Henry Fuseli: Selections from his Writings with an Introductory Study*, London, 1951, p. 185. The middle-class, Dissenting circles associated with Joseph Johnson and the *Analytical Review* were characterized by their 'anti-conservatism' rather than outright radicalism. The distinction between radicalism and 'anti-conservatism' is drawn by Helen Braithwaite, *Romanticism, Publishing and Dissent: Joseph Johnson and the Cause of Liberty*, Basingstoke, 2003, p. xiii.

34 See Dustin Griffin, *Regaining Paradise: Milton and the Eighteenth Century*, Cambridge, 1986, p. 18; Lucy Newlyn, *Paradise Lost and the Romantic Reader*, Oxford, 1993, pp. 91–118.

35 See David Simpson, *Romanticism, Nationalism and the Revolt against Theory*, Chicago and London, 1993, pp. 132–4. A rare enthusiastic account of the experience of the Milton Gallery indicates its reception in terms of fragmented, emotive spectacle rather than highly crafted narrative: Amos Simon Cottle's 'On the Milton Gallery', in Joseph Cottle, *Malvern Hills and Other Poems*, London, 1802, gives admiring lines to Thomas Lawrence, John Opie, James Barry and John Hoppner, all of whom are inspired by nature, before asking:

> – But who to thee has giv'n
> O Fuseli! the keys of Hell and Heaven?
> Taught thee to venture down the dark abyss
> Or ope the regions of primeval bliss?
>
> Whether thy Lapland orgies I behold,
> Or Arimaspian, 'scap'd with pilfer'd gold,
> Mab's junket feats; or that delusive Sprite,
> Whose pranks mislead the wondr'ing boors of night;
> The lubber-fiend, outstretch'd the chimney near,
> Or sad Ulsysses on the larboard Steer;
> Or him, with murky wings, whom crowd's invoke,
> To deal the last, but long suspended stroke,
> Th' unbody'd thought with keen delight I view,
> To' far from Nature, yet to Fancy true.
>
> Such Shakespeare's praise full-oft; who
> "spurn'd the reign
> Of panting time" – Such was thy Poet's strain. –
> Like him, no vulgar bounds thy fire repress –
> You give to sight, what Milton dar'd express!

See also the anonymous poem 'A Vision', in Knowles, *Life and Writings of Henry Fuseli*, vol. 1, pp. 435–9, with its lines 'In pleasing wonder lost, intent I gaz'd; / As Sorrow, Guilt, Despair, the scenes express'd, / Awe, Terror, Pity, sway'd by turns my breast' These reactions, together with Benjamin Robert Haydon's description of visiting Fuseli's home and studio and seeing the range of Miltonic imagery there (below, p. 310–11) and the Revd Bromley's breathless inventory of the potential imagery of the Milton Gallery (*Fuseli Letters*, p. 115), suggest that the characteristic response to Fuseli's work is one of rapid emotional change, awe, rapture and, indeed, confusion. For a sophisticated argument about the narrative character of the Milton Gallery that runs quite contrary to that being made here, see Calè, 'Henry Fuseli's Milton Gallery', esp. vol. 1, pp. 197–203.

36 See Henry Fuseli to William Roscoe, 10 March 1794, in *Fuseli Letters*, p. 93.

37 Knowles, *Life and Writings of Henry Fuseli*, vol. 1, pp. 196–7.

38 *Farington Diary*, vol. 4, p. 1226 (20 May 1799).

39 Henry Fuseli to William Roscoe, 18 June 1800, in *Fuseli Letters*, p. 212.

CONCLUSION

1 See David Bindman, *Blake as an Artist*, Oxford, 1977, pp. 13–16; Robert N. Essick, *William Blake Printmaker*, Princeton, 1980, pp. 178–86. Also, Dena Bain Taylor, 'The Visual Context of "Joseph of Arimathea among The Rocks of Albion" ', *Blake: An Illustrated Quarterly* 20 (1986), pp. 47–8.

2 Joshua Reynolds, *Discourses on Art*, ed. Robert R. Wark, New Haven and London, 1975, pp. 83–4.

3 John Flaxman to William Hayley, 26 April 1784, in *Blake Records*, ed. G. E. Bentley, London and New Haven, 2002, p. 31.

4 See Michael Phillips, 'Blake and the Terror 1792–93', *Library* sixth series, 16 (1994), pp. 263–97.

5 W. J. T. Mitchell, *Blake's Composite Art: A Study of the Illuminated Poetry*, Princeton 1978, pp. 25–6.

6 Fuseli and Blake were linked almost as soon as the latter's work became publicly visible; see the review in the *Morning Chronicle*, 27 May 1784, in *Blake Records*, ed. Bentley, p. 32. The question of Blake's audiences is addressed in Jerome McGann, *Social Values and Poetic Acts: The Historical Judgment of Literary Work*, Cambridge, Mass., and London, 1988, pp. 232–6; Morris Eaves, *The Counter-Arts Conspiracy: Art and Industry in the Age of Blake*, Ithaca, NY, and London, 1992; see also Sarce Makdisi, *William Blake and the Impossible History of the 1790s*, Chicago and London, 2003, pp. 170–3.

7 See Robert N. Essick and Morton D. Paley, eds, *Robert Blair's The Grave Illustrated by William Blake*, London, 1982; *Blake Records*, ed. Bentley, pp. 207–81.

8 Henry Fuseli, 'Prospectus of a New and Elegant Edition of Blair's Grave', quoted in *Blake Records*, ed. Bentley, p. 211.

9 Robert Hartley Cromek to William Blake, ca. May 1807, in *Blake Records*, ed. Bentley p. 242.

10 See Bindman, *Blake as an Artist*, pp. 154–62. For a speculative account of the installation see Troy R. C. Patenaude, ' "The Glory of a Nation": Recovering William Blake's 1809 Exhibition', *British Art Journal* 4 (2003), pp. 52–63.

11 Blake noted that he expected criticism in the text of his flyer, dated May 1809, 'Exhibition of Paintings in Fresco, Poetical and Historical Inventions', in *William Blake's Writings*, ed. G. E. Bentley, Oxford, 1978, vol. 2, p. 822.

12 William Blake, Advertisement, 'A Descriptive Catalogue of

Blake's Exhibition', in *William Blake's Writings*, ed. Bentley, vol. 2, p. 825.

13 Robert Hunt, *Examiner* (17 September 1809), in *Blake Records*, ed. Bentley, pp. 282–5.

14 See Eaves, *The Counter-Arts Conspiracy*, pp. 167–8.

15 See Eaves, *The Counter-Arts Conspiracy*, p. 256.

16 William Blake, annotations to Reynolds' *Discourses on Art*, in *William Blake's Writings*, ed. Bentley, vol. 2, p. 1450.

17 See Luisa Calè, 'Henry Fuseli's Milton Gallery: "Turning Readers into Spectators"' (Ph.D. diss. University of Oxford, 2001, vol. 1, pp. 84–5.

18 *William Blake's Writings*, ed. Bentley, vol. 2, p. 954.

19 Thus Blake, again: 'You think Fuseli is not a Great Painter Im Glad / This is one of the best compliments he ever had'; 'To H' (presumed to mean Robert Hunt), in *William Blake's Writings*, ed. Bentley, vol. 2, p. 938. Also, notably, the partly deleted passage from Blake's 'Public Address' (ca. 1811), recommending 'Execution Organized & minutely delineated . . . I do not mean Smoothed up & Niggled & Poco Pend and all the beauties pickd out [*illegible*] & blurrd & blotted but Drawn with a firm hand & decided at once with all its Spots & Blemishes which are beauties & not faults like Fuseli & Michael Angelo Shakespeare & Milton'; *William Blake's Writings*, ed. Bentley, vol. 2, p. 1040.

20 Edward Dayes, *The Works of Edward Dayes*, London, 1805, pp. 326–7.

21 Benjamin Robert Haydon in *The Diary of Benjamin Robert Haydon* ed. Willard Bissell Pope, Cambridge, MA, 1960–63, vol. 3 p. 200 (28 May 1827); see also the review of an engraving by Blake in the *British Critic*, September 1796, in *Blake Records*, ed. Bentley, p. 74: 'Nor can we pass this opportunity of execrating that detestable taste, founded on the depraved fancy of one man of genius [ie. Fuseli], which substitutes deformity and extravagance for force and expression, and draws men and women without skins, with their joints all dislocated.'

22 Francis Douce, notebook, *c*.1811, quoted in *Blake Records*, ed. Bentley, p. 74. Procrustes was 'a famous robber of Attica', who 'tied travellers on a bed, and, if their length exceeded that of the bed, cut off part of their limbs to make their length equal to that of the bed; but if they were shorter he stretched their bodies till they were of the same length'; John Lemprière, *Bibliotheca Classica; Or, A Classical Dictionary*, London, 2nd edition, 1792.

23 See Paul Youngquist, *Monstrosities: Bodies and British Romanticism*, Minneapolis and London, 2003. The usefulness of monstrosity in delimiting social norms may be further suggested by George Canning's recommendation of Fuseli's 'mad taste' to James Gillray in his preparation of designs for the rabidly conservative *Anti-Jacobin*; see Draper Hill, *Mr Gillray the Caricaturist*, London, 1965, p. 90.

24 *The Autobiography and Memoirs of Benjamin Robert Haydon*, Tom Taylor, ed., London 1926, vol. 1, p. 25.

25 John Taylor, *Records of my Life*, London, 1832, vol. 1, p. 302.

26 Leigh Hunt; *The Autobiography of Leigh Hunt*, ed. J. E. Morpurgo, London 1948, pp. 192–3.

27 *Autobiography and Memoirs of Benjamin Robert Haydon*, vol. 1, p. 22.

28 Charles Robert Leslie, *Autobiographical Recollections of Charles Robert Leslie*, ed. Tom Taylor, London, 1860, vol. 1, p. 37. For further accounts of Fuseli's unconventional or downright unhelpful teaching methods see Allan Cunningham, *The Lives of the Most Eminent British Painters, Sculptors and Architects*, London, 1829–33, vol. 2, p. 274; John Knowles, *The Life and Writings of Henry Fuseli*, London, 1830, vol. 1, pp. 409–11; T. Sidney Cooper, *My Life*, London, 1890, vol. 1, p. 121; 'B', 'A Flit Through the Old Royal Academy', *Polytechnic Journal* 2 (1840), pp. 66–8; 'Recollections of Fuseli. By a Gold Medallist', *Polytechnic Journal* 2 (1840), pp. 122–5. For evidence of his professional dedication to the students, see Kenneth Garlick et al., eds., *The Diary of Joseph Farington*, New Haven and London, 1978–98, vol. 7, p. 2652 (29 November 1805), vol. 8, p. 2980 (2 March 1807); letter from 'A Student' to the *Artist* (13 June 1807) in *The Collected English Letters of Henry Fuseli*, ed. David H. Weinglass, Millwood, NY, 1982, pp. 359–60; Martin Archer Shee, *Elements of Art*, London, 1809, p. 62n.

29 On Haydon see David Blayney Brown, Robert Woof and Stephen Hebran, *Benjamin Robert Haydon 1786–1846: Painter and Writer, friend of Wordsworth and Keats*, Grasmere, 1996; John Barrell, 'Benjamin Robert Haydon: The Curtius at the Khyber Pass', in *Painting and the Politics of Culture: New Essays on British Art 1700–1850*, ed. John Barrell, Oxford and New York, 1992, pp. 253–90.

30 John Barrell, ' "Laodamia" and the Meaning of Mary', *Textual Practice* 10 (1996), p. 459.

31 William Carey, *Desultory Exposition of an Anti-British System of Incendiary Publication*, London, 1819, p. 33.

32 C. A. G. Goede, *The Stranger in England: Or, Travels in Great Britain*, London, 1807, vol. 2, pp. 164, 172.

33 Erik Gustaf Geijer, *Impressions of England 1809–1810 Compiled from his Letters and Diaries*, trans. Elizabeth Sprigge and Claude Napier, London, 1932, p. 186.

34 On the condemnation of the imagination see David Simpson, *Romanticism, Nationalism and the Revolt Against Theory*, Chicago and London, 1993; John Barrell, *Imagining the King's Death: Figurative Treason, Fantasies of Regicide 1793–1796*, Oxford, 2000. The broader thesis about the ascendancy of a counter-revolutionary bourgeois class and the legitimating role of tradition and empiricism leads to the arguments forwarded by Perry Anderson in the later 1960s; see his 'Origins of the Present Crisis' and 'Components of the National Culture' in *English Questions*, London and New York, 1992. See also, importantly, Ellen Meiksins Wood, *The Pristine Culture of Capitalism: A Historical Essay on Old Regimes and Modern States*, London and New York, 1991, who follows the argument developed by Anderson (and Tom Nairn) but reworks their conclusions regarding the retrograde or incompletely modern nature of Britain. The theoretical 'fuzziness' characteristic of British cultural and intellectual life is, for Wood, a sign of its capitalist modernity rather than of the incomplete nature of the advance of bourgeois capitalism, as argued by Nairn and Anderson.

35 See Kay Dian Kriz, *The Idea of the English Landscape Painter: Genius as Alibi in the Early Nineteenth Century*, New Haven and London, 1997.

36 See Alison Yarrington, *The Commemoration of the Hero 1800–1864: Monuments to the British Victors of the Napoleonic Wars*, New York and London, 1988, p. ix; Alison Yarrington, 'Nelson the Citizen Hero: State and Public Patronage of Monumental Sculpture 1805–18', *Art History* 6 (1983), pp. 315–29; Holger Hoock, *The King's Artists: The Royal Academy of Arts and the Politics of British Culture, 1760–1840*, Oxford, 2003, pp. 257–76.

37 Anderson, *English Questions*, p. 57.

38 The phrase 'measured disorder' is taken from Simpson's discussion of Burke's 'masculinization' of the imagination, *Romanticism, Nationalism, and the Revolt Against Theory*, pp. 125–31.

39 William Blake to George Cumberland, 12 April 1827, in *William Blake's Writings*, ed. Bentley, vol. 2, p. 1667. See Makdisi, *William Blake and the Impossible History of the 1790s*, pp. 313–24.

SELECTED BIBLIOGRAPHY

Allan, D. G. C., and J. L. Abbott, eds, *The Virtuoso Tribe of Arts and Sciences: Studies in the Eighteenth-Century Work and Membership of the London Society of Arts*, Athens, Georgia, and London, 1992

Anon., *Letters Concerning the Present State of England Particularly Respecting the Politics, Arts, Manners, and Literature of the Times*, London, 1772

Anderson, Perry, *English Questions*, London and New York, 1992

Armstrong, John, *Miscellanies*, 2 vols, London, 1770

Baird, John D., and Charles Ryskamp, eds, *The Poems of William Cowper*, 3 vols, Oxford, 1980–95

Baker, Malcolm, *Figured in Marble: The Making and Viewing of Eighteenth-Century Sculpture*, London, 2000

[Baker, Robert], *Observations on the Pictures Now in the Exhibition at the Royal Academy, Spring Gardens, and Mr Christie's*, London, 1771

Bakhtin, Mikail, *Rabelais and His World*, trans. Helene Iswolsky, Bloomington, Ind., 1984

Barrell, John, *The Political Theory of Painting from Reynolds to Hazlitt: 'The Body of the Public'*, New Haven and London, 1986

Barrell, John, 'Sir Joshua Reynolds and the Englishness of English Art', in *Nation and Narration*, ed. Homi K. Bhabha, London and New York, 1990, pp. 154–76

Barrell, John, *The Birth of Pandora and the Division of Knowledge*, Basingstoke, 1992

Barrell, John, ed., *Painting and the Politics of Culture: New Essays on British Art, 1700–1850*, Oxford, 1992

Bate, W. J., John M. Bullitt and L. F. Powell, eds, *The Idler and Adventurer*, Yale Edition of the Works of Samuel Johnson, vol. 2, New Haven and London, 1963

Bate, W. J., and Albrecht B. Strauss, eds, *The Rambler*, 3 vols, Yale Edition of the Works of Samuel Johnson, vols 3–5, New Haven and London, 1969

Bell, C. F., *Annals of Thomas Banks: Sculptor, Regal Academician*, Cambridge, 1938

Bentley, G. E., ed., *William Blake's Writings*, 2 vols, Oxford, 1978

Bentley, G. E., ed., *Blake Records*, 2nd ed., London and New Haven, 2002

[Bernard, Thomas], 'Banks's Statue of Achilles', in *Director* 1 (1807), pp. 65–78

Bertelsen, Lance, *The Nonsense Club: Literature and Popular Culture 1749–1764*, Oxford, 1986

Bindman, David, *Blake as an Artist*, Oxford, 1977

Bindman, David, ed., *John Flaxman*, exhibition catalogue, Royal Academy of Arts, London, 1979

Bindman David, et al., *The Shadow of the Guillotine: Britain and the French Revolution*, exhibition catalogue, British Museum, London, 1989

Bindman, David, and Malcolm Baker, *Roubiliac and the Eighteenth-Century Monument: Sculpture as Theatre*, New Haven and London, 1995

Boime, Albert, *Art in an Age of Revolution 1750–1800*, A Social History of Modern Art, vol. 1), Chicago and London, 1987

de Bolla, Peter, *The Discourse of the Sublime: Readings in History, Aesthetics and the Subject*, Oxford, 1989

de Bolla, Peter, *The Education of the Eye: Painting, Landscape, and Architecture in Eighteenth-Century Britain*, Stanford, Calif., 2003

Bond, Donald F., ed., *The Spectator*, 5 vols, Oxford 1965

Bourdieu, Pierre, *Distinction: A Social Critique of the Judgement of Taste*, trans. Richard Nice, London, 1986

Bourdieu, Pierre, *The Rules of Art: Genesis and Structure of the Literary Field*, trans. Susan Emanuel, Oxford, 1996

Braithwaite, Helen, *Romanticism, Publishing and Dissent: Joseph Johnson and the Cause of Liberty*, Basingstoke, 2003

Brayshaw, Thomas, and Ralph M. Robinson, *A History of the Ancient Parish of Giggleswick*, London, 1932

Brewer, John, *The Pleasures of the Imagination: English Culture in the Eighteenth Century*, London, 1997

Bromley, Robert Anthony, *A Philosophical and Critical History of the Fine Arts*, 2 vols, London, 1793–95

Brown, John, *An Estimate of the Manners and Principles of the Times*, 2 vols, London, 1757–58

de Bruyn, Frans, 'Hooking the Leviathan: The Eclipse of the Heroic and the Emergence of the Sublime in Eighteenth-Century British Literature', *Eighteenth Century: Theory and Interpretation* 28 (1987) pp. 193–215

Burke, Edmund, *A Philosophical Enquiry into the Origin of Our Ideas of the Sublime and the Beautiful*, ed. James T. Bolton, Oxford, 1987

Calè, Luisa, 'Henry Fuseli's Milton Gallery: "Turning Readers into Spectators" ', 2 vols, (Ph.D. diss., University of Oxford, 2001)

Carter, Philip, *Men and the Emergence of Polite Society: Britain 1660–1800*, Harlow, 2001

Chandler, George, *William Roscoe of Liverpool 1753–1831*, London, 1953

Chard, Chloe, 'Effeminacy, Pleasure and the Classical Body', in *Femininity and Masculinity in Eighteenth-Century Art and Culture*, ed. Gill Perry and Michael Rossington, Manchester, 1994, pp. 142–61

Claeys, Gregory, 'The French Revolution Debate and British Political Thought', in *History of Political Thought* 11 (1990), pp. 59–80

Claeys, Gregory, 'The Origins of the Rights of Labour: Republicanism, Commerce, and the Construction of Modern Social Theory in Britain, 1796–1805', *Journal of Modern History* 66 (1994), pp. 249–90

Clery, E. J., *The Rise of Supernatural Fiction, 1762–1800*, Cambridge, 1995

Clery, E. J., 'The Pleasure of Terror: Paradox in Edmund Burke's Theory of the Sublime', in *Pleasure in the Eighteenth Century*, ed. Roy Porter and Marie Mulvey Roberts, Basingstoke and London, 1996, pp. 164–81

Cohen, Michèle, *Fashioning Masculinity: National Identity and Language in the Eighteenth Century*, London and New York, 1996

Colley, Linda, *Britons: Forging the Nation 1708–1837*, 2nd ed., London, 1994

Coltharp, Duane, 'History and the Primitive: Homer, Black-

well, and the Scottish Enlightenment', *Eighteenth-Century Life* 19 (1995), pp. 57–69

Cooper, Helen A., et al., *John Trumbull: The Hand and Spirit of a Painter*, exhibition catalogue, Yale University Art Gallery, New Haven, 1982

Copeland, Thomas W., et al., eds, *The Correspondence of Edmund Burke*, 10 vols, Chicago, 1958–78

Coutu, Joan, 'Eighteenth-Century British Monuments and the Politics of Empire' (PhD diss., University College, London, 1993)

Craske, Matthew, *Art in Europe 1700–1830: A History of the Visual Arts in an Era of Unprecedented Urban Economic Change*, Oxford and New York, 1997

Crawford, Robert, ed., 'Heaven-Taught Fergusson': Robert Burns's Favourite Scottish Poet: Poems and Essays, East Linton, 2003

Cullen, Fintan, *Visual Politics: The Representation of Ireland 1750–1930*, Cork, 1997

Cullen, Fintan, ed., *Sources in Irish Art: A Reader*, Cork, 2000

Cunningham, Allan, *The Lives of the Most Eminent British Painters, Sculptors and Architects*, 6 vols, London, 1829–33

[Didbin, Thomas Frognall], 'The Life of Mr Thomas Proctor', *Director* 1 (1807), pp. 193–205

Eaves, Morris, *The Counter-Arts Conspiracy: Art and Industry in the Age of Blake*, Ithaca NY, and London, 1992

von Erffa, Helmut, and Allen Staley, *The Paintings of Benjamin West*, New Haven and London, 1986

Ferguson, Frances, *Solitude and the Sublime: Romanticism and the Aesthetics of Individuation*, New York and London, 1992

Fogelman, Peggy, Peter Fusco and Simon Stock, 'John Deare (1759–1798): A British Neo-classical Sculptor in Rome', *Sculpture Journal* 4 (2000), pp. 85–126

Friedman, Arthur, ed., *The Collected Works of Oliver Goldsmith*, 5 vols, Oxford, 1966

Fryer, Edward, *The Works of James Barry*, 2 vols, London, 1809

Furniss, Tom, *Edmund Burke's Aesthetic Ideology: Language, Gender, and Political Economy in Revolution*, Cambridge, 1993

Garlick, Kenneth, et al., eds, *The Diary of Joseph Farington*, 17 vols, New Haven and London, 1978–98

Gaskill, Howard, ed., *Ossian Revisited*, Edinburgh, 1991

Gerrard, Christine, *The Patriot Opposition to Walpole: Politics, Poetry, and National Myth 1725–1742*, Oxford, 1994

Gibbons, Luke, ' "A Shadowy Narrator": History, Art and

Romantic Nationalism in Ireland 1750–1850', in *Ideology and the Historians* (*Historical Studies XVII: Papers Read Before the Irish Conference of Historians Held at Trinity College, Dublin 8–10 June 1989*), ed. Ciarin Brady, Dublin, 1991, pp. 99–127

Goodreau, David, 'Nathaniel Dance, RA (1735–1811)', (Ph.D. diss., University of California, Los Angeles, 1973)

Gould, Eliga H., *The Persistence of Empire: British Political Culture in the Age of the American Revolution*, Chapel Hill, NC, and London, 2000

Guest, Harriet, 'The Wanton Muse: Politics and Gender in Gothic Theory After 1760', in *Beyond Romanticism: New Approaches to Texts and Contexts 1780–1832*, ed. Stephen Copley and John Whale, London and New York, 1992, pp. 118–39

Guest, Harriet, *Small Change: Women, Learning, Patriotism, 1750–1810*, Chicago and London, 2000

Gunnis, Rupert, *Dictionary of British Sculptors 1660–1851*, rev. ed., London, n.d. (ca.1968)

Hägin, Peter, *The Epic Hero and the Decline of Heroic Poetry: A Study of the English Neoclassical Epic with Special Reference to Milton's 'Paradise Lost'*, Berne, 1964

Henderson, Andrea K., *Romantic Identities: Varieties of Subjectivity 1774–1830*, Cambridge, 1996

Henson, Eithne, *"The Fictions of Romantick Chivalry": Samuel Johnson and Romance*, London and Toronto, 1992

Hitchcock, Tim, and Michèle Cohen, eds, *English Masculinities 1660–1800*, London and New York, 1999

Hoock, Holger, *The King's Artists: The Royal Academy of Arts and the Politics of British Culture, 1760–1840*, Oxford, 2003

Hooker, Edward Niles, H. T. Swedenberg et al., eds, *The Works of John Dryden*, 20 vols, Berkeley, Los Angeles and London, 1956–89

Ingamells, John, ed., *A Dictionary of British and Irish Travellers In Italy 1701–1800: Compiled from the Brinsley Ford Archive*, New Haven and London, 1997

Irwin, David, 'Gavin Hamilton: Archaeologist, Painter, and Dealer', *Art Bulletin* 44 (1962), pp. 87–102

Kidson, Alex, *George Romney 1734–1802*, exhibition catalogue, National Portrait Gallery, London, 2002

King, James, and Charles Ryskamp, eds, *The Letters and Prose Writings of William Cowper*, 5 vols, Oxford, 1979–86

Knowles, John, *The Life and Writings of Henry Fuseli*, 3 vols, London, 1831; facsimile edition edited by David Weinglass, Millwood, NY, 1982

Kriz, Kay Dian, *The Idea of the English Landscape Painter: Genius as Alibi in the Early Nineteenth Century*, New Haven and London, 1997

Lewis, W. S., ed., *Yale Edition of Horace Walpole's Correspondence*, 48 vols, Oxford and New Haven, 1937–83

Macmillan, Duncan, 'The Earlier Career of Alexander Runciman and the Influences that Shaped his Style' (Ph.D. diss., University of Edinburgh, 1973)

Macmillan, Duncan, 'Alexander Runciman in Rome', *Burlington Magazine* 112 (1970), pp. 22–31

Macmillan, Duncan, ' "Truly National Designs": Runciman's Scottish Themes at Penicuik', *Art History* 1 (1978), pp. 90–98

Macmillan, Duncan, *Painting in Scotland: The Golden Age*, Oxford, 1986

Macpherson, James, *The Poems of Ossian and Related Works*, ed. Howard Gaskill, Edinburgh, 1996

McDiarmid, Matthew P., *The Poems of Robert Fergusson*, 2 vols, Edinburgh and London, 1954–56

McNairn, Alan, *Behold the Hero: General Wolfe and the Arts in the Eighteenth Century*, Quebec, 1997

Makdisi, Saree, *William Blake and the Impossible History of the 1790s*, Chicago and London, 2003

Mason, Eudo C., *The Mind of Henry Fuseli: Selections from his Writings with an Introductory Study*, London, 1951

Moore, Dafydd, *Enlightenment and Romance in James Macpherson's The Poems of Ossian: Myth, Genre and Cultural Change*, Aldershot, UK, 2003

Mullan, John, *Sentiment and Sociability: The Language of Feeling in the Eighteenth Century*, Oxford, 1988

Muschg, Walter, ed., *Heinrich Füssli: Briefe*, Basle, 1942

Newman, Gerald, *The Rise of English Nationalism: A Cultural History 1740–1830*, Basingstoke and London, 1997

O'Brien, Conor Cruise, *The Great Melody: A Thematic Biography and Commented Anthology of Edmund Burke*, London, 1992

Ogborn, Miles, *Spaces of Modernity: London's Geographies, 1680–1780*, New York and London, 1998

Pape, Walter, and Frederick Burwick, eds, *The Boydell Shakespeare Gallery*, Bottrop, Germany, 1996

Paulson, Ronald, *Hogarth*, 3 vols, New Brunswick and London 1991–3, 1992

Paulson, Ronald, *The Beautiful, Novel and Strange: Aesthetics and Heterodoxy*, Baltimore and London, 1996

Phillips, Mark Salber, *Society and Sentiment: Genres of Historical Writing in Britain, 1740–1820*, Princeton, 2000

Pocock, J. G. A., *The Machiavellian Moment: Florentine Political Thought and the Atlantic Republican Tradition*, Princeton, 1975

Pocock, J. G. A., *Virtue, Commerce and History: Essays on Political Thought and History, Chiefly in the Eighteenth Century*, Cambridge 1985

Pocock, J. G. A., *Barbarism and Religion*, Cambridge, 1999–

Pocock, J. G. A., ed., *Three British Revolutions: 1641, 1688, 1776*, Princeton, 1980

Pocock, J. G. A., ed., *The Varieties of British Political Thought, 1500–1800*, Cambridge, 1993

Pope, Alexander, trans., *The Iliad of Homer*, 2 vols, ed. Maynard Mack, Twickenham Edition of the Poems of Alexander Pope, vols 7 and 8, London and New Haven, 1967

Pope, Alexander, *The Odyssey of Homer*, 2 vols, ed. Maynard Mack, Twickenham Edition of the Poems of Alexander Pope, vols 9 and 10, London and New Haven, 1967

Pope, Willard Bissell, ed., *The Diary of Benjamin Robert Haydon*, 5 vols, Cambridge, Mass., 1960–63

Potts, Alex, *Flesh and the Ideal: Winckelmann and the Origins of Art History*, New Haven and London, 1994

Pressly, Nancy *The Fuseli Circle in Rome: Early Romantic Art of the 1770s*, exhibition catalogue, Yale Center for British Art, New Haven, 1979

Pressly, William L., *The Life and Art of James Barry*, New Haven and London, 1981

Pressly, William L., ed., 'Facts and Recollections of the XVIIIth Century in a Memoir of John Francis Rigaud Esq., RA. by Stephen Francis Dutilh Rigaud', *Walpole Society 50* (1984), pp. 1–164

Rather, Susan, 'Carpenter, Tailor, Shoemaker, Artist: Copley and Portrait Painting around 1770', *Art Bulletin 79* (1997), pp. 269–90

Raven, James, *Judging New Wealth: Popular Publishing and Responses to Commerce in England, 1750–1800*, Oxford, 1992

Reynolds, Sir Joshua, *Discourses on Art*, ed. Robert R. Wark, New Haven and London, 1975

[Ross, Walter], *A Description of the Paintings in the Hall of Ossian at Pennycuik near Edinburgh*, Edinburgh, 1773

Rosso, G. A., 'Empire of the Sea: "King Edward the Third" and English Imperial Policy', in *Blake, Politics and History*, ed. Jackie DiSalvo, G. A. Rosso and Christopher Z. Hobson, New York and London, 1998, pp. 251–72

Rouquet, André, *The Present State of the Arts in England*, London, 1755; facsimile reprint with an introduction by R. W. Lightbown, London, 1970

Sainsbury, John, *Disaffected Patriots: London Supporters of Revolutionary America 1769–1782*, Kingston, 1987

Schiff, Gert, *Johann Heinrich Füssli*, 2 vols, Zurich and Munich, 1973

Scott, Walter, ed., *The Poetical Works of Anna Seward*, 3 vols, Edinburgh, 1810

Sher, Richard, *Church and University in the Scottish Enlightenment: The Moderate Literati of Edinburgh*, Edinburgh, 1985

Simpson, David, *Romanticism, Nationalism and the Revolt Against Theory*, Chicago and London, 1993

Smith, John Thomas, *Nollekens and his Times*, ed. Wilfred Whitten, 2 vols, London and New York, 1920

Solkin, David, *Painting for Money: The Visual Arts and the Public Sphere in Eighteenth-Century England*, New Haven and London, 1993

Solkin, David, ed., *Art on the Line: The Royal Academy Exhibitions at Somerset House 1780–1836*, New Haven and London, 2001

Spector, Robert D., *English Literary Periodicals and the Climate of Opinion During the Seven Years' War*, The Hague, 1966

Stafford, Fiona J., *The Sublime Savage: A Study of James Macpherson and the Poems of Ossian*, Edinburgh, 1988

Sunderland, John, 'Mortimer, Pine and Some Political Aspects of English History Painting', *Burlington Magazine 116* (1974), pp. 217–26

Sunderland, John, 'John Hamilton Mortimer: His Life and Works', *Walpole Society 52* (1986), pp. 19–22

Swedenberg, H. T., *The Theory of Epic in England 1650–1800*, Berkeley and Los Angeles, 1944

Turpin, John, *A School of Art in Dublin Since the Eighteenth Century: A History of the National College of Art and Design*, Dublin, 1995

Wahrman, Dror, 'The English Problem of Identity in the American Revolution', *American Historical Review 106* (2001), pp. 1236–62

Wahrman, Dror, *The Making of the Modern Self: Identity and Culture in Eighteenth-Century England*, New Haven and London, 2004

Watt, James, *Contesting the Gothic: Fiction, Genre and Cultural Conflict, 1764–1832*, Cambridge, 1999

Weinglass, David H., ed, *The Collected English Letters of Henry Fuseli*, Millwood, NY, 1982

Whitley, William T., *Artists and their Friends in England, 1700–1799*, 2 vols, 1928

Williams, Carolyn D., *Pope, Homer and Manliness: Some Aspects of Eighteenth-Century Learning*, London and New York, 1993

Wilson, Kathleen, *The Sense of the People: Politics, Culture and Imperialism in England 1715–1785*, Cambridge, 1995

Wilson, Kathleen, *The Island Race: Englishness, Empire and Gender in the Eighteenth Century*, London and New York, 2003

Zwicker, Steven N., *Lines of Authority: Politics and English Literary Culture, 1649–1689*, Ithaca, NY, and London, 1993

PHOTOGRAPH CREDITS

INDEX

Figures in *italics* refer to illustrations

Académie Royale, Paris 4, 5, 27, 160
Accademia Clementina, Bologna 85, 91, 254
Accademia del Nudo, Rome 343n6
Accademia di San Luca, Rome 68
Achilles 6-7, 70-1, 181
Act of Union 54, 146, 152
Adair, John 110
Adam, Robert 27, 30, 47, 54, 103, 127, 194, 200, 202, 320n30
 monument to Major John André 200, *200*, *201*, 202-6
 monument to Colonel Roger Townshend 29, 30-32
Adam, William 54, 103
Addison, Joseph 7, 10, 18, 23, 25
Adelphi, London 103, 197, *198*
Aeneas 6, 70-1, 327n64
Aeschylus 293
Aglionby, William 18
Aikman, William 54
Aix-la-Chapelle, Treaty of 47
Akenside, Mark 7
Albani, Count Allesandro 84
Alberti, Leon Battista 4, 184
Alexander, Robert 148
Algarotti, Francesco 348n72
Aliamet, Francis
 after Robert Edge Pine, *The Surrender of Calais to Edward III 41*
All Hallow's Church, London Wall 71
Allan, David 68, 154, 194
 Hector's Farewell to Andromache 67, 68
 Self-portrait 69
Allen, William 73
Amadis the Gaul 231, 236
American War of Independence 14, 151, 193-5, 200, 206, 208, 218, 220, 221-4, 237-8, 244, 305
André, Major John 199, 200-6, *200*, *201*, 209, 220, 223, 229
Anne, Queen 23
Antigallican Society 34
Apollo Belvedere 5, *5*
Aristotle 6, 339n19

Armstrong, Dr John 164, 166, 268, 336n18, 344n22, 345n28
Arnold, Benedict 200
art education 19-20, 101-2, 195-6, 296-7, 341-2n49
Arundell, eighth earl of 163
Athamas 291-2

Bacon, John 206, 209, 322n62
 monument to William Pitt, earl of Chatham (Westminster Abbey) 206, *207*, 208-9
 monument to William Pitt, earl of Chatham (Guildhall) 206, *207*, 207-9
Baker, Robert 12-15
Bakhtin, Mikhail 316n14
Bandinelli, Baccio 174, 182
 sheet of figure studies *183*
banditti 129-34, *132-3*, *135*, 137-8, 141-2, 218-19, 242, 337n46
Banks, Thomas 13, 14, 176-82, 183, 186, 189, 253, 256-64, 280, 281, 294, 297, 322n62
 Achilles Mourning 258, 291
 Alycone Discovering the Body of her Husband Ceyx 178, 179-81, 284, 289, 291
 Caractacus Pleading Before the Emperor Claudius in Rome 177, 178
 The Death of Germanicus 176, 177-9, 284
 Design for a National Monument to the Memory of Captain Cook *181*, 186, 281
 The Falling Titan 256, *259*, 260-4, 280
 The Falling Titan (etching) *262*, 262
 Prometheus and the Vulture 177, 258
 Thetis and her Nymphs Rising from the Sea to Console Achilles for the Loss of Patroclus 179, 181,
Barendsz., Dirck 214, *215*
Barlow, William 176, 347n54
Barré, Sir Isaac 110, 207
Barrell, John 4, 311-12
Barry, James 13, 74, 76-94, 127, 145, 161-2, 168, 174, 189, 196-200, 208, 220-1, 224, 254, 266, 278, 297, 299, 305
 The Baptism of the King of Cashel by St Patrick 76
 The Death of General Wolfe 220-21, 221

decorations for the Great Room of the Society of
 Arts 197-8, *198*
Detail of Diogorades Victors 199
drawn study for *Philoctetes on the Island of
 Lemnos 89*
Lear and Cordelia 296
Philoctetes (print) 90, *91*
Philoctetes on the Island of Lemnos 85-90, *87*
*Self-portrait With Edmund Burke in the Charac-
 ters of Ulysses and a Companion fleeing from
 the Cave of Polyphemus* 92-4, *93*
The Temptation of Adam 83, *84-5*
William Pitt, Earl of Chatham 208
Bartoli, Pietro Santi
 engraving of an ancient triclinium *61*
Bartolozzi, Francesco 269
Basire, James 305
Bate, Revd Henry 116-19
Bates, Dr Benjamin 128, 288
Batoni, Pompeo 48, 50, 55, 58, 60, 97, 163, 169,
 324n11, 349n5
 Hector's Farewell to Andromache 51
 *Portrait of Charles Compton, Seventh Earl of
 Northampton 59*
Beattie, James 137-8, 141, 153, 240, 273
Beaufort, Daniel Augustus 355n32
Beaufort, Henry Somerset, Duke of 176
Beautiful, the 11, 263, 317n42
Beckford, William 227, 322n62
Beggar's Benison Club 340n30
Belisarius 121
Belloy, Dorment de 40
Belvedere Torso 90
Bermingham, Ann 175
Bernard, Sir Thomas 281-2
Bernini, Gian Lorenzo
 Neptune and Glaucus 276-7, *277*
Bindman, David 24, 222
Blackwell, Thomas 58
Blair, Hugh 150-2, 153, 341n36
Blair, Robert 206
Blake, William 12, 14, 142, 185, 221, 247-8, 273,
 305-10, 313, 361n79
 Europe a Prophecy 306, *314*
 Joseph of Arimathea among the Rocks of Albion
 305, *307, 309*
Bluck, J.
 after Augustus Pugin, view of the aisle of West-
 minster Abbey *203*
Blundell, Henry 357n54
Blyth, Robert 141
 after John Hamilton Mortimer, *Packhorse with
 Soldiers 133*
Board of Trustees for Fisheries, Manufactures and
 Improvements in Scotland 21, 152, 160, 341-2n49
Bodmer, J.J. 164
Bogle, John 54
Boileau, Nicolas 19
Bolla, Peter de 11
Boothby, Sir Brooke 227-30, *228, 238*, 354n8
Boscawen, Admiral 23, 30

Bossu, René le 4, 6, 151
Boston Massacre 116, 134
Boswell, James 325n30, 335n14
Boucher, François 78
Bourdieu, Pierre 315n8
Bowles, Thomas
 The Inside of Westminster Abbey 25
Bowyer, Robert 297, 300, 320n21
Boyd, John 56
Boydell, John 40, 248-9, 264, 297, *298-9*, 300, 309,
 366n24
Boydell, Josiah 358n80
Breitinger, J.J. 164
Bretherton, James
 after William Henry Bunbury, *The St James's Mac-
 aroni 113*
Breton, Luc-François 30
 relief on the monument to Colonel Roger Town-
 shend *29*
Bridgewater, Francis Egerton, Duke of 55, 66
British Institution, the 281
Brodie, William 152
Bromley, Revd Robert Anthony 110, 249, 251, 266
Brooke, Henry 1, 2, 312
Brown, Revd John 10, 11, 122
Brown, John (artist) 154, 185, 189
Browne, Lieutenant Henry 110
Brumoy, Fr Pierre 88
Burke, Edmund 11, 76, 77, 82, 84, 85, 92-4, 112,
 199, 207, 299, 317n42
Burke, Richard 77, 82
Burke, William 77
Burney, Charles 194-5, 196, 199, 345n34
Burney, Edward Francis 210
 view of the Royal Academy exhibition of 1784
 (east wall) *211*
 view of the Royal Academy exhibition of 1784
 (west wall) *214*
Burney, Frances 240
Burns, Robert 161
Bute, James Stuart, third earl of 34, 97, 105
Butts, John 328n8
Byres, James 79, 169, 327n54, 345n34, 348n83
Byron, lord 232

Caldwell, James
 after Henry Fuseli, *The Witches Appear to
 Macbeth and Banquo 297*
Capitsoldi, G.B. 179
Cambiaso, Luca 174, 182
Campbell, Thomas 312
Canning, George 368n23
Cape Club 152-3, 155, 159, 161, 340n30, 340n31
Caractacus 178
Carey, William 312
Carlini, Agostino 28
 design proposal for a monument to General Wolfe
 27, 320n23
Carlyle, Alexander 52-4
Carracci, Annibale 86, 157, 341n39
Carter, Elizabeth 136, 349n12

Carter, George 251n51
Carter, Thomas 283, 286
Casali, Andrea 42, 322n62, 332n35
Casanova, Giovanni Battista 80
Catherine II of Russia 256
Cervantes, Miguel de 2, 233-4
Chambers, William 12, 13, 27, 47, 103, 127, 163, 172, 189, 195, 320n19
Charles I, King 7, 46
Charles II, King 46, 124
Charlotte, Queen 306
Chêteau, Louis Charles
 after François Lemoyne, *Adam and Eve 82*
Chatham, Earl of *see* Pitt, William
Cheere, Sir Henry 38, 276, 287
Chewton, lord 164
Christie's, London 193, 257
chivalry 2, 234, 236, 238, 244
Churchill, Charles 26, 28, 43
Cicero 272
Cincinnatus 218
Cipriani, G.B. 28, 320n19, 336n18
civic humanism 2-3, 7, 270-1
civil society 3, 6, 9, 62
Clerk, Alexander 54
Clerk, Sir James 146-8, 152, 159, 160
Clerk, Sir John 146, 152
Clery, E.J. 250
climate, influence on the arts 18, 196, 295
Clive, Robert, lord 343n4
Clodion
 The River Scamadre 180, 181
Cochrane, William 68
Cocking, George 110-11
Cockerell, C.R. 365n86
Coke, Thomas 177-8
Cole, William 56
Colman, George 116, 118, 334n48, 337-8n52
Coltharp, Duane 58
conquistadors 114, 135, 186, 333n24, 337n44
Constable, W.G. 292
Cook, Captain James 182, 186, 199, 200, 211-12, 217, 222
Coote, Sir Eyre 257
copies, copying 71-2, 73-4, 75-6, 80-2, 167-8, 345-6n36
Copley, John Singleton 74, 109, 214
 The Death of Major Peirson 109, 111
 Watson and the Shark 214, 216
Corneille, Pierre 19
Cornewall, James 23
Correggio 74
Corsica 137
Cortona, Pietro da 71-2, 81
Cottle, Amos Simon 367n35
Cottrell, Clement 30
Cour, Mathon de la 78
Coutts, Thomas 164, 169, 268, 302, 345n36
Coutu, Joan 24
Cowper, William 57-8, 209, 326n54, 349n12
Cozens, Alexander 62

Creed, Major Richard 30, 202
crime, criminality 114, 134-6, 195, 218-20, 242, 333n29, 349n12
Crofts, Captain William 116, 118
Cromek, R.H. 306
Cullen, Fintan 77, 240
Culloden, battle of 106
Cumberland, Richard 36
Cummings, James 152
Cunego, Domenico
 after Gavin Hamilton, *Achilles Vents his Rage on Hector 64*
 after Gavin Hamilton, *Andromache Bewailing the Death of Hector 55, 326*
 after Gavin Hamilton, *The Anger of Achilles for the Loss of Briseis 65*
 after Gavin Hamilton, *Priam Pleading with Achilles for the Body of Hector 66*
Cunningham, Allan 129, 170, 256-7, 258, 263-4

Dance, George 68
Dance, Nathaniel 13, 47, 68-72, 75, 76, 81, 84, 97-8, 123, 160, 161, 169, 189, 269, 290, 297
 Aeneas and Venus 70
 after Pietro da Cortona, *Ananias Restoring the Sight of St Paul 71-2, 72, 81*
 The Death of Virginia 68-9, 70, 75
 Group Portrait of James Grant, John Mytton, Thomas Robinson and Thomas Wynn 49, 50
 The Meeting of Dido and Aeneas 70-1, 71
 Nisus and Euryalus 70
 satirical portrait of *James Barry 82*
 Timon of Athens 97-8, 98, 123, 332n35
Dante 293
Darly, Matthew 134
 after Edward Topham, *The Macaroni Print Shop 113*
 The Military Contrast 113-14, 114, 134
Darwin, Erasmus 335-6n16
Daulby, Daniel 242, 243, 247
Dawes, Manasseh 116, 118
Dayes, Edward 310
Deare, John 13, 14, 275, 276, 283-7, 288, 293
 Edward I and Eleanor of Castille 282, 284, 285, 291, 373n46, 364n53
 The Judgement of Jupiter 275, 284-5, 285, 289, 291
 sheet of figure studies, inscribed 'Mercury Stealing Apollo's Cattle' 287
 sheet of pen and ink drawings and annotations, titled 'Antique' 287
Debbieg, Captain Hugh 110
Declaration of Armed Neutrality 257
Delacour, William 21, 159
Delvaux, Laurent 27
Dennis, John 4, 7, 88
Diderot, Denis 78, 329n17, 329n20
Dionysius 272
Dioscuri 65, 174, 286
Diploma Work 253-4
Dolce, Ludovico 272

Domenichino 74, 158-9
drawing 5-6, 78, 85, 132, 182-3, 185, 167, 293-4
Don Quixote 2, 128, 236, 238
Drummond, Robert Hay 99
Duane, Matthew 91
duelling 134
Dublin Society 21, 34, 76, 78, 321n43
Dubos, Abbé 8, 18, 39, 196, 295
Dufresnoy, Charles 5-6, 184, 267, 271
Dumont, François 260
 Titan 260
Durno, James 332n34
Dryden, John 5, 7, 30
Earlom, Richard
 after Charles Brandoin, *The Exhibition of the Royal Academy in the Year 1771* 92
East India Company 135
Eaves, Morris 308
Edda, the 264-6
education 10, 48, 52-3, 55-8
Edward III, King 40-1, 245-7
effeminacy 10, 112-14, 116, 134, 193, 233, 237, 293, 317-18n44
empire 1, 9, 105, 120, 134-5, 145, 186, 193, 200, 220-1
emulation 6, 20, 22, 98, 103-4
'encouragement' 25, 45-6, 73, 98, 301
Ennis, Jacob 78
Epaminondas 28
epic 4, 6-7, 8, 36-7, 58, 88, 108-9, 217, 232, 234-6, 266, 312
Essenbach, Wolfram Von 231-2
Etty, William 311
Euphranor 271
Eusden, Laurence 292
exemplarity 3, 7, 11-12, 88, 100, 119-20, 216-17, 240, 293, 312

Fairborne, Sir Palmes 30, 202
Falconet, Etienne-Maurice 260
Falkland Islands 114
Farington, Joseph 280, 294, 302, 303, 309
Farnese Hercules 5
Félibien, André 5, 33
Fergusson, Adam 153-4
Fergusson, Robert 153-4, 160, 161, 337n47, 340-1n33
Fetherstonhaugh, Sir Harry 346n37
Findlater, James Ogilvy, Earl of 62
Fitzgerald, Colin 245
Fitzgerald, George Robert 116
five-point drawings 182-3
Flaxman, John 13, 14, 177, 258-9, 275, 276, 287-94, 292, 297, 306, 310, 312
 Apollo and Marpessa 289, 289
 Aurora Visiting Cephalus on Mount Ida 289, 290
 The Fury of Athamas 290-3, 291
 Hercules and Hebe 290
 The Blinding of Prometheus 292
 Tragedies of Aeschylus 292, 293
Foulis, Robert 21, 68

Foundling Hospital, London 18, 20
Fox-North Alliance 193
Francklin, Thomas 100
Fraser, Simon, lord Lovat 110
Frederick, Prince of Wales 20, 41, 46, 54, 97, 244
Free Society of Artists 195
French Revolution 14, 19, 269, 298, 299, 300, 303, 313
French Wars 14, 298
fresco 272-3, 308, 361n79
Fryer, Edward 76, 77
Fuseli, Henry 12, 13, 14, 86, 134, 155, 163-76, 165, 168, 179, 180-90, 197, 199, 227-32, 234, 238-245, 244, 247, 249-51, 253, 264-74, 286, 294, 297, 297, 298, 299, 301-3, 301, 305, 306, 308-13
 caricature of the artist leaving Italy 189, 189
 The Death of Cardinal Beaufort 170-2, 170, 185, 186
 The Death of Dido 228
 design for a 'Shakespeare Fresco': *Macbeth* 188, 189
 The Dispute Between Hotspur, Glendower, Mortimer and Worcester About the Division of England 243, 245
 Ezzelin Bracciaferro Musing Beside the Body of his Wife Meduna 232, 235
 figure study 184
 'five-point' drawing representing *Prometheus* 182
 King Lear Supported by Kent and the Fool Meeting Edgar on the Heath 185, 186
 Macbeth and the Armed Head 348n83
 The Nightmare 228, 231
 Percival Delivers Belisane from the Enchantment of Urma 230, 233, 242
 Prometheus Rescued by Hercules 261
 Satan Starting from the Touch of Ithruiel's Spear 228, 230
 Thor Battering the Mitgard Serpent 264-8, 264, 273-4
 unidentified scene (perhaps *Othar Rescuing Siritha from the Giant*) 250
 The Witches Show Macbeth Banquo's Descendents 172
 Wolfram introducing Betrand of Navarre to the Place where he had confined his Wife, 356n49

Gainsborough, Thomas 116, 124, 237
 Portrait of an Officer of the Fourth Regiment of Foot 237-8, 239, 355n35
 Reverend Henry Bate 117
Gandy, Joseph 364n57
Gardiner, Luke 55
Garrick, David 43, 107, 244
Gascoigne, Sir Thomas 347n60
Gaugain, Thomas
 after James Northcote, *Portraits of the Officers and Men who were Preserv'd from the Wreck of the Centaur* 213
gender 8, 12, 120, 130, 242-3, 305
genius 11, 165-6, 297 309-10 see also originality,

original genius
George III, King 20, 21-2, 27, 33-4, 41, 97-100, 102, 108, 120, 200, 202, 208, 223, 244, 245, 247, 331n4
George, Prince of Wales, later George IV 286
Germanicus 178
Germantown, battle of 238
Gibelin, Antoine-Esprit
 Bacchanal in a House in Strada Gregoriana . . . 175, *175*, 254
Gibbon, Edward 48, 52, 324n18
Gibbons, Grinling 23
Gibbons, Luke 76
Gillray, James 142, 218, 250, 368n23
 Tales of Wonder! 251
 The Thunderer 220
Girardon, François 19
Godwin, William 238, 247, 309, 366n32
Goldsmith, Oliver 8, 24, 25
Goltzius, Hendrick 162
Gordon, Thomas 134, 236
Gothic, Gothic romance 228-30, 232-3, 235-6, 238-42, 244-5, 250, 266, 292, 338n57, 355n32
'Gout Grec' 51
Grand Manner 4-6, 100-1, 196-7, 224, 311-13
Grand Tour 48-52, 58, 74, 81, 82-4, 153, 175
Grant, James Grant of 49, 50, 55, 62-3, 70, 72
Grantham, baron *see* Robinson, Thomas
Graves, Richard 236
Gray, Thomas 264-5
Gregson, Matthew 194, 242, 247, 357n54
Grenville, George 178
Greuze, Jean-Baptiste 78
Grey, George, lord 70
Gribelin, Simon
 after Charles Le Brun, *Alexander Before the Tent of Darius* 35
Grignion, Charles
 after Henry Fuseli, *engraved frontispiece to Remarks on Rousseau* 165
Grosley, Pierre-Jean 28, 102, 320n21
Grosvenor, Richard, lord 120
Guest, Harriet 202, 212, 242
Guildhall, London 199, 206-8, *209*
gunpowder 134, 336n33
Gwynn, John 12, 20, 45-6

Hadfield, George 364n57
hair (male) 119, 337n47
Hallé, Noël
 The Justice of Trajan 78, *79*
Hamilton, Alexander 52
Hamilton, G. 280, 363n38
Hamilton, Gavin 13, 21, 47-8, 52-68, *55*, *64-66*, 70, 74, 76, 77, 84, 97, 103, 148, 154, 160, 161, 170, 174, 178, 183, 193, 197, 293, 297, 306, 342n53, 363n38, 373n38
 Achilles Lamenting the Death of Patroclus 55, 62-4, *63*, 77
 Achilles Vents his Rage on Hector 55, 64-6, 75, 174, 306

Andromache Bewailing the Death of Hector 55, *55*, 58-61, 193, 284
painted study for *Andromache Bewailing the Death of Hector* 58, *61*
The Anger of Achilles for the Loss of Briseis 55, 66
Hector's Farwell to Andromache 67, *67*
Priam Pleading with Achilles for the Body of Hector 55
Wood and Dawkins Discovering Palmyra 55
Hamilton, Gawin 136
Hamilton, Hugh Douglas
 Portrait of Richard St George Mansergh St George 240, *241*, 355n34, 355n35
Hamilton, William 298
Handel Commemoration 200, 202
Harbord, Charles 20
Hare-Naylor, Georgina 293
Hartley, Mrs *see* White, Elizabeth
Hastings, Warren 193
Haughton, Moses
 after Henry Fuseli, *The Vision of the Lazar House* *301*
Haydon, Benjamin Robert 242, 310-11, 356n52
Hayman, Francis 17, 18, 20, 33-4, *34*, 42, 46, 58, 68, 97, 109, 172, 205, 215, 222
 The Humanity of General Amherst 33, *35*, 205
Hayward, Richard 176
Hemsterhuis, François 85
Henderson, Andrea 240
Herd, David 152, 155
Herder, Johann Gottfried 164, 268
Heriot, George 194, 196, 296
hero, the heroic, heroism 1-9, 11-12, 21, 33, 56-8, 70-1, 97, 134-5, 176, 186, 200, 202, 206, 216-17, 220, 224, 236, 240, 303-4, 312-13
Hervey, Augustus, bishop of Derry and earl of Bristol 181, 290, 364n56
Hickey, William 136
Historic Gallery 297
history 39-40, 233, 244-7
Hoare, Henry 50
Hoare, Prince 167, 185, 189, 264, 310, 360n37
Hogarth, William 8, 18, 20, 22, 26, 39, 138, 141, 172, 278, 288
Hollis, Thomas 38
Holmes, Admiral 29
Home, John 150, 153
Homer 12, 47, 56-8, 60, 115, 235-6, 243, 264, 282, 293-4, 329n29
Hope, Charles, lord 325n30
Hope, John 214
Hope, Thomas 290, 293
Horace 158
Howdalian Society 128
Howe, George Augustus, Viscount 32
Hume, Sir Abraham 280
Hume, David 39, 40, 42, 62, 70-1, 153, 164, 297, 344n24
Humphry, Ozias 190
Hunt, Leigh 308

Hunt, Robert 308, 309, 368n19
Hunter, Martin 238
Hurd, Richard 11, 48-9, 235
Hussey, Giles 91-2, 288, 331n57
 study of a nude figure 91
hygiene (personal) 134, 138

Incorporation of St Mary's Chapel, Edinburgh 145
individualism 274, 300, 312-13
Inglefield, Captain John Nicholson 200, 212-14,
 213, 217
Irwin, David 292
Ixion 280

James I, King 248
Janson, Horst 107
Jefferson, Thomas 224
Jefferys, James 185, 189
 unidentified scene 187
Jenkins, Thomas 345n34
John Bull 206
Johnes, Thomas, of Hafod 258
Johnson, Joseph 164, 248, 302, 303, 367n33
Johnson, Samuel 8, 25, 38-9, 89, 115, 303
Johnson, Sir William 110
Jones, Inigo 44
Jones, Thomas 128
Joseph of Arimathea 309
Junius, Franciscus 271

Kames, Henry Home, lord 22, 36-7, 89, 114
Kauffman, Angelica 124-6, 125, 159, 269, 283, 284
 Edgar and Elfrida 124
 Ermina Finding Tancred 124
 Trenmor and Imbaca, the Moment of her Discov-
 ery to Trenmor 159, 159
King, James 211
Knight, Edward 288
Knight, Richard Payne 175-6
Kriz, Kay Dian 312

Lairesse, Gerard de 128
Lancashire, Thomas 152
Landseer, Edwin Henry 311
Laocoön 90, 292
Lavater, Johan Caspar 164, 166, 170, 242, 266, 268,
 346n48, 356n51
Lawrence, Thomas 253, 294, 303
Le Brun, Charles 33, 40, 58, 109, 166, 204, 344n22
Leland, Thomas 234-5
Lemoyne, François 78, 82, 84
Leopold, Prince of Brunswick 215-16, 217, 217
Leslie, Charles Robert 311
libertinism 176, 298
linear style 85
Lips, Johann Heinrich
 after Henry Fuseli, plate from Johann Caspar
 Lavater, Essai sur la Physiognomie 244
Lloyd, Evan 43-4
Locatelli, John Baptist 310n19
Lock, Frederica 240

Lock, F. P. 92
Lock, William 240, 302, 360n37
Lockhart, John Gobson 342n53
Longinus 43, 158-9, 341n44
Loo, Carle van 78
Louis XIV, King of France 19, 46, 124
Loutherbourg, Phillip James de 336n23
luxury 9-10, 105, 112, 114, 119, 150, 153, 193, 269-
 71, 342n55
Lyttelton, Thomas, lord 116, 118

Macaroni, the 112-14, 113, 115, 119, 134, 134, 135-
 6, 137, 145, 153, 193, 220, 337n47
Macaulay, Catherine 40
Mackenzie, Francis Humberton 245
Mackenzie, Henry 160-1
Macklin, Thomas 297, 300
Macpherson, James 11, 115, 150, 152
Mainwairing, Henry 70
Malone, Edmund 199
Mallet, Paul-Henri 264
Malton, Thomas
 The Strand, with Somerset House and St Mary's
 Church 195
Mangan, Michael 130
Maratta, Carlo 54, 72, 299
Marigny, Marquis de 77-8
Marius, Caius 124
Marmontel, Jean-François 121-2, 333n24
Martial Macaroni, The 134, 134
Martini, Pietro Antonio
 after Johann Heinrich Ramberg, The Exhibition of
 the Royal Academy, 1787 249
masculinity 1-4, 6-7, 8-12, 49, 58, 72, 119, 129-30,
 134, 137, 144, 145, 217, 224, 254-4, 268, 273-4,
 277, 293, 313, 317-18n44, 340n30
Masucci, Agostino 54
Maurice, Thomas 56-7, 58, 204, 340n30
Maxwell-Clerk, George 159
McLaurie, Dugald 145, 146
medley, the 320n16
Mengs, Anton Raffael 48, 50, 62, 70, 74, 79, 81, 97,
 163, 324n11
 Augustus and Cleopatra 50, 53
Mercer, General 222, 223
Michelangelo and the Michelangeloesque 2, 12, 72,
 81, 170, 188, 254, 266, 267-8, 302, 305, 306, 309
Millar, Andrew 164
Miles, Captain (pseud.) 116
Milton, John 230, 243, 300, 302-3
Milton Gallery 301-3, 308, 309, 367n35
Minden, battle of 123, 126
Mitchell, Sir Andrew 164
modern-life subjects 8, 33, 36-8, 107-9
Mohawks, the 136-7, 145, 220, 337n49, 337n52
Monckton, Robert 110
Montesquieu, baron de 18, 196, 295
Montgomery, General Richard 222, 222
monuments, memorial function of 23-4, 361n5
Moore, Dafydd 151
Mortimer, John Hamilton, 13, 14, 42-4, 72, 86, 121-

4, *126-34*, *133*, *137-44*, 145, 149, 197, *218-19*, 232, 244, 247, 305
Banditti Returning 142
The Battle of Agincourt 141
Belisarius 121, 122, 123, 129
caricature group 128, *128*
Caius Marius on the Ruins of Carthage 123, 124, 126, 129
A Captain of Banditti Sending out a Party 131
The Life and Death of a Soldier 140, 141
The Progress of Vice 138-41, *139*
St Paul Preaching to the Ancient Druids in Britain 42-4, *42*, 86, 123, 127
Salvator Rosa 128, *129*
Self-portrait 128-9, *129*
Sir Artegal the Knight of Justice, with Talus the Iron Man 141-2, *143*
Mulready, William 311
Murdoch, Patrick 164

narrative 4-5, 138-41, 142, 152, 157, 176, 184, 188, 240, 303
nationalism 21, 145, 299-300
Nadir Shah ('Kouli Khan') 2
Natoire, Charles-Joseph 78
Navarre, Margaret of 356n49
Nelson, Admiral Horatio 208
Nevay, James 103, 332n34, 349n5
Newton, Francis Milner 284
Nieuwe Kerk, Amsterdam 23
Ninus 2
Niobe and her Daughter 292
Nollekens, Joseph 322n62, 332n2
Nordic myth 266
Norie, Robert 145
Nories (firm) 146
Normand, Louis Marie
 after Thomas Procter, *Ixion* 278
 after Thomas Procter, *Pirithous* 279
North, Frederick 107
Northampton, Charles Compton, Seventh Earl of 55, 58-60, *59*
Northcote, James 177, 185, 189-90, 200, 212-16, 224, 248
 Captain Inglefield Escaping from the Ship the Centaur 212-15
 The Death of Prince Leopold of Brunswick 215-16, 217
 The Death of Wat Tyler 248, *248*
Northumberland, Duke of 80
Northwick, John Rushout, second baron 364n53
nude, the 5-6, 107, 253-4, 267-8

O'Byrne, Matthias 116, 118, 137, 334n41
Oeser, Adam Friedrich 158
O'Hara, Charles 77
oil paint 270-3
Opie, John 248, 278, 303
 The Death of James I of Scotland 248
 The Death of Rizzio 248
Oglethorpe, James Edward 216, 335n14

opium 250, 358n83
Order of Cincinnati 218
Oriental tales 131
originality, original genius 11, 58, 82-4, 94, 149, 161, 171, 243, 299
Ossian 11, 115, 149-51, 155-8, 161, 264, 282
Ossian's Hall, Penicuik House, Midlothian 145, *148*, 149-50, 160, 197
Ottley, William Young 273
Otway, Thomas 124
'outlaw masculinity' 130
outline 85, 293-4
Ovid 180, 290, 291

Paetus and Arria 70, 292
Paine, James 332n34
Palladio 44
Palmerston, Henry Temple, lord 55, 66, 67-8
Parrhasius 90, 271
Pasquin, Anthony *see* Williams, John
Patrickson, Margaret 164
Paul the Apostle 42
Paulson, Ronald 8
Paye, Richard Morton 359n29
Penal Laws 76, 77, 328n4
Penicuik House, Midlothian 146, *148*, 149, 160, 197
Penn, John 364n56
Penny, Edward 37-8, 110
Percival, Perceval 232
Percy, Thomas 11, *133*
Peters, Matthew William 52
phallus, phallic symbolism 170, 175-6, 190, 254-5, 340n30
Phidias 2
Philoctetes 88
Philostratus the Younger 90
physiognomy 242, 346n48
Pigalle, J. B. 27
Piles, Roger de 72, 158, 272
Pilkington, Matthew 130, 158
Pine, Robert Edge 40-1, 41, 42, 58, 72, 102, 109, 172, 246, 322n62
Piranesi, Giovanni Battista 30, 80, 183
Pirithous 280
Piroli, Tomaso 293
 after John Flaxman, *Hector's Body Dragged at the Car of Achilles* 292
Pitt, William (later Earl of Chatham) 24-5, 28, 33-4, 105, 122, 199, 206-9, 220, 224
Pitt, William, the younger 308
Pliny 272
Plutarch 271
Pocock, J. G. A. 2-3, 39
Poet's Gallery 297, 298, 300
Poker Club 152, 155
Pole, Edward Sacheverell 123-4, 126-7, *127*
Pole, Elizabeth Sacheverell 127, *127*, 335-6n16
Pole, German 123-4
politeness, polite society 6-7, 10
Pope, Alexander 6, 24
pork, raw, consumption of 250, 358n83

Porter, Robert Ker 303

Poussin, Nicolas 19, 58, 68, 104, 158-9, 170, 299
 Death of Germanicus 60

Pressly, William 198, 254

primitivism 11, 47, 58, 150-2, 155-6

Princeton, battle of 222

printmaking, print reproduction 66, 133, 197-8, 223-4, 256, 294, 193-4, 295, 306

Procrustes 368n22

Procter, Thomas 13, 14, 259, 275, 278-83, 296
 The Accusers of Daniel Thrown in the Lion's Den 280, 362n37
 The Death of Diomedes 279, 283
 Ixion 278, 279, 362n37
 Pirithous 279, 279, 281, 362n37

Quebec, sieges of 24, 222

Quixotism 3, 14, 187-8, 200, 208, 218, 224, 240

Racine, Jean 19

Radburne Hall, Derbyshire 123-4, 127, 197

Ramberg, Johann Heinrich 200, 211, 222
 Death of Captain Cook 211-12, 212

Ramsay, Allan 38

Raphael 7-8, 12, 42-3, 68, 72, 74, 79, 81, 158-9, 181, 299, 302
 St Paul at Athens 9

Ravenet, Simon Francis
 after Francis Hayman, *The Triumph of Britannia* 34

Ravenhill, Thomas
 engraved illustration to the monument of Major John André *201*

Reeve, Clara 236, 247

reform, reformation (cultural) 9-11, 21-2, 38, 52, 67-8, 77-8, 150, 161-2, 243, 268, 294, 298, 317n42

Reformation, Protestant 18, 81, 197

Regulus, Marcus Atilius 99

Rembrandt 214

Reni, Guido 55, 74, 86, 330n41

Repton, Humphrey 300

restorations, sculptural 80-1, 169

Restout, Jean 78

Reynolds, Sir Joshua 13, 29, 38, 47, 55, 92, 100-1, 102-3, 118, 124, 138, 141, 142, 164, 168, 177, 179, 183, 185, 186, 189, 196, 197, 199, 217-20, 228, 264, 270, 271, 273, 274, 275-8, 280, 285, 292-3, 299, 305, 309
 Portrait of Lieutenant-Colonel Banastre Tarleton 217-18, 219

Richard III, King 248

Richardson, Samuel 234

Richmond, Charles Lennox, Duke of 21, 27, 36

Rigaud, John Francis 14, 175, 253, 254-6, 257, 258
 Hercules Resting from his Labours 254, 256
 Samson Breaking his Bonds 254-6, 255

Rigby, Richard 207-8

Ritson, Joseph 248

Rivers, George Pitt, lord 345n35

Robertson, William 153, 333n24

Robinson, Thomas (later baron Grantham) 49, 50-2,

55, 56, 58, 72, 82-4, 102, 103, 269, 324n11

Robinson Crusoe 236

Romney, George 34, 36-8, 110, 185, 190, 230, 306
 The Death of Wolfe 36, *37*
 Prometheus Bound 185, *188*

Rosa, Salvator 12, 121, 128-9, 130, 131, 134, 137, 142, 149, 262, 336n23
 Belisarius 121, *122*
 The Fall of the Giants 262, *263*
 Figurine 129, *130*, *131*

Roscoe, William 232, 242-3, 301, 302

Ross, Walter 146, 156-8, 159, 160, 161, 341n35, 343n59

Rossi, John Charles Felix 284, 312

Roubiliac, Louis François 24, 28, 110, 199, 287, 320n23
 monument to Sir Peter Warren 26

Rouquet, André 17-20, 22, 23, 24, 39, 97, 102, 295, 312, 318n1

Rousseau, Jean-Jacques 164-6, 199, 343n9, 344-5n24, 350n24

Rousselet, Gilles
 after Guido Reni, *Hercules on the Pyre* 86

Rowan, Archibald Hamilton 136, 237

Rowe, Nicholas 116

Rowlandson, Thomas 142
 The Champion of the People 267

Royal Academy of Arts, London 13, 20-1, 99, 100-3, 121, 142, 144, 159, 163, 164, 176, 179, 186, 189, 195-6, 209-10, 211, *211*, 212, 214, *214*, 228, 245, 248, 249, 253, 254, 258, 275, 288, 292, 295, 302, 305, 310, 312

Rubens, Peter Paul 271, 338n11

Runciman, Alexander 13, 14, 86, 145-50, 152-62, 189, 197, 232, 266, 305
 Achilles Dragging the Body of Hector around the Tomb of Patroclus 147
 Cormar Attacking the Spirit of the Waters 149
 The Death of Oscar 157, 158
 self-portrait with John Brown 154, 155
 Thetis Dipping the Infant Achilles in the Styx 146

Runciman, James 145, 338n3

Runciman, John 146
 Portrait of Alexander Runciman 154

Ruyter, Admiral de 23, 32

Ryland, William Wynne
 after Angelica Kauffman, *Eleanora Sucking the Venom out of the Wound which Edward I, her Royal Consort Received from a Poisoned Dagger 283*
 with William Sharp, after Angelica Kauffman, *The Interview Between Edgar and Elfrida after her Marriage with Ethelwold 125*

Ryley, Charles Reuben 142, 320n21

Rysbrack, Michael 26, 28, 295
 design proposal for a monument to General Wolfe 26, 320n23

Ryves, Elizabeth 227

Sadeler, Jan
 after Dirck Barendsz., *Jonah Swallowed by the*

Whale 214, *215*
St George, Richard St George Mansergh 227, 228, 229, 237-40, *239*, *241*, *242*, 355n35
 Refin'd Taste 237, *237*
St George's Field Massacre 115
St Martin's Lane Academy, London 19-20, 36, 46
St Paul's Cathedral, London 102, 199, 206, 208, 312
St Vincent, island of 135
Samson 254
Samwell, David 106, 242
Sancho, Ignatius 142
Sancho Panza 236, 238
Sandwich, Edward Montagu, earl of 30
Scaevola, Mutius 350-1n8
Scheemakers, Peter 32, 176
 monument to George Augustus, Viscount Howe 32
Schiavonetti, Louis 306
sculpture 102, 276-8, 292-3
Select Society 21, 152-3, 155
Sergel, Johan Tobias 169, 174-5, 254
 caricature portrait of Henry Fuseli *169*
 Rigaud a la Villa Madama 254, *257*
Seven Years War 9, 19, 22, 46, 48, 51-2, 105, 114, 151, 164, 207
Seward, Anna 201-2, 224, 227, 229, 238
Seward, William 302
Shackleton, Mary 199-200, 201, 208, 209-10, 211, 217, 220, 224
Shackleton, Richard 199
Shaftesbury, Anthony Ashley Cooper, Third Earl of 4, 6, 18, 269, 271
Shakespeare, William 97-8, 124, 172-4, 188, 243, 297, 299
Shakespeare Gallery (London) 297-301
Shakespeare Gallery (Dublin) 297
Sharp, Samuel 75-6
Shaw, Cuthbert 126
Shipley, William 38
Shovell, Sir Clowdisley 23
Sinbad 236
slave trade 242
Sleigh, Joseph Fenn 76
Slodtz, Pierre Ambrose 260
Smith, Adam 8, 88-9, 153, 156-7
Smith, John Raphael
 after Henry Fuseli, *Belisane and Perceval under the Enchantment of Urma* 234
Smith, John Thomas 275
Smith, William 43
Smollett, Tobias 131, 234, 236, 237
Smyth, Captain Hervey 110
Smyth, Sir Robert 169, 345n36
Society of Artists (London) 20, 21, 60, 62, 99, 100, 103, 121, 128, 138, 195
Society of Artists (Dublin) 76
Society of Arts (Society for the Encouragements of Arts, Manufactures and Commerce) 13, 20, 21, 34-46, 47, 70, 102, 103, 107, 115, 178, 197-200, *198*, 248, 258, 284, 305
Society of Dilettanti 20
Solkin, David 6, 33, 120

Somerset House 195-6, *195*, 199, 295
Sophocles 85, 88, 89, 243
Sorensen, Janet 164
Spence, Joseph 56
Spencer, John, lord 325n30
Spencer, Georgina, dowager Countess 293
Spenser, Edmund 141, 230, 243, 300
Stamp Act Crisis 45, 122
Stanhope, James, First Earl of 26
Steele, Richard 7, 8, 10, 28, 71
Steevens, George 302
Sterne, Laurence 336n18
Stothard, Thomas 142, 298, 310
Stringer, John 247
Stringer, Samuel 357n54
Stuart, James 32, 77
Sturm und Drang 344n21, 348n78
Sublime, the 11-12, 65-66, 90, 94, 130, 138, 141, 151, 158-9, 166, 172-4, 178, 240, 244, 258, 261-3, 266, 273, 287, 290-1, 305, 309
swearing 166, 345n25
Sweet, Nanora 242
sympathy 8, 31, 62, 65, 88-9, 108

Tarleton, Lieutenant-Colonel Banastre 200, 217-20, *219*
Tatham, C. H. 294
Tatham, Edward 116
Tavistock, Francis Russell, lord 55, 64, 66, 326n50
Taylor, Gary 299
Taylor, John 310
Taylor, Robert 23
Temple, William 4
Testa, Giovanni Cesare
 after Pietro Testa, *The Dead Christ* 86, *88*
Testa, Pietro 12, 86, 88, 149, 174
 Achilles Dragging the Body of Hector Around the Walls of Troy 147
 The Prophecy of Basildes 86
 The Suicide of Dido 173
Thompson, Edward 122
Thomson, James 18-19, 230, 300
Thornhill, James 43, 102
 St Paul Preaching at Athens 43
Thornton, Bonnell 10
Thorpe, John 163
Tibaldi, Pellegrino 170
 design for *St Ambrose Receives the Consular Insignia for the Governorship of Liguria and Emilia 171*
Ticonderoga, siege of 30
Timanthes 158
Time Past, Time Present 205, *206*, 209
Timon of Athens 97-8
Titian 74
Tower of London 199
Townshend, Colonel Roger 29, 30-2, 202, 204, *205*, 206
Townshend, Lady 30-1, 320n30
tragedy 7, 38, 108-9
Tresham, Henry 185, 189
Trumbull, John 218, 220, 221-4, 335n13

The Death of General Mercer at the Battle of Princeton 222, 223
The Death of General Montgomery in the Attack on Québec 222, 222
Trustees' Academy, Edinburgh 21, 159-60, 161, 341-2n49
Turnbull, George 270, 271
Tweeddale, George Hay, Maquess of 54-5
Twining, Thomas 199
Tyers, Jonathan 33
Tyler, Wat 248, 248

Ulysses 7, 93
Upper Ossory, John Fitzpatrick, Earl of 56, 326n50

Valdré, Vincenzo 175
Vandermeulen, John 322n62
Vangelder, Peter Matthias 200, 202, 204
 monument to Major John André 200
Vasari, Giorgio 268
Vauxhall Affray, the 116-119
Vauxhall Gardens, London 13, 18, 33-4, 40, 42, 46, 47, 97, 116, 222
Verhulst, Rombout 23
Vernet, Claude-Joseph 78
Vertue, George 318n1
Vico, Enea 181
Vien, Joseph-Marie 78
Virgil, Virgilian 12, 70-1, 72, 169, 290, 329n29
Virginia 70
Voltaire 121, 164, 165, 321n47
Vuillamy 283

Wahrman, Dror 12
Walpole, Horace 28-9, 135, 152, 193, 195, 207, 220, 227, 279, 295, 320n30
Walpole, Robert 193
Walton, Henry 335n13
Warburton, William 132, 233-4
Warren, Admiral Sir Peter 26, 110
Warren, General 222
Warton, Joseph 11
Warton, Thomas 11
Washington, General George 202, 204-5, 206, 218
Watts, William 194
Webb, Daniel 62, 272
Weddell, William 56
Wedgwood, Josiah 287, 288
Wendeborn, Gerhard Frederick Augustus 295-7
West, Benjamin 13, 47, 71, 72-4, 75, 76, 77, 81, 98-99, 100, 103, 104, 108-11, 114, 116, 119-20, 123, 129, 134, 145, 160, 161, 168-9, 178, 183, 190, 199, 207, 210-11, 212, 215, 220-2, 228, 245-7, 249, 251, 266, 268, 269, 278, 279, 280, 290, 293, 295, 297, 312, 327n75, 332n35, 353n72
 Alexander, the Third King of Scotland, Rescued from the Fury of a Stag 245, 246, 246
 Agrippina Landing at Brundisium with the Ashes of Germanicus 99
 The Battle of the Boyne 120

The Battle of La Hogue 120
The Death of Chevalier Bayard 120
The Death of Epaminondas 120
The Death of General Wolfe 108-11, 109, 119-20, 121, 129, 134, 145, 202, 208, 220, 222, 205
The Departure of Regulus from Rome 99-100, 99, 110, 123
General Monk Receiving Charles II on the Beach at Dover 120
Moses Receiving the Laws 199, 210
Oliver Cromwell Dissolving the Long Parliament 120
Orestes and Pylades 167, 168-9
Queen Philippa Soliciting her Husband Edward the Third to Save the Lives of the Brave Burghers of Calais 246, 247
Saul and the Witch of Endor 247
Venus and Cupid 73, 74
West, Gilbert 244
West, Robert 78
Westmacott, Richard 278
Westminster Method, the 325n29
Westall, Richard 253, 298
Westminster Abbey 13, 23-32, 25, 42, 47, 97, 105-7, 152, 199, 202-4, 203, 207, 208-9, 257, 312
Whinney, Margaret 292
White, Elizabeth ('Mrs Hartley') 116-18
Wilkes, John 43, 115, 344n22
Wilkie, David 311
Williams, Edward 248
Williams, John ('Anthony Pasquin') 78, 200
Williams, Linda 184
Williamson, Colonel George 110
Wilson, Gavin 152, 340n31
Wilson, Kathleen 186
Wilson, Richard 47, 278, 336n18
Wilton, Joseph 13, 27-9, 47, 105-8, 189, 199, 351n14
 monument to Admiral Holmes 27
 monument to General Wolfe 105-8, 107
Winckelmann, Johann Joachim 18, 62, 84-5, 90, 158, 164, 196, 276, 287, 295
Windsor Castle 210
Wolfe, General James 24-5, 27-8, 34, 36-8, 105-11, 107, 109, 114, 119-20, 199, 206, 207, 220-2, 221
Wollstonecraft, Mary 309
Woollett, William 207, 295
Woodmason, James 297
Worsley, Sir Richard 364n56
Wright, Joseph, of Derby 124, 128, 197, 227, 300, 336n18, 366n24
 Portrait of Brooke Boothby 228
 Portrait of Edward Sacheverell Pole 127
 Portrait of Elizabeth Sacheverell Pole 127
Wright, Patience 276
Wyatt, James 200

Youngquist, Paul 310

Zoffany, Johann 352n51
Zwicker, Stephen 6